Carte Blanche

Carte B

lanche

v.2 Painting

M

Contents

established

Foreword

Thousands of years before Western contact, First Nations people were responding to the vast tract of land, sky, weather, seas, tundra, ice and waterways we now call Canada by rendering images in coloured pigments. Sometimes these images were rendered on the land itself, as is the case with petroglyphs and other rock paintings, sometimes they were painted on skins, or carved and then painted on wooden poles. The spiritual world and the perceived world fused in such works, giving them a power beyond that which is easily definable. They are some of the most life-enhancing examples of the ability of image-makers to combine the universal and the intimate. "Here is the particular human that I am," they seem to say to us, "and this is the truth I see, right now."

Later came a different kind of painter: the first European cartographers, again utterly human in their tentative efforts to map the seemingly endless territory that was unfolding as they moved toward it and then across it on their voyages of "discovery." At first, confined to waterways, they recorded coastlines, following the line of a rocky shore, a bay, a river's edge and then the vast, open, liquid basins of the great lakes. Eventually, they travelled with survey teams farther and farther across the land and, with inks and coloured washes, tried to devise a shorthand that would describe for others all the newness of the geography through which they moved. Looking at those maps now, we are amazed by their innocence and wonder, and moved as well when we think of the hand that held the pen, the pencil, the brush.

The mapmakers were followed by the military watercolourists, men who were hired to make detailed pictures of what would otherwise remain inadequate verbal accounts of settlements and forts, flora and fauna, miraculous waterfalls, inland oceans, a multitude of birds and animals, and the richness and variety of native culture. Even at their most deliberately descriptive, the resulting paintings were concerned with beauty. A cloud formation or a distant forest might bring a suggestion of pantheism to the edge of a military fortress, woodland wildflowers growing near the boots of parading foot soldiers might soften the startling red of their uniforms. The small detail—a sail on the horizon, a bird in the sky—suggested intimacy and softened the whole.

Over the years, in Canadian painting, this intimacy has been consistently present: the human element, the hand that holds the tool—sometimes, in native art, the handprint itself. For this reason, it is often the imperfection, the awkward line, the broken rule, the surprising juxtaposition that will make a painting great, for the wonderful thing about painting is that it is personal. "This is the particular person I am," they seem to say, "and this is the truth I see, right now." That truth can be anything: a flat colour, an absence of colour, a precisely rendered slice of the perceived world, inner life, a vision, the recognizable, the utterly unrecognizable, a huge photo image, a selection of words, because what we have in a painting is a single human mind making a choice of what it wants to show us about coloured form. In this way, a painting is always intimate, generous and inclusive.

Jane Urquhart

I was born at the same time as many of the cultural institutions of this country: The Stratford Festival, The Canadian Opera Company, The National Ballet of Canada and, perhaps most important, The Canada Council for the Arts. As a result, I came of age during a developmental period alongside many exciting ventures in the arts at a time when Canadian painters (and Canadian writers) were being given the attention of a culturally educated public no longer content to look elsewhere for the fruits of artistic expression. By the time I was in my 20s, galleries, both public and private, were being born, important curators were flourishing, and art magazines were being published and read. There is a headiness attached to a developmental period, and a sense of an awakening community working together, through time and change, toward a common goal.

Time and change—a kind of gestation—are a part of how various movements in painting are born, hence an important element in this book's structure is its division into the categories of Emerging, Mid-Career and Established painters. Many things can happen to painters between the time they emerge and the moment when, if they are lucky enough to have survived, they can be called established. The work will change, and the person making the work will change. A Byzantine mixture of accidents, luck, circumstances, fashion, commitment, and, of course, talent will determine whether or not a painter is able to make the full journey. It is interesting to note how the numbers diminish as one moves through the three sections in the book: there are 79 Emerging Artists, 70 in Mid-career, and only 45 in the Established category. And yet, as we all have learned, a painter's placement in his or her career has little to do with the quality of the work. In fact, it can be a short distance from being established to being part of an establishment, the very thing that artists are designed to rebel against. All is in flux.

The Magenta Foundation is to be congratulated for producing this gorgeous volume, which gives Canadian painters the attention and the showplace they deserve. Artists finish paintings alone in a room, in humility and after hard work. This book is tantamount to a thunderous round of applause.

Jane Urquhart
Stratford, Ontario, April 2008

Préface

Des milliers d'années avant les premiers contacts avec la civilisation occidentale, les membres des Premières nations se servaient de pigments colorés pour représenter en images le vaste territoire, le ciel, le climat, la toundra, les glaces, les lacs et les rivières de ce qui constitue aujourd'hui le Canada. Parfois ces images étaient peintes sur des éléments du sol, comme dans le cas de pétroglyphes et autres peintures rupestres, parfois elles étaient faites sur des peaux d'animaux ou sculptées sur des pôles en bois, pour être peintes ensuite. Ces œuvres étaient des représentations de leur monde spirituel et sensoriel, ce qui leur donne une puissance presque indéfinissable. Elles démontrent le talent de leurs concepteurs à joindre l'intime et l'universel. « Voici l'être particulier que je suis » semblent-ils nous dire « et voici la réalité comme je la perçois en ce moment. »

Plus tard est venu un nouveau genre de peintre; les premiers cartographes européens. Ils étaient des gens pragmatiques qui, au cours de leurs voyages « de découverte », dessinaient la carte du territoire se déroulant presque à l'infini devant eux. Limités d'abord aux voies navigables, ils reproduisaient les littoraux en suivant les rives rocheuses, les baies, les bords des rivières et les rivages des bassins d'eau immenses et ouverts que forment les Grands Lacs. Plus tard, ils ont voyagé avec des équipes d'arpentage plus profondément à l'intérieur des terres. À l'aide d'encres et de couleurs, ils essayaient de dessiner le plus précisément possible la géographie des lieux qu'ils rencontraient. Lorsque l'on regarde ces cartes aujourd'hui, nous sommes impressionnés par leur innocence et leur beauté et l'on ressent une vive émotion en pensant à la main qui tenait le stylo, le crayon ou le pinceau qui les a dressés.

Les aquarellistes militaires ont suivi. Ils étaient engagés pour faire des dessins détaillés d'établissements et de forts, de la flore et de la faune, des mers intérieures et des chutes prodigieuses, de la grande diversité d'oiseaux et d'animaux, de la richesse et des multiples facettes de la culture autochtone. Sans eux, seuls des écrits auraient été pour nous la mémoire, parfois défaillante, de cette époque. Même dans les reproductions les plus délibérément descriptives, l'on portait une attention particulière à la beauté du résultat final. La présence lointaine de nuages en formation ou de l'orée d'un bois pouvait parfois ajouter une dimension panthéiste aux abords d'une forteresse militaire. L'ajout de fleurs sauvages aux pieds de soldats en parade permettait d'adoucir le rouge flamboyant de leur uniforme. De petits détails, comme un bateau à voiles à l'horizon ou un oiseau dans le ciel, suggèrent une certaine intimité et donne une douceur à l'ensemble de l'aquarelle.

Depuis les premières peintures canadiennes, l'intimité a constamment été présente : un élément humain, une main qui tient un outil et parfois, en art autochtone, une impression même de la main. Ce sont souvent les imperfections, le trait maladroit, les écarts de norme, les juxtapositions inattendues qui rendent une peinture grandiose, qui lui donne ce caractère unique et personnel. « Voici l'être particulier que je suis »

Jane Urquhart

semblent-ils nous dire « et voici la réalité comme je la perçois en ce moment. » Cette réalité peut être quoi que ce soit; une couleur mate, une absence de couleur, une représentation précise du monde tel que perçu, d'une intériorité, d'une vision, de ce qui est reconnaissable ou méconnaissable, une gigantesque image photographique ou une sélection de mots, parce ce qu'en fin de compte, ce qui compose un tableau est la création de l'esprit humain de ce que son auteur a lui-même choisi de nous faire découvrir en formes colorées. C'est pourquoi un tableau est toujours intimiste, généreux et inclusif.

Je suis né à la même époque où plusieurs institutions culturelles de ce pays ont vu le jour; le Festival de Stratford, le Canadian Opera Company, le Ballet national du Canada et, peut-être le plus important, le Conseil des Arts du Canada. J'ai donc grandi durant une période captivante de notre développement culturel au cours de laquelle le public cultivé commençait alors à considérer les peintres (et les écrivains) canadiens comme une source valable d'expression artistique. Quand j'étais dans la vingtaine, plusieurs galeries publiques et privées excitaient déjà, les musées étaient florissants et de nombreux magazines artistiques étaient publiés et lus. Avec le temps, l'effervescence sociale et la prise de conscience collective en période de développement culturel permettent à la société d'évoluer vers de nouveaux buts communs.

De nouveaux mouvements en peinture prennent naissances au fil du temps, et c'est le temps dont on s'est servi pour organiser le présent ouvrage, structuré par catégories d'artistes-peintres— en émergence, à la mi-carrière et de renom. Bien des choses peuvent arriver à un artiste-peintre entre le moment où il est considéré comme en émergence et le moment, s'il survit et persiste, où il sera considéré comme un peintre de renom. Avec le temps, le travail de l'artiste évoluera et l'artiste lui-même évoluera. Ce qui fait qu'un peintre connaîtra une carrière importante dépend d'un amalgame de facteurs, de chances, de circonstances, de la mode, de son engagement, et, bien sûr, de son talent. Il est intéressant de constater que le nombre d'artistes-peintres répertoriés diminue d'un chapitre à l'autre, passant de 79 artistes dans la catégorie en émergence, à 70 à la mi-carrière, jusqu'à 45 dans la catégorie de renom. Ce n'est pas parce qu'un peintre s'investit beaucoup dans sa carrière que son travail jouira d'une grande notoriété. Il est de l'essence d'un véritable artiste de s'élever contre le conformiste. Tout est en constance évolution.

Il importe de féliciter la Fondation Magenta d'avoir produit ce splendide ouvrage qui donne aux artistes-peintres canadiens l'attention et l'exposition qu'ils méritent. Humble et solitaire, l'artiste-peintre réalisent ses œuvres en leur consacrant de longues heures. Ce livre est l'équivalent d'une slave d'applaudissements retentissante.

Jane Urquhart
Stratford, Ontario, avril 2008

Marcel van Eeden, *Untitled (detail)*, 2004, graphite on paper, 7.5 × 11 inches / 19 × 28 cm

The Shape Is In A Trance

Lacking a commercial gallery, critical support or a sustainable means of earning a living, [Peter] Doig returned to Canada in 1986. He took many of his early paintings with him, where they languished in his father's barn for years.[1]

One of the most famous living painters in the world grew up in Canada. One of his most iconic works, *Country Rock,* is of the rainbow-painted culvert beside the Don Valley Parkway in Toronto that tens of thousands of Canadians would instantly recognize. And he had early paintings stashed away in a barn in Grafton, Ontario, while he painted theatre sets in Montreal and contemplated his next move.

Welcome to Canada, a country full of barns. And welcome to this, a book full of painters. Like its companion volume on Canadian photography, *Carte Blanche Vol. 2* was envisioned as a way to document the flourishing state of contemporary painting being made here today. It is not exhaustive by any means, but we are confident that a representative selection has been included. The painters are all Canadian although many were not born here, and several live and work abroad—Eli Langer in Los Angeles, Jason Gringler in Brooklyn, Medrie MacPhee in New York, Jessica Stockholder in Connecticut. Like the majority of painters in the world, their national identity now plays little or no role in what they do. The situation is made more complex by the staggering multiculturalism that defines our social fabric versus more generally homogeneous countries. Thus, it is possible to talk about German Expressionism, for example, in terms of political heritage that cannot really be usefully applied here. One can point to the American Abstract Expressionist movement in New York in the 1950s as one born of immigrants and exiles from Europe, naturally, but a contemporary corollary in Canada does not exist because there are no longer any pronounced "movements." What matters is the work, not the passport, of the painter.

For such a young country—born in 1867—there is a strong history of painting in Canada. It is one that has from the beginning been fostered by a rich international dialogue and a keen interest in cross-cultural aesthetics. For instance (and very briefly), in 1912, British Columbia painter Emily Carr showed early work that was directly inspired by Fauvism. Soon after, the Group of Seven were famously influenced by an exhibition of contemporary Scandinavian painters at the Albright-Knox Gallery in Buffalo in 1913, the same year David Milne was included in the Armory Show in New York, a pivotal exhibition in western art history. Bertram Booker, recognized as one of Canada's first abstract painters, was influenced in the late 1920s by the activities of Katherine Drier and Marcel Duchamp in New York. By 1927, the Montreal-born painter Philip Guston had moved with his family to Los Angeles where he enrolled at the Manual Arts High School with his friend and fellow student Jackson Pollock. Then in 1931, Agnes Martin, who was born in Macklin, Saskatchewan, and grew up in Vancouver, went to the States and eventually won lasting international fame for her minimalist paintings. In 1940, Alfred Pellan brought back to Quebec everything he'd absorbed after 15 years in Paris. Then the heady atmosphere and new possibilities of New York in the 1950s brought more creative exchange—the French-Canadian painter Paul-Émile Borduas meeting de Kooning, Pollock and Franz Kline is but one example. Jean Paul Riopelle, meanwhile, lived for decades in France with his life partner, American painter Joan Mitchell, and later became the first living Canadian painter to fetch over a million dollars for his work at auction.

Also during the 1950s, the Painters Eleven formed, a group of English Canadians that included William Ronald, Jack Bush and Harold Town, some of whom studied with Hans Hofmann and all of whom showed in New York. In 1957 Barnett Newman visited the artists' workshop at Emma Lake in northern Saskatchewan, to be followed by Clement Greenberg in 1962. These visits subsequently influenced many western Canadian painters such as Dorothy Knowles and William Perehudoff, both of whose work is included here. In 1965, the Museum of Modern Art opened *The Responsive Eye,* widely seen as the first comprehensive examination of Op Art. The exhibition included Guido Molinari, one of Canada's most important painters, who went on to represent Canada at the Venice Biennale in 1968. That same year, at the tender age of 31, Garry Neill Kennedy, whose

work is included in these pages, became the president of the Nova Scotia College of Art and Design in Halifax. His international vision promptly helped turn NSCAD into a legendary institution in both Canadian and international art circles. The German painter Gerhard Richter, for example, arrived there in 1978 and taught as a visiting professor. NSCAD remains widely known for the conceptual rigour of the artists in its orbit, from figures as diverse as Sol Lewitt and John Baldessari, both of whom visited and made work, to Iain Baxter& and Peter Dykhuis who are both represented here. In 1985, their peer, Christian Eckart, moved from Calgary to New York where he did a Master's degree and had Robert Morris as his graduate advisor. The paintings he subsequently made were acquired by the Guggenheim and the MoMA to name but two. Around the same time, Vancouver-born painter Graham Gillmore also moved to New York where he lived for almost 20 years and showed at Mary Boone before eventually moving to a sprawling studio in the interior of British Columbia. In the 1990s, Gillmore's friend, artist Attila Richard-Lukacs, moved to Berlin to make paintings of skin-heads, and since 2000 there have been legions of young Canadian artists who have followed to participate in its reemergence as a cultural hotspot. Thus, in roughly 133 years—by steamer, train, car and plane—Canadian painters arrived and stayed, fled and sought out, left and shone or returned and flourished.

In addition to historical framework and international dialogue, any overview of current Canadian painting should also briefly examine Canada's socio-economic conditions. Basically, there is less of everything spread out over more country. Thousands of miles of trees, prairie, mountains, lakes and rivers separate a painter in Vancouver from another in Halifax. Of course, the same could be said of New York and Los Angeles, but the difference is that more people live in California than in all of Canada. While the Internet, art magazines, blogs and flying around obviously collapses the distance—if there is a strong exhibition somewhere in the country, people will find out about it—it's not as simple as a quick trip from Berlin to Leipzig. Here, with our relatively small population of 30-odd million, there are perhaps 300 active collectors and of those 300, perhaps half are regularly collecting contemporary works, investing in the journeys of living artists over the safer and historically bonified efforts of the Group of Seven and their colleagues from the 1920s and 1930s. Indeed it can be seen quite clearly at the auctions of Canadian art, where the best-performing artists remain thoroughly dead, that the collecting base in this country has only begun to actively acquire post-war work, with the exception of Riopelle and a few other painters, let alone contemporary work. This stands in stark contrast to the international auctions where new work, often even less than ten years old, is met with feverish demand. The 2007 sale at auction in Toronto of a recent work by Vancouver artist Brian Jungen (b. 1970) for the low six figures made national headlines, while in New York or London such sums merit no mention, only paddles anxious for the next lot. And when it comes to art publishers helping to convey to an international audience the breadth of activity here, Canada is shy to the mark, shall we say, or risk-averse. Germany alone has Steidl, Hatje Cantz and Walther Konig to name but three powerful imprints, each with worldwide reach. Although many of the Canadian museums and public galleries have publishing arms that are ambitious, critical and forward-thinking, they are chronically underfunded and rarely have agreements for international distribution. Of course, the art world has grown exponentially in the last decade and that is most visible at the many art fairs around the world. These help to cement the international reputations of art stars and to introduce unknown artists to a global audience of influential people in a setting geared toward spectacle and exchange. Historically, Canadian galleries have been wary of participating because of the significant expense involved—spending tens of thousands per fair for an uncertain return—but in the last seven years, most of the top dealers have become part of this vital network. In this way, they bring their Canadian artists to the world, as they must, since the international art world does not come as often as every Saturday afternoon like it does in New York, London and Berlin. Canada is blessed with intelligent and accessible curators, most of whom answer their own phones and pay attention. A painter who wants a studio visit with a museum official can get one here with relative ease.

Clint Roenisch

But the exhibitions they mount, as rigorous and thoughtful as they tend to be, do not often travel outside Canada where they might establish an artist's international reputation.

Overall then, there appears to be several disadvantages to being a contemporary painter in Canada compared to Europe and the United States—yet Canadian painters seem to say, "so what!" What compels each of them? What to paint, how to cope with both the enormity of the medium's history and the vigour of its current dissemination, where a precedent for nearly every stylistic feint or formal gesture already exists or is being done as we speak? Still they continue to paint, each building their own worlds. As we will see, the gathering of painters here is a gamut-running exercise in stylistic, material and philosophic divergence.

Three artist statements:

I'm OK with money and making it from the sale of transposing ideas to medium.
—Thrush Holmes (Emerging)

The projects develop from an inquiry into the human psyche through the investigation of primal psychological drives, such as our ability to create beauty and the constant desire to destroy.
—Anitra Hamilton (Mid-Career)

I'm committed to the incomplete project of modernity. . . in the Socratic conception of what it means to be modern [and the idea] that the most powerful use of art may lie in its apparent uselessness.
—Christian Eckart (Established)

Three very different reasons for making paintings. One has taken a page directly from Warhol and his dictum of Business being the best Art. He paints on canvas with a brush and adds neon to try to turn the result into money. Another questions power and will through painted sculpture and works that are painted directly on the wall for a temporary period. The last has taken the ancient name (and occasional guidance) of Meister Eckart, but then makes very contemporary work that is fabricated without signs of authorship or the human hand, works that set up all the conditions for a transcendental experience for the viewer while blatantly revealing the formal mechanisms responsible, questioning the aesthetic object as a site for belief.

What is it about looking at paintings? They're dead, then they're vital and they always were. They're slow to reveal themselves, then they can be read, with signs and text, in a passing glance. They are the best test of the state of the art market, they're political, they're "now" or they're solely the province of the dead, white Establishment. They aren't conceptual enough, they're profound, they're too arty or they're too dry. They're hand-made and real in a culture of screens and mediation or they're machined up in a shop using industrial processes. They aren't on canvas or the very weave of the canvas itself becomes the subject. Someone else makes them for the artist over the phone or the painter toils directly on the wall for weeks only to have a museum technician paint it back to white when the show closes. Smug in the folds of its rich history, painting ignores the newer modes of video, performance and installation, or else it co-exists happily, produced by multi-media artists who employ all four. Paintings are made with art history reverentially in mind or ignored and satirically mocked. They're completely mapped out on the computer, but then laboriously hand-painted to look digitally rendered. They have surfaces that are tossed-off or hard-won, routed out and brushed in, poured on in one shot or worked up over years. They freely quote other sources or they seem to exist in a vacuum made only with other painters in mind. They represent the world and reflect back its atrocities, they refuse any intrusions, mute with artifice, or they're made from photographs and then look more sharply photographic than their source. They blur out the details in a myopic haze or they're "painted" on television screens, animated by white noise. They tell you what you're seeing is a lie but then offer up truths to the sensitive beholder. They lick the eyeball into full dilation, building space that isn't there and reflect back the erotic urge to absorb the Other, to melt into the picture plane. They reward sustained viewing and private interpretation or else they just strand the viewer cold. That's partly what it is about looking at paintings.

In the old days, there was linear history; there were schools of painting and isms and movements. There used to be positions staked out, painters in camps, arguments and debates, careers set ablaze or quickly flamed out by words and attacks. There were repudiations of previous styles, materials, subjects. There were retreats and advances. Like the scrapping in Mathew Reichertz's paintings, there was the Plasticiens versus the Automatistes, the Group of Seven, the Painters Eleven and the Regina Five. But now, no single group of artists truly reigns, no single critic can erase a career, no single curator can hold that much sway and no single dealer can claim to have the only relevant stable. Now, we have everything in painting, like everywhere else has everything too, the great troubling, liberating, enervating pluralism where anything goes and no one style or material or process can be discredited at a glance. Take Shary Boyle. An original sculptor, in porcelain no less, she is equally lauded for her paintings, drawings and "live" projections, often set to music. One of her most notable works, *The Clearances* (2007), was shown in London and contained two projectors, a large mural and cut-out and hung drawings using acrylic, gouache, thread, paper, gold foil and acetate. The resulting work was painterly, temporal, sculptural, light-based, drawn and site-specific.

Along with every material and technique now being eligible for use, painters have also bled out the idea of respecting genres, if they ever did. Joe Becker seems to make paintings with a clear line to Dutch still-life, both for its history of displaying abundance as a sign and for advertising the technical skill of the painter in rendering the many different kinds of hard and soft surfaces. But Becker pushes his imagery into a kind of lurid "carnivore-porn" of salacious excess with glistening details—of flayed fowl, the flesh of slugs and lobotomized chimps—all taken to delirious heights. Then, there is Andrew Morrow with his vast, sepia-toned battle scenes that involve everyone—quarterbacks, riot cops, native warriors, charging eagles, gladiators and equestrian show jumpers—and seem to mock more than make an homage to that once most exalted of genres, the massive historical myth painting.

Another genre, the portrait, is also taken apart and interrogated. Once they were painted primarily to convey the status, power and wealth of the sitter, and often commissioned with the tacit understanding that the result will physically flatter as well. John Nobrega's portraits in his *Salon de Paris* series present well-known writers from an era when this subtext was more clearly established. But here, Baudelaire, Proust and other literary figures are affectionately rendered as various species of monkey, set into painted, faux-antique frames, Proust as a retiring dandy, Baudelaire showing his teeth. Nobrega's peer, Anders Oinonen, makes paintings of flattened, saddened, burdened heads that are almost portraits of the inner life of the paint itself, of anthropomorphized paint, melancholic from the weight of its own history, despite the high-chroma flourishes of his brushwork and the sunny palette. Chris Cran's stylized heads, as anonymous as Oinonen's are invented, function most fully as portraits of the act of perceiving. Cran overlaps spaces and planes, piling up line diagrams of heads over grayscale heads behind screens of colour, confounding the eye. As with Oinonen, the subject is what the paint is doing—right now, unfolding anew every time—as much as it is about the figure caught in its grips. Tony Scherman and André Ethier also make specific demands on their materials. Scherman buries historically charged portraits underneath layers of encaustic that give them the appearance of being submerged in viscous time. Ethier's portraits are painted on board in hard, thinned-out glazes, as though he painted with the sap of exotic trees and then left them outside to dry in the sun. Both Janet Werner and Shelley Adler make portraits that appear to be of specific people, and perhaps they are, but the flattened blankness of their styles, reminiscent of Alex Katz, pushes the personality back and brings the technique forward.

Paint being pushed and pulled. Some painters have extended their practice into the sculptural field but in ways that still retain links with earlier, more traditional painters. Jessica Stockholder builds chaotic-looking installations but uses colour that is as calibrated and considered as Matisse did. The way that Chris Dorosz "paints" figures in three-dimensions using blobs of pure colour to build up forms brings Seurat's pointillism to mind just as Michelle Forsyth's wall-mounted reliefs of coloured-paper

Clint Roenisch

circles do Chuck Close. Jason Gringler inserts mirrors, plexiglass and other hard materials to give what is essentially a cubist-based motif of fractured space a distinctly menacing, contemporary aura.

Then there is landscape. Once rendered in awe-inspiring, pastoral and triumphant scenes, many of the painters here present the outdoors in an exhausted state of degradation, with acid colours, worn-out vistas, conflict, neglect, carnage, speed, waste and ruin at every turn. Scenes of a drug-induced mirage of haloed lights, harsh schematic intrusions, psychotropic blots, stains and optical migraine wonders harass the visual field—from the leached-out battlefield tableaux of Marc Séguin to the endless, urban nighttime sprawl in Dennis Ekstedt's aerial views. Buildings-on-mushrooms bloom out of Gary Evans's kaleidoscopic vistas while Dil Hildebrand's flimsy, theatre-set forests seem blatantly false. Kim Dorland's angry paintings of half-built houses look purposely half-finished. With Martin Golland, we see an architecture of lesions, of bruised ruins. Matt Killen's blank, half-started concrete shells of offices tower over the dreams of a developer under toxic skies. Sarah Nind's florescent, geometric incongruities mar the view. Brendan Flanagan's work is also distinct for how thoroughly it conveys the idea of paint as a toxic miasma, setting his scenes of cabins and hikers in congealed whorls and skeins of acidic colours. With Ehryn Torrell, the viewer stands before the post-disaster wreckage of homes torn apart, as though we'd just come squinting out of the storm shelter to find our old life erased. The calm, heightened realism that Mike Bayne uses so assuredly to portray his domestic architecture stands in quiet contrast to the mayhem in these other artist's works. The attention to detail and the miniature scale provoke overlapping atmospheres of childish wonder and suburban claustrophobia. Mary Porter's work leaves out the buildings that Holger Kalberg inserts to look so strange and dystopian. Porter's white space collapses the illusion of painting-as-window, just as Graham Fowler's bars in front of landscapes makes that very illusion their subject.

The materials of painting, free of the task of representation, are also explored by several painters here. A younger genera-

tion, including Mark Mullin, Matt Crookshank, Wil Murray and Melanie Authier, seems to engage in a manic, know-thyself examination of painting's own innards. They sample from several historically distinct schools of painting—hard-edge, op art, expressionism, the monochrome, neo-geo—and then include it all in one painting. A mash-up, as the kids used to say. In the realm of abstraction, the historical idea of "purity" is often dismissed in favour of modes that admit more of the world. Graham Gillmore produces luscious, poured enamel grounds that refer to the poured paintings of Morris Louis in the 1960s, but Gillmore disrupts the high-seriousness of the endeavour by overlaying texts such as "No Really, It's Over You Win." As though Modernism itself was throwing in the towel. Alexandra Flood's blurred brushstroke abstractions seem to purposely also look like teased and feathered hairstyles from the 1970s. Meanwhile, both Daniel Langevin and Sandra Meigs excel at a kind of Rorschach abstraction where comic figures emerge from the most economical of abstract gestures.

Every generation of artist here has found ongoing currency and continued relevance in the act of painting. As we have seen, there is a dizzying array of methods, means and materials, each pressed into the service of divergent visions. Across generations, there are painters committed to abstraction, others to figuration, others to both. There are some who use painting as only one aspect of a larger practice that might also include video, photography and sculpture. Another may have a more singular vision, immersed in the privacy of the painting studio nearly every day, dedicated to it alone for years on end. It is perhaps where they feel most alive. Barry Schwabsky wrote that at this point, "It is no longer possible to presume to know all that is going on in painting. There are too many hidden corners."[2] Like those paintings stashed away in its barns, perhaps Canada is one of those hiding spots.

The story of Harold Klunder's massive, six-panel painting *Infinity on Trial,* 2005–2007, now in the collection of the National Gallery and reproduced here, can be seen, if we like, as part of a larger narrative about painting in Canada now. Harold Klunder was born in The Netherlands in 1943. His father sheltered

Canadian soldiers in his barn during the Allied Liberation in 1946. He liked them and was grateful for their presence. The area was bombed-out and the Klunders were desperate for change, which came in 1952 when they were finally able to emigrate. They chose Canada and ended up in Montreal where his father sold vegetables. Klunder remembers his parents not being able to speak French, not knowing anyone, and the fiercely cold winters. Within a year, the family had moved to a farm near Hamilton, Ontario. Then in 1960, when Harold was 17, he moved to Toronto where he studied art at the Central Technical School and eventually became a successful painter with a long list of solo exhibitions. In 2000, he moved back to Montreal, this time with his two young daughters (who learned French). It was there in 2005 that he started *Infinity on Trial,* its title cribbed from a Bob Dylan song. It was then shown at the Visual Arts Centre and came to the attention of Pierre Theberge, director of the National Gallery of Canada, who promptly championed the work for acquisition, which was approved in 2008. Klunder has said that painting remains "a very humbling thing" but the arc of the narrative could not be more elegant.

When Klunder visited the National to see his own painting installed, he stopped first before Barnett Newman's *Voice of Fire,* the massive painting of a central red vertical band on a dark-blue ground that Newman made for Expo '67 in Montreal and that was acquired in 1990. The painting is eighteen feet high and made Klunder look quite small beside it. In an essay on whether or not art was a superstition, the late Ananda Coomaraswamy wrote that "the archetypal house repeats the architecture of the universe; a ground below, a space between, a vault above, in which there is an opening corresponding to the solar gateway by which one escapes altogether out of time and space into an unconfined and timeless empyrean. Functional and symbolic values coincide; if there rises a column of smoke to the luffer above, this is not merely a convenience, but also a representation of the axis of the universe that pillars-apart heaven and earth, essence and nature."[3] Coomaraswarmy could have been writing about Newman's painting with its vertical axis, the fiery red solar gateway, the column of smoke. Many Canadians remember the outrage and controversy that greeted the acquisition of *Voice of Fire,* particularly that of the Saskatchewan farmer who painted his own version on the side of his barn in protest. Could it be that this farmer, working his flat fields, living his whole life with the horizon in his eye, was the most agitated by this painting with its powerful heavenward pull because he, more than most, was so tethered to the earth, unable to make the leap into the vault above? Who knows? But a painting affected him and the first thing he did was to make another one. Let's look in the barn.

Clint Roenisch
Toronto, May 2008

1. Adrian Searle, *Peter Doig,* Phaidon Press, 2007.

2. Barry Schwabsky, *Vitamin P—New Perspectives in Painting,* Phaidon Press, 2002.

3. Ananda Coomaraswamy, *Christian and Oriental Philosophy of Art,* Dover, 1956.

La forme est dans une transe

N'obtenant aucun soutien des galeries commerciales ni des critiques, et ayant de la difficulté à subvenir à ses besoins, [Peter] Doig revint au Canada en 1986, rapportant avec lui plusieurs de ses premiers tableaux. Ils passeront des années à s'empoussiérer dans la grange de son paternel.[1]

L'un des plus célèbres peintres contemporains du monde a grandi au Canada. L'une de ses œuvres les plus marquantes, *Country Rock,* représente un ponceau aux couleurs de l'arc-en-ciel situé à Toronto, près du Don Valley Parkway, un endroit facilement identifiable par des dizaines de milliers de Canadiens. Dire que pendant que cet artiste peignait des décors de théâtre à Montréal en songeant à son avenir, ses premières œuvres étaient entassées dans une grange à Grafton, en Ontario!

Bienvenue au Canada, un pays qui regorge de granges. Et bienvenue, du même coup, entre les pages de ce livre qui regorge d'artistes-peintres. Tout comme son pendant sur la photographie au Canada, *Carte Blanche Vol. 2* a été conçu pour faire apprécier la situation florissante de la peinture contemporaine au Canada. Ce volume n'est en aucune façon un ouvrage exhaustif, mais nous croyons néanmoins qu'il offre un échantillon représentatif du travail des artistes-peintres canadiens d'aujourd'hui. Les peintres choisis sont tous Canadiens, bien que beaucoup d'entre eux soient nés à l'étranger et que plusieurs habitent et travaillent maintenant à l'extérieur du pays; c'est le cas par exemple d'Eli Langer à Los Angeles, de Jason Gringler à Brooklyn, de Medrie MacPhee à New York et de Jessica Stockholder au Connecticut. Comme maintenant pour la plupart des peintres à travers le monde, l'influence de leur identité nationale sur leur œuvre est aujourd'hui infime ou carrément absente. Cette situation est ici plus complexe qu'à bien d'autres endroits dans le monde compte tenu du multiculturalisme dont est imbibé le tissu social de notre société comparativement aux pays dont la population est plus homogène. Si ailleurs on peut parler d'expressionnisme allemand dans une perspective d'héritage politique, cela ne trouverait ici aucune consonance concrète. On pourrait, bien entendu, faire état du mouvement expressionniste abstrait de New York des années 1950 porté par les immigrants et les exilés venus d'Europe. Toutefois, il n'existe pas de corollaire contemporain au Canada puisque la production artistique n'y est plus divisée en « mouvements » définis. Aujourd'hui, la seule chose qui importe, c'est l'œuvre de l'artiste, et non son passeport.

Malgré sa courte existence, le Canada, qui a été constitué en 1867, possède une forte tradition en matière de peinture. Cette tradition s'est nourrie dès le début d'un riche dialogue inter nations et d'un intérêt marqué pour l'esthétique interculturelle. Par exemple, la peintre originaire de Colombie-Britannique Emily Carr réalisait déjà en 1912 (pendant une brève période) des tableaux directement inspirés du fauvisme. Peu après, en 1913, une exposition à la galerie d'art Albright-Knox de Buffalo consacrée à des peintres scandinaves contemporains aura une influence importante sur l'ensemble de l'œuvre du Groupe des Sept; la même année, David Milne participait à l'Armory Show de New York, une exposition pivot dans l'histoire moderne de l'art occidental. Bertram Brooker, reconnu comme l'un des premiers peintres abstraits canadiens, a été marqué, vers la fin des années 1920, par le travail de Katherine Dreier et de Marcel Duchamp à New York. En 1927, le peintre natif de Montréal Philip Guston, dont la famille vivait depuis peu à Los Angeles, s'est inscrit à la *Manual Arts High School* où il eut pour condisciple Jackson Pollock, qui deviendra son ami. En 1931, Agnes Martin, une artiste née à Macklin, en Saskatchewan, mais ayant passé sa jeunesse à Vancouver, est aussi allée vivre aux États-Unis. Elle acquerra plus tard une renommée internationale pour ses œuvres minimalistes. En 1940, Alfred Pellan revient au Québec imprégné de tout ce qu'il avait absorbé au cours des 15 années qu'il a vécu à Paris. L'atmosphère exaltante qui règne dans le New York des années 1950 et les nouvelles possibilités offertes par cette ville ont été à l'origine d'autres échanges créatifs : la rencontre du peintre canadien-français Paul-Émile Borduas avec Willem de Kooning, Jackson Pollock et Franz Kline n'est qu'un exemple parmi tant d'autres. Pour sa part, Jean Paul Riopelle a vécu en France pendant des décennies avec sa compagne, l'artiste peintre américaine Joan Mitchell, et deviendra plus tard le premier peintre Canadien dont une œuvre a été vendue du vivant de l'artiste pour plus d'un million de dollars lors d'un encan.

Les années 1950 ont également vu la naissance du Groupe des Onze, formé d'artistes canadiens-anglais dont William Ronald, Jack Bush et Harold Town; certains d'entre eux avaient étudié avec Hans Hofmann et tous ont participé à des expositions new-yorkaises. En 1957, Barnett Newman est invité à l'atelier des artistes d'Emma Lake, dans le nord de la Saskatchewan; la même invitation sera également faite à Clement Greenberg en 1962. Ces rencontres auront une influence marquée sur plusieurs peintres de l'Ouest du Canada comme Dorothy Knowles et William Perehudoff, dont on a reproduit ici quelques œuvres. En 1965, le Musée d'art moderne de New York présentait *The Responsive Eye*, une exposition largement considérée comme fondamentale pour le mouvement Op Art. L'exposition comprenait des œuvres de Guido Molinari, un géant de l'art abstrait au Canada, qui a représenté le pays à la Biennale de Venise en 1968. La même année, Garry Neill Kennedy, dont des œuvres sont également reproduites dans ces pages, est devenu le président du *Nova Scotia College of Art and Design* (NSCAD) de Halifax alors qu'il était âgé à peine de 31 ans. Sa vision planétaire a contribué à rapidement faire du NSCAD une institution légendaire dans les circuits artistiques canadiens et internationaux. Pour ne donner qu'un exemple, pensons au peintre allemand Gerhard Richter qui s'est joint en 1978 à l'équipe du NSCAD à titre de professeur émérite. Le NSCAD conserve encore aujourd'hui une grande renommée en raison de la rigueur conceptuelle des artistes qui y gravitent, des artistes aussi divers que Sol Lewitt et John Baldessari, qui ont tous deux travaillé au NSCAD et y ont réalisé des œuvres, ou que Iain Baxter& et Peter Dykhuis, qui sont tous deux représentés dans cet ouvrage. En 1985, leur collègue Christian Eckart a quitté Calgary pour se rendre à New York, où il a obtenu une maîtrise sous la direction de Robert Morris. Des œuvres qu'il a réalisées par la suite ont été acquises par le Musée Guggenheim et le Musée d'art moderne de New York. Environ à la même époque, le peintre natif de Vancouver Graham Gillmore a lui aussi emménagé à New York, où il vivra près de 20 ans et exposera à la galerie *Mary Boone* avant de s'installer définitivement dans un vaste studio à l'intérieur de la Colombie-Britannique. Dans les années 1990, un ami de Gillmore, l'artiste peintre Attila Richard-Lukacs, s'est

rendu à Berlin pour peindre des skinheads et, depuis l'an 2000, des légions de jeunes artistes canadiens l'ont suivi afin de participer à la renaissance du milieu culturel important de cette ville. C'est ainsi qu'en espace de 133 ans, par bateau à vapeur, par train, par voiture ou par avion, des peintres canadiens sont venus au pays pour y rester, d'autres l'ont quitté à la recherche d'inspiration, et d'autres encore sont allés vivre à l'étranger ou en sont revenus pour connaître le succès.

En plus du contexte historique et de la question du dialogue entre les différentes origines nationales qui composent la population du Canada, tout survol de la peinture canadienne contemporaine serait incomplet sans référence aux conditions socioéconomiques prévalant au pays. Le Canada, c'est en fait moins en tout, dispersé sur un grand territoire. Des milliers de kilomètres de forêts, de prairies, de montagnes, de lacs et de rivières séparent un peintre habitant Vancouver de son collègue d'Halifax. Il est vrai qu'il y a la même distance entre New York et Los Angeles, mais la différence réside dans le fait que la Californie à elle seule compte plus d'habitants que le Canada tout entier. Même si l'Internet, les magazines d'art, les carnets Web et les vols domestiques contribuent de plus en plus à réduire les distances— les gens sont maintenant informés rapidement qu'une exposition importante se tient quelque part au pays— les déplacements ne se font pas aussi simplement qu'un saut entre Berlin et Leipzig. Au Canada, compte tenu de la taille de la population (un peu plus de 30 millions d'habitants), on dénombre uniquement près de 300 collectionneurs d'œuvres d'artistes canadiens actifs. Seule environ la moitié d'entre eux ajoutent régulièrement à leur collection des œuvres contemporaines et ce faisant, investissent dans la démarche d'artistes-peintres vivants plutôt que dans des valeurs moins risquées et reconnues de longue date comme celles du Groupe des Sept et de leurs collègues des années 1920 et 1930. On constate, lors des encans canadiens d'œuvres d'art, où les artistes les plus populaires sont invariablement ceux qui sont décédés, que les collectionneurs canadiens commencent à peine à acquérir des œuvres d'après la Seconde Guerre mondiale (à l'exception de Riopelle et de quelques autres peintres), et l'on ne parle même pas d'art contemporain. Cette situation est tout à

fait à l'opposé de celle observée dans les encans internationaux, où l'on s'arrache des œuvres qui ont à peine dix ans d'existence. En 2007, la vente pour quelques centaines de milliers de dollars d'une œuvre récente de l'artiste de Vancouver Brian Jungen (né en 1970) lors d'un encan à Toronto a fait les manchettes partout au pays. À New York ou à Londres, les ventes de cette ampleur n'attirent aucune attention particulière, et l'on s'empresse de passer à l'objet suivant. D'autre part, en ce qui concerne la contribution des publications artistiques pour mieux faire connaître au public international l'étendue des activités à l'intérieur de nos frontières, on hésite encore au Canada à assumer les risques qui en découlent. À elle seule, l'Allemagne peut compter sur Steidl, Hatje Cantz et Walther Konig, pour ne nommer que trois publications d'importance jouissant d'un rayonnement planétaire. Bien que beaucoup de musées et de galeries d'art du Canada possèdent des maisons d'édition ambitieuses, critiques et avant-gardistes, ces dernières souffrent d'un manque chronique de financement et ne profitent que dans de très rares cas d'ententes de distribution internationale. Le monde de l'art a bien sûr connu une croissance exponentielle au cours de la dernière décennie, et cela est plus évident que jamais au nombre de foires des arts qui se tiennent partout dans le monde. Ces foires contribuent à renforcer la réputation à l'échelle internationale des vedettes du milieu des beaux-arts et à faire connaître de nouveaux artistes à un public composé de gens influents de partout dans le monde, le tout dans un environnement rempli de spectacles et de rencontres stimulantes. Dans le passé, les galeries canadiennes hésitaient à participer à ces événements en raison des dépenses importantes qu'elles entraînent, chaque foire représentant un investissement de quelques dizaines de milliers de dollars dont les retombées sont incertaines. Malgré tout, depuis le début du présent millénaire, la plupart des grands marchands d'art au pays se sont joints à ce réseau important. Cela leur permet de présenter des artistes canadiens au reste du monde; ils n'ont d'ailleurs guère le choix de le faire, puisque le monde de l'art international ne descend pas aussi souvent chez nous qu'il le fait à New York, à Londres ou à Berlin. Le Canada a la chance de compter dans ses rangs des conservateurs d'art intelligents et accessibles qui, pour la plupart, répondent eux-mêmes aux appels téléphoniques et demeurent ouverts aux demandes. Ici, il est relativement facile pour un peintre d'arriver à faire visiter son studio par un représentant d'un musée. Néanmoins, et bien qu'elles fassent souvent preuve de rigueur et de réflexion, il est rare que les expositions montées au Canada voyagent à l'extérieur du pays, ce qui aiderait pourtant à établir la réputation d'artistes canadiens sur la scène internationale.

Il semble donc que le fait d'être un artiste-peintre contemporain canadien présente dans l'ensemble plusieurs désavantages par rapport aux artistes-peintres européens et américains. Malgré tout, les peintres canadiens semblent peu s'en soucier. Qu'est-ce qui les motive encore? Comment décident-ils des sujets à peindre, et comment allier le poids des traditions de ce moyen d'expression et la vigueur de la peinture canadienne contemporaine lorsque pratiquement chaque manœuvre stylistique et chaque coup de pinceau ont déjà été expérimentés ou sont en train de l'être? Les artistes-peintres continuent pourtant à réaliser des tableaux, chacun créant un univers qui lui est propre. Comme vous le constaterez par vous-même, les œuvres rassemblées dans cet ouvrage couvrent l'ensemble de la diversité stylistique, matérielle et philosophique ayant cours actuellement au pays.

Trois déclarations d'artistes :

Je n'ai pas de problème avec l'argent ni avec l'idée d'en gagner en transposant des idées par le truchement d'un moyen d'expression.
—Thrush Holmes (artiste en émergence)

Les projets sont développés à la suite d'une exploration du psychique humain et d'une introspection des pulsions psychologiques fondamentales, par exemple celle de créer le beau et celle de détruire.
—Anitra Hamilton (artiste à la mi-carrière)

Je me sens lié au projet inachevé de la modernité, c'est-à-dire au concept socratique de ce que signifie être moderne et à l'idée que la manifestation la plus puissante de l'art se cache peut-être dans son inutilité apparente.
—Christian Eckart (artiste de renom)

Trois raisons très différentes de réaliser des tableaux. L'un suit les enseignements de Warhol selon lequel les affaires sont le plus grand art : il peint des canevas au pinceau et leur ajoute des artifices dans l'espoir de voir le résultat se transformer en argent. L'autre conteste l'ordre établi et réalise des sculptures peintes et des œuvres temporaires produites directement sur des murs. Le dernier s'identifie à Maître Eckart (en suit même parfois les préceptes) et réalise des œuvres éminemment contemporaines qui ne laissent aucun indice de leur auteur et où l'on ne peut deviner aucun geste de la main; ses œuvres permettent à l'observateur de vivre une expérience transcendantale en lui révélant clairement les mécanismes ayant permis la création de l'œuvre tout en remettant en question l'importance de son objet esthétique comme milieu de croyance.

Pourquoi regarder des peintures? Ce sont des objets inertes, mais combien encore essentiels de nos jours. Si les œuvres picturales se révèlent lentement, elles peuvent néanmoins, accompagnées de signes et de texte, être comprises d'un regard. Si certaines sont le meilleur indicateur de l'état du marché de l'art et sont politiques, actuelles, d'autres appartiennent à l'époque révolue de la suprématie des Blancs. Tour à tour, elles sont jugées tantôt peu conceptuelles, tantôt profondes, trop « artistiques » ou trop arides. Elles sont faites à la main et instillent du « vrai » dans la culture de l'écran, ou bien elles sont créées à la chaîne dans un atelier à l'aide de procédés industriels. Il arrive qu'elles ne soient pas faites sur canevas, ou que ce soit le canevas lui-même du tableau qui soit le sujet. Parfois, quelqu'un les réalise pour l'artiste qui donne ses instructions par téléphone, et parfois l'artiste-peintre s'échine pendant des semaines à réaliser son œuvre directement sur un mur qu'un employé du musée repeindra en blanc dès l'exposition terminée. Se drapant avec arrogance dans les plis et replis de ses riches traditions, la peinture peut ignorer les nouveaux moyens d'expression que sont la vidéo, la représentation et l'installation, mais elle peut également coexister avec eux en harmonie, maniée par des artistes multimédias qui savent habilement les marier. La peinture peut traiter les traditions avec révérence, les ignorer ou en faire des objets de satire. Il est possible aujourd'hui de concevoir des œuvres entièrement par ordinateur et de les peindre ensuite minutieusement à la main en accentuant leur caractère numérique. Des œuvres peuvent avoir été créées en un temps record ou avoir demandé beaucoup de temps et d'attention. Elles peuvent rechercher le détail ou être d'un flou imprécis, être réalisées sur-le-champ ou être le fruit de plusieurs années de travail. Certaines peintures s'inspirent librement d'autres sources et d'autres semblent exister en vase clos uniquement dans un rapport avec d'autres peintres. Elles peuvent représenter le monde et être le reflet de ses atrocités. Elles peuvent refuser toute intrusion et être subtilement silencieuses ou, quand elles sont faites à partir de photographies, paraître plus vraies que l'original. Certaines embrouillent les détails pour créer un flou, certaines sont « peintes » sur des écrans de télévision et animées par la lumière. Elles indiquent parfois que ce qui se trouve devant vos yeux n'est que pur mensonge, mais elles peuvent tout aussi bien révéler de grandes vérités à l'observateur sensible. Elles peuvent dilater entièrement les pupilles, créer des espaces qui n'existent pas et refléter le besoin érotique d'absorber l'Autre ou de se fondre dans l'image. Si l'on peut parfois les interroger longuement du regard et bâtir sa propre interprétation, elles peuvent aussi laisser l'observateur tout à fait indifférent. C'est pour toutes ces raisons, et bien d'autres encore, que l'on regarde des peintures.

Auparavant, l'art pictural évoluait comme de façon linéaire; il y avait des écoles de pensée, des courants en -isme et des mouvements caractérisés. Les positions étaient définies, les peintres se rangeaient dans des camps, des discussions et des débats avaient lieu, et des carrières démarraient en un éclair ou se transformaient en feu de paille sur la base d'un éloge ou d'une critique acerbe. Les styles, matériaux et sujets de l'époque précédente étaient mis de côté. Il y avait des retours en arrière et des mouvements vers l'avant. À l'image du scrapping dans les œuvres de Mathew Reichertz, il y avait les plasticiens contre les automatistes, le Groupe des Sept, le Groupe des Onze et les Regina Five. Mais de nos jours, aucun groupe d'artistes particulier ne tient le haut du pavé, aucun critique ou conservateur n'a le pouvoir de détruire une carrière à lui seul et aucun marchand d'œuvres

Clint Roenisch

d'art ne peut prétendre posséder la seule collection valable. Aujourd'hui, en peinture comme dans bien d'autres choses, tout peut coexister. Nous connaissons un pluralisme artistique troublant, libérateur et excitant où tout est permis et où aucun style, matériau ou procédé ne peut être discrédité au premier regard. Prenons Shary Boyle à titre d'exemple. D'abord sculpteure, ne travaillant rien de moins que la porcelaine, elle est aujourd'hui tout aussi reconnue pour ses peintures, ses dessins et ses performances de « lumière projetée » en direct, qui sont souvent accompagnées d'une trame musicale. L'une de ses œuvres les plus remarquables, *The Clearances* (2007), qui a été exposée à Londres, était constituée de deux projecteurs, d'une large murale et de dessins découpés et suspendus, le tout réalisé à l'aide d'acrylique, de gouache, de fil, de papier, de feuilles d'or et d'acétates. Élaborée en fonction de son environnement spécifique, l'œuvre était temporelle, sculpturale, lumineuse et attrayante.

Non seulement tous les matériaux et techniques peuvent maintenant être utilisés, mais les peintres ont également épuisé la notion de genres respectifs, s'ils n'y ont jamais cru. Les œuvres de Joe Becker semblent clairement liées aux natures mortes flamandes, aussi bien par la tradition de représenter l'abondance en tant que symbole que par la démonstration des compétences techniques du peintre qui représente différents types de surfaces douces et dures. Becker oriente toutefois ses créations vers une sorte de « pornographie carnivore » débordante d'excès lubriques et rehaussée de détails chatoyants—de la volaille écorchée, de la chair de limaces, des singes lobotomisés—le tout poussé jusqu'aux extrêmes les plus délirants. Il y a aussi Andrew Morrow, avec ses vastes de scènes de bataille en sépia où l'on trouve de tout—des quarts arrière, des policiers en uniforme antiémeutes, des guerriers autochtones, des aigles chasseurs, des gladiateurs et des sauteurs équestres—et qui semble se moquer, et non rendre hommage, de ce genre autrefois tant respecté que sont les grandes fresques mythiques de batailles historiques.

Un autre genre, le portrait, est lui aussi démonté et étudié. Les portraits étaient autrefois peints pour exprimer le statut, le pouvoir et la richesse de leur sujet, et souvent commandés avec l'entente tacite que le résultat soit flatteur pour le sujet. Les portraits de la série *Salon de Paris* de John Nobrega représentent les écrivains célèbres d'une époque où cette façon de faire était plus que jamais à la mode, sauf que dans ses œuvres, Baudelaire, Proust et les autres figures littéraires sont rendues, sans véritable malice, sous la forme de diverses espèces de singes posant dans de faux cadres antiques : Proust est représenté comme un dandy à la retraite et Baudelaire montre les dents. Un collègue de Nobrega, Anders Oinonen, peint des têtes aplaties, tristes et écrasées, presque des représentations de la vie intérieure de la peinture elle-même, une peinture anthropomorphisée, rendue mélancolique par le poids de son propre passé, et ce, en dépit des arabesques extravagantes du pinceau et des couleurs ensoleillées. On pourrait dire des têtes stylisées de Chris Cran, qui sont aussi anonymes que celles d'Oinonen peuvent être fictives, qu'elles représentent davantage l'acte de perception qu'un sujet donné. Cran fait chevaucher les plans et les espaces en superposant des diagrammes de têtes et des têtes achromatiques derrière des écrans de couleur, ce qui trompe l'œil. Comme avec Oinonen, le sujet de l'œuvre est autant l'acte de l'artiste—un acte présent et sans cesse renouvelé—que l'image qu'il emprisonne. Tony Scherman et André Ethier utilisent eux aussi leurs matériaux de manière très particulière. Scherman recouvre des portraits historiques de plusieurs couches d'encaustique pour leur donner l'apparence de personne submergée dans la viscosité du temps. Les portraits d'Ethier sont faits sur bois à l'aide de glacis dur et dilué, comme s'il les avait peints avec de la sève d'arbres exotiques, et sont ensuite séchés au soleil. Janet Werner et Shelley Adler réalisent des portraits de personnes qui semblent réelles, et qui peut-être le sont, mais l'absence de trait démarquant qui caractérise leur style et qui nous rappelle Alex Katz estompe la personnalité du sujet pour mieux mettre la technique en évidence.

On défait et refait la peinture. Certains peintres ont élargi leur pratique pour y inclure la sculpture tout en continuant à utiliser certaines façons de faire de peintres plus traditionnels d'autrefois. Jessica Stockholder construit des installations

d'apparence chaotique, mais utilise la couleur d'une manière aussi calibrée et précise que Matisse. La façon dont Chris Dorosz « peint » des images tridimensionnelles en utilisant des gouttes de couleur pure pour créer des formes rappelle le pointillisme de Seurat, tout comme les reliefs de cercles de papier colorés et montés sur murs de Michelle Forsyth renvoient aux œuvres de Chuck Close. Jason Gringler se sert de miroirs, de plexiglas et d'autres matériaux durs pour créer un effet de fracture à forte parenté avec le mouvement cubiste, mais qui dégage toutefois une atmosphère menaçante et contemporaine.

Et puis il y a les paysages. Autrefois sujet de scènes impressionnantes, pastorales et triomphantes, le monde est maintenant représenté, par beaucoup de peintres que vous retrouverez ici, dans un état d'épuisement et de dégradation, avec des couleurs acides, des paysages désolés, des conflits, de la négligence, du carnage, de la vitesse, du gaspillage et dans un état de ruine. Ces scènes sont parfois comme des mirages flous de lumières que pourrait voir une personne sous l'influence de drogues; de dures intrusions schématiques, des bavures psychotropes, des taches et des anomalies optiques emplissent le champ visuel — des tableaux de champs de bataille désertés de Marc Séguin à la jungle urbaine sans fin des perspectives aériennes de Dennis Ekstedt. Les bâtiments poussent sur des champignons dans les visions kaléidoscopiques de Gary Evans alors que les fragiles forêts en carton-pâte de Dil Hildebrand semblent d'une fausseté ridicule. Pleines de colère, les maisons à moitié construites de Kim Dorland semblent avoir été laissées en chantier. Martin Golland nous offre une architecture de lésions, de ruines blessées. Les édifices à bureaux inachevés de Matt Killen, lisses et sans couleurs, s'élèvent sous des cieux toxiques assombrissant les rêves de développement. Les bizarreries fluorescentes et géométriques de Sarah Nind agressent la vue. La particularité du travail de Brendan Flanagan réside dans la manière extrêmement efficace dont il transmet l'idée de la peinture en tant que miasme toxique, en plaçant ses scènes de chalets et de randonneurs au milieu de tourbillons et d'écheveaux solidifiés de couleurs acides. Pour ce qui est de Ehryn Torrell, on observe dans son œuvre les carcasses de foyers détruits par suite d'un véritable désastre, comme si l'on venait de sortir d'un bunker où l'on se serait réfugié pour échapper à la tempête et que l'on était en train de regarder les ruines de notre ancien milieu de vie totalement anéanti. L'architecture domestique représentée avec assurance par Mike Bayne dans son œuvre revêt un réalisme calme et accentué qui contraste singulièrement avec les situations chaotiques des œuvres des artistes mentionnés ci-dessus. L'attention portée aux détails et l'échelle miniature provoquent à la fois une impression d'émerveillement enfantin et de claustrophobie suburbaine. Les œuvres de Mary Porter évacuent les bâtiments que Holger Kalberg ajoute pour créer un paysage anti-utopique d'une grande étrangeté. Les espaces blancs de Porter détruisent l'illusion de l'œuvre en tant que fenêtre par laquelle on regarde, tout comme les barreaux que Graham Fowler peint devant ses paysages font de cette illusion le sujet de l'œuvre.

Les matériaux utilisés, libérés de leur vocation, font aussi l'objet d'une exploration par plusieurs des peintres présentés dans ce volume. Une nouvelle génération d'artistes, parmi laquelle on retrouve Mark Mullin, Matt Crookshank, Wil Murray et Melanie Authier, semble s'adonner à un examen frénétique et très personnel des mécanismes internes de la peinture. Ils empruntent à différentes écoles d'avant leur époque, que ce soit la peinture hard-edge, les arts visuels, l'expressionnisme, le monochrome ou le néo-géométrique, et intègrent toutes ces techniques dans une seule et même œuvre pour créer ce que l'on pourrait appeler un heureux mélange. Dans le domaine de la peinture abstraite, l'idée traditionnelle de « pureté » est souvent écartée en faveur de styles plus ouverts sur le monde. Graham Gillmore a créé à l'aide de peintures-émail des pièces riches qui renvoient aux œuvres par coulage de Morris Louis produites dans les années 1960, mais il se moque du très grand sérieux de cette entreprise en y ajoutant des phrases comme « No Really, It's Over, You Win », comme si le modernisme lui-même avait jeté l'éponge. Les abstractions aux coups de pinceau flous d'Alexandra Flood semblent vouloir rappeler intentionnellement les coiffures emmêlées et dégradées des années 1970. Pendant ce temps, Daniel Langevin et Sandra Meigs remportent

Clint Roenisch

d'excellents résultats avec une sorte d'abstraction inspirée de Rorschach d'où surgissent de drôles de silhouettes de gestes abstraits économiques.

Chaque génération d'artiste découvre de nouvelles façons de faire qui lui sont propres et continue à croire à la pertinence de créer de nouvelles œuvres. Comme que vous pouvez le constater, il existe une variété stupéfiante de méthodes, de techniques et de matériaux, chacun et chacune étant mis au service de conceptions différentes. Au fil des générations, des artistes se sont consacrés à la peinture abstraite, d'autres ont choisi l'art figuratif, et d'autres encore ont exploré les deux. Il y a des artistes pour lesquels la peinture n'est qu'un aspect d'une pratique plus large, qui peut comprendre en outre la vidéo, la photographie et la sculpture, alors que la vision d'un autre peintre peut être plus singulière, découverte au cours de longues journées passées dans l'intimité d'un atelier, et concrétisée après des années de travail consacrées uniquement à un seul projet. Peut-être est-ce dans cette intimité que les artistes se sentent le plus en vie. C'est à ce propos que Barry Schwabsky a écrit ceci : « Il n'est plus possible de prétendre tout connaître du monde de la peinture. Il y a trop d'angles cachés.[2] » Et après tout, comme ces granges dans lesquelles des œuvres dorment, peut-être le Canada recèle-t-il lui aussi des trésors à découvrir.

L'œuvre remarquable de Harold Klunder, un tableau comprenant six panneaux intitulés *Infinity on Trial 2005–2007*, qui fait maintenant partie de la collection du Musée des beaux-arts du Canada et qui est reproduit dans ce volume, peut être considéré, si l'on veut, comme un long récit sur la peinture actuelle au Canada. Harold Klunder est né aux Pays-Bas en 1943. Son père avait hébergé des soldats canadiens dans sa grange en 1946 à l'occasion de la libération des Alliés. Il les aimait beaucoup et était très reconnaissant de leur présence. Leur région a été complètement dévastée par les bombes et les Klunder cherchaient à améliorer leur sort, ce qui s'amorça en 1952 lorsqu'il leur fut possible d'émigrer. Ils choisirent de s'installer au Canada et de vivre à Montréal où le père d'Harold a vendu des légumes. Klunder se souvient encore de cette période où ses parents étaient incapables de parler français alors qu'ils ne connaissaient

personne et où ils subirent le froid intense de leur premier hiver canadien. Moins d'un an après leur arrivée, la famille décida d'aller s'établir dans une ferme en Ontario, près d'Hamilton. En 1960, alors qu'Harold est âgé de 17 ans, ils déménagèrent à Toronto où il étudia les beaux-arts au *Central Technical School*. Il acquit au fil des ans une renommée comme artiste-peintre et possède aujourd'hui à son actif une longue liste d'expositions solos. En l'an 2000, il retourne vivre à Montréal avec ses deux filles (qui prendront peu de temps à apprendre le français). C'est en 2005 qu'il s'attaqua à son œuvre *Infinity on Trial,* dont le titre est tiré d'une chanson de Bob Dylan. Cette œuvre a d'abord été exposée au Centre des arts visuels où elle a retenu l'attention de Pierre Théberge, alors directeur du Musée des beaux-arts du Canada, qui rapidement manifestera son intention de vouloir l'acquérir pour le Musée, ce qui se réalisa en 2008. Klunder a indiqué que cette œuvre était « une chose très humble », mais la courbe de son récit ne peut être d'une plus grande élégance.

Lorsque Klunder se rendit au Musée des beaux-arts pour voir son tableau, il s'arrêta d'abord devant l'œuvre de Barnett Newman intitulée *Voice of Fire*, un très grand tableau composé d'une bande verticale rouge sur fond bleu foncé que Newman avait réalisé pour l'Expo 67 et qui a été acquis par le Musée en 1990. *Voice of Fire* était suspendu plus haut que la normale, comme Newman l'a toujours voulu, et Kundler avait l'air minuscule à ses côtés. Dans un essai cherchant en autre à savoir si l'art est superstition, Ananda Coomaraswamy écrit ceci : « la maison archétype reprend l'architecture de l'univers; un sol en dessous, un espace au milieu, une voûte au-dessus, avec une ouverture correspondante à la porte solaire par laquelle l'on peut s'échapper hors du temps et de l'espace dans un empyrée à l'infini et éternel. Les valeurs symboliques et fonctionnelles se confondent : Si une colonne de fumée s'élève, ce n'est pas simplement par commodité, mais il s'agit également d'une représentation de l'axe de l'univers dont les piliers soutiennent le ciel et la terre, l'essence et la nature.[3] » Avec ces mots, Coomaraswmy aurait peu tout aussi bien décrire l'oeuvre de Newman avec son axe vertical, la porte solaire d'un rouge vif et la colonne de fumée. L'acquisition de Voice of Fire par le Musée des beaux-arts a

été accueillie dans la controverse et plusieurs Canadiens ont crié
au scandale. On a qu'à se souvenir de cet agriculteur en Saskatch-
ewan qui a peint sa propre version de cette œuvre sur un côté
de sa grange en guise de protestation. Ce pourrait-il que cet
agriculteur, travaillant chaque jour dans de grands champs plats
et passant sa vie à scruter l'horizon, soit celui qui fut le plus
bouleversé par cette peinture, qui semble vous tirer vers le ciel,
parce que lui, plus que tout autre, est enraciné à la terre, inca-
pable de s'élancer vers la voûte céleste? Qui sait? Cette peinture
l'a tellement touché que la première chose qu'il a faite a été de
vouloir la recréer. Nous devrions nous intéresser à l'intérieur
de sa grange.

Clint Roenisch,
Toronto, mai 2008

1. Adrian Searle, *Peter Doig*, Phaidon Press, 2007.

2. Barry Schwabsky, *Vitamin P—New Perspectives in Painting*, Phaidon Press, 2002.

3. Ananda Coomaraswamy, *Christian and Oriental Philosophy of Art*, Dover, 1956.

Plates

emerg

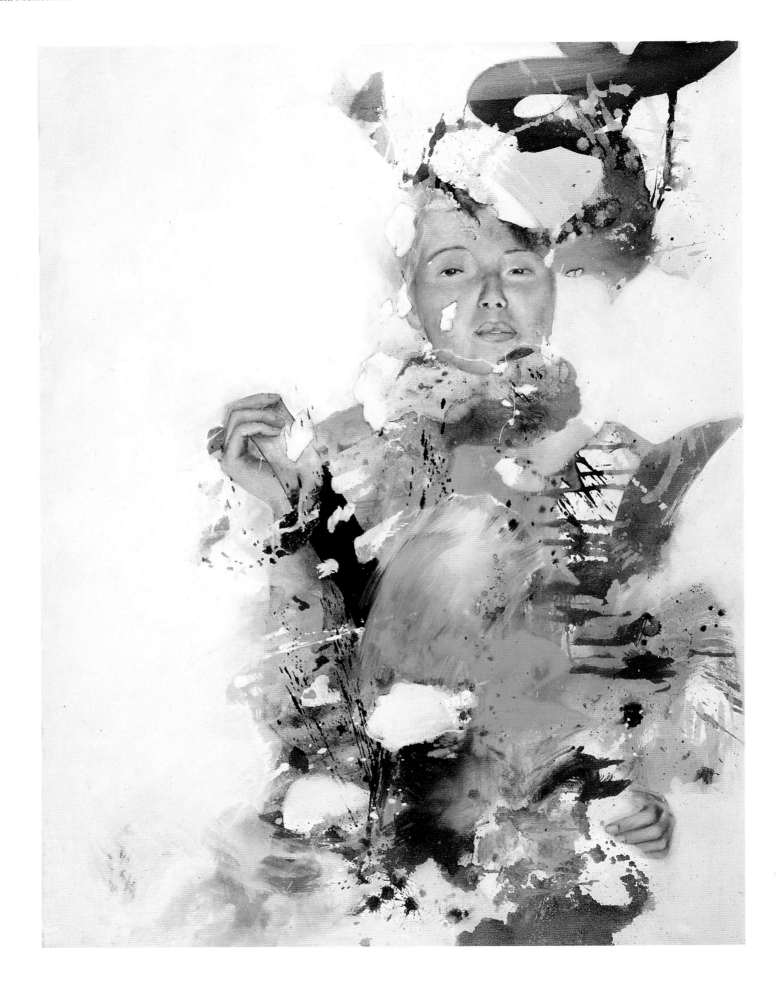

La Belle Damme Sans Merci, (The Lovely Lady Without Pity), 2006, oil, acrylic and enamel on canvas, 47.5 × 35.5 inches / 120.7 × 90.2 cm

"Working on a painting over weeks, sometimes months, it is not uncommon for the entire painting to disappear, losing all traces of its original intention. But out of this continuous re-sculpting and over-painting, unexpected results emerge. Figures begin to take shape, the painting begins to tell its own story."

Study for a Painting: Monochrome II, 2006, unstitched linen weave,
60 × 60 inches / 152.4 × 152.4 cm

"The medium of painting is the subject of my painting. However, unlike traditional painting,
which is realized through the application and addition of paint to the surface of canvas,
my work aims to create painting through the reduction of materials, a subtraction of depth,
colour and surface."

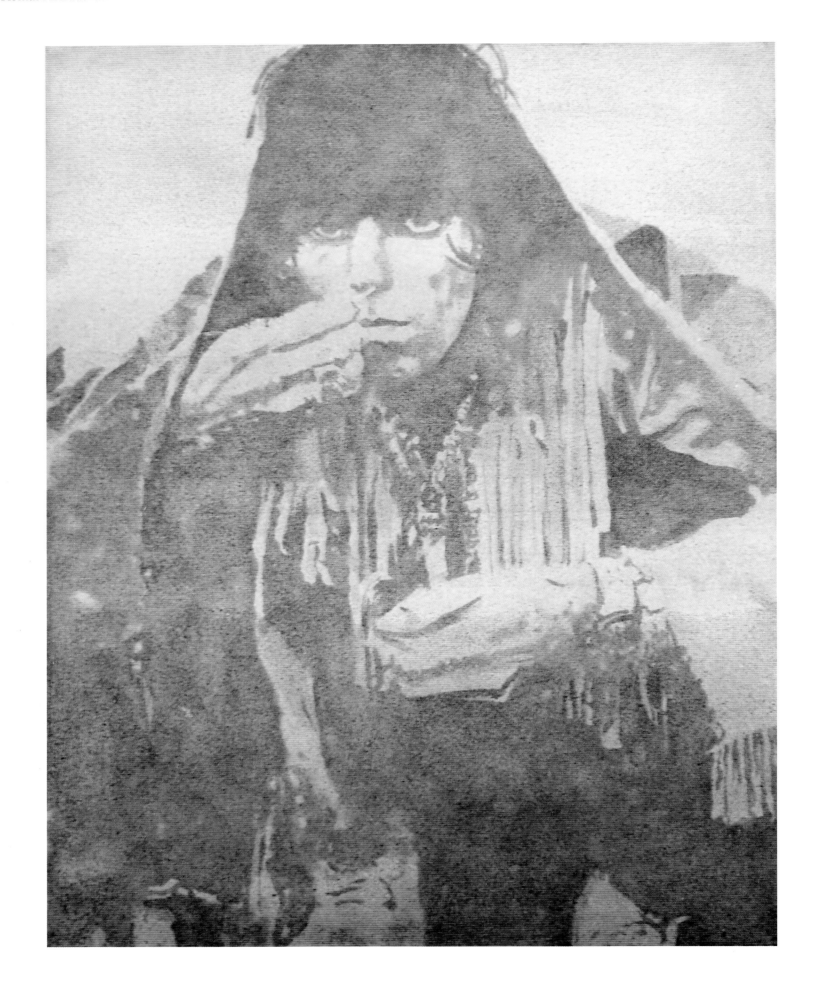

Mojave Keith, 2006, oil on canvas, 28 × 20 inches / 71.1 × 50.8 cm

"My painting practice revolves around the appropriation and manipulation of found imagery.
The sources, which are typically photographic in nature, include material derived from both
film and print, and reflect an interest in the representation of the human form."

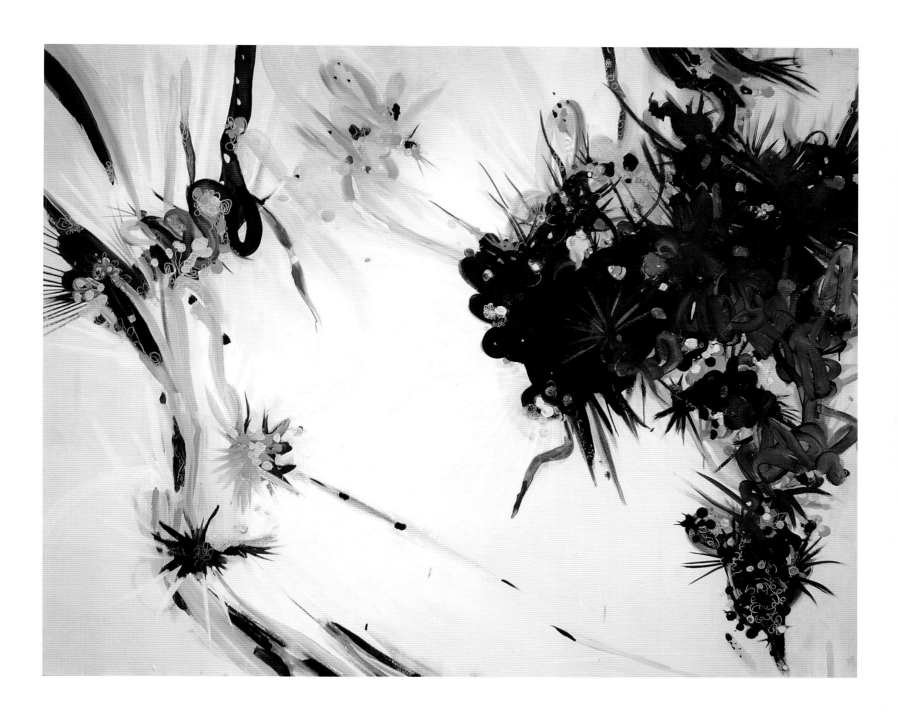

7th Bio-Mutation of Electrika, 2006, oil on canvas, 48 × 60 inches / 121.9 × 152.4 cm

"We see the world around us as a topography of semi-permanent or stable entities, but the
energy that is at the root of all matter is in a transient state. Seen through this lens, the world
dematerializes. What is left are the dynamics between things, and the notion that everything
is in a constant state of transformation."

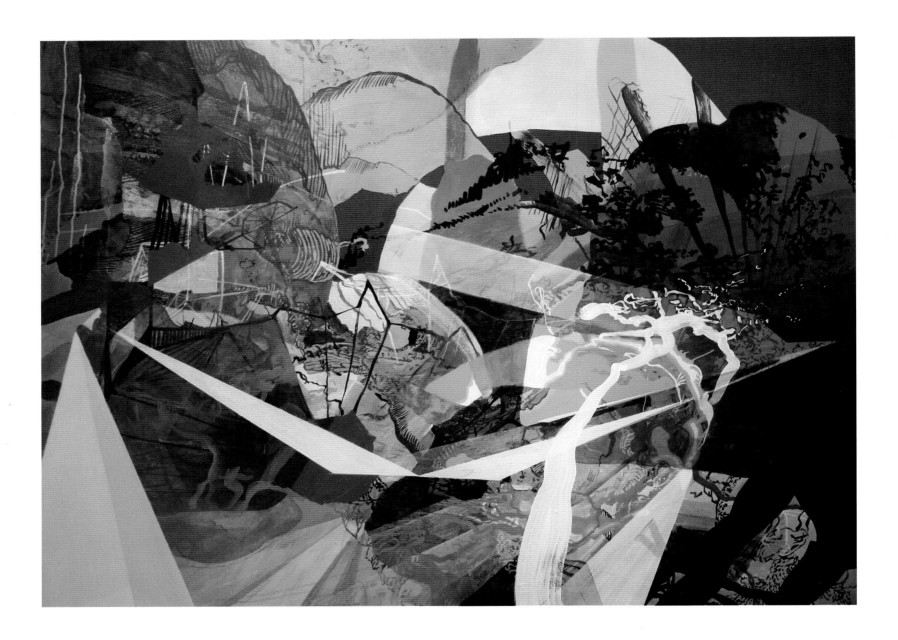

Web, 2005, acrylic on canvas, 48 × 60 inches / 121.9 × 152.4 cm

"Each of my paintings is about a journey, a journey about a negotiation of opposites: the artificial
and the organic, the technological and the natural, flatness and deep space, synthetic and natural
colour, chaos and control, the sublime and the everyday."

Untitled (White House), 2006, oil on panel, 6 × 4 inches / 15.2 × 10.2 cm

Untitled (Yellow Car), 2006, oil on panel, 6 × 4 inches / 15.2 × 10.2 cm

"I've come to feel that Realism is a totally unnecessary term coined as a means of distinguishing between Abstract and Non-Abstract painting, and that both terms are outdated, cumbersome and only serve to obscure and confuse paintings' current state."

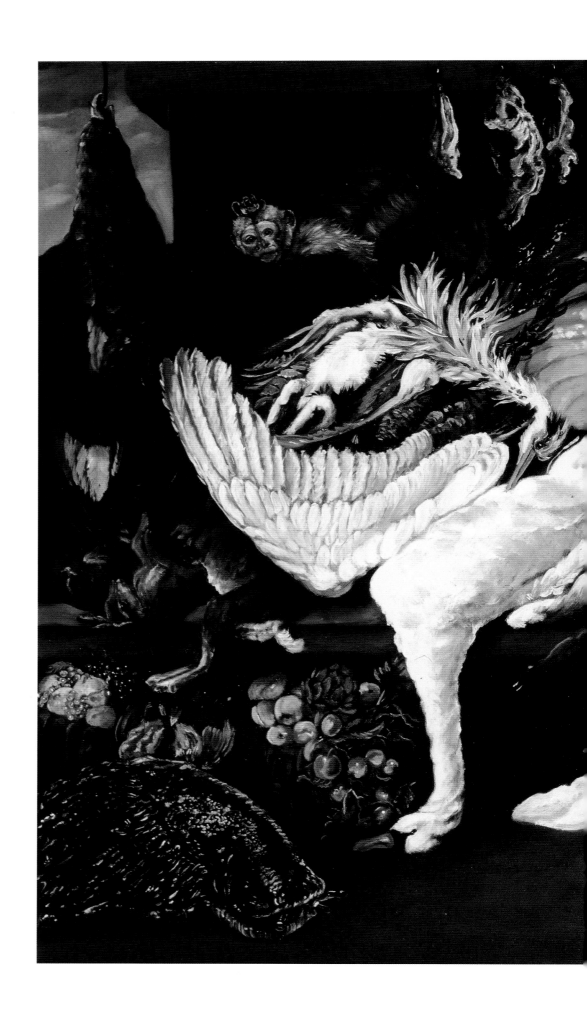

The Harvest and the Hoard, 2007, oil on panel, 24 × 36 inches / 61 × 91.4 cm

"Becker pillages characters and compositions by shamelessly pirating the masterful paintings
of antiquity, interjecting his own nefarious carnage-laden tendencies. His raw and corporeal
painting seethes with excessive neo-classical manliness, resulting in fantastically detailed
debaucherous scenes that work as both tribute and parody."

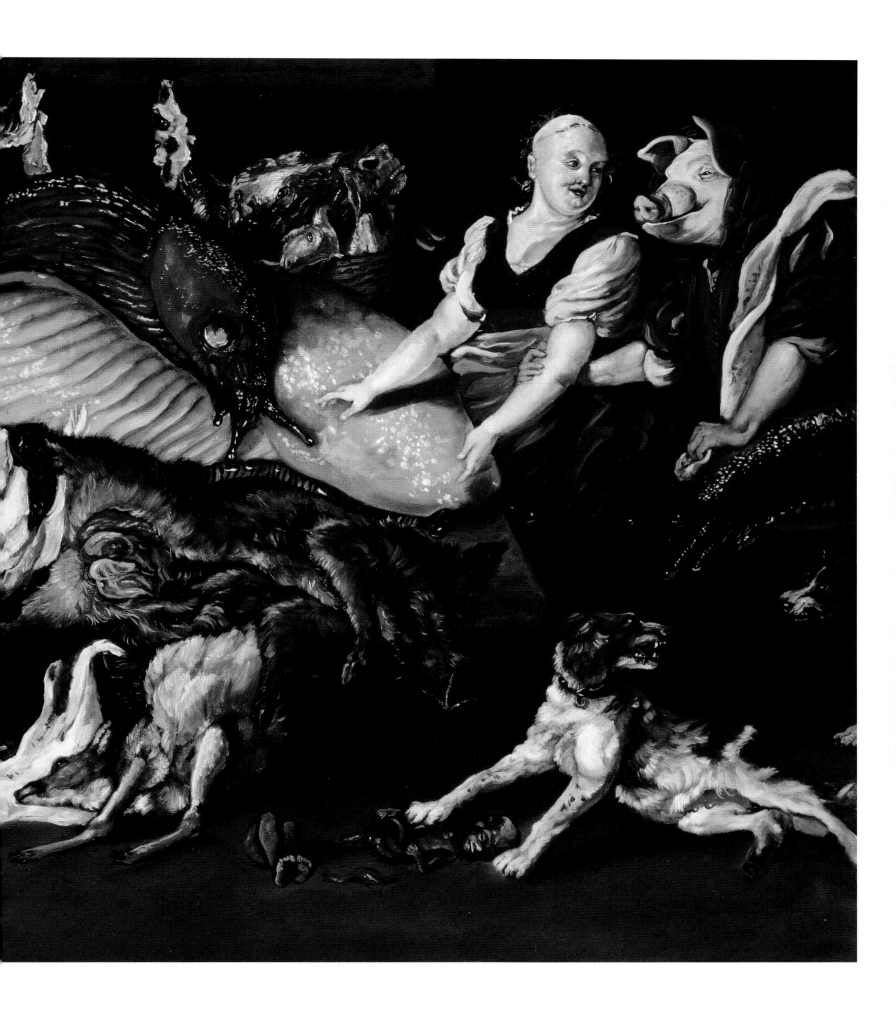

Margo, 2006, airbrush using acrylic on canvas, 36 × 36 inches / 91.4 × 91.4 cm

"I have an instilled fascination with people, portraits and the connections
we have with each other. It is a challenge to present the viewer with a precise
representation of the expressions and emotions of each subject."

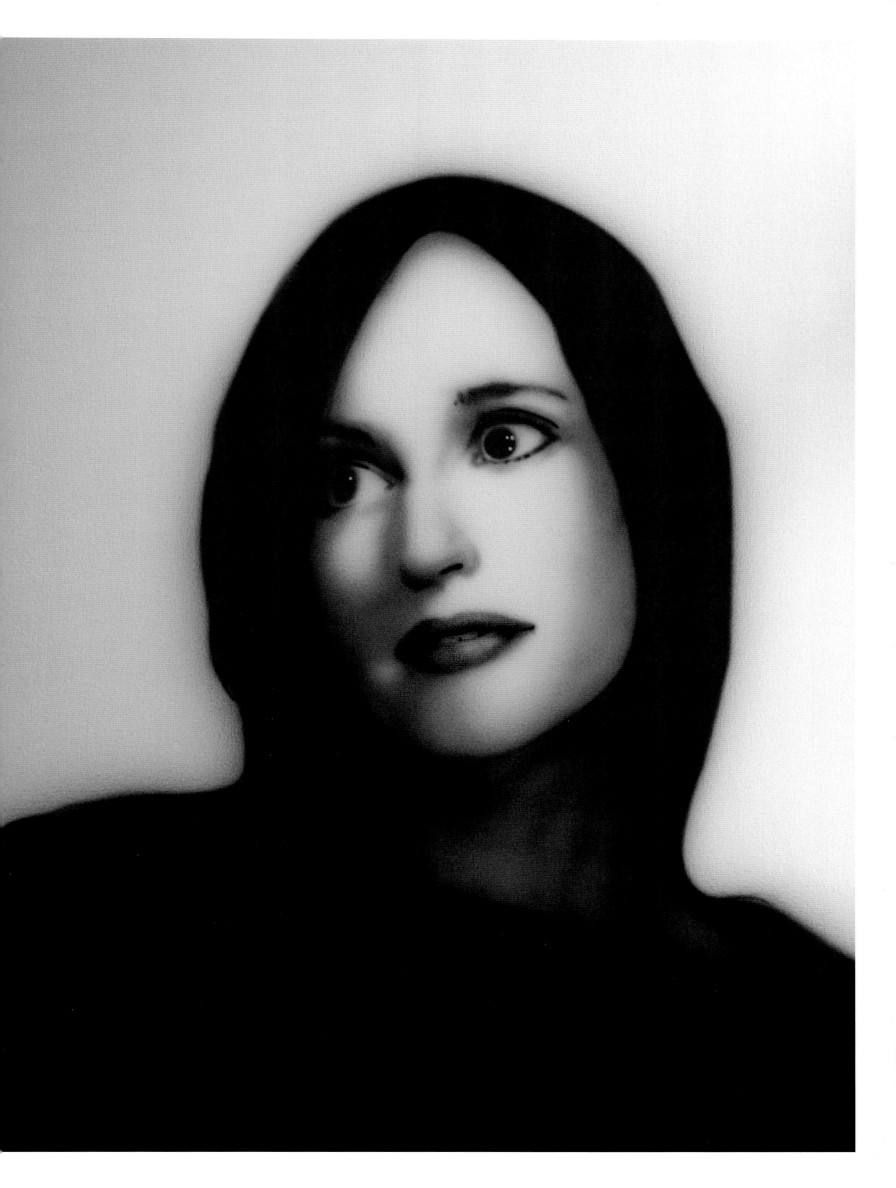

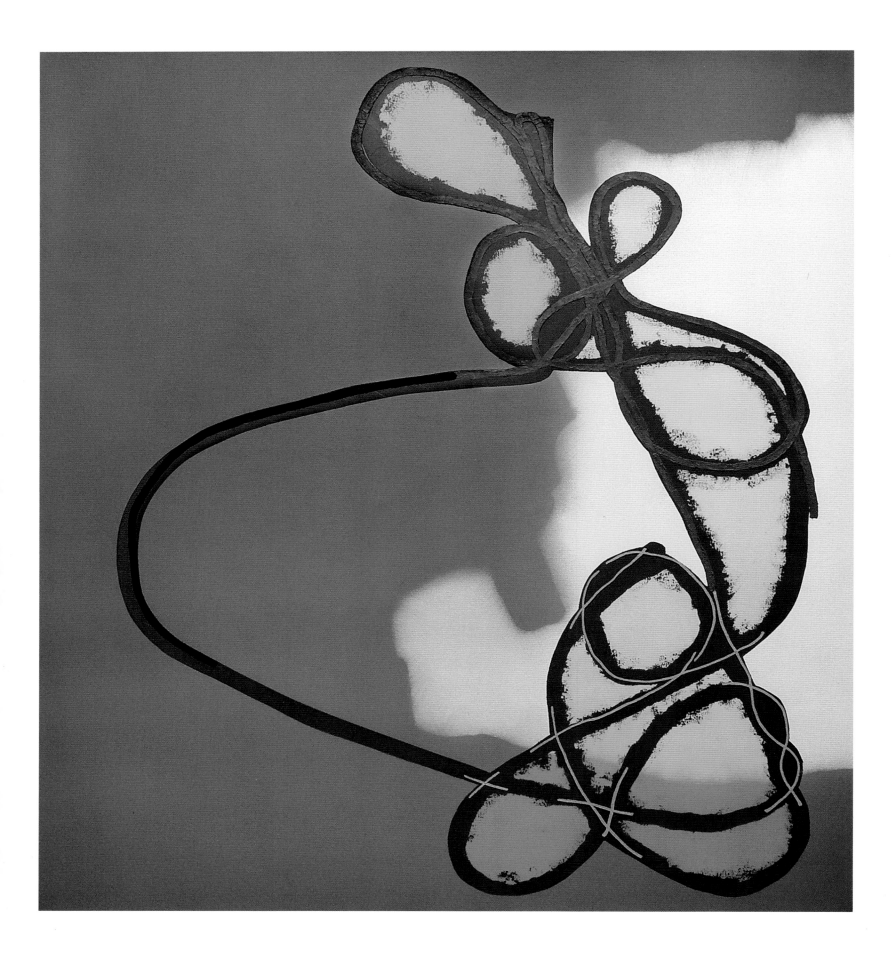

Sit Like a Heavyweight, 2006, oil on canvas, 48 × 44 inches / 121.9 × 111.8 cm

Authentic Forgery 2, 2006, oil on canvas, 36 × 30 inches / 91.4 × 76.2 cm

"These paintings are poised dangerously between the poetry in chance and the absurd. I accept
and utilize the irrational, succumb to fantasy and profit from chance with the intent on making
the viewer aware of how he or she construes a painting."

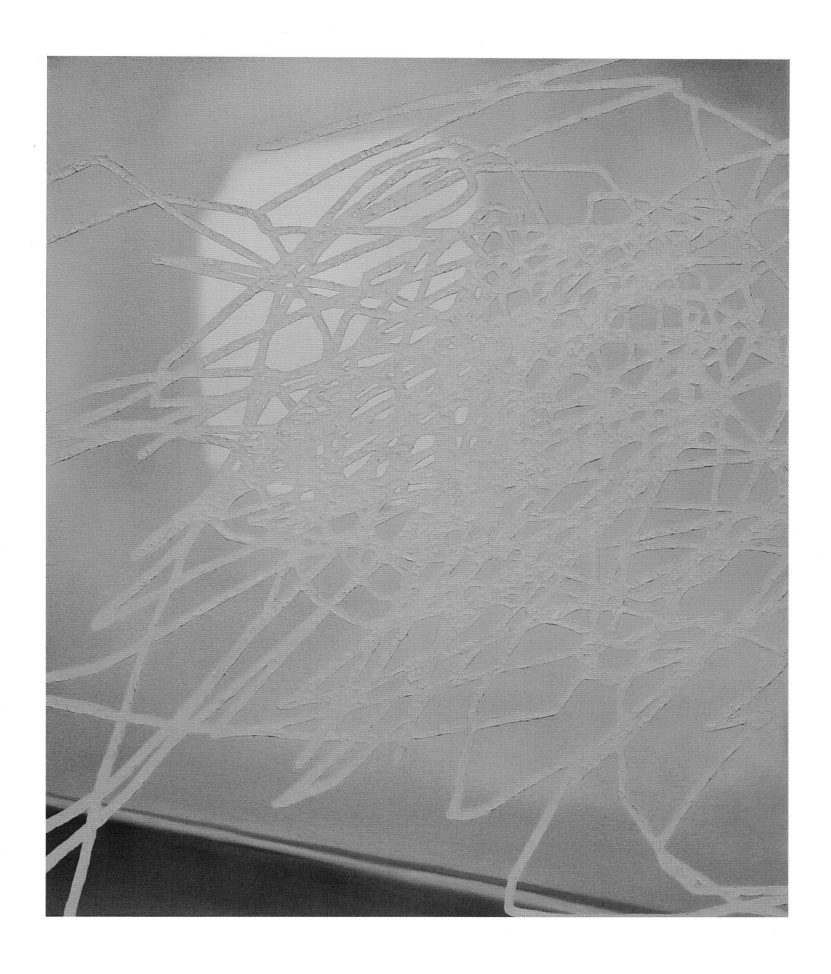

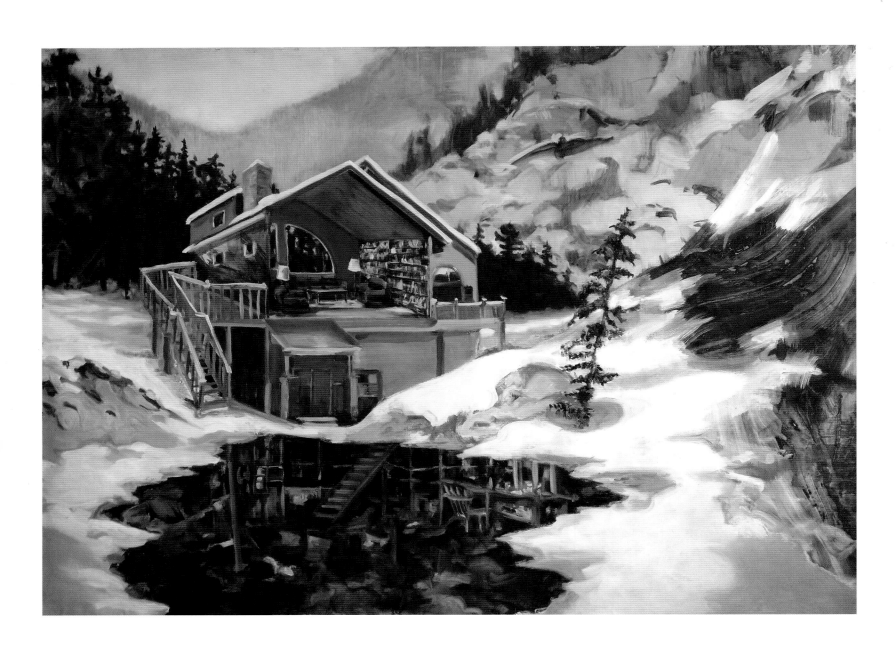

*…and to inhabit those blank, depersonalized interiors was to understand that the world was
an illusion that had to be reinvented every day.* 2007, oil on paper, 60 × 72 inches / 152.4 × 182.9 cm

"My paintings are like proposals for fictional film stills or stage sets for imaginary plays.
Visualized from passages in literature, they create spaces in between a narrative, a book space,
a film space or brain space. With cut-away walls, the paintings mimic the absent fourth wall
of theatre, film and television and allow the viewer to be both inside and outside, both spectator
and participant."

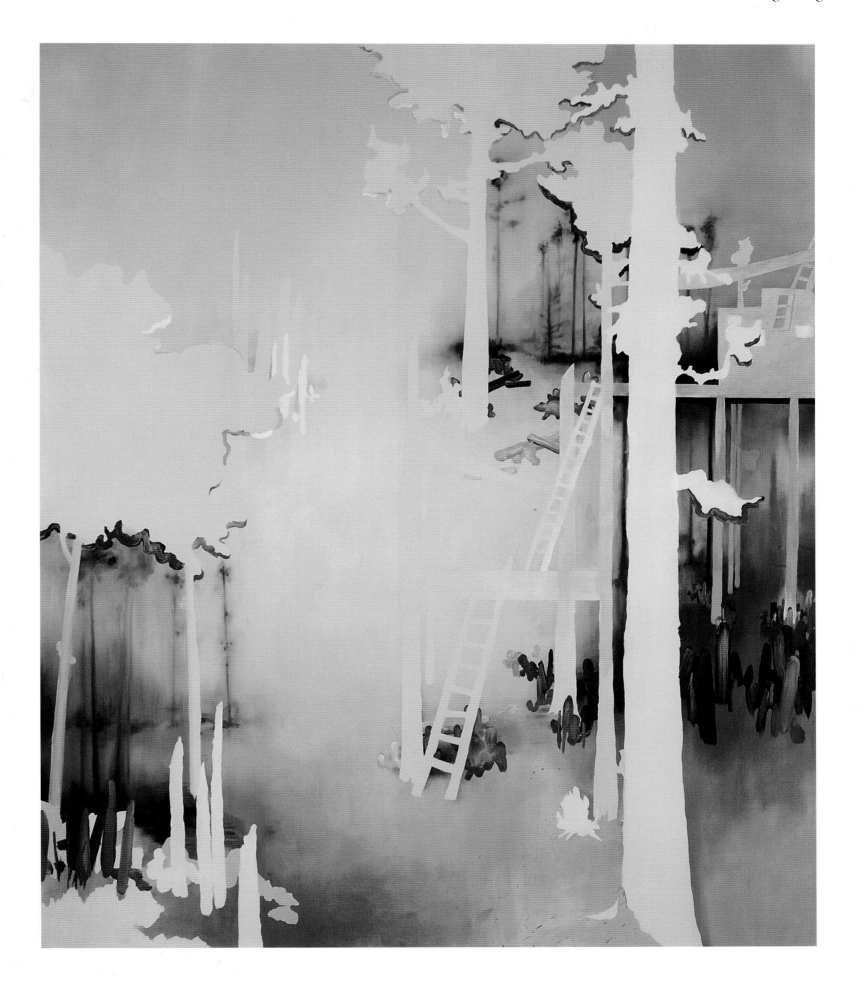

Hidden at the Center of It, 2005, oil and acrylic on canvas, 72 × 60 inches / 182.9 × 152.4 cm

"With this body of work, I have been exploring the subject of provisional living and the sublime
pastoral—what I think of as 'beauty fused with terror.' To me, these subjects suggest conditions of
wonder, uncertainty, anxiety and yet openness to possibilities, and these themes motivate my work."

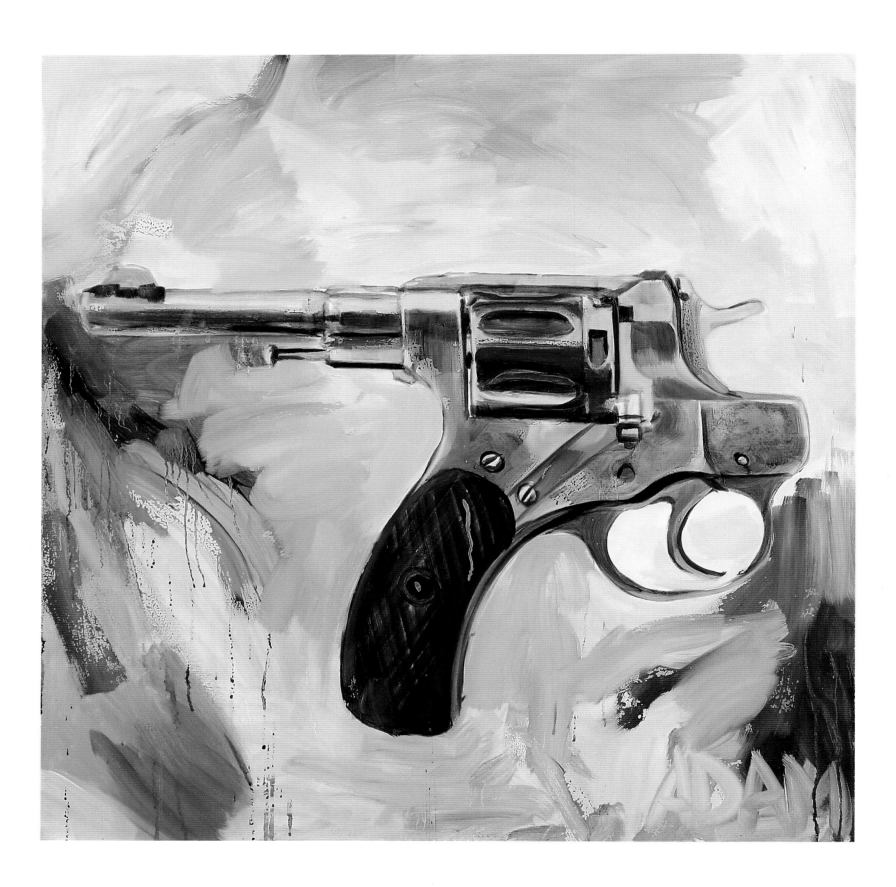

Suicide Gun, 2005, oil on canvas, 36 × 36 inches / 91.4 × 91.4 cm

"Celebrity blogs that chronicle the mundane and the grotesque are updated hourly. The filter between fact and opinion has been obliterated, and viewers are responsible for finding their own way. And today's viewer has an eye for the artificial, born from a steady diet of Photoshopped good, bad and fugly. I compare this type of existence with that of the artist, specifically the painter who must consume the imagery around him or her and produce something more beautiful, apt and personal."

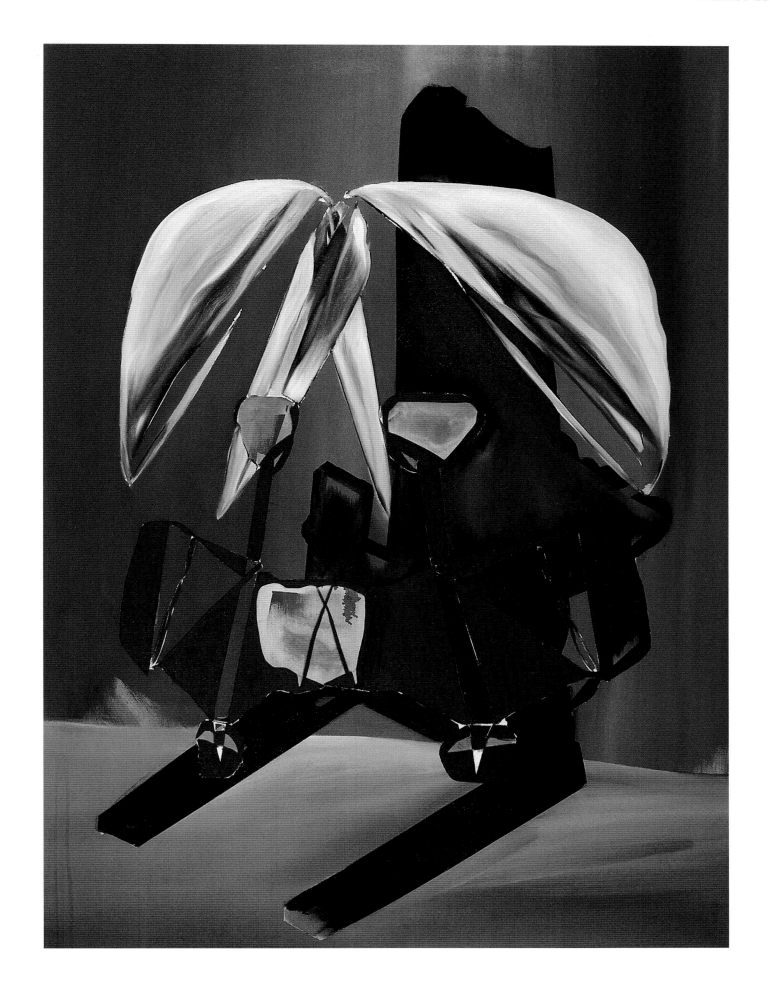

Blonde, 2005, oil and acrylic on canvas, 47 × 37 inches / 119.4 × 94 cm

"The objects in the pictures have all the qualities that our brains are designed to recognize in 'things.'
The objects have parts, anatomy, etc. The figures look like they have handy places to be grasped,
or bits look like they do something. The things look functional. They have tops and bottoms and ends,
and attach together in rational ways. Some of the pieces have been made into faces by a quick and
dumb technique of simply mirroring them."

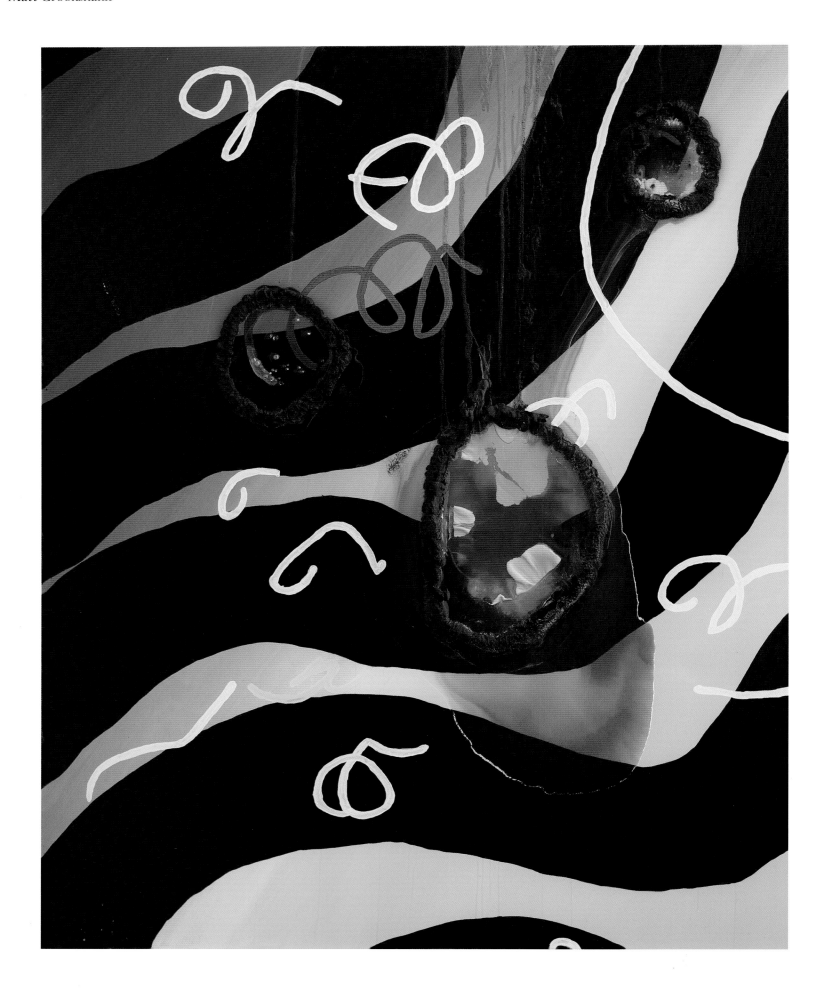

Chimera love 3 (of 5), 2005, oil and varnish on canvas, 60 × 48 inches / 152.4 × 121.9 cm

Chimera love 5 (of 5), 2005, oil and varnish on canvas, 60 × 48 inches / 152.4 × 121.9 cm

"As an artist born and raised in Saskatchewan, I am keenly aware of the space and flatness that are indicative of the prairies of Western Canada. Like the prairies, the space created by the flattened planes in modernist painting ideally allow the viewer's gaze to slow, allowing for time to explore the art created through the formal elements and the medium."

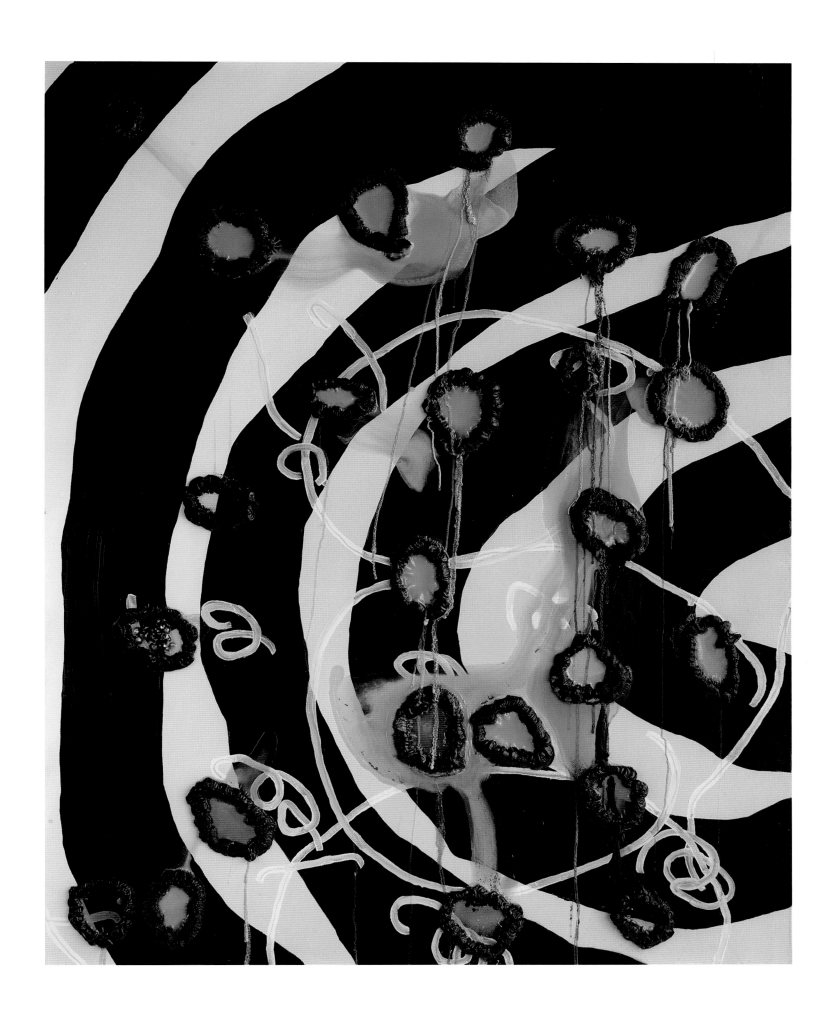

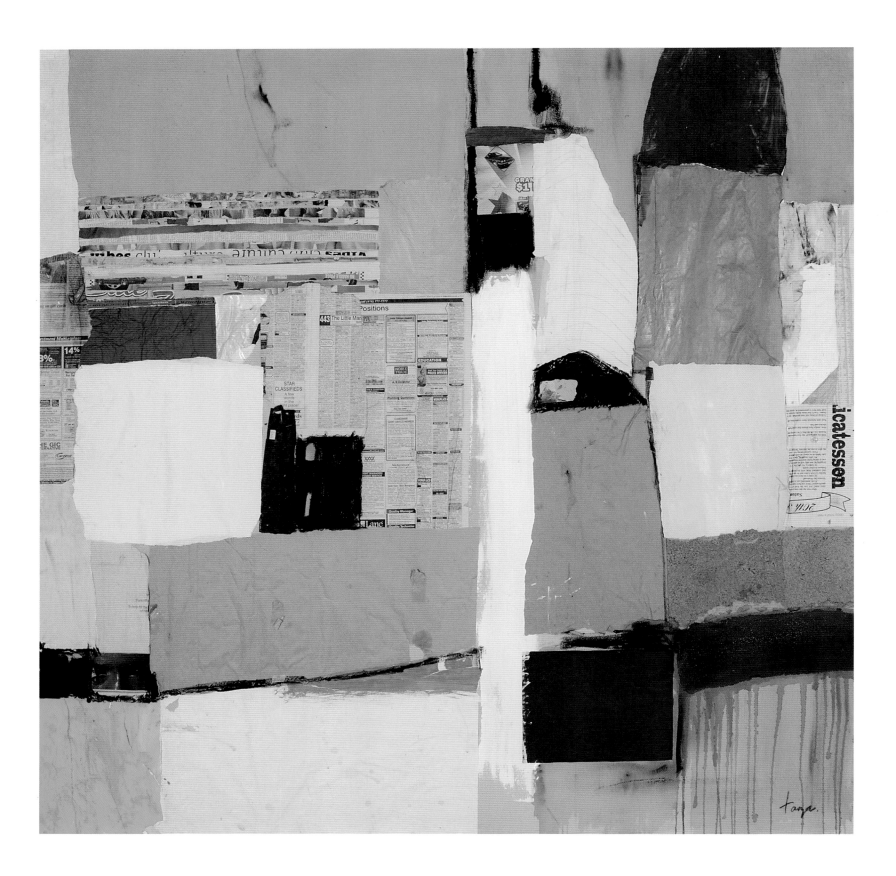

Untitled, 2007, mixed media, 60 × 60 inches / 152.4 × 152.4 cm

"Each painting will often begin with the placement of a single colour or line on the canvas and then stem from there.... Old wallpaper, faded Japanese papers, and yellowing newspaper are among my favourite printed materials. Not only do I enjoy their fragile and impermanent nature which will continue to change over time, but I often purposely leave the pieces of newspaper legible to act as a form of documentation."

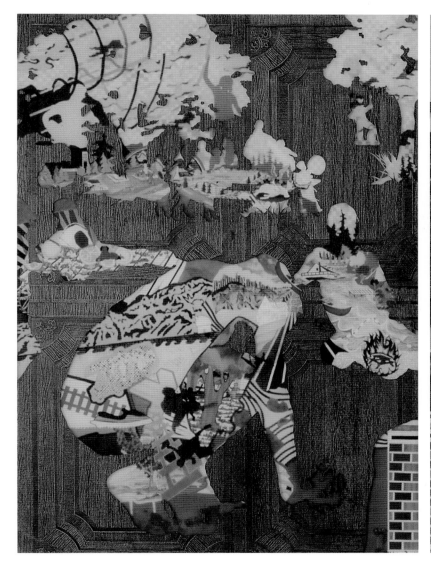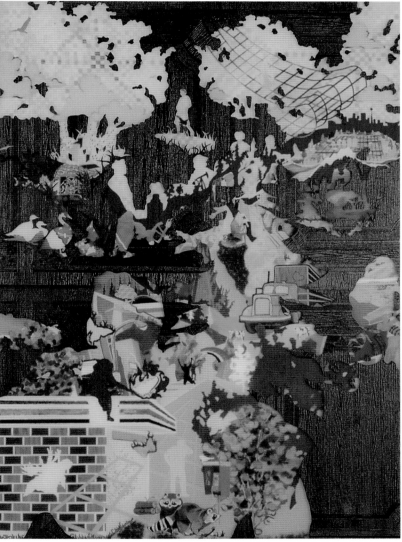

Throw Away the Emote Contol, This Is Where This Begins, 2006, acrylic, resin, and wallpaper on board, 66 × 100 inches / 167.6 × 254 cm

"The Canadian landscape, as imagined by David Foy and Jennifer Saleik, becomes a playground in which their identities as individuals and artists are first distorted and then recreated as a new composite, a singular protagonist, a Canadian 'Dick and Jane.'"

Journey of the Magi, 2006, oil on wood, 12 × 51 inches / 30.5 × 129.5 cm

"In painting, we are taught to think about light in a subtractive way, using the colour wheel as a tool
to measure paint. I have tried to think about light in an additive sense, each layer of paint adding to
the luminosity of the work, creating an unidentifiable colour that is ever changing with every viewing,
an attempt toward a pure oath of affirmation."

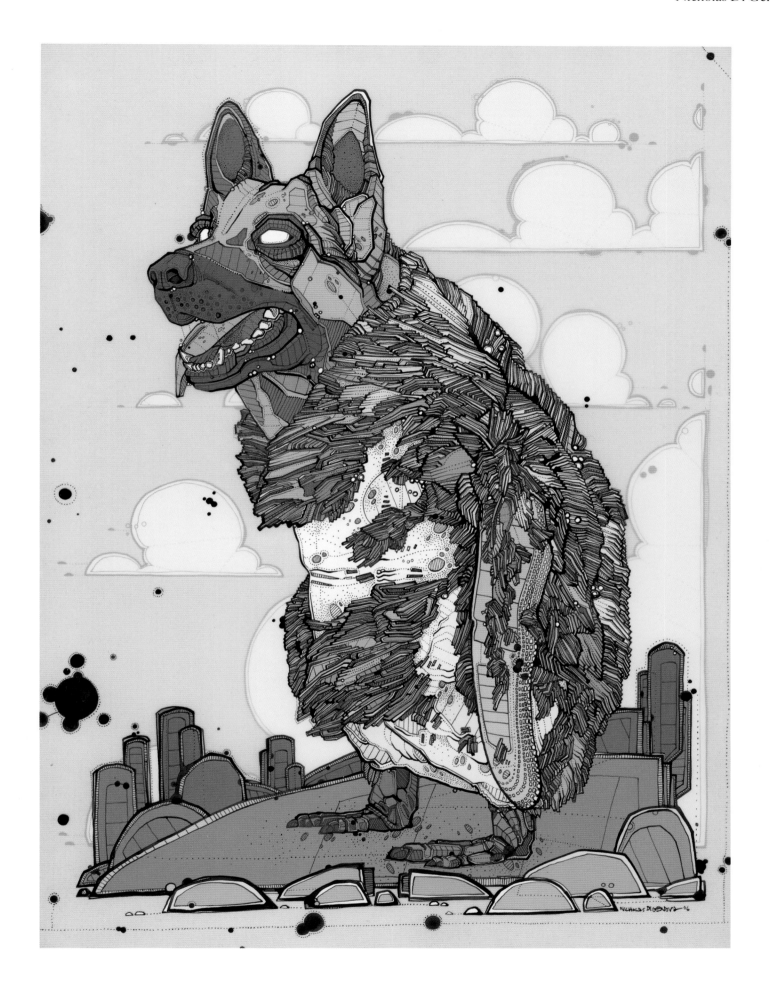

Upright Shepherd Waddler, 2006, ink and animation paint on Mylar, 15 × 11 inches / 38.1 × 27.9 cm

"Drawing on the influence of anime, comic books, Otaku culture and animal compendiums, the
work of Nicholas Di Genova features an encyclopedic range of constructed creatures, from soft
and nurturing to calculating and military."

Untitled, 2005, acrylic on canvas, 36 × 36 inches / 91.4 × 91.4 cm

"My paintings are neither purely abstract nor literally descriptive, as it is not my intention to make paintings that have an openly articulated phraseology. In effect, they are elusive and play a visual game of cat and mouse with the viewer, who in turn is placed in the position of making their own associative interpretations."

Litter, 2006, oil on acrylic, 23 × 23 inches / 58.4 × 58.4 cm

"My inspiration for the work came out of ordinary frustration with a painting I had been working
at for months, which was subsequently destroyed by primer paint and adolescent-minded vandalism.
The satisfaction of the impulsive destruction was immense, and so I began to build on it."

Wallpaper 1–12, 2006, oil, wax, wallpaper, Japanese paper, scrap-booking paper, brown wrapping
paper, digital prints, tissue paper, and Mylar on wood panels, 12 × 12 inches / 30.5 × 30.5 cm each

"The figures and wallpaper images from the past operate as signs of things that have 'gone before.'
The figures from the 1950s and 1960s also act as reminders that we, too, are in the process of
becoming context."

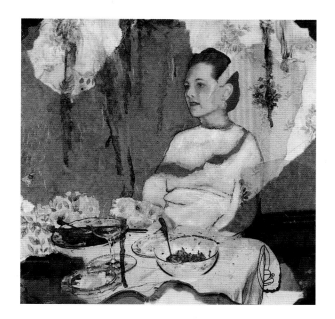
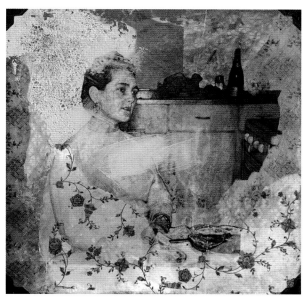
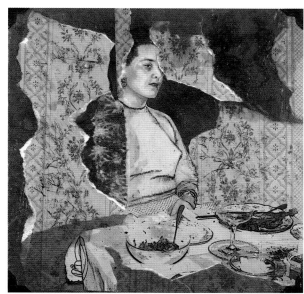
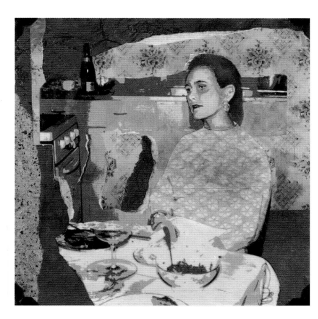
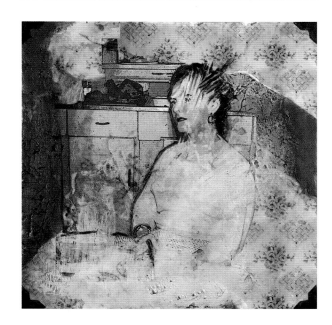

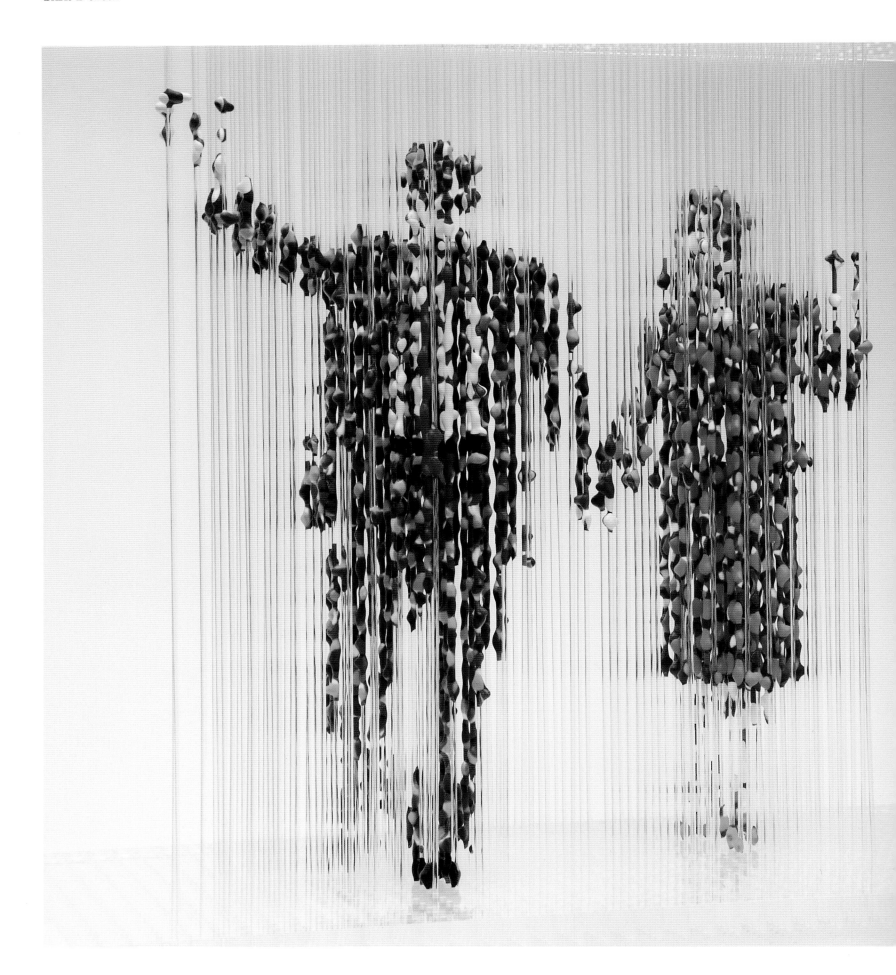

Stasis 14, 2006, paint, acrylic plastic, 150 × 246 × 81 inches / 381 × 624.8 × 205.7 cm

"Out of material discovery, I began to regard the primacy of the paint drop, a form that takes
shape not from a brush or any human-made implement or gesture, but purely from its own
viscosity and the air it falls through, as analogous to the building blocks that make up the human
body (DNA) or even its mimetic representation (the pixel)."

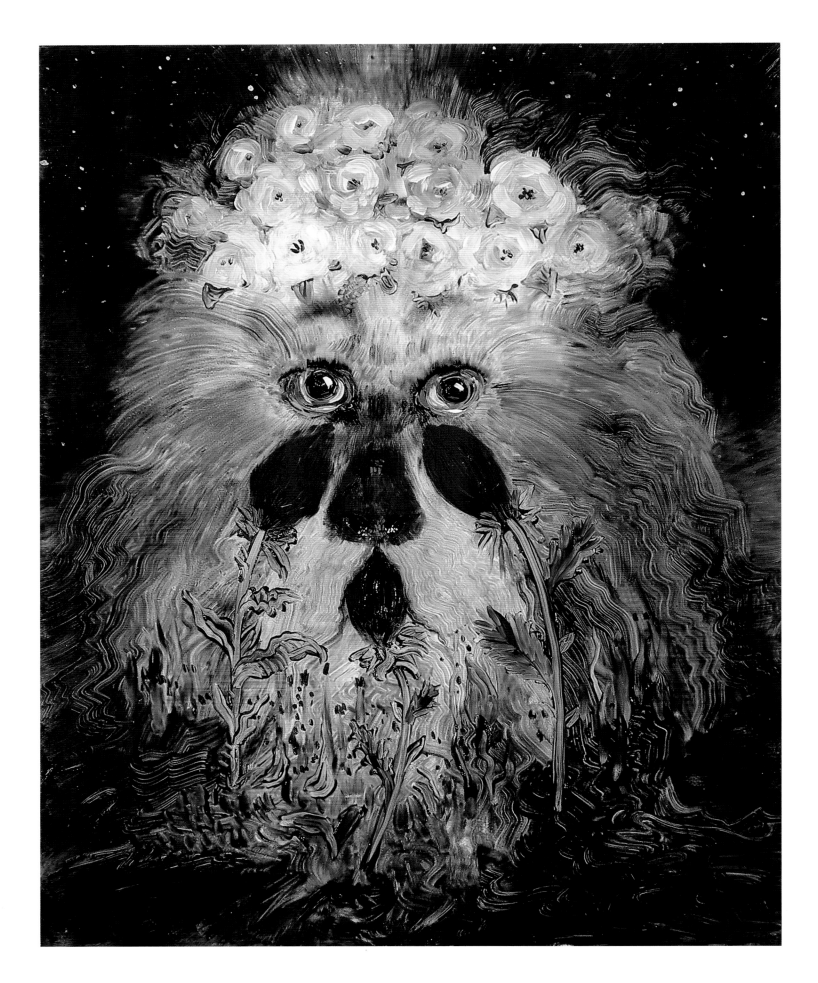

Untitled, 2006, oil on masonite, 20 × 16 inches / 50.8 × 40.6 cm

"I am interested in the racial and sexual stereotypes found in fairy tales and religious myth.
 Rather than illustrate specific stories from these sources, I prefer to be inspired by and emulate
 their latent sexuality, wonderment and xenophobia."

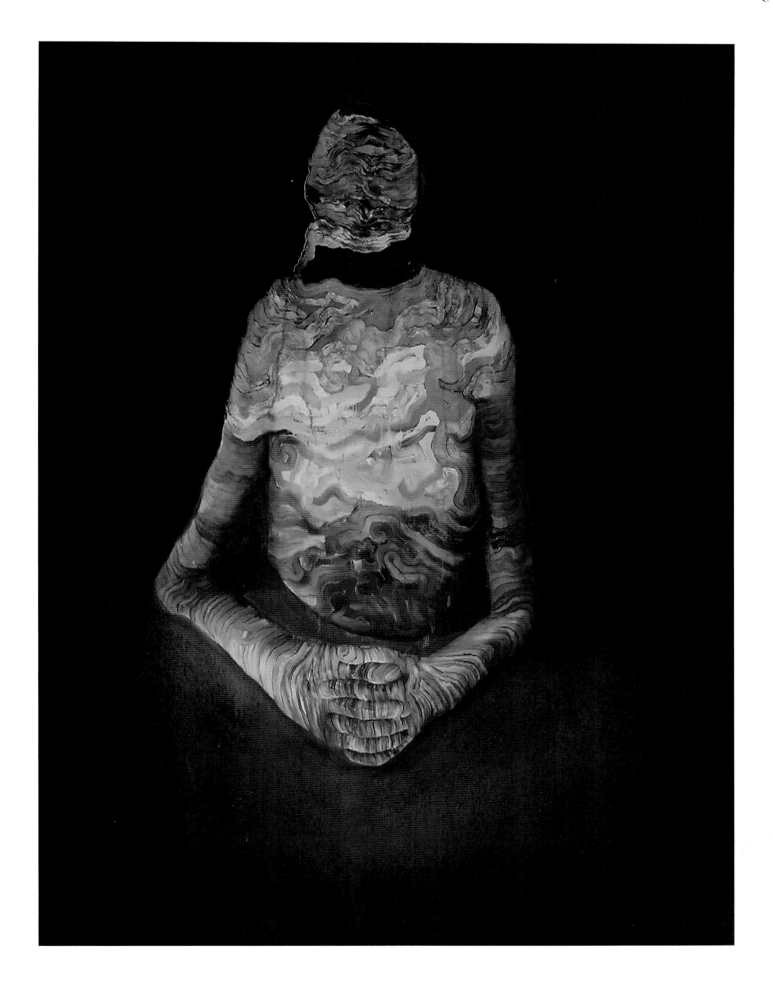

We Are Patient People, 2007, oil on canvas, 48 × 36 inches / 121.9 × 91.4 cm

"I am painting the human body as an imaginary object and as a malleable mass. His free-form
 balances between the beautiful and the grotesque, the imagined and the unimaginable,
 and ultimately references an audience's taboos, attractions and repulsions, as well as fetishes
 and desires."

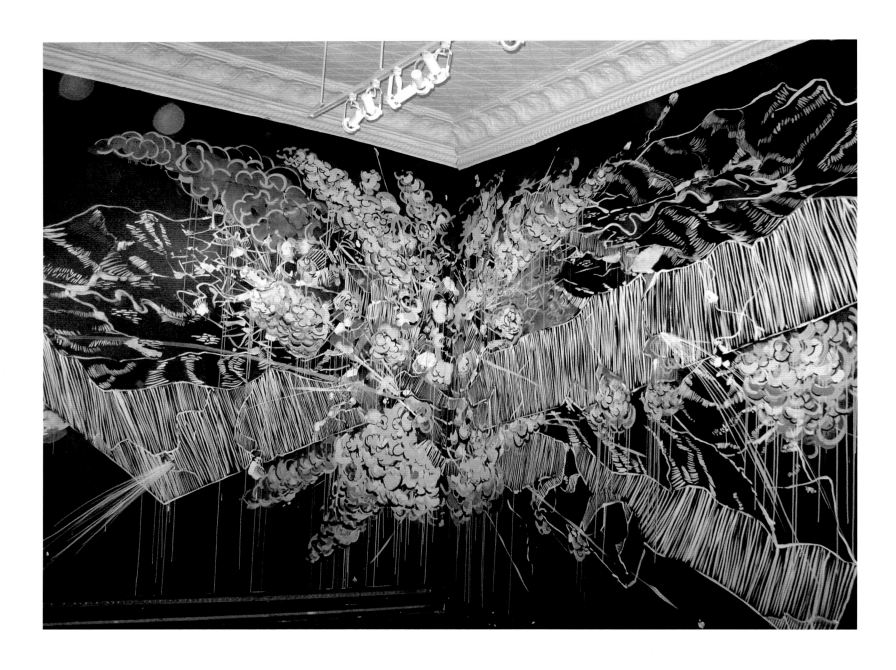

No Place 4 (3rd Space Gallery Installation), 2007, acrylic, latex house paint, and drawing inks
on wall, 120 × 312 inches / 304.8 × 792.5 cm

"Fisher reassigns geographic diagrams from their textbook domains—the realm of science—
and releases them into inky black space, floating in a vacuum. The islands crash violently and
disastrously, crumbling and grinding into oblivion. You, the viewer, are invited to witness this
suspended, frozen moment."

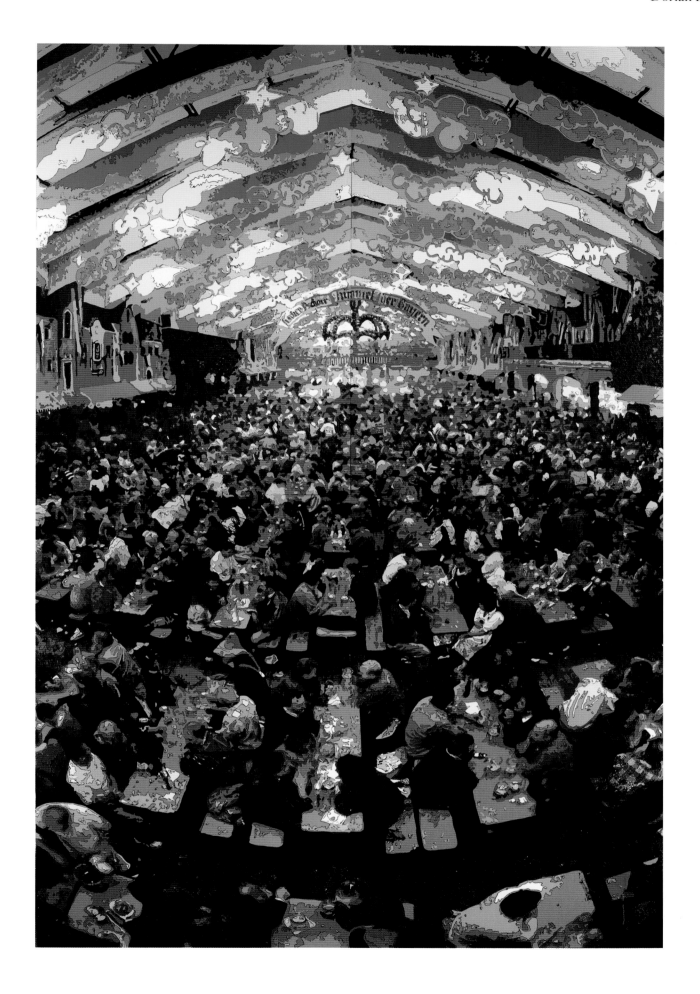

The Beer Hall, 2005, acrylic and caulking on canvas, 216 × 144 inches / 548.6 × 365.8 cm

"The images that interest me are symmetrically organized, complex masses of objects that assume
fractal-like forms. Though not overtly political, in order to maintain my interest, the images also
usually reflect my thoughts on wealth and decadence."

Brendan Flanagan

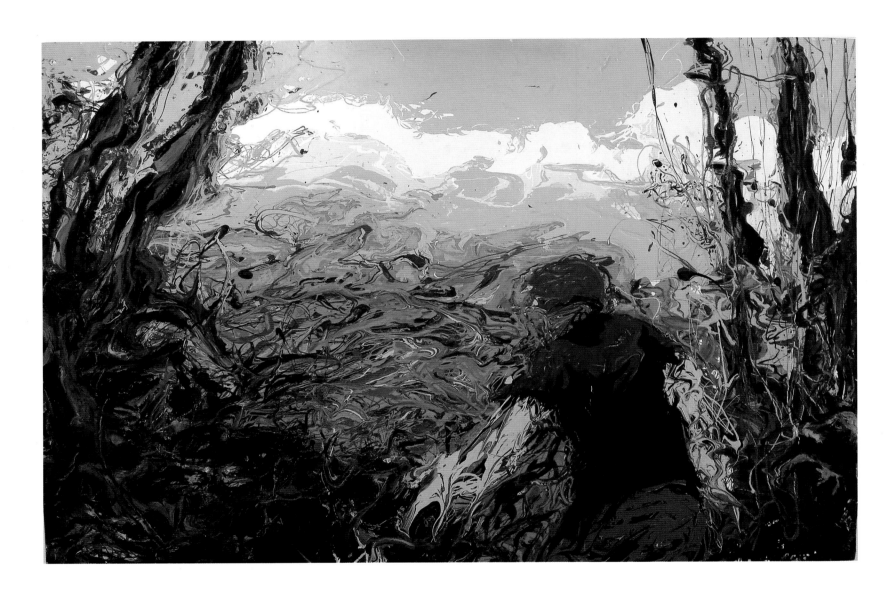

Mosquito Coast, 2007, enamel on board, 48 × 72 inches / 121.9 × 182.9 cm

"My work has evolved from a strong interest in the heroic paintings of Romanticism and my
recent experimentation with abstraction and the language of Abstract Expressionism.
My paintings attempt to reconcile these two types of figurative and non-figurative styles
into a new synthesis that keeps the epic associations of each."

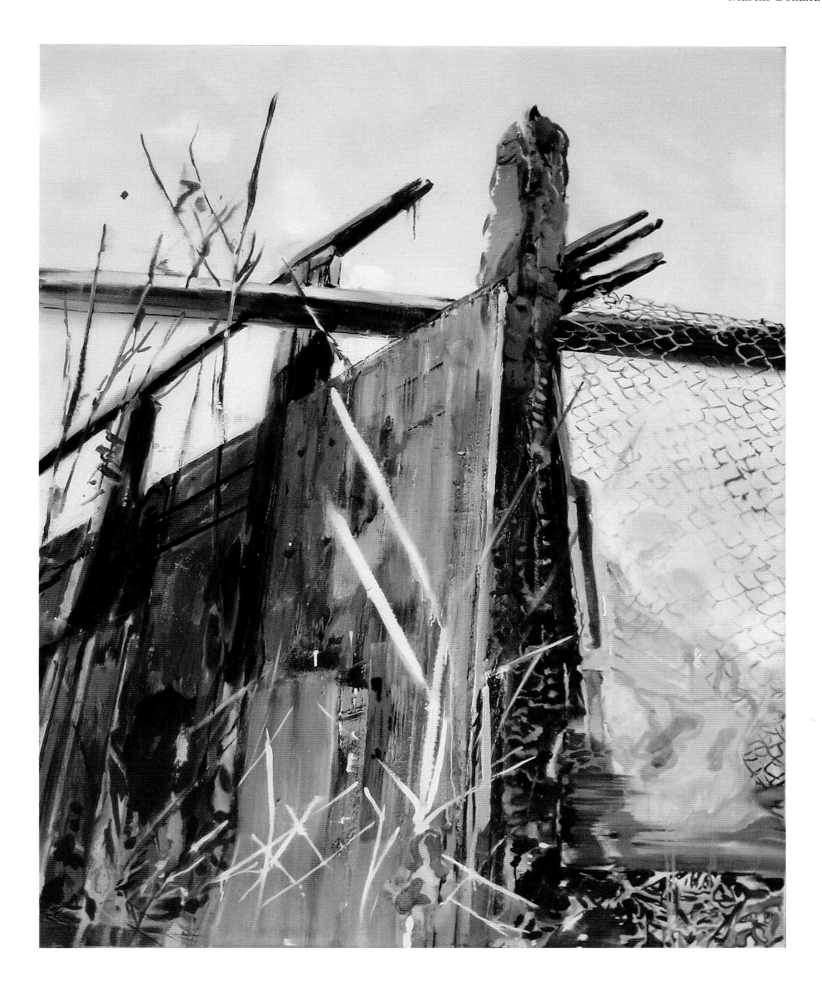

Fence, 2007, oil on canvas, 56 × 48 inches / 142.2 × 121.9 cm

"The scenes presented in my work are emptied of figures, leaving only traces of hidden activity.
My intent is to mark out the slippage between elements of safety and fear that are revealed in
these scenarios."

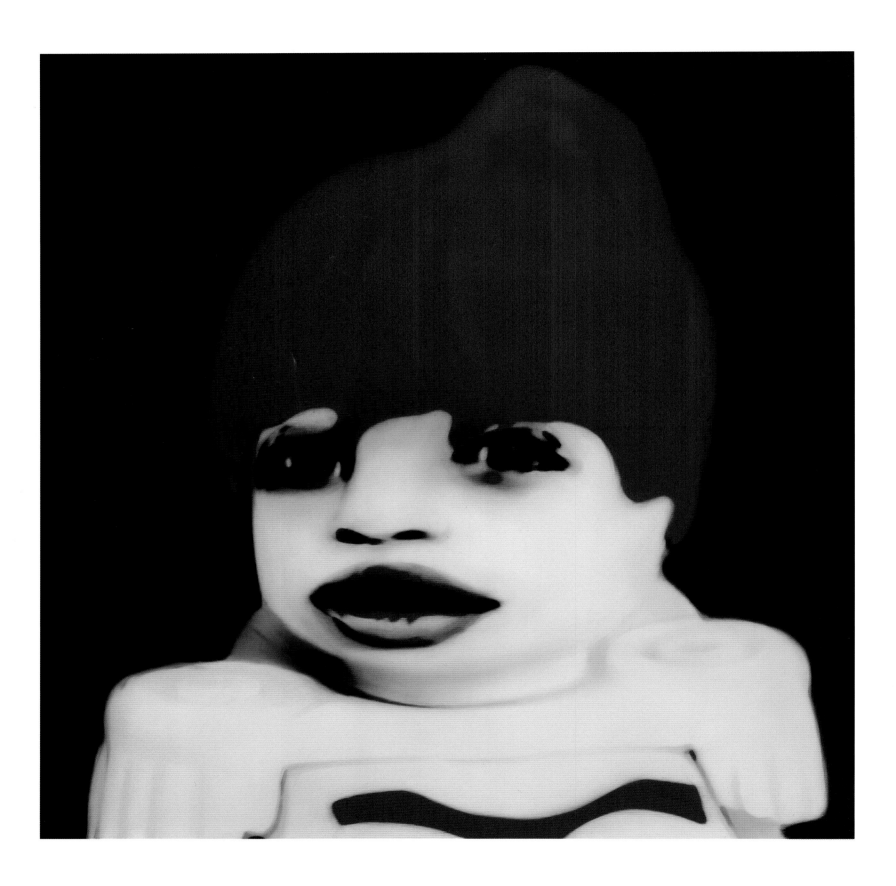

Untitled (Character #3), 2006, oil on wood panel, 48 × 48 inches / 121.9 × 121.9 cm

"It is important for me that every step of the process leaves its trace in the finished work, so that within the final gestalt of the painting the spectator can still feel the various source elements on the verge of breaking free from the whole. This kind of tension is essential for me in these paintings."

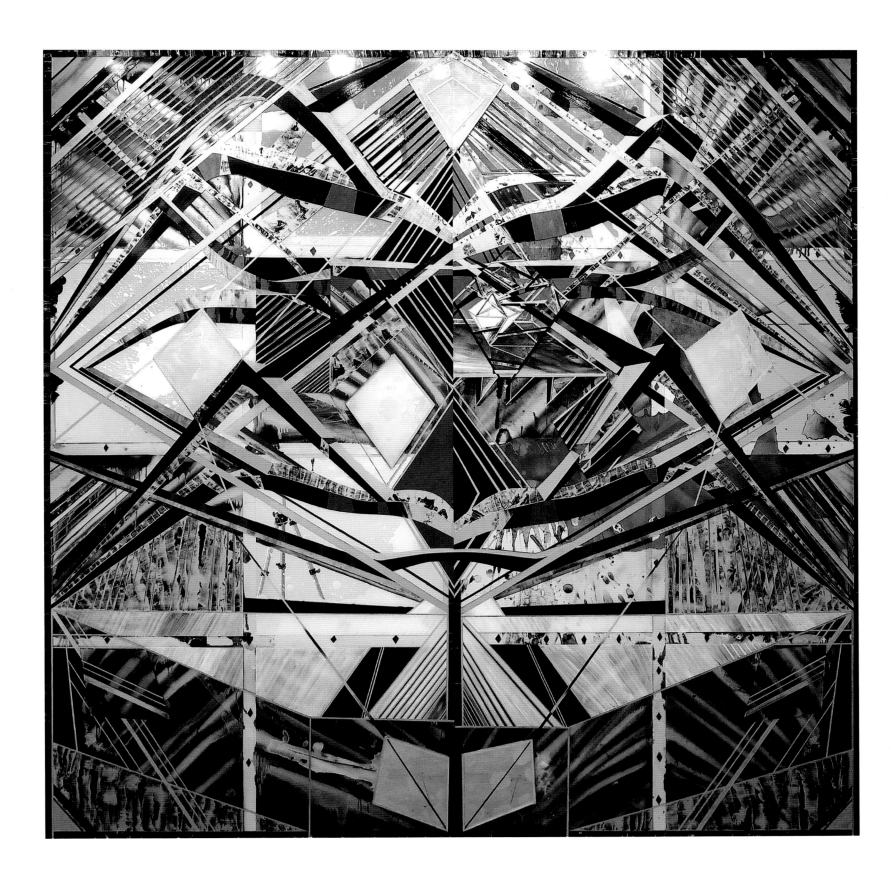

Me (New York Remix), 2007, mixed media on and behind Plexiglas,
84 × 84 inches / 213.4 × 213.4 cm

"The panopticon is an architectural structure, circular in design, with a viewing tower
at its centre. The purpose is to house a circular grouping of cells which can be viewed
continuously by a single individual. The panopticon was used as a departure point
to guide my relationship between architectural structures (and how they relate to the
spatial constraints of painting) and non-representational painting."

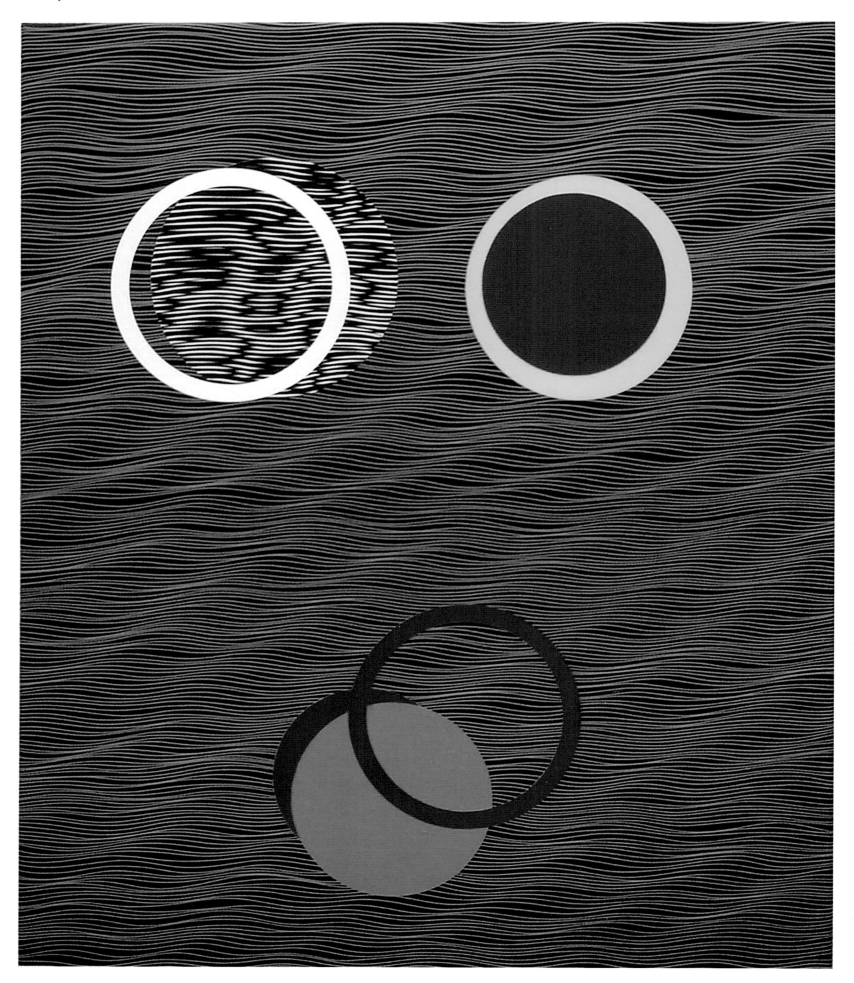

it gave her a start, 2005, acrylic on canvas, 24 × 20 inches / 61 × 50.8 cm

"These are perfectionist paintings that extol imperfect formal and social realms. I craft paintings that are slick as well as sincere, diagrammatic as well as sensual, almost self-conscious of their identity as abstract paintings."

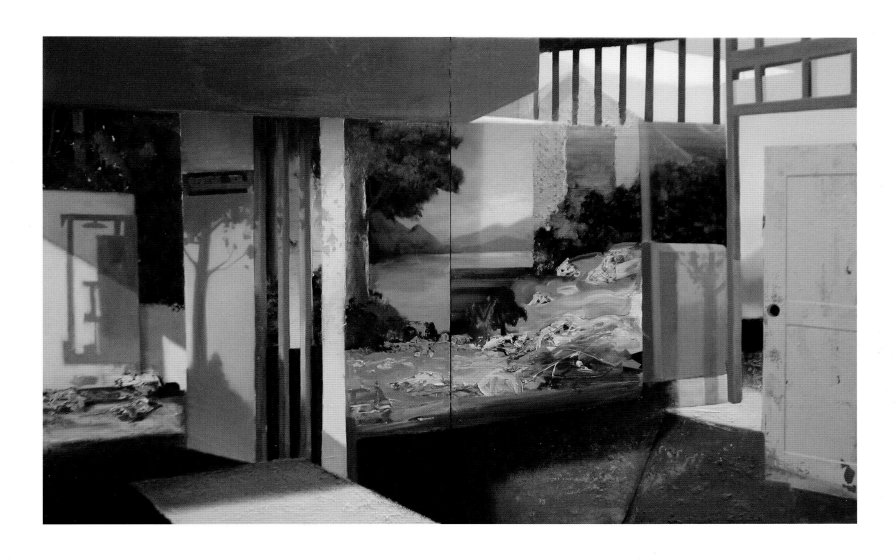

Haunted House, 2006, oil on canvas, 60 × 96 inches / 152.4 × 243.8 cm

"My work is a study in various abstractions of nature with particular emphasis on a theatrical
 view. By means of their material construction, the paintings evoke a vision of wilderness as
 a social and psychological construction, where the natural world is caught between its own
 organic nature and the sublimating forces of human intervention."

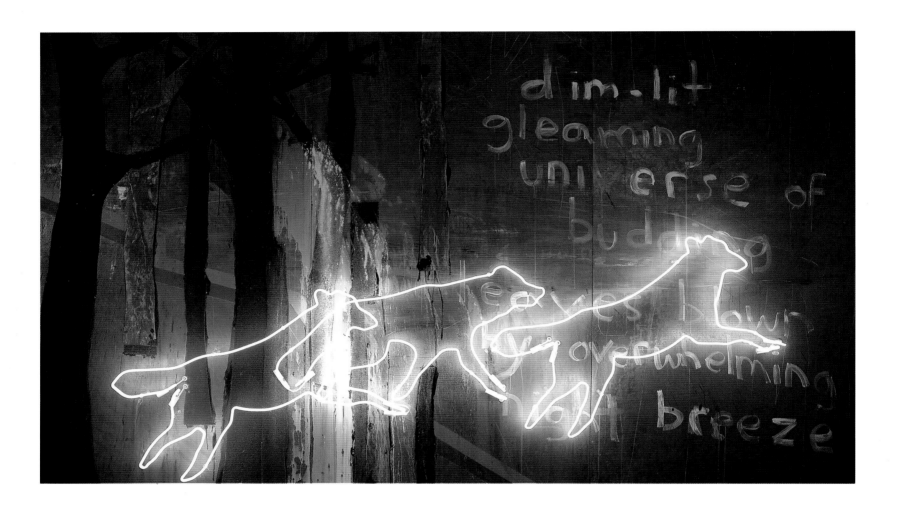

Dim-lit Gleaming Universe of Budding Leaves Blown by Overwhelming Night Breeze, 2008,
mixed media with neon lights on metal panel, 84 × 144 inches / 213.3 × 365.8 cm

"I'm ok with money and making it from the sale of transposing ideas to medium. My new
work balances the notions of art, commerce, vanity and biography. I am not speaking
to any broad-based economic idiom. I am seeking to address a more localized perspective,
the Canadian view of the business artist."

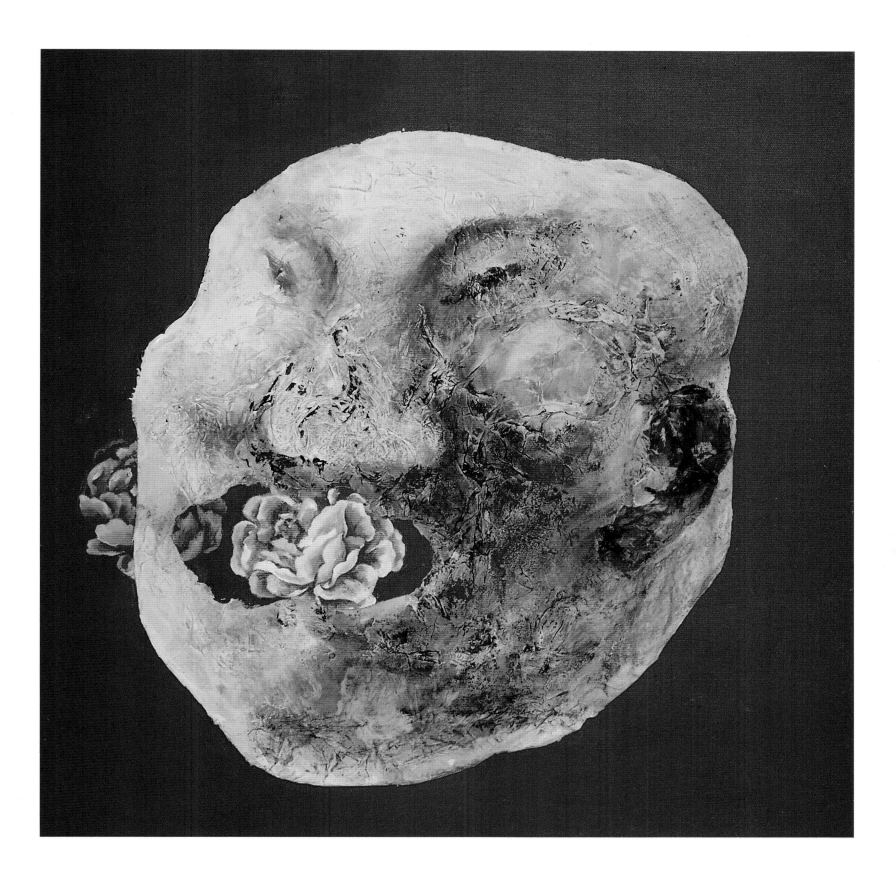

Anachronism 40, 2006, acrylic, rice paper collage on canvas, 24 × 24 inches / 61 × 61 cm

"This series is at first glance a synthesis of two traditions that reflect my own life experience
of immigrating to Canada from China. The ostensible focus of the works is the Qin Dynasty
terracotta Warriors unearthed in 1974. Though once viewed as protectors of the afterlife,
and later as the symbol of China, these icons here have new lives but in an illogical space.
By subjectively depicting familiar elements of the ancestral Chinese sculptures, I try to
counter-balance the historical and spiritual weight of my subject matter with a degree of
unfettered playfulness."

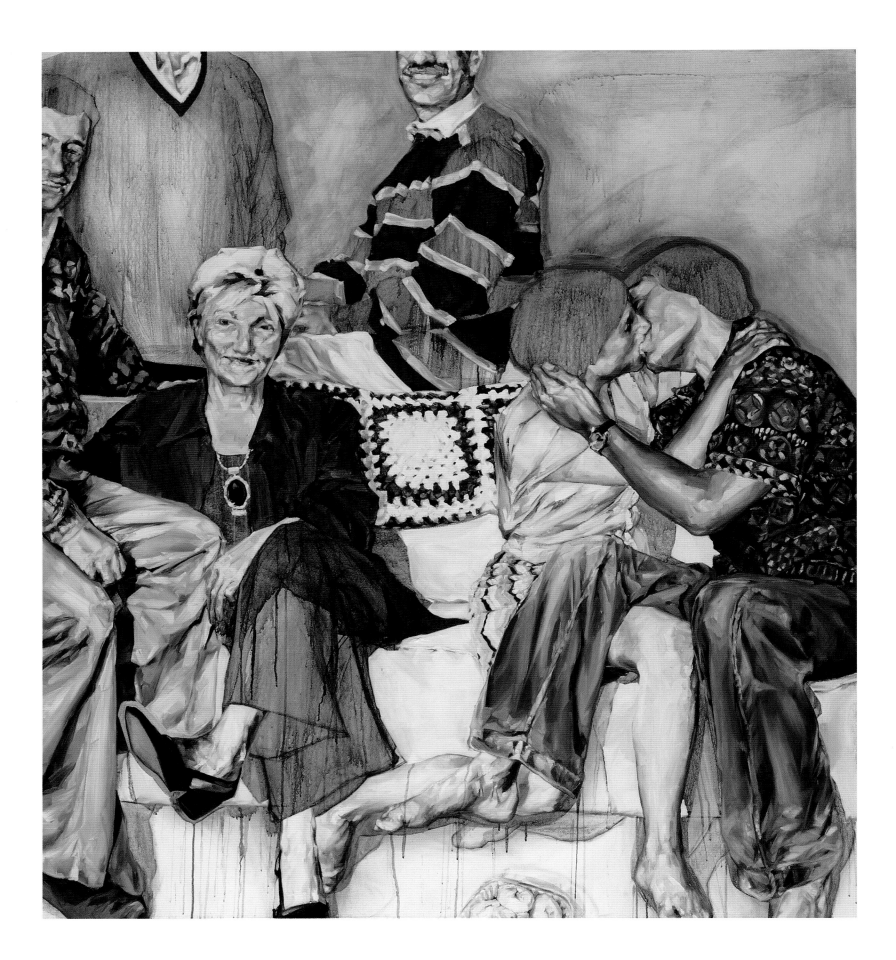

Desirable (to the right kind of people), from the series *Want to be,* 2003, oil, acrylic and charcoal on canvas, 66 × 60 inches / 167.6 × 152.4 cm

"By their very existence, the paintings have elevated the relevance of their subjects and are thereby implying that they depict a significant Event. It is not the subject itself, but the series of events surrounding its present state that is cause for its significance."

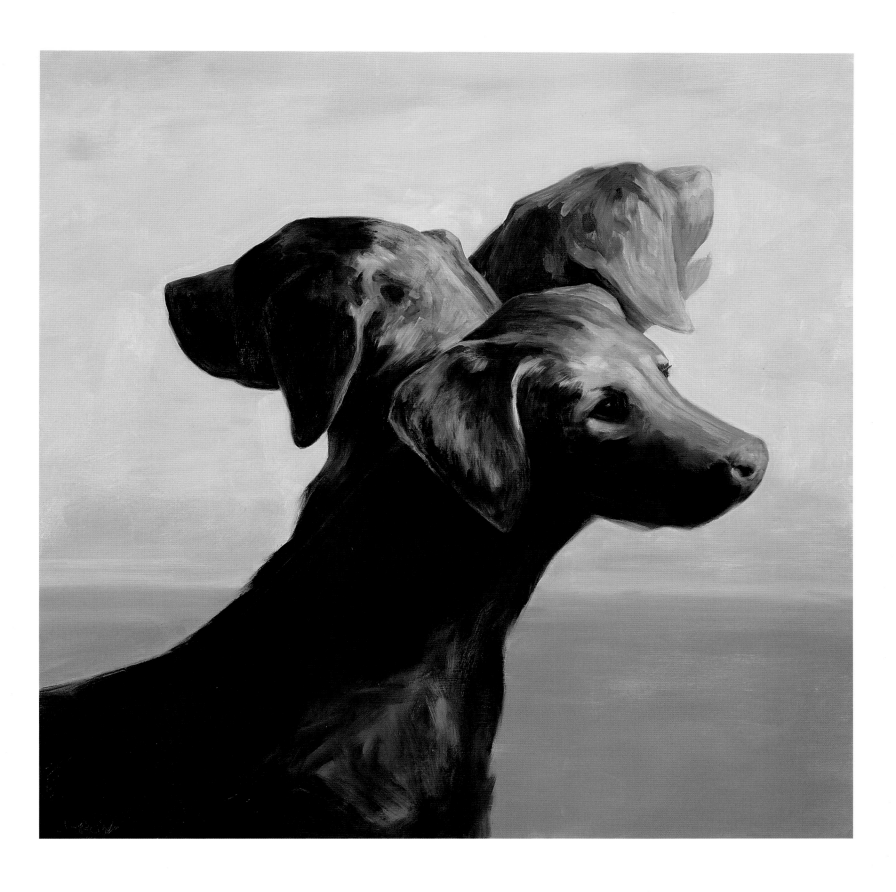

Cerberus, 2005, oil on panel, 12 × 12 inches / 30.5 × 30.5 cm

"A certain degree of realism is important to my work. Due to their monochromatic quality,
my paintings bear a relationship to photography and film. Tied up in ideas of film are questions
of truths and documentary. My paintings maintain an elastic association to reality undermining
the viewer's inherent trust in the photographic image."

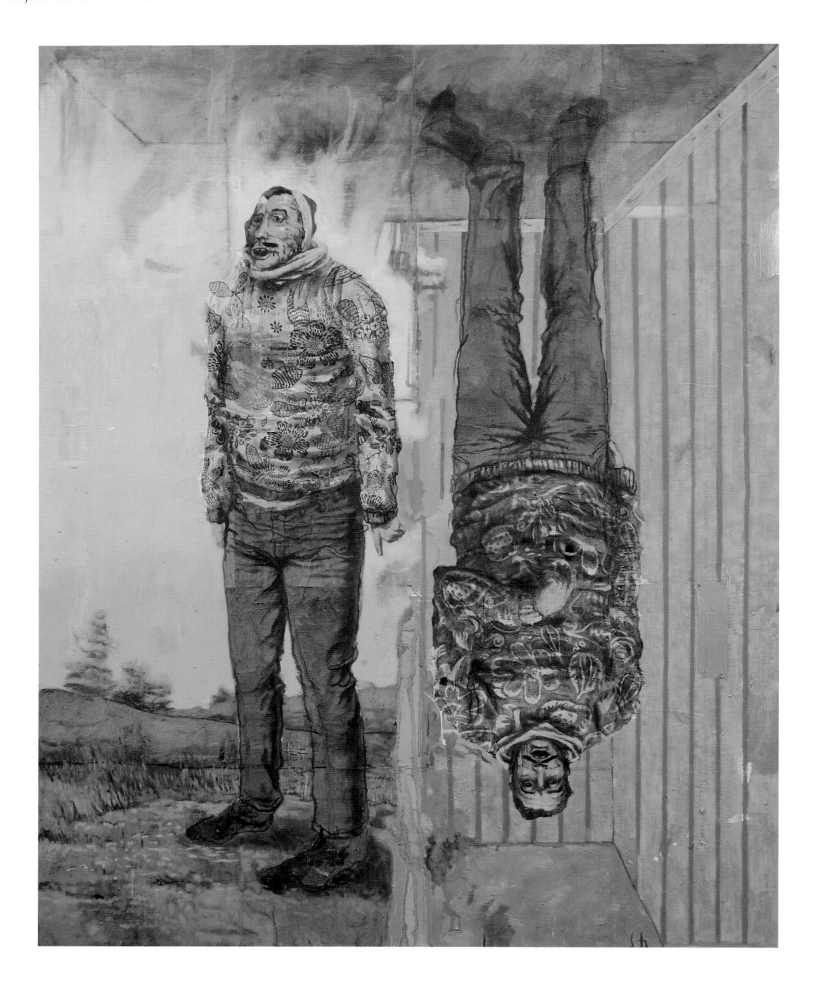

Suettrs, 2008, oil on canvas, 72 × 48 inches / 182.9 × 121.9 cm

"My practice is a cycle of ingestion, gestation and expulsion of imagery. Using the Manitoban landscape as a stage, the paintings create an ambivalent space in which the personal meets spectacle to form a solipsistic narrative plexus. With my paintings, I hope to short-circuit painting's traditional appeal toward transcendence and explore a base human absurdity."

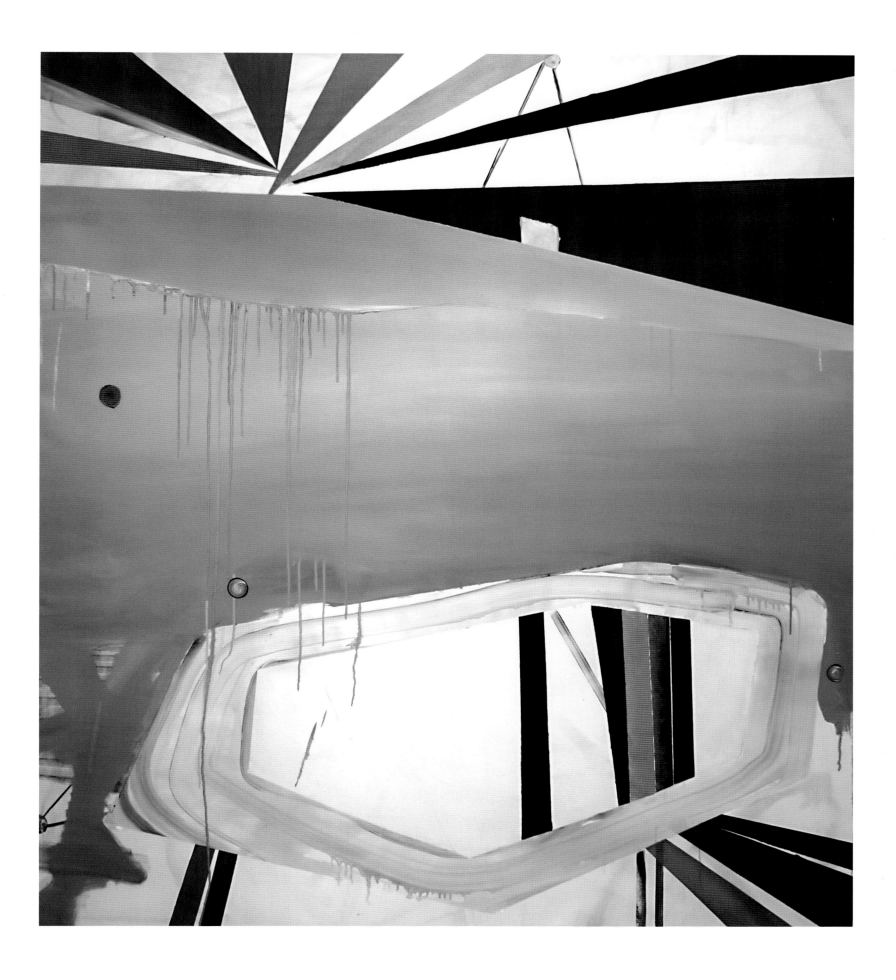

track and field, 2007, oil on canvas, 68.9 × 59.1 inches / 175 × 150 cm

"The starting points for many of the works are sources outside of an art context: fragments
of architectural elements, landscapes or digital pop cultural imagery. The multitude of imagery
creates spaces within the painting that are fragmented and often appear unstable."

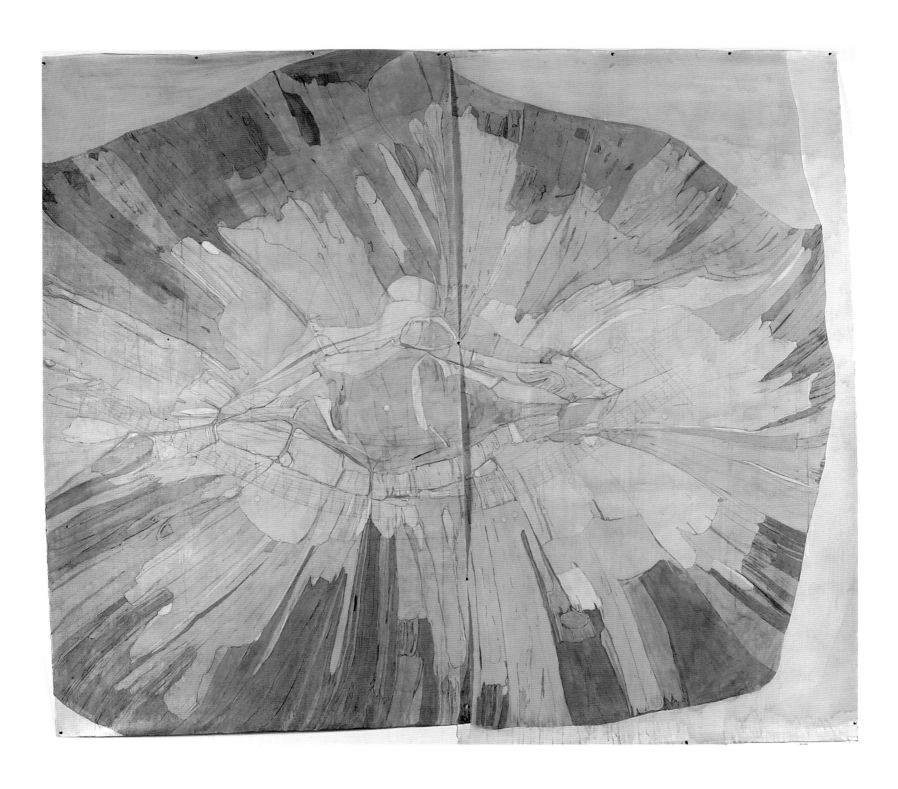

Untitled, 2007, ink, watercolour, and oil on paper, 95.7 × 119.7 inches / 243 × 304 cm

"I collect small objects, bits of organic debris: rocks, botanical pieces and bone fragments.
When I find these objects, I see small worlds within them. My drawings are a way of sharing
the space that I see within these objects."

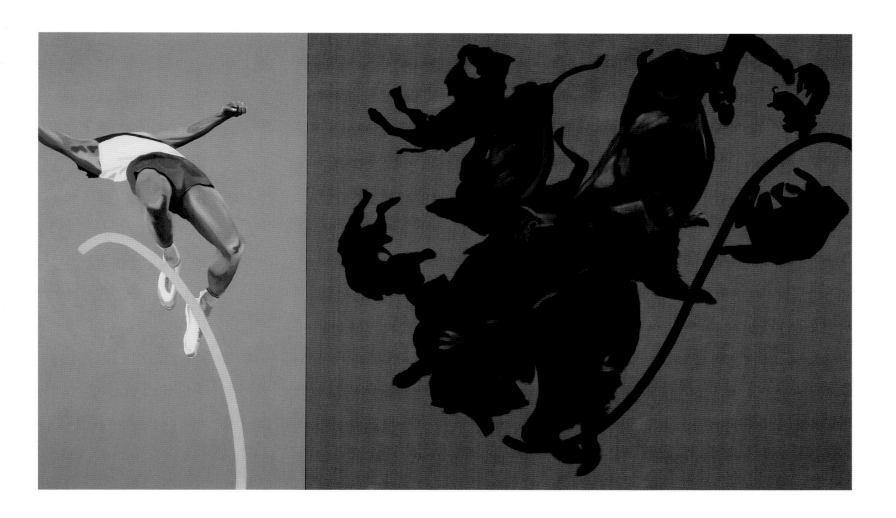

Silence is Golden, Silence is Rust, 2006, oil and acrylic on canvas, 84 × 144 inches / 213.4 × 365.8 cm

"Paint takes on a life of its own in my work. No longer is it just used to create an image, paint often
takes centre stage. Interacting with the other figures and forms that inhabit the single-toned
backdrops, paint acts as friend, foe, muse and instigator."

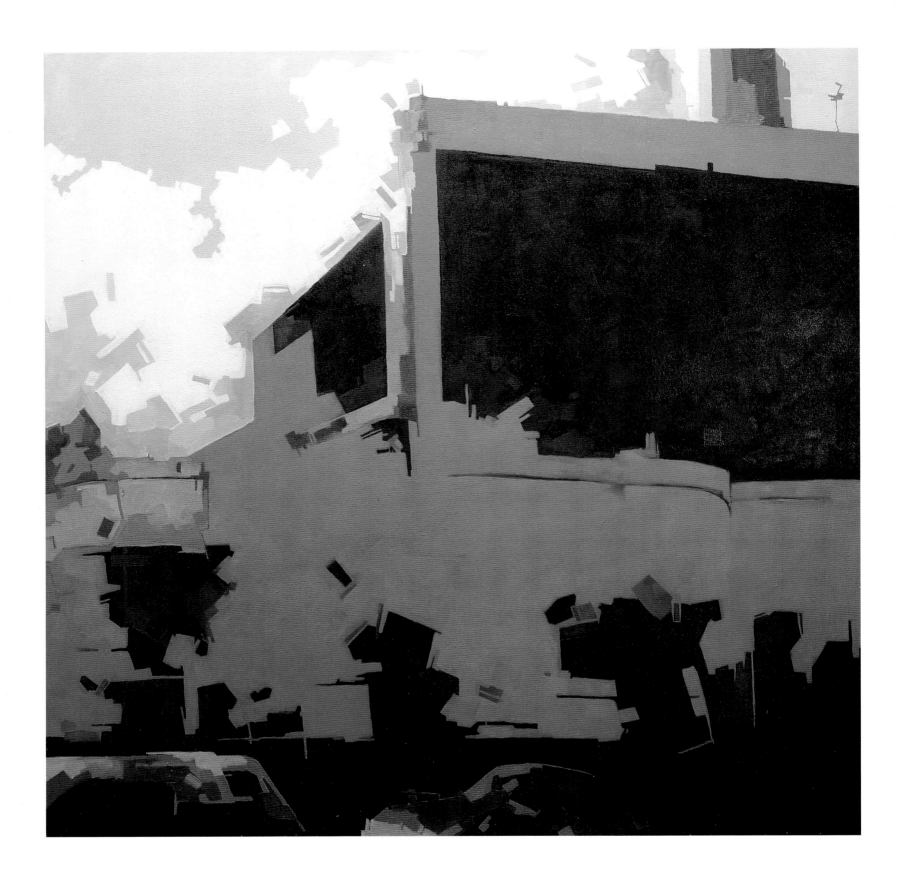

Chelsea Decon #8, 2006–07, oil on canvas, 42 × 42 inches / 106.7 × 106.7 cm

"Through my work, I seek to elaborate an 'aesthetic of entropy.' According to
the laws of thermodynamics, entropy is the evolution of order into disorder.
Corrosion, erosion, deterioration and other forms of destruction are vehicles
that lead to an ultimate 'entropic' state."

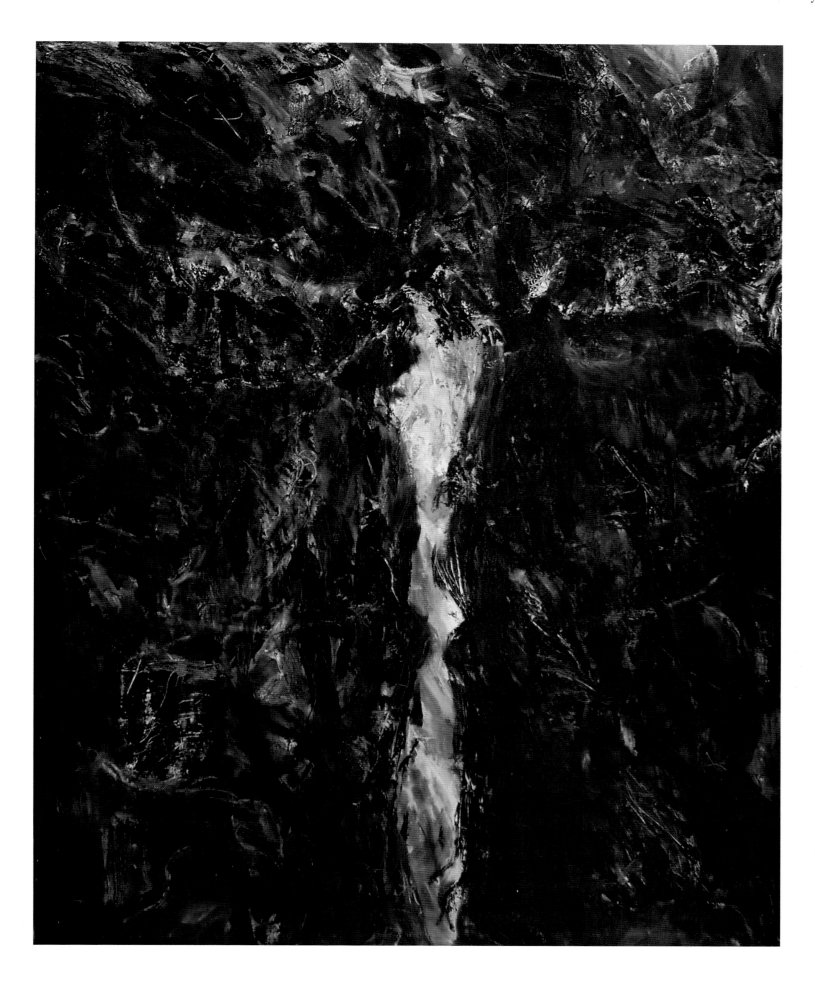

Earth.Gorge, 2006, oil on canvas, 60 × 48 inches / 152.4 × 121.9 cm

"I am always aware of the yin and yang of Nature: its light and dark, its opposing forces, its broken trees and swaying grass, and its dank swamps and angry seas. Through a process-oriented method of defining an image by adding to and then subtracting from the original, I strive to express this entwined essence of the land rather than produce pictorial representations."

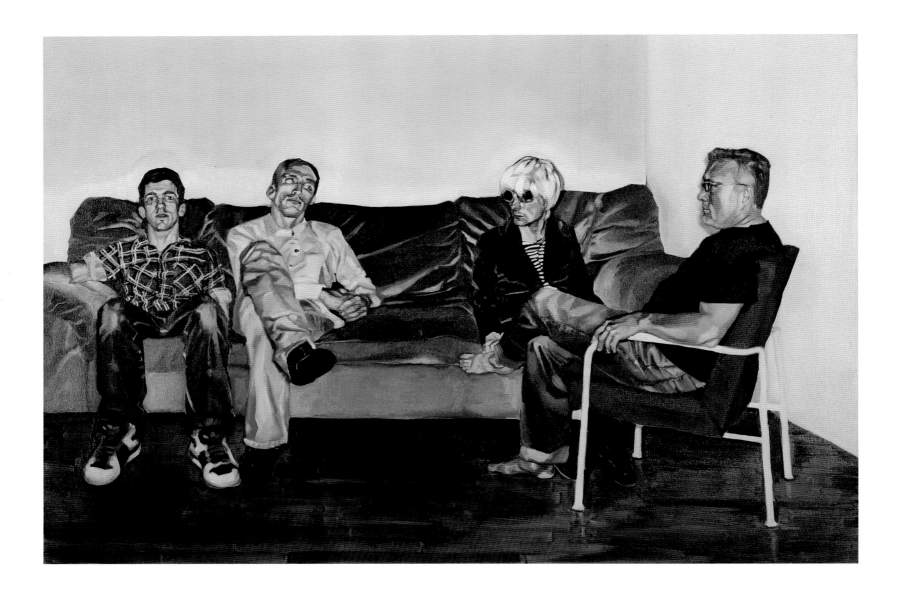

Closest He Comes (Deleted Scene from Painters Painting), 2006, oil on canvas,
42 × 60 inches / 106.7 × 152.4 cm

At the Factory (Edie and Drella), 2007, oil on canvas, 36 × 36 inches / 91.4 × 91.4 cm

"I am deeply interested in examining the intersection between personal and public histories.
To put it another way, I wish to explode individual, personal narratives so that they achieve
the scale and importance of grander social narratives."

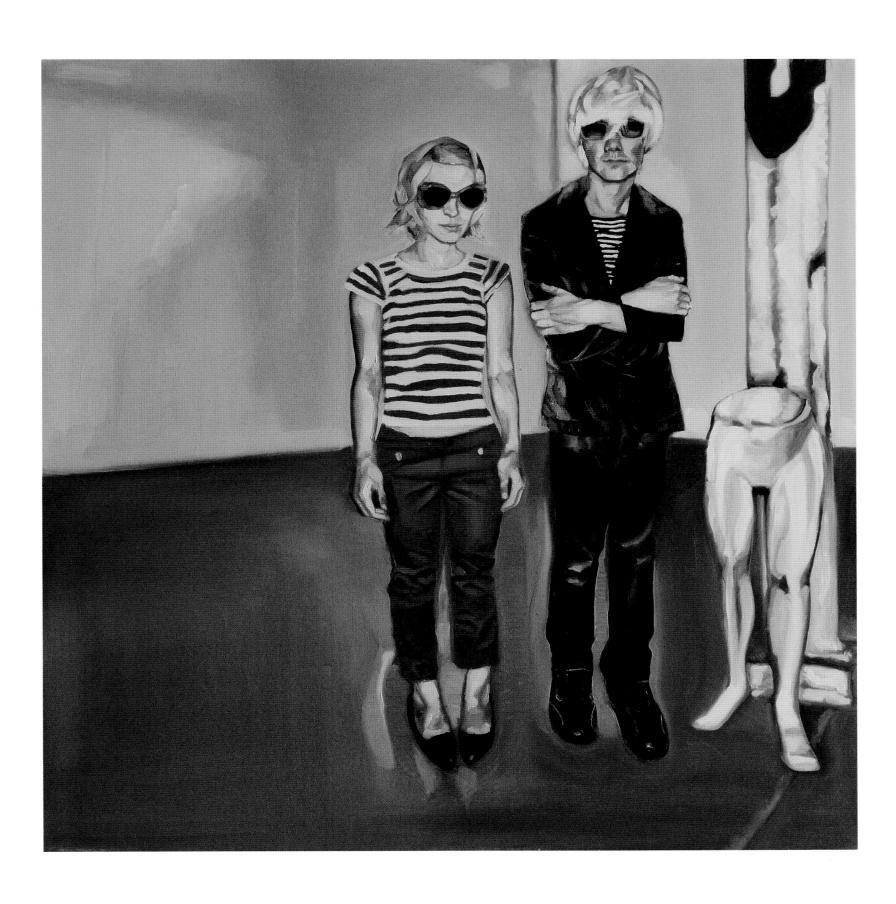

emerging

Kristina Kudryk

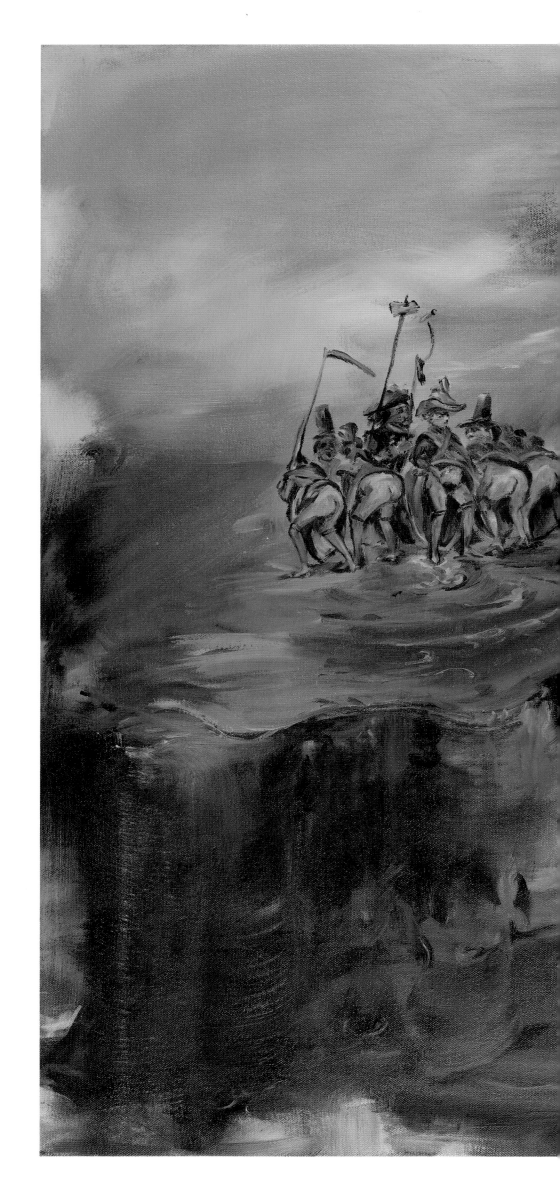

Painting of a Symbolic Gesture, 2005, oil on canvas,
30 × 36 inches / 76.2 × 91.4 cm

"Informed by the Baroque style, history painting,
Japanese prints, decoration and the way these things
exemplify excess, hyperbole and visual invention,
my work manifests the idea of a picture as both a screen
for projection, and material and social artifact."

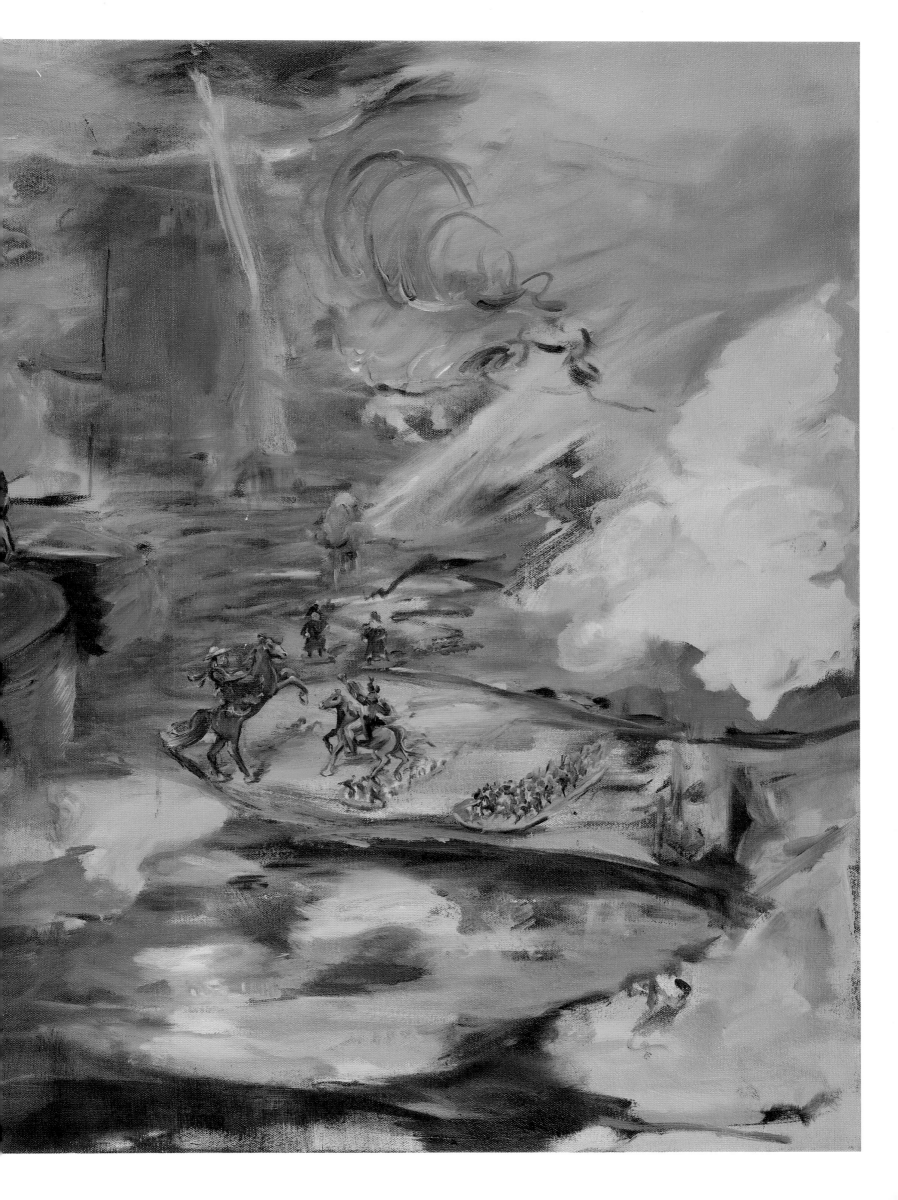

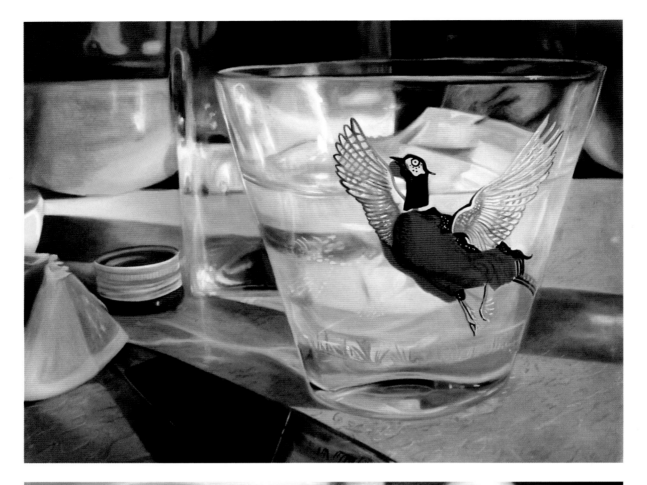

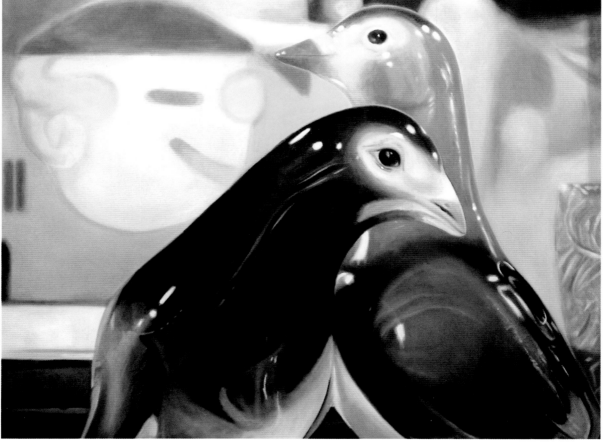

Gordon's Rocks Glass, 2007, acrylic on canvas, 48 × 60 inches / 121.9 × 152.4 cm

Blue Birds, 2007, acrylic on canvas, 48 × 60 inches / 121.9 × 152.4 cm

"Dennis Lee observed in his exploration of Al Purdy's poetry that 'the everyday physical world can at times seem other-wordly, an alternate galaxy that is both utterly present and wholly transparent, a window into some ineffable dimension where [the individual] is at once lost and at home.' It is this kind of window that I attempt to realize with paint on canvas."

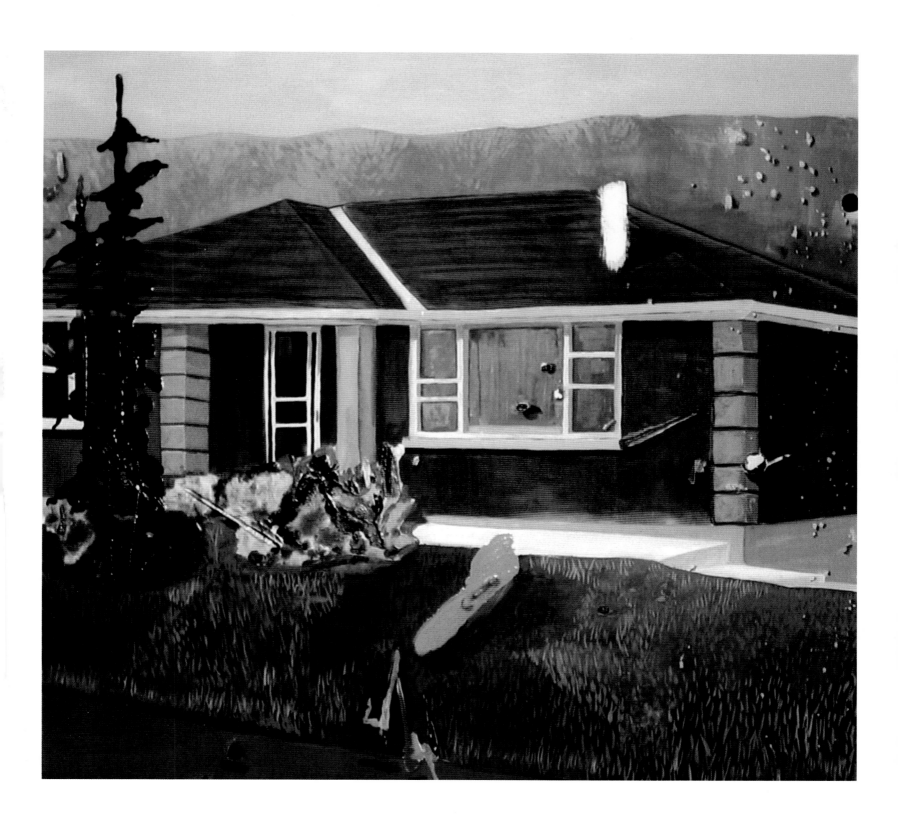

Bungalow 5, 2007, oil and enamel on board, 26 × 28 inches / 66 × 71.1 cm

"My artwork challenges visual perception of everyday spaces by revealing the overlooked nooks
and crannies of the city. It looks at places people don't usually observe and transforms them into
objects for observation—paintings."

81

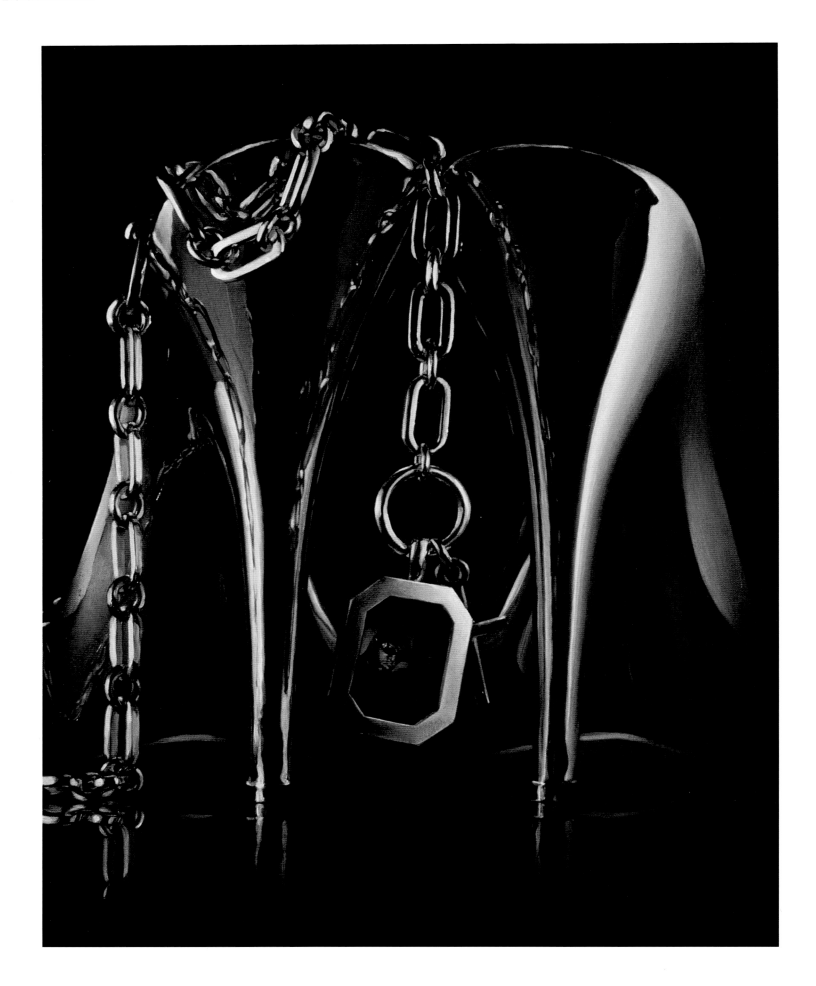

Untitled (Notorious B.I.G.), 2006, oil on canvas, 24 × 18 inches / 61 × 45.7 cm

"Mainella's work explores the history of European painting and re-introduces this tradition into contemporary art practice. His rich, sensual paintings are simulations of the traditional commissioned portraits that imagine who the patron would be in today's world. To further distinguish the works from their predecessors, the choice of imagery acts as a sardonic response to past associations of gender, race and class, while still paying tribute to painting's mystical standards. Mainella's mode of production provides, paradoxically, a vehicle for the calculated exploration of painting itself, with the end result—a series of visceral, humanistic canvasses—as evidence."

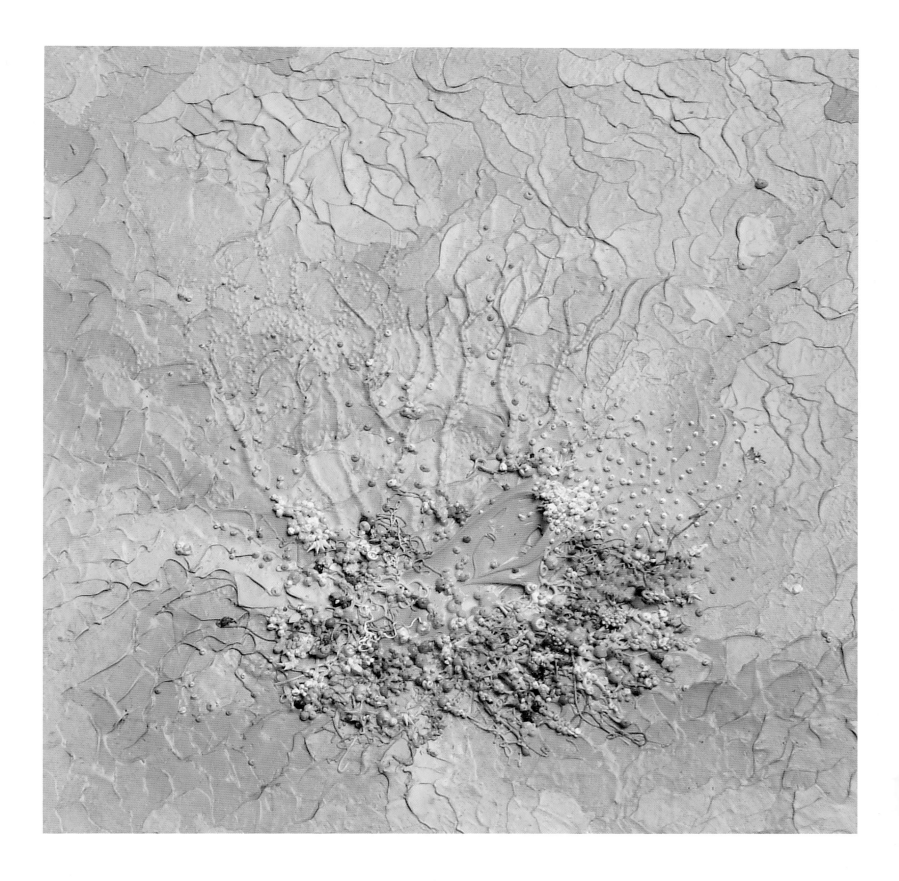

Untitled, 2006, acrylic on canvas, 16 × 16 inches / 40.6 × 40.6 cm

"My paintings lure the viewer into their teeming layers, offering surprising depth and movement.
Elaborate sculptural tangles of the surfaces elicit intimate exploration. Their stylized tactile
vocabulary builds tension between control and turmoil, the familiar and the undiscovered."

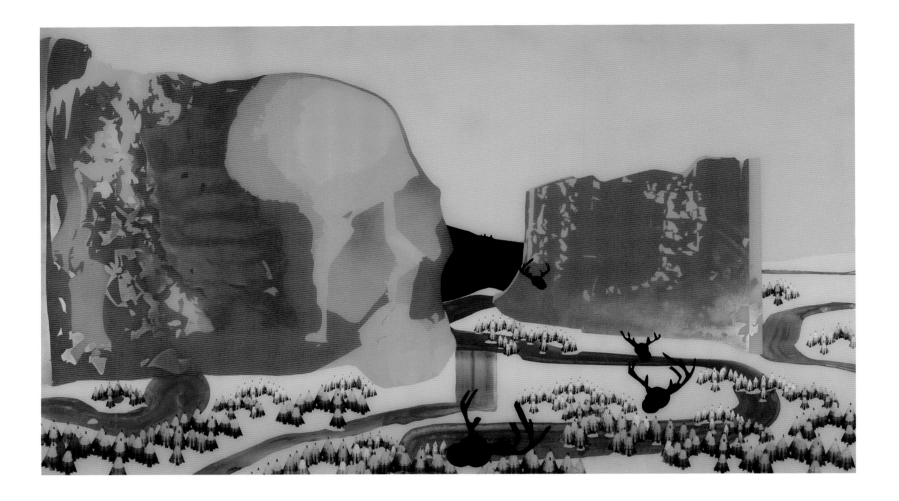

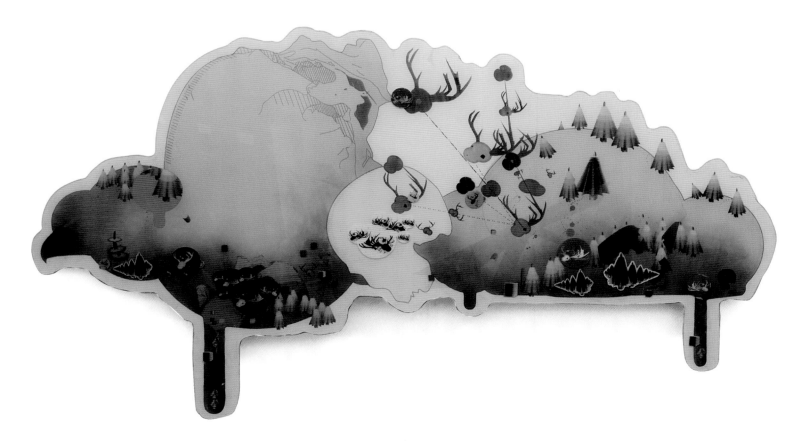

skull canyon, 2007, animation paint and aerosol on acrylic sheet, 36 × 72 inches / 91.4 × 182.9 cm

skull cloud 2, 2006, animation paint and aerosol on acrylic sheet, 24 × 46 inches / 61 × 116.8 cm

"My work is about considering the history of our landscape. All materials decompose and recompile as something new, feeding off the elements of what came before them. I use clouds to graphically suggest this, because they are a visual embodiment of this cycle. They carry the same water that ran through oceans and empires since the beginning of time."

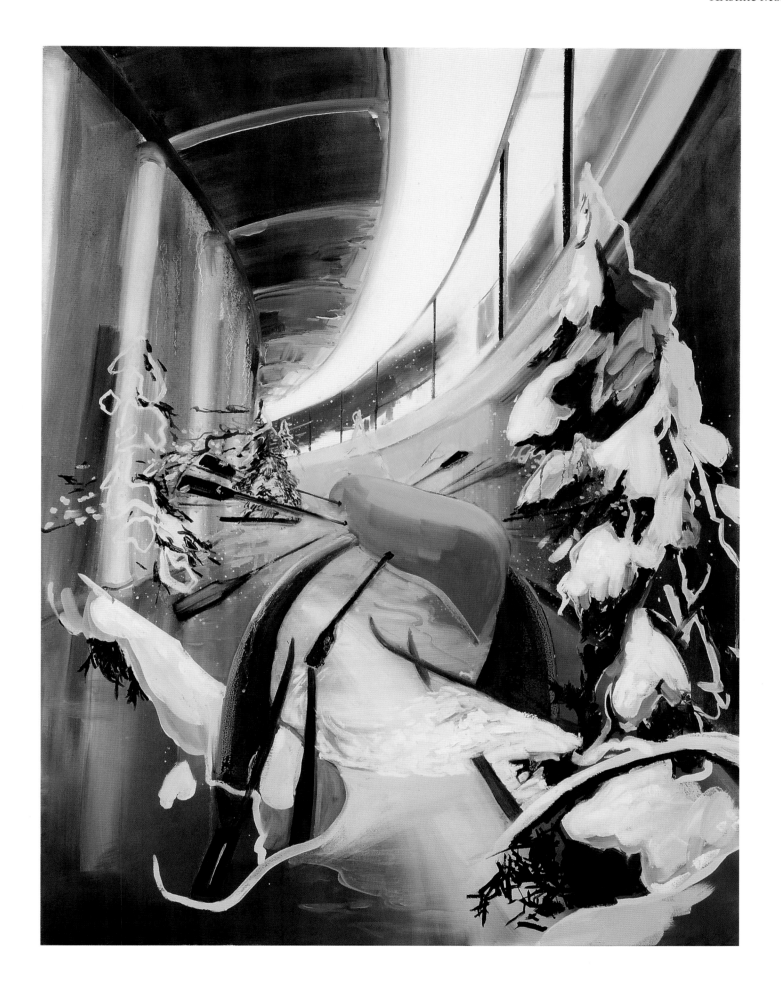

The co-operation project, 2007, oil on canvas, 40 × 30 inches / 101.6 × 76.2 cm

"Unlike their three-dimensional counterparts, these painted architectural environments cannot
 be walked through, nor touched or embodied. Missing this other sensory experience creates a
 yearning to enter into a space that is physically unattainable."

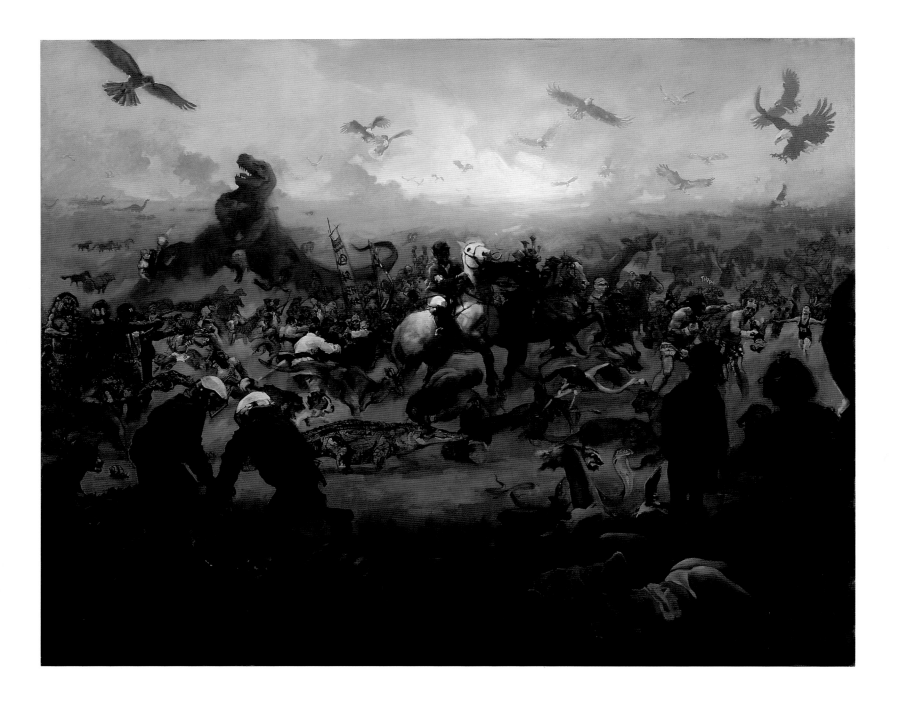

Large War Painting, 2004, oil on canvas, 72 × 90 inches / 182.9 × 228.6 cm

"I am interested in the energy and physicality of violence, and through those, the potential for
athleticism. I draw on images from a wide variety of sources, depicting many separate moments
in time, combined to create an entirely fictional scenario of battle or chaos."

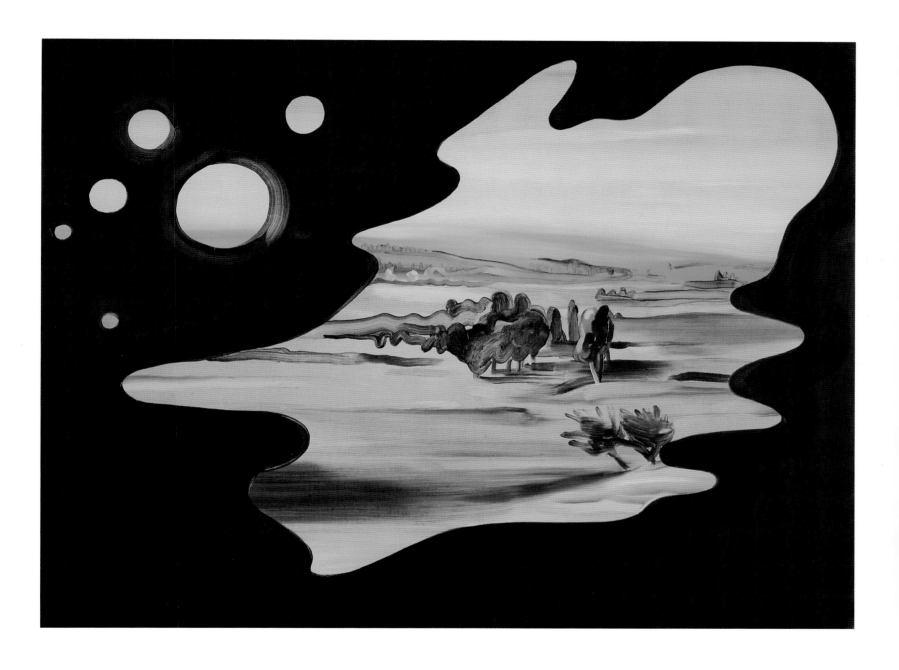

shangri-la, 2005, oil on board, 24 × 32 inches / 61 × 81.3 cm

"Alexander Pope once wrote of onomatopoeia that 'the sound should seem an echo of the sense.'
I think this comes close to describing what I'm trying to achieve in my practice."

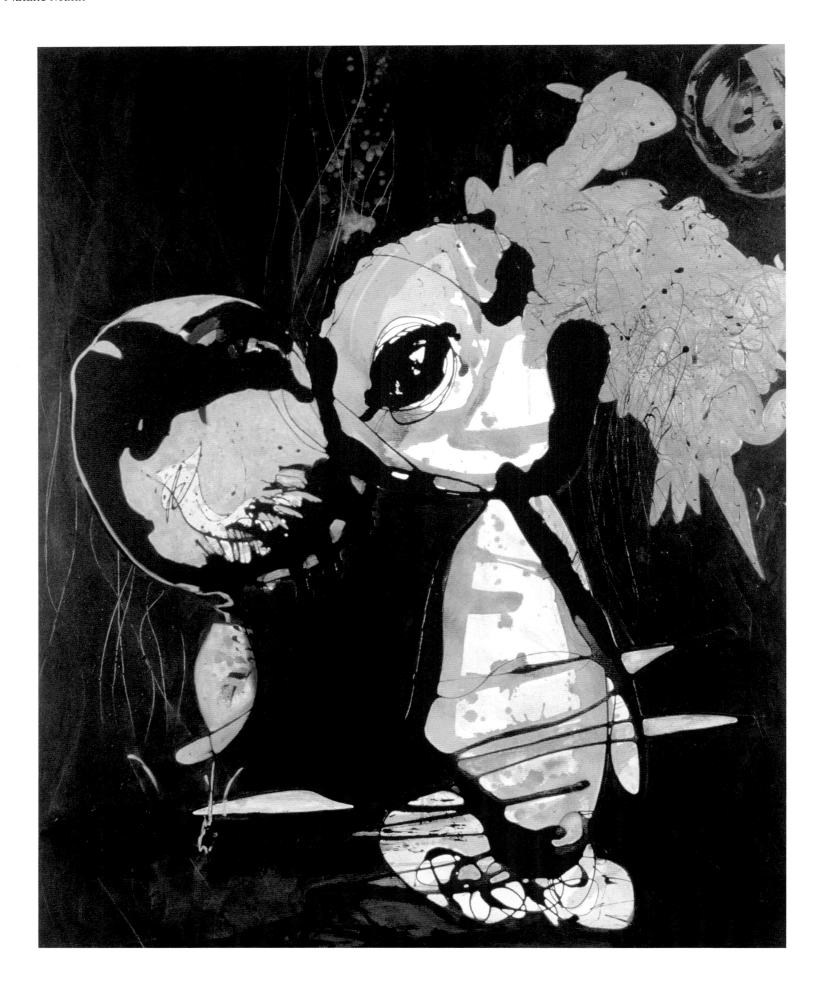

Baby Purple II, 2002, enamel on canvas, 60 × 48 inches / 152.4 × 121.9 cm

"I portray our culture caught up in the frenzied age of technology and celebrity. My characters
are lost, confused and angry. Many are looking for peace. Some have found hope and faith.
I paint them all with humour and beauty."

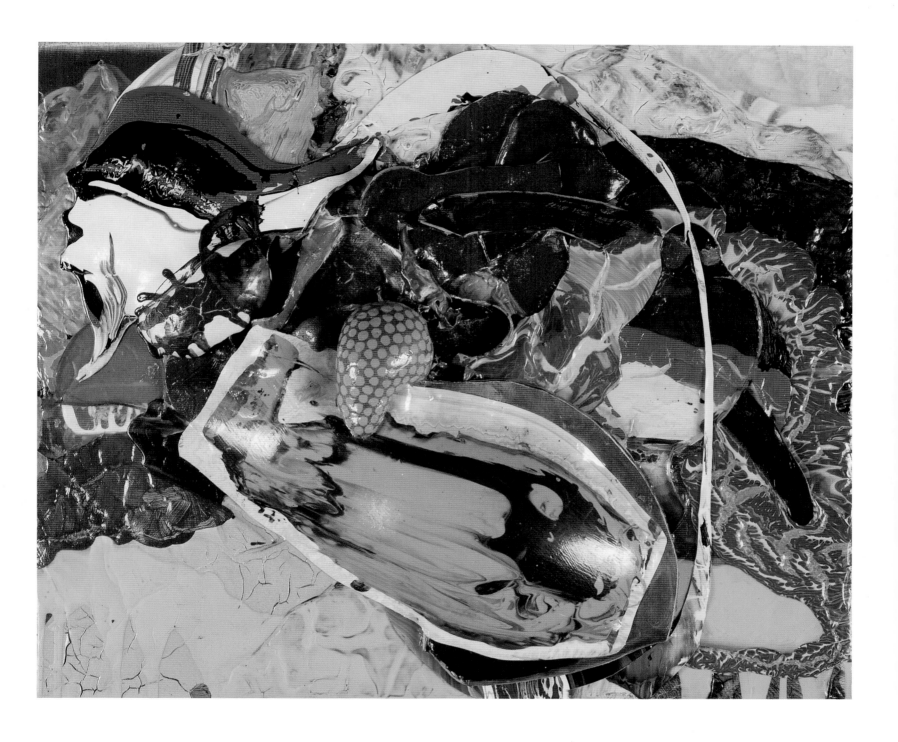

Birthday Party Shouting Shooting, 2007, acrylic and foam on board, 20 × 24 inches / 50.8 × 61 cm

"My most recent body of work takes its cues from three books: John Hawkes' *The Lime Twig,*
Djuna Barnes' *Nightwood* and Flannery O'Connor's *Everything That Rises Must Converge.*
Specifically, how personal pronoun use, point of view and narrative play can, without
self-conscious or purposeful obfuscation, solicit and order the chaos of quotidian horror,
confusion and terror in a form more permanent than its maker."

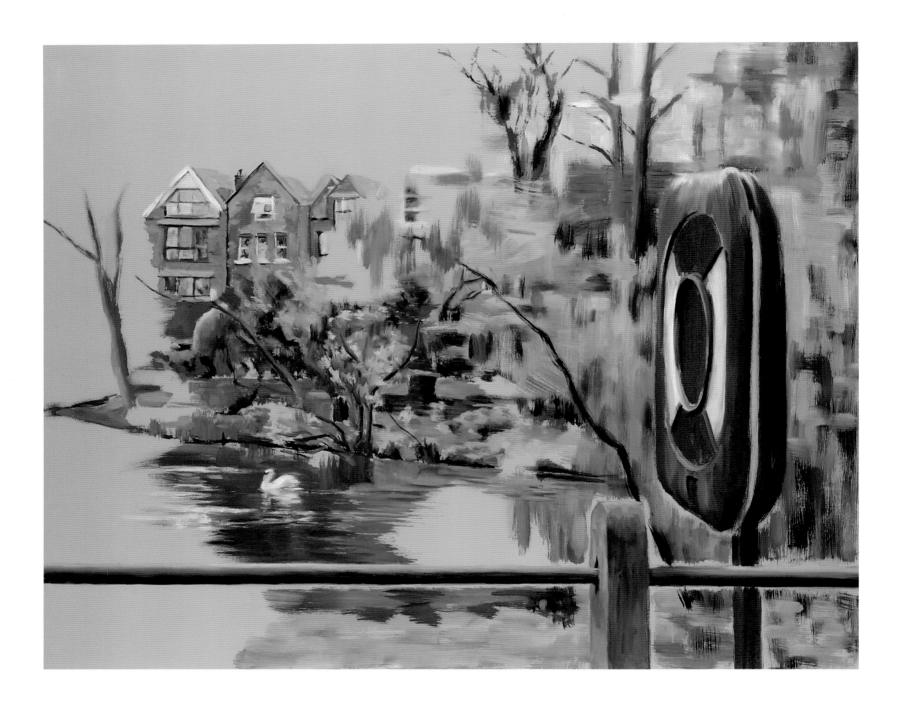

Vale of Health Pond, 2006, oil and acrylic on canvas, 48 × 60 inches / 121.9 × 152.4 cm

"The work stems from a trip I made to London. As I wandered the streets, the parks
and museums of the city, I thought about the importance of maps, the strangeness of the
unfamiliar, the way one skims the surface of things when viewing them for the first time."

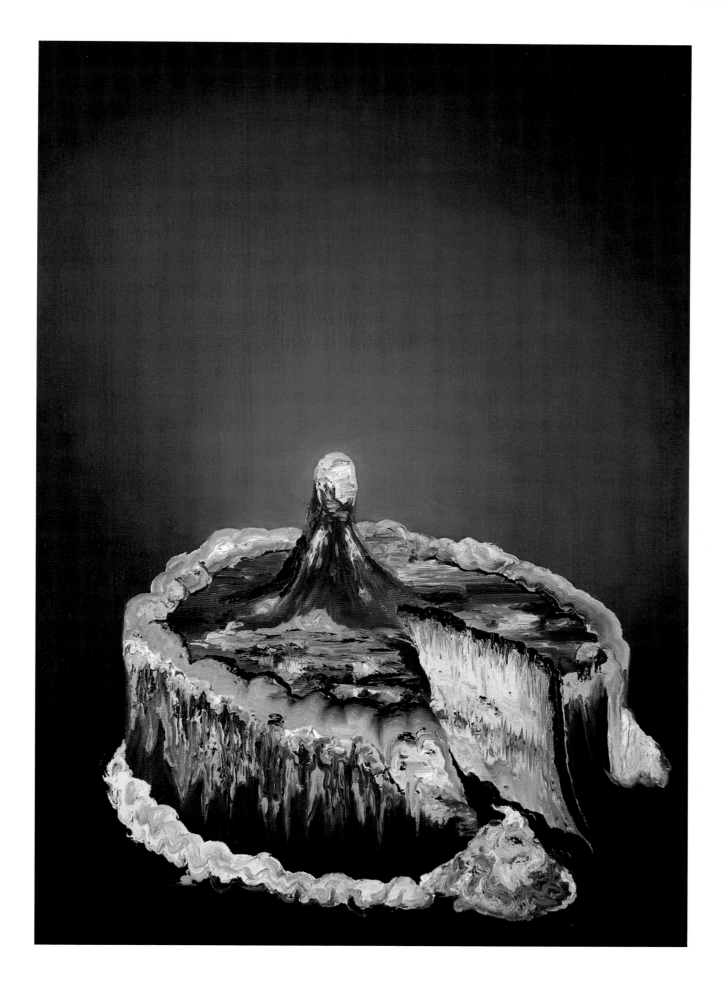

Eruption, 2005, oil on linen, 25.5 × 18 inches / 64.7 × 45.7 cm

"This body of work draws upon abstraction, surrealism and its mutant offspring—fantasy art—
 to construct hybrid images, which seem on the verge of collapse."

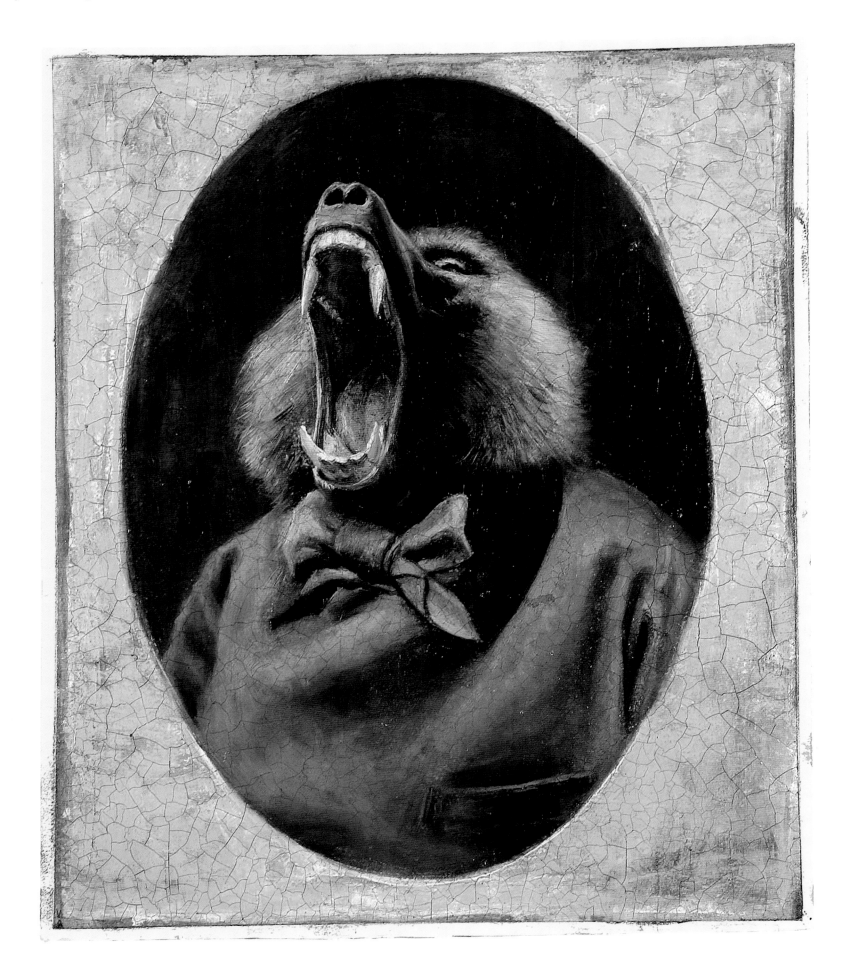

Salon de Paris 7 [Charles Baudelaire], 2005, oil on paper, 22 × 18 inches / 55.9 × 45.7 cm

"These portraits present an image of high culture bestialized, projected backwards through evolution, where art history itself becomes a metaphor for human arrogance. Romantic cultural notions of genius, heroism and transcendence were enlisted in nineteenth-century France to define the modernist avant-garde, and they persist to this day. These ideals pale before the comic but plausible image of the creative genius as monkey in fancy dress."

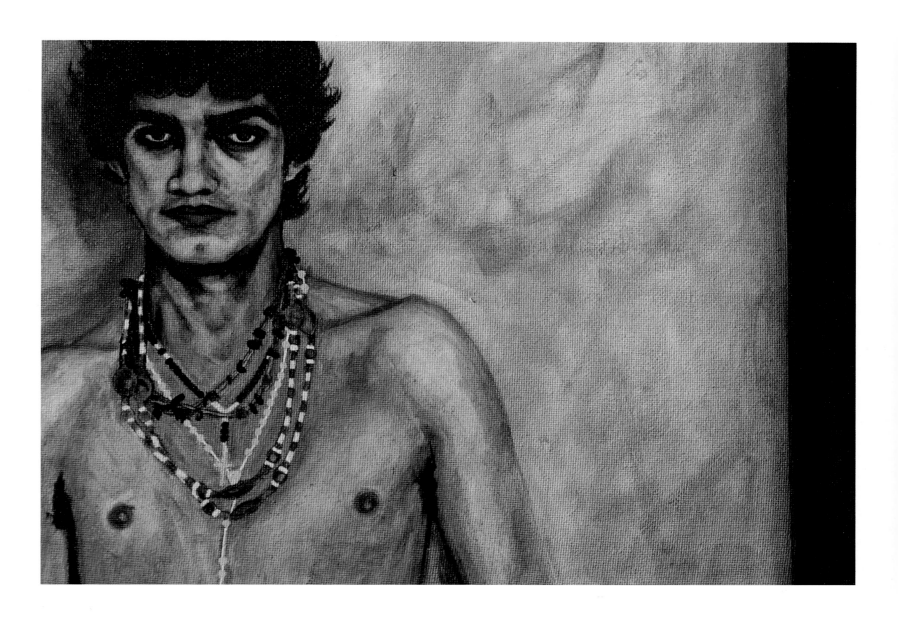

Rosario I, 2007, oil and silver leaf on canvas, 20 × 28 inches / 50.8 × 71.1 cm

"I am interested in the power of dress, whose mere presence has the ability to influence/supersede
the perception/existence of the individual. The most polar forces of emotion can be exemplified
by an individual robed in (or disrobed of) articles symbolic of power or shame."

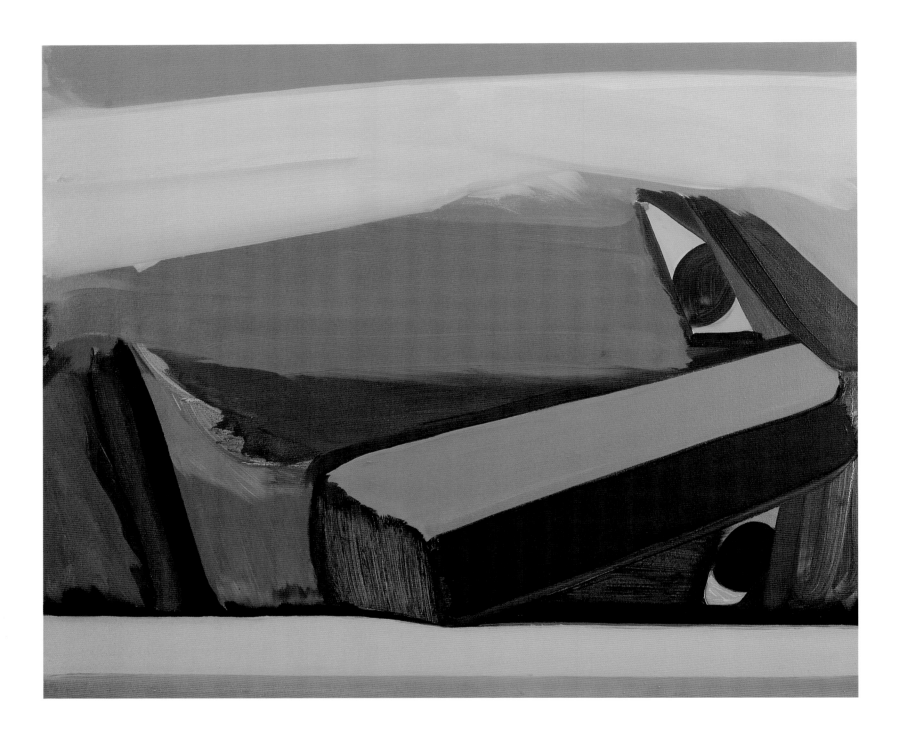

After After, 2007, acrylic and oil on canvas, 30 × 36 inches / 76.2 × 91.4 cm

"There is an innate willingness to want to find faces in things, and one's ability to see a face
in a cloud, a cliff side, in the moon or other seemingly random constructions is testament
to this desire. The face is arguably the focal point for communication on our bodies and
I want to explore this importance."

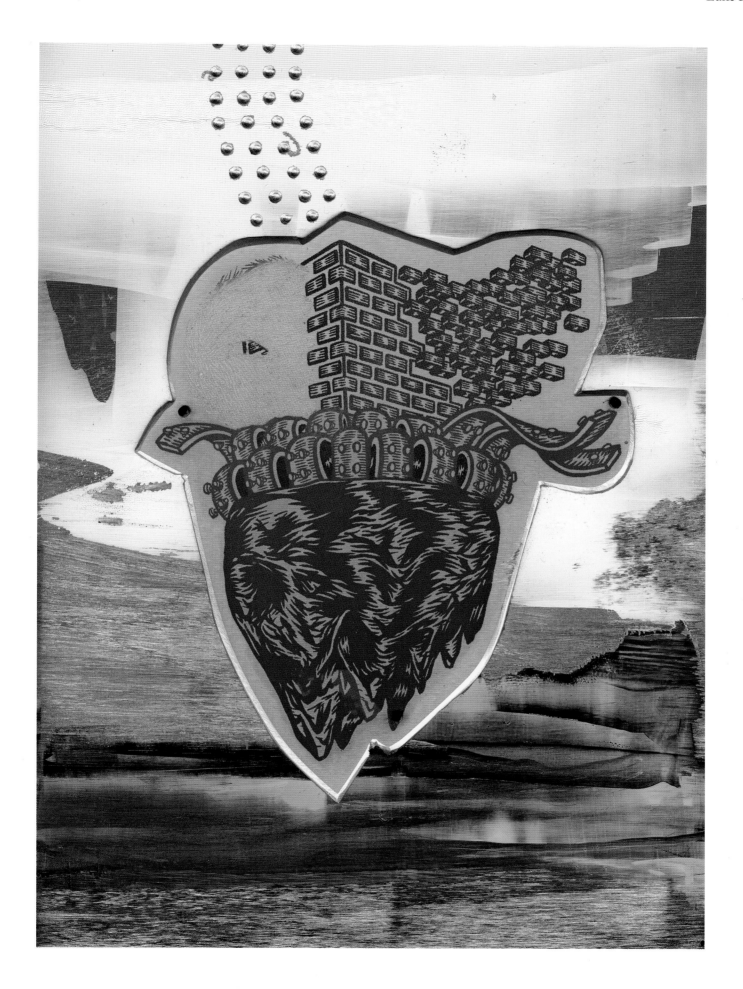

Expanding and Collapsing Brick Mountain, 2006, oil, acrylic, etching plates and steel on wood,
12 × 9 inches / 30.5 × 22.9 cm

"At the crux of my work, nature becomes intentionally crossbred with artificial substances and
intimates how our landscape has become complicated by our urban environment and growth.
The structures themselves are neutral in their intent (neither good nor evil, neither fully alive
or dead) and become a visual miasma of our current and past environmental situations."

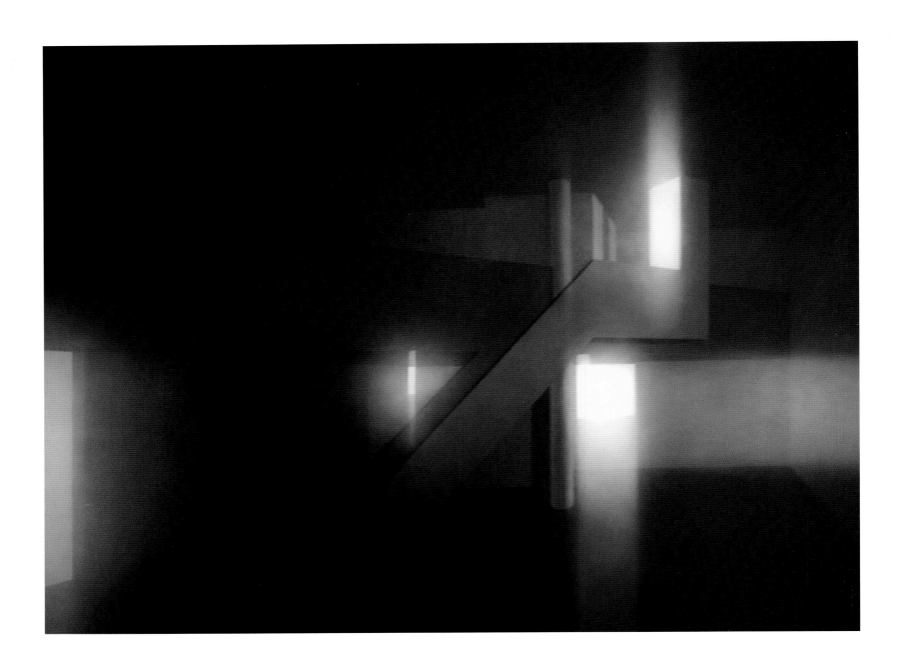

Encounters Series #12, 2007, oil on board, 36 × 48 inches / 91.4 × 121.9 cm

"My work is about an interior notion of space. Experiencing the interior, one has a sense
of the light from outside reaching in and pulling us out. The surface of the interior cavity
dematerializes as a result of the play of light and shadow. The viewer is left with the sensation
of an essentialized space; the enclosure sheds its weight, revealing an interior grasped by
the perspective of one."

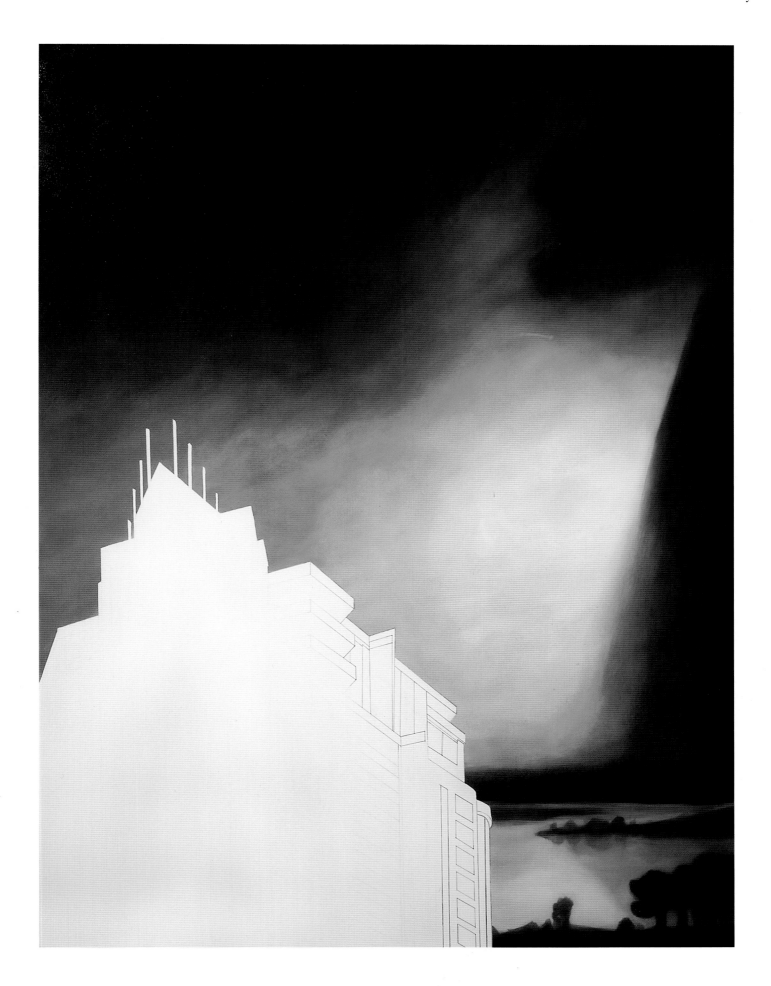

Untitled 4, 2006, oil and acrylic on masonite, 66 × 48 inches / 167.6 × 121.9 cm

"The 'artist's concept' images used to promote condos recall a nostalgic landscape of the past
but without any of the painful or abject aspects of the existing built environment. In pairing
these images with the sublime yet kitschy skies of historical landscape paintings, the work is
a meditation on uncertainty about the future and an indulgence of apocalyptic daydreaming."

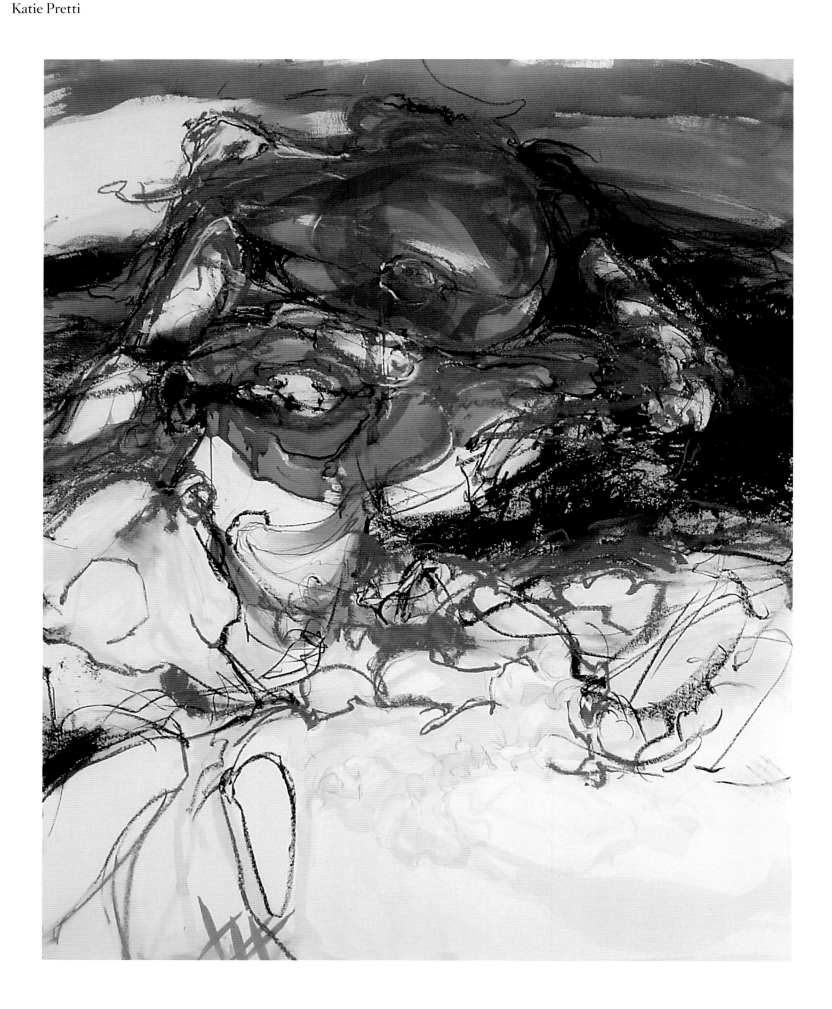

lay, lady, lay no. 2, 2007, ink wash, watercolour, oilstick, graphite, 56 × 42 inches / 142.2 × 106.7 cm

"The most important goal for me when creating work is the transmission of a particular sensation or series of sensations whose succession describes a changing or developing mood over a span of time. Every mark is one detail of a moment; each line is deliberate."

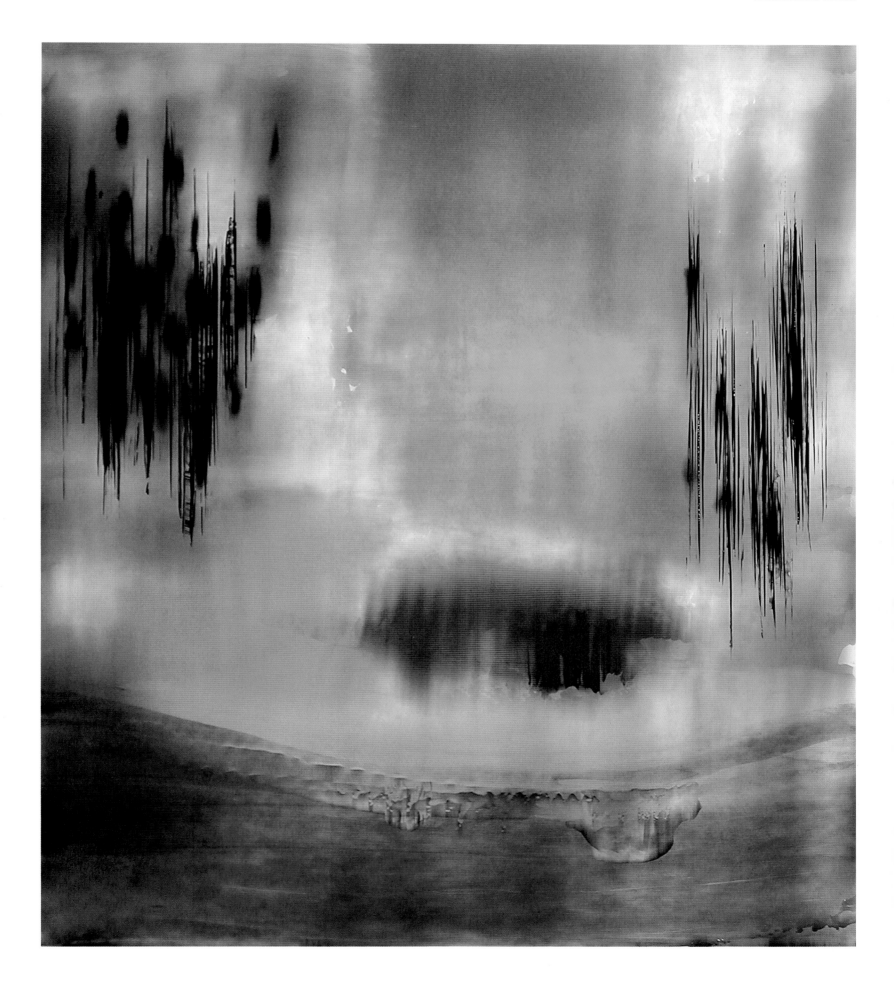

Immanent Departure, 2006, oil, alkyd and acrylic on panel, 44 × 40 inches / 111.8 × 101.6 cm

"This body of work was created after my arrival in Newfoundland from Toronto, fertilized by
the drive across the country to reach this place. Everything is new to me here. The scale is epic:
rock and trees, lakes and ocean. You can become consumed by the vastness, the enormity of
ground you could cover. Or, you can become consumed by the details; the lichen and mosses
can bring you to a standstill."

emerging
Mélanie Rocan

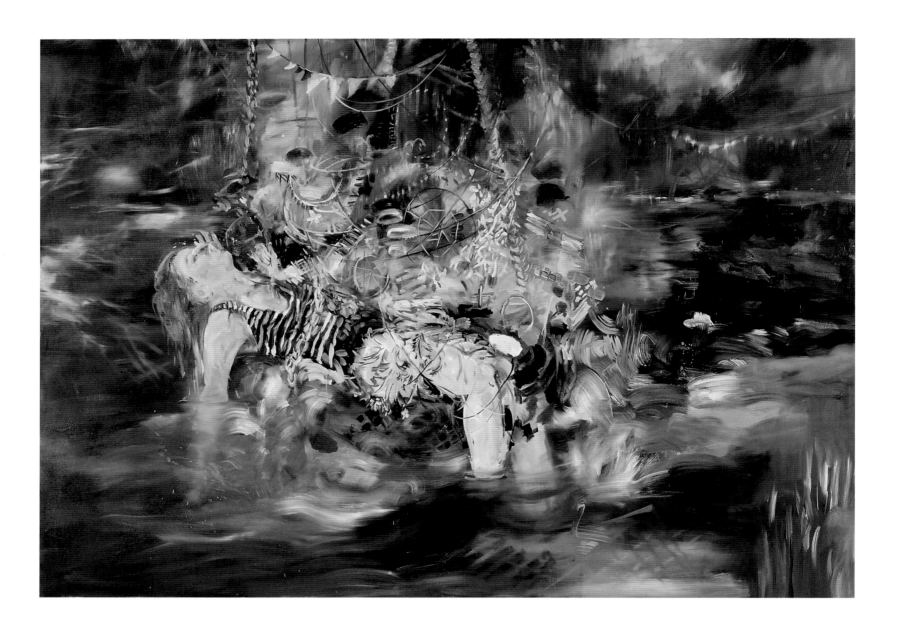

Swinging, 2007, oil on canvas, 60 × 84 inches / 152.4 × 213.4 cm

"My recent work speaks of the fragility of human beings and the reality of the subconscious state.
I want to capture a distressed beauty in the work that suggests the inner emotional condition,
highs and lows, a psychological unease."

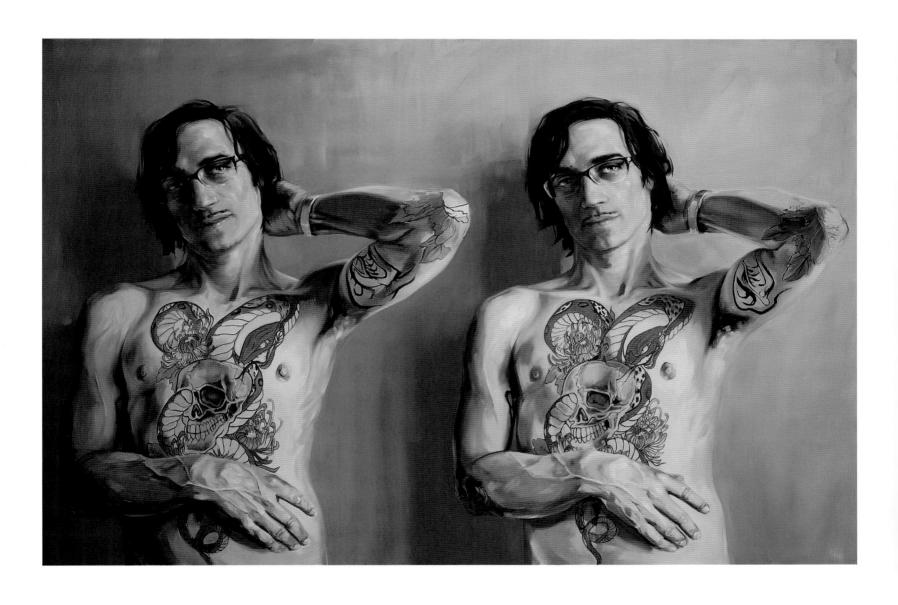

Blood Harmony 4.1, 2005, oil on canvas, 48 × 72 inches / 121.9 × 182.9 cm

"A painter is similar to an illusionist; issues of reality, representation, authorship and plausibility
are critical in both practices. In the installation of my work, I create fabricated environments
where scale and structure are referenced but never fully presented. It is a strategic suggestion
of realism that is undermined by the mark of my human hand."

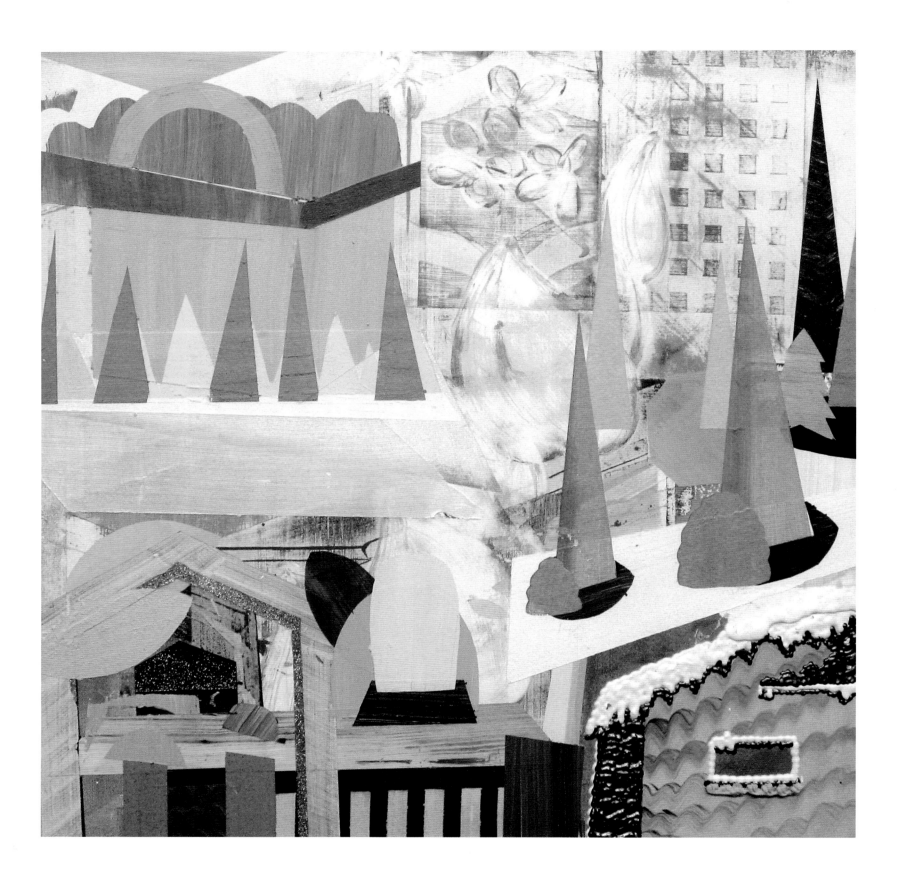

Forest Floor, 2006, acrylic paint on panel, 24 × 24 inches / 61 × 61 cm

"As a child, I would collect rocks or pinecones, wrap them up in ribbon and scraps of fabric, and leave them on my neighbour's stoop for a 'pretty little surprise.' In my attempt at turning such child-like creative impulses into art, I don't seek to evoke simply the luscious or nostalgic, I also summon resonances that are grotesque and unsettling, because as an adult, I understand that happiness is more complicated."

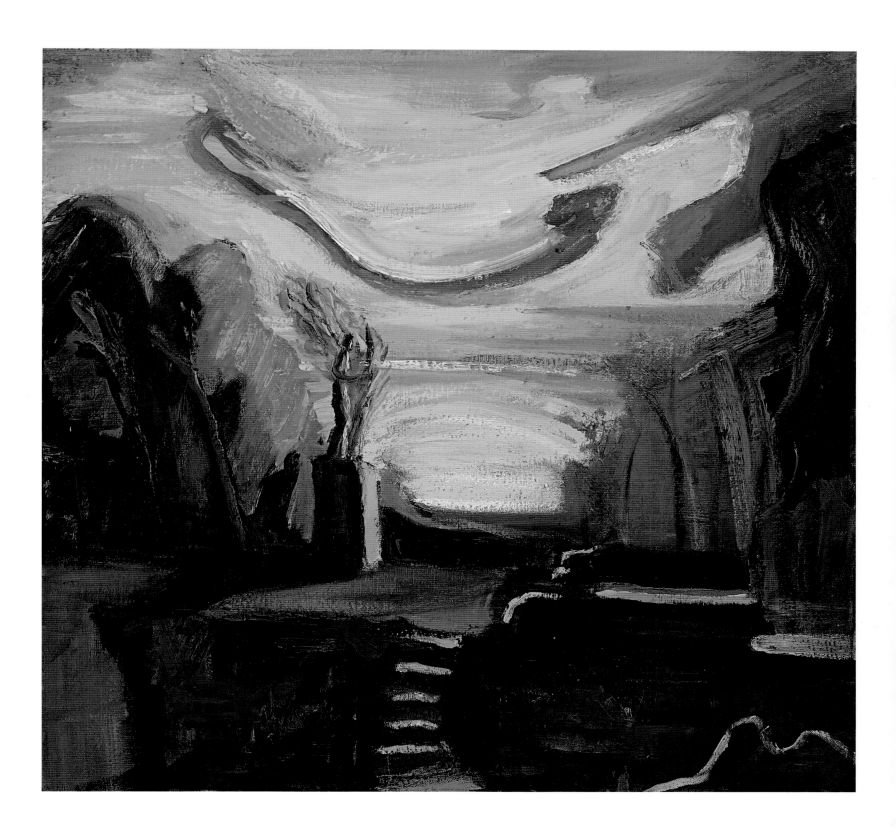

Consolation of a Shadow, 2006, oil on linen, 27 × 29 inches / 68.6 × 73.7 cm

"My paintings and drawings use recognizably classical motifs while eschewing the traditional ways in which they are represented. My process often involves a fusion of the iconic motif with landscape, which results in an ambiguous space. This juxtaposition of classical forms and atmospheric space creates a dynamic tension: forms appear at once to be both dissolving and emerging. This tension, in turn, relates to our complex relationship with tradition and the ways in which inherited imagery continues to inform our sensibilities even as we attempt to suppress or supplant it."

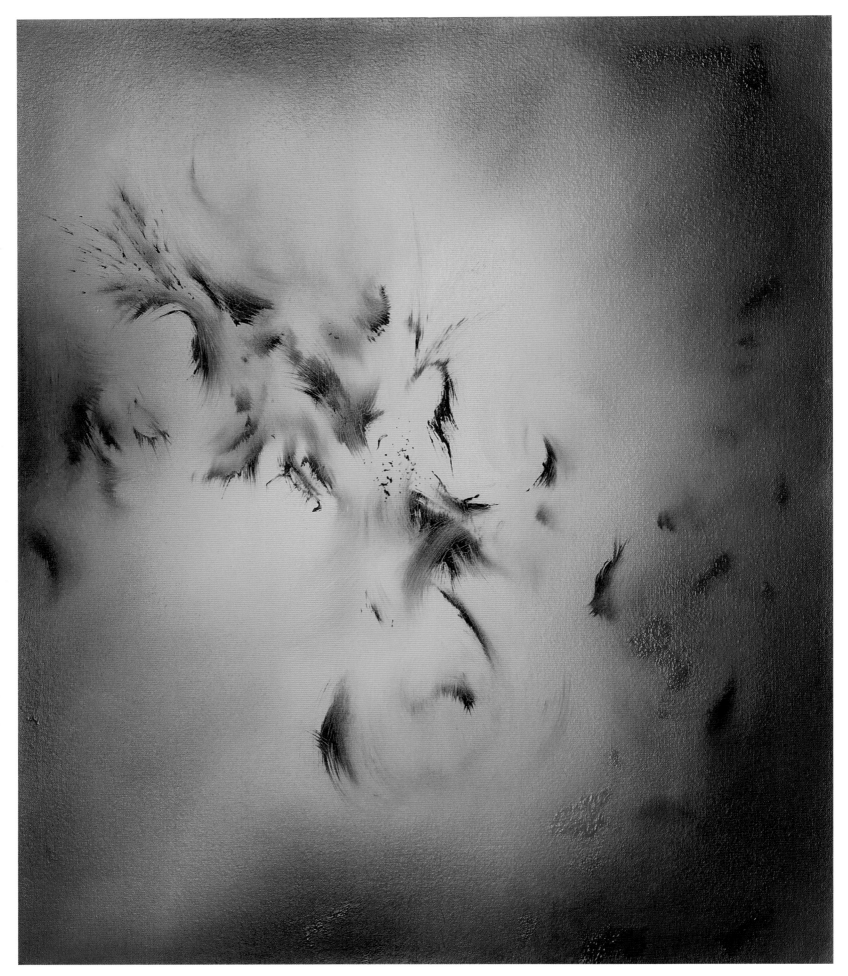

Portrait, 2007, oil on canvas, 24 × 20 inches / 61 × 50.8 cm

"My current practice includes photographing the initial stages of a painting and then manipulating
the photo through Photoshop. The initial stages of a painting are usually spontaneous, abstract
and include monochromatic elements. After digitally manipulating the image, I then return to
the canvas and through photorealist techniques paint an image of the photograph."

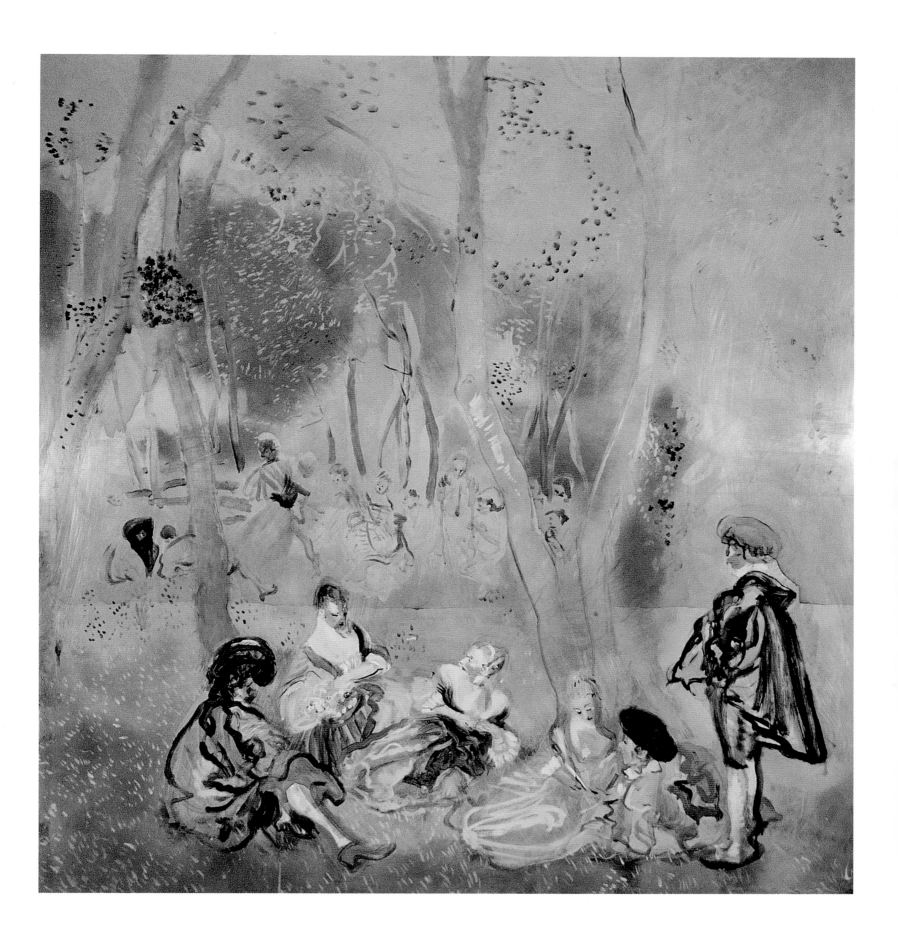

Blind, 2006, oil on aluminum, 51 × 41 inches / 129.5 × 104.1 cm

"I consider Rococo images from several perspectives. They are always perceived as still lifes,
a means to practice looking. At the same time, borrowing freely from their subjects, specifically
the fête galante, I have found a surrogate for my own life experiences."

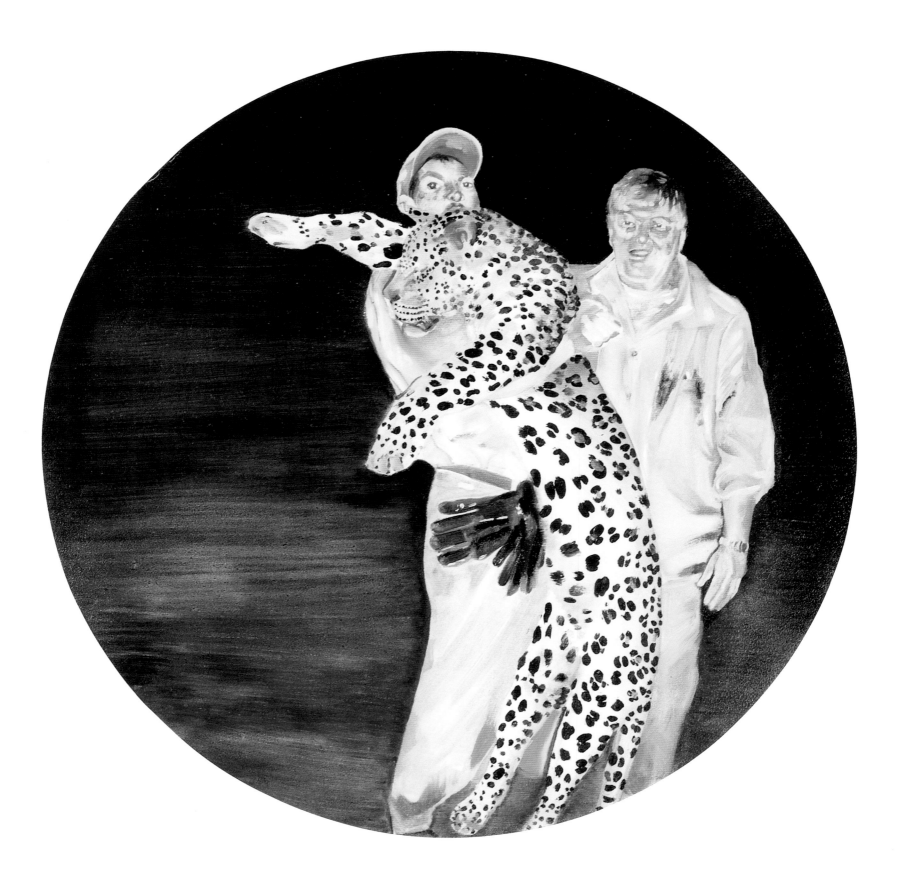

Safari #1, 2007, oil on panel, 16.5 × 16.5 inches / 41.9 × 41.9 cm

"Although the content varies from academic drawings of banal family photos to realistic
paintings of hunters and their kill, the sentiments are similar. Each image has escaped its own
banality and conveys the inherent absurdity in everyday life."

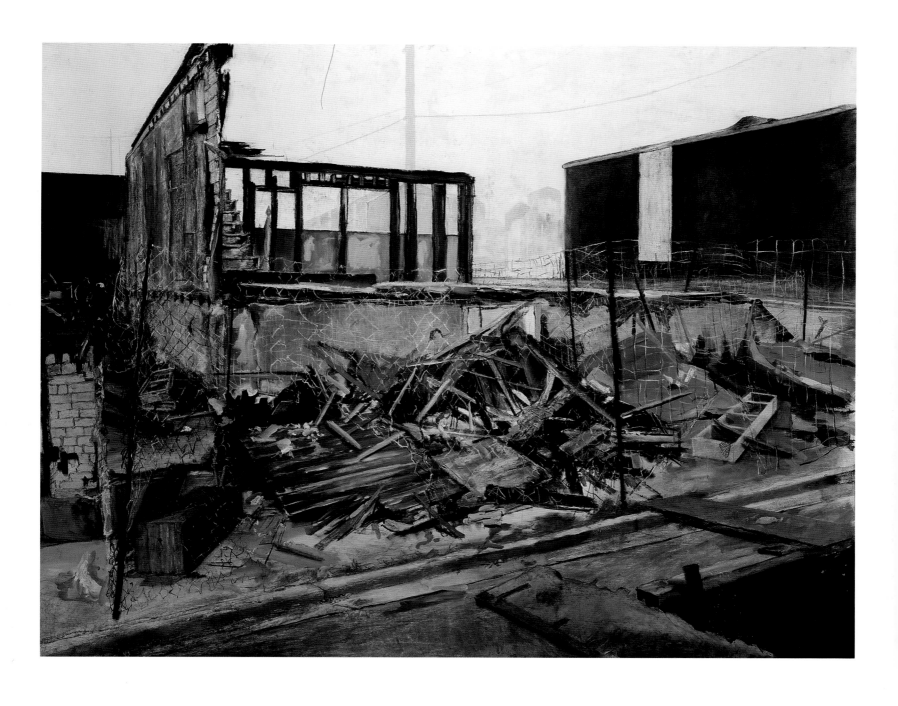

And I lowered myself in, 2005, acrylic, charcoal, pastel, and graphite on paper,
55 × 75 inches / 139.7 × 190.5 cm

"My work takes up the subject of demolition as something that represents memory and chaos
through the jumbled presence of familiar waste. A search for home is also present in my work,
where the search is often depicted through uncanny experiences in an unstable urban landscape."

emerging
Ted Tucker

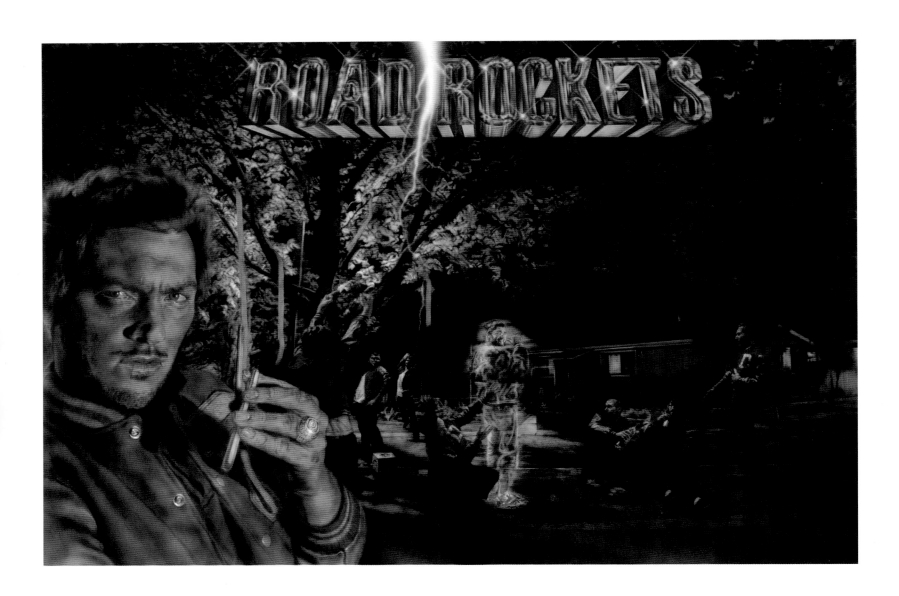

Road Rockets Alienation, 2007, acrylic on canvas, 48 × 72 inches / 121.9 × 182.9 cm

"Ted Tucker's hippocampus, the organ located in the temporal lobe, responsible for the
acquisition and navigation of memories, has been damaged. He reassembles his fragmented
history like an "exquisite corpse" into a new plausible narrative, illustrated using an archetypal
cast of inebriated frat boy youth, cheerleaders, trophies, bush bashes and keg parties."

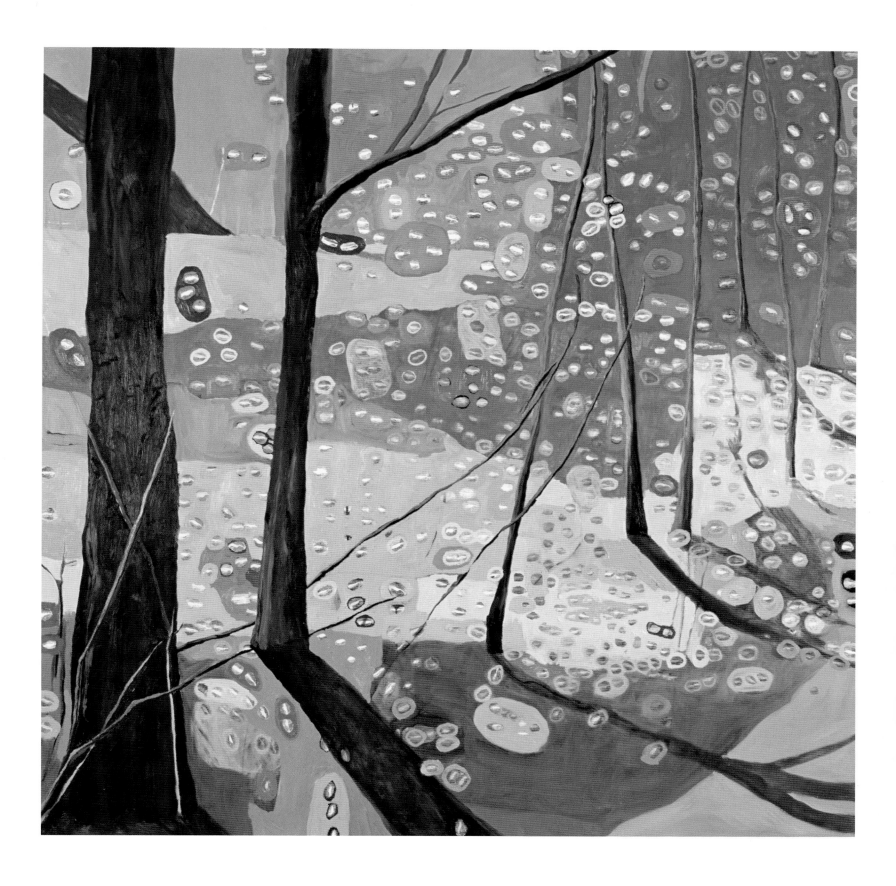

Spoiled in Rubies, 2002, oil and lipstick on canvas, 72 × 72 inches / 182.9 × 182.9 cm

"In my most recent exhibitions, I explore the boundaries or 'skin' between the body and the natural world. The surface of the canvas is first covered by kiss marks in a pattern determined by how light falls on the surface of the local landscape. The lip prints are used for their mutable symbolic significance and also for their remarkable morphological similarity to other natural forms."

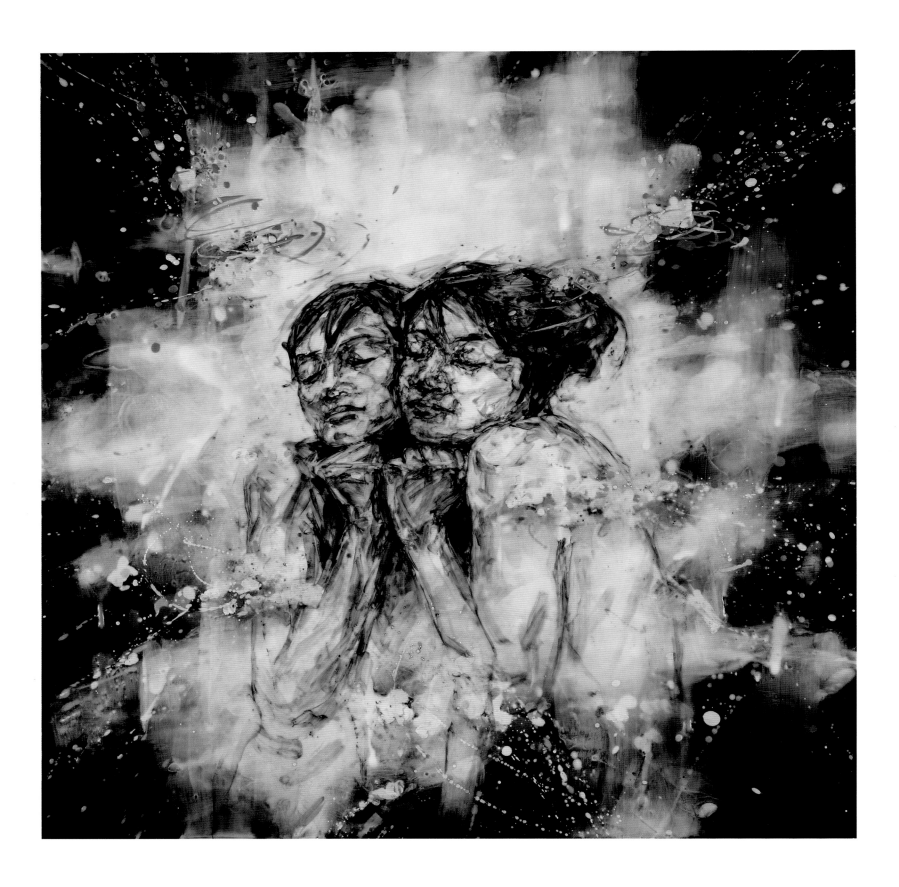

Cheek to Cheek, 2006, encaustic on panel, 30 × 30 inches / 76.2 × 76.2 cm

"Twinning, cell reproduction, cloning, mythology and demons collude in the notions of the Vanished Twin and the Doppelgänger. The ideas of these recent paintings are caught in the junctures of these two concepts. The figures, never wholly completed, are suspended in moments of merging and splitting, reproduction and loss. The paintings bump up against each other, emulating the collision of the figures represented on the surface of the canvas."

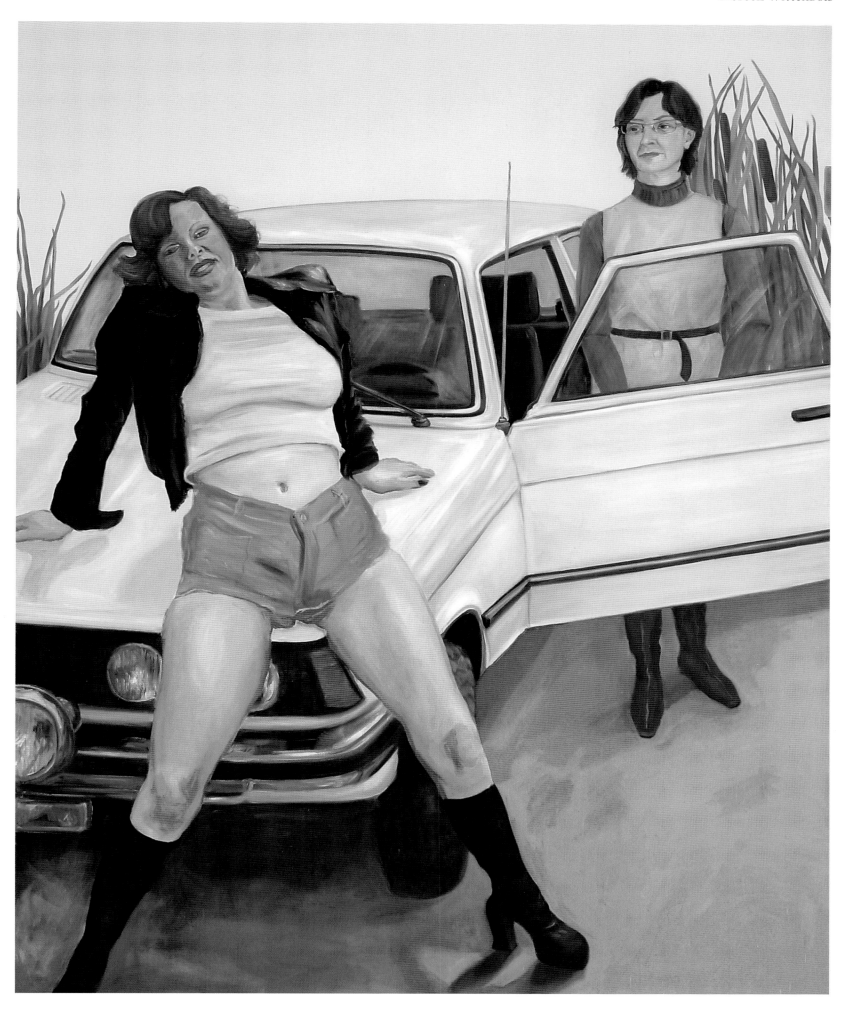

Pit Stop, 2005, oil on linen, 96.1 × 78 inches / 244 × 198 cm

"The *Sexentricité* series is inspired by society's ambivalent attitudes toward sex and the contradictions of our sex-crazed culture. These paintings look at sex in a personal, intimate, quirky and investigative manner, addressing the ongoing complexities of human sexuality."

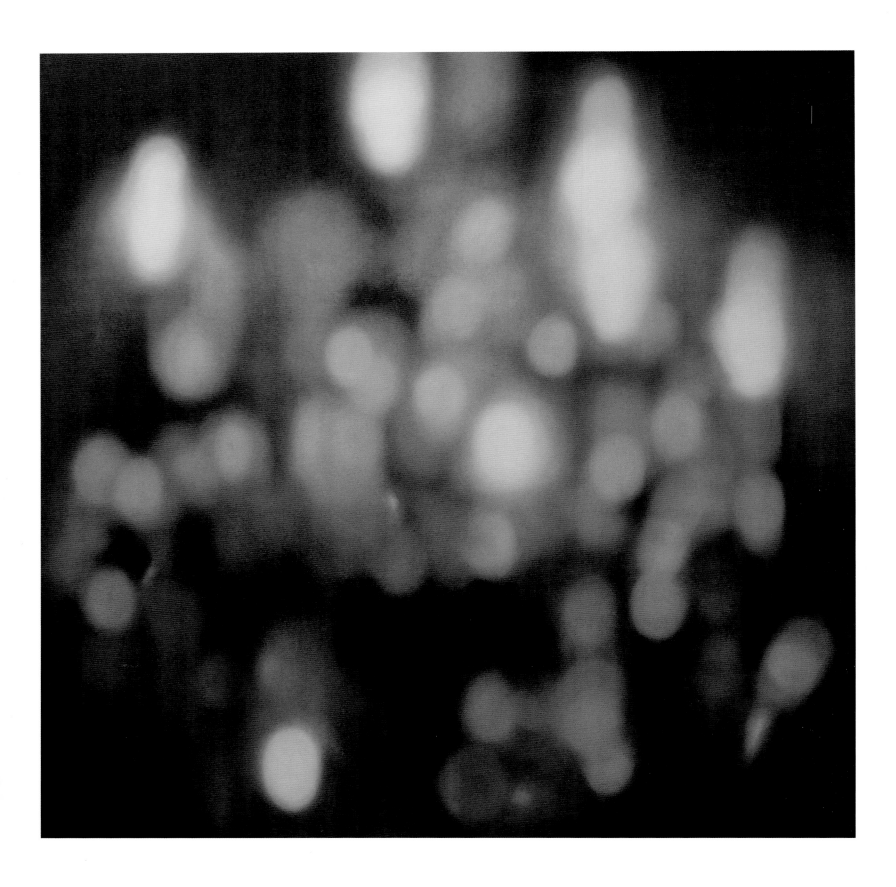

Chandelier 1, 2005, oil on canvas, 60 × 60 inches / 152.4 × 152.4 cm

"The motivational force behind this work is an investigation into the image and perception.
We tend to invest an uncritical faith in photography, accepting its documentation over one's
actual recollections."

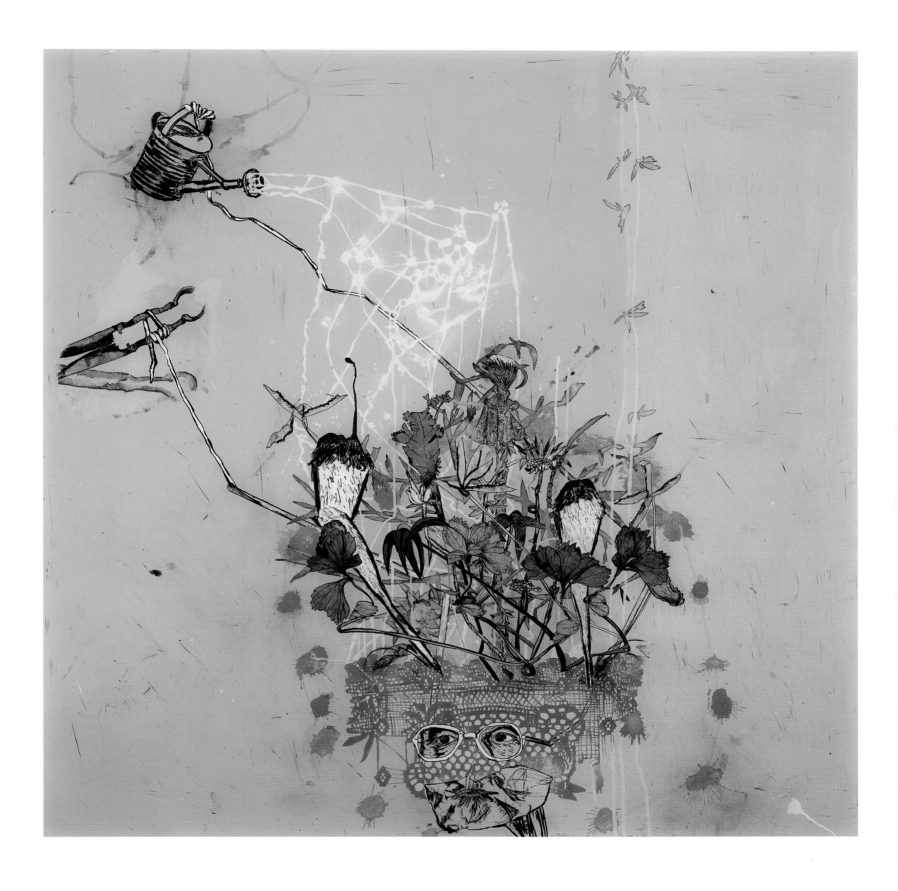

La centenaire (The Centenary), 2006, mixed media on Plexiglass, 48 × 48 inches / 122 × 122 cm

"My work, which is composed of disparate objects and hybrid beings scattered in unspecified
spaces, proposes a certain symbiosis between the human body and those of other animals.
Figures offer furtive glances or scrutinize the spectator while undertaking some obscure ritual,
the sense of which remains mysterious."

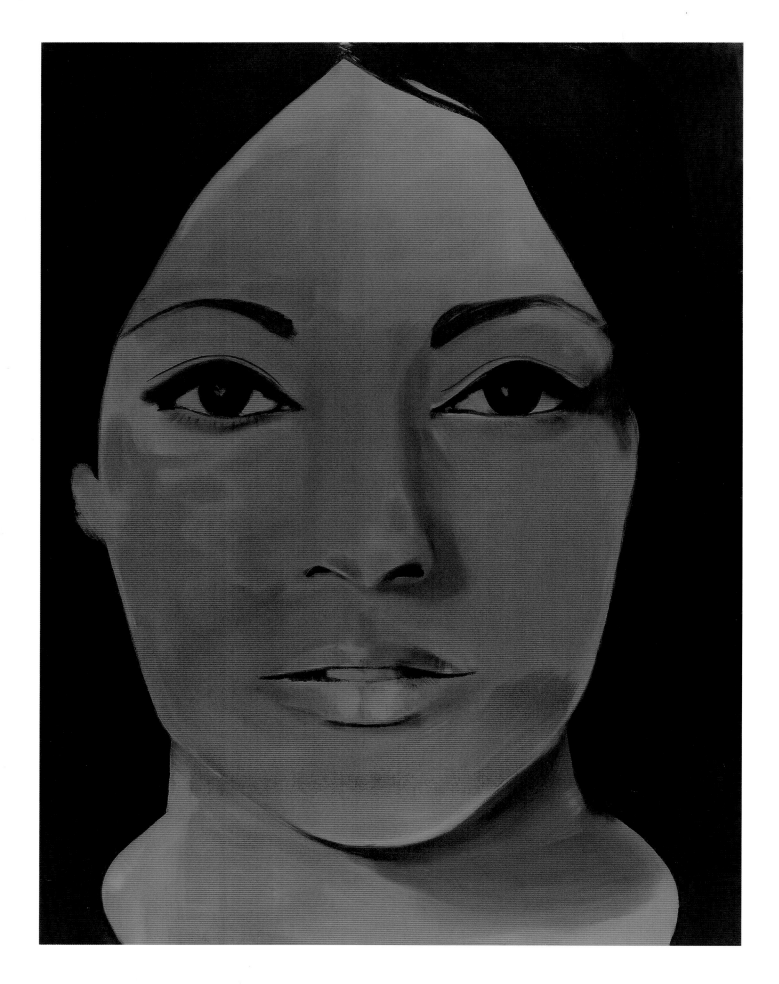

High Tension Magenta, 2006, oil on canvas, 96 × 72 inches / 243.8 × 182.9 cm

"My work centres around the face. I sometimes let the shoulders and body enter into the picture
but it is always about the face. Who is it, and what do they tell me? I don't always know."

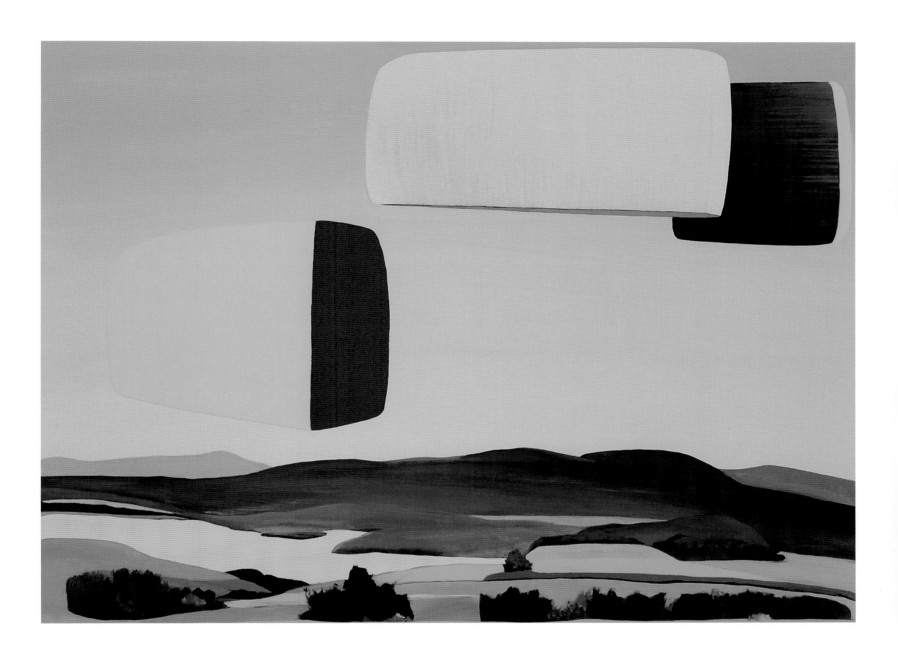

Land #3, 2008, gouache on paper, 22 × 29 inches / 55.9 × 73.7 cm

"I usually start my work outdoors. For the past eight years, I have been doing this by either
painting amongst cedar hedges in rural Canada or looking out of my studio window in Brooklyn
at the buildings and warehouses along the waterfront. I am focusing on these real-life things
and want to infuse them emotionally into my work with the seemingly disparate ideas of solitude,
fertility, need and love."

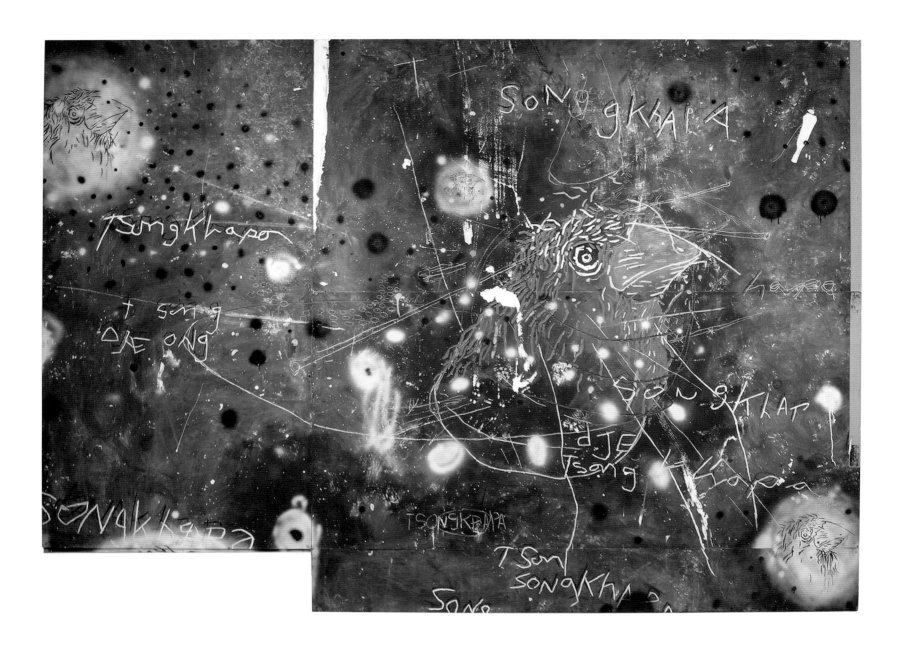

Song Khapa, 1999, acrylic, spraypaint, chalk and varnish on gauged wood,
108.3 × 144.5 inches / 275 × 367 cm

R.T.H. except for, 2006, oil, spraypaint, acrylic, collage and charcoal on wood,
90.6 inches / 230 cm diameter

"My work is always on the verge of total compositional disintegration, echoing the notion
that everything in the universe is made of energy in motion. My work proposes a state of
consciousness in a perpetual situation of flux, constantly breaking down and rebuilding. The
task here is to transform a material object, a work of art, into a conveyer of spiritual energy."

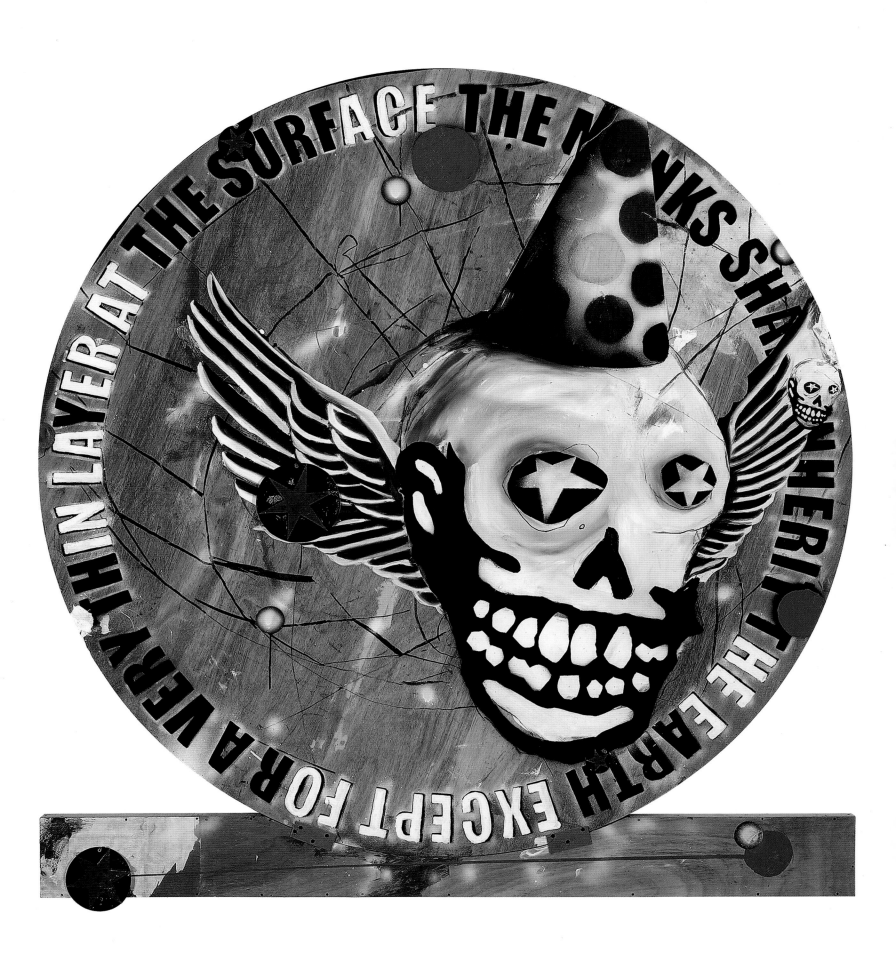

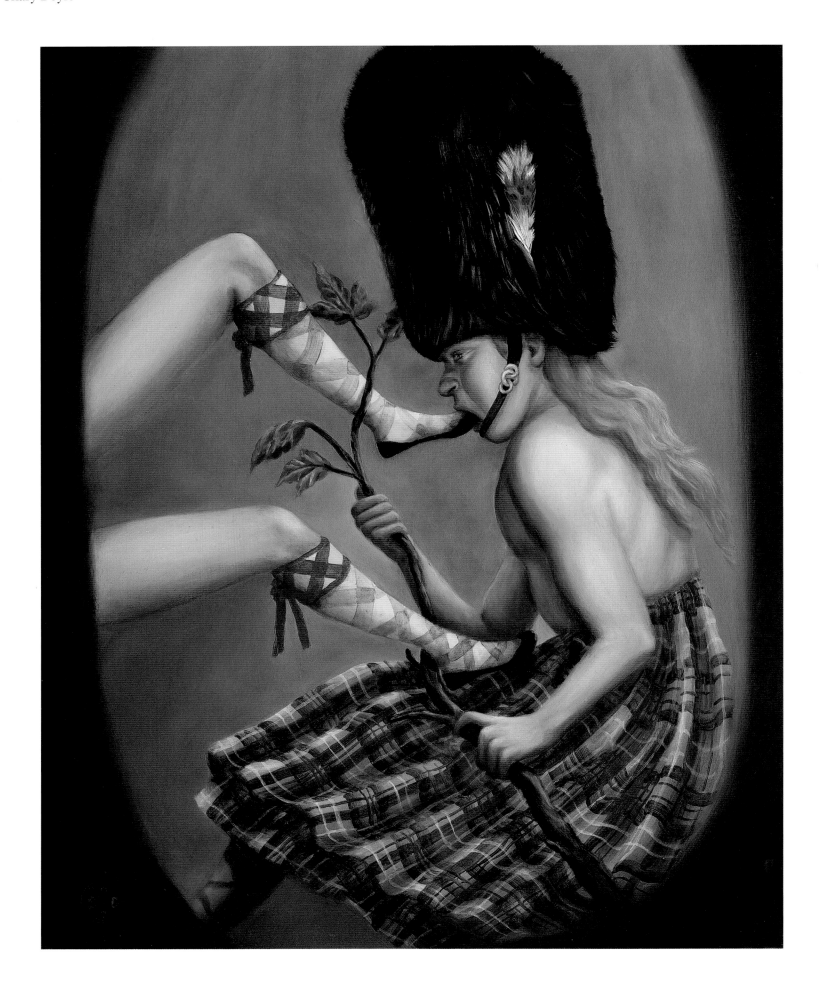

Queen's Guard, from the series *Highland,* 2007, oil on panel, 20.1 × 15.9 inches / 51 × 40.5 cm

"Balancing the tension between dated genres and contemporary subjects is central to my practice.
I approach the Portrait with the sneaky curiosity of a modern pagan at a Christian rock show."

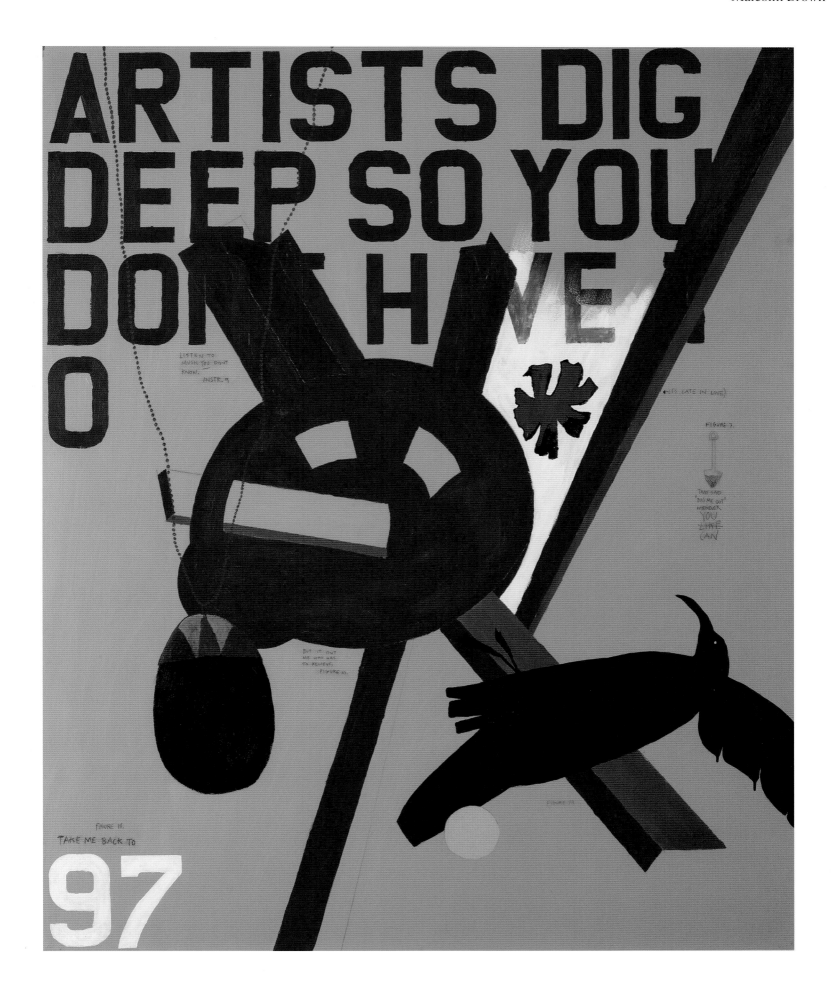

ARTISTS DIG DEEP SO YOU DONT HAVE TO, 2004, multimedia on masonite,
60 × 48 inches / 152.4 × 121.9 cm

"These paintings come from a recent larger body of work, *3 Years of GOD & GOO,* consisting of
35 text-based multimedia, with layered imagery, texts and typography: a colour-heavy babble
of exploding signs and unashamed words. The paintings are primal catch basins, revealing and
solidifying evidence from a long, erratic journey of personal ordeal and inquiry."

Matthew Carver

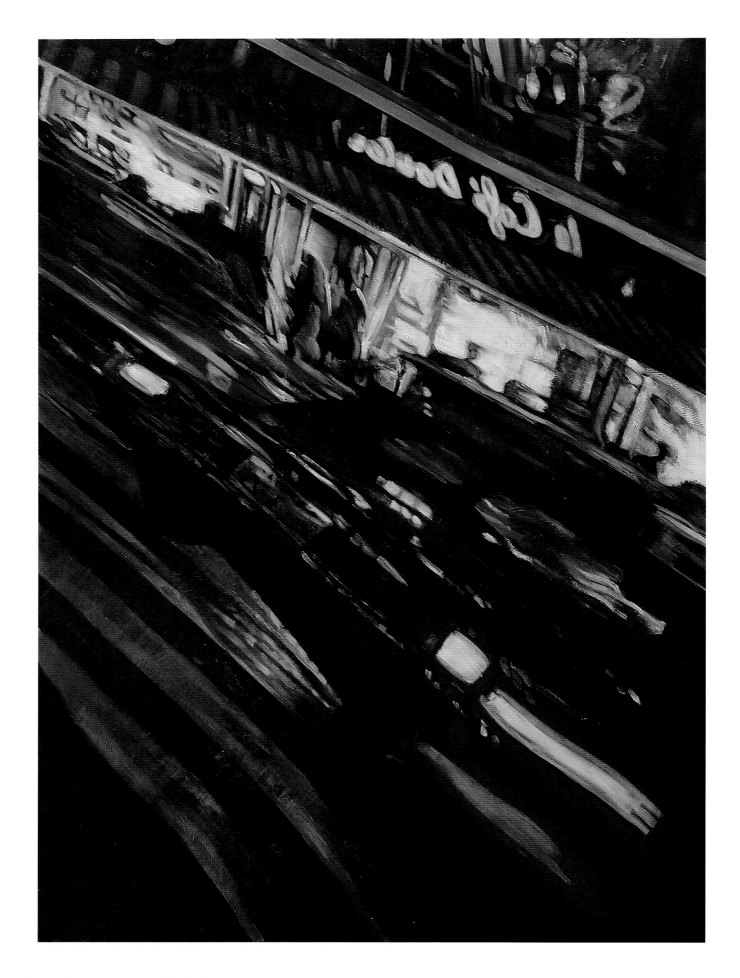

Ginza Doutor, 2005, acrylic on canvas, 133.9 × 96.1 inches / 340 × 244 cm,
courtesy of the Saatchi Gallery, London

Chuo Dori, 2005, acrylic on canvas, 133.9 × 96.1 inches / 340 × 244 cm,
courtesy of the Saatchi Gallery, London

"Art is a dialogue, one that reaches back into art history and then forward to our contemporary
realm. I believe that some of the most underrated and yet significant moments in art history have
been the interactions between the East and West."

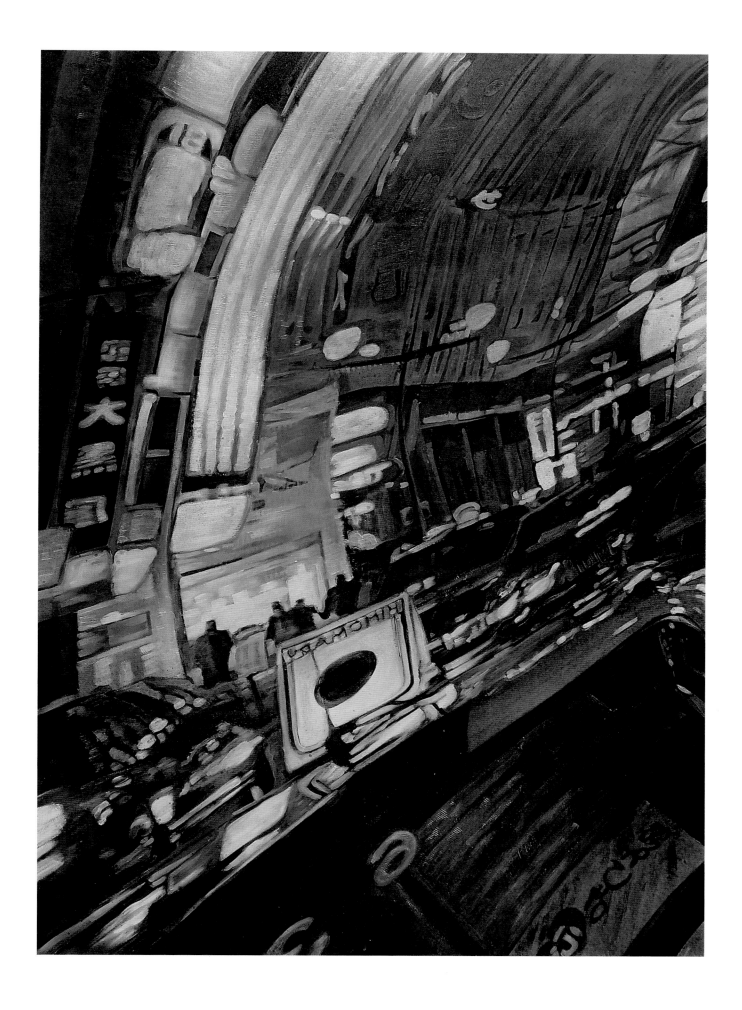

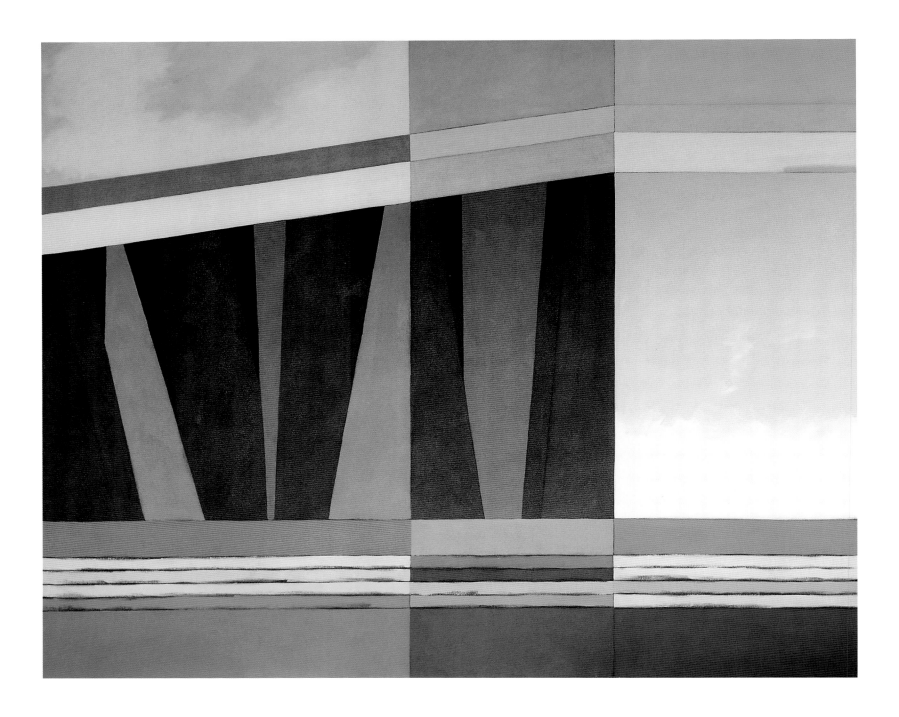

Long Shore, 2006, acrylic on canvas, 48 × 60 inches / 121.9 × 152.4 cm

Peninsula, 2006, acrylic on canvas, 60 × 84 inches / 152.4 × 213.4 cm

"Over recent years, my paintings have gradually changed from representation to abstraction.
The representational still-life objects in my earlier paintings were placed on patterned,
abstract backdrops. The abstract backgrounds and grid patterns have become the subject of
my work. My recent body of paintings is derived from colours, forms and patterns found in
specific landscapes."

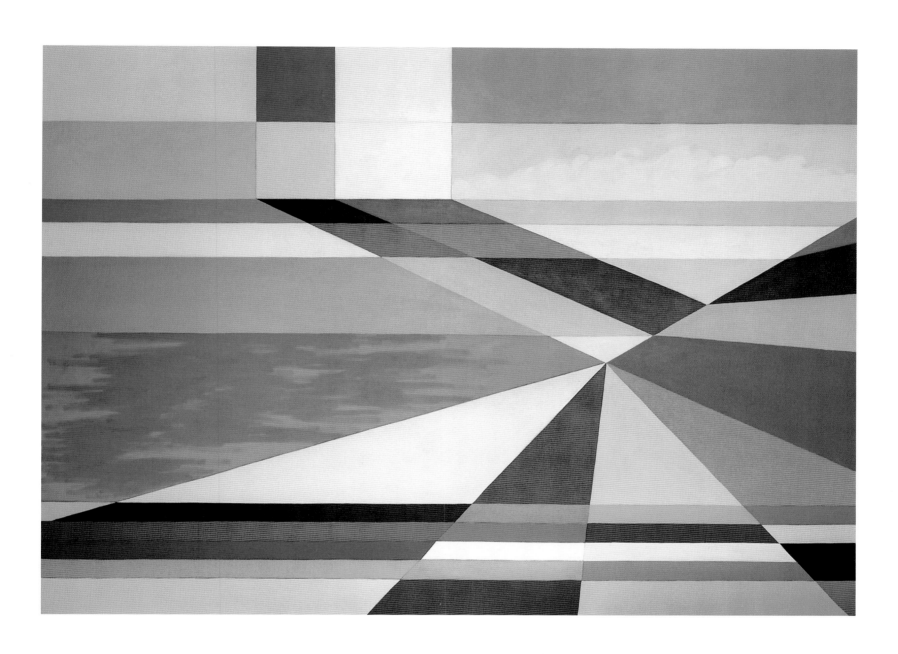

Another Kind of Reality, 2005, oil on canvas on board, 55 × 55 inches / 139.7 × 139.7 cm

Folded Them Round, 2003, oil on canvas on board, 36 × 36 inches / 91.4 × 91.4 cm

"In the construction of my paintings, I use a variety of methods to make marks, in grid formation, into a wet surface of paint to create works that reference the Modernist grid while subverting its overt order. This mark-making process causes the grid to slip out of square and the paint to pool, ooze, cut, pull and depress. I use repeated glazing techniques to fuse and flood the surface with colour. The resulting effect is atmospheric—surfaces and colours both unveiled and disrupted by a grid of small scars."

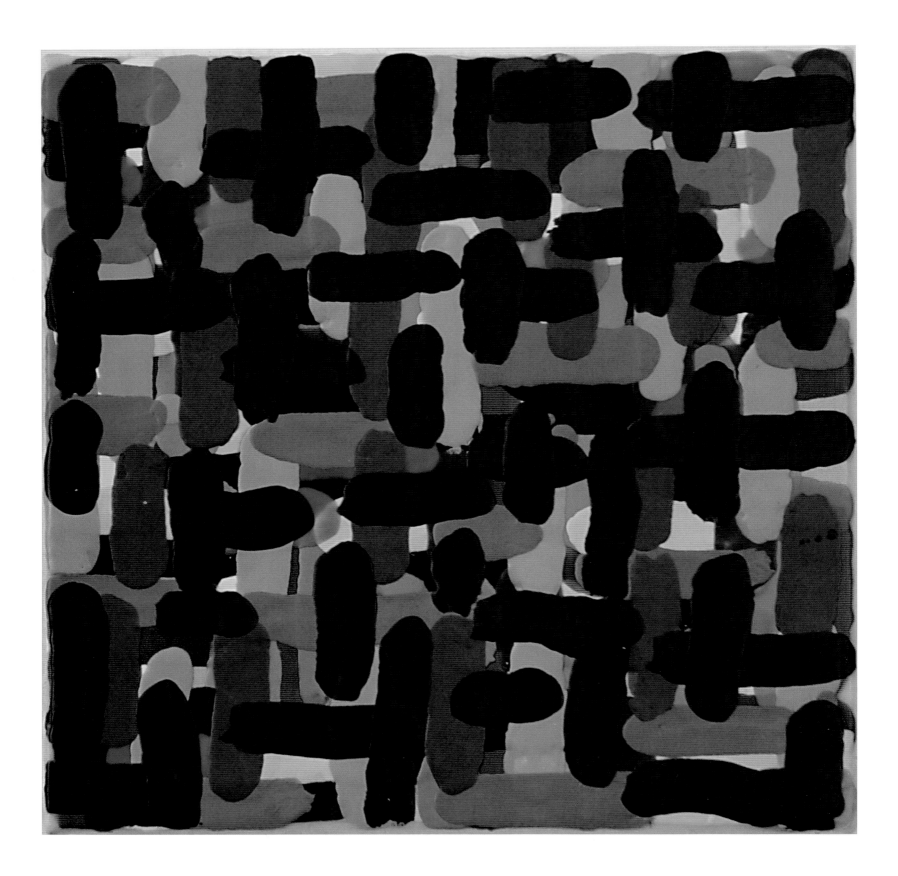

one.16.02, 2006, wax and oil on canvas, 12 × 12 inches / 30.5 × 30.5 cm

"Chardin often made copies of his own work after the fact, as did Clifford Still, and Elaine
Sturtevant copied other artists' work. I copied my own in a different medium to learn about
a new/old kind of paint. So my thinking turned to this thought: what if I made the same
painting over and over in the same medium? Or rather, what if I made the same painting many
times simultaneously?"

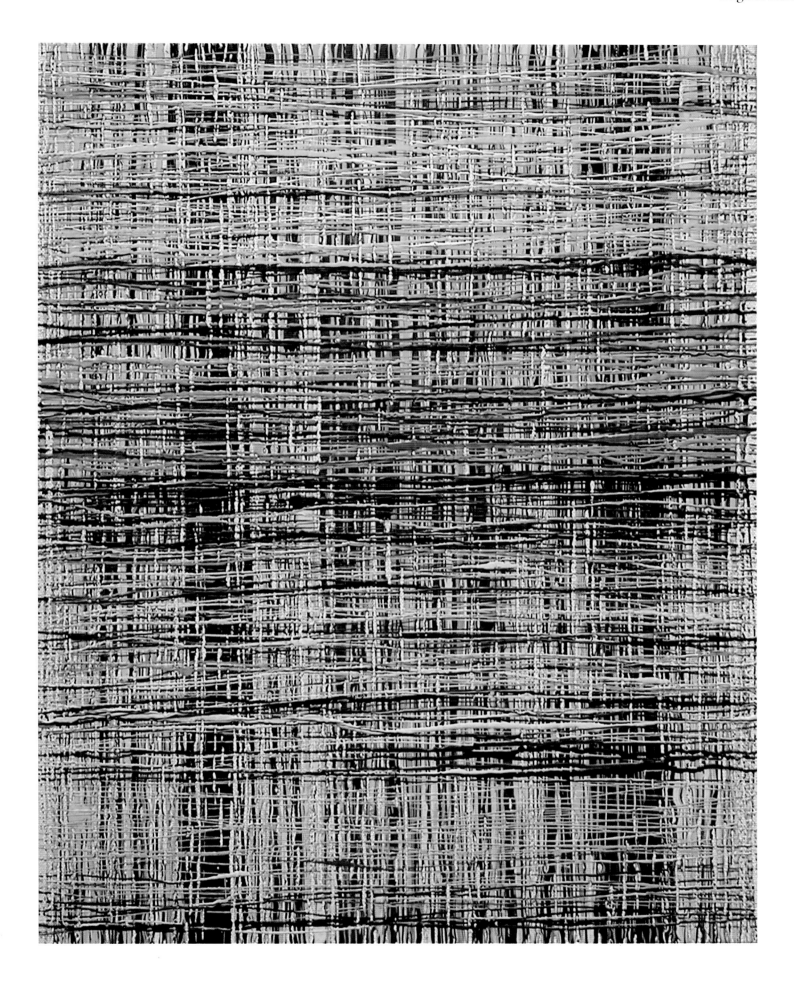

Vincent's Bedroom in Arles (Musée d'Orsay), 2004, latex on canvas, 29.1 × 22.2 inches / 74 × 56.5 cm

"Inspired by texts by van Gogh scholars such as Debra Silverman and Carol Zemel that link
van Gogh's painting to his life-long interest in weaving and artisanal activity, each of my 'woven'
paintings is based on the palette of a particular van Gogh painting."

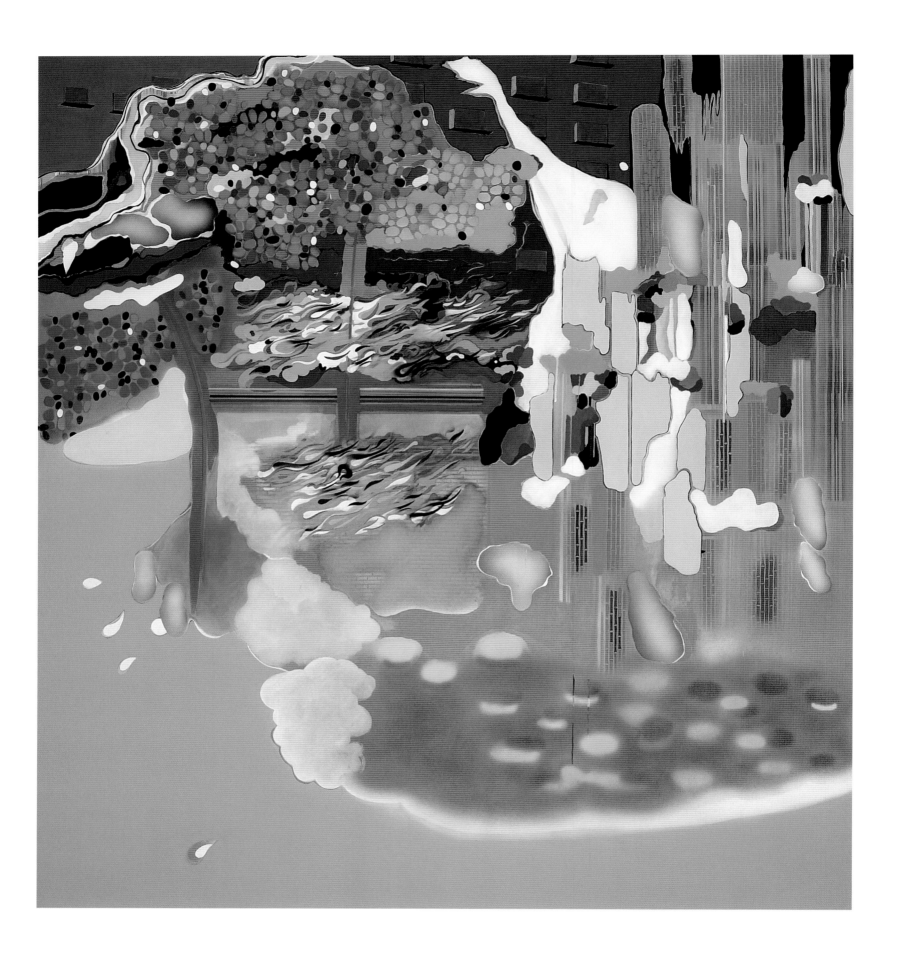

Obnubilé/Stunned, 2006, acrylic on canvas, 79.9 × 74 inches / 203 × 188 cm

The thing that moved me most, 2005, acrylic on canvas, 79.9 × 74 inches / 203 × 188 cm

"What makes Daigneault's paintings unique is his ability to be at one and the same time seductive, visionary and ambiguous yet resistant to the perils of painterly pathos. The spectator confronted by the constant mutation of images gets drawn like a child into exploring each and every detail."

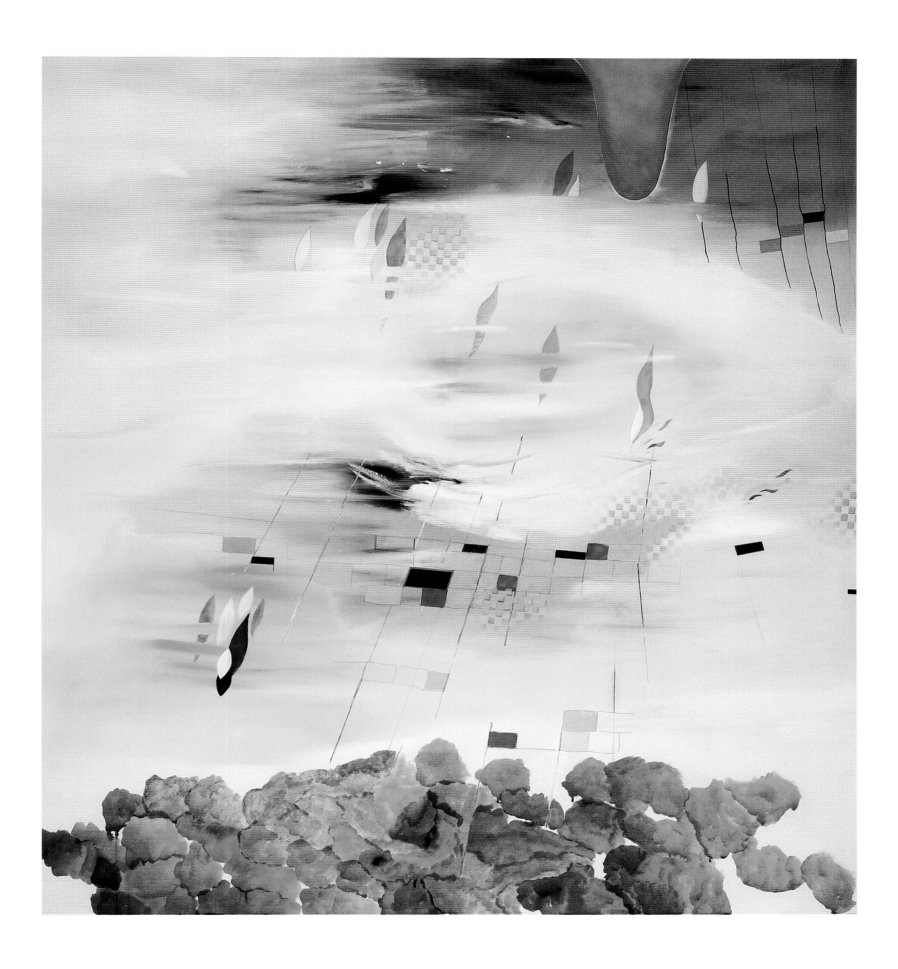

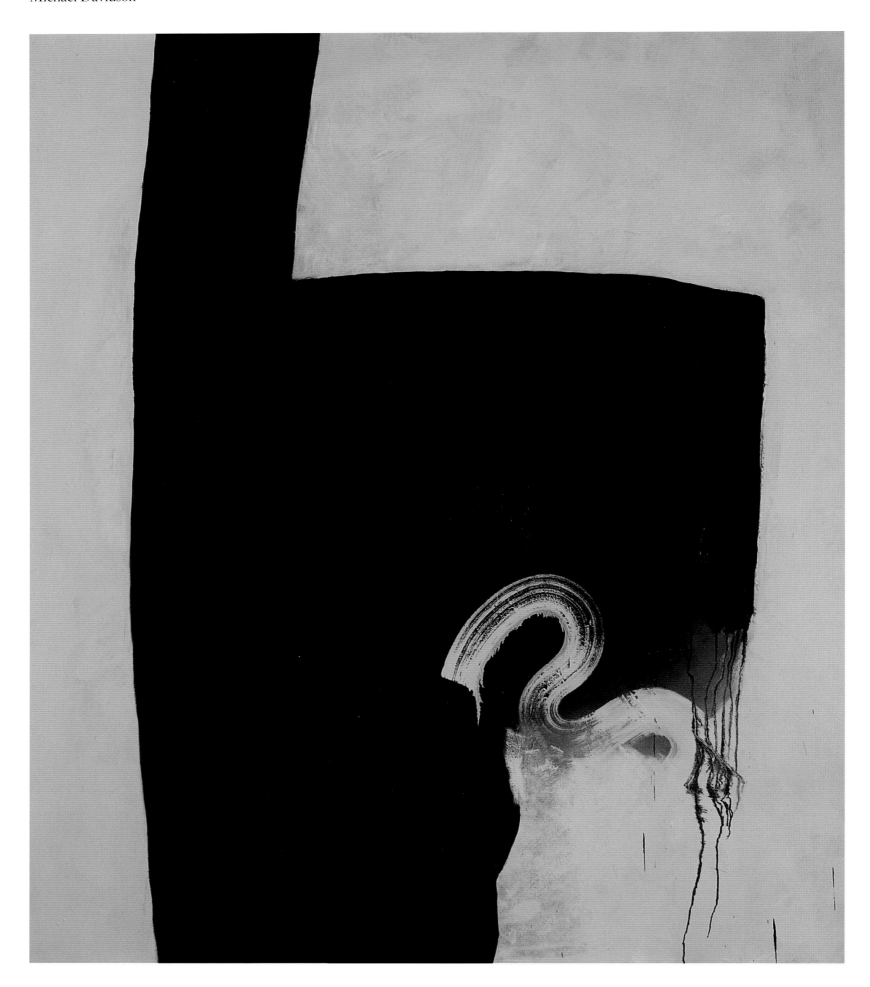

Here, Not Lost, 2007, oil on canvas, 78 × 66 inches / 198.1 × 167.6 cm

"After some 20 years of working, and thinking about it for closer to 35, I have come to understand
something about the nature of painting. In particular, I strongly believe that the work of the
1940s and 1950s, most evident in the so-called New York School (and again somewhat later in
Canada), left a legacy in visual language, as fresh and demanding as anything before it. And yet
it is unresolved."

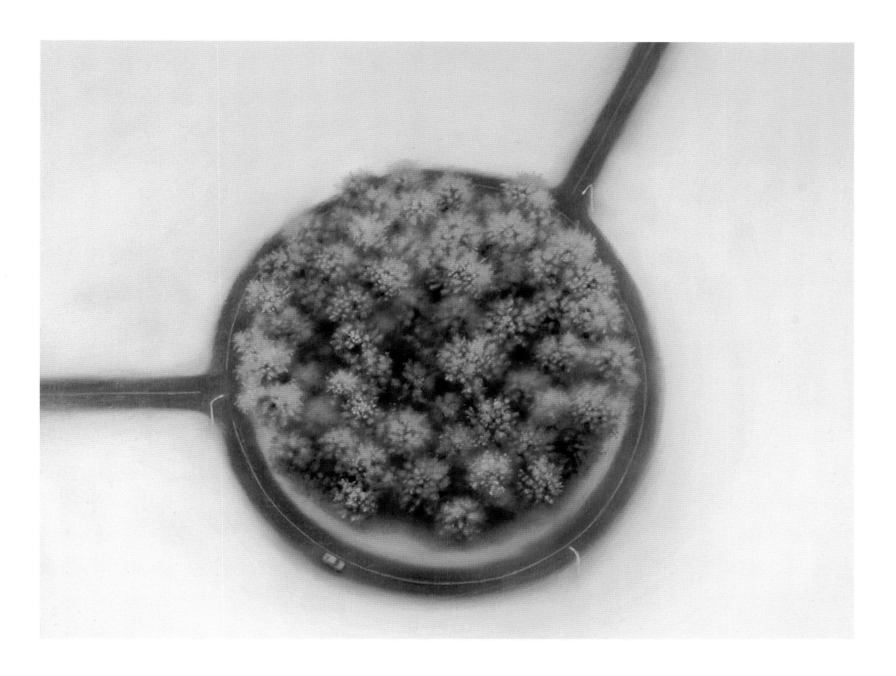

The View, 2005, oil on board, 8 × 8 inches / 20.3 × 20.3 cm

"I'm fascinated by how we landscape the landscape, the ways in which we influence and experience the environment, and the views and psychological spaces we create for ourselves. My work considers the idea of façade and artifice in landscaping, and the sentiments of comfort, desire, protection and isolation."

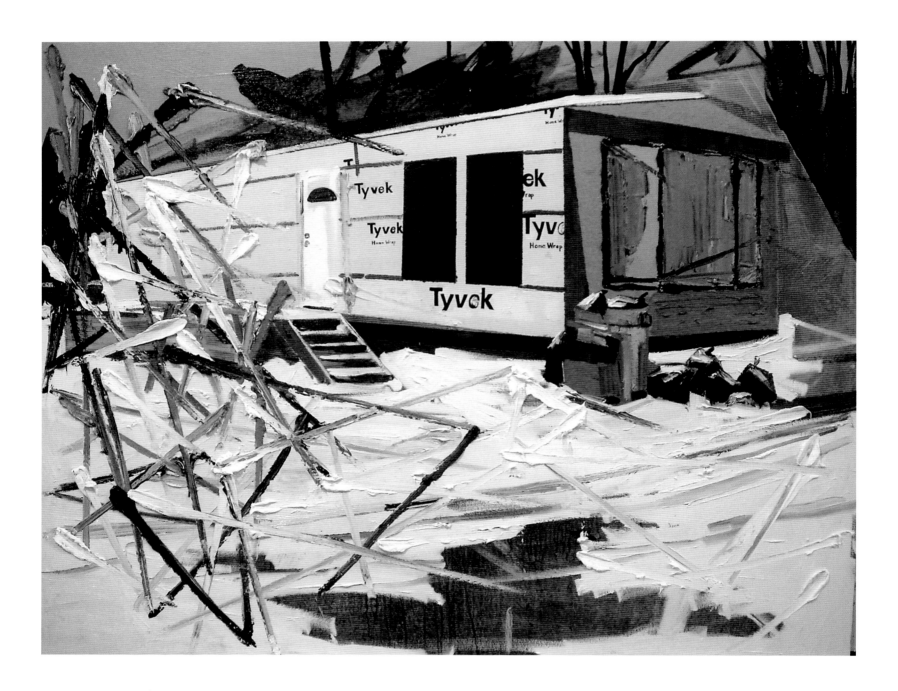

Tyvek, 2007, oil, acrylic and spray paint on canvas, 48 × 60 inches / 121.9 × 152.4 cm

Beer and Pussy, 2006, oil, acrylic and spray paint on canvas, 72 × 96 inches / 182.9 × 243.8 cm

"I am motivated by the possibilities of painting. Drawing on painting's rich visual inventory, I appropriate, combine and deconstruct the medium to reflect on the meaning, ambiguity and value of painted representation. I am interested in conjuring a social and psychological portrait through the positioning or implied absence of the figure or figures and the things and spaces that surround them."

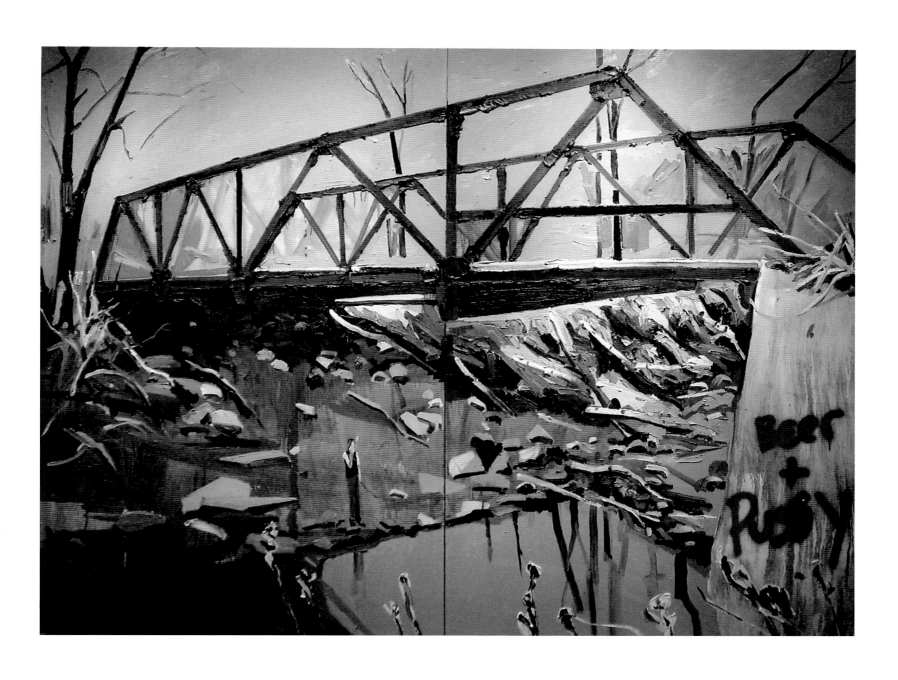

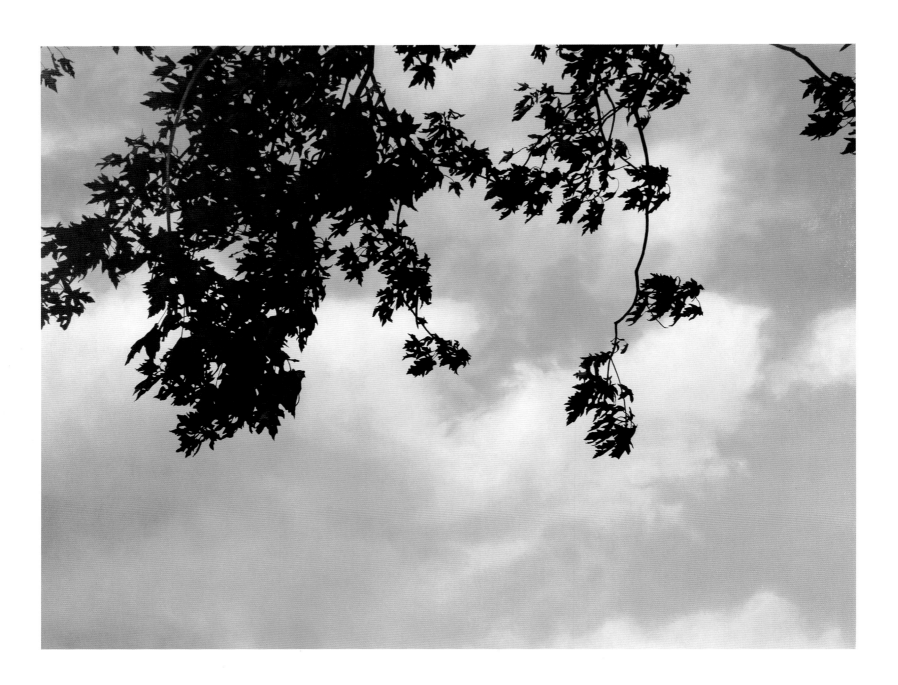

Persuasion, 2006, oil on canvas, 48 × 62.2 inches / 122 × 158 cm

"For me, the painting process requires an intense engagement with the image. Much like a blind
person who has to run their hands over something in order to 'see' it, my method of painting
requires an intimacy with the image before I can reproduce/reinterpret it. For me, there is
something very compelling about investing that level of intimacy and amount of time into these
images of transience."

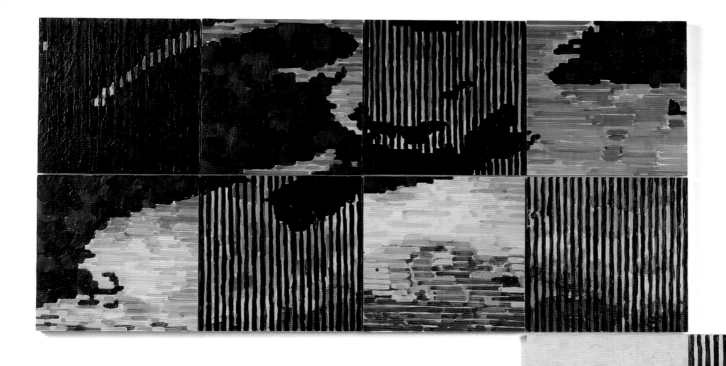

datapainting.4 (Before Juan/After Nortel), 2004, encaustic on 12 panels,
48 × 60 inches / 121.9 × 152.4 cm

"Conscious of encaustic paint's 2,500-year history, these multi-panelled works fuse
historical content with the contemporary issues while skating the line between
representation and abstraction."

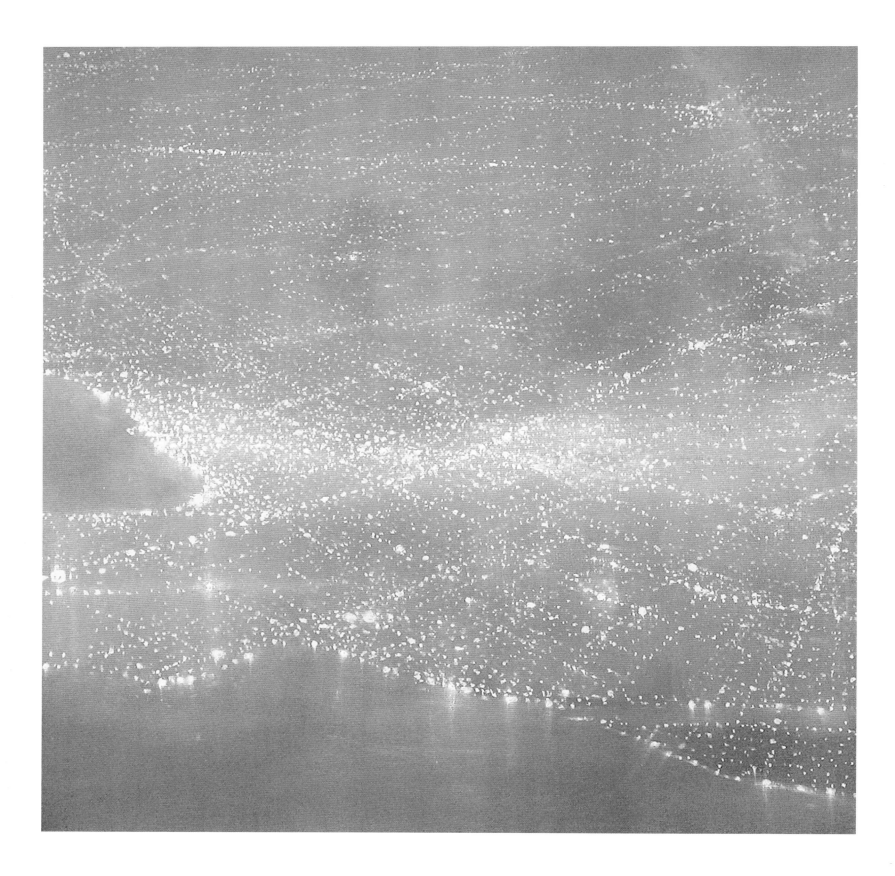

Constellation #2, 2006, oil on canvas, 35.4 × 35.4 inches / 90 × 90 cm

Instant #1, 2006, oil on canvas, 47.2 × 47.2 / 120 × 120 cm

"In my work, I have explored how distant views of illuminated cityscapes can resemble luminous organisms, with electric light acting as a kind of nervous system or pulse—a manifestation of human presence. I am also interested in how these cityscapes can resemble or evoke the cosmos or the night sky. I want to represent a perception of electric light (and its effects) as a kind of dramatic phenomenon."

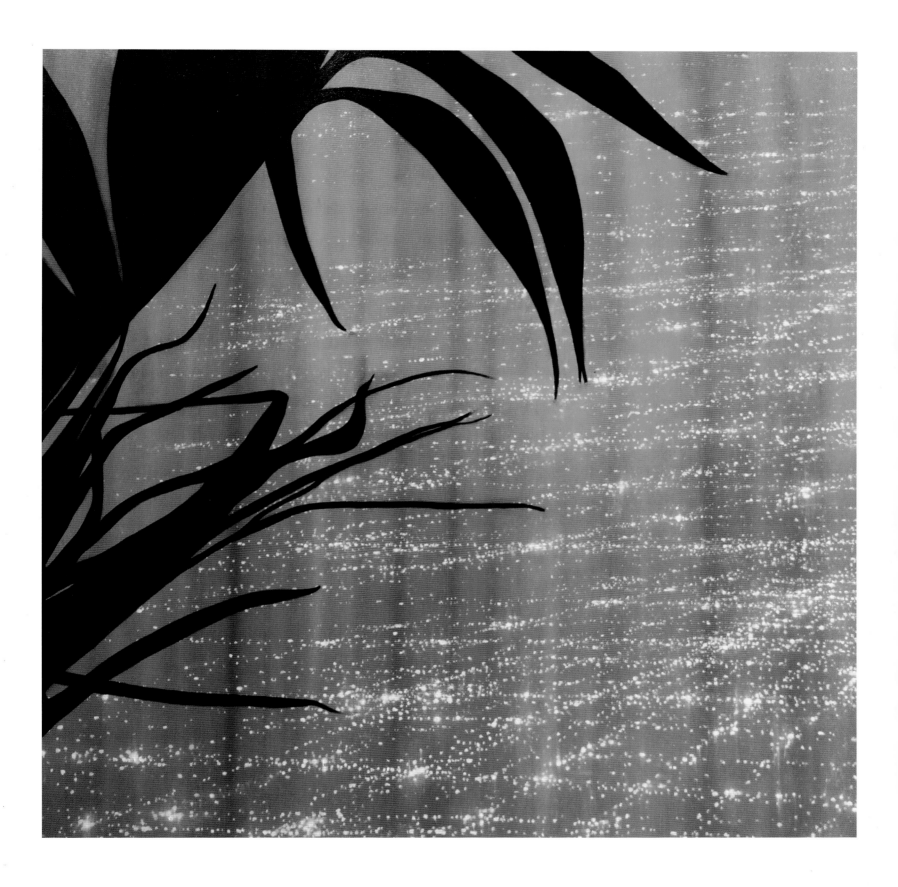

Gary Evans

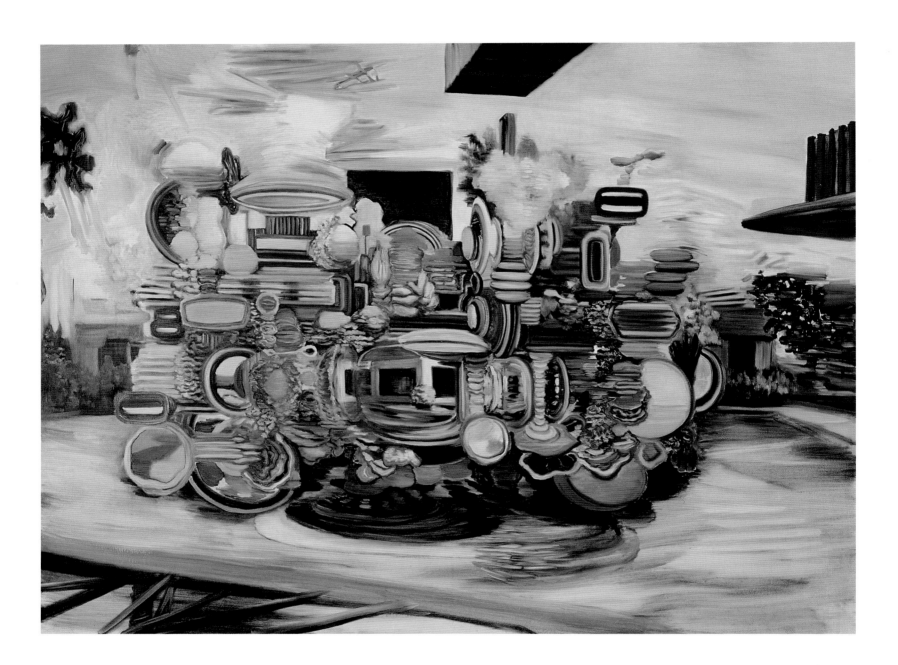

Gathered Landscape, 2006, oil on canvas, 72 × 96 inches / 182.9 × 243.8 cm

Molson Park, 2006, oil on canvas, 48 × 48 inches / 121.9 × 121.9 cm

"My work often finds its inspiration in my local surroundings, yet hovers between representations
of the real and fabricated. Often, I borrow textures and shapes that have been modified by
the process of looking. I create re-invigorated landscapes out of these shapes, in the hope of
presenting a plausible mental model that suggests or acknowledges the subliminal possibilities
of representation and creation in this plastic format."

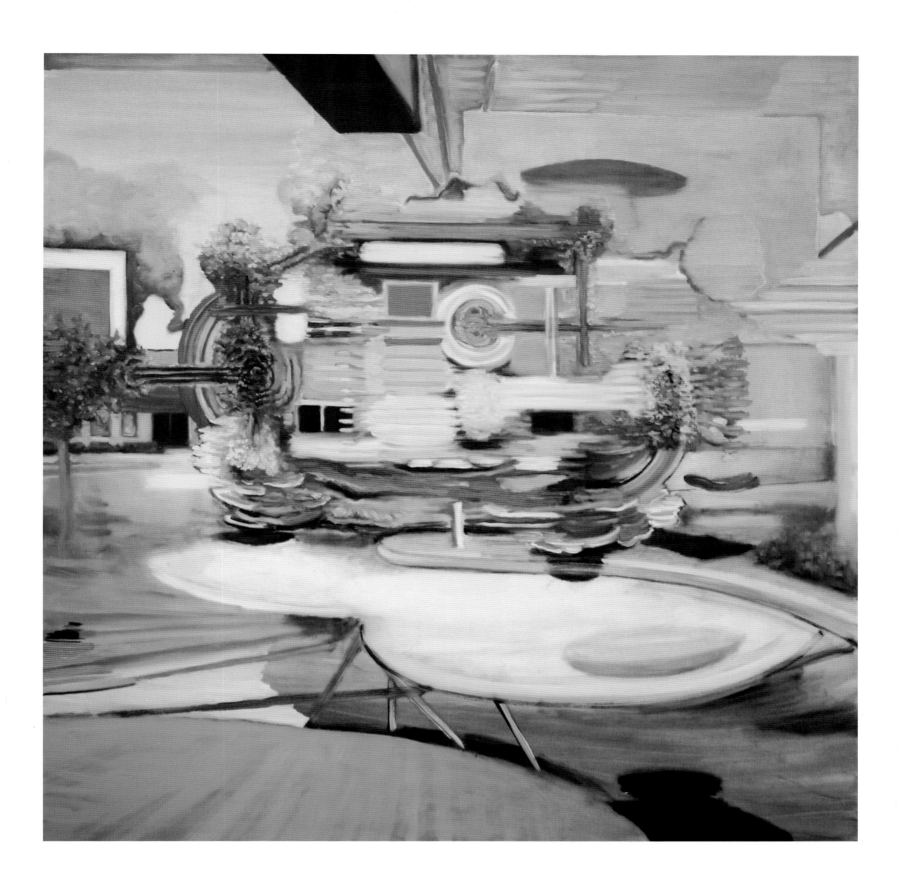

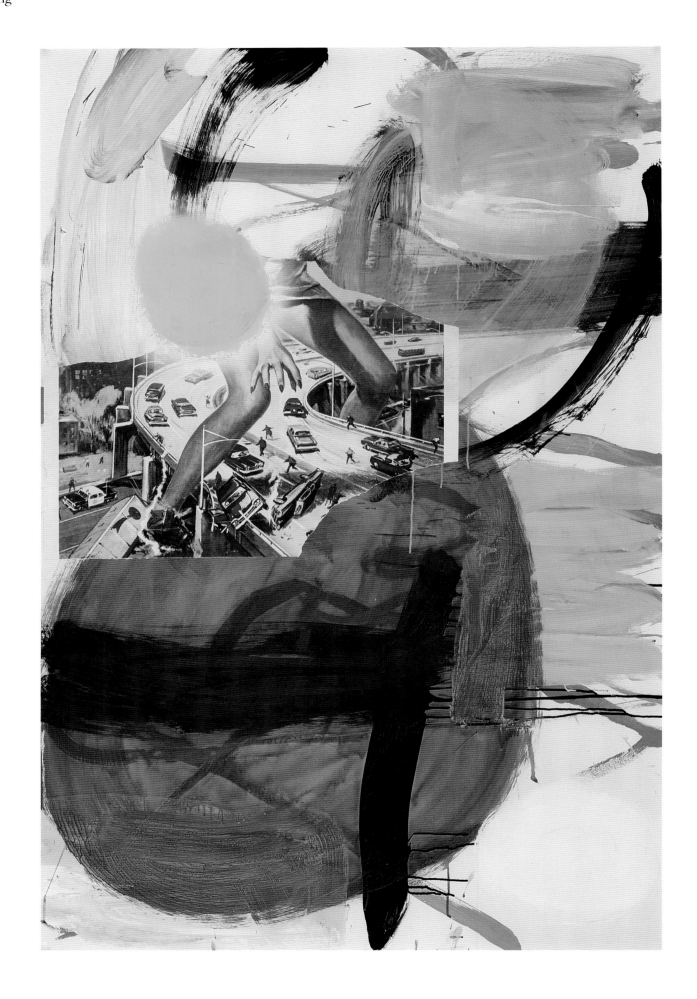

Attach 2, 2006, acrylic on paper, 70.9 × 47.2 inches / 180 × 120 cm

Big Green, 2006, acrylic on paper, 70.9 × 47.2 inches / 180 × 120 cm

"With this body of work, your first reaction is the desire to touch. The artist explores light and colour with the use of translucent materials and candy drop pours of paint. These works employ painting with various degrees of opacity allowing light to travel through paint and surface (as with the Plexiglas) and interact with other layers, creating a sense of depth and story."

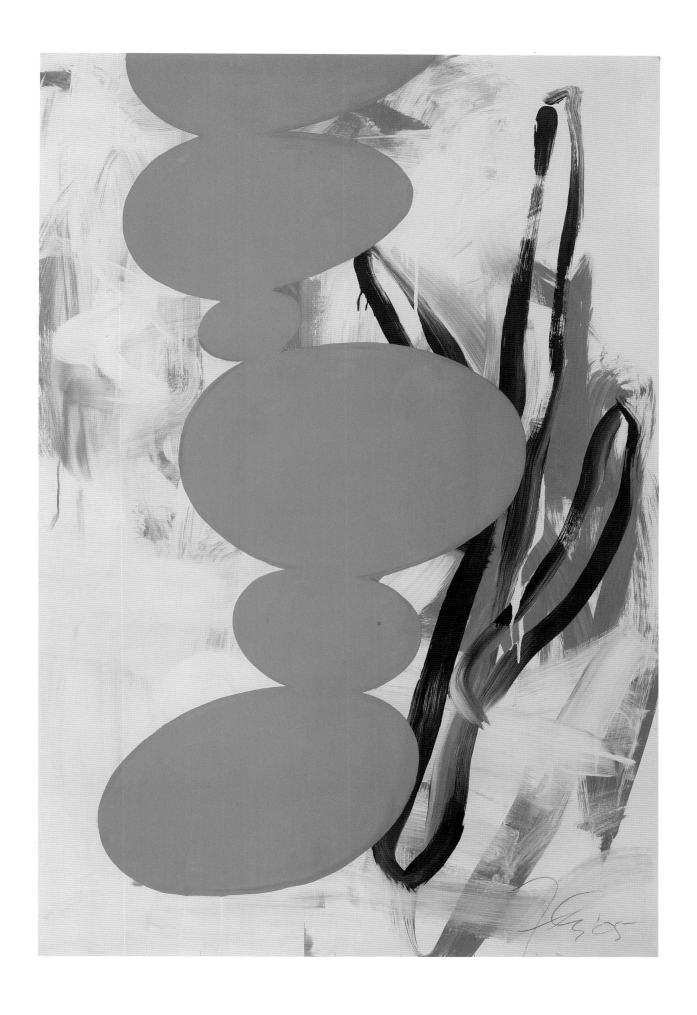

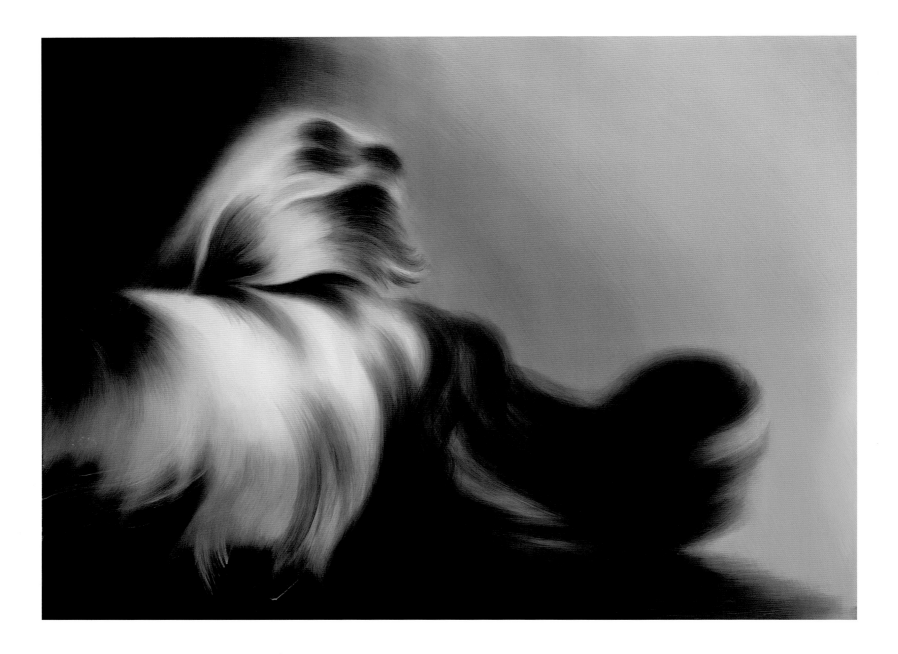

Octavia, 2004, acrylic on canvas, 40.2 × 53.9 inches / 102 cm × 137 cm

Paradise, 2006, acrylic on canvas, 53.1 × 41.3 inches / 135 × 105 cm

"The acrylic technique I use calls for several coats of tinted acrylic gloss varnish. These meticulous layers evoke the deep luminosity of traditional stained glass and 16th-century Flemish still life, while also suggesting contemporary visual mediums such as cinematic lighting, photography and television."

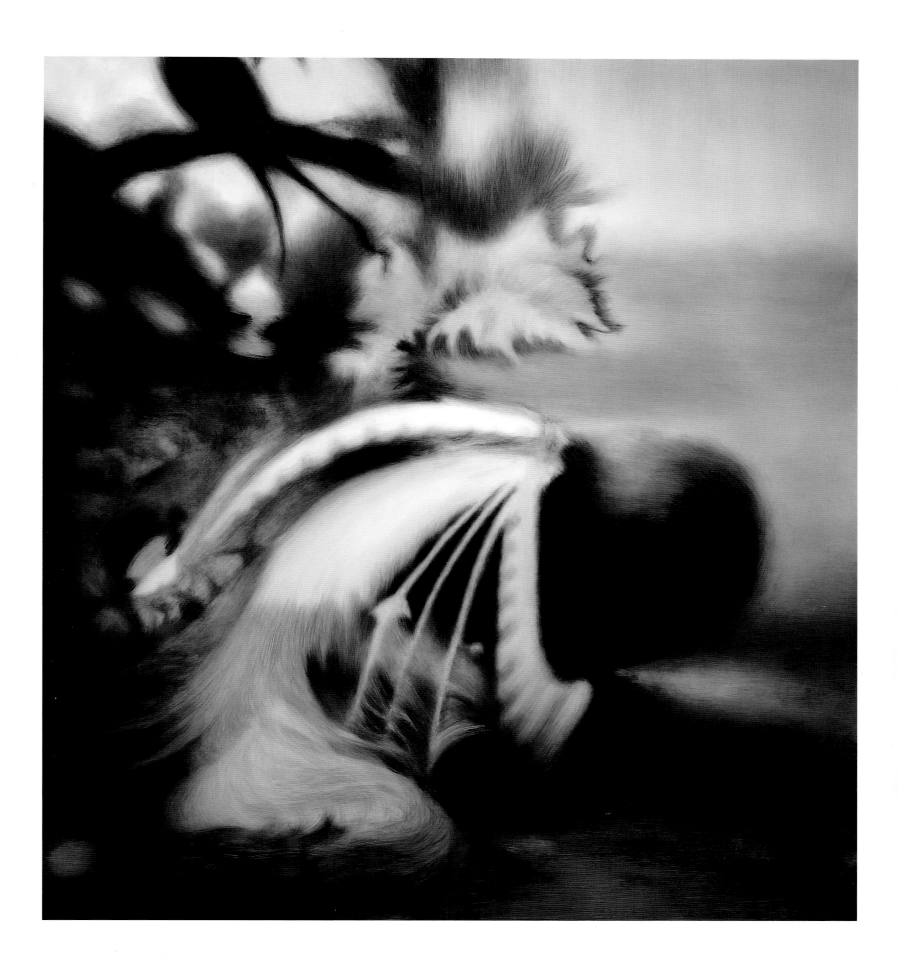

Michelle Forsyth

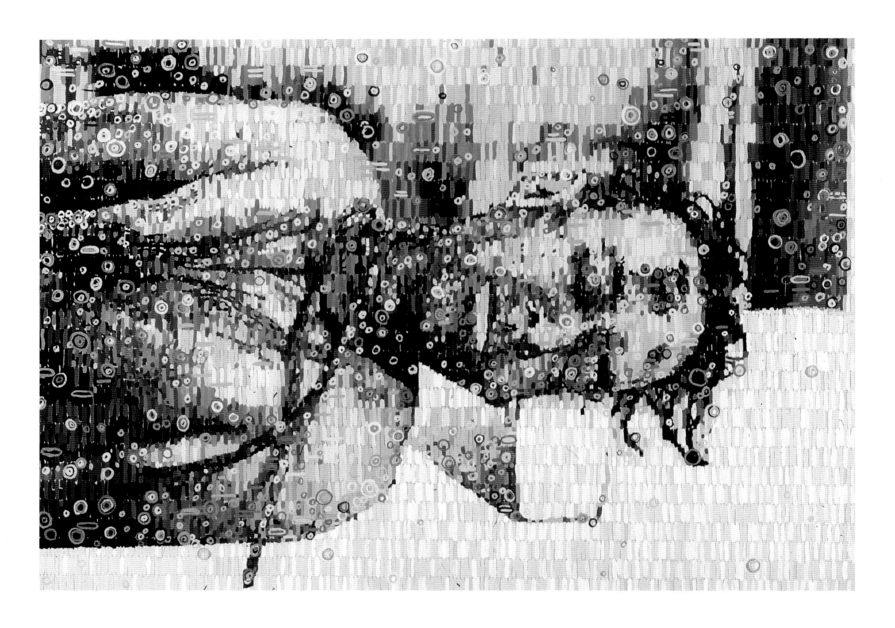

Trace Evidence 1, 2004, gouache on Mylar, 22 × 26 inches / 55.9 × 66 cm

Florescence 3 (Flowers for Iraq), detail, 2006, Color-aid paper, felt, beads and pins,
48 × 60 inches / 121.9 × 152.4 cm

"The majority of my work is culled from a vast collection and archive of catastrophic images
gathered from contemporary media sources. Acquired primarily from the Internet as well
as from newspapers, they include horrific scenes of disaster, terrorist attacks, bombings,
massacres and representations of war. I deliberately seek to abandon the efficiency and speed
of digital production, translating these images into thousands of tiny, brightly coloured
brush-marks, hole-punches, cutout circles, hand-stitches and diluted layers of watercolour."

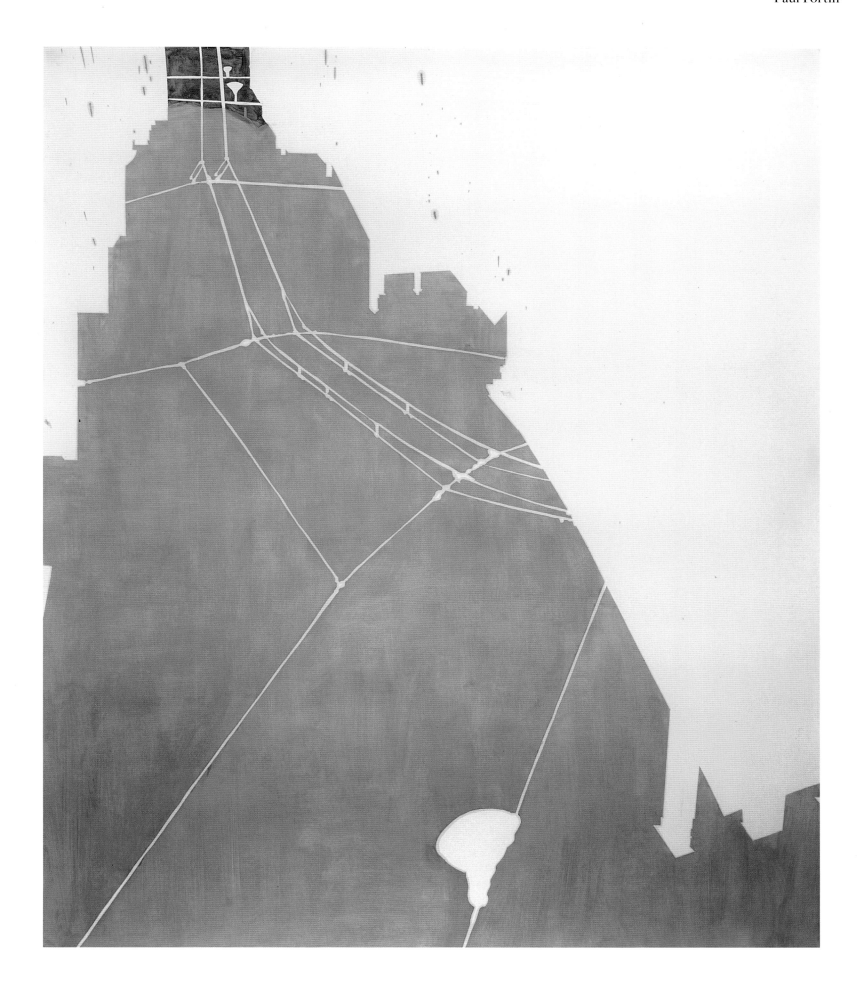

Wires, 2007, oil on paper, 74 × 62 inches / 188 × 157.5 cm

"My paintings are brief glimpses into landscapes and moments that may or may not ever fully
develop into what they truly are. I want the work to remain open and let the viewer fill in the
blanks, to absorb and construct what they are seeing for themselves. Although the paintings
may represent a void or emptiness, the interpretations that the viewer brings to the paintings
can be full of life and atmosphere."

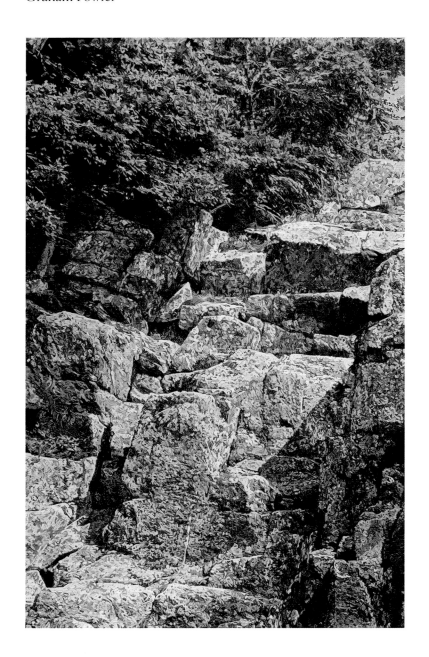

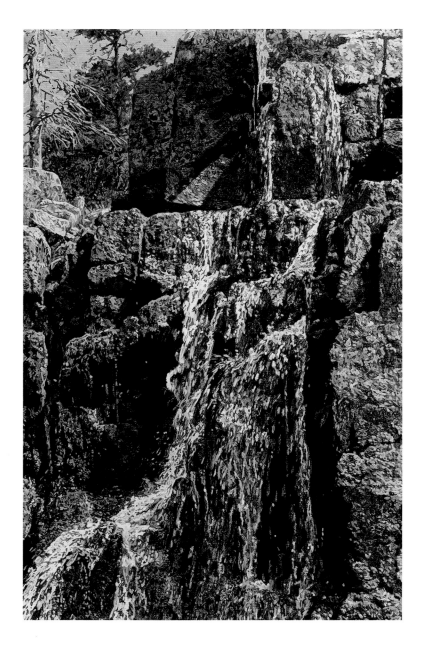

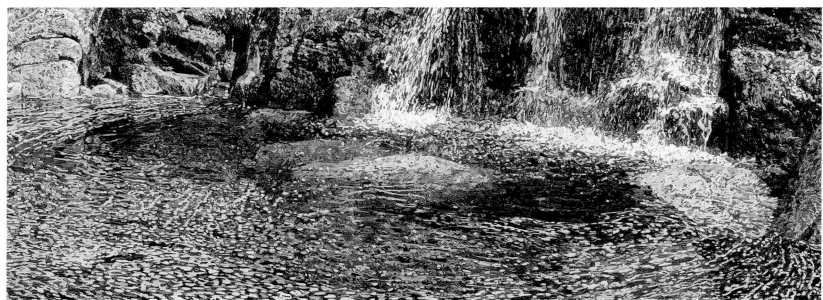

The Current That Flows Through the Source (triptych), 2000, oil on canvas,
66 × 41 inches / 167.6 x 104.1 cm (each top panel), 33 × 88 inches / 83.8 x 223.5 cm (bottom panel)

"Water fascinates me as subject matter and I have spent much of my artistic career understanding
it as visual phenomena. My paintings are a representation on how water reveals what is beneath it,
reflects what is above it, defines its own surface and is in constant flux and movement."

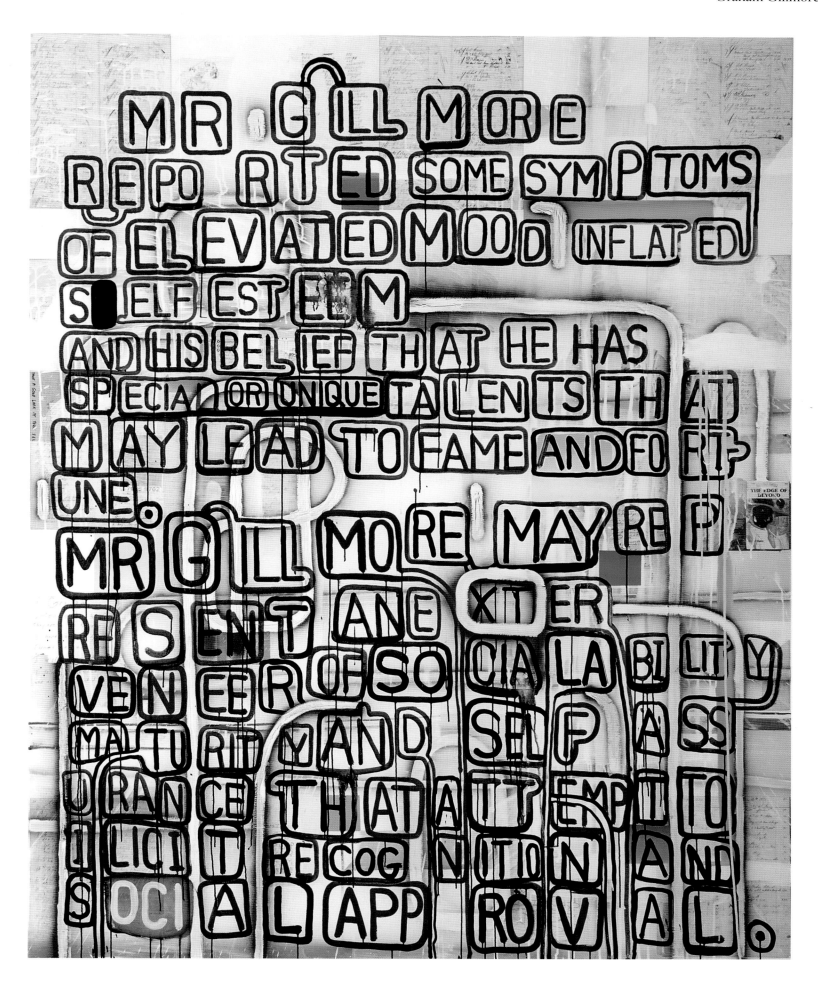

Psych Test, 2007, mixed media on canvas, 90 × 72 inches / 228.6 × 182.9 cm

"Integrated above and below a multi-layered apparitional landscape of hues and tones, Gillmore's words provide a window into the brain chatter of the artist. The words, routed into the surface, work in a combination of ways, where misspellings, spacing, how deeply layered and even the size and architecture of the characters justify their usage."

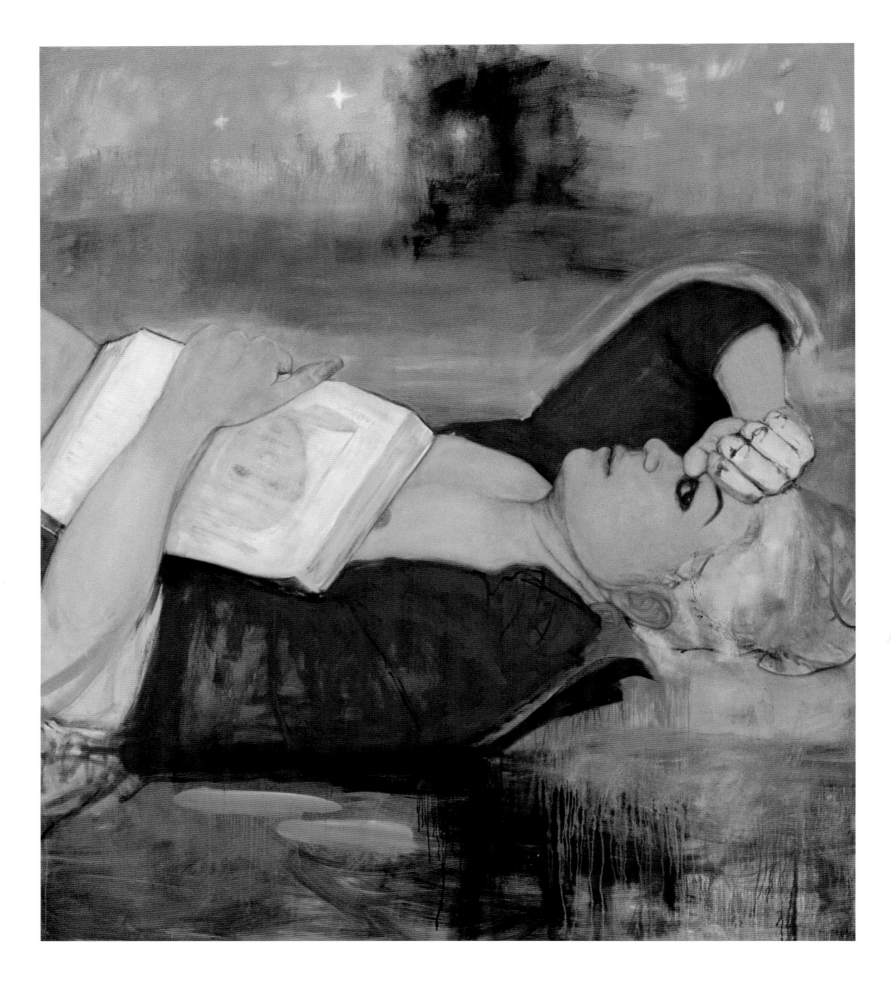

Intuition, 2003, oil on canvas, 90 × 80 inches / 228.6 × 203.2 cm

Universal Health Care, 2006, oil on canvas, 36 × 30 inches / 91.4 × 76.2 cm

"My artistic practice is based on the creation of invented characters who perform distilled
psychological, social and experiential narratives in painting tableaux. The additive and
subtractive process of painting allows me to build figures who convey the tension of a desired
communication with the viewer and with each other, expressing themes of identity confusion,
gender, sexuality, intimacy and power."

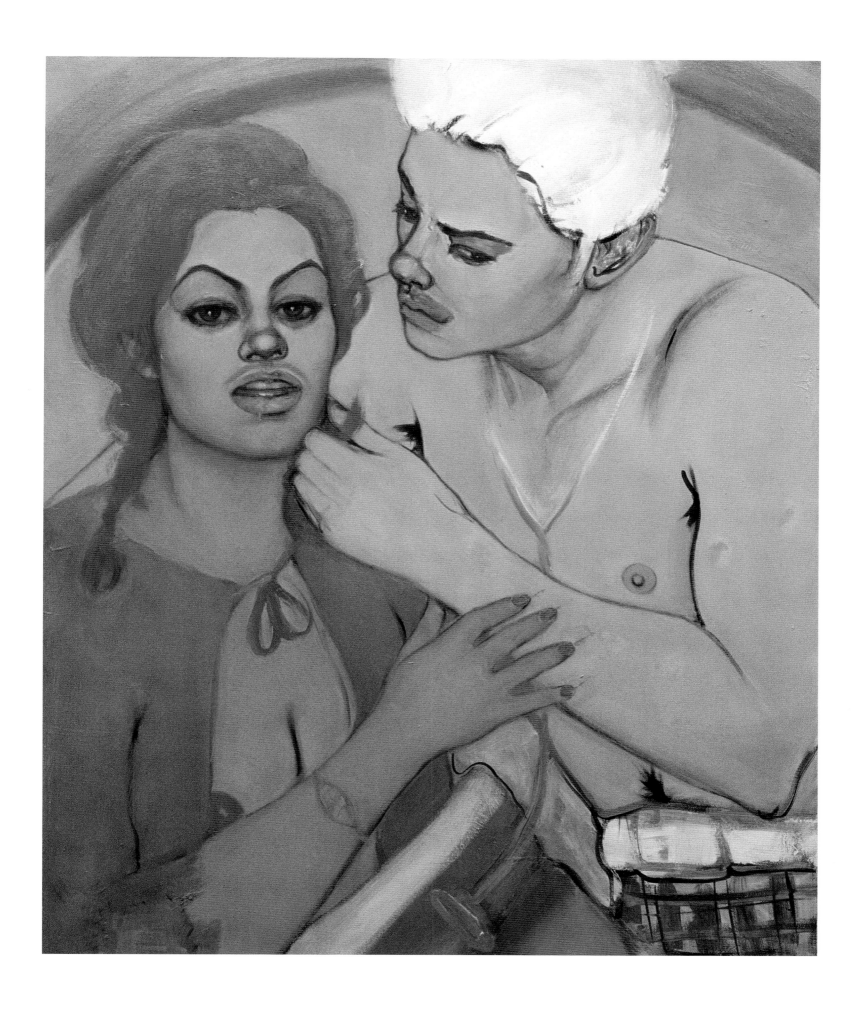

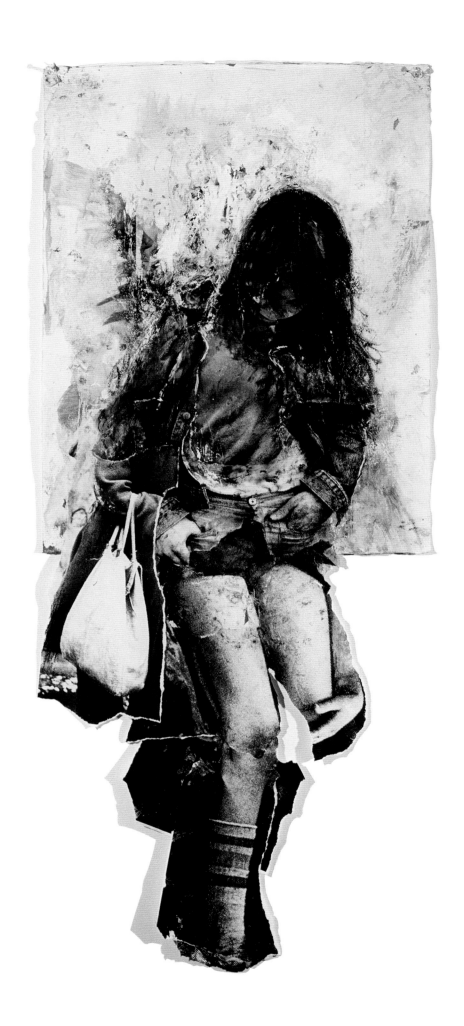

shorts, 2006, drawing, painting, collage, 50 × 30 inches / 127 × 76.2 cm

"I was taught that to add anything to a painting that wasn't paint was basically very wrong (gimmicky), not paint tradition worthy. After 'painting' for many years I got bored. I started to add 'things' into my pictures (what joy!). I rip, smudge, tear, scrape, draw, bleach, splatter, strip, drip, cut, scrub and sponge on a daily basis. My hands look like shit."

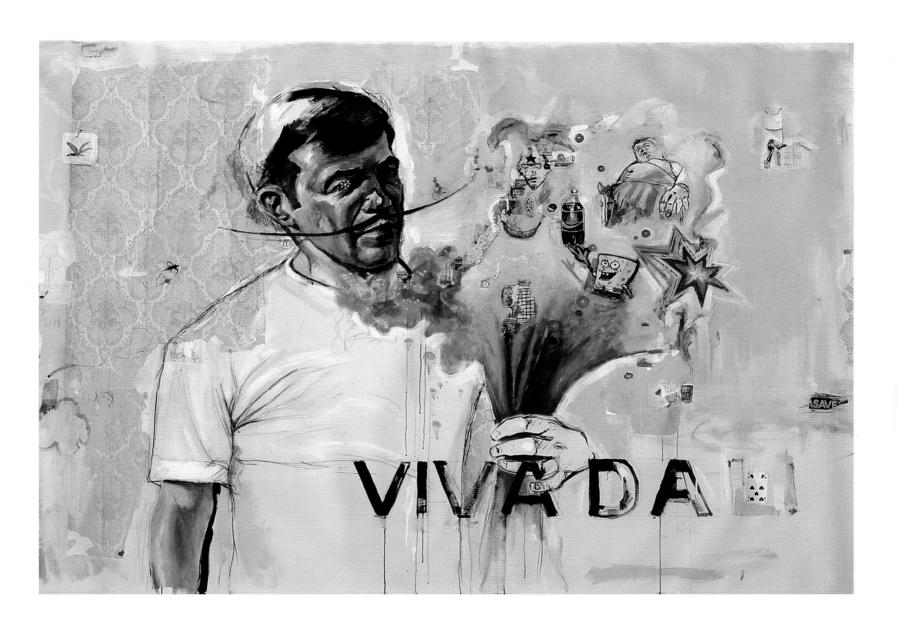

VIVA DALI (self-portrait), 2005, mixed media (oil, acrylic, pastel, pencil hb, collage) on canvas,
60 × 80 inches / 152.4 × 203.2 cm

"In my artwork, I try to push some traditional barriers related to painterly practice by using
and experimenting with new technologies such as photo, collage, film, television and digital
photography. Since moving to Canada in 1993 the focus of my work shifted to different cultural
references as I became fascinated with pop culture and consumerism."

153

Sympathy, 1997, MDF, latex paint, glaze, dimensions variable

Parade (series of 21 individual pieces), 2000, MDF, enamel paint, 60 × 3 × 0.5 inches /
152.4 × 7.6 × 1.27 cm each, in the permanent collection of the Albright-Knox Gallery

"My paintings develop from an inquiry into the human psyche through the investigation of primal
psychological drives, such as our ability to create beauty and the constant desire to destroy.
The emphasis on concealment and excessive ornamentation within the work mimics our veneer
of civility and refers to the paradox of good and evil inherent in all humans."

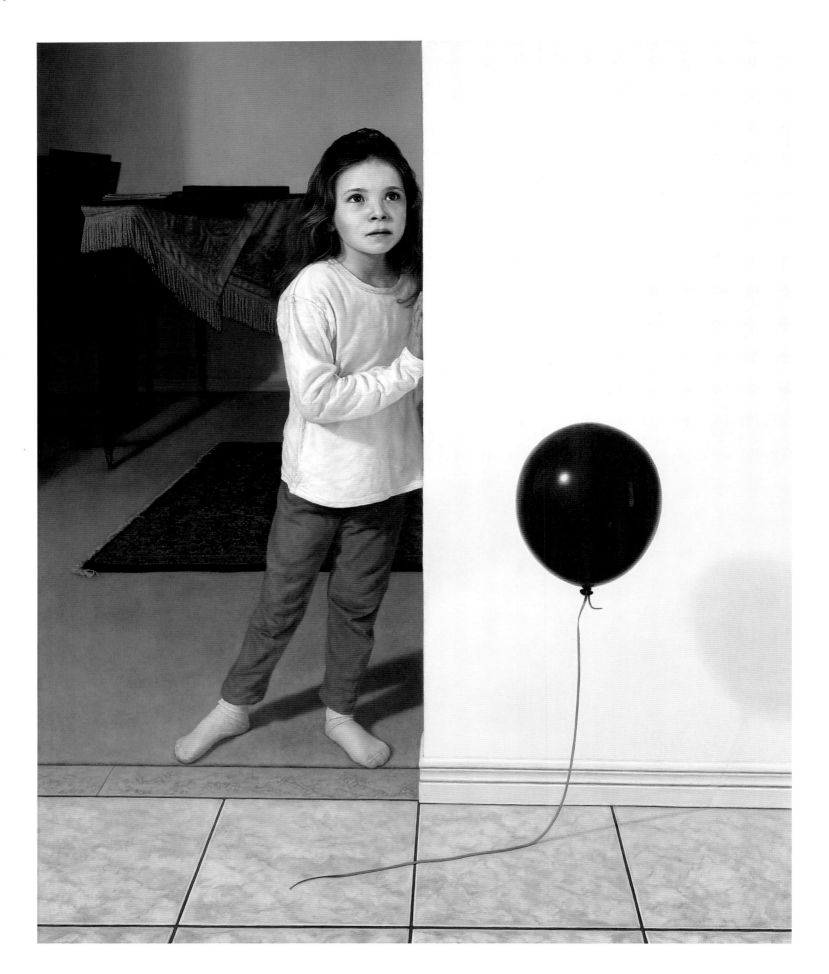

Girl with a Balloon, 2005, oil on panel, 35 × 28.25 inches / 88.9 × 71.8 cm

"It became obvious from early on that achieving the skills needed was only part of what had been
revealed in the great artworks that inspired me. It was the way in which the Masters of painting
applied their colours and constructed their works that I paid much of my attention to initially.
The ability to orchestrate the many variables of colour, tone and design into artworks was to
become my personal goal in painting."

Night Fountain XIII, 2007, acrylic on board, 36 × 26 inches / 91.4 × 66 cm

"Water is an ambiguous element constantly morphing into myriad forms both solid and transparent. I am interested in portraying water as a mirror-like object that can become the very object it reflects."

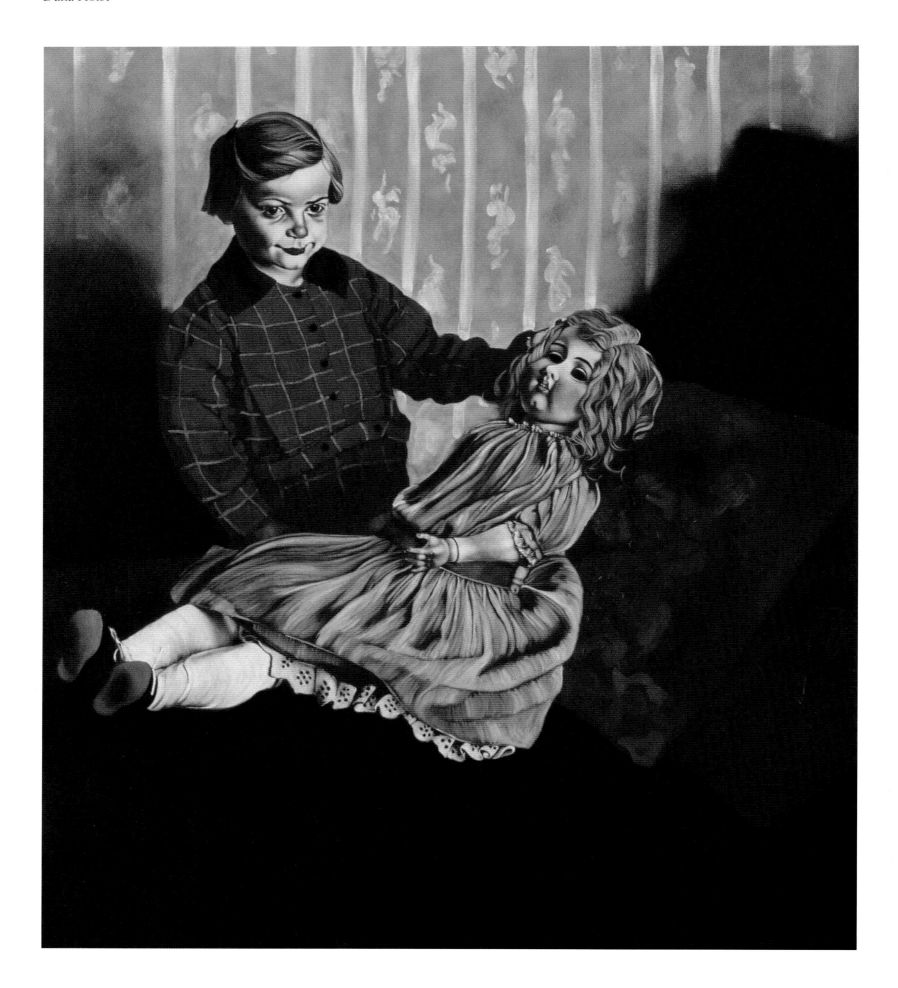

Sickbed, 2003, oil on canvas, 46 × 40 inches / 116.8 × 101.6 cm

"Dana Holst's exhibition entitled *Woebegone* is composed of two interrelated parts. The first is made up of 81 miniature oil paintings on Victorian ivory piano keys, which feature documented cases of animal abuse, and the second a group of seven large oil paintings and drawings, which depict the cyclical nature of human violence and domination."

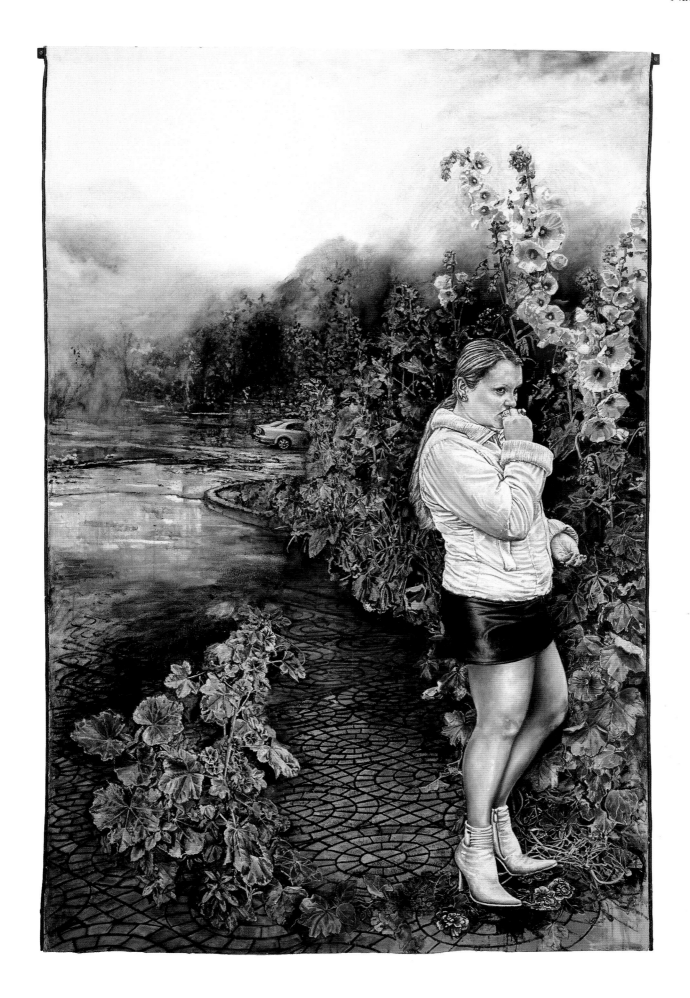

Seed Spitter, 2006–2008, oil on linen, 85 × 55 inches / 216 × 240 cm

"As a painter, I work like a theatre director, inventing archetypal personae which I then use in
my paintings. The resulting theatre of the poignantly real/absurd, stages the loss and adoption
of identities, historical memory and amnesia, and material acquisition and display."

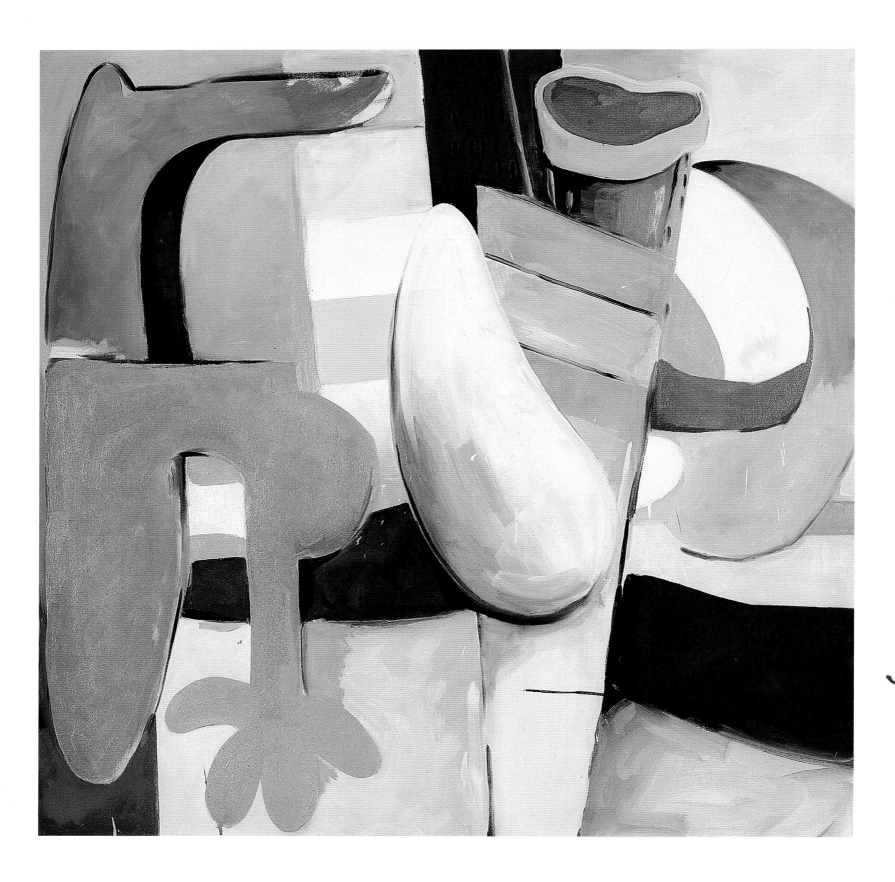

barbeque circuit, 2005, oil on canvas, 48 × 48 inches / 121.9 × 121.9 cm

cry, cry, cry, 2005, oil on canvas, 48 × 48 inches / 121.9 × 121.9 cm

"Drawn to the work of Samuel Beckett, both for its sense of humour and humanity, I keep returning to this excerpt from *The Unnamable*: '…I can't go on, I'll go on.' While I find this statement apt on a number of levels, I find it is particularly so with regard to the engagement of a current painting practice: the perfect response to repeated pronouncements of painting's exhaustion and demise."

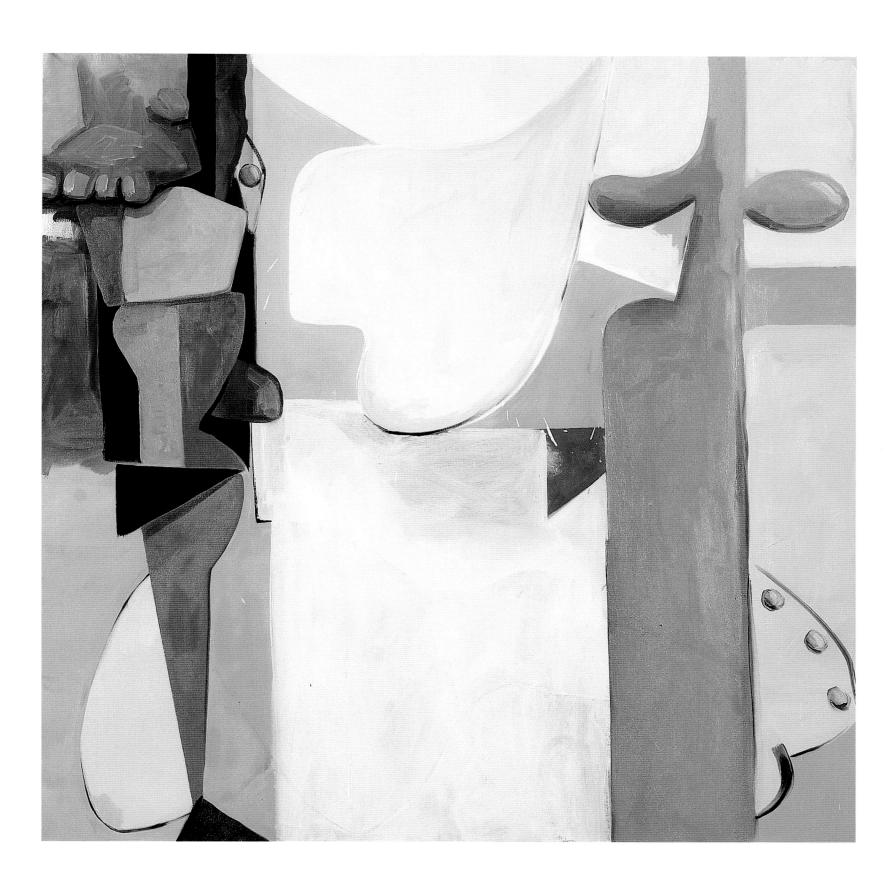

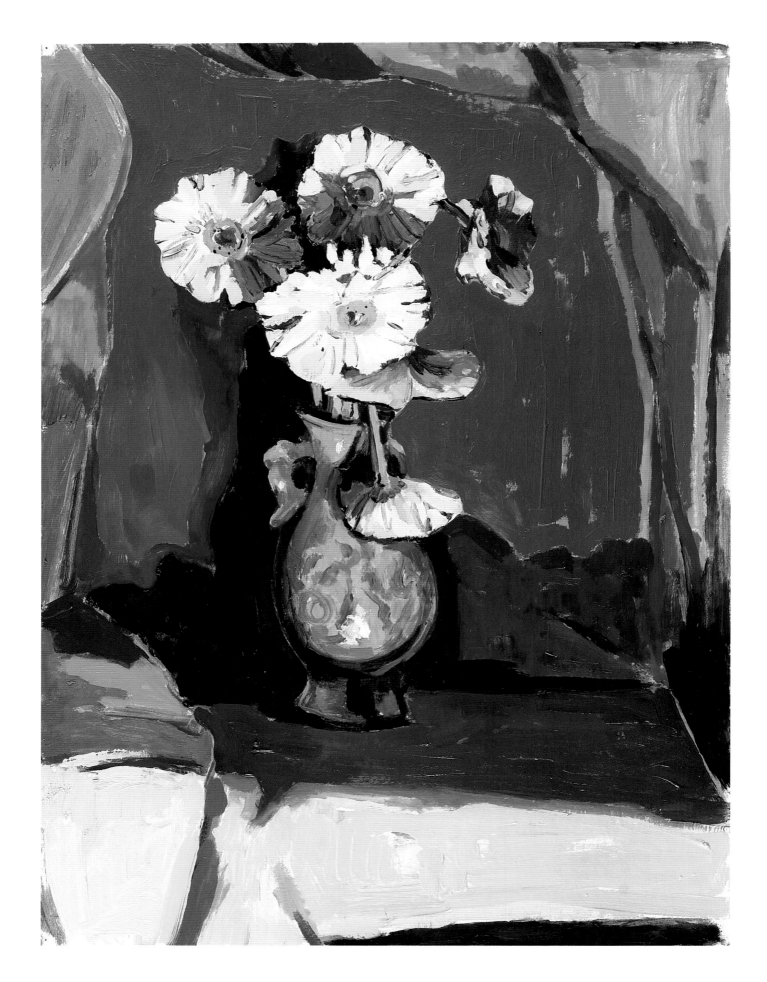

Untitled, 2008, oil on cardboard, 24 × 18 inches / 61 × 45.7 cm

"I basically did everything other than what an artist is supposed to do—think. Not thinking
turned out to be a great tool in making paintings again. In my process of making these
paintings, the intention was simply to make something interesting to look at, something that
honestly portrayed my subject, and something that engaged me in the moment of creating it,
so I wouldn't ruin it by conceptualizing it."

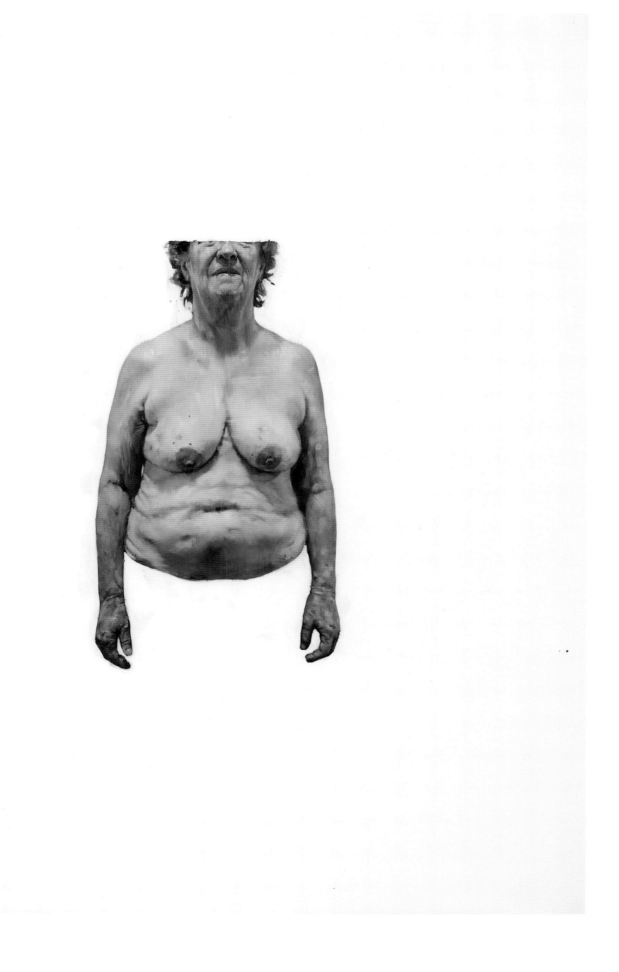

Regiment 29-09-06, 2006, oil on Mylar, 18 × 14 inches / 45.7 × 35.6 cm

"For many years now, my work has focused on the human figure. In 2003, I abandoned colour
and returned to black and white. I wanted to get away from the seductiveness of colour often
associated with painting and regain the immediacy of drawing."

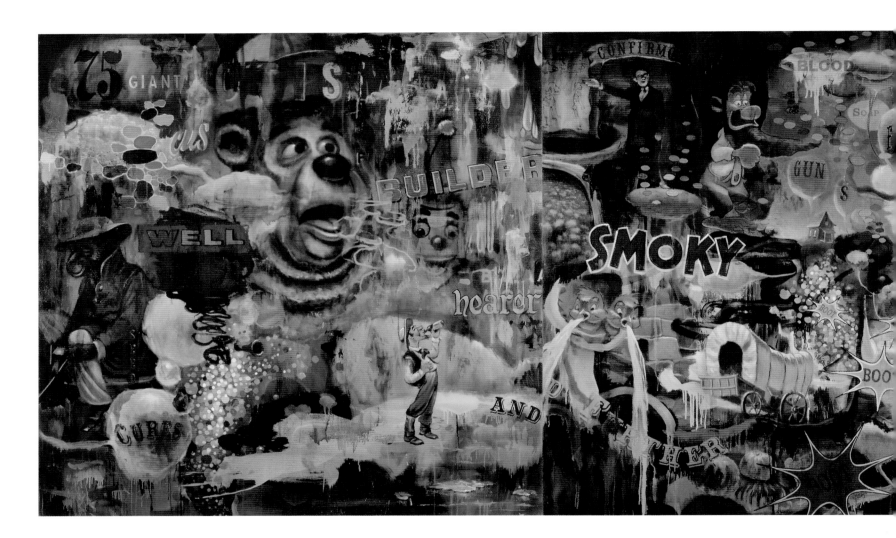

Shack of Deals, 2001, oil on canvas, 66 × 225 inches / 167.6 × 571.5 cm

"The language and images of 20th-century commercial culture guide and perform their way
through these canvases/screens, creating a river of shifting daydreams with secrets and hideouts
while the ubiquitous voice of the commercial barker is forever present."

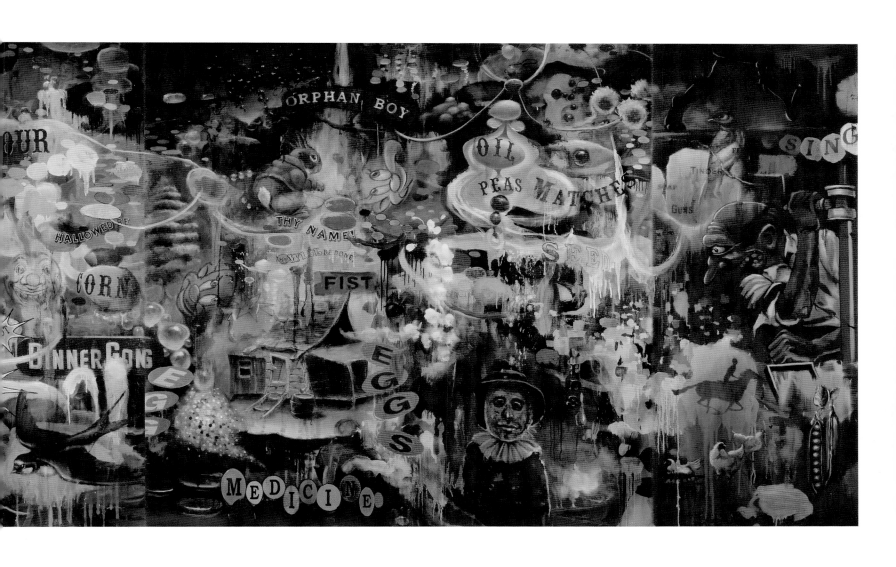

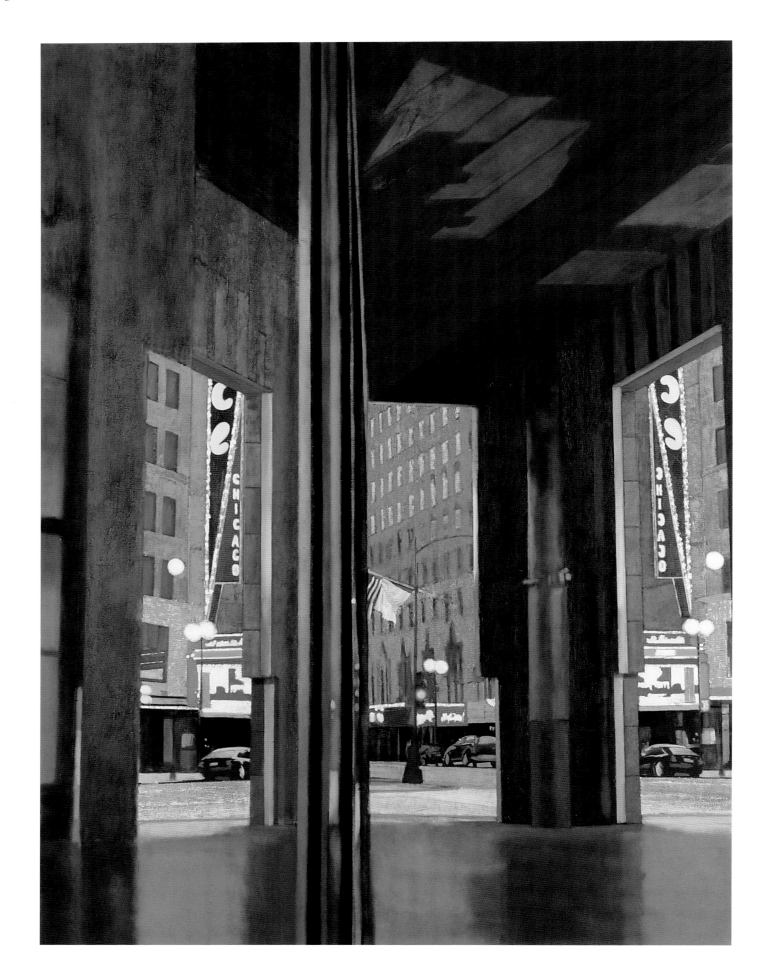

Double Cadillac Palace Theatre, 2007, oil on canvas, 106.5 × 84 inches / 270.5 × 213.4 cm

"Painting is a journey of discovery for me, and my point of departure is my immediate environment,
a social space that is saturated with a riot of imagery from the mundane to the extraordinary.
My process is a slow and reflective one that helps me give order to, and extract meaning from,
this chaotic world."

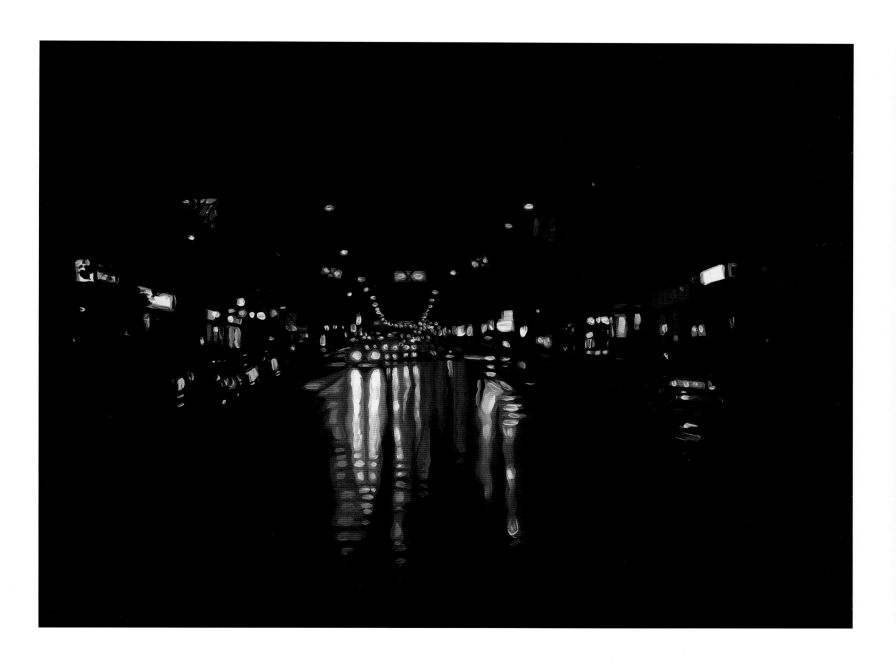

No place 124, 2005, oil on aluminum, 9.5 × 13 inches / 24.1 × 33 cm

"The places that interest me are where the edge of town used to be, but now are blurred,
 sprawling regions that show the ramifications of human over-population and destruction,
 places that are strewn with the detritus of unconsidered change and growth."

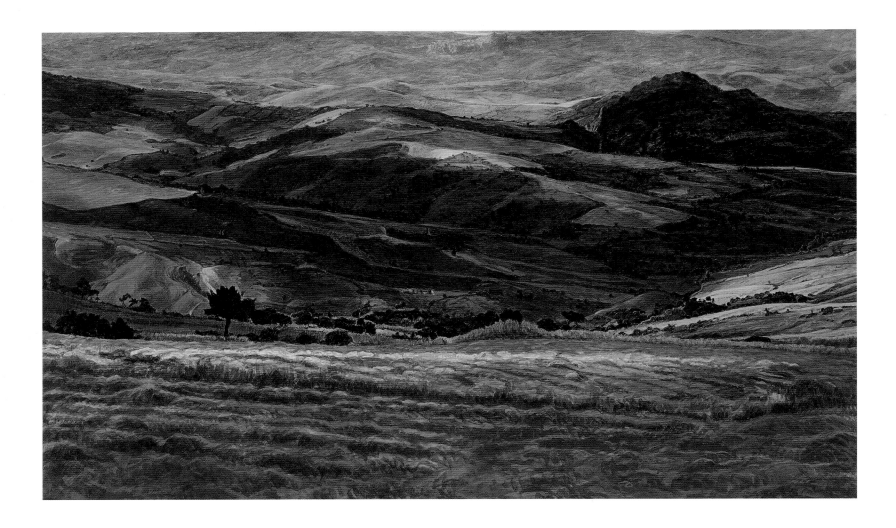

Vesperales #1, 2005, secco, 36.2 × 60.2 inches / 92 × 153 cm

"These works touch on historical, political, sociological and cultural concerns,
and could even be associated with a sort of meditative act."

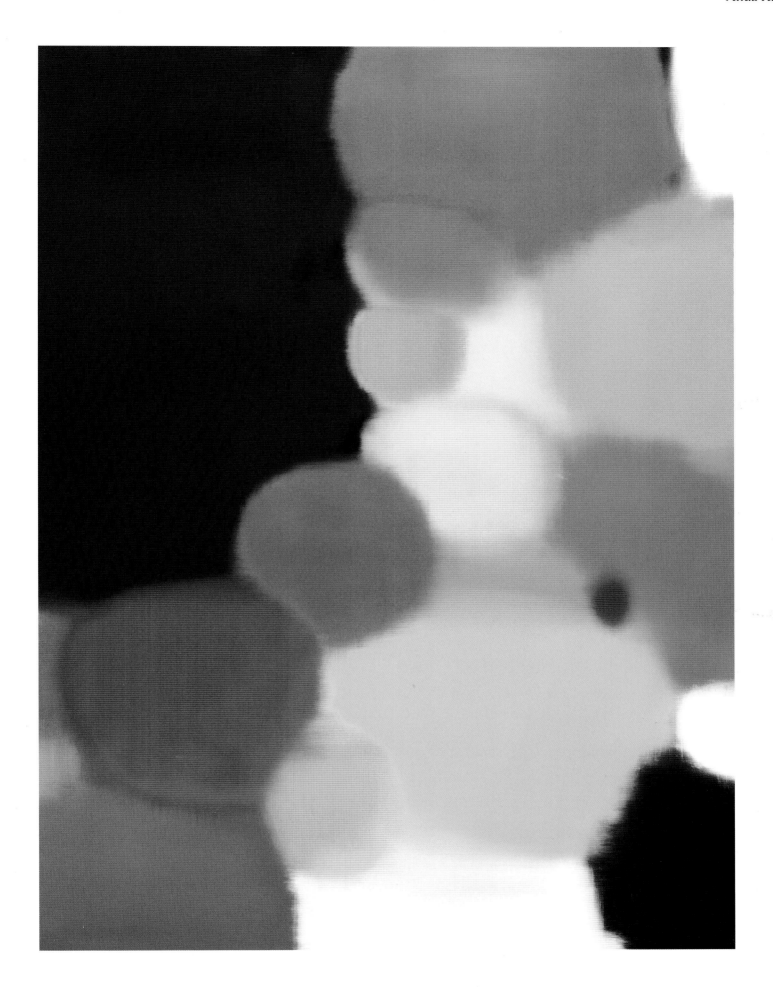

Teeter, Rise, 2006, oil on canvas, 72 × 48 inches / 183 × 122 cm

"The challenge as I see it, is to seek a resolution between painting's historic context and its
relevance today—specifically (in my case) as a means of 'explaining' the dominant drivers
of today's visual landscape: architecture, design, advertising and photography."

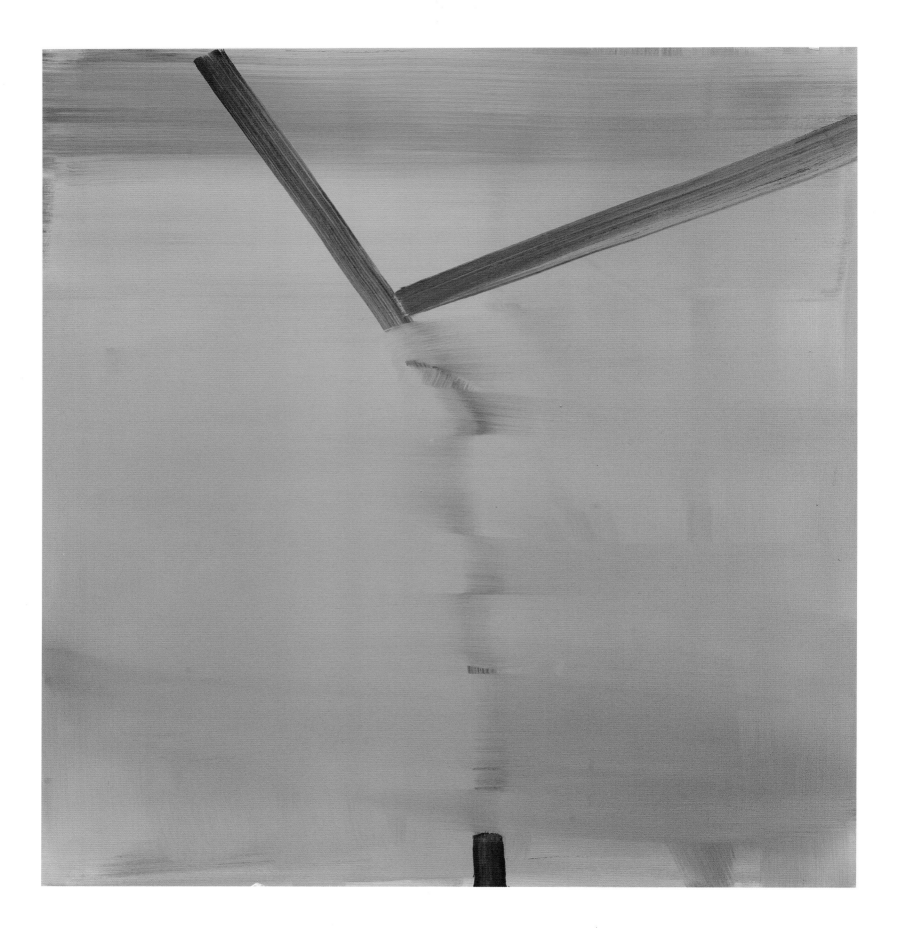

Another Realistic Painting, 2007, oil on canvas, 44 × 44 inches / 111.8 × 111.8 cm

"Mostly we don't have any idea why we feel a certain way at a certain moment and maybe this
is a prompt. Maybe we're prompted by the unseen microscopic particles of time's matters,
which are swirling around the globe and always exist forever in even their smallest property
in their tiniest elements, even as atoms. Even the flesh of pharaohs is swirling in the streets
of Los Angeles sometimes."

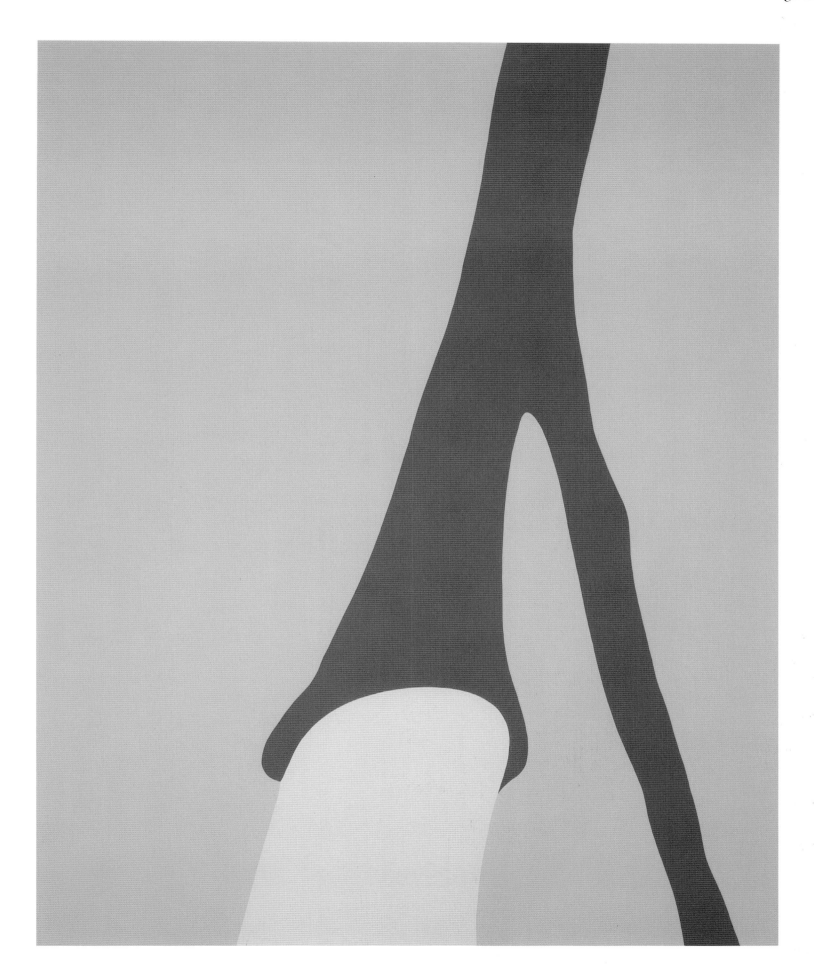

Stianes (37), 2007, enamel on wood, 60 × 48 inches / 152.4 × 121.9 cm

"The colours take on the compositional work of these pictures with a lucid and stylized
vocabulary, one close to the aesthetic of children's comics. A memory of the irresistible
attraction we all felt as children at the candy counter resurges: seductive colours, luminous
and contrasting; fantastic forms, subtle and fluid."

Angela Leach

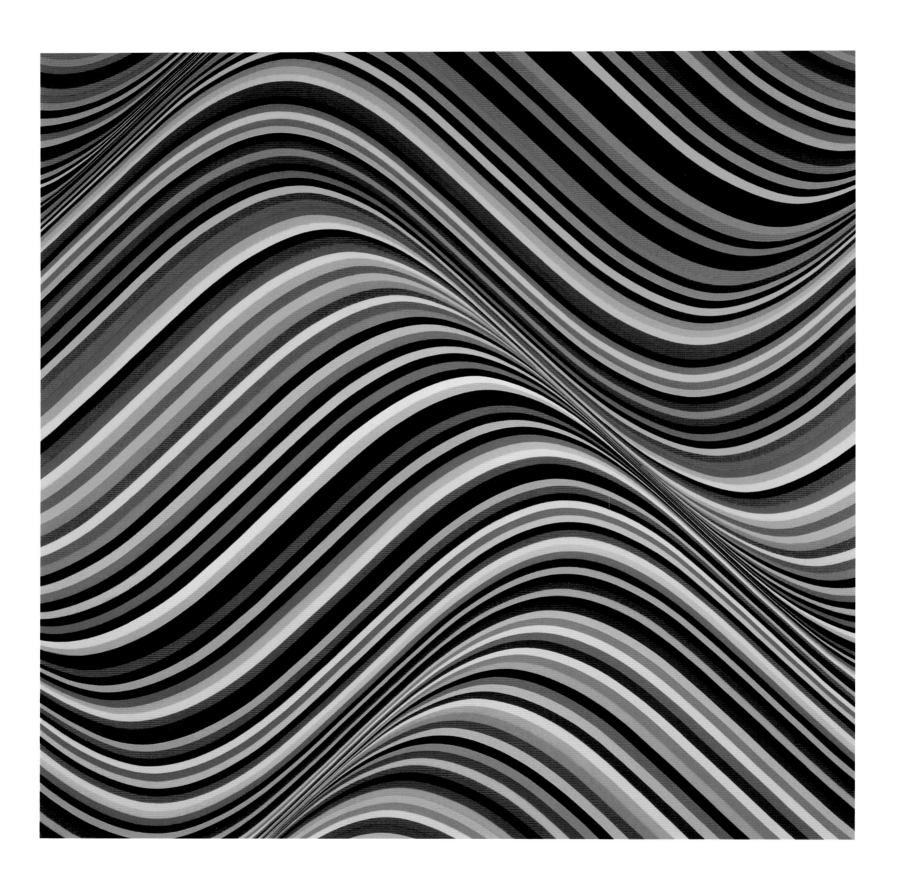

AR-Wave 87, 2006, acrylic on board, 24 × 24 inches / 61 × 61 cm

"To Angela Leach, the practice of painting is one that is limited to a series of rules and restrictions—
a process. The creativity is in the planning stages and is confined by instructions: line placement
measurements must adjust to scale of painting surface; colours, supplied by a set palette of 32,
consist in equal groupings of hot and cold, matched in range from light to dark; a cross-section
of curved lines and templates map out a grid specific to each work."

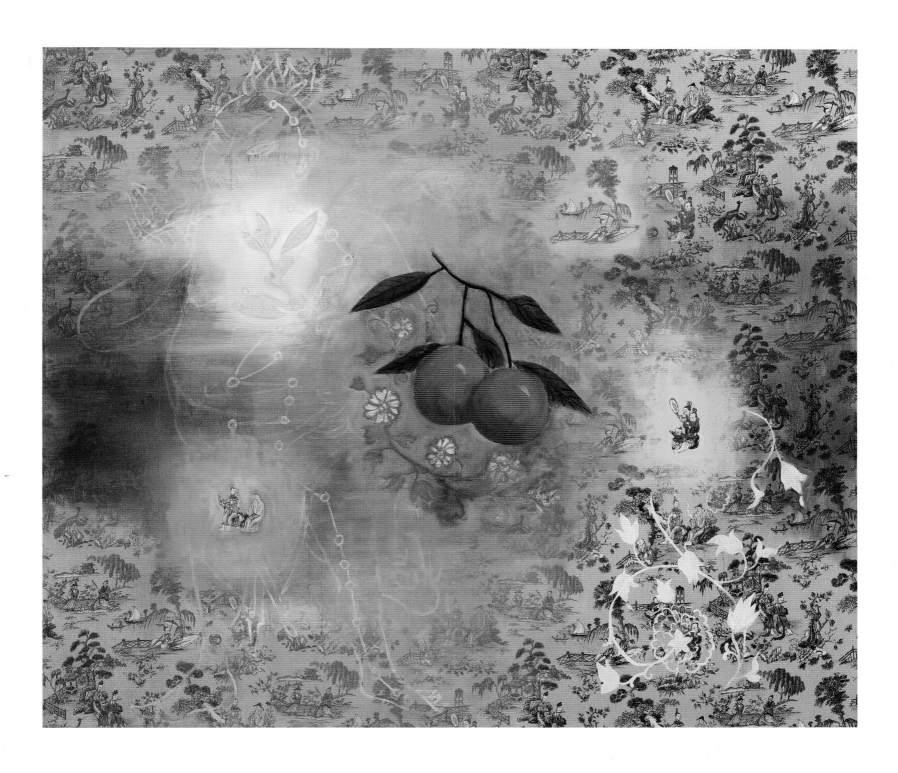

Citrus Sinesis, 2005, oil on cotton fabric printed with "Cantonese Gardens" pattern,
50 × 43 inches / 127 × 109.2 cm

"I like to mix up different systems of identification in response to the question, 'Who am I?'
The sources are from Eastern and Western medical and botanical illustration, biology, textiles,
all jumbled up to create undefined environments."

Howard Lonn

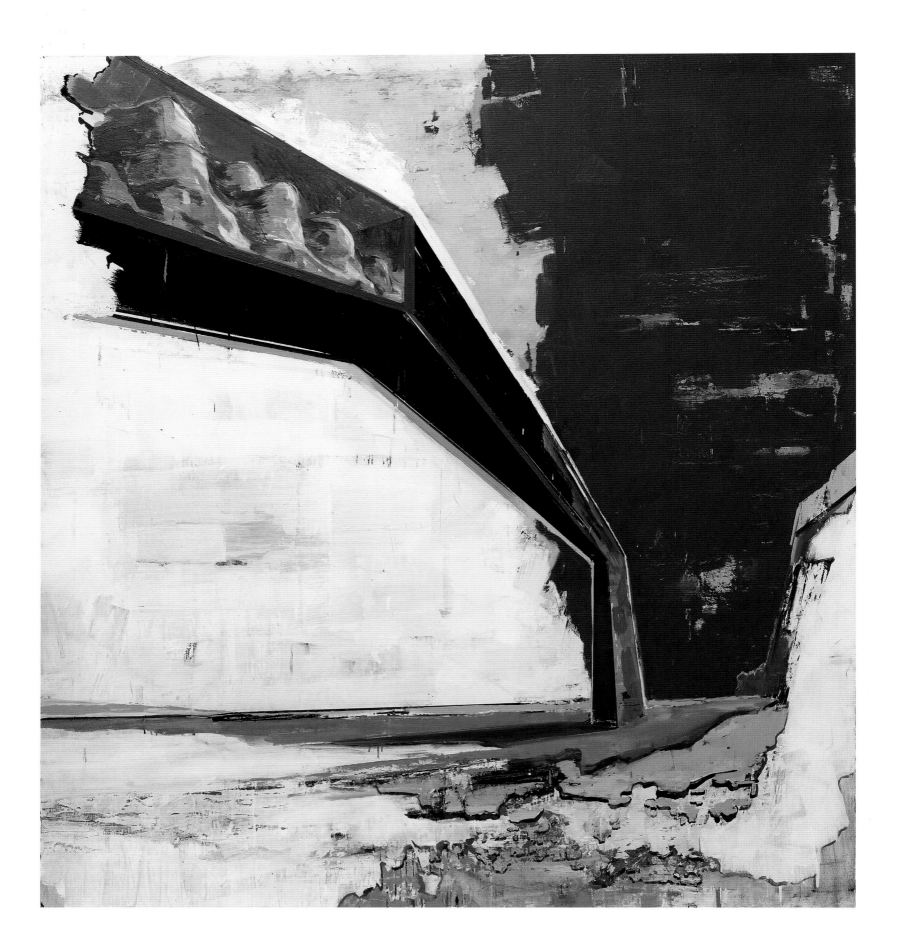

Proposal for a Public Monument, 2005, oil on canvas, 72 × 66 inches / 183 × 167.5 cm

"In recent years, my pictorial imagination has been excited by my looking at the built environment
in my immediate surroundings and the way it reflects the processes of culture, economy and
politics. My images emerge from a synthesis of fragmentary found images, perhaps memory of
a seen event, photographs I take and the inherent tactile, physical nature of painting. I do most
of my thinking about making art and images through my evolving painterly vernacular."

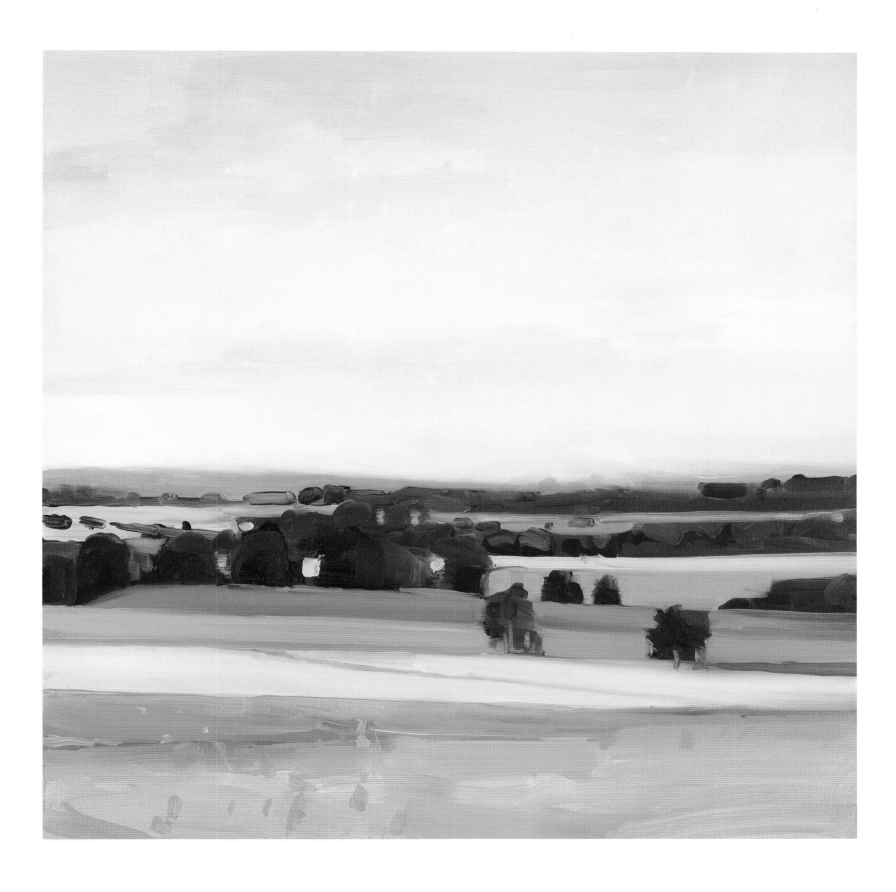

Fields (Summer), 2005, oil on canvas, 48 × 48 inches / 121.9 × 121.9 cm

"What I like to paint is less what specifically defines a particular place and more what makes
it feel familiar. I am pushing the work, simplifying it as far as I can. It is the feeling of space
that I am after and something that can resonate with the viewer—whether they have been there
or not."

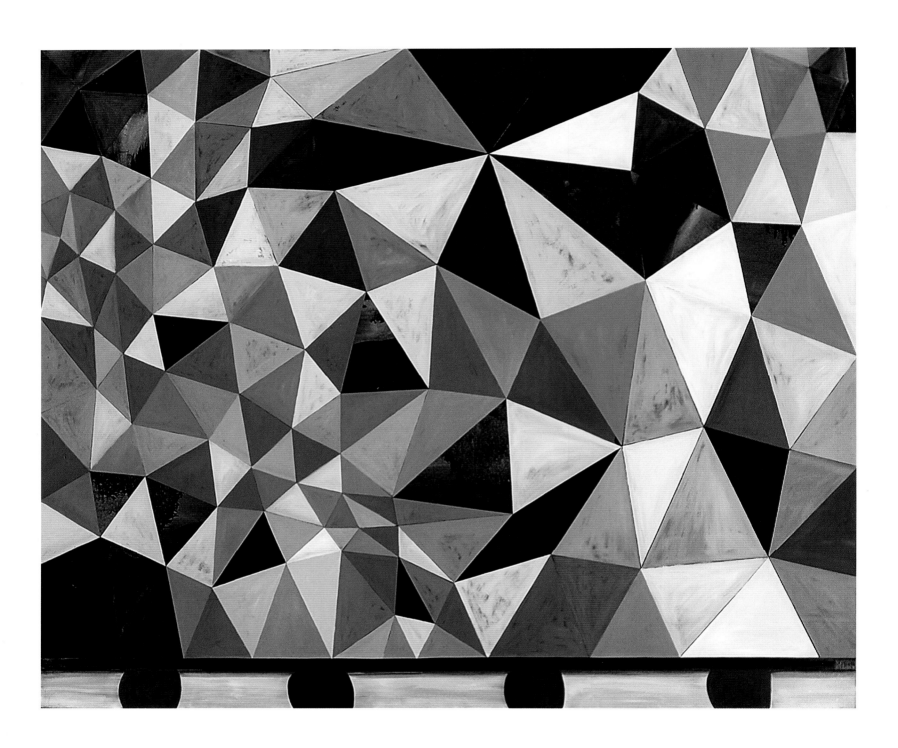

Untitled (Composition With Round Feet), 2006, oil on canvas, 75 × 90 inches / 190.5 × 228.6 cm

"My paintings are purposefully marred and compositionally awkward. In many, the triangles form a field where the geometric formations extend off the edges on three sides, but at the bottom there is a horizontal division. This division references the horizon in the genre of landscape painting, and also the naiveté of children's drawings where the bottom of the page represents the floor."

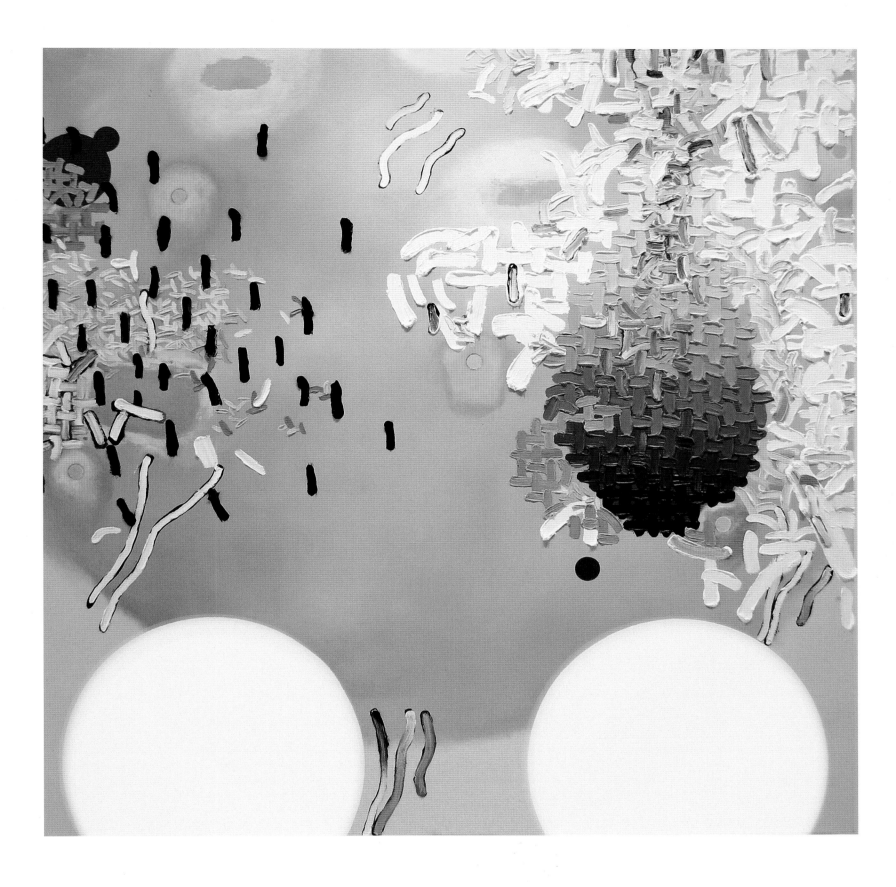

A Slow Dissolve, 2005, oil on canvas, 48 × 48 × 4 inches / 122 × 122 × 10 cm

"Though calculated in their placement and execution, the arrangement of recurring forms
 make little literal sense yet possess enough fleeting familiarity to engage the viewer in a game
 of deduction. Somewhere a narrative lurks."

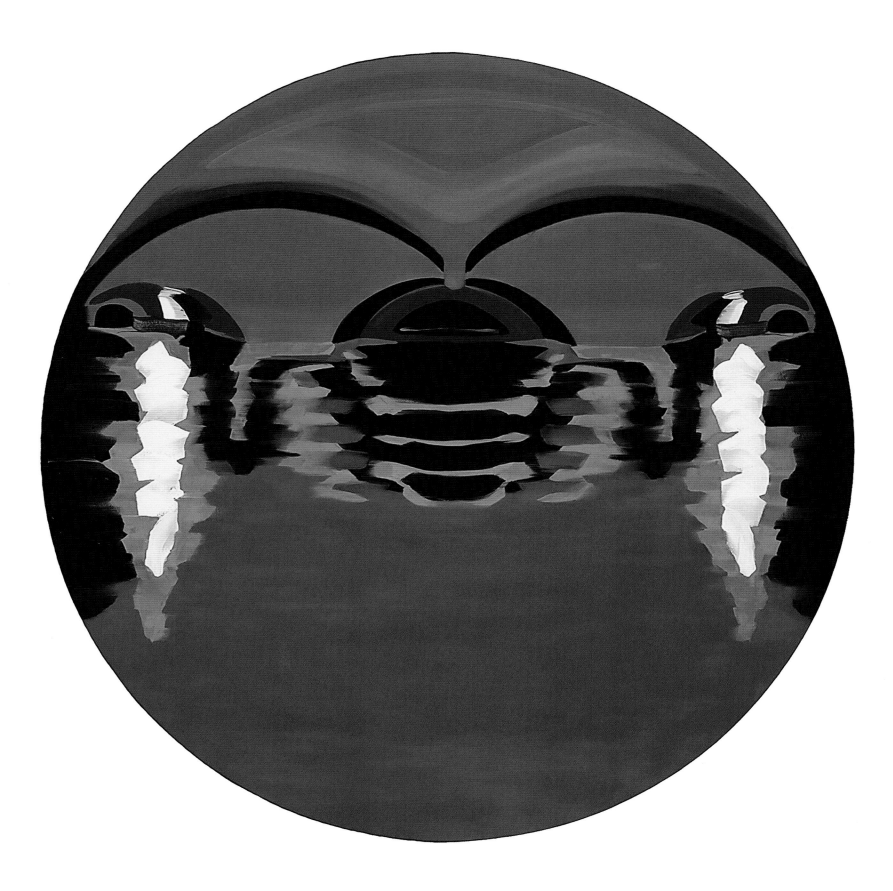

Guardian II, 2007, oil on canvas, 52 inches / 132.1 cm diameter

"Focused on imagery featuring underground mine shafts and cave systems, this work seeks to
present landscape as an internal, intimate location, rather than one viewed at a distance.
Through a process of repeating, mirroring and warping underground imagery, this series of
circular shaped paintings plays with the notion of landscape, while a suggested faciality engages
a fictionalized and personified concept of the earth."

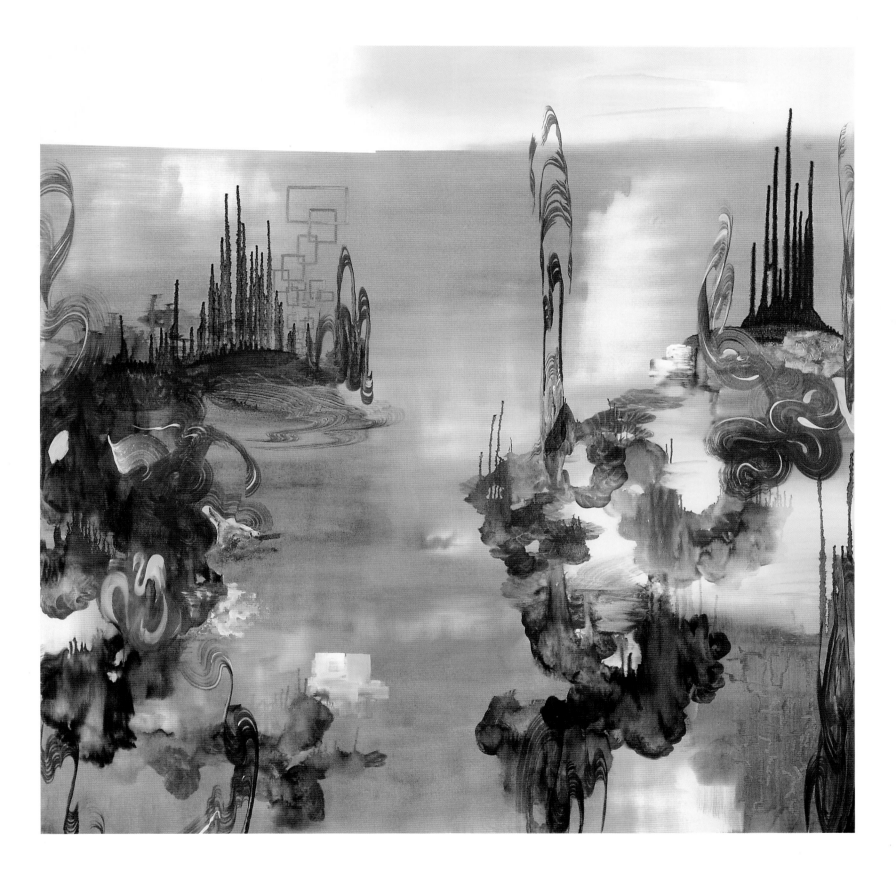

Tou5, 2007, oil on canvas, 60 × 60 inches / 152.4 × 152.4 cm

"From botanical plants to immaterial forms such as clouds, my painting process provided
the means for technical experimentation that has progressed onward to include abstraction.
My paint application shifts between deliberate action and serendipity."

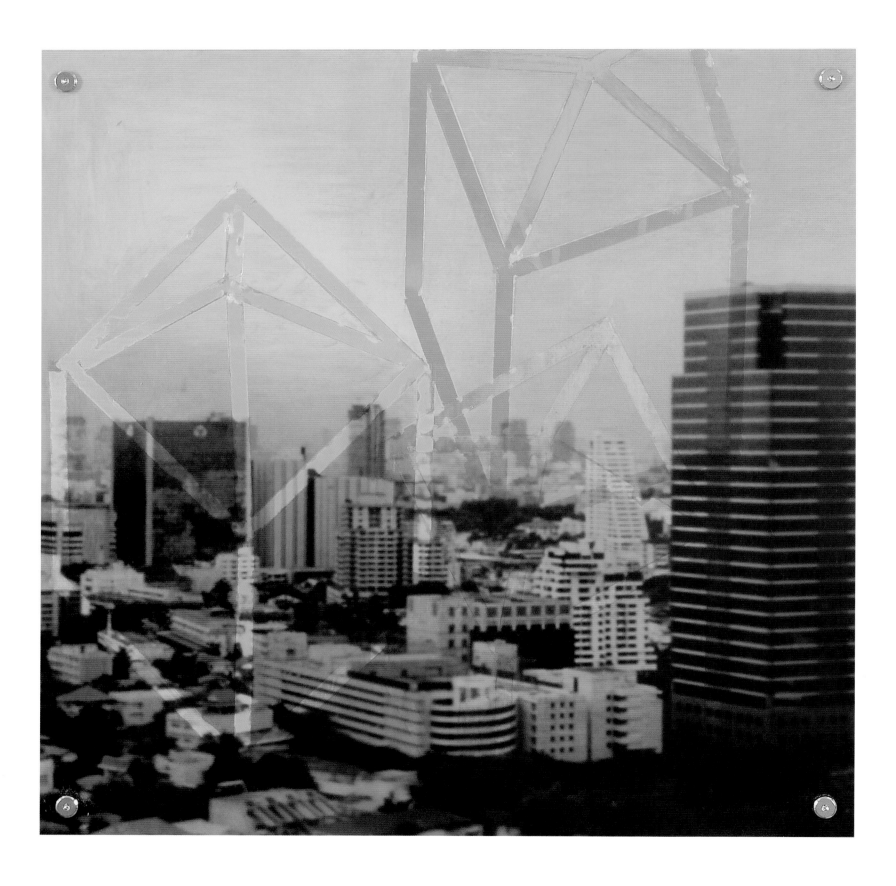

Désir #11, 2006, oil on masonite and digital print on Plexiglas, 24 × 24 inches / 61 × 61 cm

Désir #4, 2006, oil on masonite and digital print on Plexiglas, 24 × 24 inches / 61 × 61 cm

"Photographic images used in my work are fragments from a personal history and represent
a collection of memory and memorabilia. The work attempts to question how these
histories and images live in our conscious and unconscious memories, and affect our ways
of seeing and perception of reality."

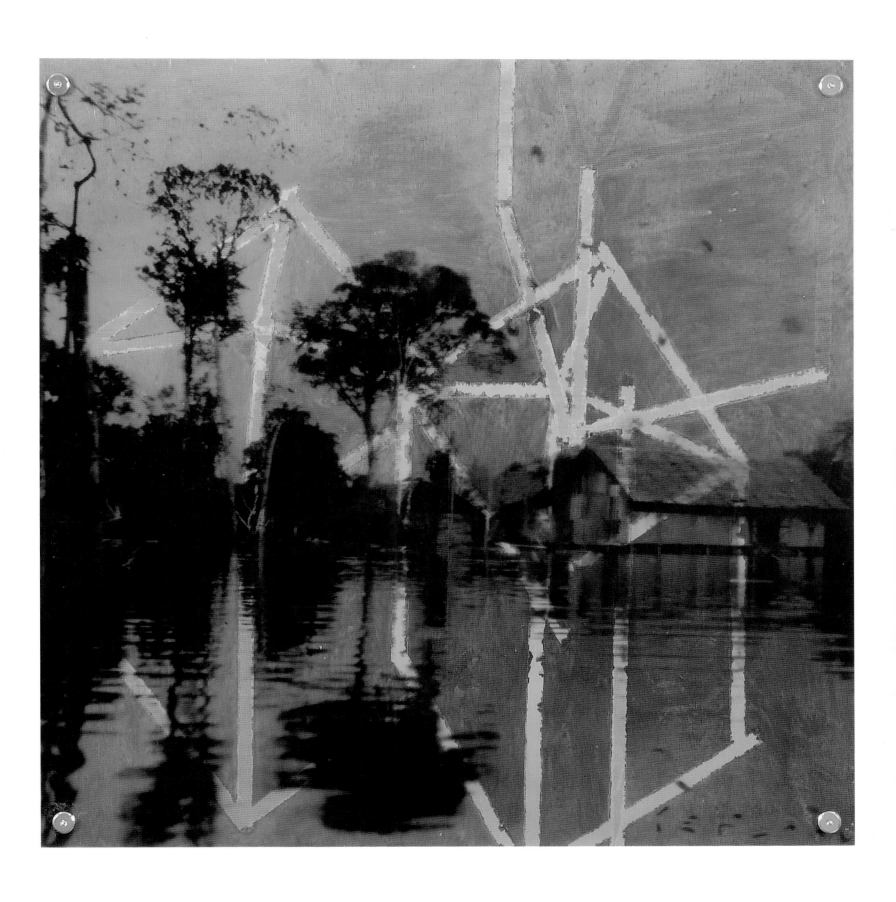

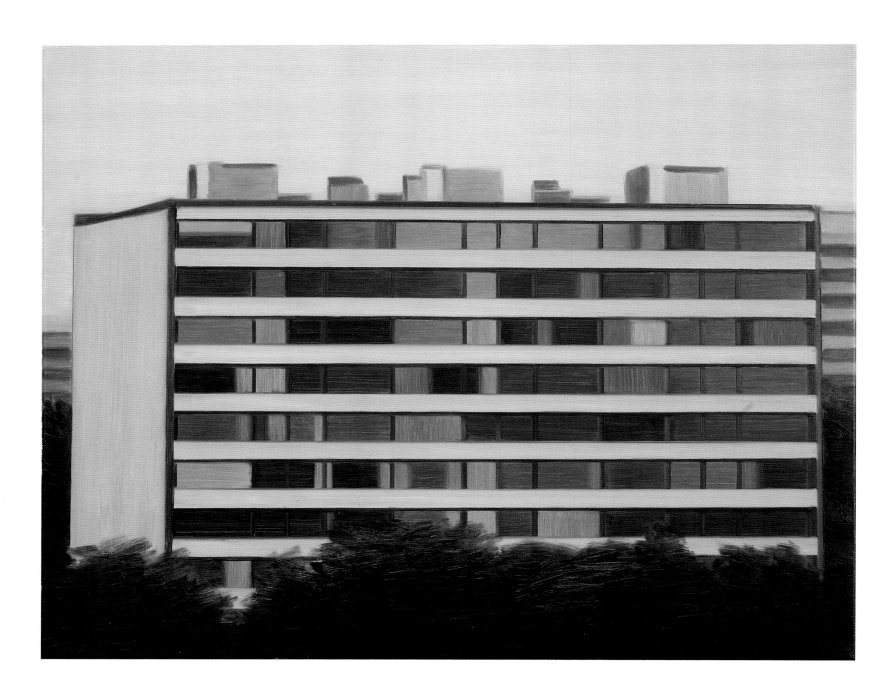

Apartment Building, 2007, oil on canvas, 22 × 28 inches / 55.9 × 71.1 cm

Birds, 2006, oil on canvas, 30 × 40 inches / 76.2 × 101.6 cm

"My painterly methodology is informed by reduction and restraint—colour is muted, contrast heightened, and all figures and extraneous details removed. Through this, the image becomes so generalized and vacant that it functions like a blank yet luminous screen, inviting the viewer to enter the space through psychological and narrative projection."

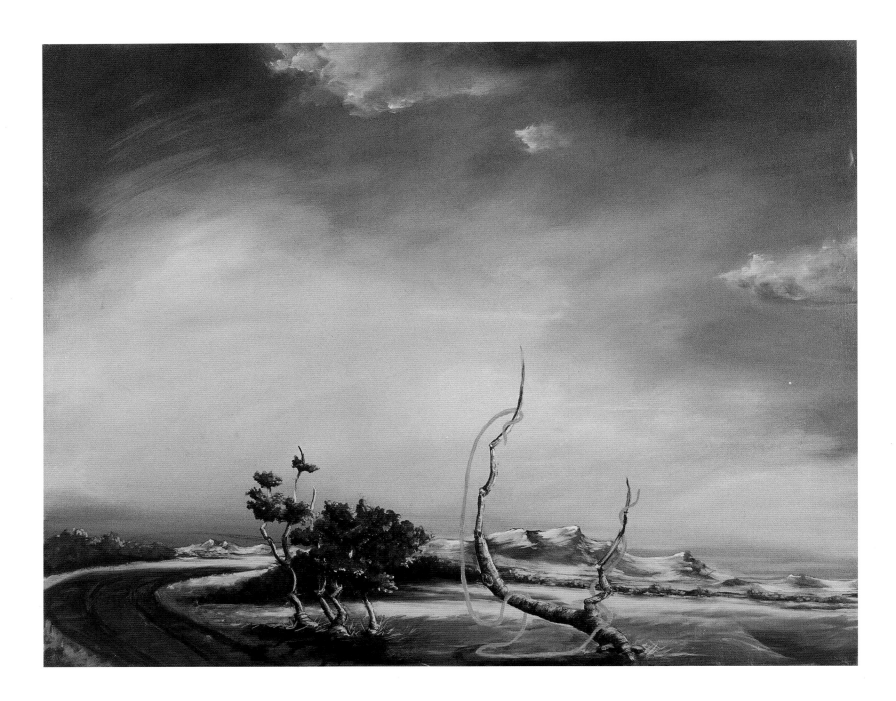

Mountain Road, 2005, oil on canvas, 24 × 28 inches / 61 × 71.1 cm

Island in San Sousi, 2004, oil on canvas, 18 × 24 inches / 45.7 × 61 cm

"The shapes of the structures in these works are determined by the characteristics of the landscapes
and their atmospheric conditions. It is the interaction between the structure and the landscape
that encourages the viewer to question their own perception and involvement within the space,
while extending the spatial experience of the painting."

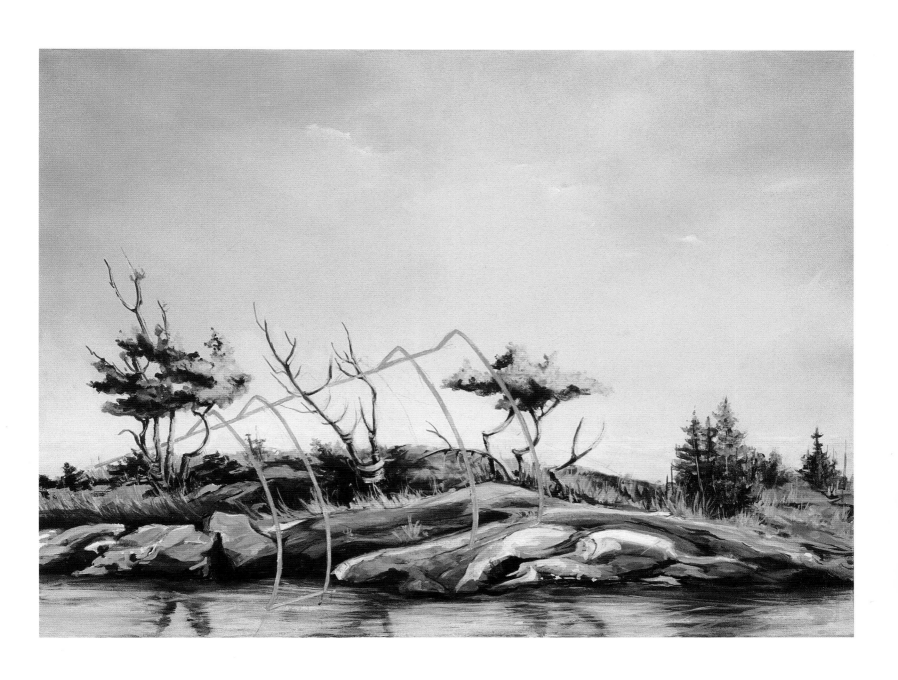

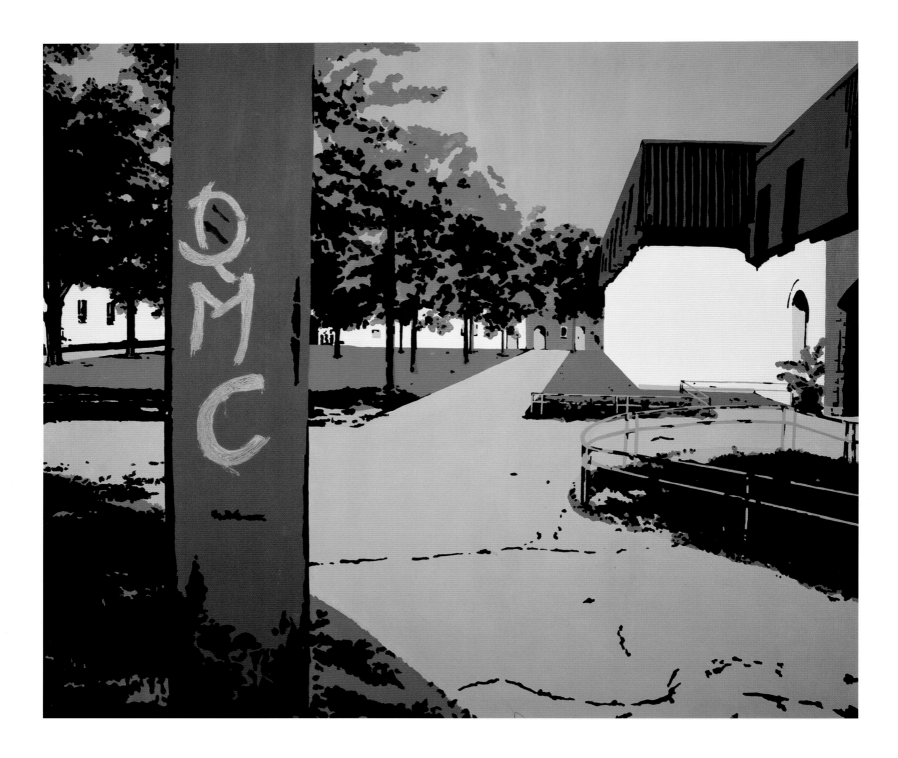

DMC, from the series *Tagging Don Mount*, 2004, acrylic and oil on canvas,
72 × 84 inches / 182.9 × 213.4 cm

Coming Soon—Homes for the Rich!, 2003, acrylic and oil on canvas,
72 × 72 inches / 182.9 × 182.9 cm

"Pascal Paquette is a social documentarian whose work focuses on the transformation
of culture that occurs when two or more economic, social or cultural realities collide."

Catherine Perehudoff

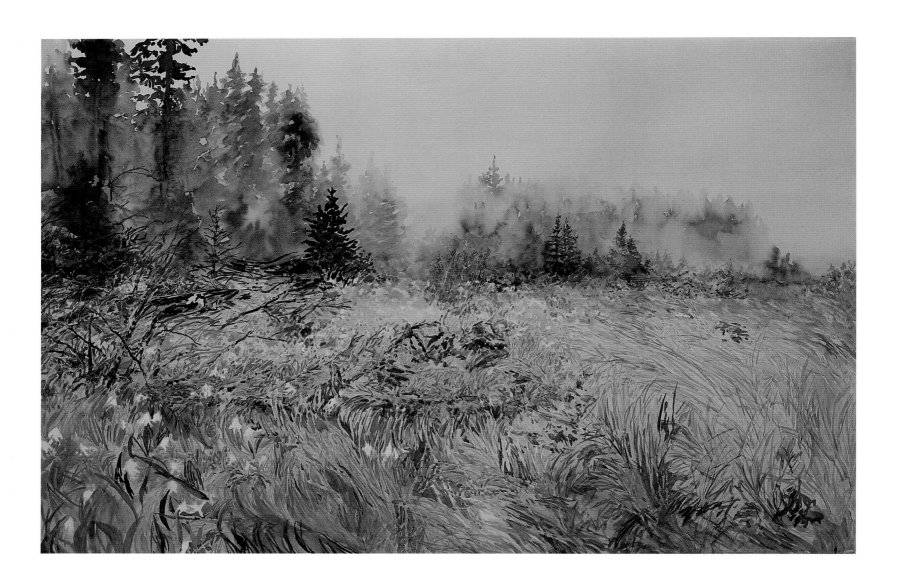

Trees in the Mist, 2006, acrylic on canvas, 40 × 60 inches / 101.6 × 152.4 cm

"Avoiding a predetermined methodology or predictable techniques, I prefer
to respond naturally to the subject matter. The transparency of colour reveals
each brush stroke and maintains the surface freshness. Using landscape as
my metier and nature as inspiration, I want to create monumental scenes out
of unified marks and dashes of luminous colour."

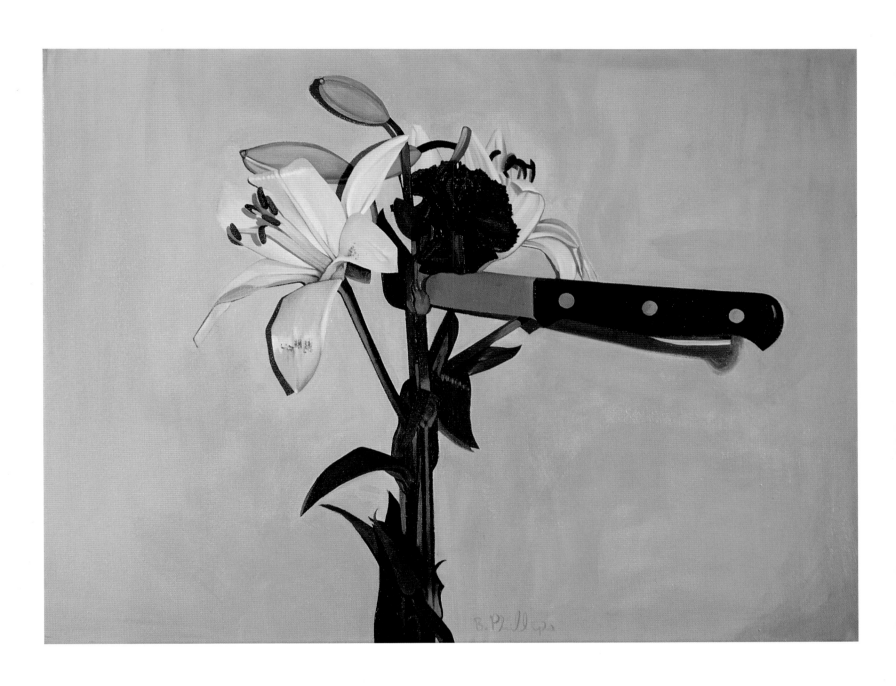

Still Life with Hard Feelings, 2006, oil on canvas, 18 × 24 inches / 45.7 × 61 cm,
collection of Hauser & Wirth, Zurich

"I believe in the power of intuition. As a result, my work is largely biographical
and personal. I would liken my work more to confessionalist poetry than any
trope of conceptualist concerns in painting."

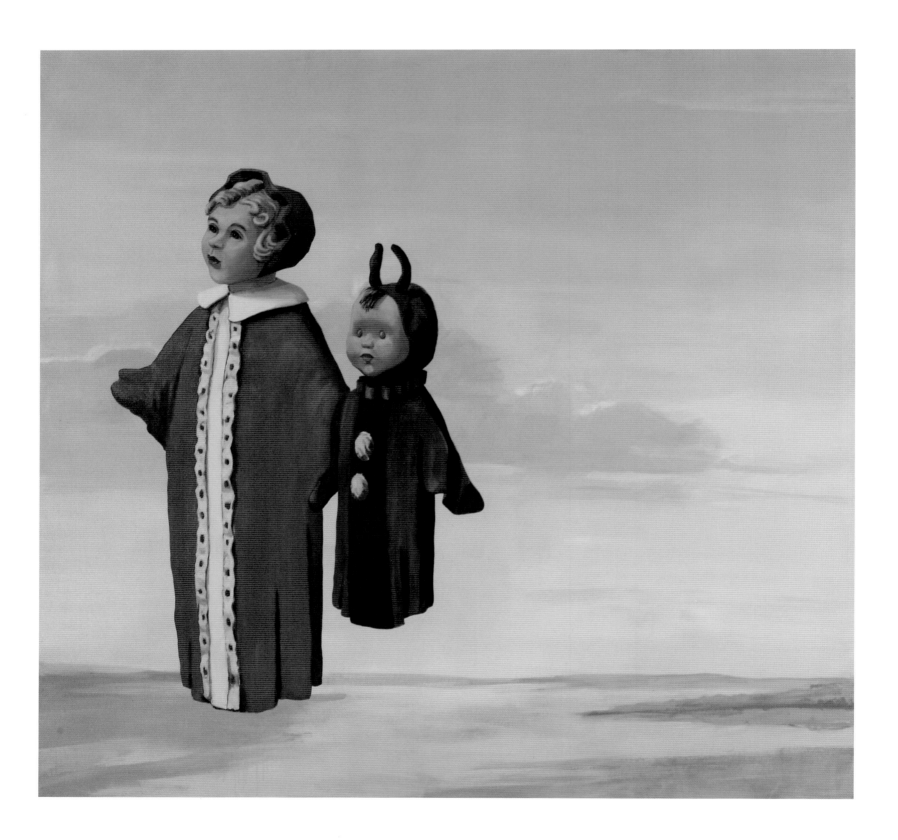

In the Sweet By and By (A Panorama), panel 7, 2005, oil and acrylic on canvas,
80.1 × 84.1 inches / 203.5 × 213.5 cm

"The techniques and subjects I am currently involved with draw upon my experiences as a visual
and scenic artist, in particular, still-life painting and scenic painting for opera. My aim was
to present a painted image in a way that asks one to view the subject unfolding in a sequential
fashion much like how one experiences a theatrical performance."

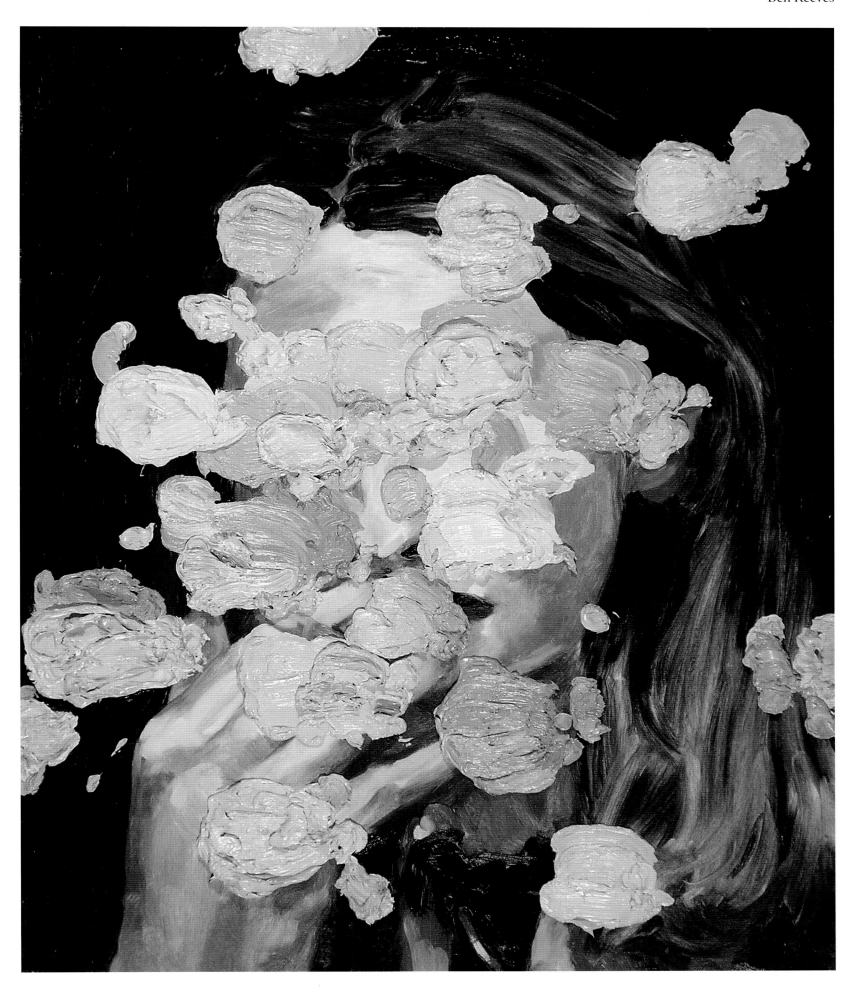

Smoker 3 (Girl), 2007, oil on linen, 36 × 30 inches / 91.4 × 76.2 cm

"In my pictures of snow, falling petals and smoke, I am interested in transitory moments where
 the commonplace becomes hallucinatory."

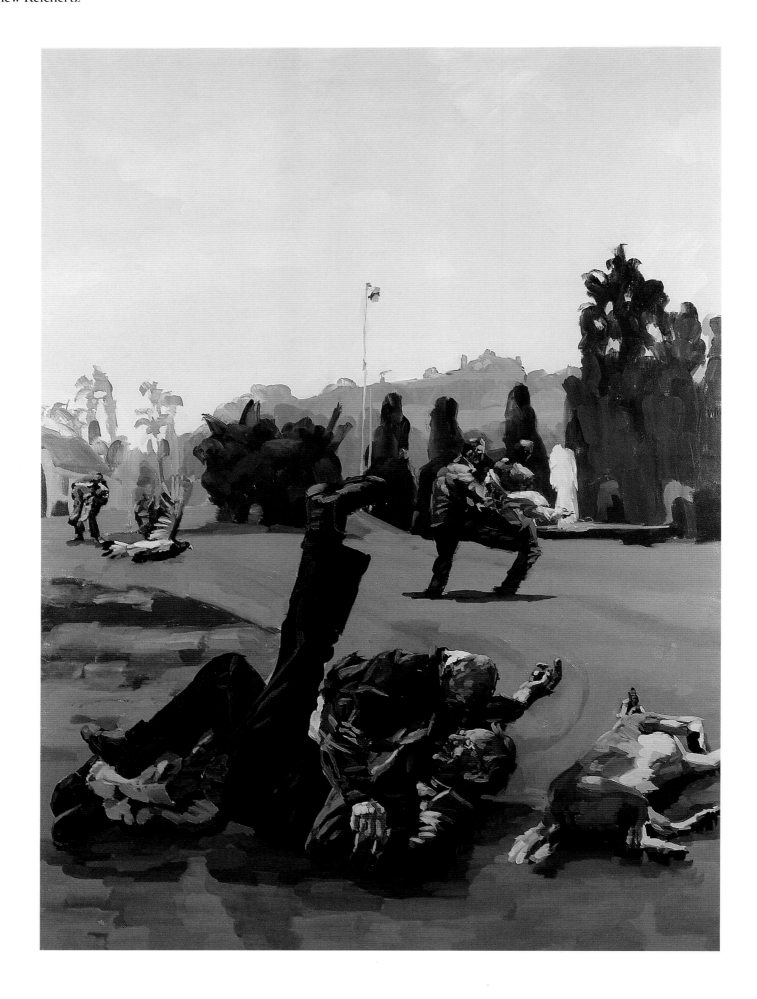

The Fight, 2 of 7, 2007, oil on canvas, 87 × 67 inches / 221 × 170.2 cm

The Fight, 4 of 7, 2007, oil on canvas, 87 × 67 inches / 221 × 170.2 cm

"The recognizable landmarks in the work situate the fictional violence in a city that has been ravaged by swarmings and muggings in the last several years. What became apparent to me as the paintings developed was how choreographed and therefore aestheticized fictionalized violence is when set beside a real experience of violence."

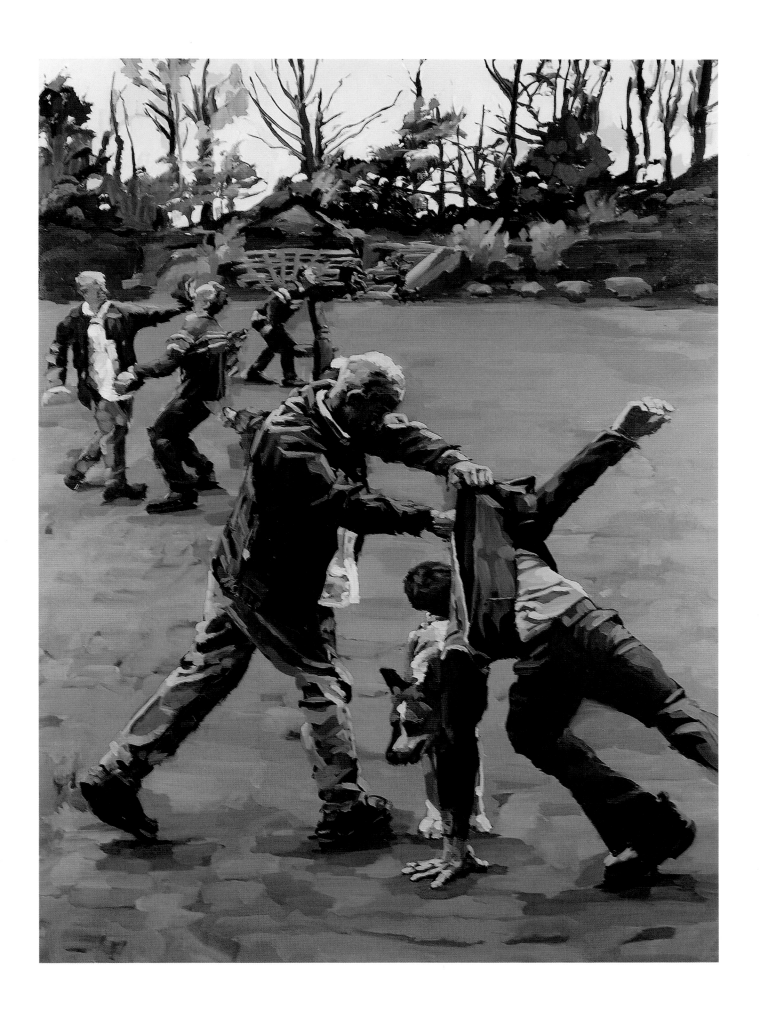

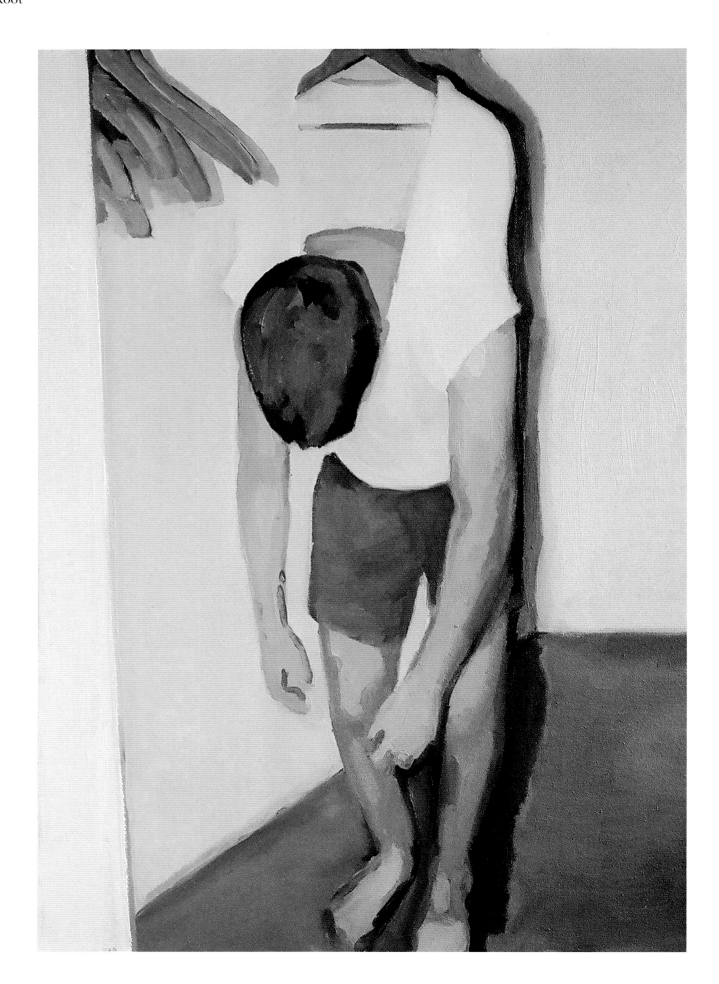

Hangers, 2007, oil on canvas, 34 × 28 inches / 86.4 × 71.1 cm

"Creating the impression of the hidden or of a shrouded cartography beyond the painting
is a tendency that repeats throughout my work. In this way, the image is a fragment of a stalled
drama where the viewer is invited to consider what might be suppressed outside the frame."

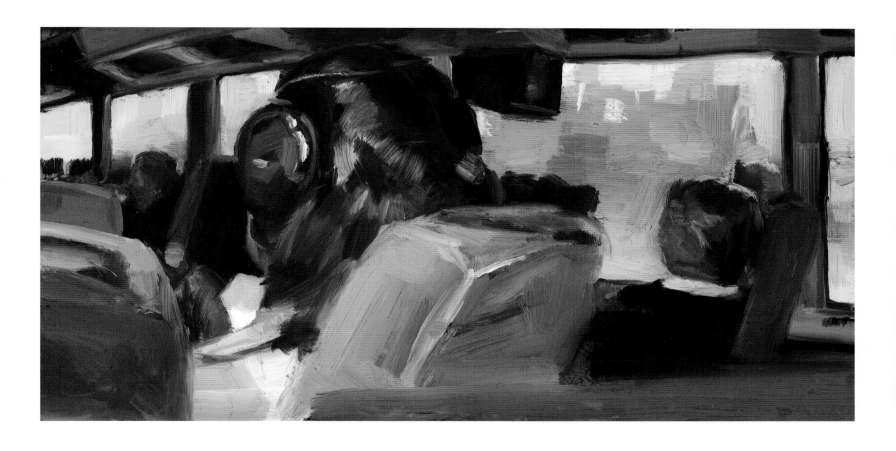

Untitled (Bus Passenger), 2006, oil on Mylar on wood, 4 × 8 inches / 10.2 × 20.3 cm

"The project is a focus on the background clutter of our subconscious and how our subconscious
draws connections with and informs our everyday conscious thought. Almost everything is a
representation and a remembering of the thoughts and images our subconscious refuses to forget."

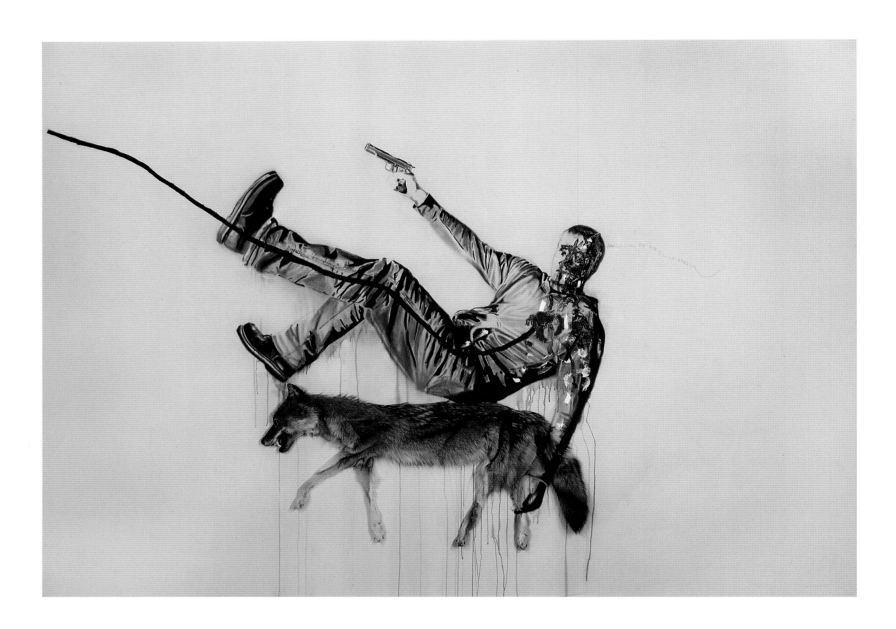

I Love America and America Loves Me, 2007, multimedia (oil on canvas, coyote),
84 × 120 inches / 213.5 × 305 cm

Void 2, 2006, oil on canvas, 108 × 160 inches / 274.3 × 406.4 cm

"I am interested in exploring a number of contemporary urban issues in my work:
the dominance of surveillance; youth culture; mass media and the politics of representation;
police brutality; tragedy and voyeurism; and commodity and consumerism."

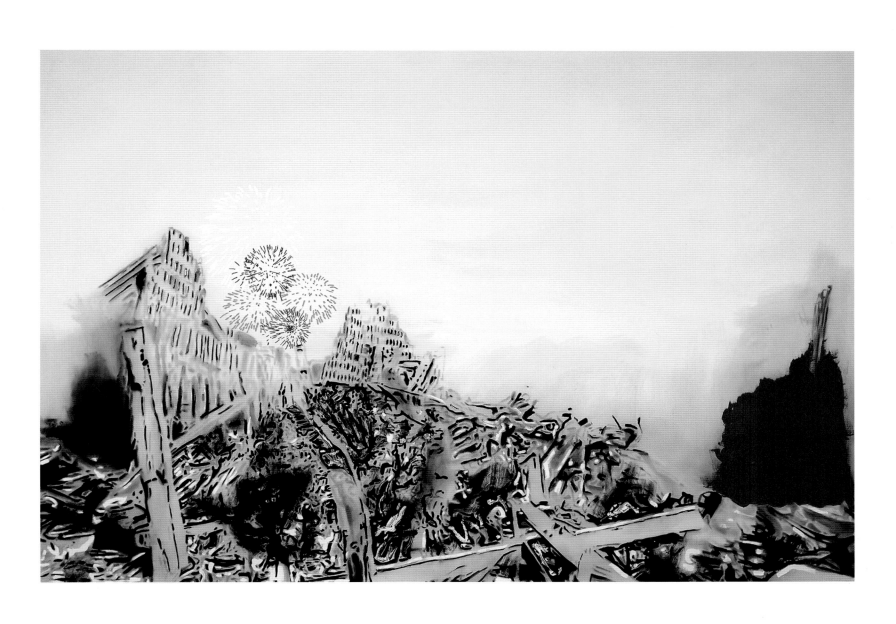

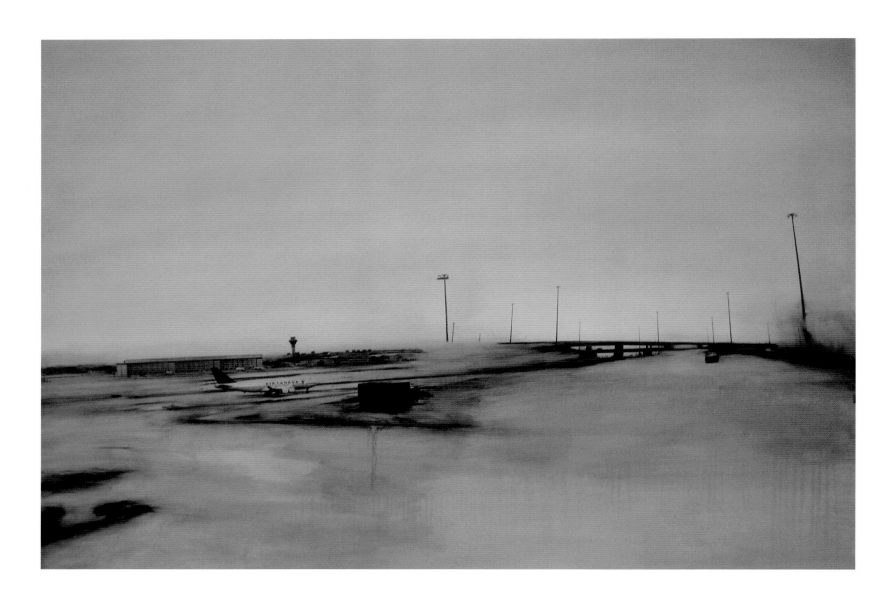

Perimeter #2, 2004, oil and toner on Mylar mounted on masonite, 28 × 44 inches / 71.1 × 111.8 cm

Tarmac Study, 2007, oil and toner on Mylar mounted on masonite, 11 × 15 inches / 27.9 × 38.1 cm

"My work focuses on the architecture and landscape of the transitional area between urban and rural settings. The transition, dislocation and isolation experienced driving through this sprawling landscape is used in these works as a metaphor for change and the resulting broader feelings of anxiety and uncertainty."

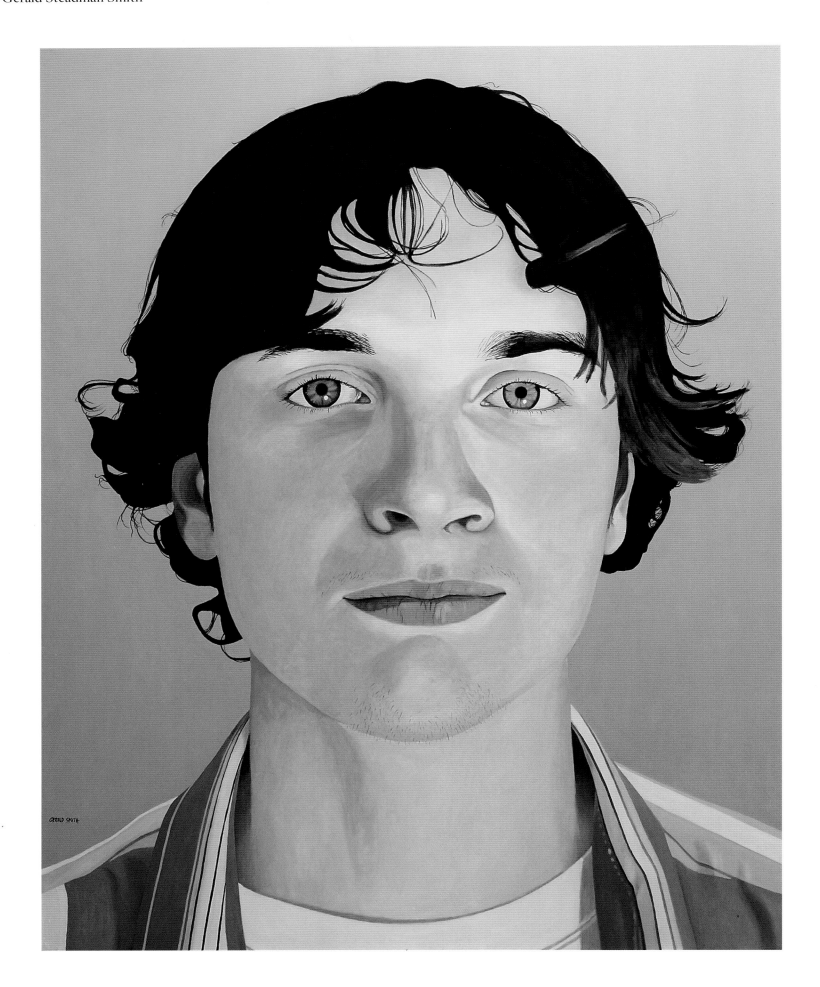

Jeremy Smith, 2007, oil on canvas, 66 × 54 inches / 167.6 × 137.2 cm

"I believe each person wears on their face the story of a lifetime: a story of their innate intelligence,
their cares and joys, and the wonderful sense of being alive. I am confident also that all people
have some element of beauty, not necessarily physical beauty, but a beauty of soul and spirit that
can be brought out and enhanced through my art."

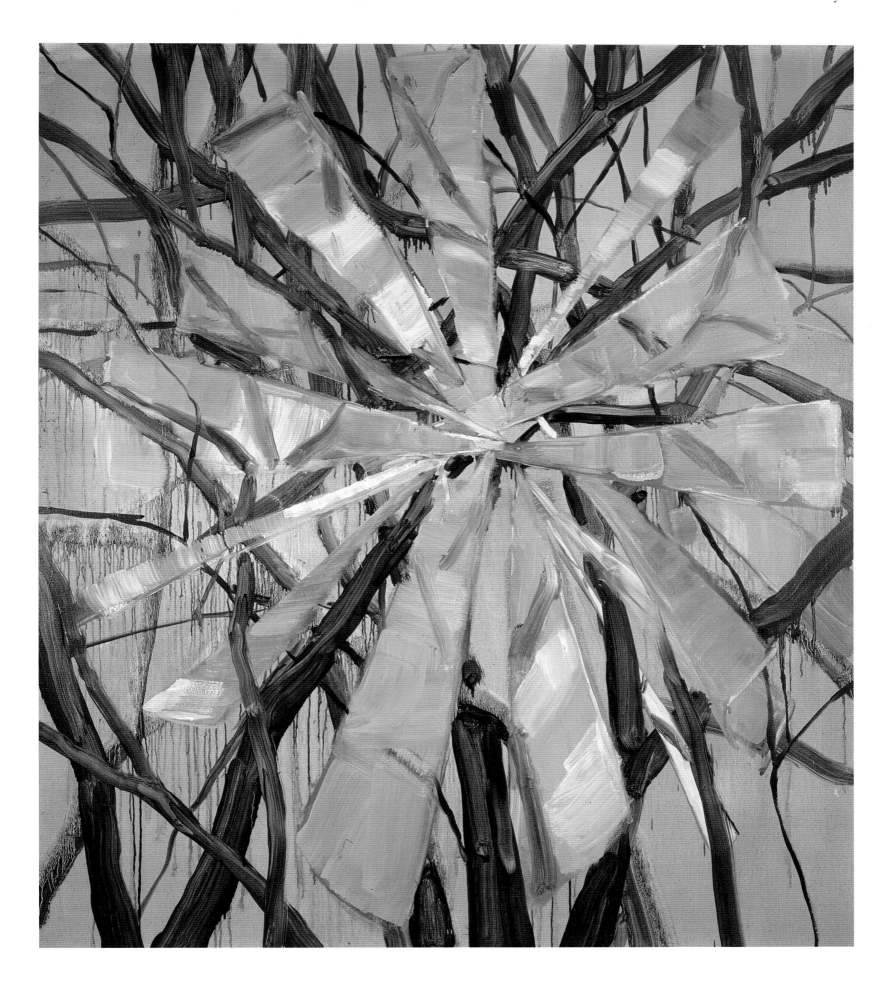

Smashed Mirror, 2006, oil on canvas, 59.5 × 53 inches / 151.1 × 134.6 cm

"Through the formal constructions of pop and religion—such as monuments, stages,
light and transparency—I aim to present an iconic absence."

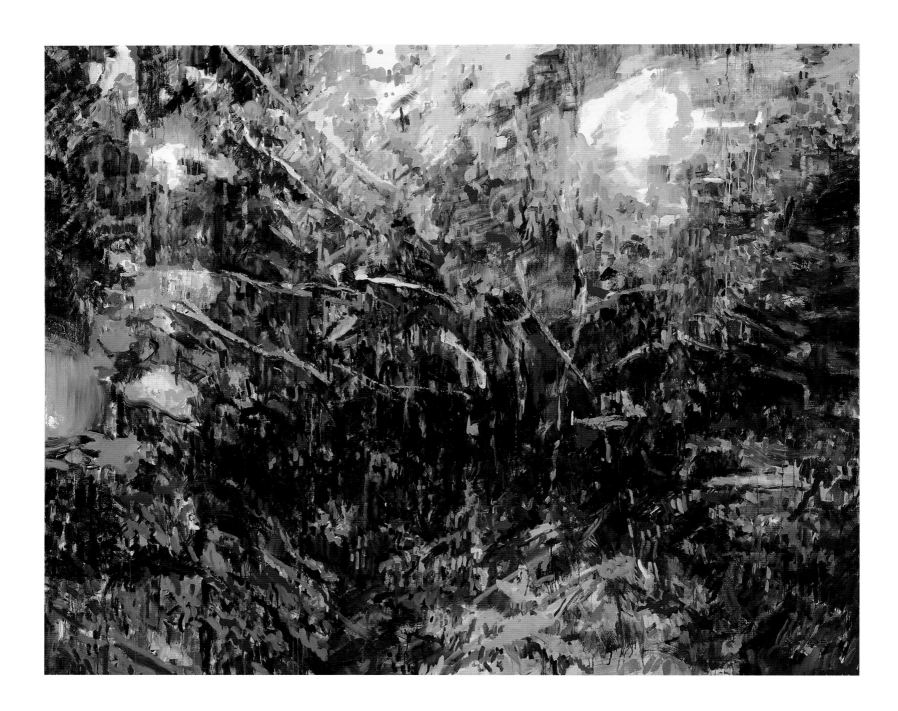

Road to Lily Dale I, 2006, oil on canvas, 80 × 99 inches / 203.2 × 251.5 cm

Road to Lily Dale II, 2006, oil on canvas, 80 × 99 inches / 203.2 × 251.5 cm

"If painting could speak like video, what might it look like? This is the question I've recently posed to myself in the studio, in the spirit of Walter Benjamin, who once suggested that the translator 'must expand and deepen his language by means of the foreign language.' I've begun in a straightforward way, basing my paintings on those tiny 30-second movies you can take with your digital camera."

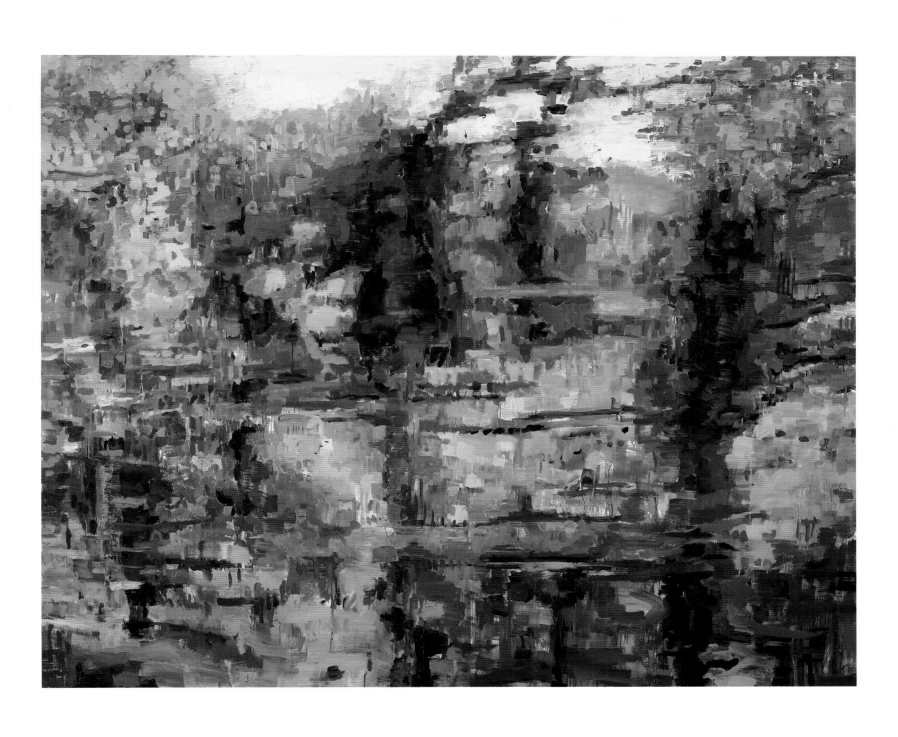

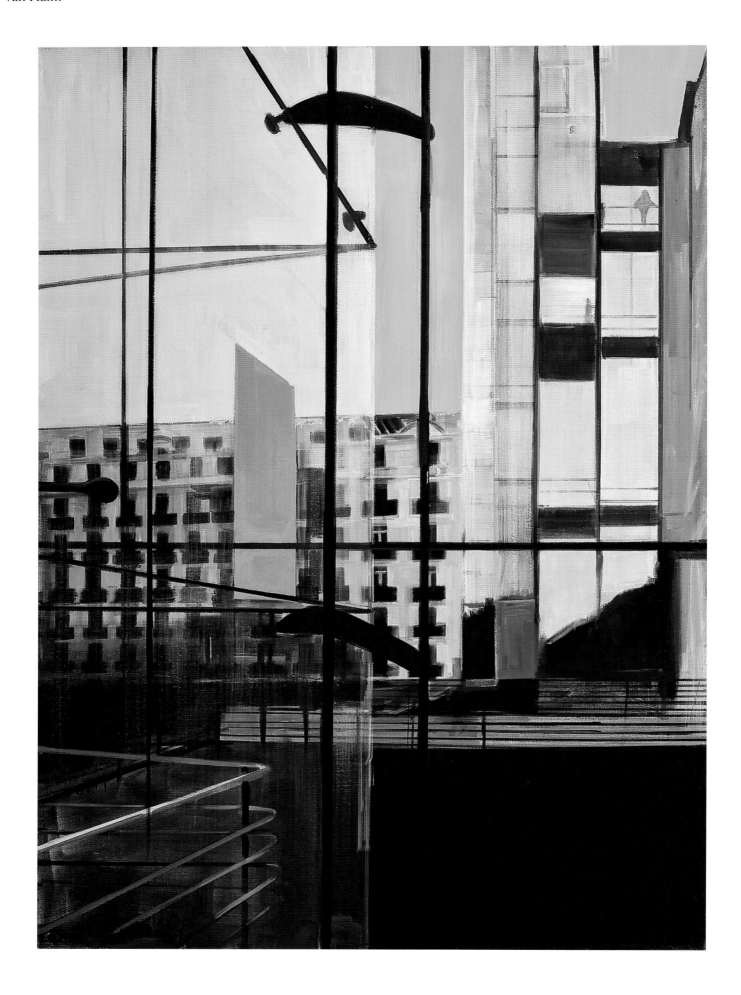

Madrid, 2005, vinyl polymer on linen, 55.1 × 39.4 inches / 140 × 100 cm

"Where we live has formed the basis for my work for over 30 years. This has taken many forms,
including paintings, painted constructions and installation works. Regardless of the form the
work has taken, I have continued to look at the underpinnings of lived space either in the public
or private realms as it represents cultural and social paradigms."

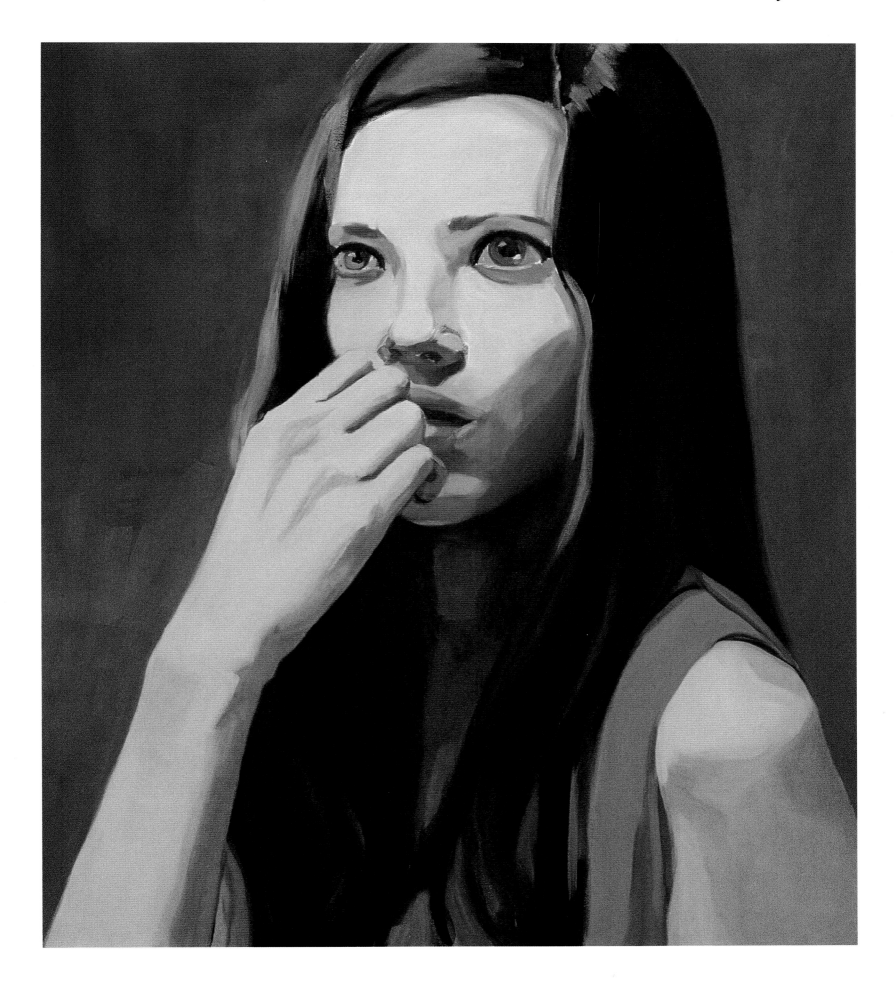

Wide Eyed Girl, 2002, oil on canvas, 54 × 42 inches / 137.2 × 106.7 cm

"There is a disjunction, a sense of alienation and psychological remove, between the iconic
 figures and the constructed landscapes they inhabit. The underlying subject of the work remains
 a primal experience of isolation or alienation."

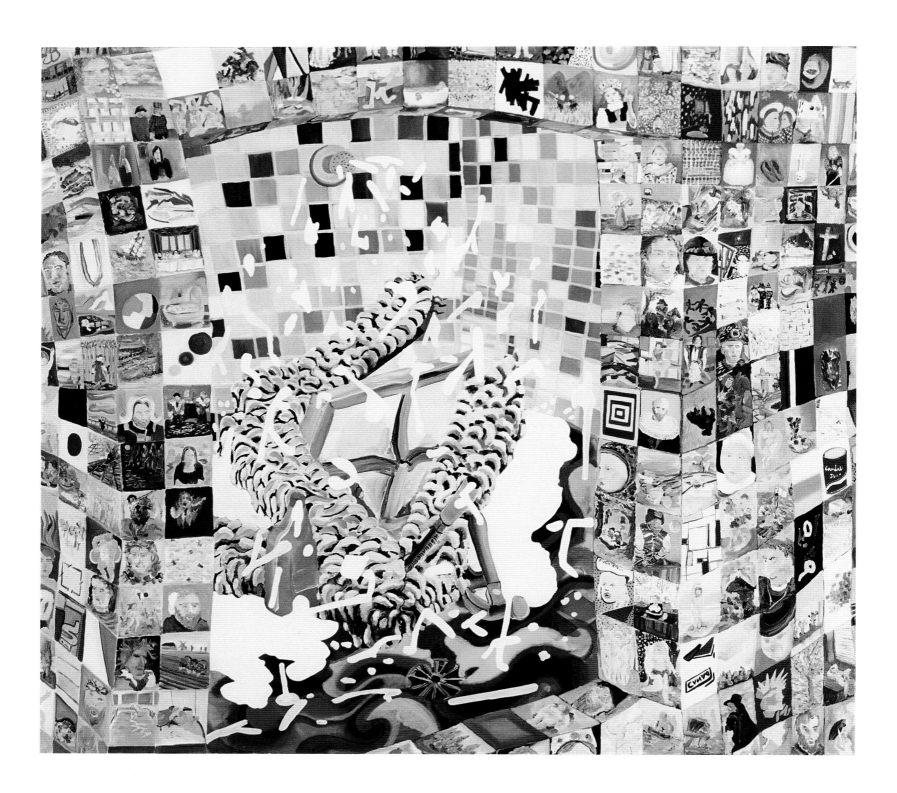

Spits and Pieces, 2006, acrylic and oil on canvas, 66 × 74 inches / 167.6 × 188 cm

Business in the Front, Party in the Back, 2006, acrylic and oil on canvas,
90 × 78 inches / 228.6 × 198.1 cm

"In many of my canvasses, the viewer is made overtly aware of the artist's presence through
the use of iconic symbols, specifically those of the painter. Scenes from the artist's studio
are frequently embellished with humorous references to historical paintings, and historical
and contemporary critical debate."

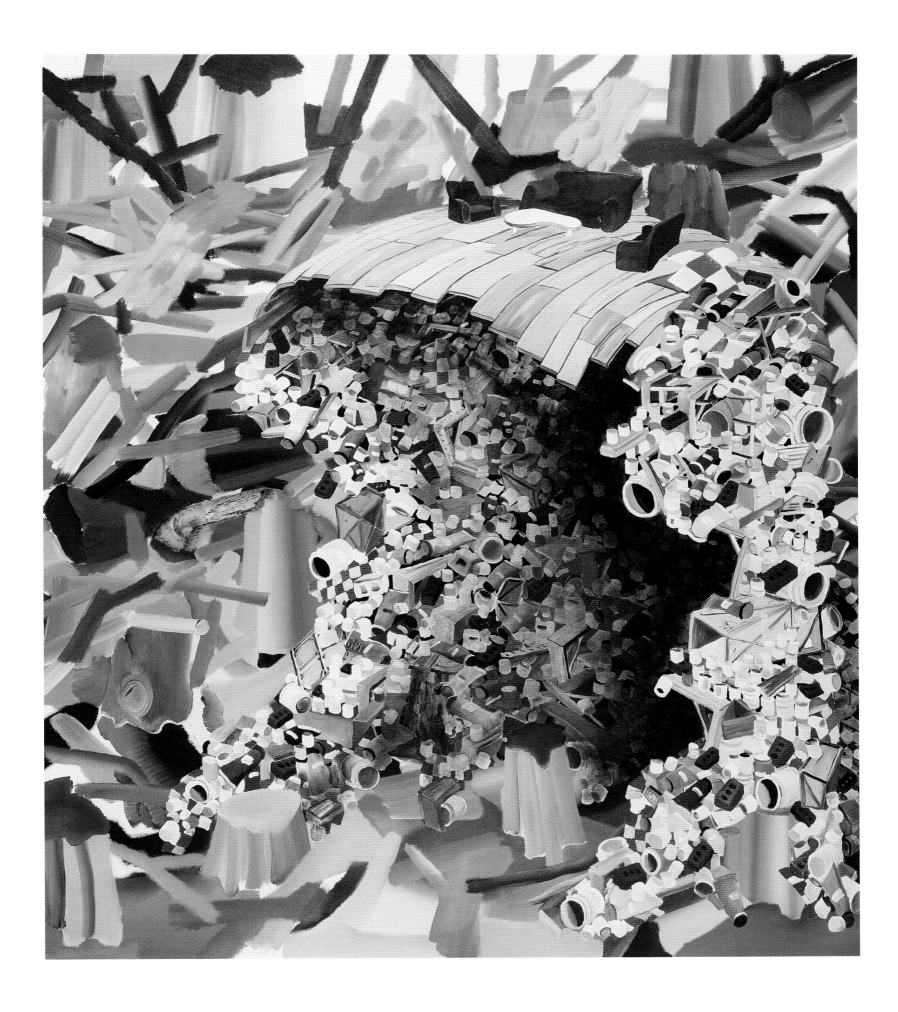

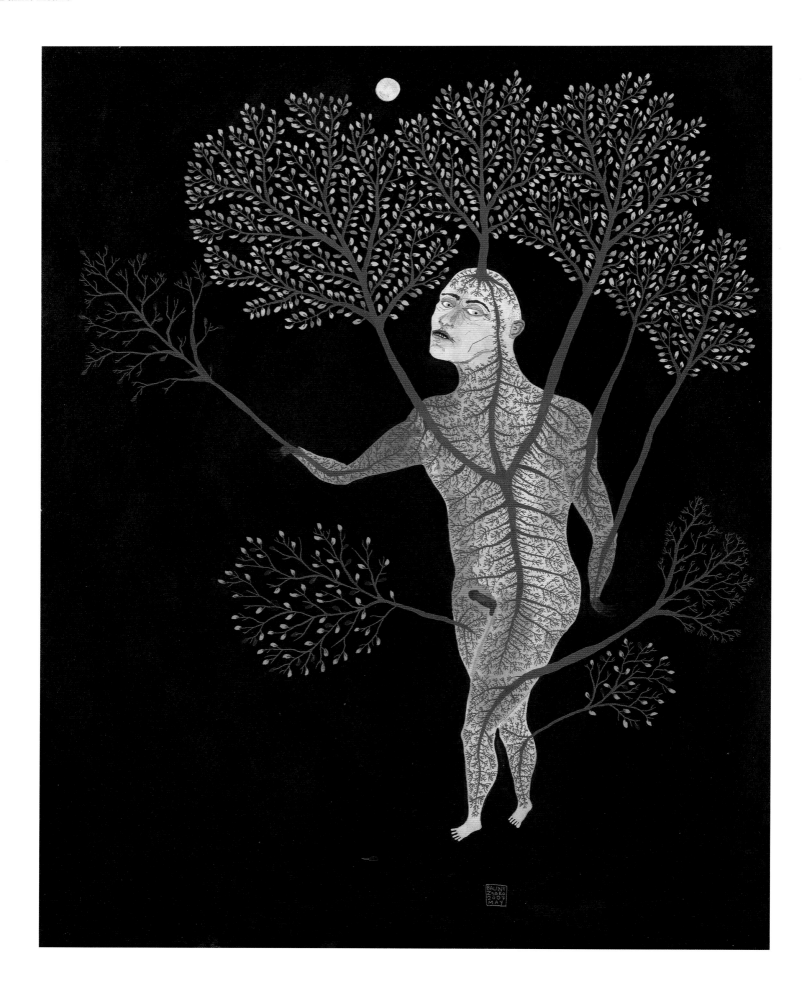

Untitled, 2007, watercolour and ink on paper, 14 × 11 inches / 35.6 × 27.9 cm

Untitled, 2006, watercolour and ink on paper, 16 × 12 inches / 40.6 × 30.5 cm

"I am interested in how humans take on animal attributes and how human attributes are assigned to animals. Each figure presents an opportunity to contemplate various tales of love, death, failure, hope and futility."

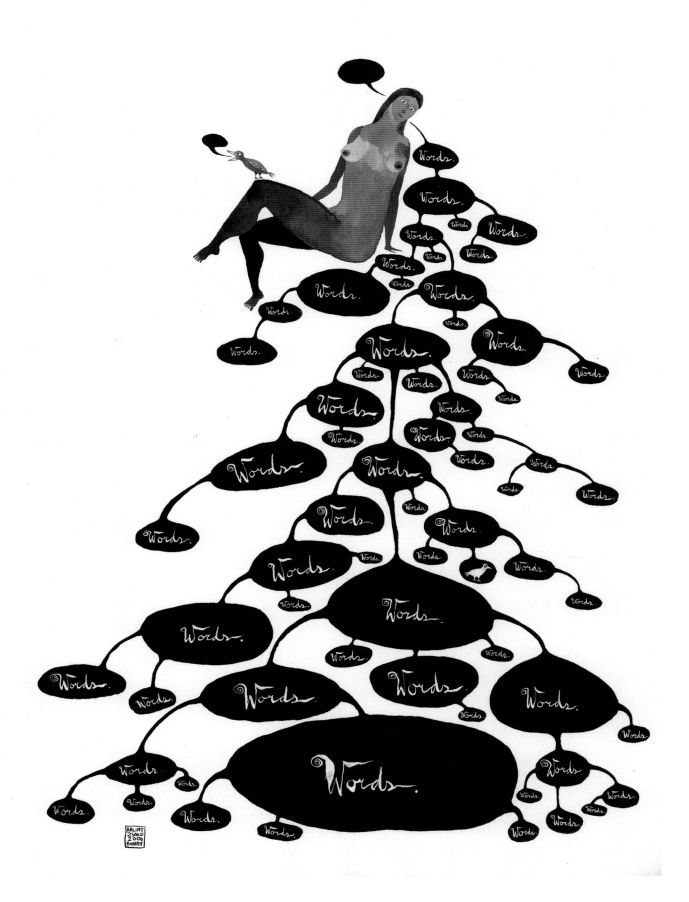

establ

ished

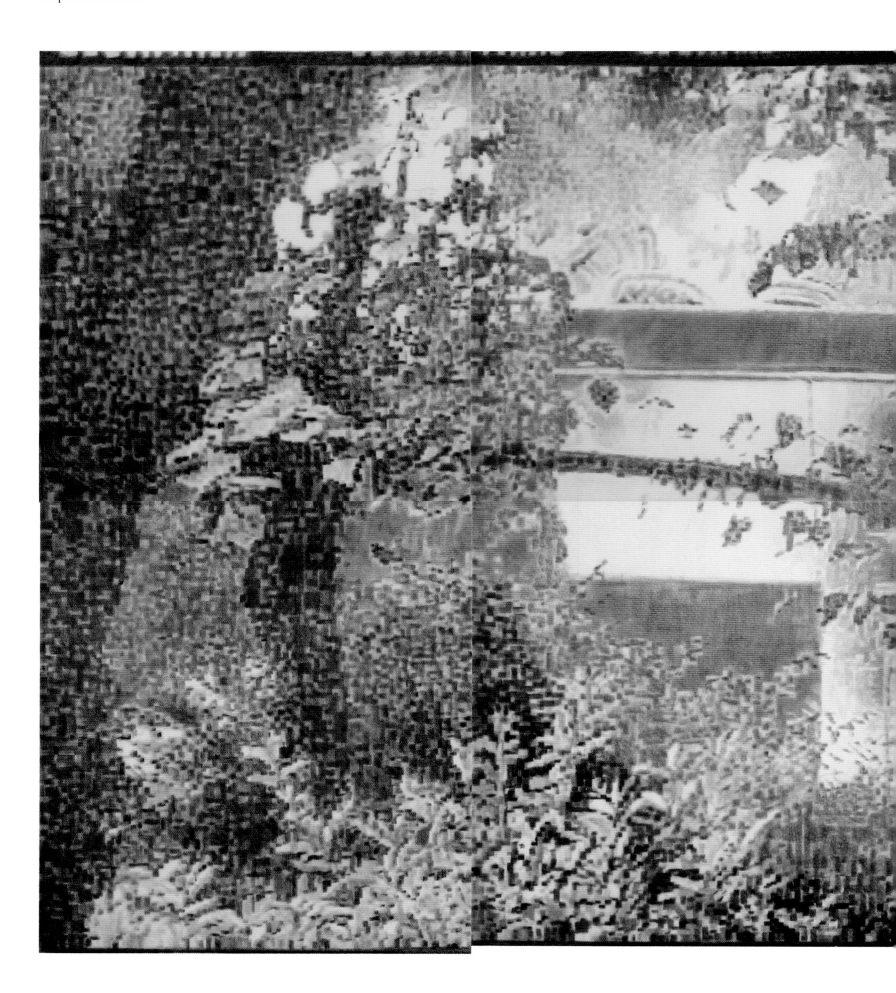

Untitled (London Bombing), 2006, crayon rubbing on Mylar, 78 × 130 inches / 195 cm × 330 cm

"I am interested in the view from here. That is to say, the privileged position in North America at a safe distance from conflict…Rather than being repulsed and refusing to engage with the subject of the pictures, the soft palette slows down our reading of the imagery, letting the meanings sink in. For most of us, these are not our personal experiences but we must, I think, take it personally."

established
John Armstrong and Paul Collins

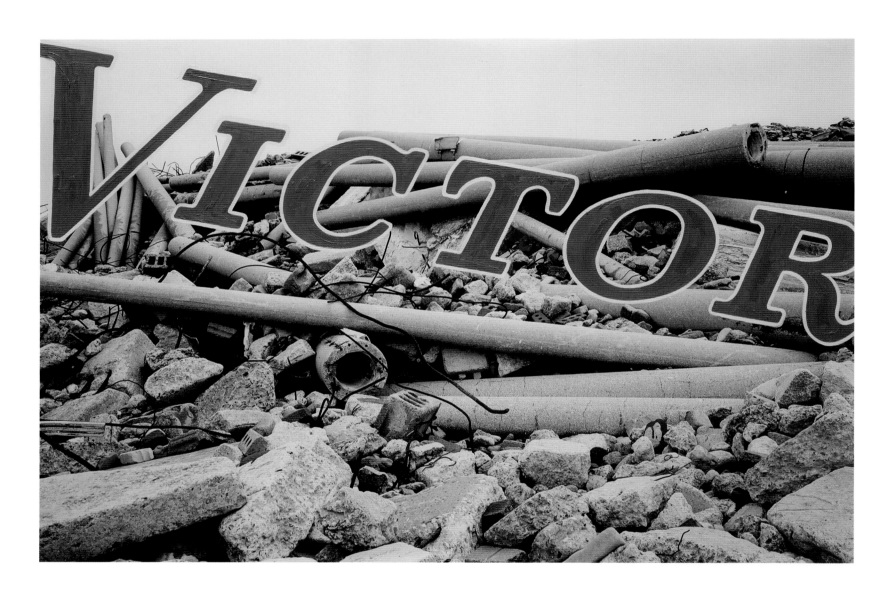

Victor, 2007, oil on chromogenic print, 20 × 30 inches / 50.8 × 76.3 cm

Happy, 2007, oil on chromogenic print, 20 × 30 inches / 50.8 × 76.3 cm

"Our painted photographs might be likened to hand-painted signage and images on storefront windows. But rather than having a commercial purpose, our signage sets out to create a resonance with the underlying image that may be poetic, absurd and, at times, editorial."

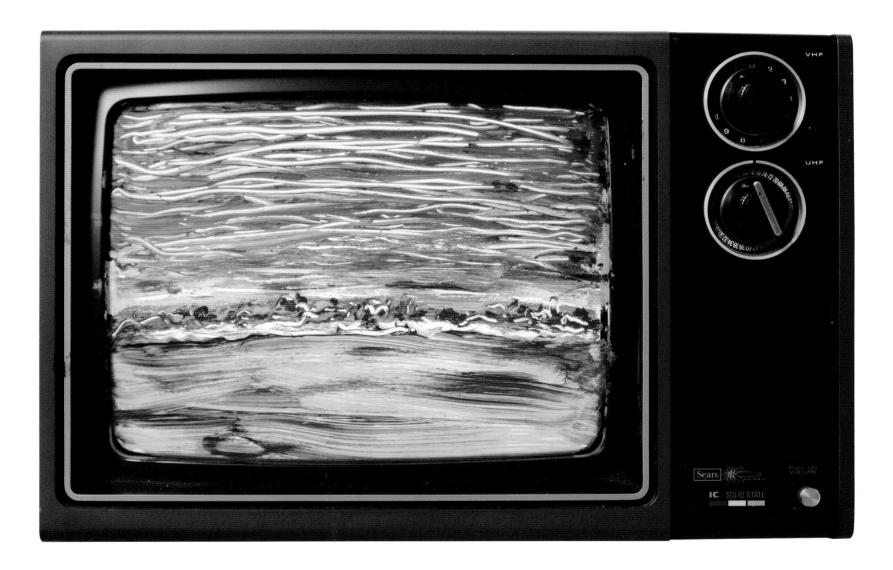

Landscape by the Sea, 2007, from the series *Television Works,* acrylic paint on reclaimed Sears television,
13.5 × 18.6 × 15 inches / 34.3 × 47.2 × 38.1 cm

Northern Canada, 2007, from the series *Television Works,* acrylic paint on reclaimed RCA television
and reclaimed sculpture stand, 40.5 × 14.6 × 12 inches / 102.9 × 37 × 30.5 cm

"My interest is to examine and critique: art, media and information systems; corporate, consumer
and popular culture; rural and urban existence; technological developments in the natural world;
global and ecological concerns; the idea of landscape; and human visual perception in broad terms."

Les humanités CCLIV, 2007, acrylic on canvas, 48 × 72 inches / 122 × 183 cm

Les humanités CCLXXXIV, 2007, acrylic on canvas, 30 × 48 inches / 76 × 122 cm

"I like to use painted books as a strategy against loss, even though worn books, metaphorically,
 evoke the passage of time and reveal one's own finiteness."

Rockbound, Atlantic, 2006, oil on canvas, 48 × 42 inches / 121.9 × 106.7 cm

Primal Light, Pacific, 2006, oil on canvas, 55 × 44 inches / 139.7 × 111.8 cm

"I revel in the infinite variety of the natural world and my work is an act of preservation.
To preserve the natural world is to preserve a language. It's the language of the wind and
shifting light, of stillness, silence and space. It allows us to converse with the other voices,
the voices of our true aspirations, our regrets, our hopes."

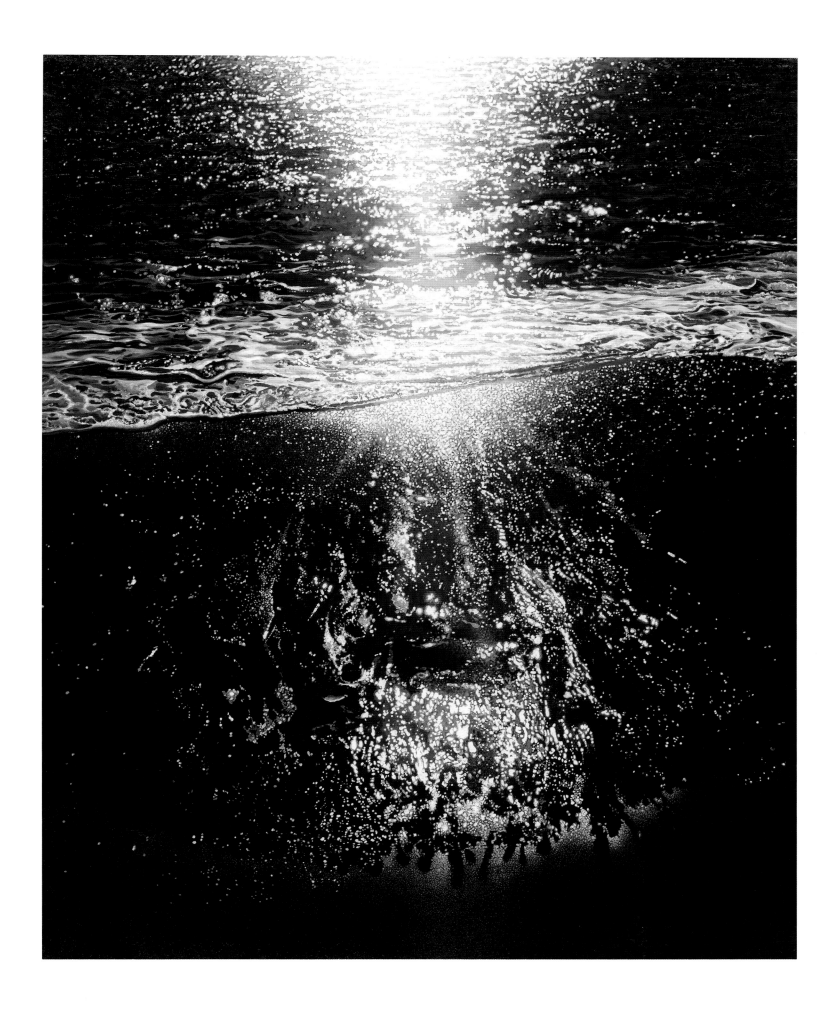

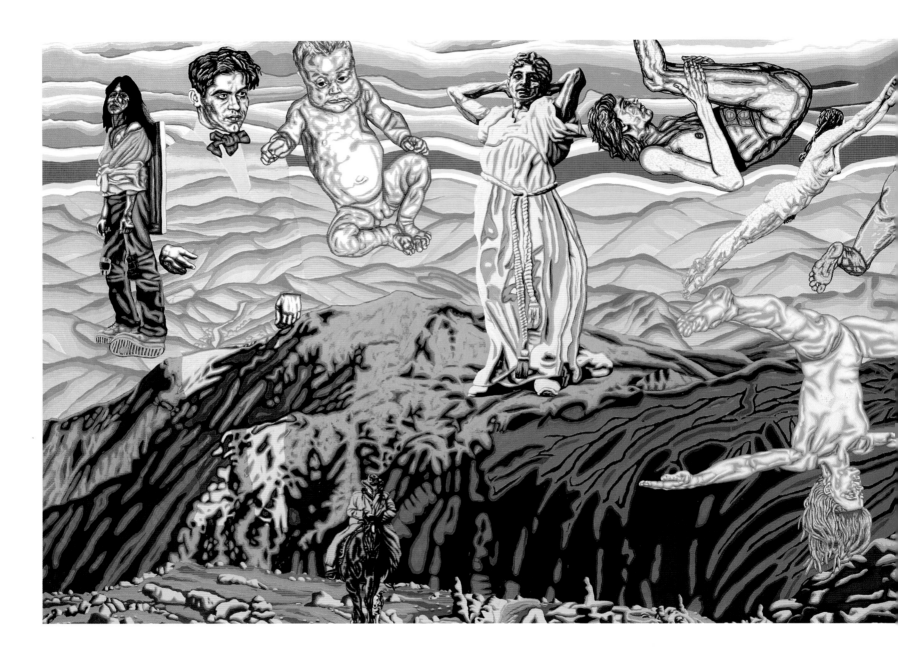

Canadology–Perpetual Motion Machine, 1992–93, acrylic on canvas,
90 × 246 inches / 229 cm × 625 cm

"My art is a quest for understanding my life. This entails an exploration of the Canadian
experience that shapes everything about me. It also leads to an examination of what
happens when I take a Canadian iconography into the greater world and set it alongside
those of other cultures."

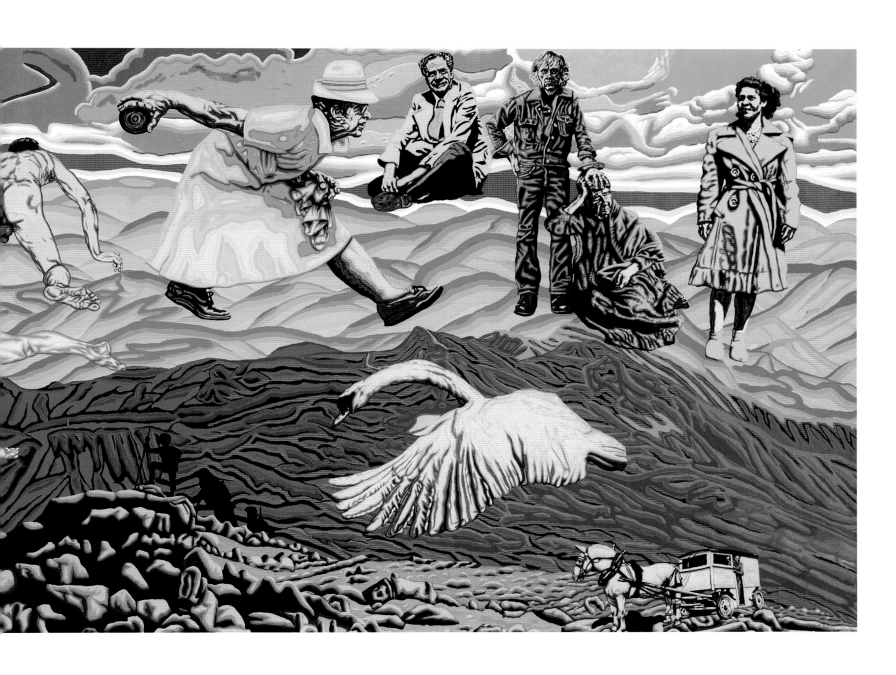

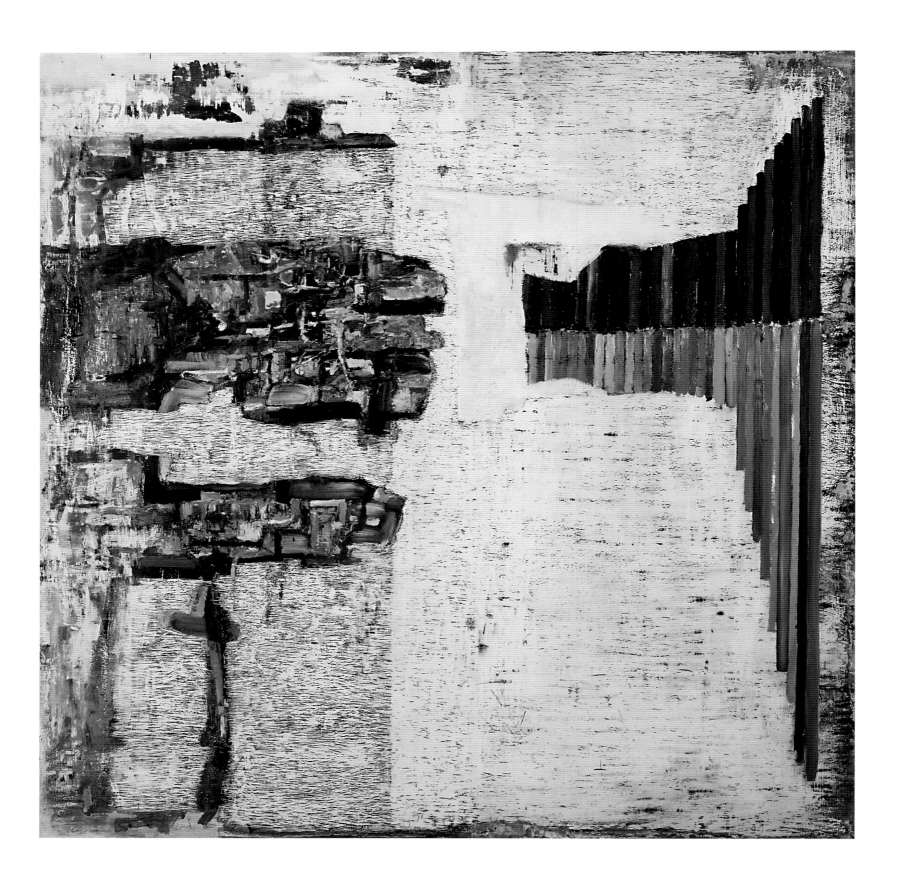

November 14, 2011, 2005-2006, oil on wood, 74 × 74 inches / 188 × 188 cm

Grimm #55, 2006, oil on wood, 20 × 16 inches / 50.8 × 40.6 cm

"Is a statement really neccesary? Isn't it obvious that I paint so as to leave words behind,
to put an end to the irritating question of how or why?" —Henri Michaux

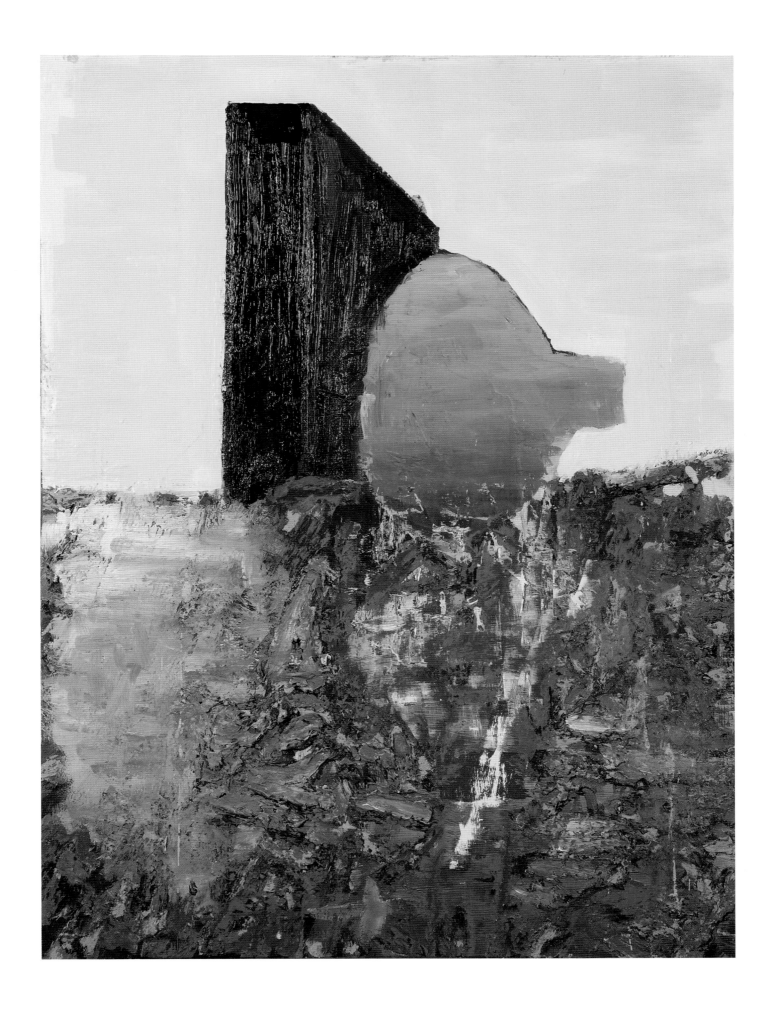

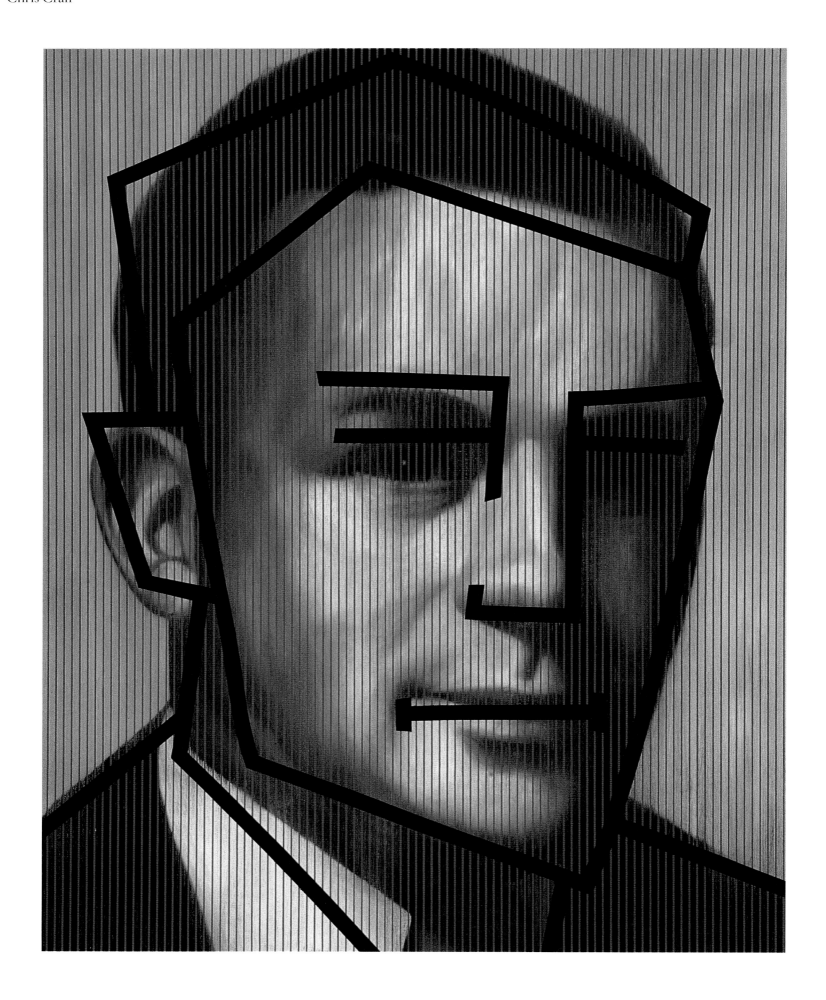

Red Man / Black Cartoon, 1990, oil and enamel on board, 60 × 48 inches / 152 × 122 cm

Happyface—Boat on Still Life With Birds, 2005, oil and acrylic on canvas, 48 × 36 inches / 121.9 × 91.5 cm

"I am interested in why we are hard-wired to gaze easily into the space of painting and why and how the rhetorical strategies of vision and perception prevent us from looking at painting as inert material on a flat surface that we know it to be."

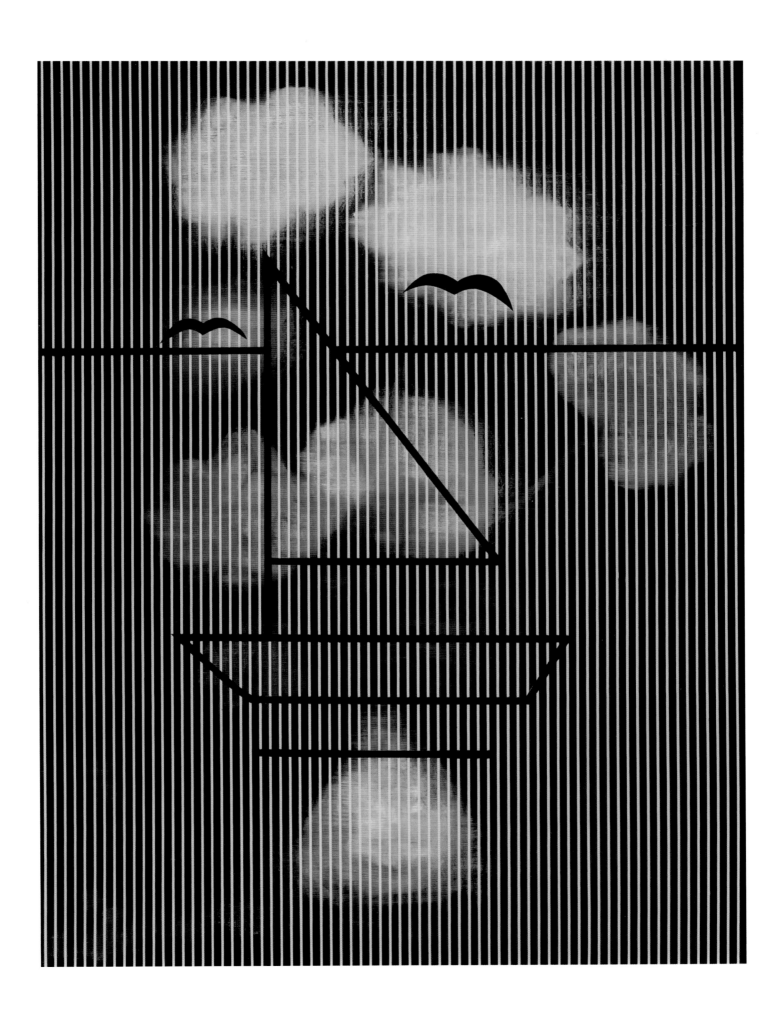

established

Karin Davie

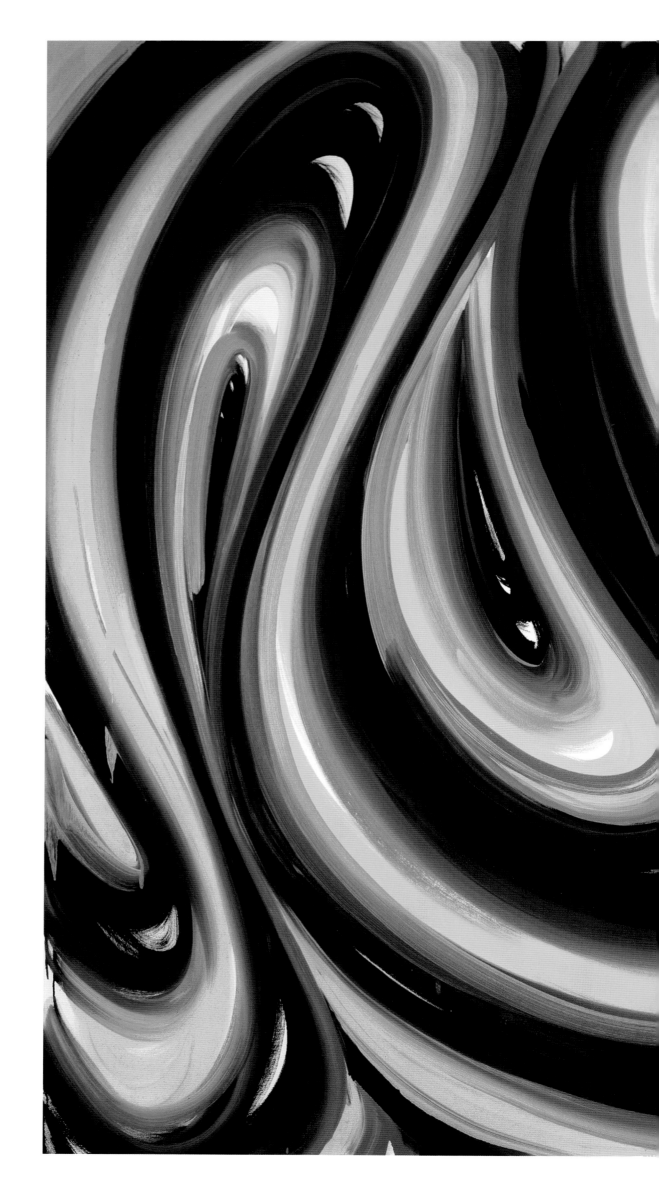

Pushed, Pulled, Depleted & Duplicated #1, 2002,
oil on canvas, 84 × 108 inches / 213.4 × 274.3 cm

"I see an ongoing theme in my work as the
struggle between what gets revealed and what
gets concealed. It's the irrepressible image.
In giving form to something that is both an
emotion and an idea, I've imagined a kind
of corporeal being with its raw parts discarded,
exposed and in a state of collapse; the 'guts of
the painting' come undone."

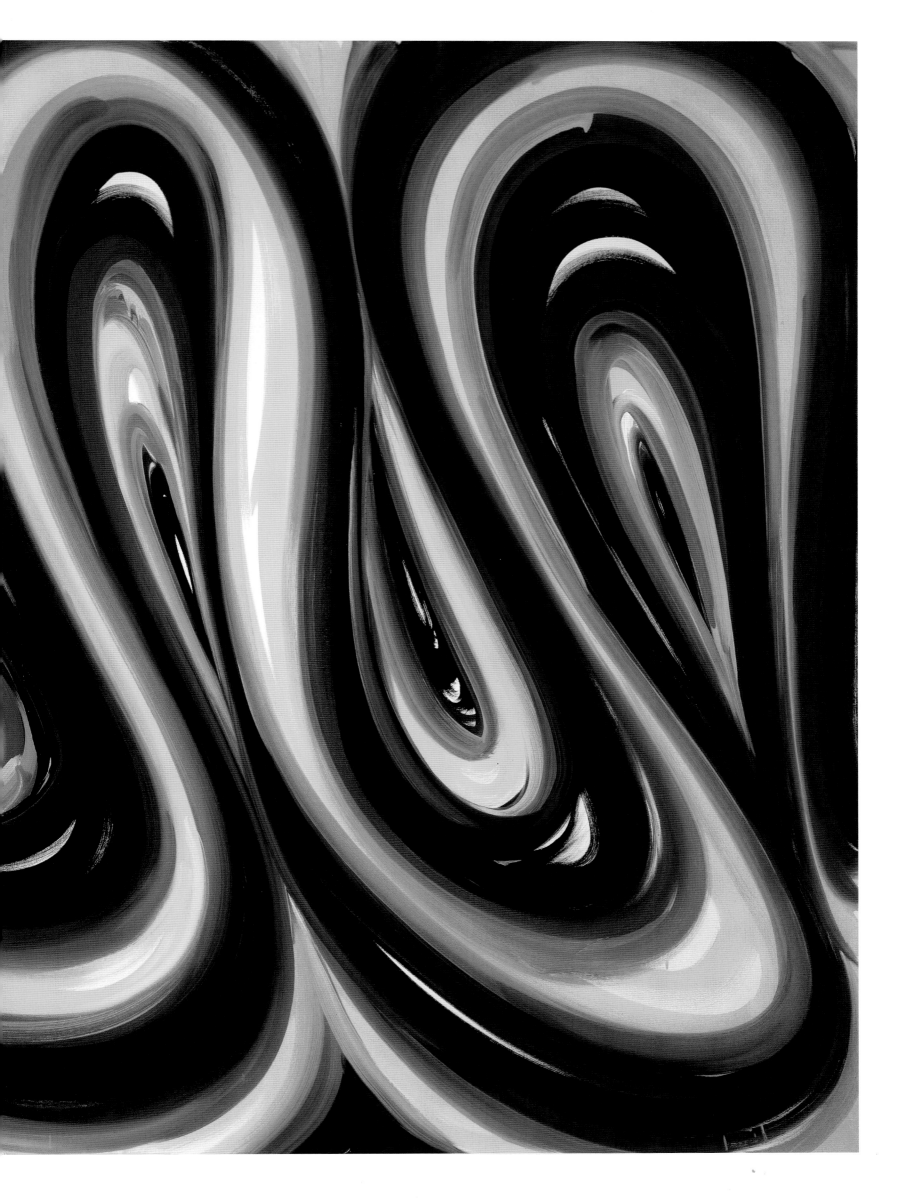

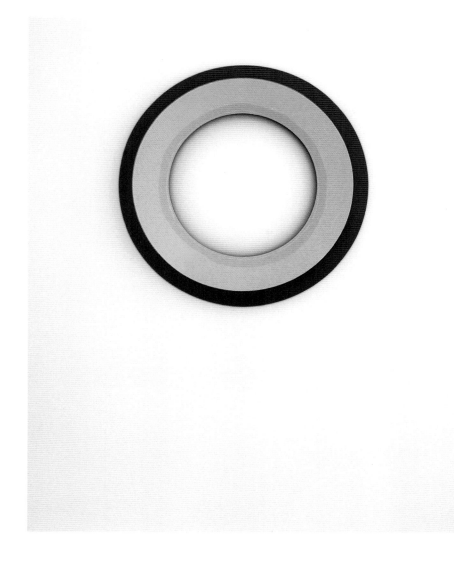
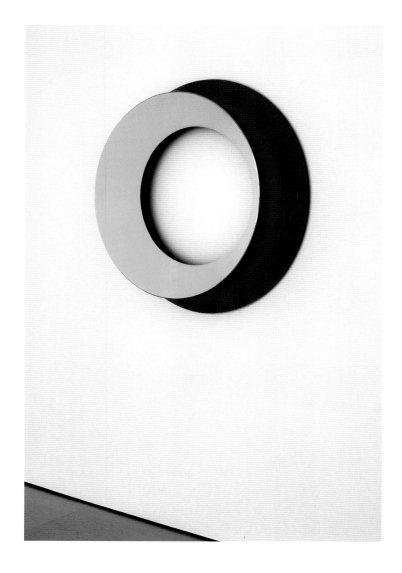

Intersecting Frusta, 2005, acrylic urethane on aluminum, 42 inches / 106.7 cm diameter × 1 inch / 2.5 cm (2 views)

White Painting #614, 1990, textured formica on birch plywood with 23 carat gold on pine and poplar moulding, 84.5 × 54.5 inches / 214.6 × 138.4 cm

"I seem to traffic in intangibles and have never been interested in the utility of art works merely for the servicing or conveying of meaning or for being 'about' something. The works I create are the by-product and end result of the small set of gestures and operations left over to me after a very rigorous process of elimination."

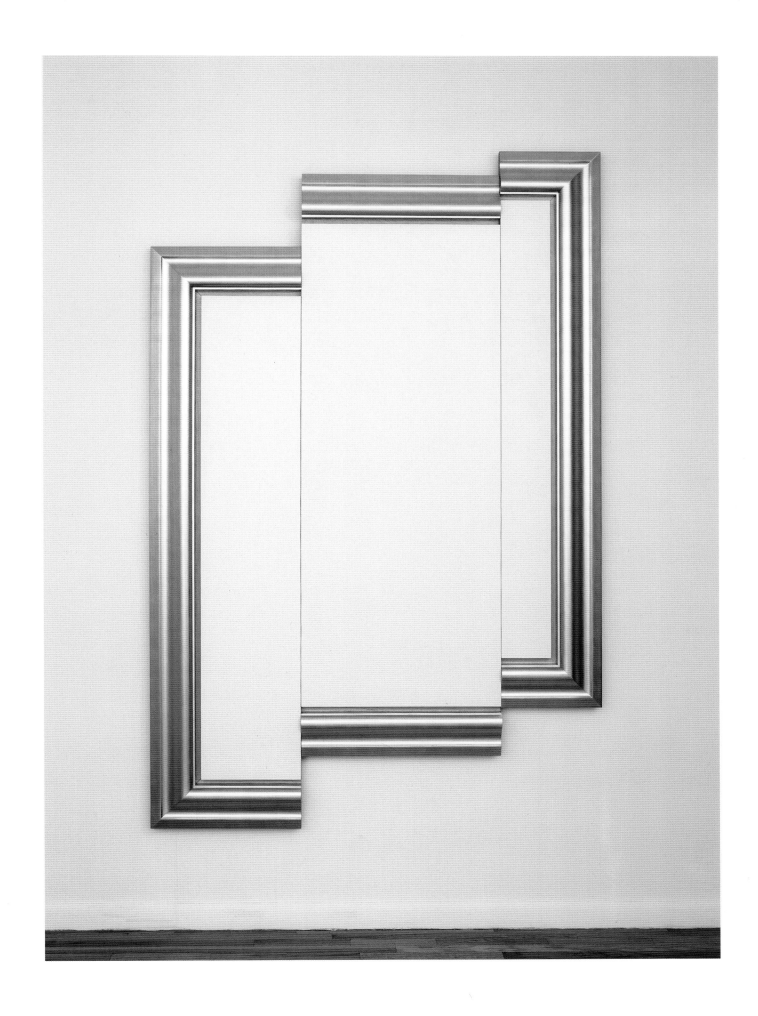

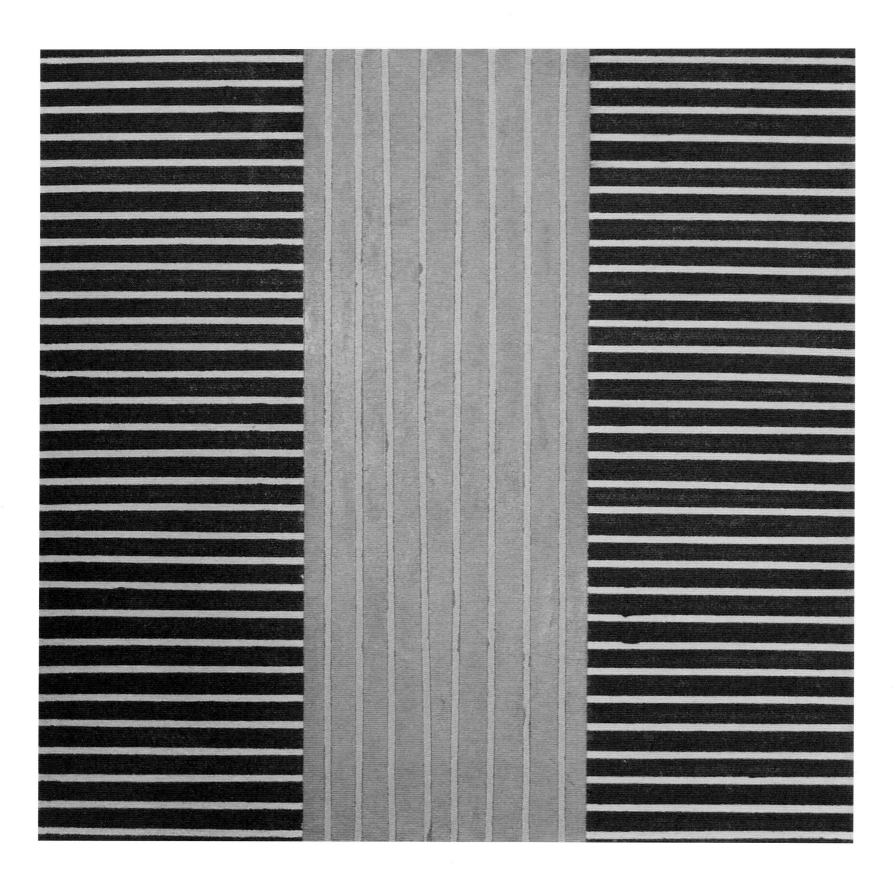

Upon Entry, 2005, oil on canvas, 24.4 × 24.4 inches / 62 × 62 cm

Departure, 2008, oil on Mylar, 35.4 × 31.5 inches / 90 × 80 cm

"In my work, colour functions as a factual component, one hue being equal in importance to any other hue. Colour is chosen intuitively by weight and by presence, not necessarily by its representational properties, commercial or natural. I like to think of the colour as being in the paintings, not on the surface—like tattoos."

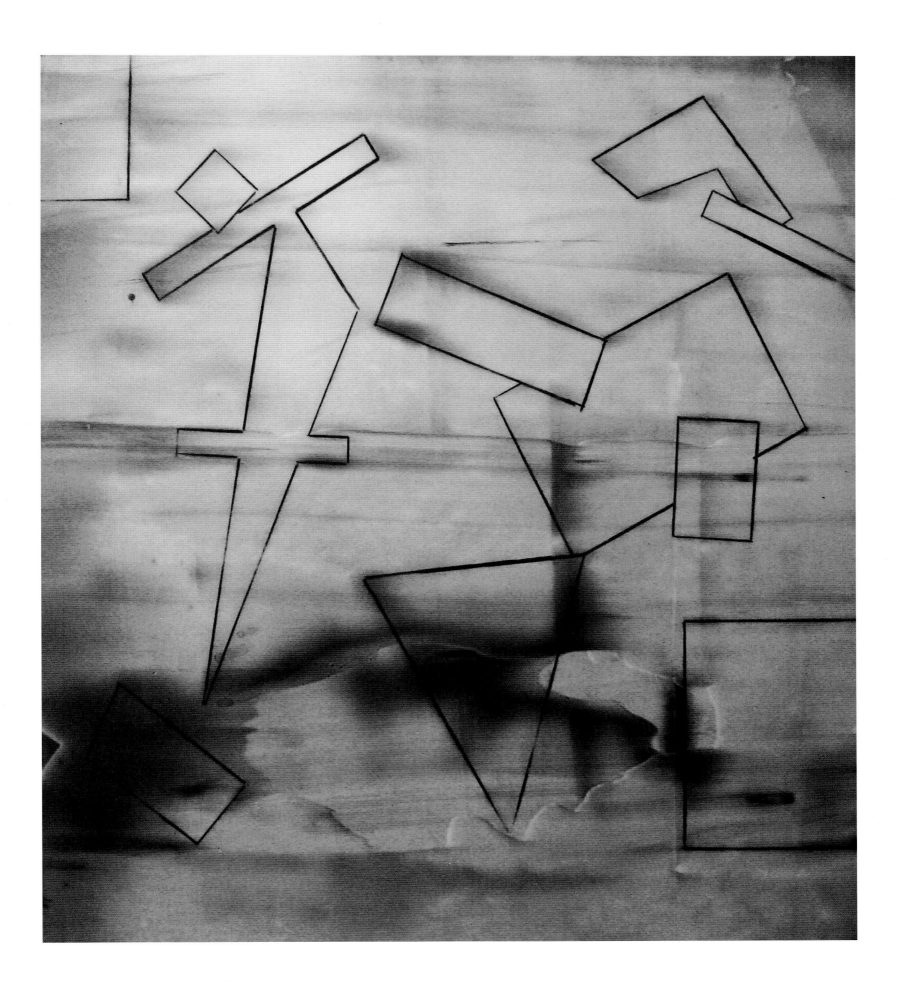

Dreaming of Flying: Moth #8, 2007, oil on canvas, 48 × 48 inches / 121.9 × 121.9 cm

"Falk has memories of fields of juicy, red watermelons, the fragility and economy of eggs,
her mother's gardens, piles of fresh fruit from the neighbour's cherry tree, homemade
shoes and dresses, a colourful Parcheesi game board with mesmerizing illustrations of
rural scenes. Visceral moments such as these, rising from the midst of economic difficulty,
would later resurface in the content of her work."

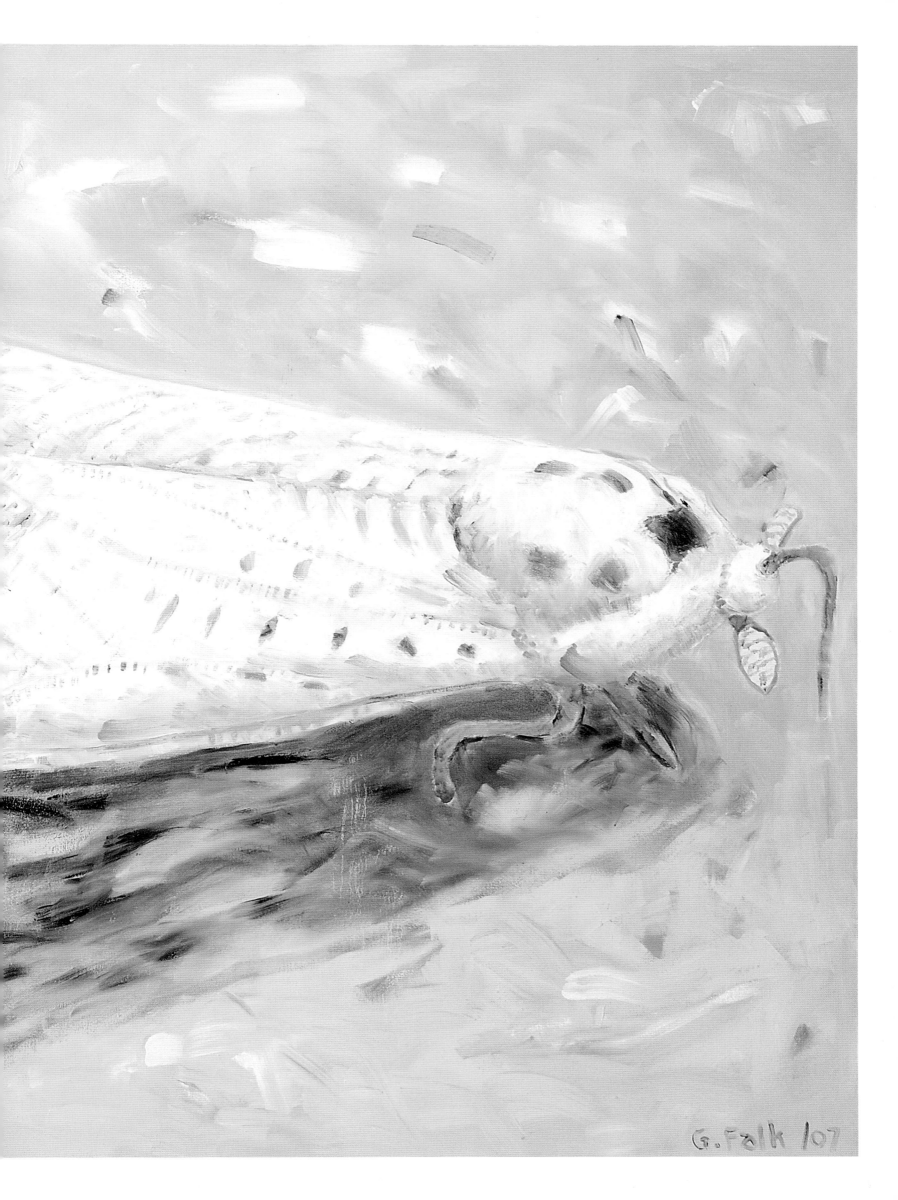

G.Falk /07

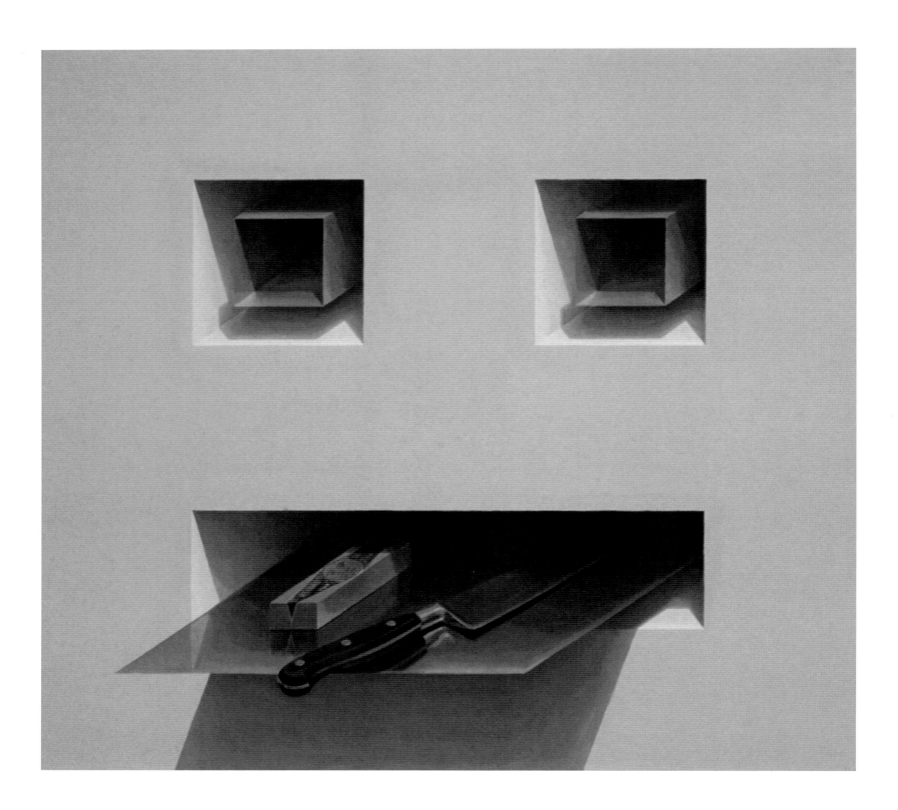

Sharpening Stone and Knife, 1995, oil on canvas, 22 × 24 inches / 56 × 61 cm

Turbot, 1995, oil on canvas, 22 × 24 inches / 56 × 61 cm

"My interest in industrial production has often led to works that question
the definitions separating cultural products from natural specimens."

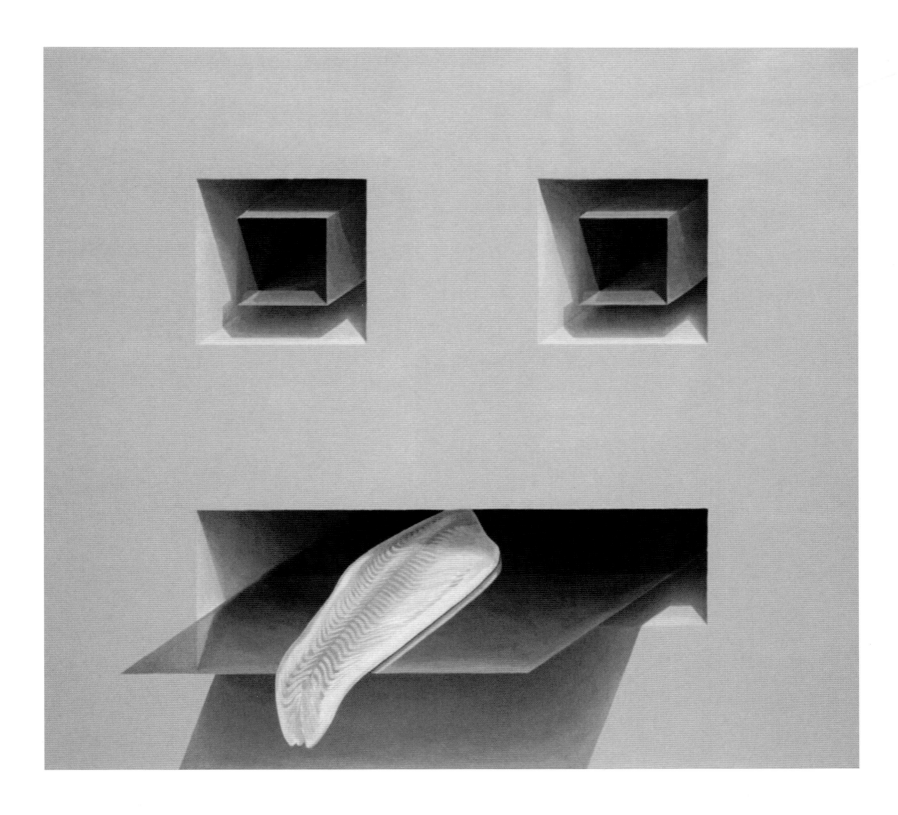

Dundas Square, 2007, oil on canvas, 40 × 60 inches / 101.6 × 152.4 cm

"My paintings are an expressionist response to the spaces I inhabit. My work explores how architecture can dictate social behaviour and how gestures can reveal the personal within the impersonal."

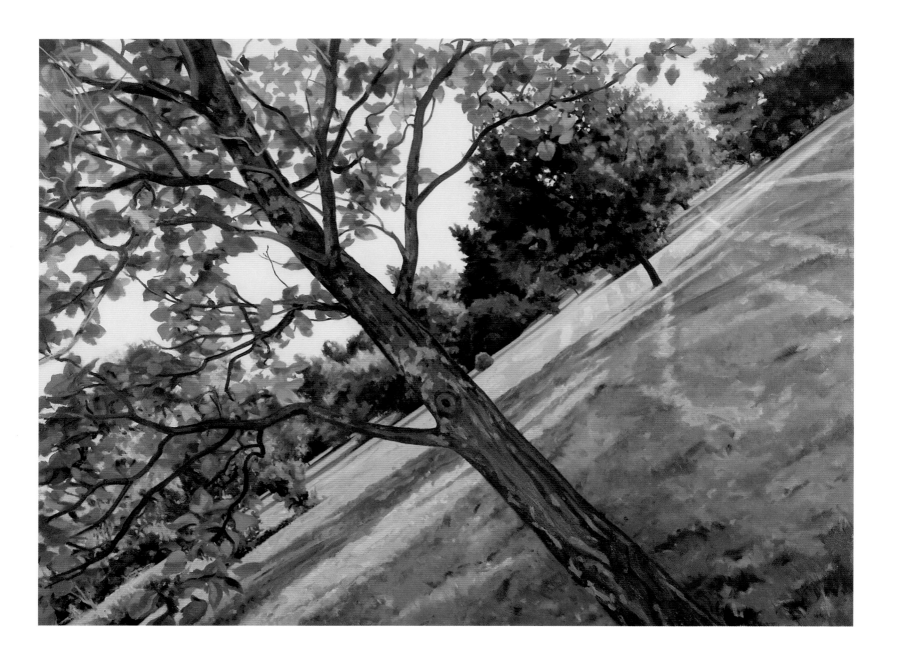

crossed out landscape, 2008, oil on canvas, 54 × 72 inches / 137 × 183 cm

pink peony/white vase, 2005, oil on canvas, 24.8 × 18.9 inches / 63 × 48 cm

"For me, painting re-positions the human body against the all-pervasive technical instrumentality
of our culture. As painting encounters a subject, an imaginatively interpretive process is engaged
involving both sensuality and intelligence."

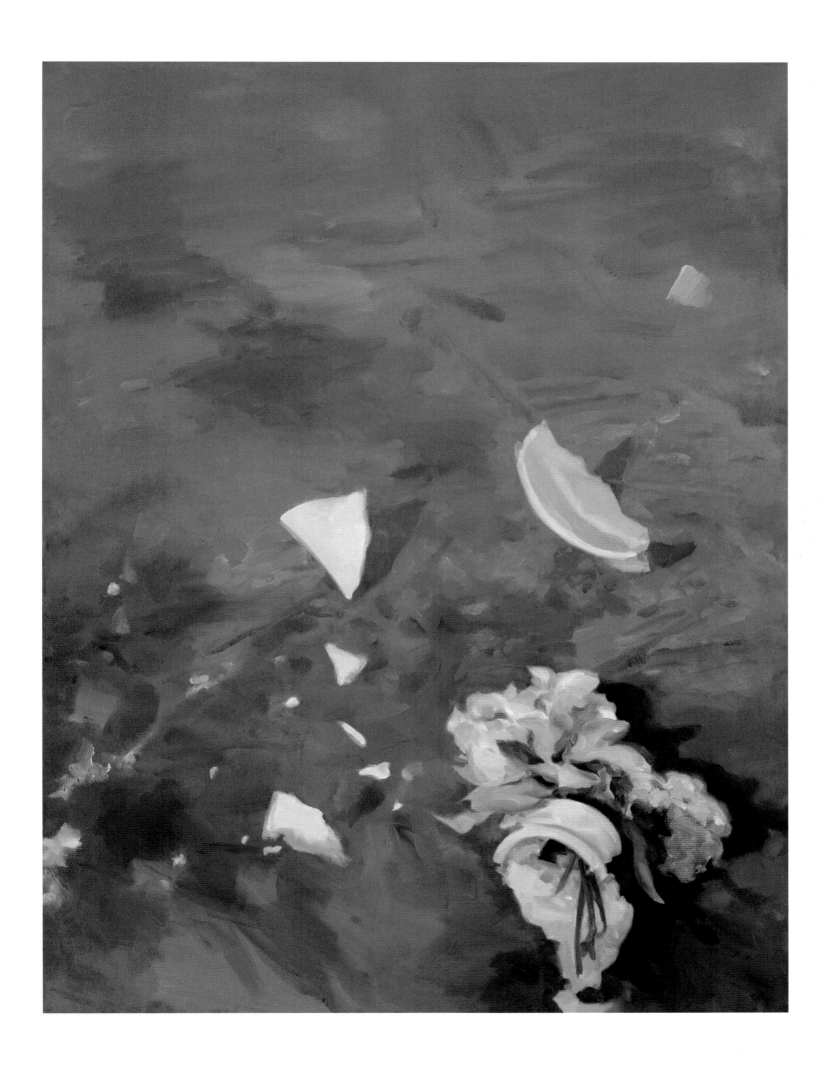

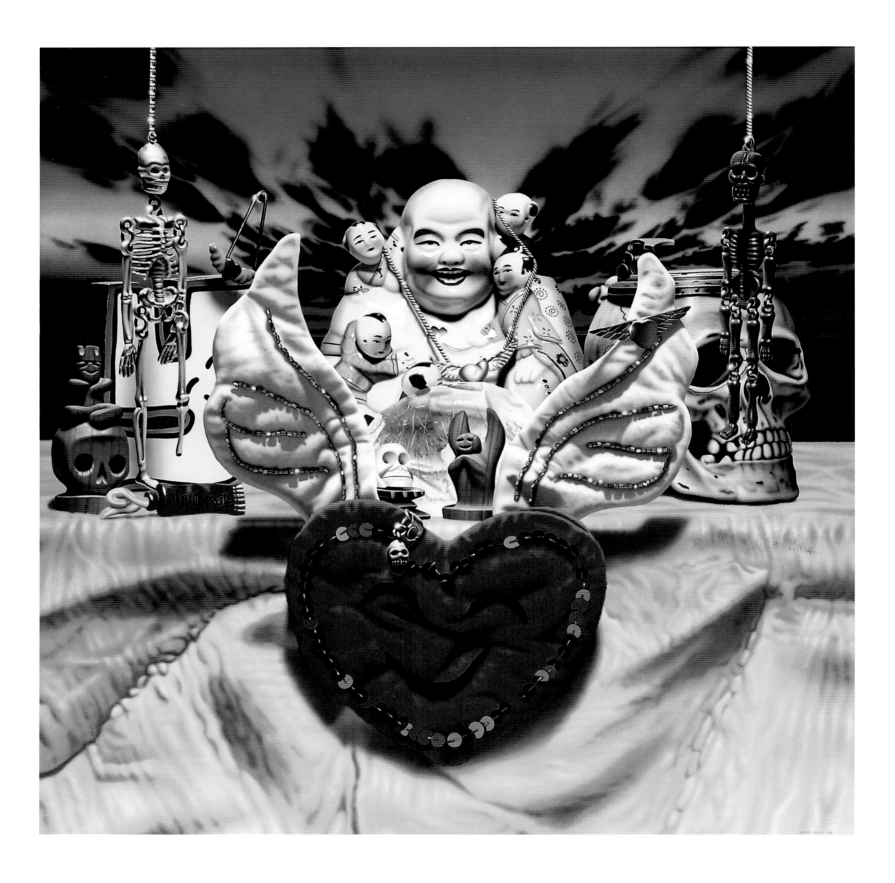

Angel, 1989, acrylic on canvas, 60 × 60 inches / 152.4 × 152.4 cm

Artist's Palette II, 1998, acrylic on canvas, 18 × 27 inches / 45.7 × 68.6 cm

"Sometimes likened to an urban archaeologist, I make still life paintings that mine the
rich complexity of contemporary urban life. They are reflective of personal and
collective values manifested through the flotsam and jetsam of turn-of-the-century
urban North American culture."

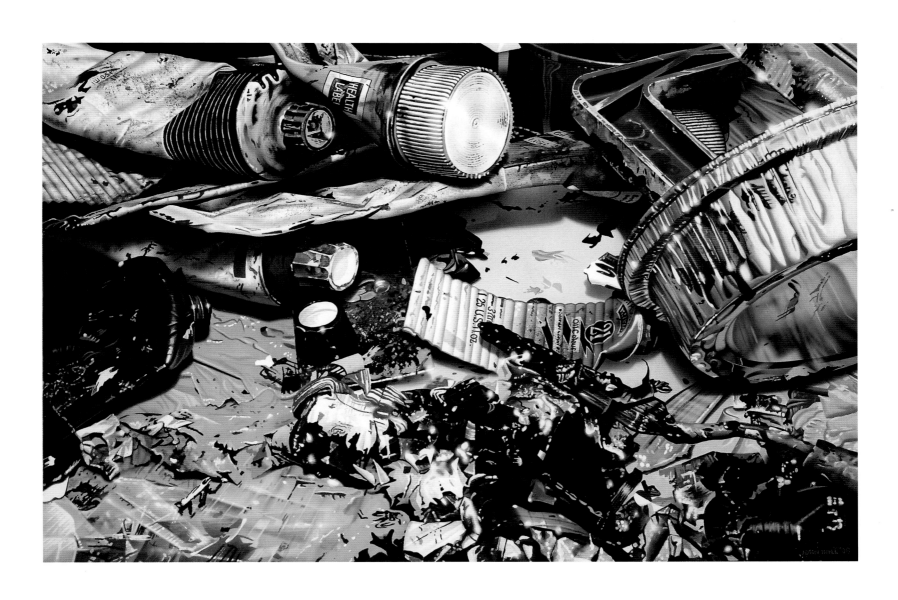

John Hartman

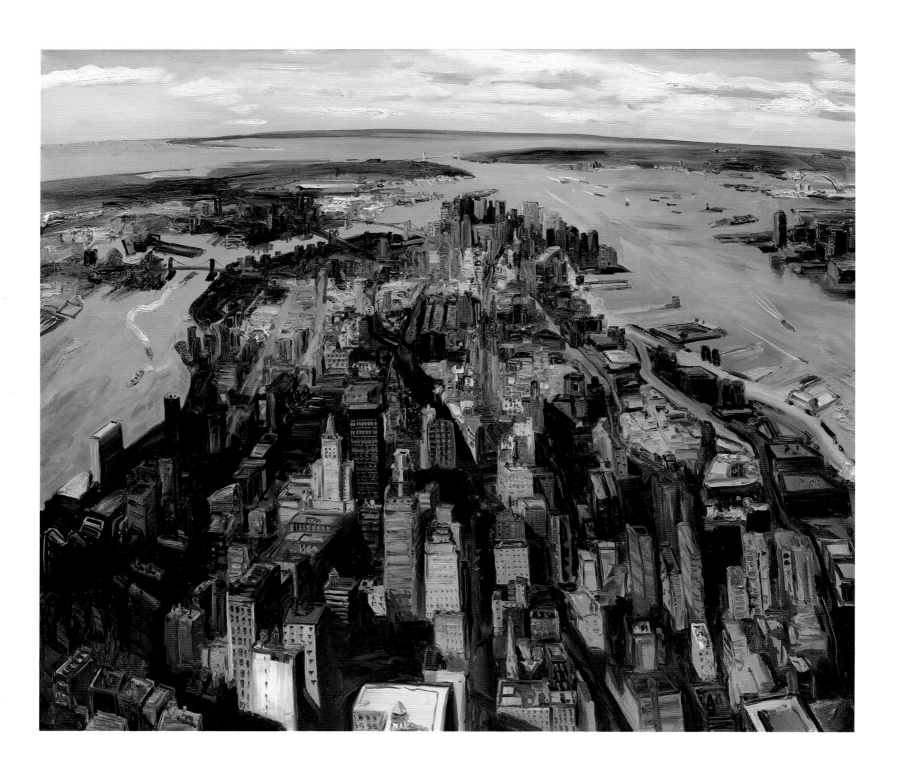

Lower Manhattan, 2006, oil on linen, 78 × 90 inches / 198.1 × 228.6 cm

Vancouver From Above Burrard Inlet, 2006, oil on linen, 78 × 90 inches / 198.1 × 228.6 cm

"The shorelines, buildings and roadways reveal the shapes and juxtapositions of the natural and the man-made. The bodies of water have a beautiful quality of reflected light that contrasts with the density of the urban areas. The paintings cast a personal perspective on our major port cities."

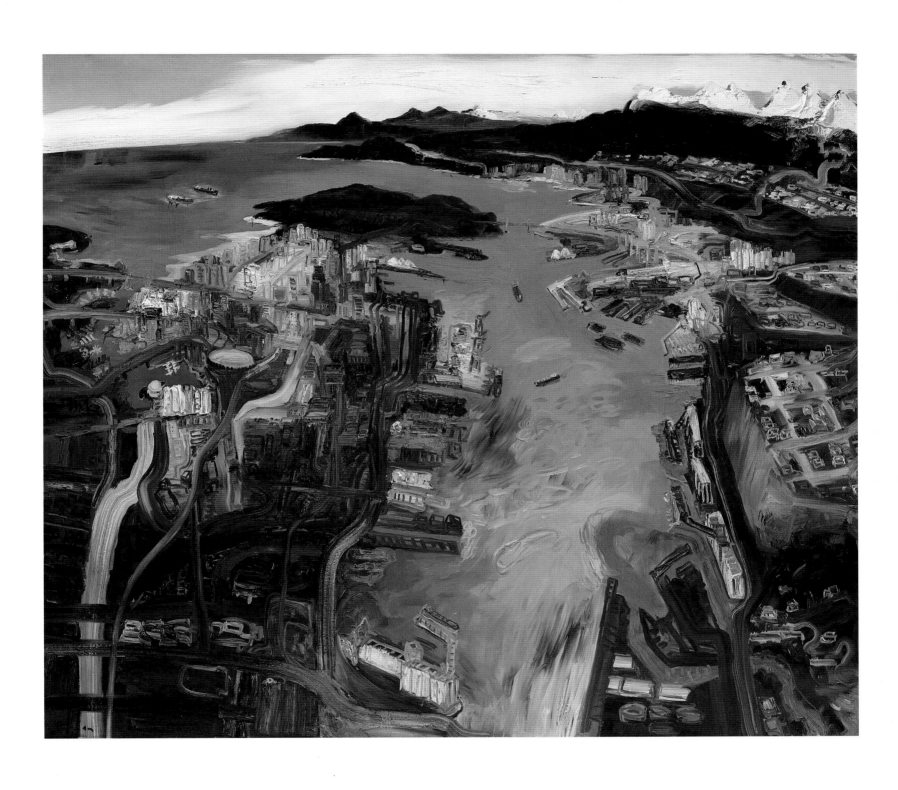

Cement/Head/05, 2005, oil, wax medium and digital print on heavy weight paper,
40 × 58 inches / 101.6 × 147.6 cm

"The violated female body and the natural world ravaged by industry superimposed over it,
offer a comparison of our relationship to nature with the cultural construct of destroyed
feminine beauty."

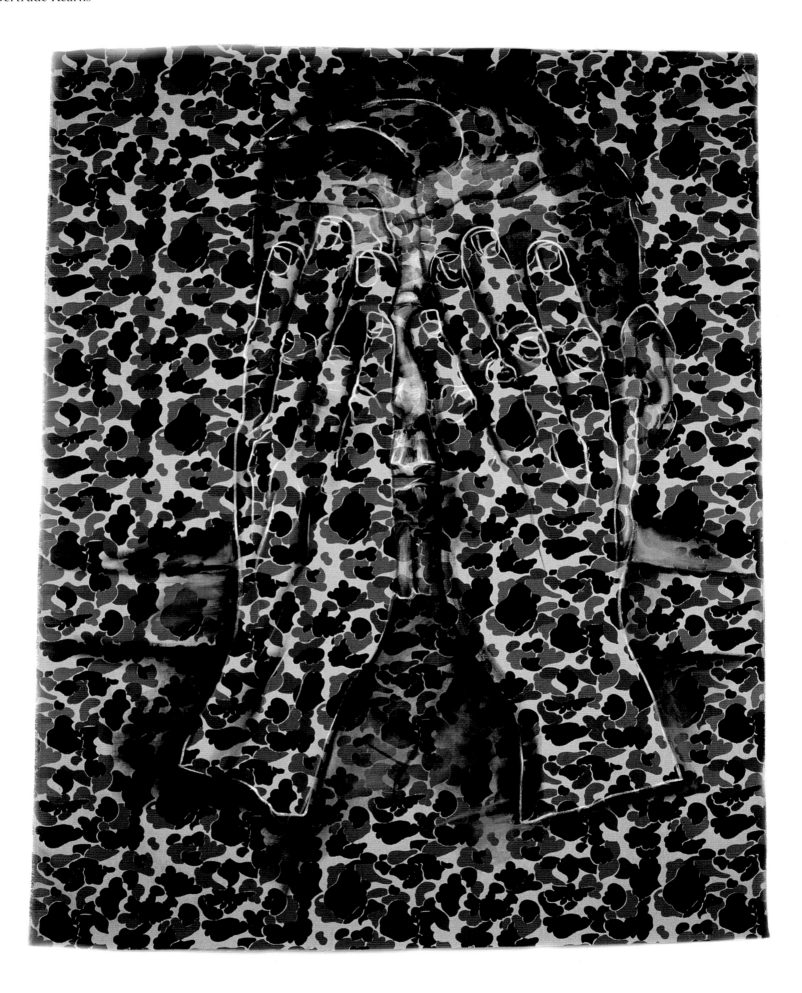

Dallaire #6, from the series *UNdone:Dallaire/Rwanda,* 2002, enamel, oil on nylon,
70.8 × 61 inches / 180 × 155 cm

Piety Prozac and Proclivities, from the series *John Bentley Mays,* 2005, ink, acrylic on 4-ply board,
60.2 × 40.2 inches / 153 × 102 cm

"Interest in internal and external conflicts and the play of conscience has directed certain themes.
Abstract work has continued to be equally significant as an expression of the dynamics of self."

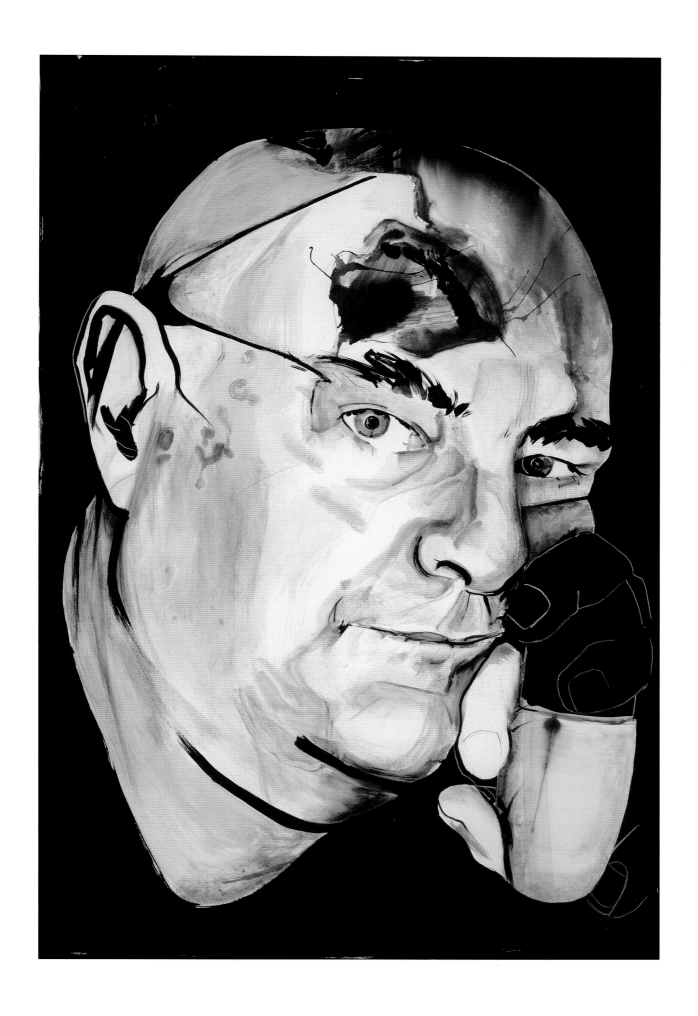

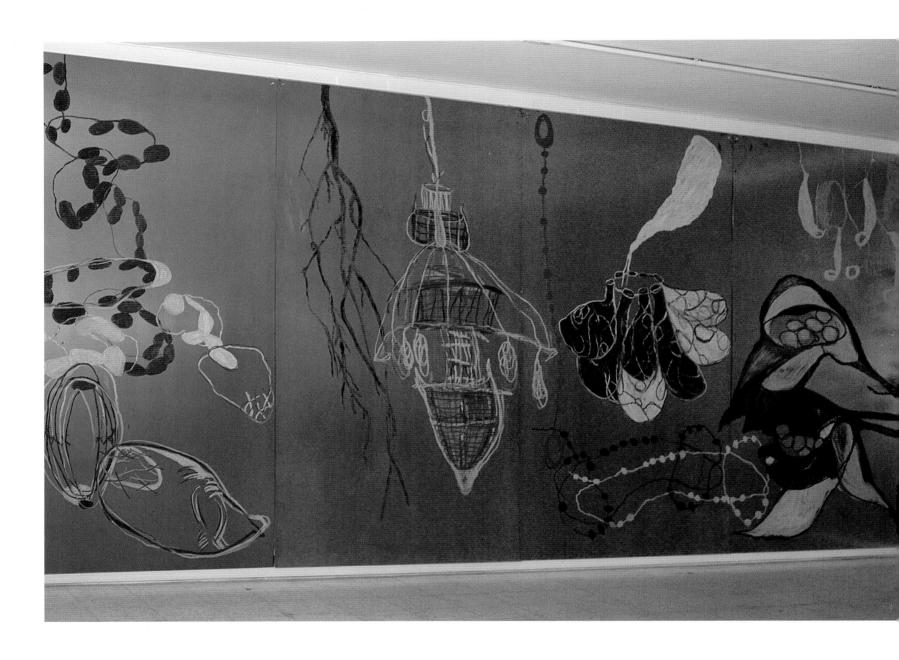

Steel Notebook, 2005, oilstick on steel, 96 × 384 inches / 243.8 × 975.4 cm

"My drawings and paintings are concerned with the strength of vulnerability, fragility and slowness. They come from a space of intuition, sensuality and instinctive intelligence."

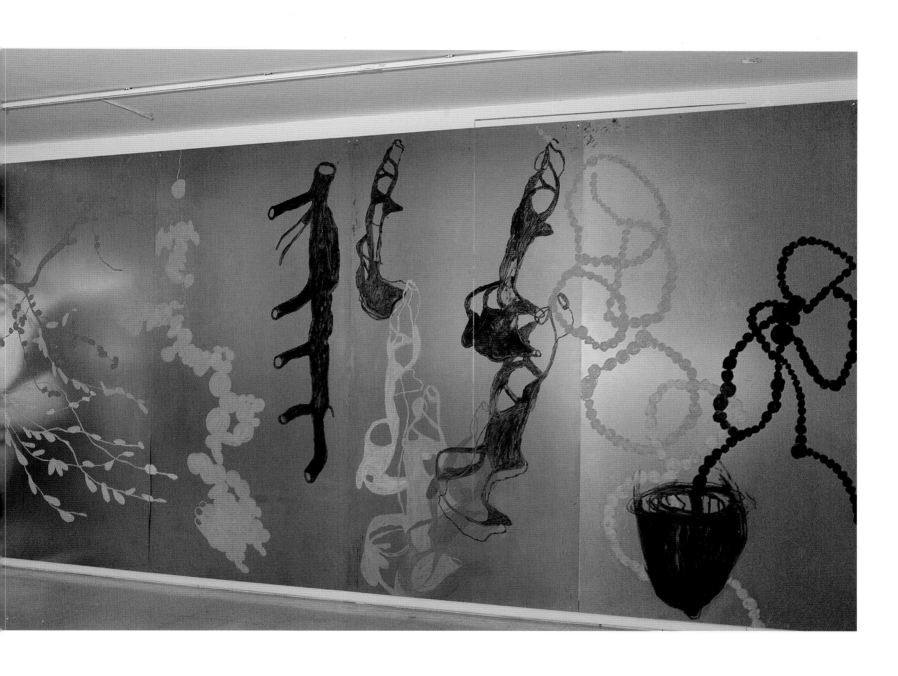

established
Garry Neill Kennedy

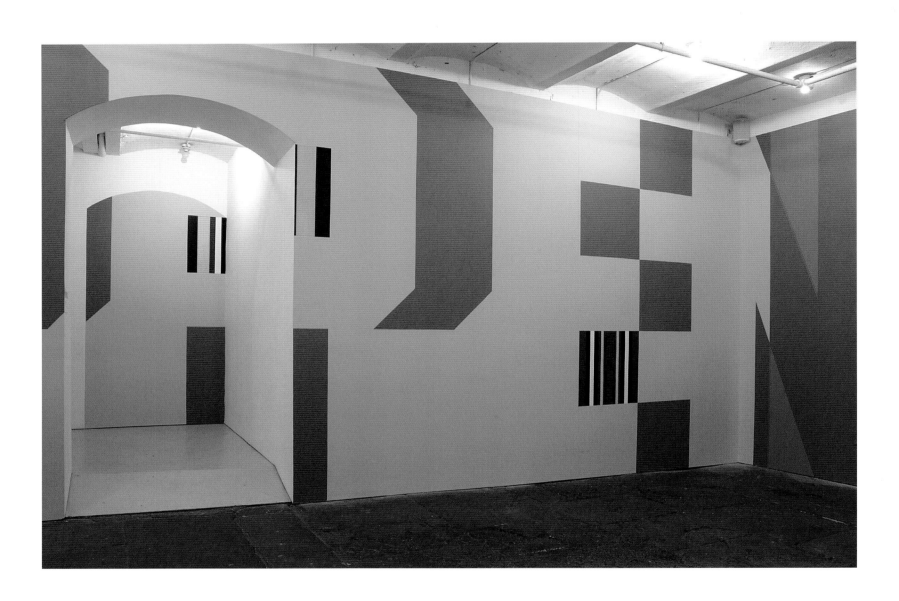

Shit Happens, 2006, latex paint on wall, 180 × 1,440 inches / 457. × 3,657.6 cm

The Colours of Citizen Arar, 2007, latex paint on wall, 156 × 2,280 inches / 396.2 × 5,791.2 cm

"I found that by asking questions like, 'What goes on here?' or 'What is this about?' of the place or site of painting, similar questions could be asked of the conditions of paintings' surroundings or context—e.g. the function of museums and galleries, their support systems, the relationships of the artist, the curator and the critic—questions of the components of the institutional structure of art."

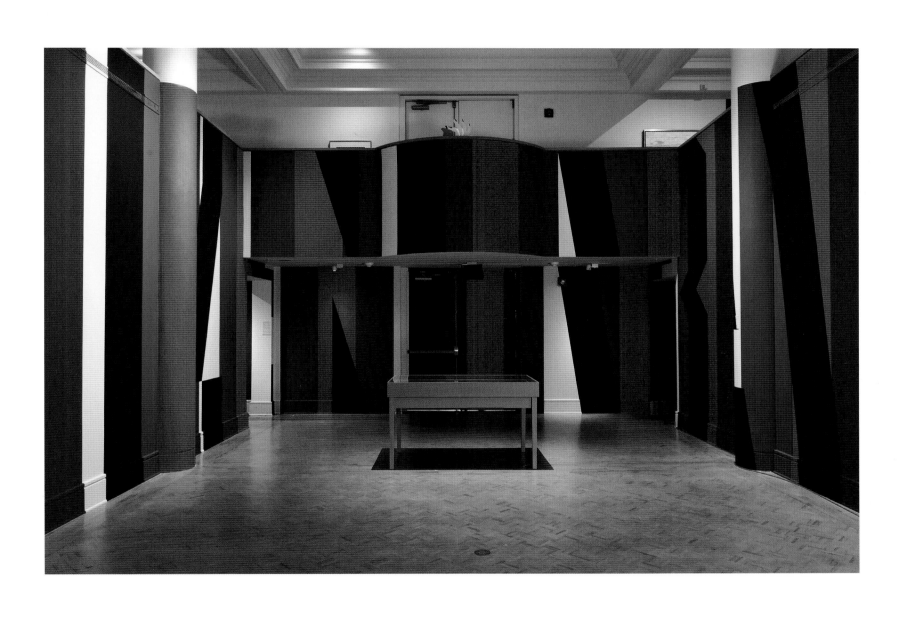

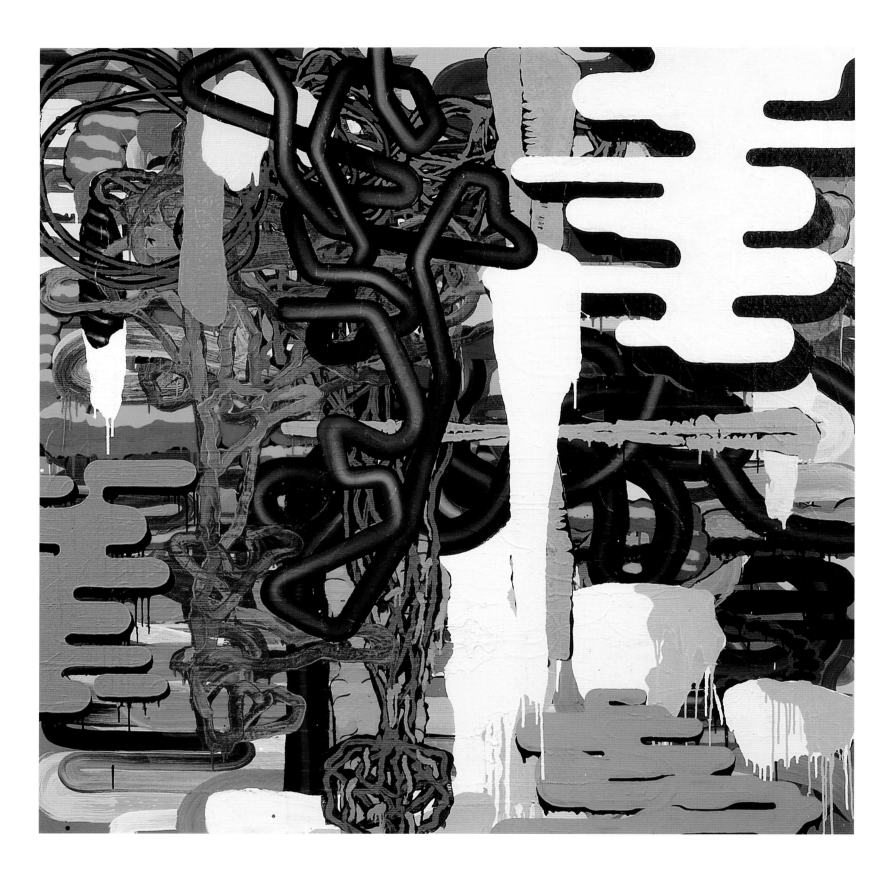

Three Paintings on a Pop Song #1, 2008, oil and alkyd on canvas, 66 × 66 inches / 167.6 × 167.6 cm

Three Paintings on a Pop Song #3, 2008, oil and alkyd on canvas, 66 × 66 inches / 167.6 × 167.6 cm

"Max Ernst coined the term 'fever vision' in the early 1920s to describe a kind of visual delirium and psychological slippage that can occur in front of certain kinds of visual assemblages. I am finding myself increasingly attracted to this notion because of the implied emphasis in a loss of control on the part of the viewer in attempting to apprehend meaning."

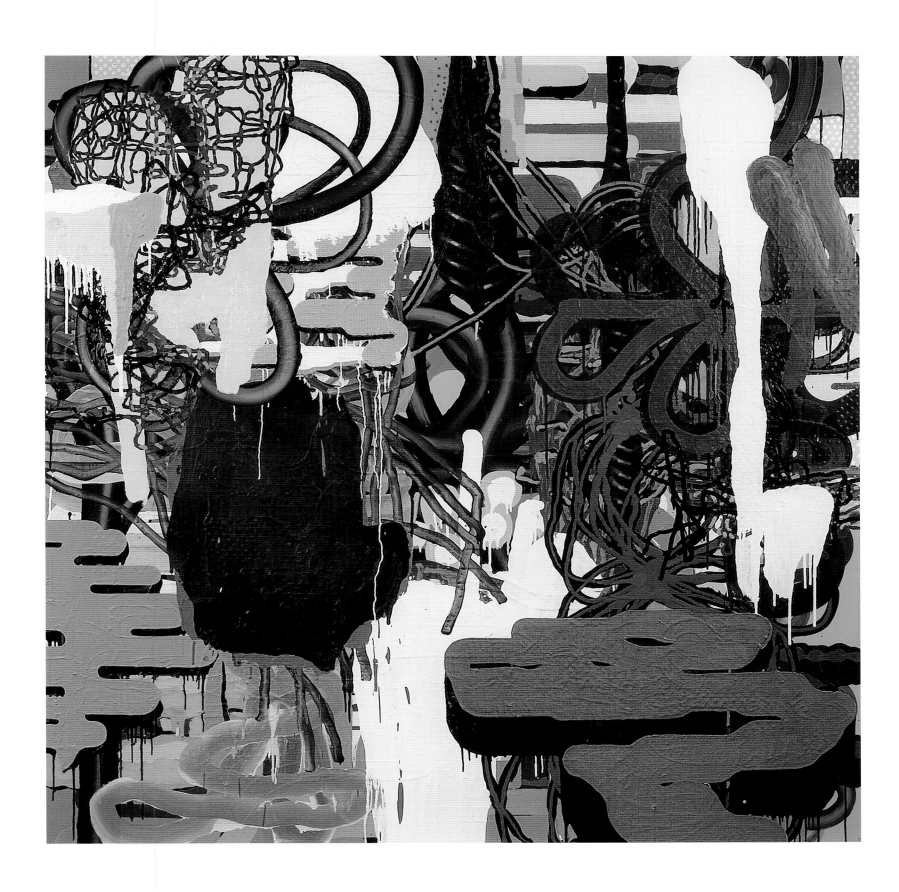

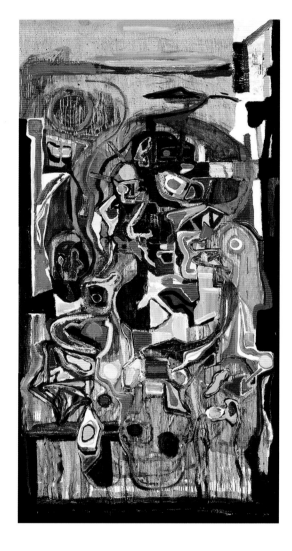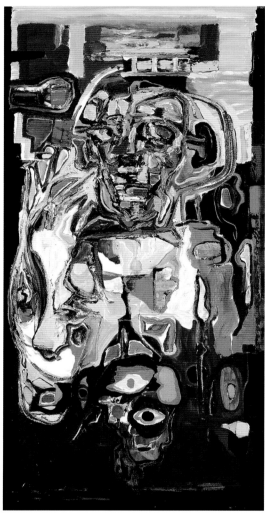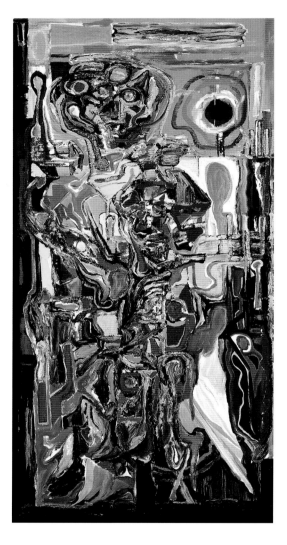

Infinity on Trial, 2005–2007, oil on canvas, 6 panels, 100 × 50 inches / 254 × 127 cm each,
100 × 300 inches / 254 × 762 cm total, collection of The National Gallery of Canada

"When paint becomes more than just paint, the painting begins to have a life. I move paint
around to connect with where I have been and where I'm going. I trust my intuition and
try not to second guess what may or may not work."

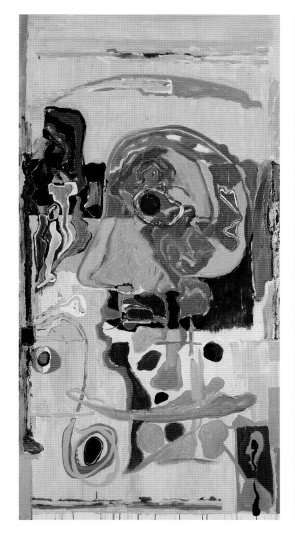 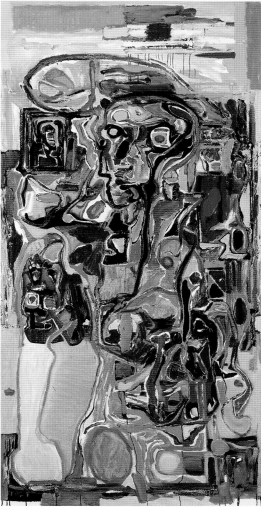 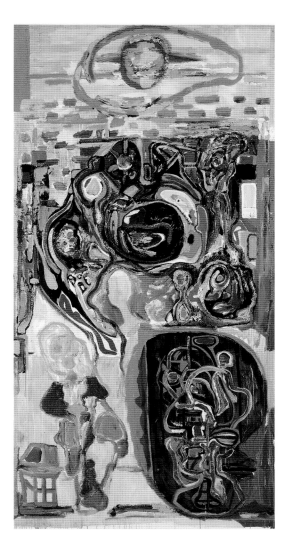

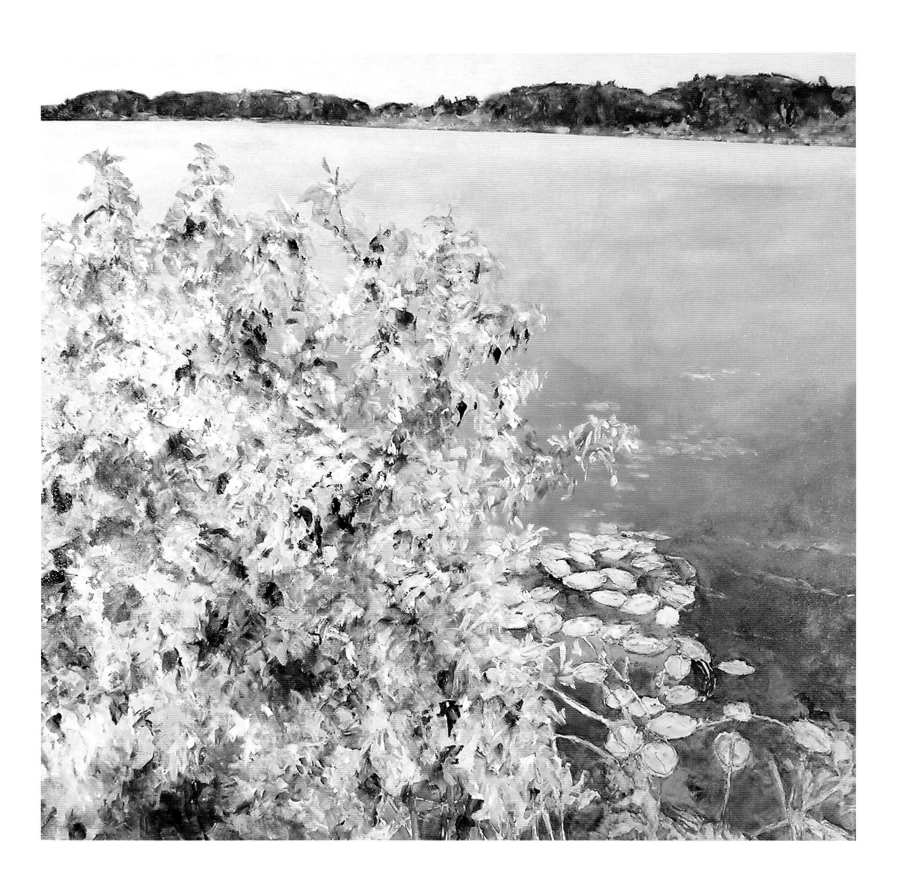

Yellow Bush, 1999, acrylic on canvas, 36 × 36 inches / 91.4 × 91.4 cm

Dark Reeds, 1998, acrylic on canvas, 36 × 36 inches / 91.4 × 91.4 cm

"A sense of place, which has always been important to me, is also important to my audience.
People connect with and are curious about the location of the images in the paintings."

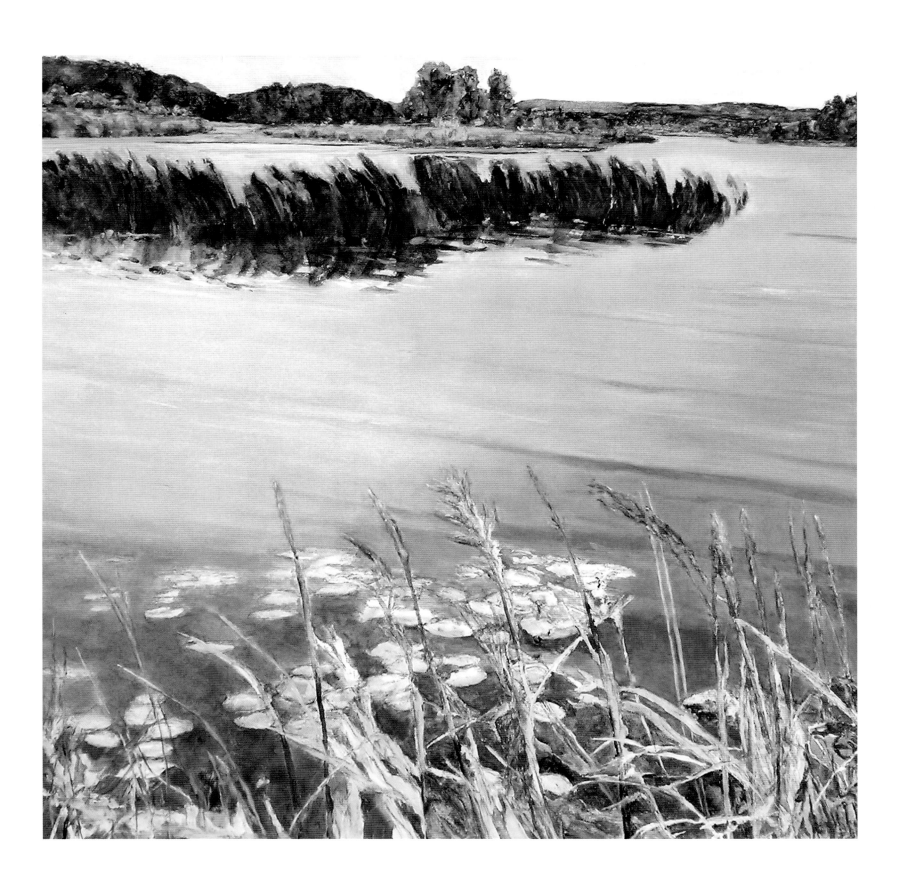

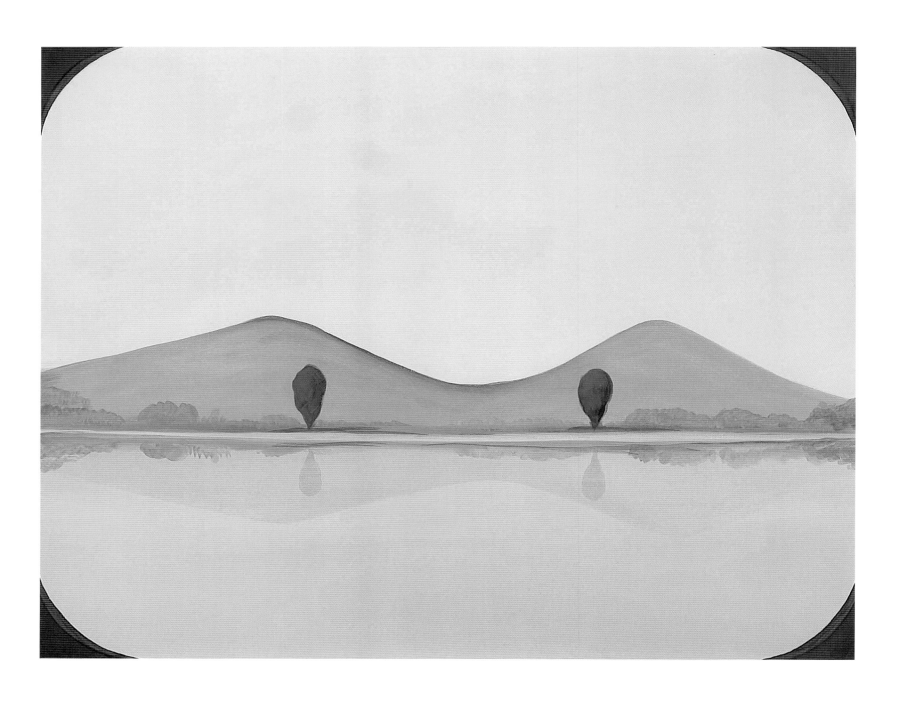

Two Trees, 2005, acrylic on canvas, 28 × 36 inches / 71.1 × 91.4 cm

Green Zone (Colour Bars), 2006, acrylic on canvas, 24 × 36 inches / 61 × 91.4 cm

"For me, painting is a medium of the present—it is a powerful vehicle for communication
of observation and lived experience far-reaching into the future."

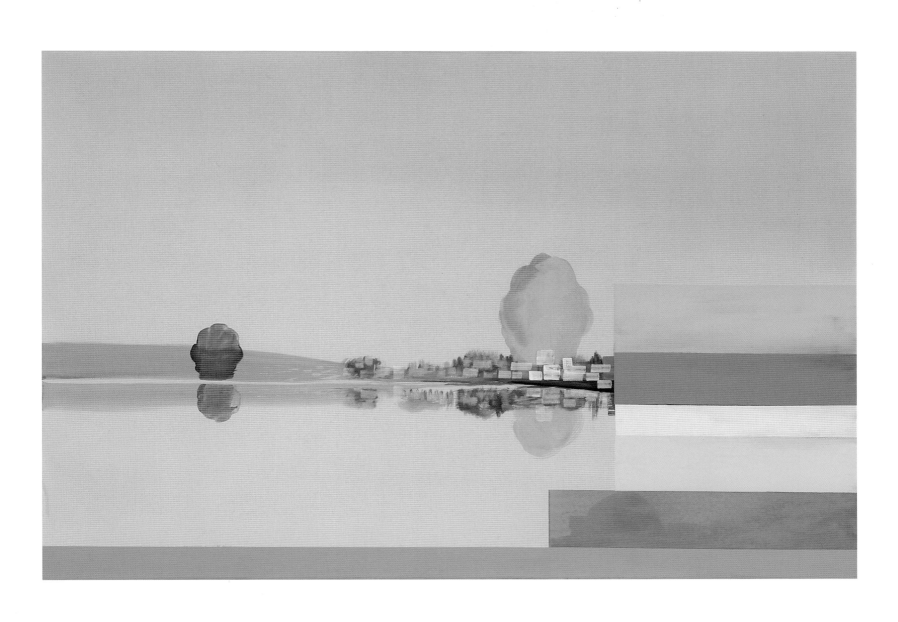

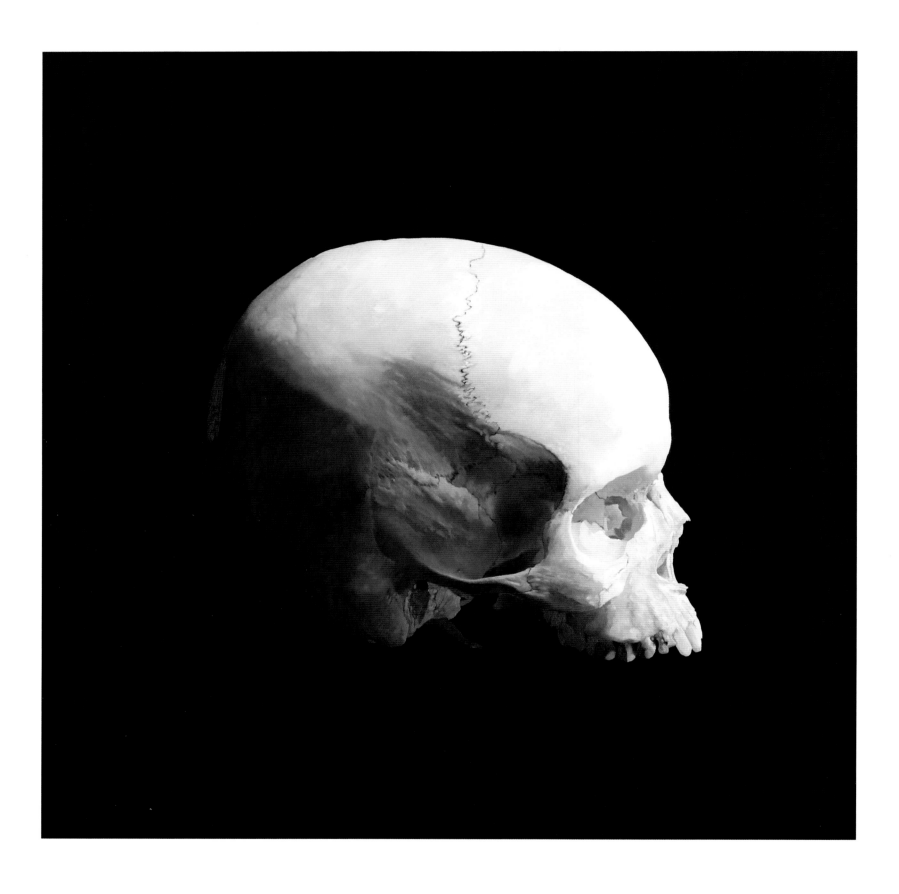

Skull, (from Keep Out), 2007, oil, alkyd and ink transfer on canvas, 36 × 36 inches / 91.4 × 91.4 cm

Skull, (not for finding), 2007, oil, alkyd and ink transfer on canvas, 84 × 60 inches / 213.4 × 152.4 cm

"The work is cyclical, constantly shifting, moving, mutable, yet returning to essential propositions
that explore conditions of stability and instability, speed, time and memory. Type and style
polarities do not exist for me. When I paint, all the pictures are the same."

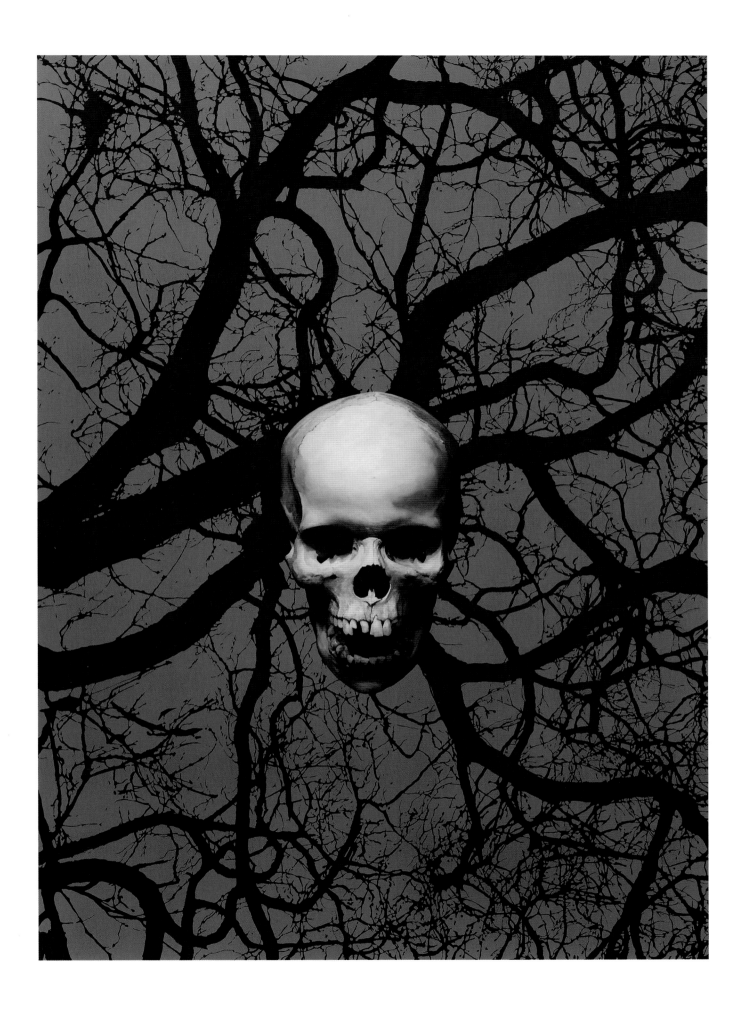

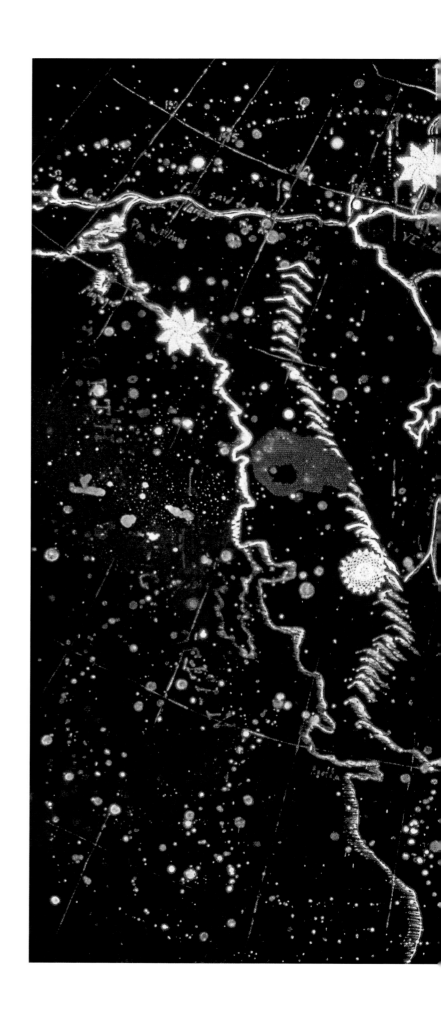

Space Station (Falls Said to be the Largest in the Known World So Far), 1999,
synthetic polymer on linen, 90 × 126 inches / 228.6 × 320 cm

"The paintings are avidly viewed and read by professionals from other disciplines,
notably historians, geographers and poets."

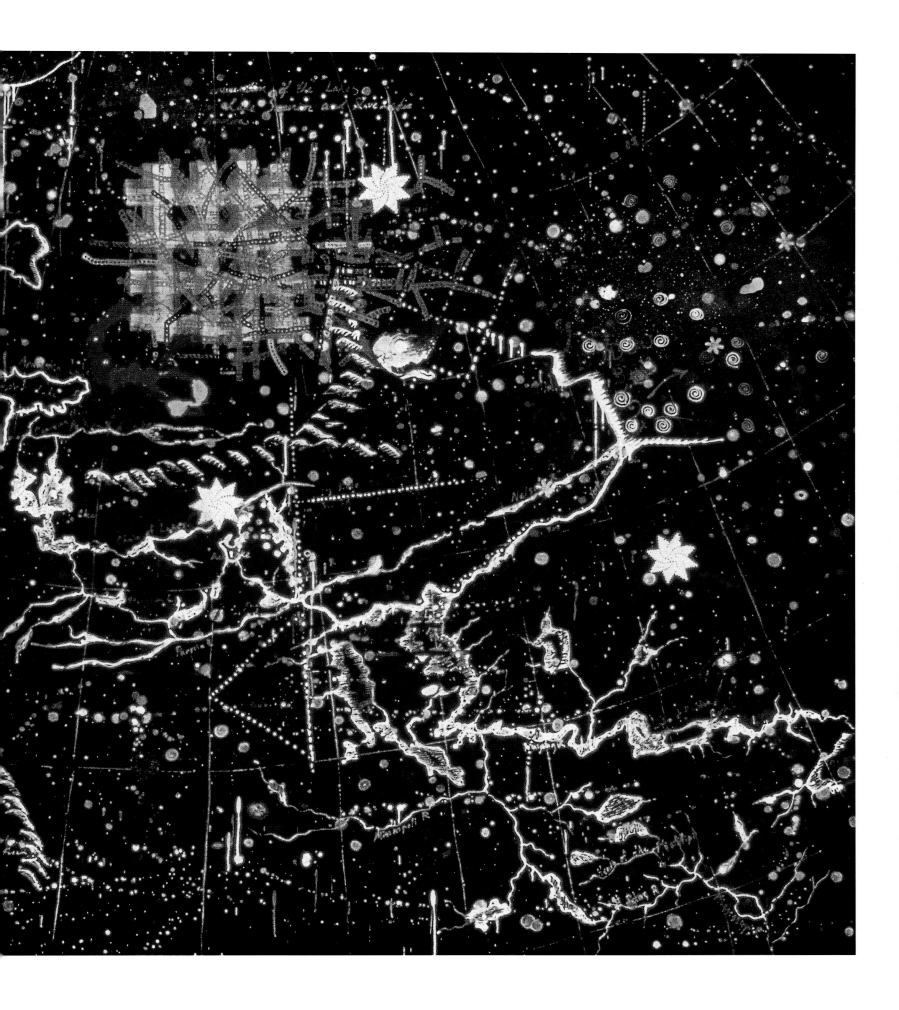

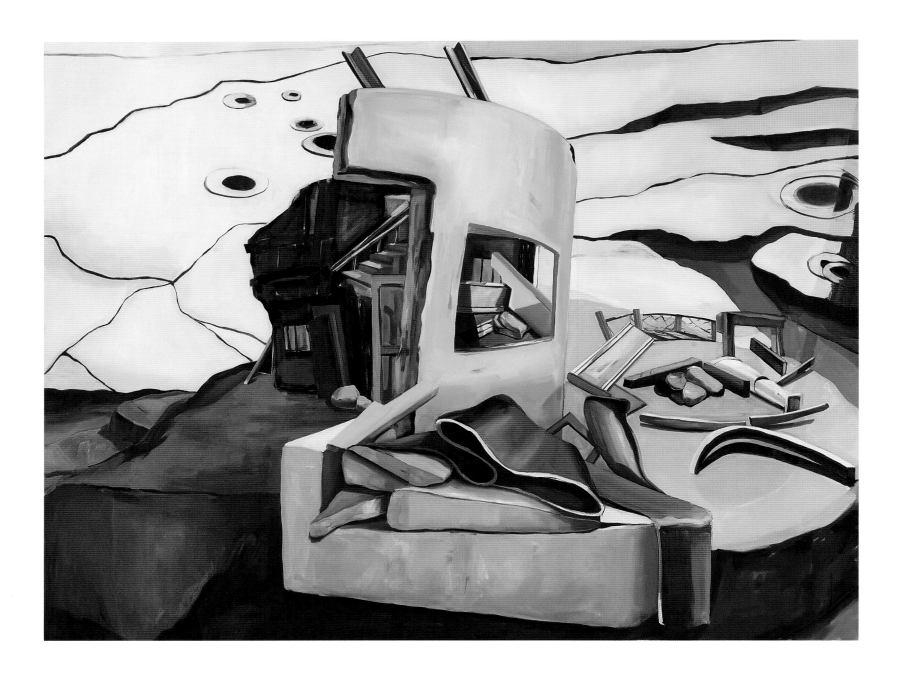

Command Centre, 2006, oil on canvas, 64 × 84 inches / 162.6 × 213.4 cm

Pop Goes the Weasel, 2005, vinyl polymer on canvas, 65 × 98 inches / 165.1 × 248.9 cm

"The central preoccupation in my work has been a meditation on survival and the conflation
of real and imaginary worlds. Although the paintings retain a private and personal lexicon of
imagery, the subject matter references recent political and social events."

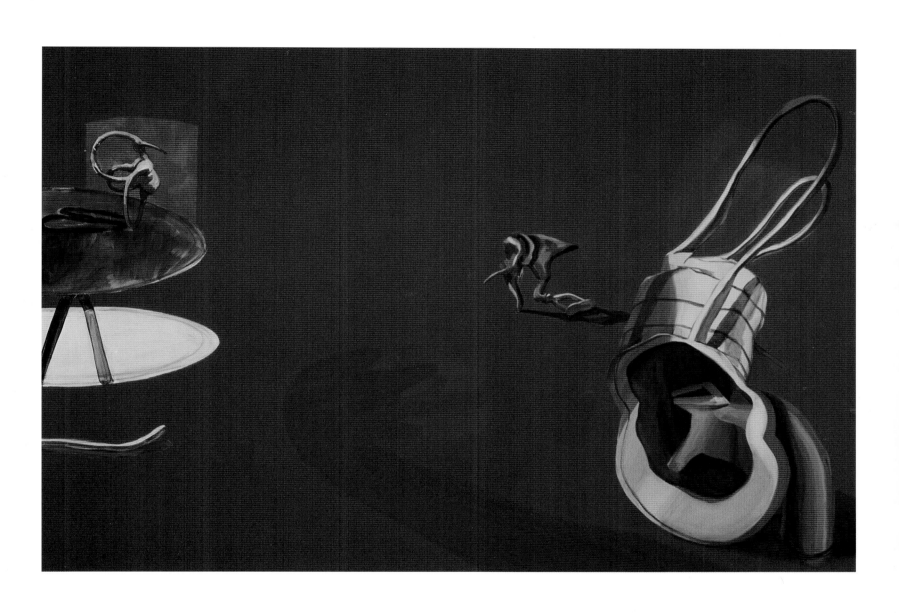

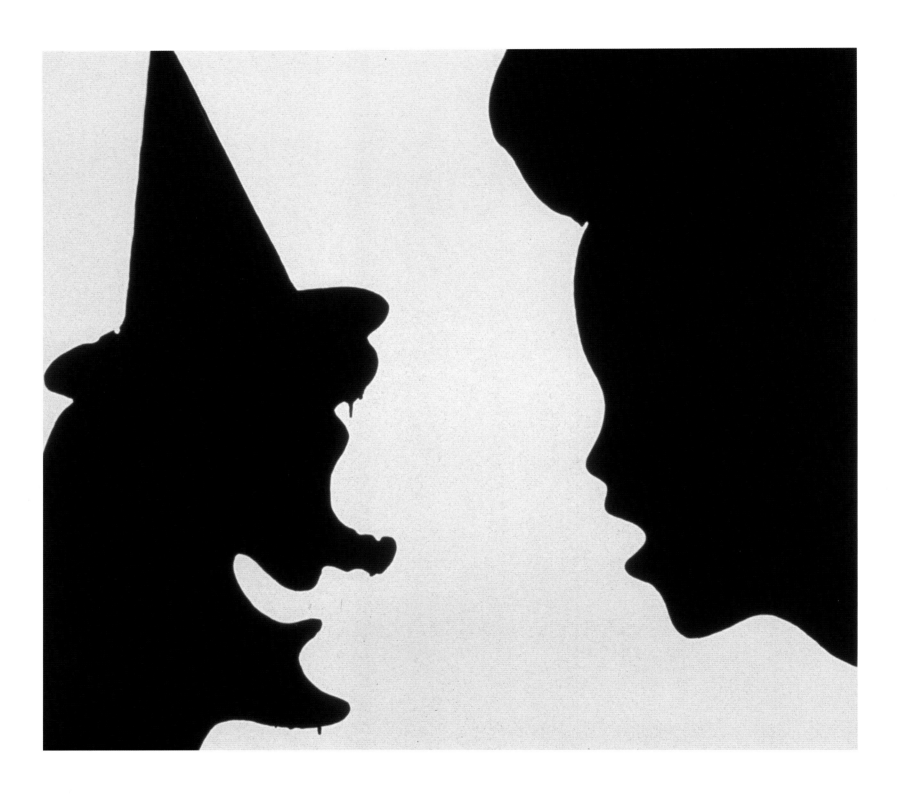

Bump.Blue, 2003, oil and gesso and canvas on board, 46 × 48 inches / 116.8 × 121.9 cm

Girl Kissing Ducks.Blue, 2004, oil and gesso and canvas on board, 37 × 37 inches / 94 × 94 cm

"Like the work of the visionary artist Adolph Wolfi, there is obsession with the edges of the canvas. No canvas edge escapes the compositional dynamic. There is no illusionary space, only form."

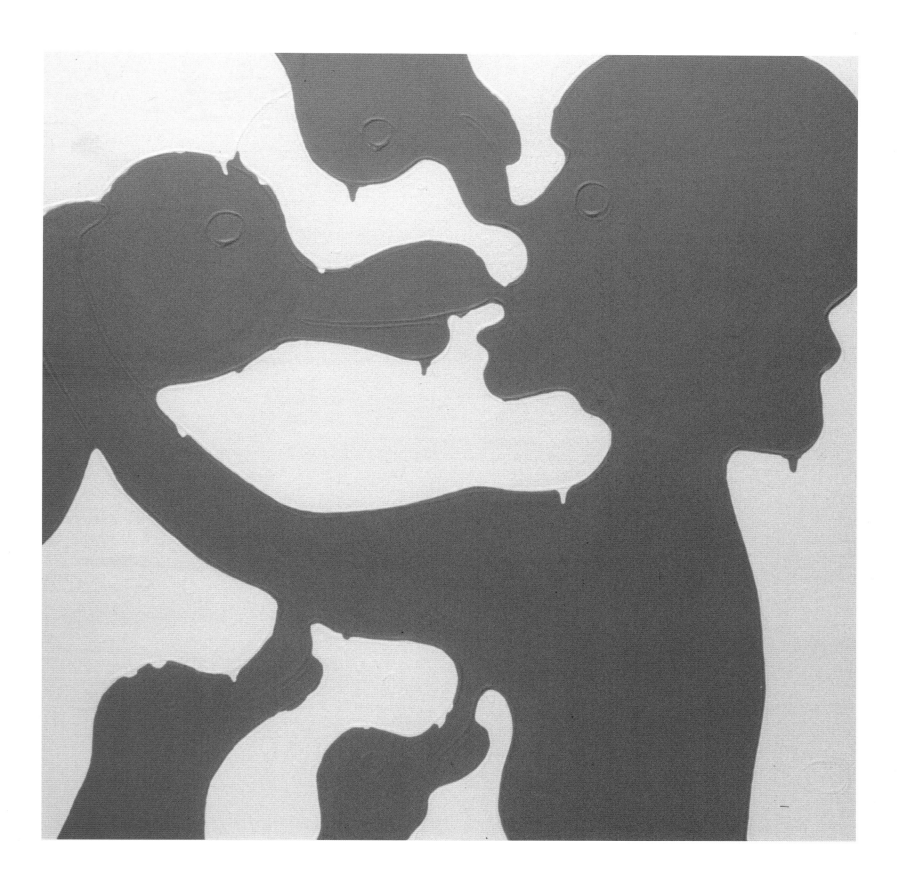

Castle Shore, 2005, acrylic and oil on canvas, 54 × 48 inches / 137.2 × 121.9 cm

"I make the space in my paintings reminiscent of the sea, outer space or a landscape. Symbols enter or leave on the edges. The vastness of these spaces and how they are altered by what enters or departs intrigues me."

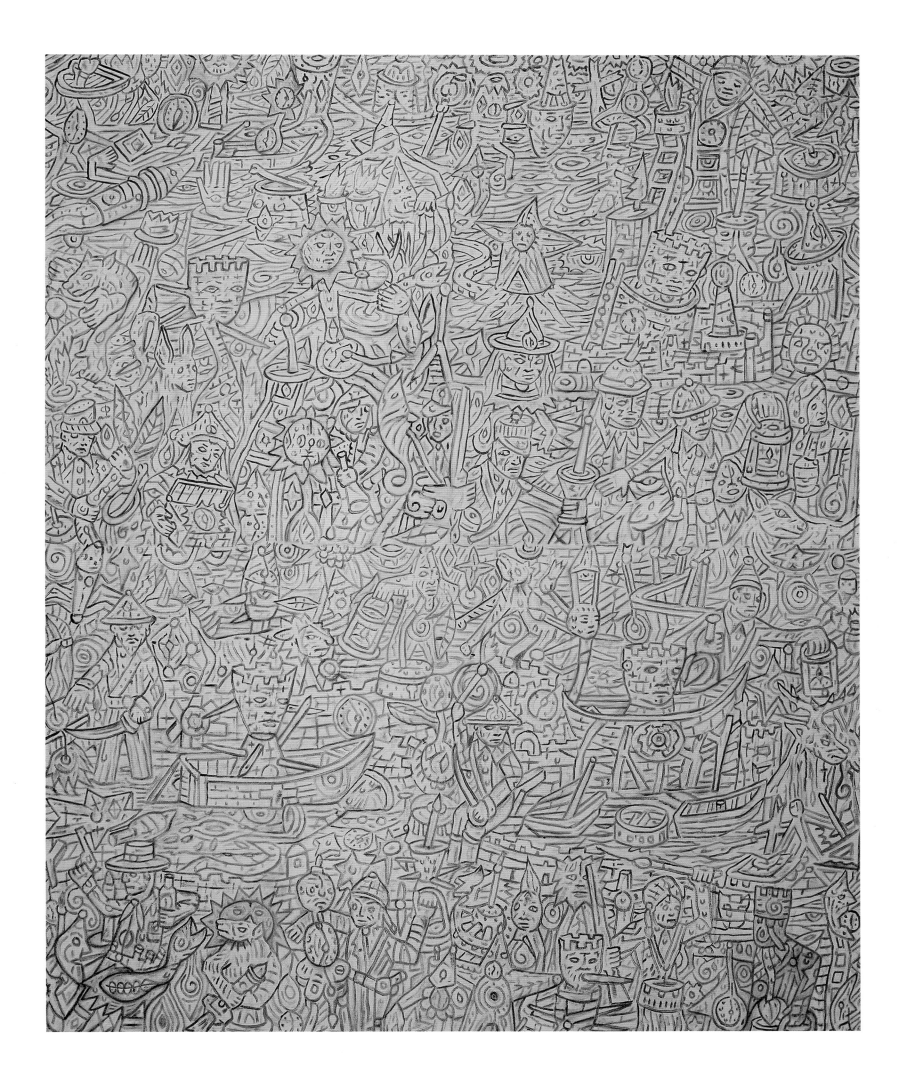

Untitled, AC-65-001, 1965, acrylic on canvas, 34.8 × 29 inches / 88.4 × 73.7 cm

"My connection to the Prairie, the North Saskatchewan River and the rural
community in which I grew up provided me with a personal foundation and
a sense of place upon which my artwork could develop and thrive."

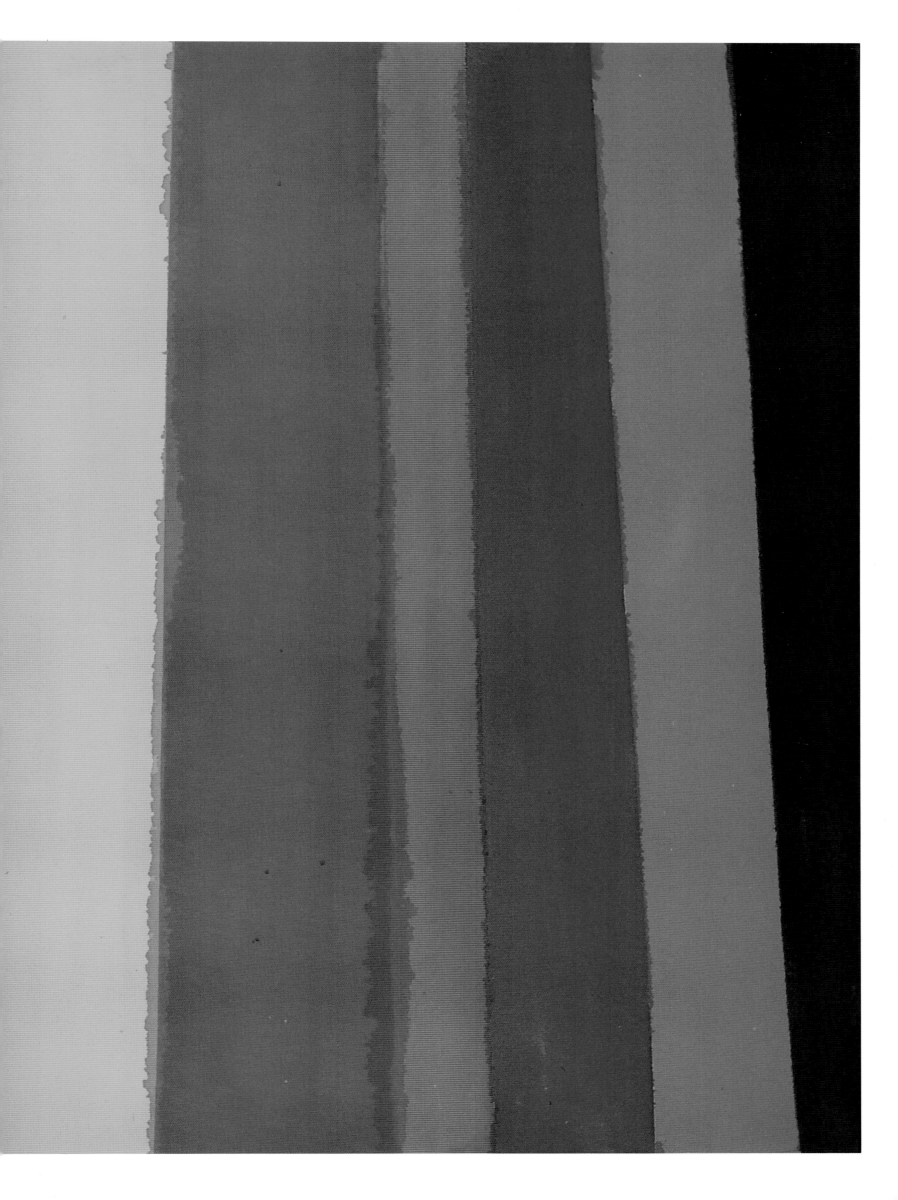

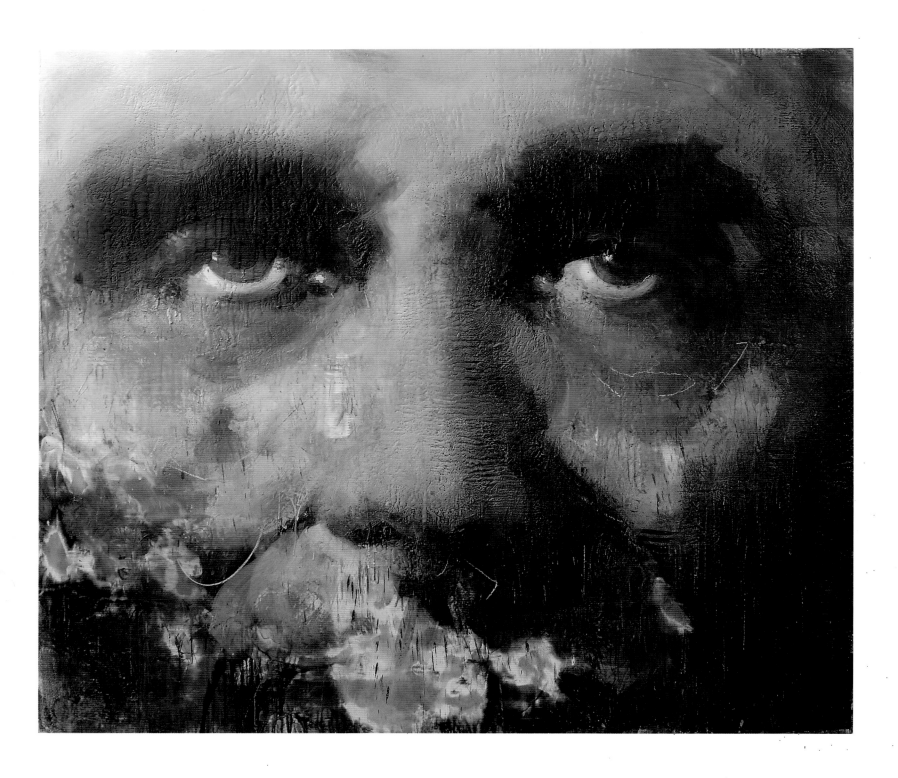

Lincoln, from the series *About 1865,* 2004–2006, encaustic on canvas, 84 × 96 inches / 213.4 × 243.8 cm

Lady Macbeth, from the series *Banquo's Funeral,* 1994, encaustic on canvas, 40 × 36 inches / 101.6 × 91.4 cm

"Artists are always asked questions pertaining to the 'what' and really only want to talk about the 'how.'
The 'how' cannot be spoken about without the 'doing,' and the 'doing' cannot be spoken about without
'being in doing.' This leaves artists at a great impasse in talking about their work, which quite often
leads to tedium, boredom and, finally, irritation. This explains at least in part why so many artists in their
maturity elect to say little or nothing. I am getting close, but not quite there yet."

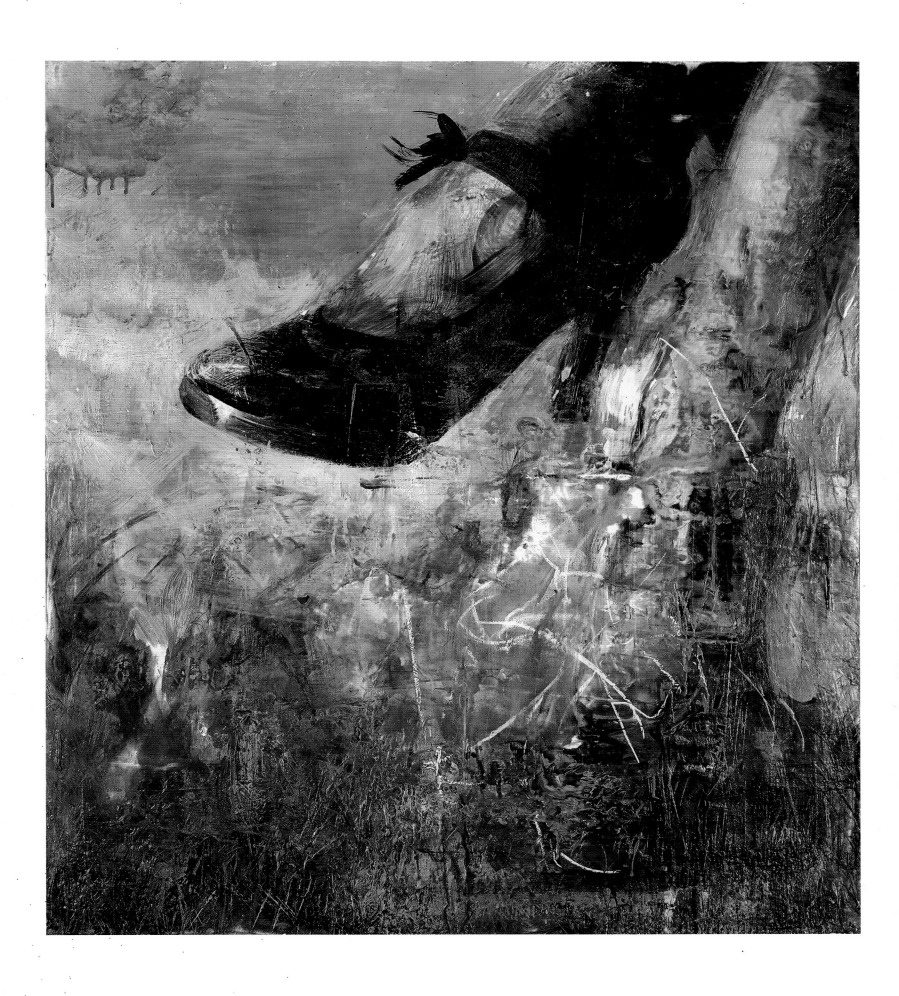

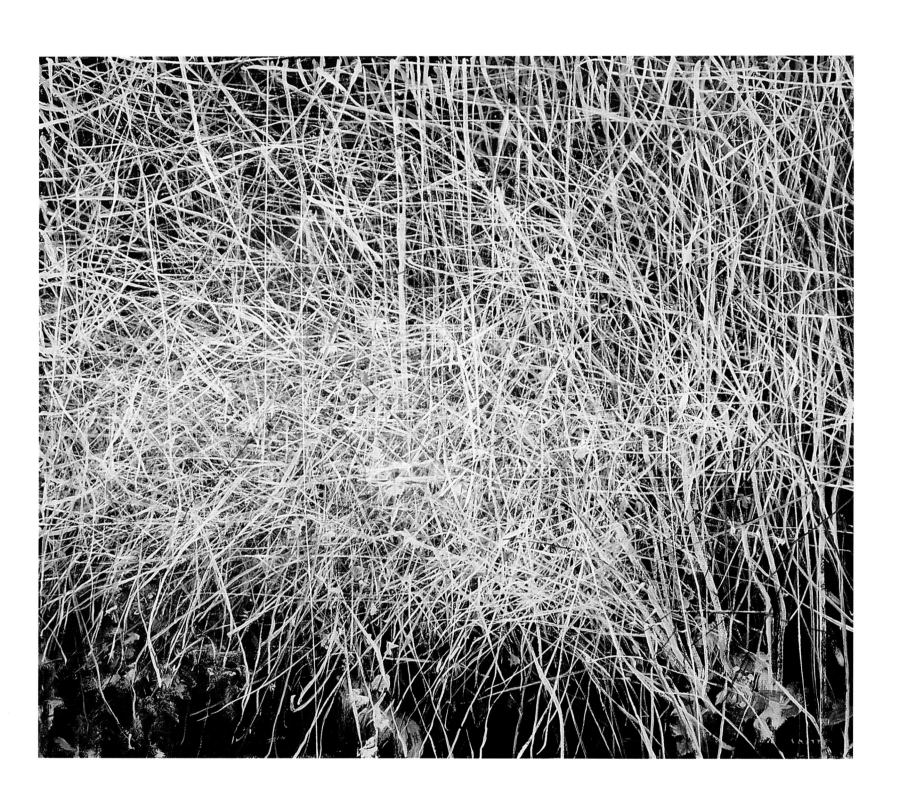

Whytecliff Shore, 2006, acrylic on canvas, 60 × 67 inches / 152.4 × 170.2 cm

January Snow, 2006, acrylic on canvas, 60 × 67 inches / 152.4 × 170.2 cm

"For more than 50 years Smith has painted the Canadian landscape and has consistently
explored the mediums of drawing, painting and printmaking in inventive and expressive ways.
Never satisfied, he continues to explore and express new visions and exciting vistas daily."

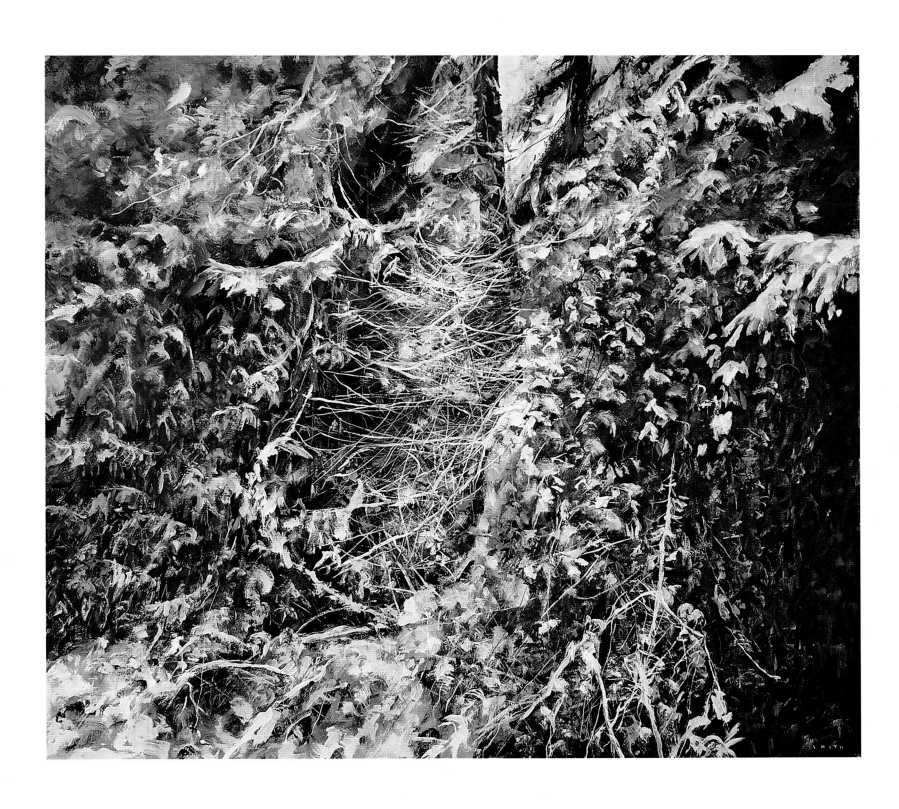

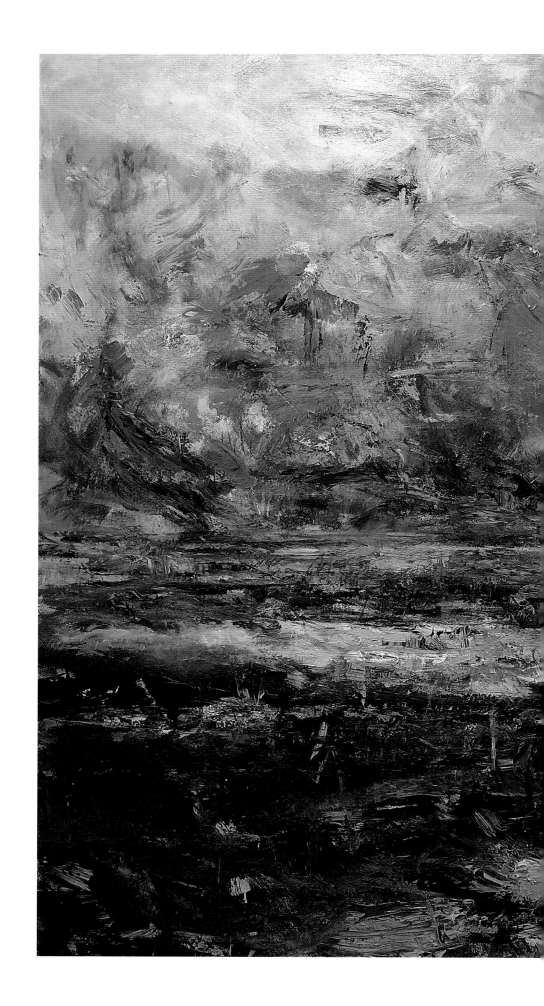

Cradle of Words, 2005, acrylic on canvas,
102 × 150 inches / 259 × 381 cm

"I sometimes work on and over each painting for years,
until, for me, the work comes alive. The surfaces become
the unedited layers of this searching. By rekindling
sensations of light, distance and time, my paintings
further an investigation of the fugitive nature of recall
and observation."

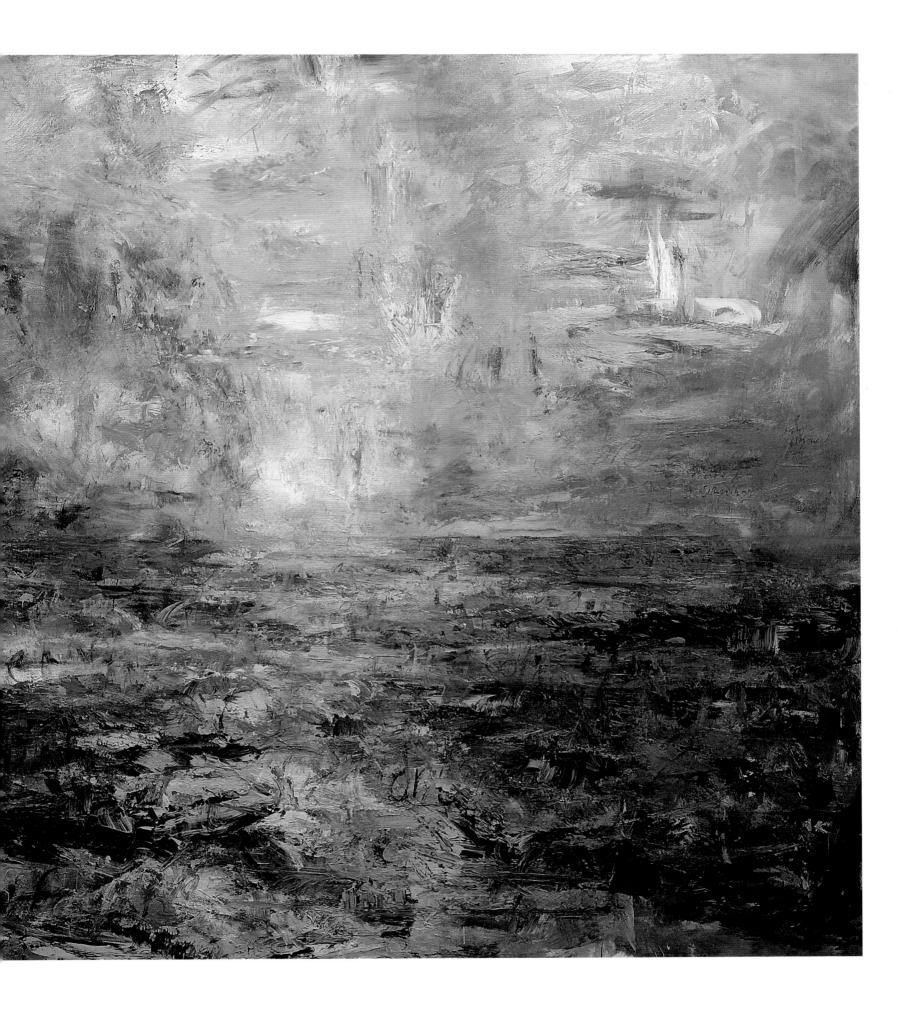

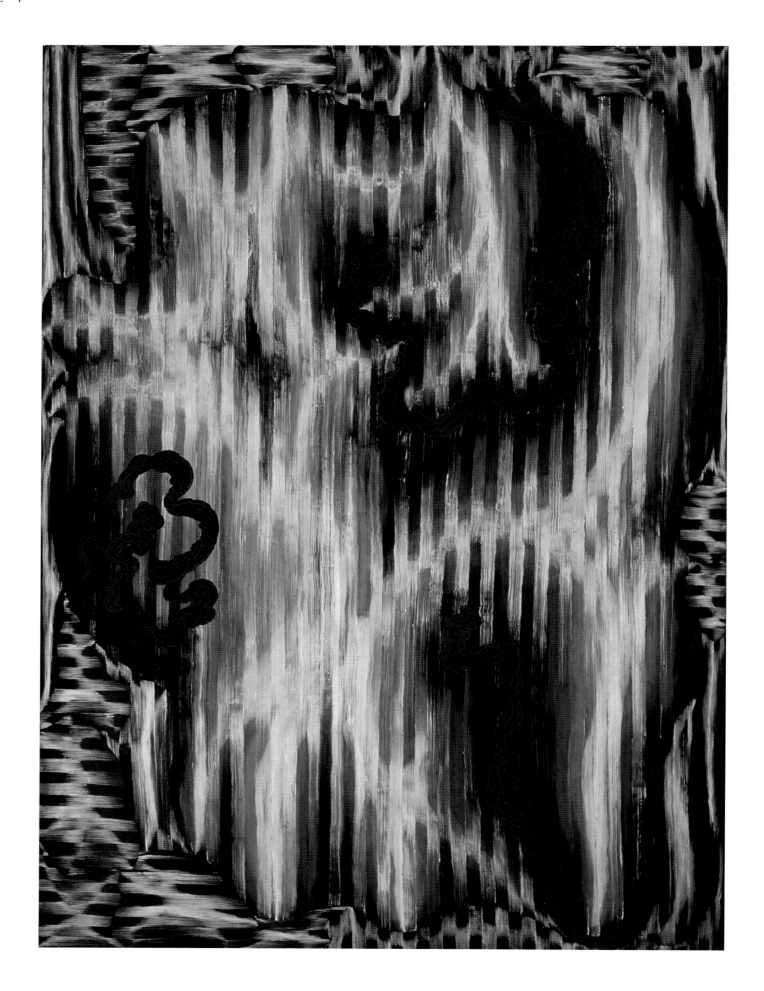

Image Name, 2002, oil on canvas, 72 × 50 inches / 182.9 ×127 cm

Huron Blue, 2006, oil on canvas, 40 × 30 inches / 101.6 × 76.2 cm

"I strive to make paintings a workout for the eye, the mind and the body. This for me provides
an inspiring creative process between audience and artwork."

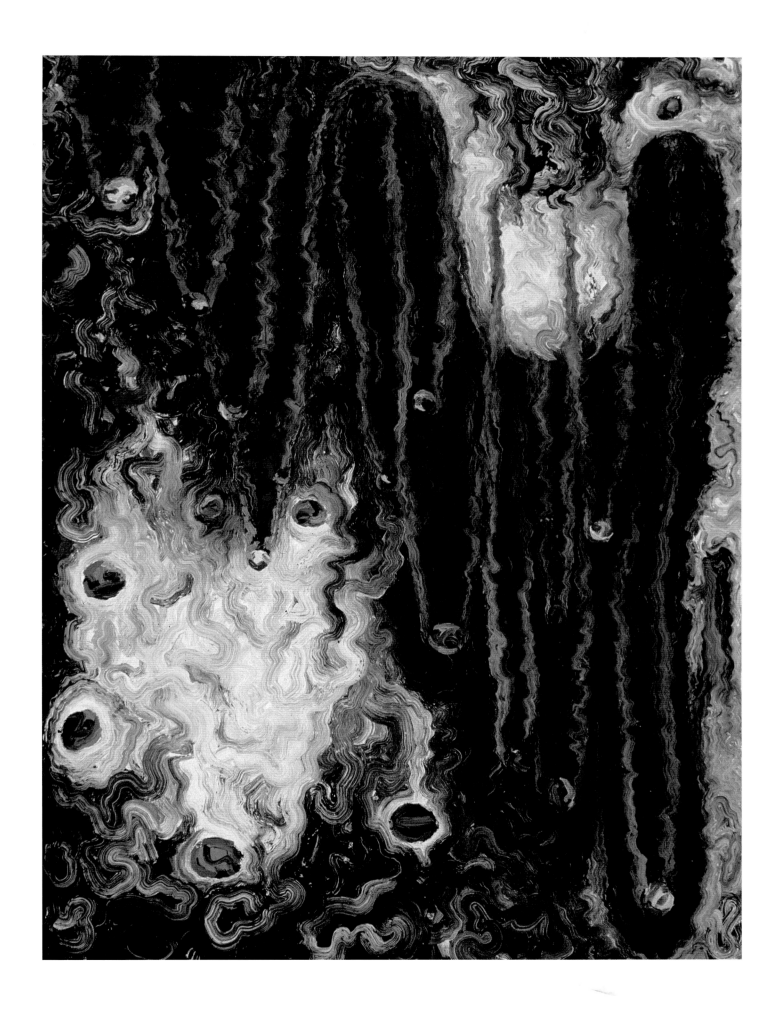

Your Skin in This Weather Bourne Eye—Threads & Swollen Perfume, 1995, concrete, Structo-Lite,
miscellaneous building materials, paint, carpet, lamps, electrical cord, purple plastic stacking crates,
swimming pool liner, steel, stuffed shirts, pillows, paper mache, balls, ground floor of Dia Center
for the Arts on 22nd St., NYC

"My work doesn't have a frame, in the usual sense, nor a pedestal. But it often relies on its status
as art to be a gestalt; it would otherwise not exist as a separate entity among everything else. Each
piece relies on its context for definition and also on the idea of 'frame' that we all carry with us."

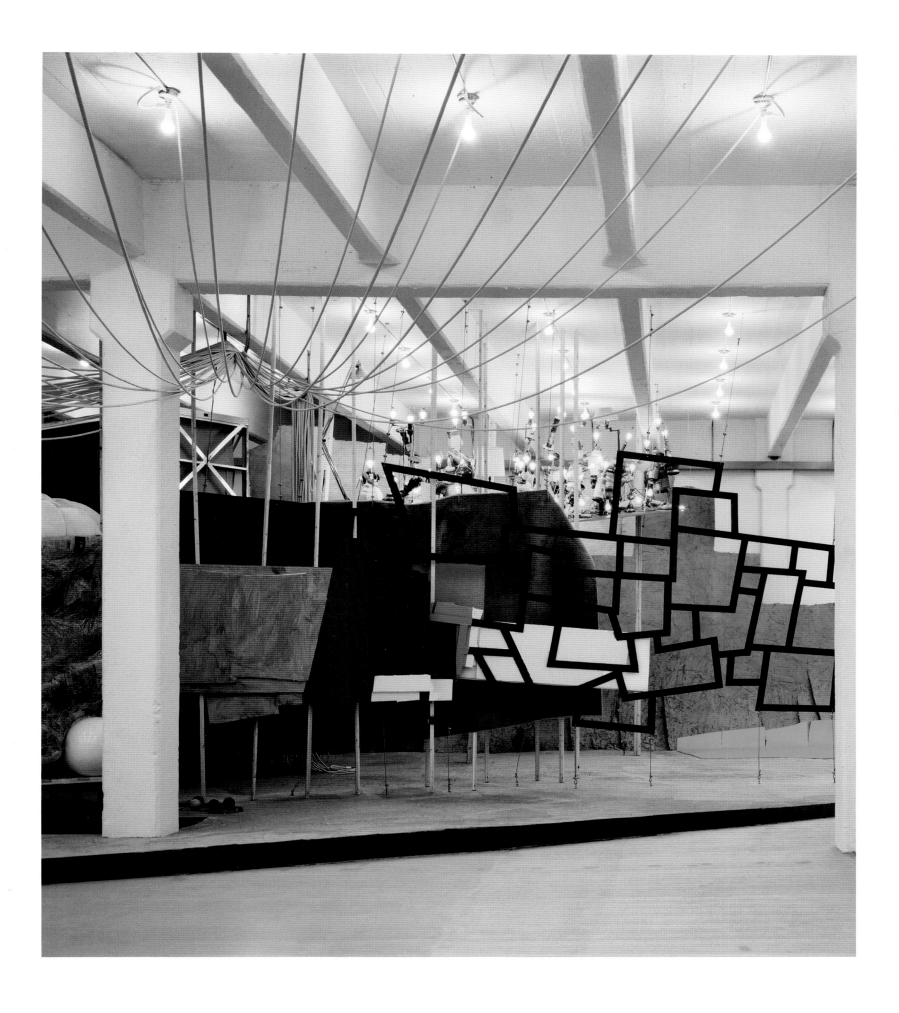

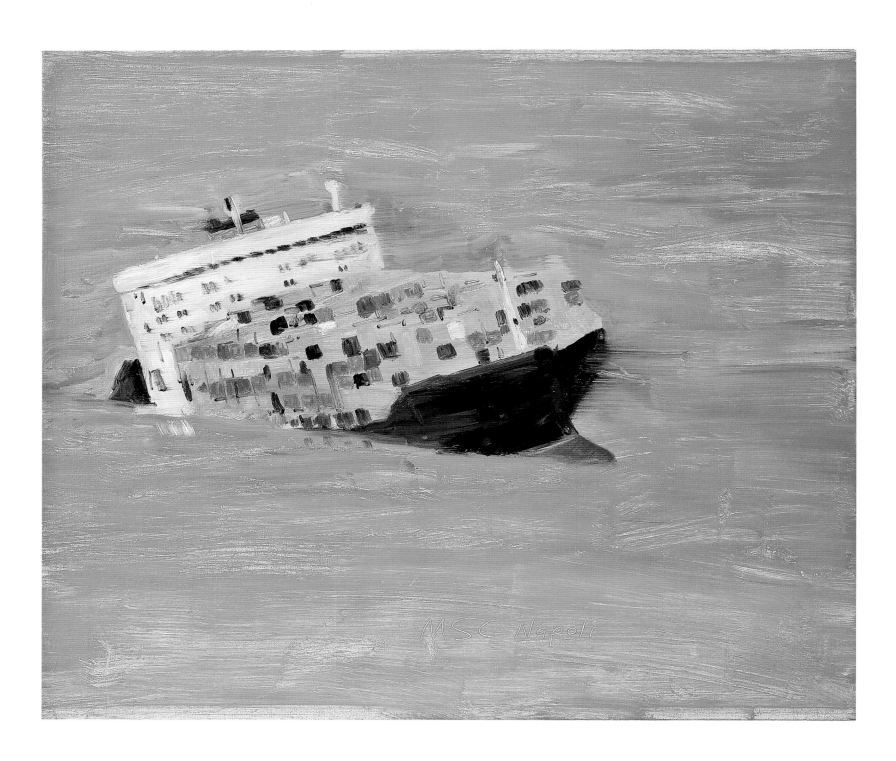

MSC Napoli, 2007, oil on canvas, 20 × 24 inches / 50.8 × 61 cm

London Apt Fire, 2007, oil on canvas, 20 × 22 inches / 50.8 × 55.9 cm

"These works are derived from imagery culled from the news media, the Internet and my own photographs. My work addresses issues of the public and private realm, surveillance and a world under stress."

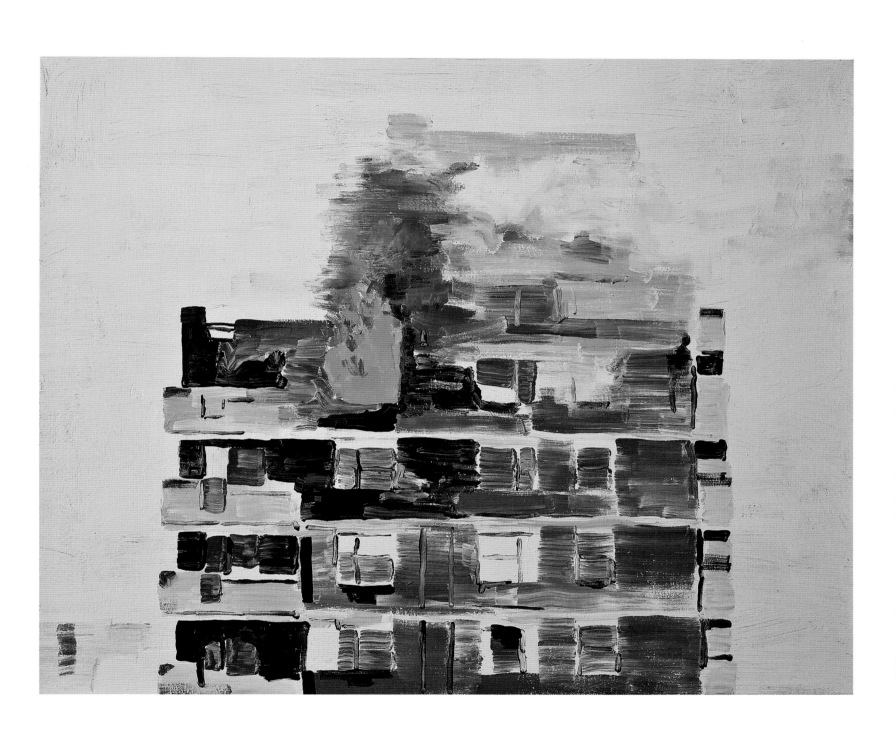

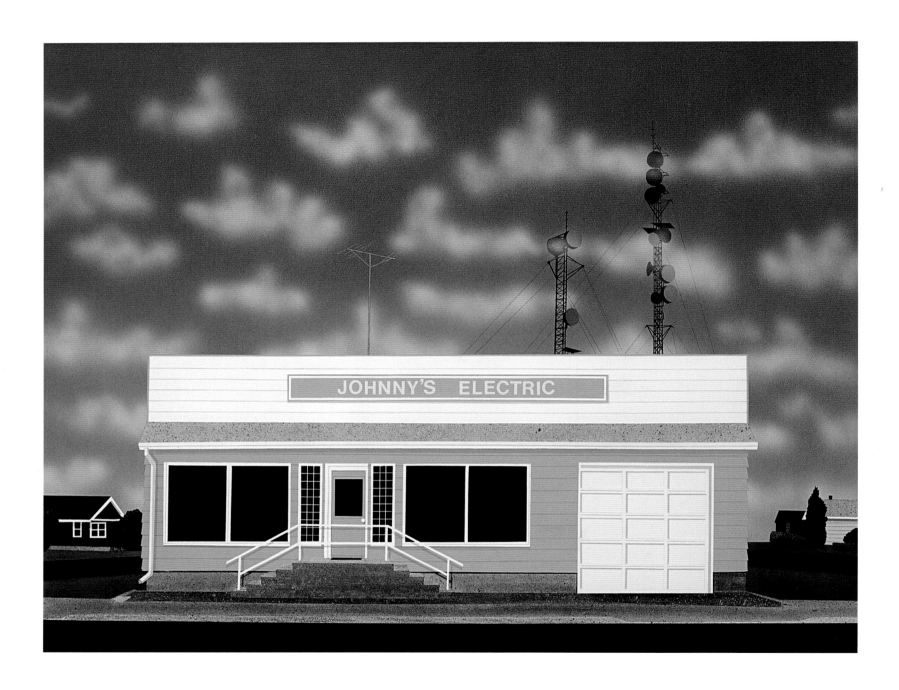

David Thauberger

Johnny's Electric, 1991, acrylic on canvas, 43 × 56 inches / 109.2 × 142.2 cm

Antique Store, 1993, acrylic on canvas, 41 × 54 inches / 104.1 ×137.2 cm

"The depersonalized techniques of smooth surfaces, unmodulated colour and elements from
the commercial world (window screen, glitter) are indicators of the influence popular culture
has had on society's perception of the landscape."

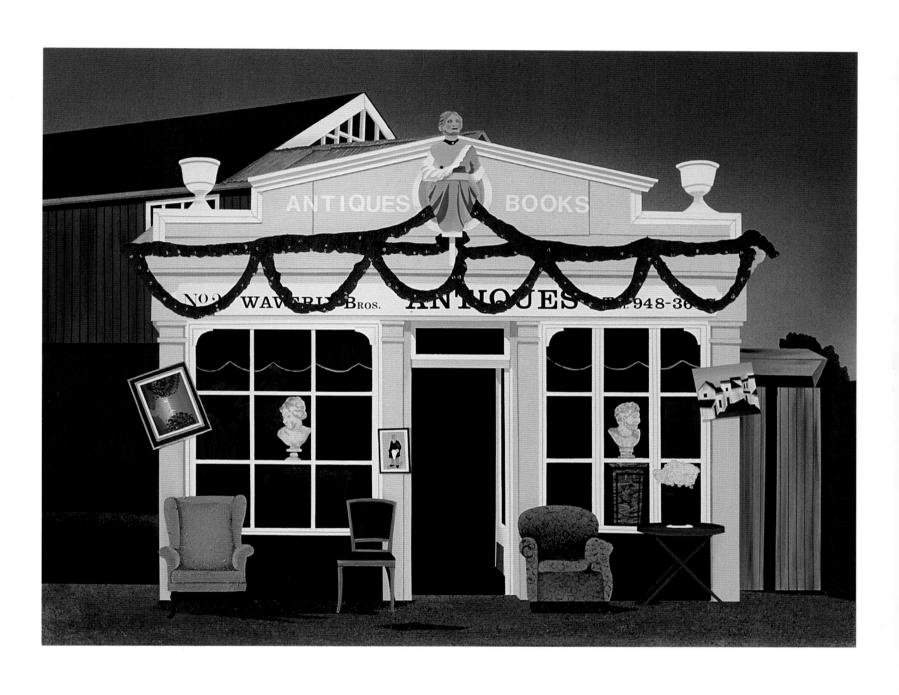

established
David Urban

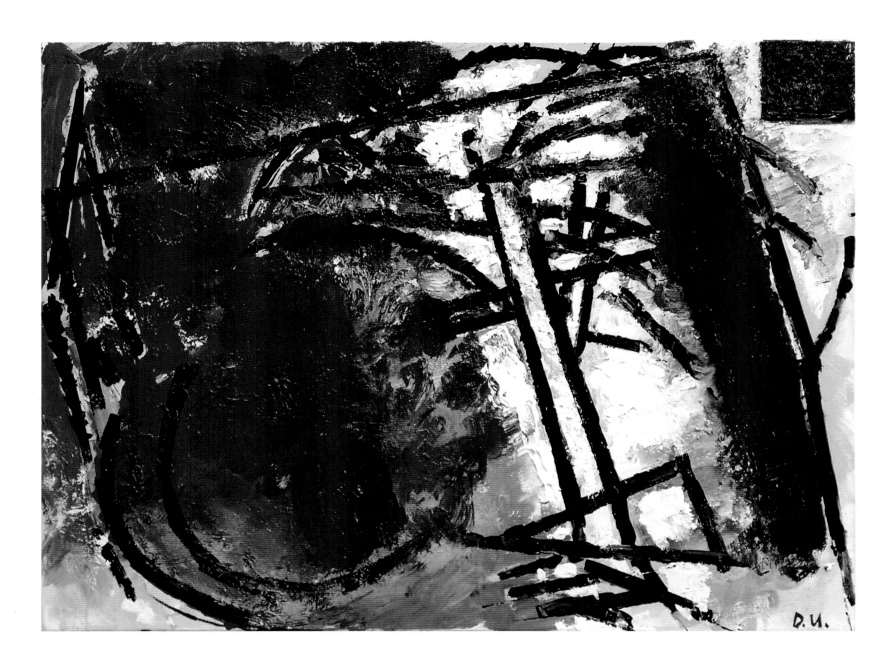

Tree on Paper, 2007, acrylic and oil on canvas, 30 × 40 inches / 76.2 × 101.6 cm

Idiom of the Hero, 2007, acrylic and oil on canvas, 60 × 48 inches / 152.4 × 121.9 cm

"Making art is primarily an attempt to discover what art is. Consequently, an artist is not a consensus seeker and an art historian should not be, either. The unity amongst artists is nothing other than their collective commitment to an idiosyncratic vision of art, relentlessly pursued and through will and dedication given ascent."

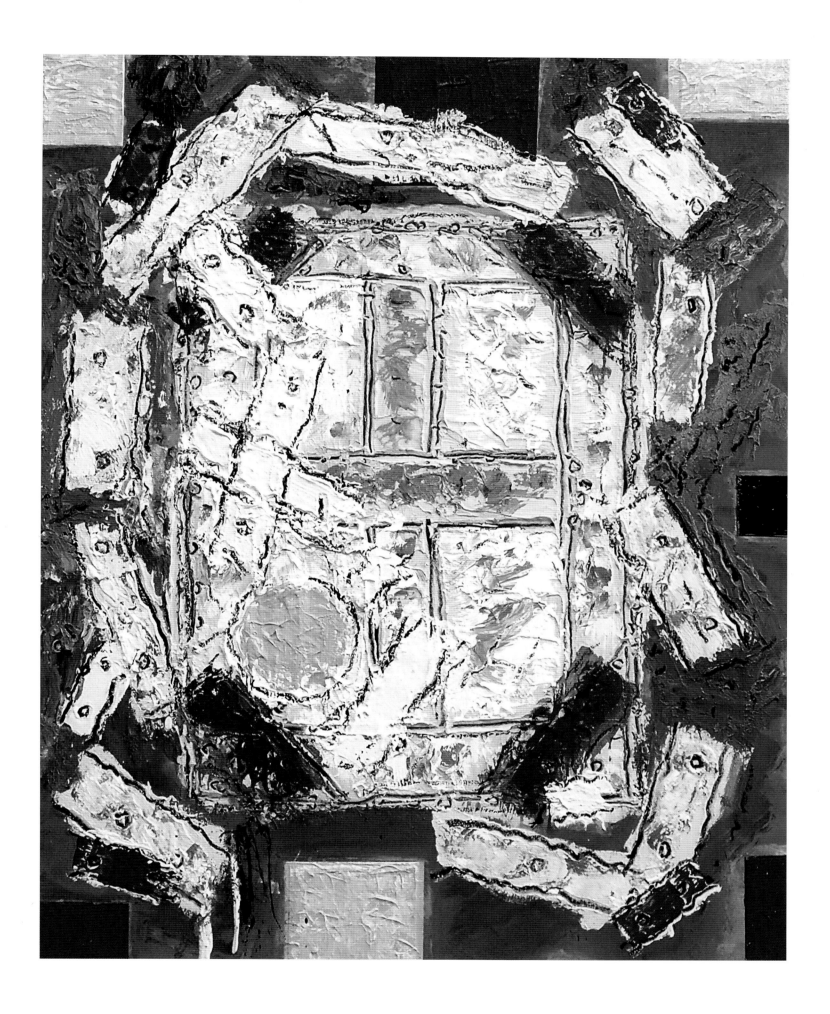

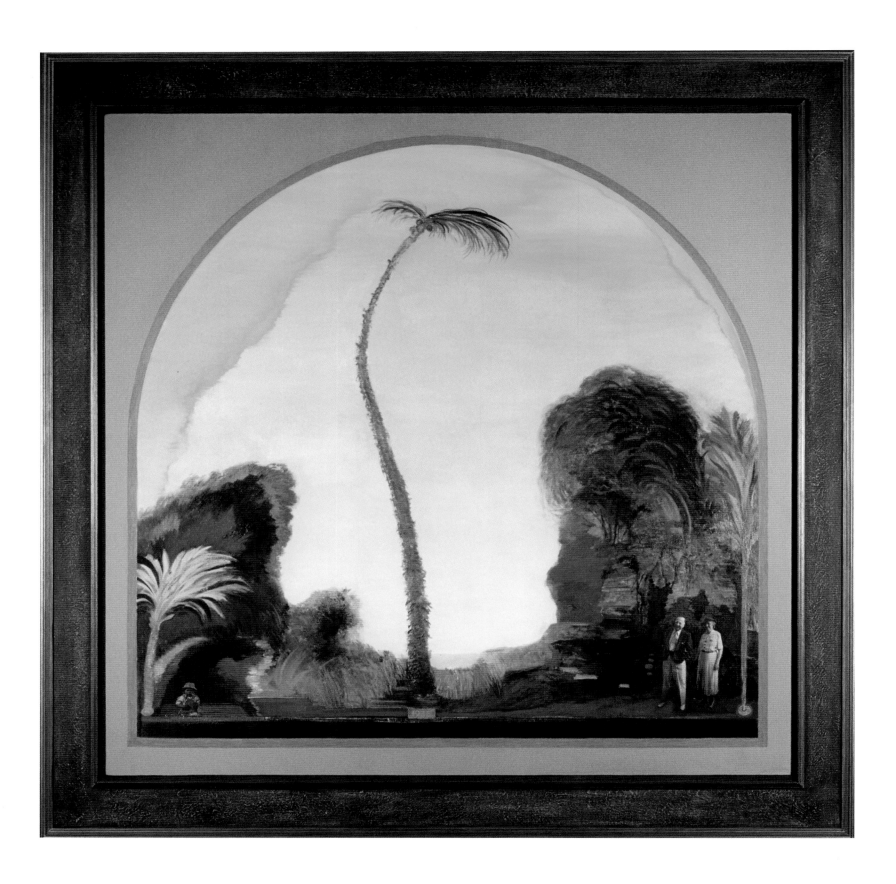

My Garden in 1936, 1999, oil and collage on gessoed board, 35 × 34.9 inches / 89 × 88.7 cm

My Garden With Slope, 2002, oil and collage on gessoed board, 35.5 × 35.5 inches / 90.2 × 90.2 cm

"My grandmother was quite a strong influence throughout my life. She was an artist in the sense
that she liked landscaping the grounds of our house, which were considerable. She had ponds
made; there was a wood; there was an old barn in the back of the house. It was like an oasis of
quiet. This probably had an influence on making me into a landscape artist, which is basically
what I would define myself as."

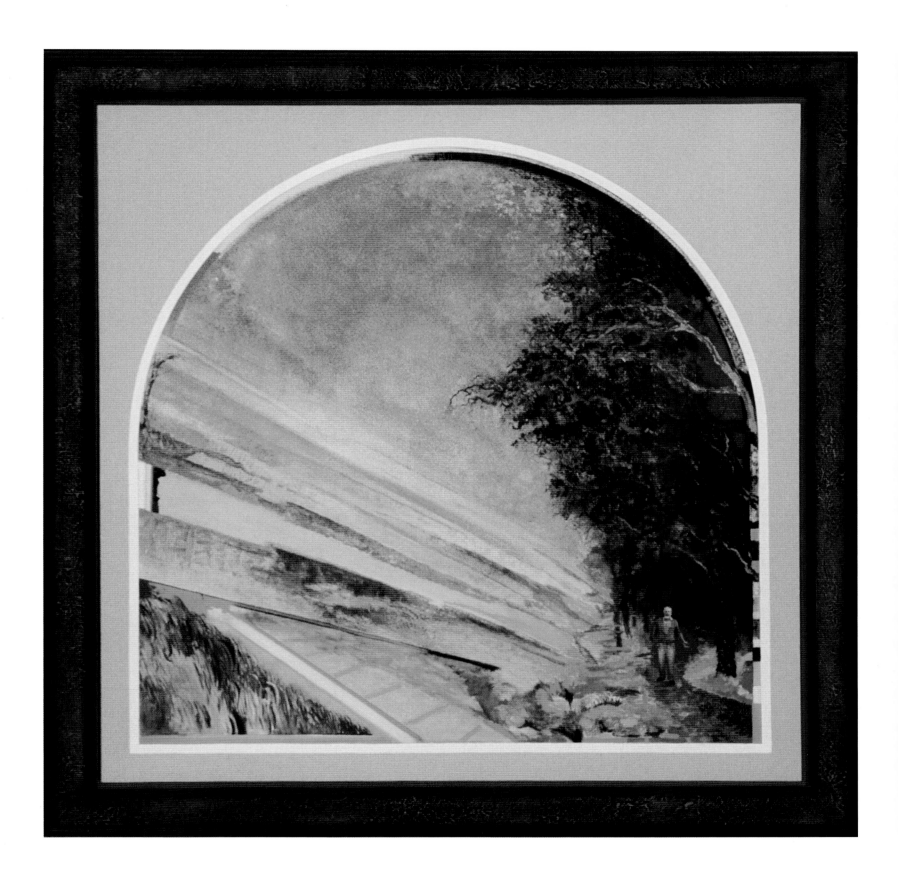

established
Peter von Tiesenhausen

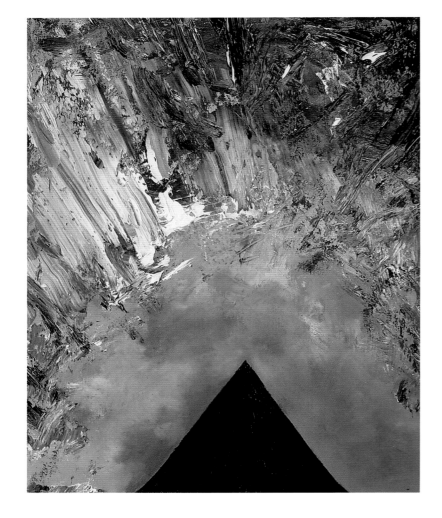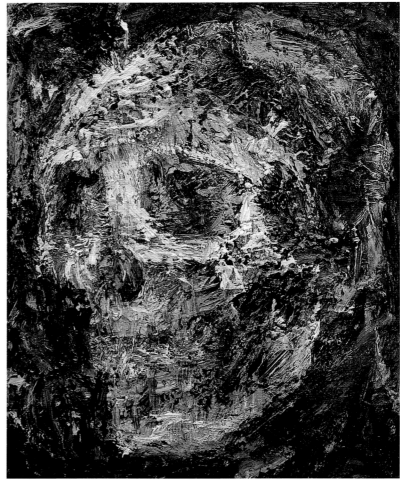

Mecca, 2006, oil on canvas, 20 × 16 inches / 50.8 × 40.6 cm

Mortalis, 2007, oil on canvas, 24 × 30 inches / 61 × 76.2 cm, collection of Brian Richer and Victoria Taylor

Rules of Engagement, 2007, oil on canvas, 24 × 24 inches / 61 × 61 cm, private collection

"There is little distinction between my art and my life. It is all my practice and I am led by both. It is an attempt to find the truth, a search for meaning and authenticity."

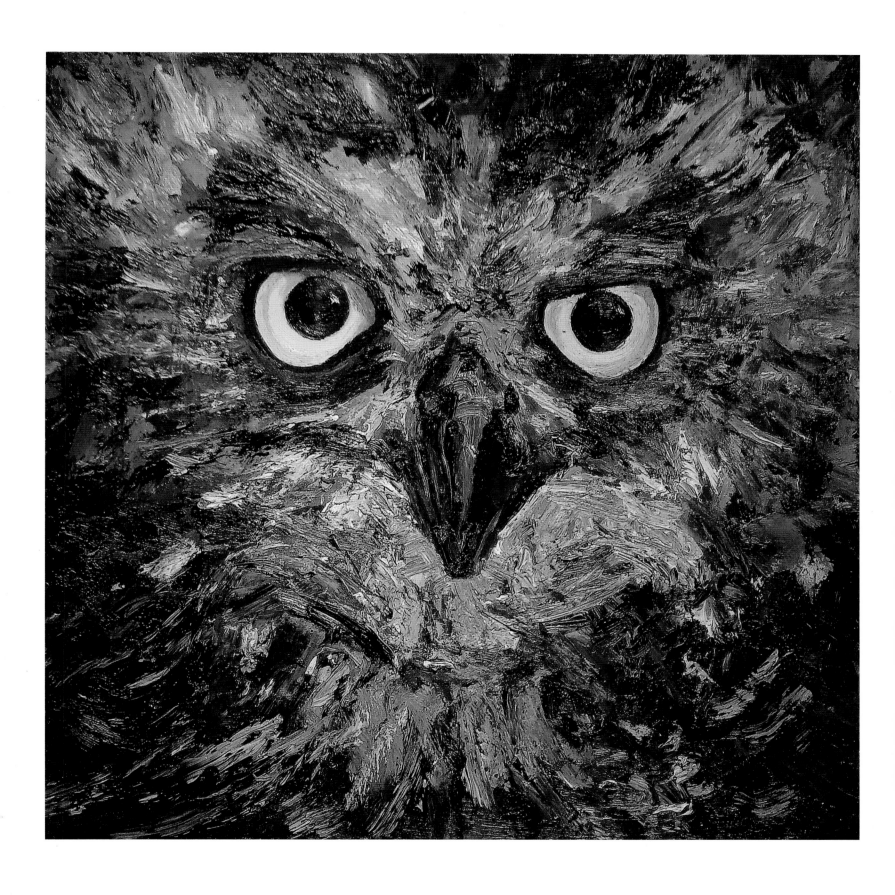

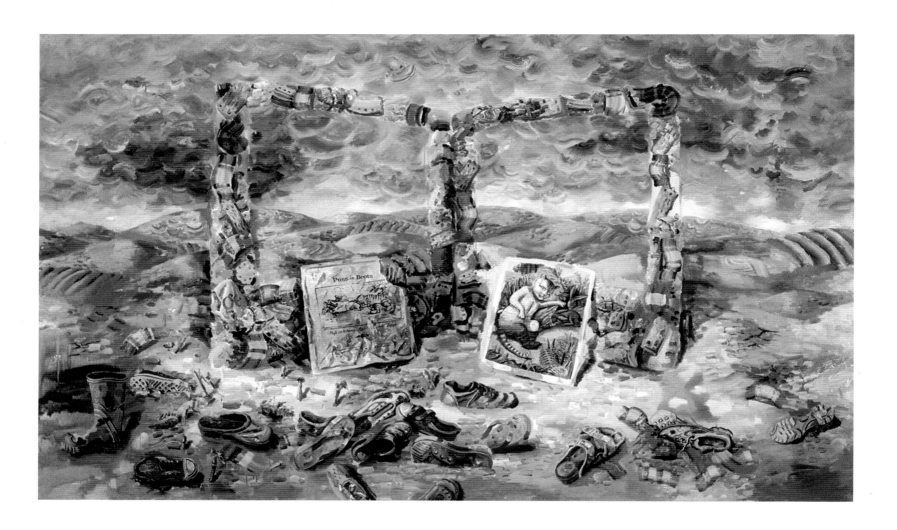

Puss 'n Boots #10, 2007, acrylic on canvas, 72 × 120 inches / 182.9 × 304.8 cm

Transformation, 2007, acrylic on canvas, 78 × 120 inches / 198.1 × 304.8 cm

"The illustrated book has been a recurrent theme in my work for a number of years.
I have sought to understand how it can act as a metaphor for early experience, both
on a historical and developmental level."

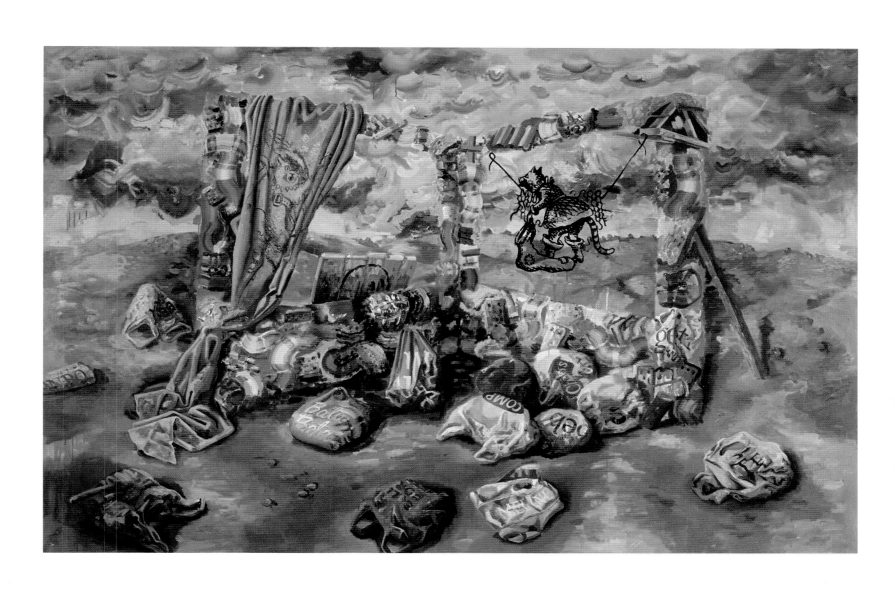

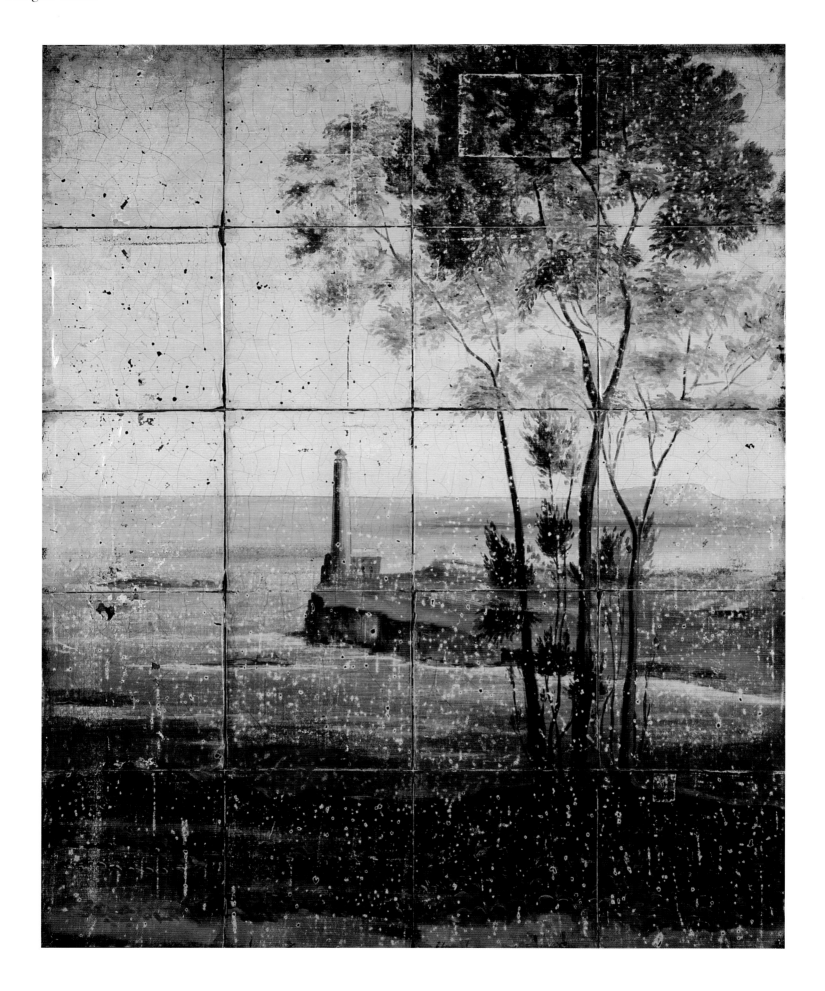

Untitled #306, 2001, oil on paper, 60 × 48 inches / 152.4 × 121.9 cm

Untitled #A-58, 2007, oil on panel, 44 × 32 / 111.8 × 81.3 cm

"Making an image that captures a sense of the other world is tricky. Lazy meanderings with the brush are a good way to start. I've developed a way of painting with thin paint, tweaked brushes and an unusual stroke that helps get a non-linear process going. It's a process where the imagery seems to spring forth from the brush, like a shortcut to the subconscious."

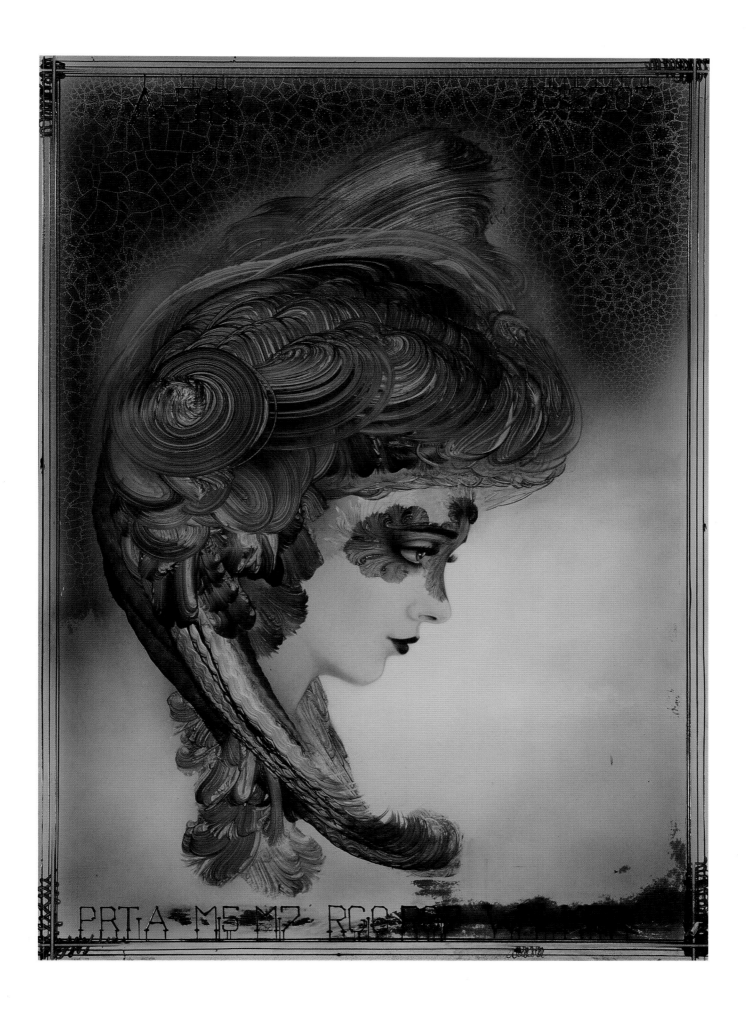

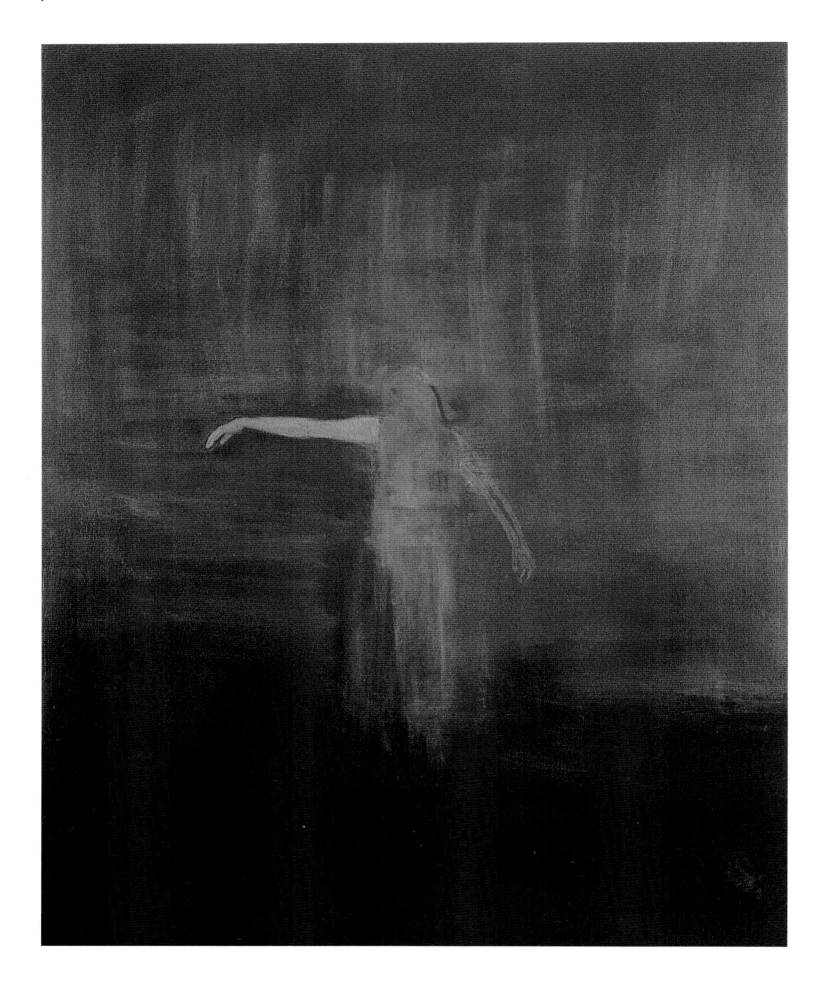

Figure With Blue Arms, 2004, oil on canvas, 40 × 32, inches / 101.6 × 81.3, collection of
Musée des beaux-arts de Montréal

Broken Building, 1993, oil on canvas, 78 × 60 inches / 198.1 × 152.4 cm

"I am interested in keeping all the elements of painting in play: surface, depth and illusion."

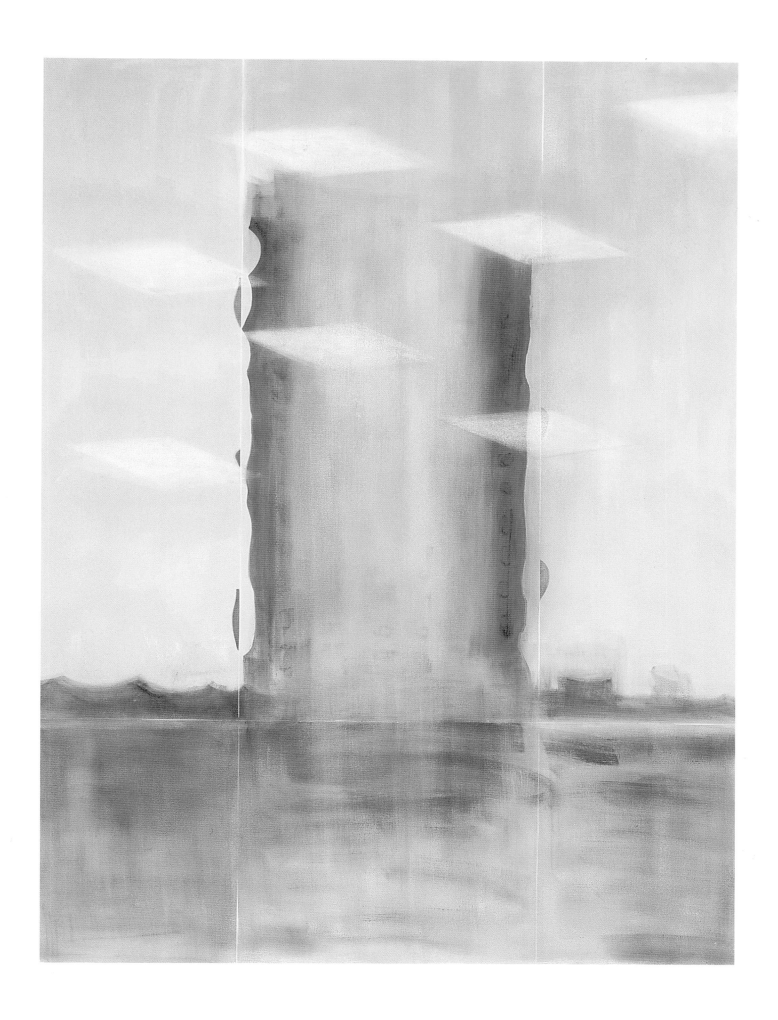

Contributors

emerging

Fiona Ackerman

BIRTH DATE January 25, 1978 RESIDES Vancouver EDUCATION BFA, Emily Carr Institute of Art and Design, Vancouver, 2002; DEC Creative Arts, Dawson College, Montreal, 1998 SELECT SOLO EXHIBITIONS *Fiona Ackerman*, Galerie Soleil, Montreal, 2006 SELECT GROUP EXHIBITIONS *The Artist Project*, Art Fair, Toronto, 2008; *Halcyon Days*, Diane Farris Gallery, Vancouver, 2007; *Portrayal*, Diane Farris Gallery, Vancouver, 2007; *Heavy Sky Over Surabaya*, Galerie Jürgen Kaspar, Nuremberg, Germany, 2005; *Flip the Page*, Antisocial Gallery, Vancouver, 2005; *Painting on the Edge*, Federation of Canadian Artists Gallery, Vancouver, 2005 WEBSITE fionaackerman.com

Abbas Akhavan

BIRTH DATE November 28, 1977 RESIDES Vancouver EDUCATION MFA, University of British Columbia, 2006; BFA, Concordia University (Honours in Art History and Visual Arts), 2004 SELECT SOLO EXHIBITIONS *To be titled*, Third Line Gallery, Dubai, U.A.E., 2009; *Clean Sweep*, Centre A, Vancouver, 2009; *To be titled*, Diaz Contemporary, Toronto, 2009; *Correspondences*, Stratagem Pacific, Vancouver, 2007; *Vacate*, Storage Gallery, Vancouver, 2007 SELECT GROUP EXHIBITIONS *About Time II*, Gallery Vanessa Quang, Paris, 2008; *As the Mood Strikes Us*, Platform Gallery, Winnipeg, 2008; *Everything Should Be As Simple As It Is But Not Simpler*, Western Front Gallery, Vancouver, 2008; *Orientalism & Ephemera*, Centre A, Vancouver, 2008; *The Lotus Eaters*, Western Front (New Media Screening), Vancouver, 2007; *About Time II*, Nordjyallandds Kunstmuseum, Aalborg, Denmark, 2007; *Arabizamee Casa*, Arabe Festival, Madrid, 2007; *Strange Bedfellows*, Morris & Helen Belkin Gallery, Vancouver, 2006; *RBC Canadian Painting*, Contemporary Art Gallery, Vancouver, 2006; Art Gallery of Calgary, Calgary, 2006; Musee D'Art Contemporain de Montreal, Montreal, 2006; Kitchener-Waterloo Art Gallery, Kitchener, Ont., 2006; Museum of Contemporary Canadian Art, Toronto, 2006 AWARDS Graduate Fellowship, University of British Columbia, 2005–2006; Semi Finalist, RBC Canadian Painting Award, 2006 PUBLICATIONS *Helen's Cookbook*, Abbas Akhavan, Marina Roy, eds., Vancouver, Helen Pitt Gallery, 2007; *Long Distance: Between Location & Emotion*, Dubai: The Third Line, 2007 (Exhibition Catalogue); *Strange Bedfellows: One Use for Spectacle*, Anne Lesley Selcer, Vancouver, Morris & Helen Belkin Art Gallery, 2006 (Exhibition Catalogue); *Common Room: Liz Park, Jesse Birch, Sophie Brodovitch, Kegan J.J. McFadden*, University of British Columbia, Belkin Satellite Gallery, 2006 (Exhibition Catalogue); *Zankowicz, Kate, The Space That is Left: Exploring the Monument & Its Ruin*, Concordia University, 2005 WEBSITE abbasa.ca

Romas Zenon Astrauskas

BIRTH DATE June 25, 1971 RESIDES Toronto EDUCATION MFA, Parsons, New York, 1997 SELECT SOLO EXHIBITIONS *Sewers of Mars*, Greener Pastures Contemporary Art, Toronto, 2006 SELECT GROUP EXHIBITIONS *Behind the Wall of Sleep*, Greener Pastures Contemporary Art, Toronto, 2005 AWARDS Joan Mitchell Foundation Award, Joan Mitchell Foundation, New York, 1997 WEBSITE romas.ca

Tasha Aulls

BIRTH DATE November 19, 1972 RESIDES Toronto and London, U.K. EDUCATION MFA, Goldsmiths, University of London, London, U.K., 2009 SELECT SOLO EXHIBITIONS *Between the Big Bang and the Big Bomb*, p|m Gallery, Toronto, 2006 SELECT GROUP EXHIBITIONS *L'Avenir en Question*, Centre D'art Contemporain, Baie St. Paul, Quebec, 1999; *Prickle and Gleam*, p|m Gallery, Toronto, 2008; *Gold and Delicious*, The Apple Tree, London, U.K., 2008; *Potentially Mighty*, p|m Gallery, Toronto, 2006; Toronto International Art Fair (2005–2007) AWARDS Ontario Arts Council Emerging Visual Artists Grant PUBLICATIONS Corsano, Otino, Artist Interviews 2006; *Prickle and Gleam* (Exhibition Catalogue), p|m Gallery, Toronto, 2008 WEBSITE tashaaulls.com, pmgallery.ca

Melanie Authier

BIRTH DATE August 4, 1980 RESIDES Toronto EDUCATION MFA, University of Guelph, Guelph, Ont., 2006; BFA, Concordia University, Montreal, 2002 SELECT SOLO EXHIBITIONS *This Could Be the Place*, Michael Gibson Gallery, London, Ont., 2007; *Karma Kanyon*, aceartinc., Winnipeg, 2007 SELECT GROUP EXHIBITIONS *9th Annual RBC Canadian Painting Competition*, Ontario College of Art and Design, Toronto; Galerie d'art Louise-et-Reuben-Cohen, Université de Moncton, Moncton; MacLaren Art Centre, Barrie, Ont.; Winnipeg Art Gallery, Winnipeg; Emily Carr Institute Art and Design, Vancouver; *Cartographies*, Elissa Cristall Gallery, Vancouver, 2007; *Kolour Your World*, Edward Day Gallery, Toronto, 2006; *StART*, Studio 21 Fine Art, Halifax, 2006; *Selected Works*, Michael Gibson Gallery, London, Ont., 2006 AWARDS Honourable Mention, RBC Canadian Painting Competition, Royal Bank of Canada, Toronto, 2007; OGS (Ontario Graduate Scholarship), Government of Ontario, Guelph, Ont., 2005; The Board of Graduate Studies Research Scholarship, University of Guelph, Guelph, Ont., 2004; The Guido Molinari Studio Arts Award, Concordia University, Montreal, 2003; The Heinz-Jordan Materials Award, Concordia University, Montreal, 2001 and 2002 COLLECTIONS Royal Bank of Canada, Toronto; TD Bank, London, Ont.; Government of Foreign Affairs, Ottawa; Private collections PUBLICATIONS *What We Saw at Exhibitions in the West*, Helena Wadsley, Gallerieswest; *Art Seen: Reinventing Abstraction*, Stacey Abramson, Uptown, 2007; *The Beautiful and the Sublime*, Artscape, Susan Scott, 2007; RBC Canadian Painting Competition, Leah Sandals, Royal Bank of Canada, 2007 WEBSITE gibsongallery.com

Mike Bayne

BIRTH DATE 1977 RESIDES Kingston, Ont. EDUCATION MFA, Concordia University, Montreal, 2004; BFA, Queen's University, Kingston, Ont., 2001; BAH, Queen's University, Kingston, Ont., 2001 SELECT SOLO EXHIBITIONS *Untitled*, Morgan Lehman Gallery, New York (upcoming) 2008; *Houses, Stripmalls, Fields and Factories*, Katharine Mulherin Contemporary Art Projects, Toronto, 2006; *Untitled*, Katharine Mulherin Contemporary Art Projects, Toronto, 2005; *Two Rooms*, Katharine Mulherin Contemporary Art Projects, Toronto, 2004 SELECT GROUP EXHIBITIONS Carri Secrist Gallery, Chicago, 2007; Caron Golden Gallery, New York, 2007; *TIAF*, Toronto, 2007; *Scope*, Basel, Switzerland, 2007; *Scope*, New York, 2007; *Scope*, Miami, 2006; *Scope*, London, 2006; *Affair at the Jupiter*, Portland, 2006; *Art 212*, New York, 2006; *Art Chicago*, Chicago, 2006; *Scope*, New York, 2006 AWARDS Toronto Arts Council Emerging Artist Grant, 2005; McConnell Graduate Scholarship, Concordia University, Montreal, 2004; Best Painting Award, Toronto Outdoor Art Exhibition, 2001; Shotton Scholarship, Queen's University, 1997 WEBSITE katharinemulherin.com

Joe Becker

BIRTH DATE July 11, 1978 RESIDES Toronto EDUCATION AOCAD, Ontario College of Art & Design, 2003 SELECT SOLO EXHIBITIONS *Beckerwood*, Mind Control Gallery, Toronto, 2005; *The Age of the Swine*, Christopher Cutts Gallery, Toronto, 2007 SELECT GROUP EXHIBITIONS *Scope*, New York, 2008, Christopher Cutts Gallery, New York, 2008; *Arco 2008*, Christopher Cutts Gallery, Madrid, 2008; *Summer Splash*, Christopher Cutts Gallery, Toronto, 2007; *Scope*, New York, 2007, Christopher Cutts Gallery, New York, 2007; *DC Düsseldorf 2007*, Christopher Cutts Gallery, Düsseldorf, Germany, 2007 WEBSITE joebecker.org

Eben K. Bender

BIRTH DATE July, 22, 1981 RESIDES Vancouver EDUCATION Self Taught SELECT SOLO EXHIBITIONS *Chronicle*, Snap Contemporary Art Gallery, Vancouver, 2007; *Vista*, Midtown Gallery, Vancouver, 2006; *The Great Unknown and the Portraits*, Misanthropy Gallery, Vancouver, 2004 SELECT GROUP EXHIBITIONS *Electromagnetic Explorations*, A440Hz Gallery, Vancouver, 2007; *Ritual*, Snap Contemporary Art Gallery, Vancouver, 2006; *Cheaper Than a One Night Stand*, Fracture Industries at Art House Gallery, Vancouver, 2006; *Diminished Congress*, Misanthropy Gallery, Vancouver, 2005; *But I Will Remain…Johnny Cash Memorial*, Misanthropy Gallery, North American Tour, 2004 WEBSITE flickr.com/photos/e-bender

Chris Bennett

BIRTH DATE November 18, 1973 RESIDES London, U.K. EDUCATION BFA, Alberta College of Art + Design, Calgary, 1997; Diploma (Painting—With Distinction), Alberta College of Art + Design, Calgary, 1996 SELECT SOLO EXHIBITIONS *I'm Smarter, I'm Better Looking* (Two person exhibition), Medicine Hat Museum & Art Gallery, Medicine Hat, Alta., 2004; *New Works*, Paul Kuhn Gallery, Calgary, 2003; *New Paintings*, Combine, Calgary, 2002; *AGC Portable: Chris Bennett—Suncor Building*, organized by the Art Gallery of Calgary, Calgary, 2001; *Transformations*, +15 Window Project, Calgary, 1996 SELECT GROUP EXHIBITIONS *There's No Place Like Home*, Homestead Gallery, London U.K., 2006; *Unrepentant Exposure I & II*, Paul Kuhn Gallery, Calgary, 2005; *Flash in the Pan*, Trade Apartments, London, U.K., 2005; *Windowlicker*, Clint Roenisch Gallery, Toronto, 2003; *New Works*, Paul Kuhn Gallery, Calgary, 2003; *Alberta Biennial of Contemporary Art*, Edmonton Art Gallery/Nickle Arts Museum, Edmonton/Calgary, 2002; *Dreamy: Landscapes and Simulations*, Calgary Institute of Modern Art, Calgary, 2001 AWARDS Travel Grant, Canada Council for the Arts, 2004; Project Grant, Alberta Foundation for the Arts, 2004; C Grant, Canada Council for the Arts, 2003; RBC New Canadian Painting Competition (Western Selection), Royal Bank of Canada, 2002; Project Grant, Alberta Foundation for the Arts, 2000; Simon Chang & Phyllis Levine Foundation Scholarship, ACAD, 1994 COLLECTIONS Edmonton Art Gallery; Alberta Foundation for the Arts; Esplanade Arts & Heritage Centre; RBC Investments Global Private Banking; Private collections

Julie Beugin

BIRTH DATE April 6, 1982 RESIDES Montreal EDUCATION BFA, Emily Carr Institute, Vancouver, 2004; MFA, Concordia University, Montreal, 2008 SELECT SOLO EXHIBITIONS *TBA*, Optica, Montreal, 2008 SELECT GROUP EXHIBITIONS *Pop Philosophy*, Access Artist-Run Centre, Vancouver, 2007; *The New*, Patrick Mikhail Gallery, Ottawa, 2007; *Collision*, Art Mûr, Montreal 2007; *Fantastic Four*, Butchershop Gallery, Vancouver, 2005; *The Home Show*, Misanthropy Gallery, 2004 AWARDS Senior Awards, B.C. Arts Council, 2006 and 2007; Power Corporation of Canada Scholarship, Concordia University, Montreal, 2006; J.A. DeSeve Entrance Award, Concordia University, Montreal, 2005; Mary Plumb-Blade Award, Emily Carr Institute, Vancouver, 2004 PUBLICATIONS *Pop Philosophy*, Rachelle Sawatsky, co-published by Projectile Publishing and Access Artist-Run Centre, 2007 WEBSITE juliebeugin.com

Leigh Bridges

BIRTH DATE November 21, 1972 RESIDES Vancouver and Berlin EDUCATION MFA, University of Victoria, 2005 SELECT SOLO EXHIBITIONS *Outpost*, Paul Petro Contemporary, Toronto, 2008; *Hinterland*, Bjornson Kajiwara Gallery, Vancouver, 2007; *Landscape People*, Leif Magne Tangens Gallery, Skien, Norway, 2007; *Roughing It*, Main Gallery, University of Victoria, Victoria, 2005 SELECT GROUP EXHIBITIONS *North South East West*, Paul Petro Contemporary, Toronto, 2008; *Spring Fling 4: C Magazine Fundraiser*, Birch Libralato Gallery, Toronto, 2008; *Somewhere Else*, Wilde Gallery, Berlin, 2007; *Streams, torrents, lakes…and sunsets, for example*, PROGRAM Gallery, Berlin, 2007; *Rapt: Contemporary Art Gallery (CAG) Fundraiser*, Vancouver, 2007; *Spring Fling 3: C Magazine Fundraiser*, Georgia Scherman Projects, Toronto, 2007; *Christmas Spice*, Paul Petro Contemporary, Toronto, 2007; *Toronto Art Fair*, Paul Petro Contemporary, Toronto, 2007 AWARDS UVic Graduate Fellowships, University of Victoria, Victoria, 2004 and 2005; Travel Grants, University of Victoria, Victoria, 2004 and 2005 PUBLICATIONS *Rapt: CAG Fundraiser Catalogue*, Contemporary Art Gallery Vancouver, 2007; *Selecta 2006 Catalogue*, Westspace Gallery, Sydney, Australia, 2006; *d'Or (Goin' Solo)*, OR Gallery, Vancouver, 2006 WEBSITE leighbridges.com

Adam Brooks

BIRTH DATE July 3, 1979 RESIDES Winnipeg EDUCATION BFA (First Class Honours), University of Manitoba, Winnipeg, 2002 SELECT SOLO EXHIBITIONS *Rejected & Unknown*, <SITE> Gallery, Winnipeg, 2005 SELECT GROUP EXHIBITIONS *Canadian Filmmakers Festival*, Varsity Cinemas, Toronto, 2007; *Supernovas*, Winnipeg Art Gallery, Winnipeg, 2006; *Royal Art Lodge Doll Show*, Royal Art Lodge, Winnipeg, 1998 AWARDS Visual Arts C Grant, Manitoba Arts Council, Winnipeg, 2006; Individual Artist Grant, Winnipeg Arts Council, Winnipeg, 2006 PUBLICATIONS *Supernovas*, Christabel Wiebe, The Winnipeg Art Gallery, 2006; *Manitoba Supernovas*, Amy Karlinsky, Galleries West, 2006 COLLECTIONS Mr. & Mrs. Harvey Levy, Private collection; Mr. Hank Finlayson, Private collection; Mr. Jason McDonald, Private collection; Ms. Connie Pilgrim, Private collection; Dr. Suzanne Newman, Private collection; Mr. & Mrs. Joanne Barnes WEBSITE adambrooks.net

Matthew Brown

BIRTH DATE December 22, 1976 RESIDES Vancouver EDUCATION MFA, Concordia University, Montreal, 2006; BFA, University of Victoria, Victoria, 1998 SELECT SOLO EXHIBITIONS *Matthew Brown*, Tracey Lawrence Gallery, Vancouver, 2007 SELECT GROUP EXHIBITIONS *Short Stories*, London Museum, London, U.K., 2008; *2x4*, Tracey Lawrence Gallery, Vancouver, 2007; *Dripped, Dropped, Split, Upended, Exploded*, Tracey Lawrence Gallery, Vancouver, 2007; *Tinyvices*, Studio Bee, Tokyo, Proyectos/Monclova, Mexico City, White Flag Projects, St. Louis, and Collette, Paris, 2007; *Paint*, Vancouver Art Gallery, Vancouver, 2006; *A Summer Group Show*, Marlborough Gallery, New York, 2006 AWARDS B.C. Arts Council Level 1 Project Assistance Grant, B.C. Arts Council, Victoria, 2007; RBC Painting Competition Award for Western Canada, Royal Bank of Canada, Toronto, 2006; B.C. Arts Council Senior Scholarship Award, B.C. Arts Council, Victoria, 2004; Architecture Landscape & Design Admission Fellowship, University of Toronto, Toronto, 2003 COLLECTIONS Dil Hildebrand, Private collection; National Bank of Canada; Musée d'Art Contemporain de Montréal; Canada Council Art Bank PUBLICATIONS *Not Brown*, Lee Henderson, Tracey Lawrence Gallery, 2008; *Paint: A Psychedelic Primer*, Monika Szewczyk, Scott Watson, Neil Campbell, Elizabeth Macintosh, Vancouver Art Gallery, 2006 WEBSITES birthdaycakeisland.com; lionspile.ca

Matt Crookshank

BIRTH DATE October 19, 1975 RESIDES Toronto EDUCATION BFA, Queen's University, Kingston, Ont., 1998 SELECT SOLO EXHIBITIONS *Cross Eyed*, Skew Gallery, Calgary, 2008; *Crazy Eights*, LE, Toronto, 2008; *Lick the Frost of the Dream*, LE, Toronto, 2007; *Special Powers*, Bobby Five Gallery, Toronto, 2007; *Brains I*, LE, Toronto, 2006; *Brains II*, Skew Gallery, Calgary, 2006; *Chimera Cesspool [of Sin]*, Solo Exhibition, Toronto, 2005; *Midnight Tornado*, Luft Gallery, Toronto, 2003; *Eternal Flame*, Sis Boom Bah, Toronto, 2002 SELECT GROUP EXHIBITIONS *I Regress*, single channel video exhibition curated by Christina Vassallo, PAM Booth, Scope, Miami, 2006; *20×2*, video exhibition curated by R.M. Vaughan, Buddies in Bad Times, Toronto, 2006; *Square Foot*, AWOL Gallery/Project Spaceman, New York, 2005; *One Night Show*, curated by Ann Marie Peña, Gallery 291, London, 2004 AWARDS Emerging Artists Grant, OAC, Toronto, 2002 WEBSITE mattcrookshank.com

Tanya Cunnington

BIRTH DATE June 21, 1978 RESIDES Toronto EDUCATION AOCAD, Toronto, 2001 SELECT SOLO EXHIBITIONS *Passed in the Stuck*, Loop Gallery, Toronto, 2008; *Time Traveler*, Loop Gallery, Toronto, 2007 SELECT GROUP EXHIBITIONS *Tanya Cunnington and Bewabon Shilling*, The Orillia Museum of Art and History, Orillia, Ont., 2007; *The Still Parade*, The Arthur Shilling Studio & Gallery, Rama, Ont., 2006; *Diversions*, Magic Door Gallery, Sunderland, Ont., 2006; *Square Foot*, AWOL Gallery, Toronto, 2005; *If I Had a Hi-Fi*, Mercer Union, Toronto, 2002; *A Love Story*, Mercer Union, Toronto, 2001 AWARDS The Eric Freifeld Scholarship for Excellence in Figurative Art, Ontario College of Art and Design, Toronto, 2001 WEBSITE tanyacunnington.com

Dave and Jenn (David Foy and Jennifer Saleik)

BIRTH DATES January 6, 1982; January 7, 1983 RESIDE Calgary
EDUCATION Diploma in Fine Art, Grant MacEwan College, Edmonton,
2003; BFA, Major in Painting, Alberta College of Art and Design,
Calgary, 2006 SELECT SOLO EXHIBITIONS *In which the honourable
company explores its territories*, Truck Gallery +15 Project Space, Calgary,
2006; *Jenn and Dave do Las Vegas*, Marion Nicoll Gallery, Calgary, 2005
SELECT GROUP EXHIBITIONS *Miniatures*, Banff Center for the Arts,
Banff, Alta., 2006; *The Eighth Annual RBC Canadian Painting Competition*,
traveling exhibition, 2006; *Merge*, Skew Gallery, Calgary, 2006 AWARDS
The Eighth Annual RBC Canadian Painting Competition Western
Semi-Finalists, 2006 WEBSITE skewgallery.com/dave_and_jenn.htm

Mel Davis

BIRTH DATE May 11, 1973 RESIDES Berkeley, Calif. EDUCATION
MFA, San Francisco Art Institute, San Francisco, 2005; Slade School
of Art, London, U.K., 2002; BFA, Concordia University, Montreal,
1999 SELECT SOLO EXHIBITIONS *Leptis Magna*, Larry Becker
Contemporary Art, Philadelphia, 2008; *Mel Davis–Paintings*, Cecile
Moochnek Gallery, Berkeley, California, 2006; *New Paintings*,
NavtaSchulz Gallery, Chicago, 2006; *Snow Day*, Diego Rivera Gallery,
San Francisco, 2004 SELECT GROUP EXHIBITIONS *Close Calls*,
Headlands Center for the Arts, Sausalito, California, 2008; *In Light*,
Larry Becker Contemporary Art, Philadelphia, 2007; *Aqua Art Fair*,
NavtaSchulz Gallery, Miami, 2007; *Making Peace*, Three Walls,
Chicago, 2007; *2x2*, Oakland Art Gallery, Oakland, California, 2007;
Some, Larry Becker Contemporary Art, Philadelphia, 2007; *Polyptychs*,
COCA, Seattle, 2007; *Ripples*, The Oakland Art Gallery, Oakland,
California, 2007; *Bridge Miami Art Fair*, NavtaSchulz Gallery, Miami,
2006 AWARDS Canada Council for the Arts Grant, 2006; The Irene
Pijoan Memorial Award for Painting, The San Francisco Art Institute
MFA Painting Prize, 2004; International Student Grant, The San
Francisco Art Institute, 2004; Conseil des Arts et Lettres du Québec
grant, 2001; Recipient of the Mills Prize for Painting, 1998 COLLECTIONS
Greenfield Partners, Chicago; Hyatt, Santa Clara, California; Capitol
Group Los Angeles; Wellington Management Boston; Apulent, Seattle;
Concordia University, Montreal PUBLICATIONS *Making Peace*
catalogue, James Elkins, Threewalls, Grace, Chicago, 2007; *Bridge Art
Fair Miami 2006* catalogue, 2006 WEBSITE meldavis.peachpitpie.com

Nicholas Di Genova

BIRTH DATE April 1, 1981 RESIDES Toronto EDUCATION Arts
Diploma, OCAD, Toronto, 2005 SELECT SOLO EXHIBITIONS *Birds
are Terrifying Creatures*, LE Gallery, Toronto, 2007; *Death From Below*,
Fredericks and Freiser Gallery, New York, 2006; *Due West of the
Happy-Lake Hills*, LE Gallery, Toronto, 2005; *At the Water's Edge*,
LE Gallery, Toronto, 2004 SELECT GROUP EXHIBITIONS *Toronto
Underground*, Art x Life Gallery, Tokyo, 2007; *Pick of the Harvest*,
Thinkspace Gallery, Los Angeles, 2006; *Future Species*, MOCCA,
Toronto, 2005; *Characters at War*, Gallery Zentralburo, Berlin, 2004
COLLECTIONS Whitney Museum of American Art; Coleccao Madeira
Corporate Services, Portugal; Fidelity Investments PUBLICATIONS
Time to Chew, Triclops Studio, 2004 WEBSITE mediumphobic.com

Paul Dignan

BIRTH DATE August 12, 1962 RESIDES Elmira, Ont. EDUCATION
PGHD in Fine Art, Slade School of Fine Art, London, U.K., 1987; BA
(Hons) in Painting and Drawing, Grays School of Art, Aberdeen,
Scotland, 1985 SELECT SOLO EXHIBITIONS *Upland Gain*, Cambridge
Galleries, Ontario, 2007; *Licker*, Visual Research Centre, Dundee
Contemporary Arts, Scotland, 2000; *Distilled* (with Cora Cluett),
Khyber Centre for the Arts, Halifax, 1999; *Dignan/Guild*, Tribes
Gallery, New York, 1997; *Focus* (with Danny Rolph), Paton Gallery,
London, U.K., 1996; *Waiting Room Paintings*, Kunstcentrum Haagweg,
Leiden, The Netherlands, 1995 SELECT GROUP EXHIBITIONS
Illuminating the Source, Kitchener-Waterloo Art Gallery, Ont., 2006;
Level, Centre for Contemporary Art, Leiden, The Netherlands, 2000;
Tik Tak Tok, Museum of Contemporary Art, Skopje, FYR Macedonia,
2000; *Ground*, Catalyst Arts, Belfast, 1998; *Satellite*, Scottish Arts
Council Touring Exhibition, 1996; *New Art in Scotland*, Centre for
Contemporary Art, Glasgow and Aberdeen Art Gallery, 1994 AWARDS
Mid Career Grant, Canada Council for the Arts, 2007; Artists Award,
The Scottish Arts Council, 1999; Assistance Grant, The Scottish Arts

Council, 1997; The Rome Scholarship in Painting, The British Academy,
London, 1995 PUBLICATIONS *Upland Gain*, Ivan Jurakic, Cambridge
Galleries, 2007; *Distilled*, Kevin Henderson/Mathew Reichertz, The
Khyber Centre for the Arts, Halifax, 1999; *Focus*, Godrey Worsdale,
Paton Gallery, London, 1996; *New Art in Scotland*, Nicola White, Centre
for Contemporary Art, Glasgow, 1994 WEBSITE pauldignan.com

Brian Donnelly

BIRTH DATE June 7, 1979 RESIDES Toronto EDUCATION AOCAD;
Drawing and Painting, Ontario College of Art and Design, 2003
SELECT SOLO EXHIBITIONS *Brian Donnelly*, Leslie's Art Gallery, Bridel,
Luxembourg, 2008 SELECT GROUP EXHIBITIONS *Summer Splash*,
Christopher Cutts Gallery, Toronto, 2007; *Young Emerging Artists*,
Leslie's Art Gallery, Bridel, Luxembourg, 2007; *Said and Done,* Antisocial
Gallery, Vancouver, 2006; *I Am,* James Baird Gallery, St. John's, 2005;
Good in Bed, James Baird Gallery, St. John's, 2005 COLLECTIONS
(Private) Los Angeles; Luxembourg; Montreal; Ottawa; Prague;
Toronto; Seattle; Winnipeg AWARDS Gustav Weisman Memorial
Award, OCAD, Toronto, 2001; Takao Tanabe Scholarship, OCAD,
Toronto, 2002 WEBSITE briandonnelly.org

Teri Donovan

BIRTH DATE January 1, 1950 RESIDES Toronto EDUCATION Part-time
Program, Ontario College of Art, Toronto, 1988; Part-time Program,
Maryland Institute College of Art, Baltimore, 1984; B. Ed., University
of Toronto, 1976; Hon. BA, Fine Arts, York University, Toronto, 1974
SELECT SOLO EXHIBITIONS *Remember Me*, Gallery 1313, Toronto, 2007;
Wallpaper, Propeller Centre for the Visual Arts, Toronto, 2007; *Skirts*,
Propeller Centre for the Visual Arts, Toronto, 2005 SELECT GROUP
EXHIBITIONS *Celebration*, curated by Kathryn Hogg of the Glenhyrst
Art Gallery of Brant, Gallery 1313, Toronto, 2008; *Triple X, Visual Arts
Ontario 30th Anniversary Exhibition*, Toronto, Thunder Bay, Sault Ste.
Marie, Niagara, 2005–2006; *Refuse to Die*, curated by Olga Korper,
Propeller Centre for the Visual Arts, Toronto, 2005; *Portrait! Who and
What Are You*, Varley Art Gallery, Unionville, 2005 AWARDS Exhibition
Assistance Grant, Ontario Arts Council, Toronto, 2005 COLLECTIONS
City of Toronto Archives, Permanent Collection; Goodmans LLP;
McDonalds Fine Art Collection; Steam Whistle Brewery PUBLICATIONS
Artery, Review of *Securnomore by Ilona Staples*, Gallery 1313, 2005
WEBSITE teridonovan.org

Chris Dorosz

BIRTH DATE September 24, 1972 RESIDES San Francisco EDUCATION
MFA, Nova Scotia College of Art & Design, Halifax, 1997; BFA,
Concordia University, Montreal, 1994 SELECT SOLO EXHIBITIONS
The Painted Room, Canadian Clay and Glass Museum, Waterloo, 2007;
Stasis, Leo Kamen Gallery, Toronto, 2006; *Recent Paintings*, Mission 17
Gallery, San Francisco, 2003; *Virtual Ecstasy*, Eyelevel Gallery, Halifax,
2002; *Recent Work*, Plug-In Gallery, Winnipeg, 1999 SELECT GROUP
EXHIBITIONS *I.O.U.*, Mission 17 Gallery, San Francisco, 2007; *Selections
from the Royal Bank of Canada Collection*, Elliot Lewis Gallery, Vancouver,
2004; *Newton's Prism*, Gallery 1.1.1, Winnipeg, 2003; *NewFangle*, Herbst
International Exhibition Hall, San Francisco, 2001; *Do Try This at Home*,
Mount St. Vincent University Art Gallery, Halifax, 2001 AWARDS
Production Grant, Canada Council for the Arts, Ottawa, 2007; RBC
New Painting Competition, Toronto, 2003; Production Grant, Canada
Council for the Arts, Ottawa, 2003; Joseph Beuys Memorial Scholarship,
Nova Scotia College of Art & Design, Halifax, 1996 COLLECTIONS
Bank of Montreal, Toronto; Bennett Jones, Toronto; Canada Council
for the Arts Art Bank, Ottawa; Lotto-Quebec, Montreal; Manitoba
Arts Council, Winnipeg; Regional Municipality of Ottawa-Carleton,
Ottawa; Royal Bank of Canada, Toronto WEBSITE chrisdorosz.com

André Ethier

BIRTH DATE June 12, 1977 RESIDES Toronto EDUCATION BFA, Concordia University, Montreal, 2001 SELECT SOLO EXHIBITIONS Honor Fraser, Los Angeles, 2008; *Deep Purpose*, Greener Pastures Contemporary Art, Toronto, 2007; *This is Positive Thinking, Man*, Kevin Bruk Gallery, Miami, 2007; *Let's Keep This Jam Casual*, Derek Eller Gallery, New York, 2007; Mogadishni CPH, Copenhagen, 2007; Galeria Marta Cervera, Madrid, 2006; Galeria Glance, Torino, Italy, 2006; Skew Gallery, Calgary, 2006; Greener Pastures Contemporary Art, Toronto, 2006 SELECT GROUP EXHIBITIONS *Face Forward*, LeRoy Neiman Gallery, Columbia University, New York, 2008; *Distinctive Messengers*, House of Campari, New York, 2007; *Momento Mori*, Mireille Mosler, Ltd., New York, 2006; *Art on Paper 2006*, Weatherspoon Art Museum, Greensboro, North Carolina, 2006; *Summer Group Exhibition*, Derek Eller Gallery, New York, 2006; *Helter/Helter*, Gallerie Anne de Villepoix, Paris, 2006; *Darkness Ascends*, MOCCA Toronto, 2006; *Inaugural Group Exhibition*, Derek Eller Gallery, New York, 2006; Galerie Jette Rudolph, Berlin, 2005 WEBSITE derekeller.com

Scott Everingham

BIRTH DATE December 12, 1978 RESIDES Toronto EDUCATION BFA, NSCAD, Halifax, 2004; MFA, University of Waterloo, Waterloo, Ont., 2009 SELECT SOLO EXHIBITIONS *New Paintings*, Snap Contemporary Art, Vancouver, 2008; *Subtle Bodies*, La Petite Mort Gallery, Ottawa, 2008; *Missing Persons*, G+ Gallery, Toronto, 2006 SELECT GROUP EXHIBITIONS *Hide & Seek*, LandymoreKeith Contemporary Art, Toronto, 2008; *I Like to Rock!*, La Petite Mort Gallery, Ottawa, 2007; *Portraiture*, 64 Steps Contemporary Art, Toronto, 2007; *Group Exhibition*, Hive Gallery, Los Angeles, 2007; *IPWMTT*, HeadQuarters Gallery, Montreal, 2007; *Stare*, The Brick Lane Gallery, London, U.K., 2006 AWARDS Keith & Win Shantz Internship (Los Angeles), University of Waterloo, Waterloo, Ont., 2008; Graduate Enhancement Scholarship, University of Waterloo, 2007 and 2008; Ontario Arts Council Grant, OAC, Toronto, 2006; Visual Arts Grant, London, Ont., 2002 PUBLICATIONS *Artist Feature*, Cu Van Ha, Preston Catalogue, No. 8, Ottawa, 2007 WEBSITE scotteveringham.com

Stephen F. Fisher

BIRTH DATE December 28, 1979 RESIDES Halifax EDUCATION BFA, NSCAD University, Halifax, 2004 SELECT SOLO EXHIBITIONS *No Place*, Third Space Gallery, Saint John, 2007 SELECT GROUP EXHIBITIONS *Pulse*, Mount Saint Vincent University Art Gallery, Halifax, 2006

Dorian FitzGerald

BIRTH DATE January 6, 1975 RESIDES Toronto EDUCATION BA Art and Art History, University of Toronto and Sheridan College, 2001 SELECT GROUP EXHIBITIONS *The Machine and the Flesh*, Art System, Toronto, 2001; *Ripe*, Propeller Centre for the Visual Arts, Toronto, 2002; *Let Me Count the Ways*, Gallery 1313, Toronto, 2003; *Hang Pals*, Fran Hill Gallery, Toronto, 2005; *Common Ends*, Niagara Gallery, Toronto, 2006; *Massive Party*, AGO Fundraiser, Toronto, 2007 AWARDS Emerging Artist Grant, Ontario Arts Council, 2006; Emerging Artist Grant, Toronto Arts Council, 2006 WEBSITE dorianfitzgerald.com

Brendan Flanagan

BIRTH DATE May 5, 1983 RESIDES Toronto EDUCATION BFA, OCAD, Toronto, 2007 SELECT SOLO EXHIBITIONS *Mighty Magnificence*, LE Gallery, Toronto, 2007 SELECT GROUP EXHIBITIONS *Keeping It Real*, The Drake Hotel, Toronto, 2007; *Art With Heart Auction*, Casey House, Toronto, 2007; *Young Romantics*, Gallery 1313, Toronto, 2007 AWARDS Emerging Artist Award, Art With Heart, TD Waterhouse, Toronto, 2007; Weston Art Fellowship, Delta Foundation, Delta, B.C., 2004 COLLECTIONS George Hartman; Roy Bernardi WEBSITE brendanflanagan.ca

Martin Golland

BIRTH DATE 1975 RESIDES Toronto EDUCATION MFA, University of Guelph, Guelph, Ont., 2006; BFA, Concordia University, Montreal, 1998 SELECT SOLO EXHIBITIONS *Shapeshift*, Birch Libralato Gallery, Toronto, 2008; *Dark Town*, Felix Ringel Galerie, Dusseldorf, Germany, 2007; *What is Said and What is Meant*, MacDonald Stewart Art Centre, Guelph, Ont., 2006; *Haven*, Massey Gallery, Art Gallery of Greater Victoria, Victoria, B.C., 2004 SELECT GROUP EXHIBITIONS *Cartographies*, Elissa Cristall Gallery, Vancouver, 2007; *8th Annual RBC Canadian Painting Competition*, MOCCA, Toronto; Kitchener-Waterloo Art Gallery, Kitchener-Waterloo, Ont.; Musee d'art contemporain, Montreal; Art Gallery of Calgary; Contemporary Art Gallery, Vancouver, 2007; *Taking a Walk With the Dog*, Leo Kamen Gallery, Toronto, 2006; *stART: Emerging Artists Across Canada*, Studio 21 Fine Art, Halifax, 2006; *Domestic Bliss*, Open Space, Victoria, 2006 AWARDS Canada Council Production Grant, 2003, 2007; Toronto Arts Council Grant, 2006; Ontario Graduate Scholarship, University of Guelph, 2006; Margaret Priest Scholarship, University of Guelph, 2005; Board of Graduate Studies Research Scholarship, University of Guelph, 2004; The Birks Family Foundation Scholarship, Concordia University, 1995 PUBLICATIONS *Domestic Bliss* (catalogue), Roy Green, Open Space, Victoria, 2006 WEBSITE birchlibralato.com, felixringel.com

Nicolas Grenier

BIRTH DATE March 25, 1982 RESIDES Montreal EDUCATION BFA, Concordia University, Montreal, 2004 SELECT SOLO EXHIBITIONS *Eden*, Art Mûr Gallery, Montreal, and LandymoreKeith Contemporary Art, Toronto 2008; *Jeu Noir*, LandymoreKeith Contemporary Art, Toronto, 2007; *Introduction to the LEGO Project*, St-Laurent plus Hill Gallery, Ottawa, 2006; *Portraits*, Art Mûr Gallery, Montreal, 2006; *L'Étrangeté du Réel*, Festival International de Musique Actuelle de Victoriaville, Victoriaville, Que., 2005; *Le Grand Jeu*, Art Mûr Gallery, Montreal, 2005 SELECT GROUP EXHIBITIONS *The Tour of 15 (RBC Painting Competition)*, Museum of Contemporary Canadian Art, Toronto, Kitchener-Waterloo Art Gallery, Kitchener, Museum of Contemporary Art, Montreal, Art Gallery of Calgary, Calgary, Contemporary Art Gallery, Vancouver, 2006; *Art et Fiction*, Art Mûr Gallery, Montreal, 2006; *Humans*, James Baird Gallery, Pouch Cove, Nfld. 2006; Sur la peau, CEDEX (UQAM), Montreal, 2005 AWARDS Bourse de la Fondation du Maire de Montréal, FMMJ, Montreal, 2007; Semi-Finalist, RBC Canadian Painting Competition, 2006; Guido Molinari Prize in Studio Arts, Concordia University, Montreal, 2004; John A. Murphy Scholarship in Drawing, Concordia University, Montreal, 2004 COLLECTIONS Loto-Québec Collection, Province of Québec, Canada; Direction of the Financial Services, Concordia University, Montreal; Jacques-Rousseau High School, Longueuil, Que.; Private collections WEBSITE nicolasgrenier.com

Jason Gringler

BIRTH DATE December 15, 1978 RESIDES New York and Toronto EDUCATION AOCAD, 2001, Toronto SELECT SOLO EXHIBITIONS *Various States of Undress, Construction and Repair*, The Proposition, New York, and Angell Gallery, Toronto, 2008 SELECT GROUP EXHIBITIONS *Gothic Intrusion*, The Proposition, New York, 2008; *Songs of the Apocalypse*, curated by David Liss, Galerie Art Mûr, Montreal, 2007; *Love/Hate*, Curated by David Liss, Museum of Contemporary Canadian Art, Toronto, 2007; *Thoughts*, The Unnameable, Feature Inc, New York, 2007 AWARDS Toronto Arts Council Emerging Artist Grant, Toronto, 2006; TOAE Best Mixed Media Painting Award, Toronto, 2003; Award of Excellence TOAE board of directors, Toronto, 2001; Richard J. Lemieux Memorial Fund Scholarship, Toronto; David L. Stevenson Award, Toronto; OCAD Drawing and Painting Medal, Toronto; Nora E. Vaughan Award, Toronto; Charles Magee Memorial Tuition Scholarship, Toronto; The Libby Selznick Altwerger Award, Toronto COLLECTIONS Department of Foreign Affairs and International Trade Canada, Ottawa, 2007; BMO Financial Group, Corporate Art Collection, Toronto, 2007; Stikeman Elliot, Toronto, 2006; BMO Financial Group, Corporate Art Collection, London, U.K., 2006 WEBSITE bleachmodern.com

Bradley Harms

BIRTH DATE August 25, 1970 RESIDES Calgary EDUCATION MFA, School of the Art Institute of Chicago, 2003 SELECT SOLO EXHIBITIONS *Bradley Harms*, Newzones Gallery of Contemporary Art, Calgary, 2008; *Bradley Harms*, Angell Gallery, Toronto, 2008; *really new new paintings!*, Angell Gallery, Toronto, 2007; *Blitzen*, Newzones Gallery of Contemporary Art, Calgary, 2006; *Analog*, Newzones Gallery of Contemporary Art, Calgary, 2005 SELECT GROUP EXHIBITIONS *Top 10*, Angell Gallery, Toronto, 2006; *Art Chicago*, Newzones Gallery of Contemporary Art, Chicago, 2006; *AAF Contemporary Art Fair New York*, Newzones, New York, 2005; *Experiment 400/5*, Gallery 500, Chicago, 2005; *Alberta Artists Seen*, National Arts Centre, Ottawa, 2005; *Art Miami*, Newzones, Miami, 2005; *Art Fur Zeitgenossische Kunst 1*, Lothringer Dreizehn, Munich, 2004; *The Element of Temporary*, San Francisco Arts Commission, San Francisco, 2004 AWARDS Purchase Grant, Canada Council Artbank, Ottawa, 2005, 2007; Visual Arts Project Grant, Alberta Foundation for the Arts, 2007; Production Grant, Calgary Foundation, Calgary, 2000 WEBSITE bradleyharms.com

Dil Hildebrand

BIRTH DATE September 17, 1974 RESIDES Montreal EDUCATION MFA, Concordia University, Montreal, 2008; BFA, Concordia University, Montreal, 1998 SELECT SOLO EXHIBITIONS *Long Drop—A Hanging*, Pierre-François Ouellette Art Contemporain, Montreal, 2008; *Dil Hildebrand—New Work*, Pierre-François Ouellette Art Contemporain, Montreal SELECT GROUP EXHIBITIONS *EntreVoir*; Galerie de l'UQAM, Montreal, 2008; *Snow Falls in the Mountains Without Wind*, St. Paul Street Gallery, Auckland, New Zealand, 2007; *Unique Viewpoints: Recent Work by Quebec Artists*, National Arts Centre, Ottawa; *Verdure*, Pierre-François Ouellette Art Contemporain, Montreal, 2006 AWARDS Winner of *2006 RBC Canadian Painting Competition*

Thrush Holmes

BIRTH DATE September 26, 1979 RESIDES Toronto EDUCATION OCAD drop out, 1999 SELECT SOLO EXHIBITIONS *Thrush Holmes*, The Lowe Gallery, Santa Monica, California, 2008; *Every Million Golden Universe*, Thrush Holmes Empire, Toronto, 2008; *Thrush Holmes*, Galerie St-Laurent + Hill, Ottawa, 2007; *New Pretty (as Truman Couture)*, Thrush Holmes Empire, Toronto, 2007; *Money is Alright*, Thrush Holmes Empire, Toronto, 2007; *We Are All Images*, Thrush Holmes Empire, Toronto, 2007; *Confessions of an Art Star*, The Lowe Gallery, Atlanta, Georgia, 2006 SELECT GROUP EXHIBITIONS The Lowe Gallery, Atlanta, Georgia, 2007; Galerie St-Laurent + Hill, Ottawa, 2006; *The Empire Takes Atlanta*, The Lowe Gallery, Atlanta, Georgia, 2005; The Lowe Gallery, Santa Monica, California, 2005; *Toronto International Art Fair*, Toronto, 2005 COLLECTIONS Elton John; Halle Barry; Dreamworks; Sony; Government of Ontario WEBSITE thrushholmesempire.com

Jing Yuan Huang

BIRTH DATE January 30, 1979 RESIDES Montreal and Beijing EDUCATION MFA, The School of the Art Institute of Chicago, 2008; BFA, Concordia University, Montreal, 2005; The Second Foreign Language Institute, Beijing, 2001 SELECT SOLO EXHIBITIONS *Anachronism*, Art Gallery of Southwestern Manitoba, Brandon, Man., 2009; *Anachronism*, Centre Culturel de Verdun, Verdun, Que., 2008; *Anachronism*, ARTsPLACE, Annapolis Royal, N.S., 2008; *Anachronism*, RCA Visual, St. John's, 2008; *Anachronism*, Muséum Laurier, Victoriaville, Que., 2008; *Anachronism*, Centre Culturel de Drummondville, Que., 2007; *Anachronism*, Galerie Sans Nom, Moncton, N.B., 2006; *Anachronism*, Gallery 101, Ottawa, 2006; *Anachronism*, Gallery SAS, Montreal, 2006 SELECT GROUP EXHIBITIONS *The Wind From the East*, Modern Fuel, Kingston, Ont., 2008; *MFA Thesis Show*, Gallery 2, Chicago, 2008; Collins, Lefebvre & Stoneberger Gallery, Montreal, 2007; *TreasureHunt*, C5, Barcelona, 2006; *The Third Graduation Show*, VAV Gallery, Montreal, 2005; *Salon Rouge*, VAV Gallery, Montreal, 2004 WEBSITE imhuangjingyuan.blogspot.com

Gillian Iles

BIRTH DATE March 25, 1971 RESIDES Toronto EDUCATION AOCAD (Hons.), Painting and Drawing Program, OCAD, Toronto, 1997; BSc. (Gen.), University of Guelph, Guelph, Ont., 1993 SELECT SOLO EXHIBITIONS *Potential Disasters, Minor Upsets and Small Victories*, Galerie St. Ambroise, Montreal, 2006; *Suggestions for Achieving a Successful Childhood and an Ideal Life*, Kabat Wrobel Gallery, Toronto, 2003; *Want to Be*, Katharine Mulherin Contemporary Art Projects, Toronto, 2003; *Party Face*, Katharine Mulherin Gallery, Toronto, 2002; *Unconditional Love, Among Other Things*, Propeller Gallery, Toronto, 1999 SELECT GROUP EXHIBITIONS *From Miami, With Love*, AWOL Gallery, Toronto, 2008; *You Don't Wanna Miss That Sh!t: A Survey of Toronto Painters*, Curated by Katharine Mulherin, Gladstone Hotel, Toronto, 2005; *Mixer03*, Mix Magazine, Mind Control Gallery, Toronto, 2005; *Room*, Loop Gallery, Toronto, 2000; *Drawing 2000*, John B. Aird Gallery, Toronto, 2001 AWARDS Ken Purvis Portrait Award, Toronto Outdoor Art Exhibition, Toronto, 2001; D.L. Stevenson Best Painting Award, Toronto Outdoor Art Exhibition, Toronto, 2000; Jury Award: Drawing 2000, John B. Aird Gallery, Toronto, 2000; NCR Canada Limited Best Student Award, Toronto Outdoor Art Exhibition, Toronto, 1997; Mrs. W.O. Forsyth Scholarship, 4th Year Women Painters, OCAD, Toronto, 1997 WEBSITE gillianiles.com

David Joron

BIRTH DATE January 11, 1972 RESIDES Toronto EDUCATION University of Toronto, Art History; Ontario College of Art, Honours Certificate, 1996 SELECT SOLO EXHIBITIONS *Easy*, MEG Gallery, Toronto, 1999; *Spilled Milk*, Hart House, University of Toronto, 1998 SELECT GROUP EXHIBITIONS *Square Foot*, AWOL Gallery, Toronto, 2006; *Adventure*, Gallery 1313, Toronto, 2002; *Leisure*, Gallery 1313, Toronto, 2001; *Paradiso*, Kensington Lofts, Toronto, 1997; *Purgatory*, Weave, Toronto, 1997; *Inferno*, Bar Inferno, Toronto, 1996 AWARDS Third Prize, University of Toronto, Hart House Annual Juried Exhibition, Toronto, 2000; Best Painter, D.L. Stevenson and Sons, Toronto Outdoor Art Exhibition, Toronto, 1999; Second Prize, University of Toronto, Hart House Annual Juried Exhibition, Toronto, 1997

Krisjanis Kaktins-Gorsline

BIRTH DATE November 12, 1980 RESIDES New York EDUCATION MFA, Columbia University, New York, 2008 SELECT SOLO EXHIBITIONS *A Warmer Lot*, Katharine Mulherin Contemporary Art Projects, Toronto, 2007 SELECT GROUP EXHIBITIONS *Subconscious City*, Winnipeg Art Gallery, Winnipeg, 2008

Holger Kalberg

BIRTH DATE 1967 RESIDES Vancouver EDUCATION MFA, Chelsea School of Art, London, U.K., 2007; Emily Carr College of Art and Design, Vancouver, 2001 SELECT SOLO EXHIBITIONS *Holger Kalberg*, Agnes Etherington Art Centre, Queen's University, Kingston, Ont., 2009; *Neubau*, Monte Clark Gallery, Toronto, 2008; *Makeshift1*, Galerie Bertrand & Gruner, Geneva, 2006; *Habitat*, Monte Clark Gallery, Vancouver, 2005; *Sideways*, Galerie Hellengrand, Duisburg, Germany, 2004 SELECT GROUP EXHIBITIONS *Works on Paper*, Galerie Bertrand & Gruner, Geneva, 2008; *Masters Degree Show*, Chelsea School of Art, London, U.K., 2007; *Paint*, Vancouver Art Gallery, Vancouver, 2006; *Reciprocal Influences*, Monte Clark Gallery, Toronto, 2004; *RBC Painting Competition*, various locations in Canada, 2004 PUBLICATIONS *Paint*, Vancouver Art Gallery, Vancouver, 2006 AWARDS Short-listed for RBC Painting Award, Western Canada Finalist, 2002, 2005 and 2006 WEBSITE monteclarkgallery.com

Sarah Kernohan

BIRTH DATE July 6, 1980 RESIDES Kitchener, Ont. EDUCATION BFA, Ontario College of Art and Design, Toronto, 2008 SELECT GROUP EXHIBITIONS *Toronto Outdoor Art Exhibition: Best of 2007*, First Canadian Place Gallery, Toronto, 2008; *Lineal Investigations*, Housatonic Museum of Art, Bridgeport, Connecticut, 2007; *Pronto*, The Great Hall at OCAD, Toronto, 2007; *Zero to One Presents Gareth Lichty, Ian James Newton and Sarah Kernohan*, Zero to One Gallery, Kitchener, Ont., 2007; *Toronto Outdoor Art Exhibition*, Nathan Phillips Square, Toronto, 2007; *A Metá Dell'opera*, Stuidio Via Nazionale, Florence, 2006; *51st Exhibition of International Artists*, Mayday, Florence, 2006 AWARDS

Best Drawing Award, *The Globe and Mail*/Toronto Outdoor Art Exhibition, Toronto, 2007; Best Student Drawing Award, Andrew Sookrah/Toronto Outdoor Art Exhibition, Toronto, 2007; Woman's Art Association of Hamilton Scholarship, Ontario College of Art and Design, Toronto, 2007; Sully Corth Memorial Fund Scholarship and Andre Beaulieu Bursary, Ontario College of Art and Design, Toronto, 2006 WEBSITE sarahkernohan.com

Trevor Kiernander

BIRTH DATE September 18, 1975 RESIDES London, U.K. and Montreal EDUCATION MFA Art Practice, Goldsmiths, University of London, London, U.K., 2009; BFA with Distinction, Painting & Drawing, Concordia University, Montreal, 2006; Interpretive Illustration Diploma, Sheridan College, Oakville, Ont., 2000 SELECT SOLO EXHIBITIONS *Relative Detachments*, Art Mûr, Montreal, 2007; *Form, Fond, Couleur*, La Fabriq, Montreal, 2005; *This Happens*, Cambridge Centre for the Arts, Cambridge, Ont., 2002 SELECT GROUP EXHIBITIONS *Stanley Mills Purchase Prize Exhibition,* FOFA Gallery, Montreal, 2007; *Collection 1*, Parisian Laundry, Montreal, 2006; Galerie St. Laurent & Hill, Ottawa, 2006; *Square Foot*, AWOL Gallery, Toronto, 2006; *Graduating Students Exhibition,* VAV Gallery, Montreal, 2006; *The Only Way Out Is In*, Leonard & Bina Ellen Gallery, Montreal, 2006; *Type Cast*, Founderie Darling Foundry, Montreal, 2006; *Concordia Painting & Drawing Dept Show*, Art Mûr, Montreal, 2006 AWARDS Shortlisted: Eastern Division, RBC Painting Competition, Toronto, 2007; Stanley Mills Purchase Prize, Concordia University, Montreal, 2006; Production grant, Art Matters, Montreal, 2006; Pearls of Wisdom Bursary, Concordia University, Montreal, 2005; Fine Arts Student Alliance Special Project Grant, Montreal, 2005; VP Services Chartwell's Purchase Prize, Concordia University, Montreal, 2004; Nominated: Brian T. Counihan Award for Outstanding Contribution to Student Life, Concordia University, Montreal, 2004 COLLECTIONS L. Cailbeaux & J. Hanspal, London, U.K.; James D. Campbell, Montreal; Concordia University, VP Services, Montreal; M. Darveau and H. Recchia, Montreal; Pierre Dorion, Montreal; Rawi Hage, Montreal; Luc LaRochelle, Montreal; Stanley Mills Collection, Concordia University, Montreal; Parisian Laundry, Montreal; Earl Pinchuk & Gary Blair, Montreal PUBLICATIONS *Relative Detachments/ Un certain détachment*, Katie Apsey and Lyn Crevier, Les Éditions Art Mûr, 2007 WEBSITE trevorkiernander.com

Matt Killen

BIRTH DATE July 1, 1974 RESIDES Toronto EDUCATION BFA, Concordia University, Montreal, 1998; MFA Université du Québec à Montréal, Montreal, 2001 SELECT SOLO EXHIBITIONS *Chelsea Decon*, Le Gallery, Toronto, 2007; *Broken Buildings, Stormy Skies*, Lennox Contemporary, Toronto, 2005; *Borborygme*, Mercer Union (Peephole), Toronto, 2004; *Hommage à un monument disparu*, Galerie S Douglas, Montreal, 2001; *Site/Non-Site*, Public Installation, Montreal, 1999-2008 SELECT GROUP EXHIBITIONS *Merge*, AGO Art Rental + Sales Gallery, Toronto, 2008; *Objet 01: Les derniers jours d'un bain public*, presented by the Centre de recherche urbaine de Montréal, Piscine Saint-Michel, Montreal, 2002; *Kiosque d'infiltration touristique*, Centre des arts actuels Skol, Montreal, 2000; *Buoy*, Quartier Ephémère, Montreal, 1998

Helen Kilsby

BIRTH DATE 1959 RESIDES Oyama, B.C. EDUCATION BFA (Hons), University of British Columbia, Okanagan, Kelowna, B.C., 2004; Diploma of Fine Arts (Hons), Okanagan University College, Kelowna, B.C., 2001 SELECT SOLO EXHIBITIONS *Earth Tapestries*, Salmon Arm Art Gallery, Salmon Arm, B.C., 2006; *Conduits & Fissures*, Vernon Art Gallery, Vernon, B.C., 2006; *Elemental,* Nelson Art Gallery, Nelson, 2004 SELECT GROUP EXHIBITIONS *Painting on the Edge* and *Open Print Show*, Federation of Canadian Artists Juried Show, Vancouver, 2007; *Art in the Heart of the City*, Vernon, B.C., 2007; *Women Against Violence*, Rotary Center for the Arts, Kelowna, B.C., 2006; *U8,* SOPA Gallery, Kelowna, B.C., 2006; *New Works,* Beyond Art Gallery, Vernon, B.C., 2006; *Small Matters*, Vernon Art Gallery, Vernon, B.C., 2005/2007; *Art Fete,* Arts For Ever, Kelowna, B.C., 2005; *Art on the Line*, Kelowna Art Gallery, Kelowna, B.C., 2005; Vernissage Gallery, Selected Show, Kelowna, B.C., 2005 AWARDS Okanagan University College Medal of Fine Arts, OUC, Kelowna, B.C., 2004; Okanagan University College President's Purchase Award, OUC, Kelowna, B.C., 2003

Sholem Krishtalka

BIRTH DATE May 6, 1979 RESIDES Toronto EDUCATION MFA, York University, Toronto, 2006; BFA, Concordia University, Montreal, 2001; DEC Beaux-Arts, Dawson College, Montreal, 1998 SELECT SOLO EXHIBITIONS *Wish You Were Here*, Paul Petro Small Works and Multiples, Toronto, 2007; *Idiot Sketches*, Lennox Contemporary Art Gallery, Toronto, 2006; *Idiot Sketches (Queen Street)*, Zsa Zsa Gallery, Toronto, 2004 SELECT GROUP EXHIBITIONS *Christmas Spice*, Paul Petro Contemporary Art, Toronto, 2007; *Nightlight—Bright Light*, Nuit Blanche Installation, Toronto, 2006; *Skin of the City*, Gales Gallery, Toronto, 2006; *Pot Modern*, Zsa Zsa Gallery, Toronto, 2005; *Imaging a Lover's Discourse*, Toronto Free Gallery, Toronto, 2005 AWARDS Purchase Prize, Schulich School of Business, Toronto, 2006; Elizabeth Greenshields Foundation Award, Greenshields Foundation, Toronto, 2005; Visual Arts Research Grant, Fonds de Recherche Québécois en Art et Culture, Montreal, 2004 WEBSITE sholem.ca

Kristina Kudryk

BIRTH DATE December 13, 1972 RESIDES Vancouver EDUCATION MFA, University of Calgary, Calgary, 1998 SELECT SOLO EXHIBITIONS *Pictures of a Modern World*, Bjornson Kajiwara Gallery, Vancouver, 2006; *A Room With a View*, Art Gallery of Alberta, Edmonton, 2004; *Kissing Cousins*, La Centrale, Montreal, 2002; Radiant, Harcourt House, Edmonton, 2001 SELECT GROUP EXHIBITIONS *Por'tri-choor*, 64 Steps, Toronto, 2007; *Group Show*, Bjornson Kajiwara Gallery, Vancouver, 2007; *Taking the Dog for a Walk,* Leo Kamen Gallery, Toronto, 2006; *Winter Seasonal*, Bjornson Kajiwara Gallery, Vancouver, 2006; *5 Painters*, Helen Pitt Gallery, Vancouver, 2004; *Group Show*, State Gallery, Vancouver, 2006; *Sweet and Low*, The Other Gallery at The Banff Centre, Banff, 2003 AWARDS Creation/Production Grant, The Canada Council for the Arts, 2004; Project Grant, The Alberta Foundation for the Arts, 2004; Resident Artist, The Banff Centre, 2003; Project/Travel Grant, The Alberta Foundation for the Arts, 2002; Travel Grant, Canada Council for the Arts, 2002; Finalist, Enbridge Award for Emerging Artist, Edmonton, 2002; Finalist, The New Canadian Painting Competition, RBC, 2001; Undergraduate Award for Excellence in Printmaking, KPMG and University of Alberta, Edmonton, 1995 WEBSITE kristinakudryk.com

Melanie MacDonald

BIRTH DATE December 17, 1976 RESIDES St. Catharines, Ont. EDUCATION BA Hon. Art & English, Brock University, St. Catharines, Ont., 2000 SELECT SOLO EXHIBITIONS *New Paintings*, Cobalt Gallery, Toronto, 2008; *Realtors*, Dennis Tourbin Members' Gallery–Niagara Artists' Centre, St. Catharines, Ont., 2006; *Chach-ka*, Gallery CRAM, St. Catharines, Ont., 2006; *Dishes and Things,* Jordan Art Gallery, Jordan, Ont., 2003; *Good Morning*, Denis Tourbin Members' Gallery– Niagara Artists' Centre, St. Catharines, Ont., 2004 SELECT GROUP EXHIBITIONS *One-Dimensional Space*, Modern Fuel, Kingston, Ont., 2008; *(the return of) 3-D Exquisite Corpse,* curated by Christine Cosby, Dennis Tourbin Members' Gallery–Niagara Artists' Centre, St. Catharines, Ont., 2008; *Queen West Art Crawl*, Toronto, 2006, 2007; *Toronto Outdoor Art Exhibition*, 2005, 2006, 2007; *Watermarks: A Reflection of Our Community*, St. Catharines City Hall, St. Catharines, Ont., 2007; *The Dirty Show*, Niagara Artists' Centre*,* St. Catharines, Ont., 2006; *St. Catharines in Person*, St. Catharines City Hall, St. Catharines, Ont., 2006; *Toronto & New York Square Foot IV,* AWOL Gallery & Project Spaceman, Williamsburg, Brooklyn, N.Y., 2005 AWARDS Exhibition Assistance, Ontario Arts Council, 2001, 2002, 2004, 2007; Volunteer of the Year, Niagara Artists' Centre, St. Catharines, Ont., 2004; Juror's Award–*On the Twelve*, Rodman Hall Arts Centre, St. Catharines, Ont., 2001, 2002 PUBLICATIONS *CRAM Presents Local Artist Melanie MacDonald*, Christine Ford, Brock Press, 2006 WEBSITE melaniemacdonald.ca

Laura Madera

BIRTH DATE December 13, 1978 RESIDES Guelph, Ont. EDUCATION BFA, Emily Carr Institute, Vancouver, 2002; MFA (in progress) University of Guelph, Guelph, Ont., 2009 SELECT SOLO EXHIBITIONS *Private Moments in Public Places*, Nuit Blanche and Tatar Gallery, Toronto, 2007; *Borderlands*, Atelier Gallery, Vancouver, 2005; *Private Moments in Public Places*, SWARM Blinding Light Cinema, Vancouver, 2002; *Painting in Transit*, Media Gallery ECI, Vancouver, 2002

SELECT GROUP EXHIBITIONS *Thanksgiving*, Silas Marder Gallery, Bridgehampton, N.Y., 2007; *Recolony*, Tatar Gallery, Toronto, 2007; *The Big Show*, Silas Marder Gallery, Bridgehampton, N.Y., 2006; *Help Your Self*, Helen Pitt Gallery, Vancouver, 2006; *Group 6*, Tatar Gallery, Toronto, 2003; *mis_ Space Show*, Douglas Udell Gallery, Vancouver, 2001; *Moving Through Stop*, Vancouver International Airport, Vancouver, 2001 AWARDS Board of Graduate Studies Research Scholarship (BGSRS), University of Guelph, Guelph, Ont., 2007; Visual Arts Development Award (VADA), Vancouver Contemporary Art Gallery and the Vancouver Foundation, Vancouver, 2006; Millennium Scholarship Award, Millennium Foundation, Ottawa, 2000 PUBLICATIONS *Help Your Self*, Carey Ann Schaefer, Lance Blomgren, Helen Pitt Gallery, 2006 WEBSITE lauramadera.com

Derek Mainella

BIRTH DATE 1973 RESIDES Toronto SELECT SOLO EXHIBITIONS *Death and the Maiden, Parts I and II*, Greener Pastures Contemporary Art, Toronto, 2006 SELECT GROUP EXHIBITIONS *To Get Her*, ATM Gallery, New York, 2007; *Beyond the Wall of Sleep*, Greener Pastures Contemporary Art, Toronto, 2006; *Two Weeks in Autumn*, Greener Pastures Contemporary Art, Toronto, 2005 COLLECTIONS Absolute Vodka, Katherine Bernhardt, Roger Haas, Erik Parker, A.G. Rosen, Ranbir Singh (Private Collections)

Meghan McKnight

BIRTH DATE May 2, 1980 RESIDES Toronto EDUCATION BA, Hons., Visual Studies and English, University of Toronto, Toronto, 2004 SELECT SOLO EXHIBITIONS *Oolites and Vibrissae*, p|m gallery, Toronto, 2006; *New Work*, p|m Gallery, Toronto, 2004; *The Sundew Mimicries*, Propeller Centre for the Visual arts, Toronto, 2004 SELECT GROUP EXHIBITIONS *Prickle and Gleam*, p|m gallery, Toronto, 2008; *Mexico Arte Contemporaneo*, p|m gallery, Mexico City, 2008; *Aqua Miami Wynwood*, p|m gallery, Miami, 2007; *Toronto International Art Fair*, p|m gallery, Toronto, 2007; *Different Strokes*, The Drake Hotel, Toronto, 2006; *Repeat After Me*, Flux Factory, Queens, N.Y., 2006; *Interstate*, Koffler Gallery, Toronto, 2004; *Room Service*, The Gladstone Hotel, Toronto, 2004; *All Inclusive*, Propeller Centre for the Visual Arts, Toronto, 2004 AWARDS Semi-finalist, RBC Canadian Painting Competition, Toronto, 2005 COLLECTIONS The Granite Club Collection, Toronto; The Donovan Collection, St. Michael's College in the University of Toronto; Joanne Tod, Private Collection; Otino Corsano, Private Collection WEBSITE pmgallery.ca

Alex McLeod

BIRTH DATE July 23, 1984 RESIDES Toronto EDUCATION BFA, OCAD, Toronto, 2007 SELECT GROUP EXHIBITIONS *Young Romantics*, Gallery 1313, Toronto, 2007; *Foot Long Show*, Alfie's Art Garage, Minneapolis, Minn., 2006; *Wall-Paper2*, XPACE, Toronto, 2006 AWARDS Best Computer Generated/Manipulated, TOAE Purchase Award, Toronto 2007 WEBSITE alxclub.com

Kristine Moran

BIRTH DATE March 6, 1974 RESIDES New York and Toronto EDUCATION MFA, Hunter College, New York, 2008; BFA, OCAD, Toronto, 2004 SELECT SOLO EXHIBITIONS *New Work*, Skew Gallery, Calgary, 2008; *The Dissolution Plan*, Angell Gallery, Toronto, 2005; *Trip Wire*, Angell Gallery, Toronto, 2004 SELECT GROUP EXHIBITIONS *Hunter MFA Grad Show*, Time Square Gallery, New York, 2008; *The Possibility of Framing Infinity*, The Dalton Gallery, Atlanta, 2008; *Perfect Competition*, Washington D.C., 2007; *Top 10*, Angell Gallery, Toronto, 2006; *Hybridity/Ambivalence*, Amos Eno Gallery, New York City, 2006; *Showcase 05*, Cambridge Gallery, Cambridge, 2005; *RBC New Painting Competition*, MOCCA, Toronto, 2005; *Futurama*, Propeller Centre, Toronto, 2004; *Drive*, Skew Gallery, Calgary, 2004; *Just Enough to Tickle*, Drabinsky Gallery, Toronto, 2004; *Fond of My Countach*, LE Gallery, Toronto, 2004 AWARDS Honourable Mention, Central Canada Regional Winner, 2005; RBC New Painting Competition; Governor General's Academic Medal, OCAD, 2004; Ontario College of Art and Design Medal, 2004; 401 Richmond Career-Launcher Prize, 2004; Drawing and Painting Medallist Scholarship, OCAD, 2004; M. W.O. Forsyth Scholarship, OCAD, 2004 WEBSITE kristinemoran.com

Andrew Morrow

BIRTH DATE January 24, 1973 RESIDES Chelsea, Que. EDUCATION MFA, University of Ottawa, Ottawa, 2009 SELECT SOLO EXHIBITIONS *Love and War*, Art Gallery of Sudbury, Sudbury, Ont., 2007; *War Paintings*, Edward Day Gallery, Toronto, 2004 SELECT GROUP EXHIBITIONS *Responses*, Gallery 115, Ottawa, 2008; *Local 416*, Edward Day Gallery, Toronto, 2007; *The Little Art Show*, Hang Man Gallery , Toronto, 2006; *Canadian Art Magazine Gallery Hop*, 132 Queen's Quay East, Toronto, 2005; *RBC Canadian Painting Competition*, Museum of Contemporary Canadian Art, Toronto, 2004 AWARDS RBC Emerging Artist Award Nominee, Toronto Arts Council Foundation, Toronto, 2007; Exhibition Assistance Award, Ontario Arts Council, Toronto, 2005; Grants to Visual Artists, Toronto Arts Council, Toronto, 2004; RBC Investments 6th Annual Canadian Painting Competition Nominee, Royal Bank of Canada, Toronto, 2004 COLLECTIONS Caisse de Dépôt et de Placement du Québec; Museum of Contemporary Art, Montreal; Musée National des Beaux Arts, Quebec City; Cirque du soleil, Montreal; Bibliothèque nationale du Québec, Montreal; Loto-Québec, Montreal; Kitchener-Waterloo Art Gallery, Kitchener, Ont., Ernst & Young; Osler, Hoskin & Harcourt; Banque d'œuvres d'art du Conseil des arts du Canada; Banque Nationale du Canada WEBSITE andrewmorrow.com

Andrea Mortson

BIRTH DATE November, 11, 1969 RESIDES Sackville, N.B. EDUCATION BFA, Queen's University, Kingston, Ont., 1992 SELECT SOLO EXHIBITIONS *This Burning World*, Struts Gallery, Sackville, N.B., 2006; *365 Small Paintings of Chandeliers*, Gallerie Connexion, Fredericton, 1999 SELECT GROUP EXHIBITIONS *Blush to Oblivion*, Khyber Gallery, Halifax, 2007; *Outcasted Dreamers,* Sappy Records Music Festival, Sackville, N.B., 2007; *Kosmos*, The Ottawa Art Gallery, Ottawa, 2006; *RBC Investments Canadian Painting Competition Finalist Exhibition,* Museum of Contemporary Canadian Art, Toronto; McMaster Museum of Art, Hamilton; New Brunswick Museum, Saint John; The Edmonton Art Gallery, Edmonton, 2004 AWARDS Creation Grant, New Brunswick Arts Board, 1999; Travel Grant, Canada Council for the Arts, 1999; Visual Arts Emerging Artist Grant, Ontario Arts Council, 1997 COLLECTIONS Canada Council Art Bank PUBLICATIONS *Kosmos*, Emily Falvey, The Ottawa Art Gallery, 2006; *Artists in a Floating World*, Tom Smart, The Beaverbrook Art Gallery, 2000; *365 Small Paintings of Chandeliers*, Ray Cronin, Gallerie Connexion, 1999 WEBSITE andreamortson.com

Natalie Munk

BIRTH DATE November 14, 1974 RESIDES New York EDUCATION BA, Brown University, Providence, Rhode Island, 1997; Fashion Design, Parsons School of Design, Paris, 1996 SELECT SOLO EXHIBITIONS *Peekaboo*, Corkin Shopland Gallery, Toronto, 2006; *Portraits*, The Spoke Club, Toronto, 2004; *Hide and Seek*, Spike Gallery, New York, 2002; *Somebody...Please Help Me Up* (Performance Piece), Paragon, Providence, Rhode Island, 1997 SELECT GROUP EXHIBITIONS *All About Me*, Spike Gallery, New York, 2003; *Exposures, Curated by Heidi Lee Art*, Townhouse Gallery, New York, 2002; *Young Designer Showcase*, Eickholt Gallery, New York, 2002; *DUMBO ArtExpo*, Brooklyn, N.Y., 2002; *Three,* Sarah Doyle Gallery, Providence, Rhode Island, 1997 WEBSITES corkingallery.com; nataliemunk.com

Wil Murray

BIRTH DATE January 11, 1978 RESIDES Montreal EDUCATION Alberta College of Art & Design, Calgary, 2000 SELECT SOLO EXHIBITIONS *The Strange Space That Will Keep Us Together*, Belkin Satellite Gallery, Vancouver, 2008; *The Brawl of the Beast*, Bilton Center For Contemporary Art, Red Deer, Alta., 2008; *Machines Molles*, Notman House, Montreal, 2007; *Strawberry Alarmist Talk Radio*, Loop Gallery, Toronto, 2007; *All Dressed Up Like a Little Man*, Patrick Mikhail Gallery, Ottawa, 2006 SELECT GROUP EXHIBITIONS *Songs of the Apocalypse*, Art Mûr Gallery, Montreal, 2007; *New Painters: Abstractions & Distractions*, Patrick Mikhail Gallery, Ottawa, 2006; *RBC Canadian Painting Competition Exhibition*, MOCCA, Toronto, St. Mary's University Gallery, Halifax, Bau-Xi Gallery, Vancouver, Galerie Sussex, Ottawa, 2005; *5 Painters*, Helen Pitt Gallery, Vancouver, 2004 AWARDS Eastern Finalist, RBC Painting Competition, Toronto, 2005 PUBLICATIONS *The Strange Space That Will Keep Us Together,*

exhibition catalogue, Jacqueline Mabey, Belkin Satellite Gallery, 2008; *Machines Molles*, exhibition catalogue, Marie-Douce St. Jacques, Art Pop, Montreal, 2007; *5 Painters*, exhibition catalogue, Jeremy Todd & Erin Sheehan, Helen Pitt Gallery, Vancouver, 2004; *A Conversation With Wil Murray*, Jeremy Todd, Helen Pitt Gallery, Vancouver, 2004 WEBSITE wilmurray.com

Val Nelson

BIRTH DATE 1960 RESIDES Vancouver EDUCATION Honours Diploma in Media Arts, Emily Carr College of Art and Design, Vancouver, 1988 SELECT SOLO EXHIBITIONS *Minding the Gap*, The Works Art & Design Festival, Edmonton, touring to Bau-Xi Gallery, Toronto, 2007; *Merci pour le flash*, Bau-Xi Gallery, Vancouver, 2006; *You Are Here*, Bau-Xi Gallery, Toronto, 2005; *Shimmer*, Bau-Xi Gallery, Vancouver, 2004; *Tourist*, Studio Blue Gallery, Vancouver, 2003 SELECT GROUP EXHIBITIONS *Horizons + Intersections*, Contact Toronto Photography Festival, Bau-Xi Gallery, Toronto, 2007; *Toronto International Art Fair*, Metro Toronto Convention Centre, Toronto, 2004–2007; *RBC Investments New Canadian Painting 5 Year Retrospective*, Elliott Louis Gallery, Vancouver, 2004; *Artropolis Road Show*, 13 public galleries throughout B.C., 2003; *RBC Investments New Canadian Painting Competition,* touring to Pavillion Gallery, Winnipeg; Museum London, London; Art Gallery of Nova Scotia, Halifax; Realtime Gallery, Toronto, 2003 AWARDS Semifinalist, New Canadian Painting Competition, Canadian Art Foundation/RBC Investments, Western Canada, 2003; Visual Arts Development Award, Vancouver Foundation/Contemporary Art Gallery, Vancouver, 2003; Honourable Mention, Seymour Art Gallery, North Vancouver, 2003; Award of Excellence, Delta Art Gallery, Delta, 2002 WEBSITE valnelson.ca

Mark Neufeld

BIRTH DATE February 25, 1972 RESIDES Vancouver and Berlin EDUCATION MFA, University of Victoria, 2005 SELECT SOLO EXHIBITIONS *Pictures at an Exhibition,* SuperBien Gallery, Berlin Germany, 2007; *A Word for Every Painting,* Leif Magne Tangens Gallery, Skien Norway, 2007; *Flicker,* Projekt 0047, Berlin Germany, 2006; *Lumph,* Bjornson Kajiwara Gallery, Vancouver, 2005; *Lumph,* MFA Exhibition, University of Victoria Gallery, Victoria, 2005; *Riot for a Rose,* Xeno Gallery, Vancouver, 2003 SELECT GROUP EXHIBITIONS *Plaskett Award Group Show,* Concourse Gallery, Vancouver, 2008; *Spring Fling 4–C Magazine Fundraiser,* Birch Libralato Gallery, Toronto, 2008; *A Life Worth Dying For,* Wilde Gallery, Berlin Germany, 2007; *Streams, torrents, lakes...and sunsets, for example,* PROGRAM Gallery, Berlin, 2007; *Spring Fling 3 – C Magazine Fundraiser,* Georgia Scherman Projects, Toronto, 2007; *May Invitational,* Bjornson Kajiwara, Vancouver, 2007 AWARDS Canada Council for the Arts Project Grant, 2007; Joseph Plaskett Award, Joseph Plaskett Foundation, 2005; University of Victoria Graduate Fellowship, University of Victoria, Victoria, 2005; Travel Grant, University of Victoria, Victoria, 2004 and 2005 PUBLICATIONS *Selecta 2006 Catalogue*, Westspace Gallery, Sydney, 2006 WEBSITE markneufeld.com

John Nobrega

BIRTH DATE October 27, 1974 RESIDES Toronto EDUCATION Diploma, OCAD, 1997 SELECT SOLO EXHIBITIONS *Inhuman*, Edward Day Gallery, Toronto, 2008; *Infinite Justice*, Edward Day Gallery, Toronto, 2006; *Salon de Paris*, Edward Day Gallery, Toronto, 2005; *Dandy in the Underworld*, Fleurs Du Mal, Toronto, 1999 SELECT GROUP EXHIBITIONS *Songs of the Apocalypse*, Art-Mûr, Montreal, 2007; *LoVe/HaTe: New Crowned Glory in the G.T.A.*, Museum of Contemporary Art, Toronto, 2007; *Scope New York*, Ashley Gallery, New York, 2006; *Palm Beach 3*, Ashley Gallery, Miami, 2006; *Scope London*, Ashley Gallery, London, U.K., 2005 AWARDS Ontario Arts Council Grant, Toronto, 1999; Eric Frefield Award, Ontario College of Art and Design, Toronto, 1997 COLLECTIONS Agnes Etherington Art Centre, Queen's University, Kingston, Ont. WEBSITE edwarddaygallery.com

Nigel Nolan

BIRTH DATE November 13, 1980 RESIDES Toronto, Buenos Aires EDUCATION AOCAD, 2006 SELECT SOLO EXHIBITIONS *Disrobe*, LE Gallery, Toronto, 2006; *Thank You South America*, Lehmann + Leskiw Fine Art, Toronto, 2006; *Sales Help—A Publicly Shared Exhibition*, Lehmann Leskiw + Schedler Fine Art, Toronto, 2004 SELECT GROUP

EXHIBITIONS *Toronto International Art Fair*, LE Gallery, Toronto, 2007; *Le Trois*, LE Gallery, Toronto, 2006; *Ontario College of Art and Design Medal Winners Exhibition*, Ontario College of Art and Design, Toronto, 2006; *Body Language*, Lehmann + Leskiw Fine Art, 2006; *Hard Drawing*, Lehmann + Leskiw Fine Art, Toronto, 2005; *Go West*, OCAD Drawing and Painting Thesis Exhibition, Tatar Galley, Toronto, 2005; *Making More Than One*, LE Gallery, Toronto, 2005; *Ontario College of Art and Design Printmaking Thesis Exhibition*, String Gallery, Toronto, 2005; *Spark*, Propeller Gallery, Toronto, 2004 AWARDS Ontario College of Art and Design Medal, OCAD, Toronto, 2006; Fred Hagan Memorial Scholarship, OCAD, Toronto, 2006; Nora E. Vaughan Award, OCAD, Toronto, 2006; Spoke Club Membership Prize, OCAD, Toronto, 2006; Women's Art Association of Hamilton Tuition Scholarship, OCAD, Toronto, 2004; Sharon Merkur Memorial Scholarship for Excellence in Wood Block Printmaking, OCAD, Toronto, 2004 COLLECTIONS The Agnes Etherington Art Centre, Kingston, Ont. PUBLICATIONS *The Woodcut Artist's Handbook*, George A. Walker, Foreword by Barry Moser, Firefly Books, 2005 WEBSITE nigelnolan.com

Anders Oinonen

BIRTH DATE March 30, 1977 RESIDES Toronto EDUCATION MFA, University of Waterloo, Waterloo, Ont., 2004; AOCAD, Toronto, 2001 SELECT SOLO EXHIBITIONS *Gone Like Tomorrow*, Mehr (Midtown), New York, 2007; *outTHEwindow*, Greener Pastures Contemporary Art, Toronto, 2007; *CTRL Group One*, CTRL Gallery, Houston, 2007; *its.what.its*, Greener Pastures Contemporary Art, Toronto, 2006 SELECT GROUP EXHIBITIONS *A Loaf of Bread, a Carton of Milk and a Stick of Butter,* Hudson Franklin, New York, 2008; *RBC Painting Competition*, OCAD, Toronto, Galerie d'art Louise-et-Reuben-Cohen, Université de Moncton, Moncton, MacLaren Art Centre, Barrie, Winnipeg Art Gallery, Winnipeg, Emily Carr Institute of Art and Design, Vancouver, 2007; *Blacknight*, Nuit Blanche, Toronto, 2007; *Keepin' It Real*, The Drake Hotel, Toronto, 2007 AWARDS Exhibition Assistance, Ontario Arts Council, Toronto, 2007; Emerging Artist Grant, Toronto Arts Council, Toronto, 2006; Emerging Artist Grant, Ontario Arts Council, Toronto, 2006 COLLECTIONS Musée d'art contemporain de Montréal WEBSITE meanders.ca

Luke Painter

BIRTH DATE November 29, 1977 RESIDES Toronto EDUCATION BFA, OCAD, Toronto, 2001; MFA, Concordia University, Montreal, 2005 SELECT SOLO EXHIBITIONS *Phantasm*, Angell Gallery, Toronto, 2008; *Misty Mountain Hop*, Angell Gallery, Toronto, 2007; *Babel*, Transmedia Billboard-Year Zero-One Project; *Pipe Dreams*, Angell Gallery, Toronto, 2005; *Pipe Dreams*, Bourget Gallery, Montreal, 2005; *Tiny Utopias*, Angell Gallery, Toronto, 2004; *Roadside Attraction*, Angell Gallery, Toronto, 2003 SELECT GROUP EXHIBITIONS *New Work*, Bonneau-Samames Art Contemporain, Marseille, 2008; *Slick 07 Contemporary Art Fair*, Paris, 2007; *Coercive Atmospherics*, DUMBO Arts Center, New York, 2007; *Toronto International Art Fair*, Toronto, 2007; *Salon Ecarlate III*, Marion Graves Muger Art Gallery, New Hampshire, 2006; *Scope International Art Fair*, Miami, 2005; *AFF Contemporary Art Fair*, New York, 2005; *Decalage*, The Parisian Laundry, Montreal, 2005; *Salon Ecarlate*, Galerie Espace, Montreal, 2004; *Scope International Art Fair*, Los Angeles, 2003 AWARDS Graduate Fellowship, Concordia University, Montreal, 2003; 1st Prize Graduate Printmaking Award, Loto-Quebec, Montreal, 2003; MFA Entrance Scholarship—Mike Rakmil Award, Concordia University, Montreal, 2002; Don Phillips Scholarship, Open Studio, Toronto, 2002; Medal Winner for Printmaking, OCAD, Toronto, 2001; Charles Pachter Award, OCAD, Toronto, 2001 WEBSITE lukepainter.ca

Dimitri Papatheodorou

BIRTH DATE December 4, 1964 RESIDES Toronto EDUCATION BES. B.Arch., University of Waterloo, Waterloo, Ont., 1989 SELECT SOLO EXHIBITIONS *New Work,* James Baird Gallery, Toronto, 2008; *New Work,* Snap Contemporary Art, Vancouver, 2007; *Encounters*, Gallery 1313, Toronto, 2007; *New Work,* James Baird Gallery, Pouch Cove, Nfld., 2006; *The Reveal*, Propeller Centre for the Visual Arts, Toronto, 2005; *Windmills*, Propeller Centre for the Visual Arts, Toronto, 2004; *Ghosts*, the Distillery Visitors Centre, Toronto, 2003; *Empty Space*, Coop on Scollard, Toronto, 2003; *5 Years*, Gallery 401, Toronto, 2002

SELECT GROUP EXHIBITIONS *Gallery Artists*, Snap Contemporary Art, Vancouver, 2007; *Sticks + Stones*, Spin Gallery, Toronto, 2006; *Wegway Annual Curated Show*, Fran Hill Gallery, Toronto, 2006; *Members Show*, Propeller Centre for the Visual Arts, Toronto, 2005 WEBSITE dimitripapatheodorou.com

Mary Porter
BIRTH DATE 1979 RESIDES Toronto EDUCATION MFA, York University, Toronto, 2007; BFA, NSCAD University, 2001 SELECT SOLO EXHIBITIONS *The space to be.*, Toronto Free Gallery, Toronto, 2007; *Recent Works*, Anna Leonowens Gallery, Halifax, 2002 SELECT GROUP EXHIBITIONS *Titres III*, Librairie L'Ecume Des Jours, Montreal, 2008; *Milk Milk Lemonade*, Redhead Gallery, Toronto, 2007; *Titles*, Balfour Books, Toronto, and Amherst Books, Amherst, 2007; *Here is Where We Meet*, The Gales Gallery, Toronto, 2007; *Blush to Oblivion*, The Khyber Centre for the Arts, Halifax, 2007; *Tangents*, The Gales Gallery, Toronto, 2007; *Condo BOOM!*, The Theatre Centre, Toronto, 2006; *Remote Splendour*, 64 Steps Contemporary Art and Design, 2006; *Skin of the City*, The Gales Gallery, 2006; *Random Thought Generator*, The Gales Gallery, Toronto, 2006; *Endnote*, Anna Leonowens Gallery, Halifax, 2001 AWARDS Visual Artist Grant, Toronto Arts Council, 2007; Canadian Graduate Scholarship, SSHRC, 2006; Graduate Entrance Scholarship, York University, Toronto, 2005

Katie Pretti
BIRTH DATE July 6, 1980 RESIDES Toronto EDUCATION Fine Arts Diploma, Printmaking, OCAD, Toronto, 2004 SELECT SOLO EXHIBITIONS *Damsels and Distress*, LE Gallery, Toronto, 2007; *Grander Failures*, Galerie Simon Blais, Montreal, 2007; *Dominant Recessives*, LE Gallery, Toronto, 2007; *Under, Over and Over*, LE Gallery, Toronto, 2006; *Vaginas in Their Natural Habitat*, Queen West Art Crawl—Artists' Open Studio, Toronto, 2004; *Above My Sofa*, artart, Toronto, 2004 SELECT GROUP EXHIBITIONS *Valentine's Day Show*, Bjornson Kajiwara Gallery, Vancouver, 2008; *Mulled Mix*, Bjornson Kajiwara Gallery, Vancouver, 2007; *Standard Form's First 3 Books*, Art Metropole, Toronto, 2007; *May Invitational*, Bjornson Kajiwara Gallery, Vancouver, 2007; *Le Trois*, LE Gallery, Toronto, 2006; *This Distance*, LE Gallery, Toronto, 2006; *Deck the Walls*, Lehmann Leskiw Fine Art, Toronto, 2005; *The Drawing Room*, Bjornson Kajiwara Gallery, Vancouver, 2005; *Hard Drawing*, Lehmann Leskiw Fine art, Toronto, 2005; *Love the Ladies*, Gallery 61, Toronto, 2005 AWARDS Student Honourable Mention, *Outdoor Art Exhibition*, Toronto, 2004; Open Studio Prize, OCAD Printmaking Award, Toronto, 2004; Printmaking Scholarship, OCAD, Toronto, 2003; Printmaking Award, OCAD, Toronto 2002 PUBLICATIONS *Sonority of Words*, Standard Form, Toronto, 2007 WEBSITE katiebondpretti.com

Aleksandra Rdest
BIRTH DATE February 25, 1979 RESIDES Toronto EDUCATION OCAD, Toronto, 2002 SELECT SOLO EXHIBITIONS *Pouch Cove*, James Baird Gallery, St. John's, 2007; *New Paintings*, Pari Nadimi Gallery, Toronto, 2003 SELECT GROUP EXHIBITIONS Bjornson Kajiwara Gallery, Vancouver, 2007; *Fuzz*, Newzones, Calgary, 2007; *Le Soleil Noir*, Tatar Gallery, Toronto, 2007; *My Secret City*, Nuit Blanche, Toronto, 2006; *Spell*, Thames Art Gallery, Chatham, U.K., 2006; *In Transit*, Gosia Koscielak Gallery, Chicago, 2005; *Spell*, Mendel Art Gallery, Saskatoon, 2005; *Spell*, Robert McLaughlin Gallery, Oshawa, Ont., 2005; *Trans* Big Studio Gallery, Yokohama, Japan, 2004 AWARDS Short-listed for the RBC Painting Competition, Canada-wide, 2007; Production Grant, Canada Council for the Arts, 2007; David L. Stevenson Scholarship, OCAD, Toronto, 2002; A.V. Issacs Tuition Scholarship, OCAD, Toronto, 2001 COLLECTIONS Royal Bank of Canada; Holt Renfrew; Canaccord Capital Corporation; Burnac Corporation WEBSITE aleksrdest.com

Mélanie Rocan
BIRTH DATE September 19, 1980 RESIDES Winnipeg EDUCATION MFA, Concordia University, Montreal, 2007; MFA, Exchange Program, Glasgow School of Art, Glasgow, 2005; BFA, Honours Degree, Painting Thesis, University of Manitoba, Winnipeg, 2003 SELECT SOLO EXHIBITIONS *Naturally Tied*, Paul Petro Contemporary Art, Toronto, 2008; *Testing the Limits*, Paul Petro Multiples and Small Works, Toronto, 2007; *Les Murs sont Tombes*, La Maison des Artistes,

Winnipeg, 2007; *Dark and Lonely*, Paul Petro Contemporary Art Gallery, Toronto, 2006; *Familiar Places*, Paul Petro Contemporary Art Gallery, Toronto, 2005 SELECT GROUP EXHIBITIONS *Ignition 4*, Leonard & Bina Ellen Art Gallery, Montreal, 2007; 2 person show with Erica Eyres, Project Room, Glasgow, 2007; *RBC Painting Competition*, Museum of Contemporary Canadian Art, Toronto; Kitchener-Waterloo Art Gallery; Musee d'Art Contemporain de Montreal; Art Gallery of Calgary; Contemporary Art Gallery, Vancouver, 2006; *Supernovas*, Winnipeg Art Gallery, Winnipeg, 2006 AWARDS Winnipeg Arts Council, Professional Development Grants, 2006–2007; Winnipeg Arts Council Production Grant in the Visual Arts, 2006; Manitoba Arts Council Student Bursary, 2005-2006; Manitoba Arts Council Grant, Creation/Production in the Visual Arts 'C', 2004; Millennium Scholarship Awards, Canadian Millennium Scholarship Foundation, 2001, 2002 and 2003 COLLECTIONS Doris McCarthy Gallery, University of Toronto, Scarborough, Ont.; Royal Bank of Canada, Winnipeg offices PUBLICATIONS *RBC Painting Competition* catalogues, 2006 and 2007; *Supernovas* catalogue, Winnipeg Art Gallery, 2006

Kristi Ropeleski
BIRTH DATE November 10, 1977 RESIDES Toronto EDUCATION MFA in Visual Art, York University, Toronto, 2008; BFA in Studio Art, Conferred with Distinction, Concordia University, Montreal, 2002; DEC in Fine Arts, Dawson College, Montreal, 1997 SELECT SOLO EXHIBITIONS *White Noise*, Lennox Contemporary, Toronto, 2008; *Look at Me When I'm Talking to You*, Artguise, Ottawa, 2004; *Blood Harmony*, Zeke's Gallery, Montreal, 2004 SELECT GROUP EXHIBITIONS *Committed to Ink*, Sullivan Goss, Santa Barbara, 2008; *Beyond Representation*, Scion, San Francisco, 2006; *Visages et le Temps Perdu*, Warren G. Flowers Gallery, Montreal, 2005; *Electric Art Derby 2*, Casa del Popolo, Montreal, 2002 AWARDS Social Sciences and Humanities Research Council of Canada Graduate Research Grant, Government of Canada, Toronto, 2007; Graduate Scholarship, York University, Toronto, 2006; The Elizabeth Greenshields Award, The Elizabeth Greenshields Foundation, Montreal, 2006 WEBSITE kristiropeleski.com

Leah Rosenberg
BIRTH DATE April 2, 1979 RESIDES San Francisco EDUCATION MFA, California College of Art, San Francisco, 2008; BFA Emily Carr Institute, Vancouver, 2003; New York Studio Program, New York, 2002 SELECT SOLO EXHIBITIONS *Sweet Raw* (with Siobhan Humston), Jacana Gallery, Vancouver, 2006; *Pretty on the Inside on the Pretty on the Outside*, Moule, Vancouver, 2006; *Maux Faux*, Zulu Records, Vancouver, 2006; *Pretty Please*, the Whip Gallery, Vancouver, 2005; *Plus+* (with George Vergette), Bjornson Kajiwara Gallery, Vancouver, 2005; *Case Study*, the lowercase gallery, Vancouver, 2005; *Happy Day*, the Lobby Gallery, Vancouver, 2005 SELECT GROUP EXHIBITIONS *Bay to Barley*, Hastings College Art Gallery, Hastings, Nebraska, 2007; *the Big Tiny*, Red Ink Studios, San Francisco; *G-13*, Spare Room Gallery, San Francisco; plaYspace Auction 2007, California College of Art, San Francisco; *Optimism*, The Hardware Store Gallery, San Francisco; *Aggregate Set*, LES Gallery, Vancouver; *Us & Them*, The Anderson Gallery, Virginia Commonwealth University, Virginia; *Seasonal Artist Exhibition*, Jacana Gallery, Vancouver, 2005; *Metier*, SYNC—Nettwerk Studio, Vancouver; *MAD*—mainspace art + design, Mainspace, Vancouver; *Welcome*, 536 House, Vancouver; *Arts for Life Silent Auction Preview*, Jacana Gallery, Vancouver; *Artists at Emma Lake*, Kenderdine Campus, Emma Lake, Sask.; *Red Is Best*, Jennifer Kleinsteuber Gallery, Vancouver AWARDS Richard K Price Scholarship, California College of Art, San Francisco, 2007, 2008 WEBSITE leahrosenberg.org

François Xavier Saint-Pierre
RESIDES Toronto EDUCATION MFA, University of Waterloo, Waterloo, Ont., 2006; BFA, Concordia University, Montreal, 1999 SELECT SOLO EXHIBITIONS *A Distant Order*, Stewart Hall Art Gallery, Montreal, 2009; *All Experience is an Arch*, Corkin Gallery, Toronto, 2007; *MFA Thesis Exhibition*, University of Waterloo Art Gallery, Waterloo, Ont., 2006 SELECT GROUP EXHIBITIONS *Toronto International Art Fair*, with Corkin Gallery, Toronto, 2006–2007; *Art Basel Miami Beach*, with Corkin Shopland Gallery, Miami Beach, 2006; *RBC Painting Competition*, MOCCA, Toronto; MACM, Montreal; KWAG, Kitchener, Ont.; Art Gallery of Calgary, Calgary; CAG, Vancouver, 2006; *Simply Curious*, Corkin Shopland Gallery,

Toronto, 2006; *Drawer*, Harbourfront Centre Case Studies, Toronto, 2003 AWARDS Exhibition Assistance Grant, Ontario Arts Council, Toronto, 2007; Brucebo Summer Studio Residency, Canadian-Scandinavian Foundation, Gotland, Sweden, 2007; Semi-finalist–Central Canada, RBC Canadian Painting Competition, 2006; Shantz Fellowship, University of Waterloo, Waterloo, Ont., 2005 PUBLICATIONS *26: Michael Davidson*, Translinear Publishing, Toronto, 2007; RBC Canadian Painting Competition: 10th Anniversary Publication, Royal Bank of Canada, Toronto, 2008 WEBSITE corkingallery.com

Joomi Seo

BIRTH DATE June 16, 1981 RESIDES Vancouver EDUCATION BFA, Emily Carr Institute of Art and Design, Vancouver, 2007; Mobility Program, School of the Museum of Fine Arts, Boston, 2006 SELECT GROUP EXHIBITIONS *Bliss*, Diane Farris Gallery, Vancouver, 2007; *Graduation Show*, Charles H. Scott Gallery, Emily Carr Institute of Art and Design, Vancouver, 2007; *Performance Show*, Concourse Gallery, Emily Carr Institute of Art and Design, Vancouver, 2007; *The Catalyst*, Concourse Gallery, Emily Carr Institute of Art and Design, Vancouver, 2006; *Connecting Flights*, Concourse Gallery, Emily Carr Institute of Art and Design, Vancouver, 2006; *Salon Show*, BAG Gallery, School of the Museum of Fine Arts, Boston, 2005 WEBSITE joomiseo.com

Keer Tanchak

BIRTH DATE June 15, 1977 RESIDES Chicago EDUCATION MFA, School of the Art Institute of Chicago, Chicago, 2003; BFA, Concordia University, Montreal, 2000 SELECT GROUP EXHIBITIONS *Sampling*, Bjornson Kajiwara Gallery, Vancouver, 2007; *The Idea of Reflection*, Galerie Sandra Goldie, Montreal, 2007; *Selected Paintings*, Hotel Gault, Montreal, 2007; *Lifted Pictures*, Navta Schulz Gallery, Chicago, 2006; *Exporting Pop: A Western Fantasy*, Kuwait Art Foundation and Dean Project, Dubai, 2008; *Biennial 24*, South Bend Regional Museum of Art, South Bend, Indiana, 2007; *Entre Chien et Loup*, Bleu Acier Inc., Tampa, Florida, 2006; *Hot Touch*, Galerie Sandra Goldie, Montreal, 2006; *lls sont jeunes*, Galerie Simon Blais, Montreal, 2001 AWARDS Purchase Prize, South Bend Regional Museum of Art, South Bend, Indiana, 2007; MFA Fellowship, School of the Art Institute of Chicago, Chicago, 2003; The Brucebo, Brucebo Fine Art Foundation, Visby, Sweden, 2003; Studio Arts Award, Concordia University, Montreal, 2000; Heinz Jordan Painting Prize, Concordia University, Montreal, 1999 COLLECTIONS South Bend Regional Museum of Art, South Bend, Indiana; Fasken Martineau, Montreal; Hyatt Fisherman's Wharf, San Francisco; Visby Kunstmuseum, Visby, Sweden; Roy Heenan of Heenan Blaikie, Montreal; S.L. Simpson, Toronto PUBLICATIONS *Fragonard, Regards Croisés*, Jean-Pierre Cuzin and Dimitri Salmon, Edition Mengès, 2007; *New American Paintings*, Volume 71, Open Studios Press, 2007; *Gallery Guide*, International Collectors Edition, LTB, New York, 2006; *Toronto International Art Fair Catalogue*, 2005; *paint-or-die*, text by Jody Pauline Patterson, Peach Pit Pie, 2000 WEBSITE keertanchak.com

Corri-Lynn Tetz

BIRTH DATE November 18, 1975 RESIDES Montreal EDUCATION BFA, Emily Carr, Vancouver, 2003; Art and Design Diploma, Red Deer College, Red Deer, Alta., 1998 SELECT GROUP EXHIBITIONS *Sampling*, Bjornson Kajiwara Gallery, Vancouver, 2007; *Playwrights Montreal Art Auction*, Saidye Bronfman Centre, Montreal, 2006; *Portrait Show*, Bjornson Kajiwara Gallery, Vancouver, 2006; *The Drawing Room*, Bjornson Kajiwara Gallery, Vancouver, 2005; *Once Removed*, Third Avenue Gallery, Vancouver, 2004 AWARDS Takao Tanabe Scholarship, Emily Carr, Vancouver, 2003; Ian and Hope Cook Travel Bursary, Red Deer College, Red Deer, Alta., 1998; Northlands Park Art and Design Award, Red Deer College, Red Deer, Alta., 1998

Ehryn Torrell

BIRTH DATE October 13, 1977 RESIDES Guelph, Ont. EDUCATION MFA, Nova Scotia College of Art and Design University, Halifax, 2006; Combined Honours B.A. (Visual Art & English), McMaster University, Hamilton, Ont., 2000 SELECT SOLO EXHIBITIONS *The Pink House*, Centre des arts actuels Skol, Montreal, 2008; *The Pink House*, Gallery Connexion, Fredericton, 2007; *The Pink House*, Anna Leonowens Gallery, Halifax, 2005 SELECT GROUP EXHIBITIONS *Reciprocal*, Universidad de La Magdalena, Santa Maria, Colombia and

McMaster Museum of Art, Hamilton, Ont., 2008; Charles H. Scott Gallery, Vancouver, 2008; *Traces*, Skew Gallery, Calgary, 2008; *Kära Ragna*, Babel Art Space, Trondheim, Norway, 2007; *Haptic*, Contemporary Art Forum Kitchener and Area, Kitchener, Ont., 2007; *Habituation*, Forest City Gallery, London, Ont., 2007; *Transparent*, The Granary, Fiskars, Finland, 2007; *Impassé*, Truck Gallery, Calgary, 2006 AWARDS Travel Grant to an International Artist Residency, Canada Council for the Arts, Ottawa, 2007; Joseph Plaskett Foundation Award, Joseph Plaskett Foundation, Canada/England, 2006; Residency Scholarship, The Banff Centre, Banff, Alta., 2004; Joseph Beuys Memorial Scholarship, Nova Scotia College of Art & Design University, 2004; Graduate Scholarship, Nova Scotia College of Art and Design University, 2003; Artist in Education Grant, Ontario Arts Council, Toronto, 2002–2003; Humanities Medal for Special Achievement, McMaster University, Hamilton, Ont., 2000 PUBLICATIONS *Informal Architecture*, Anthony Kiendl, Black Dog Publishing, 2008 WEBSITE ehryntorrell.com

Ted Tucker

BIRTH DATE May 7, 1978 RESIDES Toronto EDUCATION AOCAD, Ontario College of Art & Design 2002 SELECT SOLO EXHIBITIONS *Dominance & Affection*, Fran Hill Gallery, Toronto, 2004; *Delete All Cookies*, Fran Hill Gallery, Toronto, 2003 SELECT GROUP EXHIBITIONS *Scope New York*, Christopher Cutts Gallery, New York, 2008; *Scope Miami*, Christopher Cutts Gallery, Miami, 2008; *Summer Splash*, Christopher Cutts Gallery, Toronto, 2007; *BlazeDays*, Christopher Cutts Gallery, Toronto, 2006 AWARDS John Alfsen Award, OCAD, Toronto, 2001; Curry's Art Store Prize, OCAD, Toronto, 2001; Above Ground Art Supply Award, OCAD, Toronto, 2000 WEBSITE tedtucker.ca

Pearl Van Geest

BIRTH DATE May 16, 1958 RESIDES Guelph, Ont. EDUCATION AOCA Diploma, Ontario College of Art, Toronto, 1996; Bachelor of Education, University of Toronto, 1986; Bachelor of Science, University of Guelph, 1980 SELECT SOLO EXHIBITIONS *Of Possession*, Cambridge Galleries: Preston, 2008; *New Work (Love on the Rocks)*, James Baird Gallery, Pouch Cove, Nfld., 2007; *Eat Me*, Katharine Mulherin Contemporary Art Projects, Toronto, 2006; *Down the Garden Path*, Gallery Stratford, Stratford, Ont., 2006; *Sugar Bush*, Katharine Mulherin Contemporary Art Projects, Toronto, 2005; *This Pale Mouth*, Macdonald Stewart Art Centre, Guelph, Ont., 2002; *Fool For Love*, Bus Gallery, Toronto, 2002; *Skin Deep*, Katharine Mulherin Gallery, Toronto, 2001; *New Work*, Deleon White Gallery, Toronto, 1998 SELECT GROUP EXHIBITIONS *Hysteria Festival of Women*, Buddies in Bad Times Theatre, Toronto, 2006; *Kiss Paintings: Massive Party*, Art Gallery of Ontario, Toronto, 2006; *Cross-Canada Suitcase Tour*, Mccleave Gallery, 2005; *Motherlode*, Women's Art Resource Centre, Toronto, 2003; *Blue*, V. MacDonnell Gallery, Toronto, 2000; *Myth City Saga*, Art Gallery of Mississauga, 1999; *Tall Orders: On the Spiritual in Art*, Propeller Centre, Toronto, 1999 AWARDS Travel Grant, Canada Council for the Arts, 2005; Finalist RBC Canadian Painting Competition, 2003; Art Bank Purchase, Canada Council for the Arts, 2001 and 2003; Emerging Artist Grant, Ontario Arts Council, 2003; Devona Paquette Memorial Award, W. O. Forsyth (Woman Painter) Award, Student Union Award, Ontario College of Art and Design, Toronto, 1996; Friends of OCA Scholarship, Ontario College of Art, Toronto, 1993 COLLECTIONS Macdonald Stewart Art Centre, Guelph, Ont.; Art Bank: Canada Council for the Arts WEBSITE pearlvangeest.com

Natalie Majaba Waldburger

BIRTH DATE April 27, 1970 RESIDES Toronto EDUCATION MFA, NSCAD, Halifax, 2004; AOCA, Ontario College of Art, Toronto, 1996; BA, Queen's University, Kingston, Ont., 1996 SELECT SOLO EXHIBITIONS *Double You*, Bau-Xi Gallery, Toronto, 2006; *Lament*, Bau-Xi Gallery, Vancouver, 2005; *Folie à Deux*, Katharine Mulherin Gallery, Toronto, 2004; *Something of a Terrible Wonder*, Anna Leonowens Gallery, Halifax, and Xexe Gallery, Toronto 2004; *Wanton Leap*, Real Art Ways, Hartford, Connecticut, and Katharine Mulherin Gallery, Toronto, 2003 SELECT GROUP EXHIBITIONS *Wynwood for Art Basel*, Wren Sharp Gallery, Miami, 2005; *Square Foot NY*, AWOL, Williamsburg, N.Y., 2005; *Precarious*, Agnes Etherington Art Centre, Kingston, Ont., 2004; *When I Get Up in the Morning and Go to Work*, Struts Gallery, Sackville, N.B., 2002; *Seaworthy*, Edward Day Gallery,

Toronto, 2001; *Collective Unconscious Project*, York Quay Gallery, Toronto, 2000 AWARDS *Best Local Artist Award*, Xtra, Toronto, 2004; *Royal College of Art Travel Award*, NSCAD, London U.K., 2003; *Gentles and Kay Award* TOAE, Toronto, 2000/2001; *Medal of Excellence: Drawing and Painting*, Ontario College of Art, Toronto, 1996; Canada Council Grants, Toronto, 1999, 2000, 2001 and 2005, Ontario Arts Council Grants 2000 and 2002 COLLECTIONS Agnes Etherington Centre, Kingston, Ont.; Ken Thompson, Toronto; Taylor Thompson, Toronto; Lady Tamara Grosvenor, London, U.K.; Nicole Loppacher, Herisau, Switzerland; Helen Griffiths, Toronto; Sarah Strange, Vancouver; Osler, Hoskin & Harcourt WEBSITE nmwaldburger.com

Doreen Wittenbols

BIRTH DATE January 24, 1974 RESIDES Amsterdam EDUCATION MFA, Concordia University, Montreal, 2002; AOCAD, Toronto, 1997 SELECT SOLO EXHIBITIONS *You, Me & Duende*, Duende Studios, Rotterdam, 2006; *sexentricité*, Galerie B-312, Montreal, 2005; *unfinished*, Galerie McClure, Montreal, 2001 SELECT GROUP EXHIBITIONS *Stockwell Studios Summer Exhibition,* Stockwell Studios, London, U.K., 2007; *Just Paintings*, Galerie RAM, Rotterdam, 2006; *Code 3*, Galerie 1313, Toronto, 2004; *Positions*, Galerie La Centrale, Montreal, 2002; *Facult(é)y Exposition*, Leonard & Bina Ellen Art Gallery, Montreal, 2002 AWARDS Research & Creation Project Grant, Canada Council for the Arts, 2002 and 2005; Artistic Research & Creation Project B Grant, Conseil des Arts et des Lettres du Québec, 2003; Joyce Melville Memorial Scholarship, Concordia University, Montreal, 2001; Stanley Mills Purchase Prize, Concordia University, Montreal, 2000; Governor-General's Award, OCAD, Toronto, 1997; M. Joan Chalmers Award, OCAD, Toronto, 1997; OCAD Medal Award – Drawing & Painting, OCAD, Toronto, 1997 PUBLICATIONS *Sexentricité: New Paintings by Doreen Wittenbols*, Kevin ichi De-Forest, Galerie B-312, 2005; *Unfinished, Wittenbols Down the Rabbit Hole,* Mikaela Bobiy; *A Series of Beginnings*, Sarah Gayle Key, Galerie McClure, 2001 WEBSITE doreenwittenbols.com

Laura Wood

BIRTH DATE February 7, 1980 RESIDES Toronto EDUCATION BA, University of Waterloo, Waterloo, Ont., 2003 SELECT SOLO EXHIBITIONS *Memories of Leda*, Lehmann Leskiw Fine Arts, Toronto, 2006 SELECT GROUP EXHIBITIONS *Le Soleil Noir*, Tatar Gallery, Toronto, 2007; *Abstract*, Lehmann Leskiw Fine Arts, Toronto, 2006 COLLECTIONS Las Olas, Miami; Superior Ink, New York; Four Seasons Hotel, Dubai; The Hazelton Hotel, Toronto; St. Regis Hotel, San Francisco WEBSITE laurawood.ca

Max Wyse

BIRTH DATE August 16, 1974 RESIDES Montreal, Paris SELECT SOLO EXHIBITIONS *Jardin dans la peau*, Galerie Simon Blais, Montreal, 2008; *Geophagic Man,* Bjornson-Kajiwara Gallery, Vancouver, 2007; *Étranger,* Centre d'exposition en art actuel Plein-Sud, Longueuil, Que. 2007 SELECT GROUP EXHIBITIONS *The Crooked Mirror*, Envoy Gallery, New York, 2007; *Inflorescences,* Centre Clark, Montreal, 2007; *Déjà Vu,* curated by Bernard Lamarche, Musée Régional de Rimouski, Que., 2006 AWARDS Creation Grants, Conseil des Arts et des Lettres du Québec, 2005 and 2007 PUBLICATIONS *L'homme 100 têtes à la recherche du réel*, text by Luis de Moura Sobral, Centre d'exposition en art actuel Plein-Sud, 2007 WEBSITE maxwyse.com

mid-career

Shelley Adler

BIRTH DATE July 22, 1961 RESIDES Toronto EDUCATION MFA, Boston University, 1987; BFA, York University, Toronto, 1983; Edinburgh College of Art, 1982 SELECT SOLO EXHIBITIONS Nicholas Metivier Gallery, Toronto, 2006; *Anonymous*, Loop Gallery, Toronto 2005; *Making Faces*, State Gallery, Vancouver, 2002 SELECT GROUP EXHIBITIONS *Making Room*, Harbourfront, Toronto, 2006; *Paint Jam*, Dyan Marie Projects, 2006; *Just Enough to Tickle*, Drabinsky Gallery, Toronto, 2004 AWARDS Drawing Award, Blackwood Gallery, 1997; Nan Foundation Graduate Scholarship, Boston University, Boston, 1986 WEBSITE shelleyadler.com

Louise Belcourt

BIRTH DATE March 21, 1961 RESIDES Brooklyn, N.Y. and Metis-sur-Mer, Que. EDUCATION BFA Mount Allison University, Sackville, N.B., 1983 SELECT SOLO EXHIBITIONS *Louise Belcourt*, Galerie Vidal-St. Phalle, Paris, 2007; *A Bigger World*, Jeff Bailey Gallery, New York, 2006; *Water, Land, Mammal*, Patricia Sweetow Gallery, San Francisco, 2005; *Wriggling Philosophical Life*, Jeff Bailey Gallery, New York, 2004; *Louise Belcourt*, Peter Blum Gallery, New York, 1997 SELECT GROUP EXHIBITIONS *Block Party*, Daniel Weinberg Gallery, Los Angeles, 2006; *Tête à Tête*, Greenberg Van Doren Gallery, New York, 2005; *Open House*, The Brooklyn Museum of Art, Brooklyn, N.Y., 2004; *Three Painters: Louise Belcourt, Eva Lunsager, Cameron Martin*, Artemis Greenberg Van Doren, New York, 2001; *Art on Paper*, Weatherspoon Art Gallery, Greensboro, N.C., 1998; *Summer Selections*, The Drawing Center, New York, 1996 AWARDS Pollock-Krasner Foundation Grant, New York, 2000; Elizabeth Greenshields Foundation Grants, Montreal, 1984 and 1985 COLLECTIONS Deutsche Bank; Montreal Museum of Fine Arts; Fleming Museum, University of Vermont; Council for the Estate of Francis Picabia, Paris; Progressive Art Collection; Nokia Corporation; Le Ministre des Communautés Culturelles et de L'Immigration, Government of Quebec; Wellington Management Corporation WEBSITE louisebelcourt.net

Sylvain Bouthillette

BIRTH DATE June 1, 1963 RESIDES Montreal EDUCATION MFA, Concordia University, Montreal, 1991; BFA, Concordia University, Montreal, 1984 SELECT SOLO EXHIBITIONS Galerie Optica, Montreal, 2008; *Dharma Bum*, Mendel Art Gallery, Saskatoon, 2008; *Dharma Bum*, Saint Mary's University Art Gallery, Halifax, 2008; Galerie L'oeuvre de l'Autre, Université de Chicoutimi, Que., 2007; *Dharma Bum*, Musée Régional de Rimouski, Rimouski, Que., 2007; Everything is Perfect, Clint Roenisch Gallery, Toronto, 2004; *Tigre*, Galerie Trois Points, Montreal, 2004; *Zeichnungen und Druckgrafiken*, Front Store, Basel, Switzerland, 2001; *Rigodon*, Oboro Gallery, Montreal, 1999 SELECT GROUP EXHIBITIONS *Québec Gold*, Reims, France, 2008; *Ils causent des systèmes*, Musée national des beaux-arts du Québec, 2007; Musée d'art contemporain, Montreal, 2003; *Wasserwerk 3*, Wiesenbrücke, Riehen, Switzerland, 2001; *Artifice II*, organisée par le centre Saidye Bronfman, Montreal, 1998; *De fougue et de passion*, Musée d'art contemporain, Montreal, 1997; *Reclaiming Paradise: Survival of Montreal paintings in the '90s*, Centre des arts Saidye Bronfman, Montreal, 1996 COLLECTIONS Caisse de Dépôt et de Placement du Québec; Museum of Contemporary Art, Montreal; Musée du Québec, Quebec City; Cirque du soleil, Montreal; Bibliothèque nationale du Québec, Montreal; Loto-Québec, Montreal; Kitchener Waterloo Art Gallery, Kitchener, Ont.; Ernst & Young; Osler, Hoskin & Harcourt; Banque d'oeuvres d'art du Conseil des arts du Canada; Banque Nationale du Canada AWARDS Bourse longue durée, Conseil des Arts et des Lettres du Québec, 2006; Bourse longue durée, Conseil des Arts et des Lettres du Québec, 2004; Traveling grant, Canada Council for the Arts, 2003; Bourse longue durée, Conseil des Arts et des Lettres du Québec, 2002; Creation/Production grant, Canada Council for the Arts, 2002; Ernst & Young, Great Canadian Printmaking Competition, Third Prize, 2001; Residency Conseil des Arts et des Lettres du Québec à Bale, Switzerland, 2001; Creation/Production grant, Canada Council for the Arts, 1999; Bourse longue durée, Conseil des Arts et des Lettres du Québec, 1996 PUBLICATIONS *Dharma Bum,* Bernard Lamarche, Musée Régional de Rimouski et Expression Centre d'exposition de Saint-Hyacinthe, 2006

Shary Boyle

BIRTH DATE May 26, 1972 RESIDES Toronto EDUCATION Diploma, Fine Arts, OCAD, Toronto, 1994 SELECT SOLO EXHIBITIONS *The History of Light*, Southern Alberta Art Gallery, Lethbridge, Alta., 2008; *The Clearances*, Space Gallery, London, U.K., 2007; *Aspects and Excess*, Canadian Clay and Glass Gallery, Waterloo, Ont., 2007; *Lace Figures*, The Power Plant, Toronto, 2006; *Companions*, Or Gallery, Vancouver, 2004 SELECT GROUP EXHIBITIONS *Pandora's Box*, Dunlop Gallery, Regina, 2008; *The Sobey Art Award*, Art Gallery of Nova Scotia, Halifax, 2007; *Darkness Ascends*, MOCCA, Toronto, 2006; *Alternative Girlhood: Diaristic Indulgence and Contemporary Female Artists*, State University of New York Gallery, Brockport, N.Y., 2006; *Important Canadian Art*, ZieherSmith Gallery, New York, N.Y., 2004 AWARDS International Residency, Canada Council for the Arts, London U.K., 2007; Chalmers Foundation Award, Ontario Arts Council, 2004; Project Grant, Ontario Arts Council, 2003; Project Grant, Canada Council for the Arts, 2001; K.M. Hunter Artist Award, Ontario Arts Council, 2000 COLLECTIONS Paisley Museum of Art, Scotland; The National Gallery of Canada, Ottawa; Ydessa Hendeles Foundation, Toronto; Art Gallery of Ontario, Toronto; Musée des beaux-arts de Montreal, Quebec; Winnipeg Art Gallery, Winnipeg; The Rooms, St. John's; The Morris and Helen Belkin Art Gallery, University of British Columbia; Agnes Etherington Art Centre, Queen's University, Kingston, Ont. Publications: *Otherworld Uprising*, Conundrum Press, Montreal, 2008; *Zoetrope*, Francis Ford Coppola, AZX Publications, San Francisco, 2007; *Furniture*, Die Gestalten, Berlin, 2007; *Kramers Ergot #6*, Buenaventura Press, Los Angeles, 2006; *Witness My Shame*, Conundrum Press, Montreal, 2004 WEBSITE sharyboyle.com

Malcolm Brown

BIRTH DATE March 23, 1966 RESIDES Toronto EDUCATION Self-taught SELECT SOLO EXHIBITIONS *Dig Deep*, The Spoke Club Gallery, Toronto, 2006; *God & Goo 2*, Spin Gallery/Diesel Gallery, Toronto, 2006; *3 Years Of God & Goo*, DeLeon White Gallery, Toronto, 2004; *Our Logo/Our Town*, The Drake Hotel Lobby, Toronto, 2004; *Drive-By*, Harbourfront Centre Gallery, Toronto, 2001 SELECT GROUP EXHIBITIONS *Final Show*, Zsa Zsa Gallery, Toronto, 2005; *Istvan Kantor's The Blood Must Flow*, MOCCA, Toronto, 2005; *Year End Show*, Spin Gallery, Toronto, 2005; *TAAFI*, The Drake/Gladstone Hotels, Toronto, 2004 WEBSITE supercrasher.ca

Matthew Carver

BIRTH DATE July 18, 1968 RESIDES Berlin EDUCATION MFA (Distinction), Chelsea College of Art and Design, London, U.K., 2005; BFA (Hons.), York University, Toronto, 1992 SELECT SOLO EXHIBITIONS *The Floating World*, London Regional Museum, London, Ont., 2008; *Bright Lights, Big City*, Taksu Singapore, Singapore, and Gallerie Taksu, Kuala Lumpur, 2007; *Neo Tokyo*, Pari Nadimi Gallery, Toronto, 2004; *Distemper*, 64 Steps Contemporary Art, Toronto, 2001 SELECT GROUP EXHIBITIONS *Gallery Group Exhibition*, Galerie Caprice Horn, Berlin, 2008; *Anticipation*, Gallery One One One, London, U.K., 2007; *Noon Day Demons: Hold Onto Your Ego*, Studio 1.1, London, U.K., 2007; *Disposable Fetish*, The Nunnery Gallery, London, U.K., 2007; *Cropped*, Slot, Alexandria, Australia, 2007 AWARDS Singleton Family Scholarship, The Banff Centre for the Arts, 2001; Individual Artist – Emerging Artist Grant, Ontario Arts Council, 2001; The Canadian Emerging Artist Prize, First Prize (now known as RBC Canadian Painting Prize), RBC & Canadian Art Foundation, 2000 COLLECTIONS Canadian Art Collection RBC Financial Group; Ontario Securities Commission; Saatchi Collection, London, U.K. PUBLICATIONS *Gutter Dreams*, Lisa Le Feuvre, John Cussans and Shelagh Cluett, Chelsea College of Art and Design and University of the Arts, London, U.K., 2006 WEBSITE matthewcarver.net

Moira Clark

BIRTH DATE 1950 RESIDES Toronto EDUCATION BFA, York University, Toronto, 1973 SELECT SOLO EXHIBITIONS *Red Ochre and Blue Grey*, XEXE Gallery, Toronto, 2006; *A Decade of Painting: 1995 to 2005*, XEXE Gallery, Toronto, 2005; *Interior Life: Prints and Paintings by Moira Clark*, Preston Gallery/Cambridge Galleries, Cambridge, Ont., 2003; *Sonnets*, Loop Gallery, Toronto, 2003; *Sea Change*, Loop Gallery, Toronto, 2002 SELECT GROUP EXHIBITIONS *Something for Everyone I to IV*, XEXE Gallery, Toronto, 2004-2007; *Woof*, Fran Hill Gallery, Toronto, 2005; *TSA 30: Toronto School of Art Faculty Exhibition*, York Quay Gallery, Toronto, 1999; *Encore: The Station Gallery Revisited*, The Station Gallery, Whitby, Ont., 1995; *Chronicles*, University of Moncton Art Gallery, Moncton, 1993 AWARDS Residency, Pouch Cove Foundation, Pouch Cove, Nfld., 2004; Canada Council for the Arts, Travel Grant, Ottawa, 2004; Ontario Arts Council, Materials Assistance Grants, Toronto, 1987, 1988, 1991 and 2003 COLLECTIONS Paint Canada Council Art Bank; Art Gallery of Hamilton; City of Toronto Archives; Department of External Affairs; Providence Centre, Toronto; Art Gallery of Peterborough, Ont.; Burnaby Art Gallery, B.C.; University of Saskatchewan; City of York Board of Education, Ont.; Ernst & Young; Bank of Montreal PUBLICATIONS *Interior Life: Paintings and Prints by Moira Clark*, Gordon Hatt, Cambridge Galleries, 2003; *Place Setting*, John Armstrong, Tableau Vivant Gallery/Moira Clark, 1999; *TSA 30: Toronto School of Art 30th Anniversary Faculty Retrospective*, John Massier/Thomas Hendry, Toronto School of Art, 1999; *Art for Enlightenment: A History of Art in Toronto Schools*, Rebecca Sisler, Fitzhenry & Whiteside, 1995; *Encore: The Station Gallery Revisited*, Linda Paulocik, Whitby Arts Incorporated, 1995 WEBSITES ccca.ca; xexegallery.com

Cora Cluett

BIRTH DATE December 14, 1960 RESIDES Elmira, Ont. EDUCATION MFA, University of Guelph, Guelph, Ont., 1996; BFA, Nova Scotia College of Art and Design, Halifax, 1988 SELECT SOLO EXHIBITIONS *I Lived Here, I Lived There*, Kitchener-Waterloo Art Gallery, Kitchener, Ont., 2008; *Always As If*, Wynick Tuck Gallery, Toronto, 2005; *Scavenger's Daughter*, Art Gallery of Nova Scotia, Halifax, 2003; *A Wet Moon*, Wynick/Tuck Gallery, 1998; *Now We Are Alone Together*, Macdonald Stewart Art Centre, Guelph, Ont., 1996 SELECT GROUP EXHIBITIONS *Abstract Painting in Canada*, Art Gallery of Nova Scotia, Halifax, 2008; *Pulse-Film and Painting After the Image*, Mount Saint Vincent Art Gallery, Halifax, 2006, and Wynick Tuck Gallery, 2008; *Beyond/In Western New York*, Albright-Knox Art Gallery, Buffalo, 2005; *The Big Abstract Show*, The Painting Center, New York, 1999; *Perspective '96*, Art Gallery of Ontario, Toronto, 1996 AWARDS Mid-Career Arts Grant, Ontario Arts Council, Toronto, 2008; Mid-Career Arts Grant, Canada Council for the Arts, Ottawa, 2003 and 2005; SSHRC Seed Grant, University of Waterloo, Waterloo, Ont., 2003; Travel Grant, Canada Council for the Arts, Ottawa, 1999; Governor General's Academic Gold Medal, University of Guelph, Guelph, Ont., 1997 PUBLICATIONS *Abstract Painting in Canada*, Roald Nasgaard, Art Gallery of Nova Scotia and Douglas & McIntyre, 2007; *Beyond/In Western New York*, Holly E. Hughes, Albright-Knox Art Gallery, 2005; *Scavenger's Daughter*, Ray Cronin, Art Gallery of Nova Scotia, 2003; *Contingency and Continuity: Negotiating New Abstraction*, Ron Shuebrook and Judith Nasby, Macdonald Stewart Art Centre, 1998; *Perspective '96*, Jessica Bradley, Art Gallery of Ontario, Toronto, 1996-1997

Nicole Collins

BIRTH DATE February 28, 1962 RESIDES Toronto EDUCATION MVS, University of Toronto, Toronto, 2009; BA (Hons.), University of Guelph, Guelph, Ont., 1988 SELECT SOLO EXHIBITIONS *Stroke for Stroke*, Wynick/Tuck Gallery, Toronto, 2006; *Dimension*, Halde Galerie, Widen, Switzerland, 2004; *Branch*, Wynick/Tuck Gallery, Toronto, 2003; *Sample*, The Canadian Embassy Gallery, Tokyo, 2002; *One Mark*, Wynick/Tuck Gallery, Toronto, 2001 SELECT GROUP EXHIBITIONS *Ann Thinghuus und Nicole Collins*, Halde Galerie, Widen, Switzerland, 2007; *Pulse: Abstract Painting and Film*, Mount St Vincent University Gallery, Halifax, 2006; *You Don't Wanna Miss That Sh!t*, Gladstone Hotel, Toronto, 2006; *Crossing the Line*, The Painting Center, New York, 2005; *Death in the Studio: Studio Death Snapshots*, Book Project by Hannes Priesch + Niki Lederer, Vienna, New York and Toronto,

2004 AWARDS Canada Council Travel Grant (Switzerland) 2004; Canada Council Travel Grant (Tokyo) 2002; Ontario Arts Council Exhibition Assistance (Tokyo) 2002; Canada Council Travel Grant (London, U.K.) 2001; Artists' Residency, Triangle Artists' Workshop, New York, 2000 PUBLICATIONS *Abstract Painting in Canada*, Roald Naasgard, Douglas & McIntyre/Art Gallery of Nova Scotia, 2007; *Rewind: Nicole Collins*, Wynick/Tuck Gallery, Toronto; *Sample*, Ihor Holubizky, catalogue of exhibition at The Canadian Embassy, Tokyo, 2002 WEBSITE nicolecollins.com

Dagmar Dahle

BIRTH DATE 1958 RESIDES Lethbridge, Alta. EDUCATION BFA, University of Victoria, Victoria, 1986; MFA, Nova Scotia College of Art and Design, Halifax, 1991 SELECT SOLO EXHIBITIONS *Weaving Van Gogh*, Moose Jaw Museum and Art Gallery, Moose Jaw, Sask., 2008; *Lost Bird Collecting*, Southern Alberta Art Gallery, Lethbridge, Alta., 2006; *Weaving van Gogh*, Akau Inc., Toronto, 2006; *China Birds*, Grunt Gallery, Vancouver, 2000; *China Bird*, A Room Under the Stairs, Montreal, 1999; *Slip*, Stride Gallery, Calgary, 1998; *Letter*, Helen Pitt Gallery, Vancouver (collaboration with Vida Simon), 1998; *Letter*, Galerie Articule, Montreal (collaboration with Vida Simon), 1997; *She Would Be Long*, Access Gallery, Vancouver, 1997; *She Was Big*, Gallerie Articule, Montreal, 1994 SELECT GROUP EXHIBITIONS *Collecting Collecting*, University of Lethbridge Art Gallery, Lethbridge, Alta., 2007; *Current*, Southern Alberta Art Gallery, Lethbridge, Alta., 2006; *Alberta Biennial of Contemporary Art*, Edmonton Art Gallery, Edmonton, and Nickle Arts Museum, Calgary, 2002; *Crows*, Ace Art, Winnipeg, 2001; *25 Pieces of Art*, Open Space Gallery, Victoria, 1997; *Women's Visions Women's Stories*, Amelia Douglas Gallery, New Westminster, B.C., 1995; *Ravel/Unravel*, Redhead Gallery, Toronto, 1995; *Perfect Bound, Books by Artists*, Grunt Gallery, Vancouver, 1995; *Last to Be Done, First to Be Seen, Handmade Books and Bookworks*, Eye Level Gallery, Halifax, 1993 AWARDS Canada Council International Residencies Program in Visual Arts, Paris, 2008; Alberta Foundation for the Arts Project Grant, 2005; University of Lethbridge Research Fund Award, 2004; Canada Council Mid-Career Grant, 2001; B.C. Arts Council Visual Arts Grant, 1997; Canada Council B Grant, 1996; Canada Council Short-Term Grant, 1995 PUBLICATIONS *Lost Bird Collecting*, Exhibition Catalogue, Essay by Carol Williams, Southern Alberta Art Gallery, 2008; *Utopic Impulses: Essays in Contemporary Ceramic Practices*, Ruth Chambers, Amy Gogarty, Meireille Peron, eds., Ronsdale Press, Vancouver, 2007; *Letter*, Exhibition Pamphlet, Essay by Jack Stanely, Gallerie Articule, Montreal, 1997; *Notebook Projects*, Contemporary Art Gallery, Vancouver, 1996; *Harbour Vol. 2 No. 2*, Montreal, 1993; *Last to Be Done, First to Be Seen, Handmade Books and Bookworks*, Exhibition Catalogue, essay by Barbara Lounder, Eye Level Gallery, Halifax COLLECTIONS University of Lethbridge Art Gallery; Alberta Foundation for the Arts WEBSITE dagmardahle.net

Michel Daigneault

BIRTH DATE 1959 RESIDES Toronto and Montreal EDUCATION MA, Art History and Studio, University of Montreal, Montreal, 1995; BA, Philosophy, Art History and Studio Art, University of Montreal, Concordia University, 1985 SELECT SOLO EXHIBITIONS *The Thing That Moves Me the Most*, Akau Inc., Toronto, 2008; *The Other Side of Abstraction*, Trois Points Gallery, Montreal, 2007; *Quand la couleur signifie*, University of Trois-Rivières, Que., 2006; *Clock in clock off clock on clock out clock up*, Pari Nadimi Gallery, Toronto, 2001; *Les yeux de la tête*, Expression, Art Centre of Saint-Hyacinthe, Que., 1998 SELECT GROUP EXHIBITIONS *The Meeting*, Manif D'art 4, The Quebec City Contemporary Art Biennial, 2008; *Dessine le*, François Mitterrand Art Centre, Périgueux, 2007; *Unique Viewpoints: Recent Work by Quebec Artists*, National Arts Centre, Ottawa, 2007; *Dialogue(s)*, Contemporary Art Museum of Montreal, 2002; *Painting and Drawing*, Ohio State University, Columbus, Ohio, 2001 AWARDS A Grant, Quebec Council for the Arts, 2000-2001; B Grant, Canada Council for the Arts, 1996 and 2000; Pollock-Krasner Foundation, New York, 1990; PS1, Canada Council for the Arts, 1989 COLLECTIONS National Gallery of Canada; Art Bank of Canada; Contemporary Art Museum of Montreal; University of Lethbridge, Alta; Joliette Museum, Quebec; Quebec Museum; Royal Bank of Canada; National Bank of Canada; Hydro Quebec; Bank of Montreal WEBSITE yorku.ca/daigneau/

Michael Davidson

BIRTH DATE September 24, 1953 RESIDES Toronto EDUCATION BFA (Hons.), University of Guelph, Guelph, Ont., 1988 SELECT SOLO EXHIBITIONS *New Paintings*, Katharine Mulherin Gallery, Toronto, 2002 SELECT GROUP EXHIBITIONS *Building Picturing*, The Painting Center, New York, 2007; *Crossing the Line*, The Painting Center, New York, 2005; *Advent*, Halde Gallery, Zurich, Switzerland, 2003; *20th Anniversary*, Triangle New York, 2002; *Paintings Painted*, Platform Gallery, London, U.K., 2001 AWARDS Residency, Triangle New York, 2002 COLLECTIONS Art Gallery of the Region of Peel, Ont.; CIBC World Markets, BCE Place; Donovan Collection, St. Michael's College, Toronto; MacLaren Art Centre; MOCCA; Ontario College of Art And Design; PCL Constructors Canada Inc.; Robert McLaughlin Art Gallery; Seneca College, Newnham Campus; Tom Thomson Memorial Art Gallery PUBLICATIONS *26*, co-authored by Nicole Collins, Ihor Holubizky, Francois Xavier St. Pierre, Father Daniel Donovan, TRANSlinear Publishing, 2007; *Death in the Studio*, co-authored Hannes Priesch + Niki Lederer, Vienna, New York, 2004; *TRANSlinear*, co-authored by Ihor Holubizky, David Moos, Joseph R. Wolin, McMaster Museum of Art, 1999

Melissa Doherty

BIRTH DATE October 8, 1967 RESIDES Kitchener, Ont. EDUCATION Honours BA (Fine Arts), University of Waterloo, Waterloo, Ont., 1993; B.Ed., Nippissing University, North Bay, Ont., 1994 SELECT SOLO EXHIBITIONS *Into the Woods*, Galerie Art Mûr, Montreal, 2008; *Micro/Macro*, Doris McCarthy Art Gallery, University of Toronto, 2006; *New Paintings*, Edward Day Gallery, Toronto, 2006; *The View*, The Red Head Gallery, Toronto, 2005; *My Own Nature*, Robert Langen Gallery, Wilfrid Laurier University, Waterloo, 2000 SELECT GROUP EXHIBITIONS *Local Landscapes*, Glenhyrst Gallery, Brantford, Ont., 2008; *Bridge Art Fair*, Fleetwing Gallery, Miami, 2007; *Green is the New Black*, Melanee Cooper Gallery, Chicago, 2007; *Mexico Arte Contemporaneo*, Ashley Gallery, Mexico City, 2007; *Studio Alert Series*, Kitchener-Waterloo Art Gallery, 2006; *Obsession*, Edward Day Gallery, Toronto, 2006; *Art Chicago*, Ashley Gallery, Chicago, 2006; *Second Biennial*, Kitchener-Waterloo Art Gallery, 2005; *Hi-Light*, Edward Day Gallery, Toronto, 2005; *Contemporary Landscape Exhibit*, Queen's Park, Toronto, 2001 AWARDS *Mid-Career Grant*, Ontario Arts Council, 2007; *Creation/Production Grant*, Canada Council, 2003 and 2005; *Project Grant*, Waterloo Region Arts Fund, 2005; *Finalist*, RBC New Canadian Painting Competion, 2002; *Doris McCarthy Painting Award*, Wellington County Museum and Archives, Elora, 2001; *Emerging Artist Grant*, Ontario Arts Council, 2001 COLLECTIONS University of Toronto; University of Waterloo; Progressive Art Collection (U.S.); Royal Bank of Canada; BMO; Citibank; Fidelity; Femart Collection PUBLICATIONS *Art With Heart*, Casey House, auction catalogue, 2004 and 2005 WEBSITE melissadoherty.com

Kim Dorland

BIRTH DATE February 2, 1974 RESIDES Toronto EDUCATION MFA, York University, Toronto, 2003; BFA, Emily Carr Institute of Art and Design, Vancouver, 1998 SELECT SOLO EXHIBITIONS *Kim Dorland*, Bonelli Arte Contemporanea, Mantova, Italy, 2008; *North*, Freight + Volume, New York, 2008; *Somewhere in the Neighbourhood*, Bonelli Contemporary, Los Angeles, 2007; *About a Girl*, Angell Gallery, Toronto, 2007; *Over the Fence*, Skew Gallery, Calgary, 2007 SELECT GROUP EXHIBITIONS *Rear/View*, Freight + Volume, New York, 2007; *Out Behind the Shed*, Richard A. and Rissa W. Grossman Gallery, Lafayette College, Easton, Penn., 2007; *RBC Canadian Painting Competition Exhibition*, OCAD, Toronto; Galerie d'art Louise-et-Rueben-Cohen, Universite de Moncton; McLaren Art Centre, Barrie, Ont.; Winnipeg Art Gallery; Emily Carr Institute, Art + Design, Vancouver, 2007; *Oil Spill: New Painting in Ontario*, SAW Gallery, Ottawa, 2007; *Notions of Wilderness*, Kasia Kay Art Projects, Chicago, 2007 AWARDS Emerging Visual Artist Grant, Ontario Arts Council, 2006; Creation Grant, Toronto Arts Council, 2004; Emerging Artist Creation/Production Grant, Canada Council for the Arts, 2004 COLLECTIONS The Sander Collection, Berlin; Oppenheimer Collection, Nerman Museum of Contemporary Art, Kansas City, Kansas; The Glenbow Museum, Calgary PUBLICATIONS *Kim Dorland*, Interview and text by Robert Enright, Bonelli Contemporary, 2008; *Into the woods*, Manuela Brevi, contemporaneamente, 2006 WEBSITE kimdorland.com

Renée Duval

BIRTH DATE September 6, 1963 **RESIDES** Montreal **EDUCATION** MFA, Concordia University, Montreal, 1991; Fine Arts Diploma, Emily Carr College of Art and Design, Vancouver, 1986 **SELECT SOLO EXHIBITIONS** *Qualia*, Art Mûr, Montreal, 2008; *Scope*, Herringer Kiss Gallery, Calgary, 2008; *(T)here*, Angell Gallery, Toronto, 2007; *Une euphorie ordinaire*, Art Mûr, Montreal, 2006; *Reverb*, Art Mûr, Montreal, 2004 **SELECT GROUP EXHIBITIONS** *Summer Group Show*, Angell Gallery, Toronto, 2006; *Pictoral Navigations,* Maison de la Culture Marie-Uguay, Montreal, 2006; *A Group of Seven*, Canadian Embassy, Washington, D.C., 2005; *Vues de paysages*, Galerie McClure, Montreal, 2003; *Du Québec a Marseille*, Artena, Marseille, France, 2002 **AWARDS** Artistic Practice Grant, Conseil des Arts et des Lettres du Québec, 2000 and 2007; Travel Grant, Conseil des Arts et des Lettres du Québec, 2007; Travel Grant, The Canada Council for the Arts, 2004; Creation/Production Grant, The Canada Council for the Arts, 1999 **COLLECTIONS** Alcan Collection; Canada Council Art Bank; Centre D'Exposition Baie-St-Paul Collection; Europe's Best Corporate Collection; Gildan Corporate Collection; Loto Québec; Royal Bank of Canada Collection **PUBLICATIONS** *RBC Painting Competition 10th Anniversary Publication*, 2008; *Une Euphorie Ordinaire*, exhibition brochure, 2006 ; *Pictoral Navigations* exhibition publication 2006; *Les Femmeuses*, exhibition catalogue 2005; *Vues de Paysages*, exhibition publication, 2003 **WEBSITES** ccca.ca; artmur.com; herringerkissgallery.com; angellgallery.com

Peter Dykhuis

BIRTH DATE September 23, 1956 **RESIDES** Halifax **EDUCATION** BFA, Calvin College, Grand Rapids, Mich., 1978 **SELECT SOLO EXHIBITIONS** *Mixed Messages*, Red Head Gallery, Toronto, 2008; *You Are Here*, Saint Mary's University Art Gallery, Halifax, 2007; *Paper Maps*, Red Head Gallery, Toronto, 2006; *Datapaintings*, Red Head Gallery, Toronto, 2004; *Radar Sights*, The Owens Gallery, Mount Allison University, Sackville, N.B., 2003 **SELECT GROUP EXHIBITIONS** *The Imaginary Line*, Buffalo Arts Studio, Buffalo, 2008; *Zoomandscale*, Academy of Fine Arts, Vienna, Austria, 2008; *The Divas and Iron Chefs of Encaustic*, McKinney Avenue Contemporary, Dallas, 2008; *The Pale Blue Dot*, The Art Gallery of Regina, 2008; *The Bomarc: In the Shadow of the Shield*, WKP Kennedy Gallery, North Bay, Ont., 2007 **AWARDS** Winner, Eastern Canada, *New Canadian Painting Competition*, RBC Investments/ Canadian Art, Toronto, 2003; Juror's Award, *Encaustic Works '01*, Muroff-Kotler Visual Art Gallery, Ulster County Community College, SUNY, Stone Ridge, N.Y., 2001 **COLLECTIONS** Carleton University, Ottawa; City of Toronto; Department of Foreign Affairs and International Trade, Ottawa; Laurentian University Museum and Arts Centre, Sudbury, Ont.; Mount Saint Vincent University, Halifax; Nova Scotia Art Bank; Royal Bank of Canada, Toronto; Saint Mary's University Art Gallery, Halifax; The Chase Manhattan Bank N. A., New York; The Station Gallery, Whitby, Ont. **PUBLICATIONS** *The Divas and Iron Chefs of Encaustic*, (catalogue), Essays by Joanne Mattera and Virginia Spivey, Virginia Commonwealth University, School of the Arts, Richmond, Virginia, 2007; *You Are Here*, (catalogue), Essays by Robin Metcalfe, Hugh Millward and Cathy Conrod, Saint Mary's University Art Gallery, Halifax, 2007; *CrossWords*, (catalogue), Essay by Gil McElroy, Moose Jaw Art Museum, Moose Jaw, Sask., 1998; *World View: The G-7 Suite*, (catalogue for the Canadian Embassy, Tokyo), Eye Level Gallery, Halifax, 1998 **WEBSITE** dykhuis.ca

Dennis Ekstedt

BIRTH DATE July 17, 1961 **RESIDES** Montreal **EDUCATION** MFA, Concordia University, Montreal, 1993; Diploma in Fine Arts, Emily Carr College of Art and Design, Vancouver, 1986 **SELECT SOLO EXHIBITIONS** *TBA*, Art Mûr, Montreal, 2008; *TBA*, Katharine Mulherin Contemporary Art Projects, Toronto, 2008; *Scintillations*, Patrick Mikhail Gallery, Ottawa, 2007; *Dissolve*, Herringer Kiss Gallery, Calgary, 2007; *Temporary Constellations,* Art Mûr, Montreal, 2006 **SELECT GROUP EXHIBITIONS** *Abracadabra*, Edward Day Gallery, Toronto, 2008; *Retrospective,* Centre d'exposition de baie-Saint-Paul, Baie-Saint-Paul, Que., 2007; *Pictoral Navigations,* Maison de la culture Marie-Uguay, Montreal, 2006; *La peinture figurativement contemporaine,* Art Mûr, Montreal, 2003; *Du Quebec a Marseille,* L'association Artena, Marseille, France, 2002 **AWARDS** Artistic Research and Creation Grant, Conseil des arts et des lettres du

Quebec, Montreal, 2008; Project Grant, Canada Council for the Arts, Montreal, 2007; RBC New Canadian Painting Competition, Eastern Canada Winner, Royal Bank of Canada, Montreal, 2002; Creation/ Production Grant, Canada Council for the Arts, Montreal, 2000 and 2002 **COLLECTIONS** The Royal Bank of Canada; Centre d'Exposition de Baie-Saint-Paul; Gildan Inc.; Hydro Québec; Loto-Quebec; Europe's Best Corporate Collection; Canadian Department of Foreign Affairs and International Trade **PUBLICATIONS** *New Canadian Painting Competition 2002* (catalogue),RBC Investments, 2002; *RBC Canadian Painting Competition 10th Anniversary Publication*, RBC Investments, 2008; *19th Symposium International de la Nouvelle Peinture au Canada, L'etre au monde,* Paul Lussier, Vie des Arts, 2001; *Pictoral Navigations* (catalogue), Renée Duval, Maison de la culture Marie-Uguay, 2006; *Paint or Die,* Jody Pauline Patterson, PeachPitPie, 2000 **WEBSITES** ccca.ca; herringerkissgallery.com; artmur.com

Gary Evans

BIRTH DATE February 19, 1966 **EDUCATION** AOCA, 1989 **SELECT SOLO EXHIBITIONS** *Hovercraft*, Paul Petro Contemporary Art, Toronto, 2007; *Station*, Art Gallery of Windsor, Ont.,2007; *State Park,* Paul Petro Contemporary Art, Toronto, 2006; *Seeing Things*, Tom Thomson Memorial Art Gallery, Owen Sound, Ont., 2001; *Field Trip*, Kelowna Art Gallery, Kelowna, B.C., 1998 **SELECT GROUP EXHIBITIONS** Art Gallery of Stratford, Stratford, Ont.,2008; *Envisioning Landscape*, MacLaren Art Centre, Barrie, Ont., 2007; *Tina B Biennial*, Prague, Czech Republic, 2006; *Suburbia*, Art Gallery of Peel, Brampton, Ont., 2001; *True North*, Kaoshung Museum of Fine Arts, Taiwan, 1999 **PUBLICATIONS** *Seeing Things: The Paintings of Gary Evans*, David Liss, Nell Tenhaff, Stuart Reid, 2001; *Passing Through: The Paintings of Gary Evans*, Clint Roenisch, 1998

Joe Fleming

BIRTH DATE December 29, 1964 **RESIDES** Toronto **EDUCATION** Illustration, Sheridan College, Oakville, Ont., 1986 **SELECT SOLO EXHIBITIONS** *Beauty Queens and Cowboys*, Gallery Taksu, Singapore, 2007; *Cold Comfort, Hard Wood*, DeLeon White Gallery, Toronto, 2007; *Shanty Town*, Artcore Gallery, Toronto, 2005; *Sweet Tooth*, Jennifer Kostuik Gallery, Vancouver, 2004; *Frolic*, Gallery Taksu, Kuala Lumpur, 2003 **SELECT GROUP EXHIBITIONS** *Canadian Artists*, Gallery Taksu, Kuala Lumpur, 2007; *Gladstone Hotel*, Katharine Mulherin Contemporary, Toronto, 2006; *Expanding*, Jennifer Kostuik Gallery, Vancouver, 2005, Artcore Gallery, Toronto, 2004; *Drawn to the Future*, Conlon Seigal Gallery, Santa Fe, New Mexico, 2001 **COLLECTIONS** Trimark Mutual Funds; Price Waterhouse Coopers (Malaysia); HSBC (Malaysia); American Barrick; Magna International; Choo Mai Lin; Cathay Organization (Malaysia); Australian High Commission; Edmonton Art Gallery; Museum of Civilization (Canada); Michelle Yeow/Jean Todt **WEBSITE** joefleming.com

Alexandra Flood

BIRTH DATE October 21, 1969 **RESIDES** Greenwich, N.B. **EDUCATION** Diploma of Fine Arts, OCAD, Toronto, 1992 **SELECT SOLO EXHIBITIONS** *Pageant*, The New Brunswick Museum, Saint John, 2008; *Lustre*, Galerie Louise et Rueben Cohen/Universite de Moncton, Moncton, 2006; *Minx*, Struts Gallery, Sackville N.B., 2003; *Sugar*, Saint Mary's University Art Gallery, Halifax, 2001; *Gem Hour*, Gallery Connexion, Fredericton, 2000 **SELECT GROUP EXHIBITIONS** *Three Person Show* (with Jason Dunda and Carl Dalvia), Katharine Muherin Contemporary Art Projects, Toronto, Fall 2008; *Vision*, The Beaverbrook Art Gallery, Fredericton, 2004; *Recent Acquisitions*, the Beaverbrook Art Gallery, Fredericton, 2000; *Browser*, Roundhouse Gallery, Vancouver, 1997; *Young Contemporaries*, London Regional Art Gallery, London, Ont., 1992 **AWARDS** Miller Brittain Award for Excellence in the Visual Arts, The New Brunswick Arts Board, Fredericton, 2008; Strathbutler Shortlist Prize, The Sheila Hugh Mackay Foundation, Rothesay, N.B., 2007; Strathbutler Shortlist Prize, The Sheila Hugh Mackay Foundation, Rothesay, N.B., 2006; Delphina Studios Spanish Residency Award, Delphina Studios Trust, London, U.K., 1994; Graduation Medallist, OCAD, Toronto, 1992 **COLLECTIONS** Beaverbrook Art Gallery, New Brunswick; The Sheila Hugh Mackay Foundation Inc.; University of New Brunswick; New Brunswick Art Bank **PUBLICATIONS** *Transit-Atlantic Crossings*, Essays by Colin Ardley and Ingrid Mueller, ArtContact, 2005; *On Hair and Paint*, Solo Exhibition Publication with

Essay by Donna Wawzonek, Struts Gallery, 2003; *Sugar,* Essay by John Murchie, Saint Mary's University Art Gallery, 2002; *Gem Hour*, Solo Exhibition Catalogue, Essay by Dr. Lianne McTavish, Gallery Connexion, 2000; *High Junk,* Essay by John Massier, Koffler Gallery, 1998 WEBSITE alexandraflood.ca

Michelle Forsyth

BIRTH DATE February 5, 1972 RESIDES Pullman, Washington EDUCATION MFA, Mason Gross School of the Arts, Rutgers University, N.J., 2001; BFA, University of Victoria, B.C., 1996 SELECT SOLO EXHIBITIONS *Then & There: Work From the One Hundred Drawings Project*, Deluge Contemporary Art, Victoria, 2008; *Paperwork,* The Hogar Collection, Brooklyn, N.Y., 2007; *Marking Time: Work From the One Hundred Drawings Project*, Lorinda Knight Gallery, Spokane, Washington, 2007; *Routine Incidents*, Charleston Heights Art Center, Las Vegas, 2006; *Loops and Dashes*, Shift Gallery, Seattle, Washington, 2006 SELECT GROUP EXHIBITIONS *Cutting Fine, Cutting Deep*, The University Art Gallery, Sewanee: The University of the South, Sewanee, Tennessee, 2008; *Drawn to the Wall,* Jundt Art Museum, Spokane, Washington, 2007; *The War on Terror: Abstract Painting in Today's World*, Hiestand Galleries, Oxford, Ohio, 2007; *Spitting Images*, Truck, Calgary, 2006; *Push Play*, Mercer Union, Toronto, 2003 AWARDS GAP Grant, Artist Trust, Seattle, Washington, 2007; Project Grant, Canada Council for the Arts, Ottawa, 2007; Professional Artist Grant, Canada Council for the Arts, Ottawa, 2005 WEBSITE michelleforsyth.com

Paul Fortin

BIRTH DATE March 21, 1972 RESIDES Inuvik, NWT EDUCATION MFA Program, Nova Scotia College of Art and Design, Halifax, 2003; AOCAD, Toronto, 1998; Off-Campus Study, Maine College of Art, Portland, Maine, 1997 SELECT SOLO EXHIBITIONS *White*, Patrick Mikhail Gallery, Ottawa, 2008; *()*, ODD Gallery, Dawson City, Yukon, 2007; *Boca del Drago*, CCA7 Inter-Americas Gallery, Port of Spain, Trinidad & Tobago, 2006; *The Third or Fourth Day of Spring*, Lobby Gallery, Vancouver, 2006; *Without a Trace*, The Showroom, Chicago, 2001 SELECT GROUP EXHIBITIONS *Jökulhlaup*, Populus Tremula, Akureyri, Iceland, 2007; *Cyclone*, Proverommet–Bit Teatergarasjen, Bergen, Norway, 2007; *connectdisconnect*, Comox Valley Art Gallery, Courtenay, B.C., 2004; *Plot*, Anna Leonowens Gallery, Halifax, 2004; *Threshold(s)*, Artspace, Peterborough, Ont., 1998 AWARDS Artist in Residence, Kulturhuset USF, Bergen, Norway, 2007; International Residency Program, Canada Council for the Arts/CCA, Ottawa/Port of Spain, Trinidad, 2006; Optic Nerve Thematic Residency, Banff Centre for the Arts, Banff, Alta., 2005; Creation/Production Grant, Canada Council for the Arts, Ottawa, 2005; Project Assistance Grant, British Columbia Arts Council, Vancouver, 2002 PUBLICATIONS *The Third or Fourth Day of Spring*, Zuzia Juszkeiwicz, Lobby Gallery, 2006; *Artropolis 2001*, A.T. Eight Artropolis Society, 2001; *Home Sweet Home*, Heather Webb, Artspace, 2000; *Artwork*, B.C. Festival of the Arts Visual Arts Program, B.C. Festival of the Arts, 1999 WEBSITE paulfortin.ca

Graham Fowler

BIRTH DATE 1952 RESIDES Saskatoon EDUCATION MFA, Concordia University, Montreal, 1998; BFA, Nova Scotia College of Art and Design, Halifax, 1975 SELECT SOLO EXHIBITIONS *Experiences of the Liquid World*, Douglas Udell Gallery, Vancouver, 2007; *The Water Paintings*, Mendel Art Gallery, Saskatoon, 2002; *New Work*, Douglas Udell Gallery, Edmonton, 1997; *Graham Fowler, Recent Work*, Nancy Poole's Studio, Toronto, 1992; *Recent Works*, The Art Gallery of Nova Scotia, Halifax, 1985 SELECT GROUP EXHIBITIONS *Canadian Landscapes: Graham Fowler, Catherine Perehudoff*, The Gallery on Cork Street, London, U.K., 2008; *The Claustrophobic Forest*, Kenderdine Gallery, University of Saskatchewan, Saskatoon, 2002; *Transformation, Imaging Nature*, Mendel Art Gallery, Saskatoon, 2000; *From Atlantic Canada*, Art Gallery of Nova Scotia, Halifax, 1999; *Canadian Landscapes: Graham Fowler & Catherine Perehudoff*, Gruen Gallery, Chicago, 1996 AWARDS Professional Development, Keyano College, Fort McMurray, 1988; Concordia Teaching Fellowship, Concordia University, Montreal, 1980; Short-Term Canada Council Grant, 1977, 1978 and 1979 COLLECTIONS Bental Corporation, Vancouver; Dominion Securities, Toronto; Art Gallery of Nova Scotia, Halifax; Alberta Art Foundation, Edmonton; Nova Scotia Art Bank, Halifax; University of Saskatchewan; Shaw Cable, Calgary; University of

Lethbridge, Alta.; Kamloops Art Gallery, B.C.; Government of Ontario, Social Development, Toronto PUBLICATIONS *Canadian Landscapes,* Catherine Perehudoff and Graham Fowler, Keith Bell, Calvin Redlick, The Gallery on Cork Street, London, U.K., 2008; *Graham Fowler, The Water Paintings,* George Moppett, Mendel Art Gallery, 2002; *Graham Fowler,* Peter Purdue, Douglas Udell Gallery, 1995; *Recent Works: Graham Fowler,* Paul Duval, The Gallery of Nova Scotia, 1985; *Organic Life in Fluid Motion,* Graham Metson, The Art Gallery, Mount Saint Vincent University, 1978 WEBSITE grahamfowler.com

Graham Gillmore

BIRTH DATE February 20, 1963 RESIDES New York and Winlaw, B.C. EDUCATION Emily Carr College of Art and Design, Vancouver, 1986 SELECT SOLO EXHIBITIONS *Graham Gillmore,* Monte Clark Gallery, Toronto, 2007; *It's Over You Win,* Kevin Bruk Gallery, Miami Beach, Florida; *Misguided by Invoices,* Pierogi, Leipzig, Germany, 2006; *Graham Gillmore,* Galleria OMR, Mexico City, 2006; *Graham Gillmore,* Mary Boone Gallery, New York, 2002 SELECT GROUP EXHIBITIONS *Judith Rothschild Foundation Contemporary Drawings Collection,* Museum of Modern Art, New York, 2009; *Learn to Read,* Tate Modern, London, U.K., 2007; *The Basement Show,* The Art Gallery of Calgary, 2004; *Ironical Instinct,* Galeria Cardi, Milan, 2001; *Cinco Continentas a Una Ciudad,* International Salon of Painting, Mexico City, 1999 PUBLICATIONS *Graham Gillmore,* Douglas Coupland, Monte Clark Gallery Vancouver/ Toronto, 2007; *I Hate to Talk Even to People I Know,* Juan Pablo Marcias, OMR Gallery, Mexico City, 2006 WEBSITE monteclarkgallery.com

Eliza Griffiths

BIRTH DATE November 1, 1965 RESIDES Montreal EDUCATION Completed Art History and Theory coursework for MA, Carleton University, Ottawa, 1995; BFA, Concordia University, Montreal, 1991 SELECT SOLO EXHIBITIONS *Varieties of Behaviour*, Douglas Udell Gallery, Vancouver, 2007; *Optimistic Dysfunction*, Katharine Mulherin Contemporary Art Projects, Toronto, 2005 ; *Eliza Griffiths Paintings: 1995-2002*, Hallwalls Contemporary Arts Center, Buffalo, 2002; *Stories of Girls*, Curated by David Liss, The Saidye Bronfman Centre, Montreal; *Karate Girls & Proteges*, Mercer Union, Toronto, 1997 SELECT GROUP EXHIBITIONS *Generations*, The Art Gallery of Alberta, Edmonton, 2008; *Canadian Stories*, Morgan Lehman Gallery, New York, 2006; *ARCO*, Katharine Mulherin Contemporary Art Projects, Madrid, Spain, 2005; *First View*, The Art Gallery of Ontario, Toronto, 2004; *Serial Killers: Elements of Painting Multiplied by Six Artists*, Platform Gallery, London, U.K., 2000 AWARDS Concordia University, Faculty Research Grant, 2007; City of Ottawa, Production Grant, 2004; Canada Council for the Arts, Mid-Career Grant, 2003; Ontario Arts Council, Mid-Career Grant, Ontario Arts Council, 2003; Canada Council for the Arts, Mid-Career Grant, 1999 COLLECTIONS The Art Gallery of Ontario; The Canada Council Art Bank; Hart House, University of Toronto; The Beaverbrook Gallery; The City of Ottawa; The Ottawa Art Gallery PUBLICATIONS *Poseurs*, exhibition catalogue, Matthew Reichertz, St. Mary's University Gallery, 2002 WEBSITE artengine.ca/elizagriffiths

Angela Grossmann

BIRTH DATE 1955 RESIDES Vancouver EDUCATION MFA, Concordia University, Montreal, 1991; Emily Carr College of Art and Design,1985 SELECT SOLO EXHIBITIONS *Lonely Mirror*, Edward Day Gallery, Toronto, 2007; *Swagger*, Diane Farris, Vancouver, 2007; *Mirror, Mirror*, Newzones, Calgary, 2006; *Alpha Girls*, Edward Day Gallery, Toronto, 2005 SELECT GROUP EXHIBITIONS *Girlhood*, McCord Museum, Montreal, 2005; *Image and Imagination*, Le Mois de la Photo, Montreal, 2005; *The Basement Show*, Art Gallery of Calgary, 2004; *The Basement Show*, Vancouver, 2003; *Portrayal*, Diane Farris Gallery, Vancouver, 2003; *Crime and Punishment*, Mendel Art Gallery, Saskatoon, 2001 AWARDS Canada Council A Grant, 2004; British Columbia Cultural Fund Award, 2003; Canada Council B Grant, 1997 COLLECTIONS ABN AMRO International Bank, Amsterdam; Art Gallery of Greater Victoria, Victoria; Appleton Museum of Art, Ocala, Florida; Canada Council Art Bank, Ottawa; Canadiana Fund Heritage Art Collection, Ottawa; Federation CJA, Montreal; Kamloops Art Gallery, B.C.; Museum Abteiberg, Mönchengladbach, Germany; National Gallery of Canada, Ottawa; Vancouver Art Gallery; Vancouver WEBSITE edwarddaygallery.com

Sadko Hadzihasanovic

BIRTH DATE 1959 RESIDES Toronto EDUCATION MFA, University of Belgrade, Serbia, 1984; BFA, Academy of Fine Arts, Sarajevo, Bosnia and Herzegovina, 1982 SELECT SOLO EXHIBITIONS *Under Plum Tree*, MacLaren Art Centre, Barrie, Ont., 2007; *Best Of Sadko*, Kunsthaus Miami, Miami, 2007; *What is Wonderful World?*, Paul Petro, Toronto, 2006; UB Anderson Gallery, Buffalo, as part of *Beyond/In Western New York*, 2005; *Icons*, Mestna Galerija (City Art Gallery), Ljubljana, Slovenia, 2005 SELECT GROUP EXHIBITIONS *Life or Death of ID*, Curated by S. Frater, McMaster Museum of Art, Hamilton, Ont., 2006; *11th International Visual Arts Biennial-Values*, Pancevo, Serbia, 2004; *Memories Et Temoignages*, Leonard & Bina Ellen Art Gallery, Concordia University, Montreal, 2002; *One Century of Art in Bosnia*, Art Gallery of Bosnia, Sarajevo, Bosnia & Herzegovina, 2000; *Manifest Destiny*, Curated by Stuart Reid, Art Gallery of Mississauga, Ont., 1998 AWARDS Canada Council for the Arts, Paris Studio, 2007; Ontario Art Council, Visual Grant for Senior Artist, 2005; Canada Council for the Arts, Visual Grant for Mid-Career Artists, 2006; Toronto Art Council, Grant for Visual Art, 2001; Canada Council for the Arts, Visual Grant for Mid-Career Artists, 1999 PUBLICATIONS *Sadko Hadzihasanovic, Greatist Hitz*, text in French and English by Ingrid Mayrhofer, Sagamie Edition D'art, Alma, Que., 2007; *Under Plum Tree*, Curated by Sandra Fraser, Exhibition Catalogue, MacLaren Art Centre, Barrie, Ont., 2007; *Sadko*, Essay by Stuart Reid, Centre for Contemporary Culture, Concordia, 2004; *11. Biennial of Visual Arts Values*, Catalogue, Gallery of Contemporary Art, Pancevo, Serbia 2004; *Memories and Testimonies*, Catalogue with text by Loren Lerner, Leonard and Bina Ellen Art Gallery, Concordia University, Montreal WEBSITES ccca.ca/artists/hadzihasanovic.html; kunsthaus.org.mx; paulpetro.com

Anitra Hamilton

BIRTH DATE 1961 RESIDES Toronto and Berlin SELECT SOLO EXHIBITIONS *Kent State/Humpty Dumpty*, Greener Pastures Contemporary Art, Toronto, 2008; *Hey Auslander*, Kunstverein Stuttgart, Germany, 2008; *Retrospective on Parade*, Art Gallery at York University, Toronto, 2007 SELECT GROUP EXHIBITIONS *Intrude 366: Art & Life*, Zendai MoMA, Shanghai, 2008; *Art is Not Mute*, Ersta Konsthall, Gotenborg, Sweden, 2008; Art Gallery of Ontario, Toronto, 2008 AWARDS Artist Grant, Toronto Friends of the Visual Arts, Toronto, 2006; Chalmers Arts Fellowship, Ontario Arts Council, Toronto, 2003 COLLECTIONS The Albright-Knox Gallery, Buffalo; Nestle Canada Incorporated, Toronto PUBLICATIONS *The Shape of Colour: Excursions in Colour Field Art 1950–2005*, Claire Schneider, Art Gallery of Ontario, 2005; *Free Sample*, John Massier, Mount Saint Vincent University, 2005; *Officina America*, Renato Barilli, Mazzotta, 2002

John Hansen

BIRTH DATE October 29, 1957 RESIDES Markham, Ont. EDUCATION AOCA, Toronto, 1980 SELECT SOLO EXHIBITIONS *Introducing John Hansen*, Nancy Poole's Studio, Toronto, 1995 SELECT GROUP EXHIBITIONS *The Best of the Contemporaries*, Loch Gallery, Calgary, 2008; *Toronto International Art Fair 2007*, Toronto, 2007; *Figure & Landscape: Painting*, Loch Gallery, Toronto, 2007; *Interiors: Fantasy, Illusion, Reality*, Loch Gallery, Toronto, 2006; *Invitational Figure Show*, Loch Gallery, Toronto, 2005 AWARDS Adeline Rockett Award, CSPWC, Toronto, 1988; Elizabeth Greenshields Memorial Grant, Elizabeth Greenshields Foundation, Florence, Italy, 1979 PUBLICATIONS *The Best of the Contemporaries*, David Loch, 2007; *The Best of the Canadian Contemporaries*, David Loch, 2006; *Toronto 2006 International Art Fair*, Linel Rebenchuk, 2006 WEBSITE johnhansenartist.com

Katharine Harvey

BIRTH DATE 1963 RESIDES Toronto EDUCATION BFA, Queen's University, Kingston, Ont., 1986; MFA, University of Victoria, B.C., 1996 SELECT SOLO EXHIBITIONS *Recent Work*, Nicholas Metivier Gallery, Toronto, 2008; *Water Fall*, Galerie Art Mûr, Montreal, 2006; *Waterfall*, Rodman Halls Arts Centre, St. Catharines, Ont., 2006; *Storefront*, Durham Art Gallery, Durham, Ont., 2004; *Storefront*, Cambridge Galleries, Preston, Ont., 2003 SELECT GROUP EXHIBITIONS *The Light Fantastic*, Nicholas Metivier Gallery, Toronto, 2007; *A Group of Seven*, Canadian Embassy, Washington, D.C., 2005; *Surface Sensible*, Le Centre D'exposition, Baie-St-Paul, Que., 2004; *S.O.S.*, Tom

Thomson Memorial Art Gallery, Owen Sound, Ont., 2003; *Undoing the Landscape*, Painting Center, New York, 2002 AWARDS Mid-Career Grant, Ontario Arts Council, Toronto, 2007; Visual Arts Grant, Toronto Arts Council, Toronto, 2003 and 2007; Ontario Arts Council Visual Arts Grant, Toronto, 2003; Visual Arts Grant, Canada Council, Toronto, 2000 COLLECTIONS Bank of Montreal; Colliers Macaulay Nicolls Inc.; Colonia Treuhand Limited; Famous Players Media; Focus Publishing; Macrae Design Inc.; Osler Hoskin & Harcourt; Royal Bank of Canada WEBSITE katharineharvey.com

Dana Holst

BIRTH DATE June 26, 1972 RESIDES Edmonton EDUCATION BFA (Hons.), University of Waterloo, Waterloo, Ont., 1995 SELECT SOLO EXHIBITIONS *Woebegone*, Katharine Mulherin Contemporary Art Projects, Toronto, 2006; *Pounding*, Galerie St. Laurent + Hill, Ottawa, 2006; *Dancing Girls, Act I*, Galerie St. Laurent + Hill, Ottawa, 2004; *Dancing Girls, Act II*, Katharine Mulherin Contemporary Art Projects, Toronto, 2004; *Dolly*, Vanderleelie Gallery, Edmonton, 2003 SELECT GROUP EXHIBITIONS *Beastie*, Galerie St. Laurent + Hill, Ottawa, 2007; *Spider Girls*, Scope—New York, Alternative Art Fair, New York, 2005; *Girl's Own*, Hamilton Artists' Inc., Hamilton, Ont., 2001; *Waiting for Your Tongue*, James Baird Gallery, St. John's, 2001; *Interrupted Viewing*, University of Waterloo Art Gallery, Waterloo Ont., 2001 AWARDS Best in Show, Toronto Outdoor Art Exhibition, Toronto, 2000; Honourable Mention, Ernst & Young, Great Canadian Printmaking Competition, Toronto, 2000; Print Award, Blackwood Gallery, Paperbacked/Paperbound, Mississauga Ont., 1997; Runner Up Best of Show, Cambridge: The Library and Gallery, Cambridge, Ont., 1995; Toronto Sun Best Drawing Award, Toronto Outdoor Art Exhibition, Toronto, 1995 COLLECTIONS Alberta Foundation for the Arts; Anges Etherington Art Centre, Kingston, Ont.; Art Bank, Canada Council, Ottawa; Carleton University Art Gallery, Ottawa WEBSITE danaholst.com

Natalka Husar

BIRTH DATE 1951 RESIDES Toronto EDUCATION BFA, Rutgers University, N.J., 1973 SELECT SOLO EXHIBITIONS *Blond With Dark Roots*, Art Gallery of Hamilton, Ont., Winnipeg Art Gallery; Beaverbrook Art Gallery, Fredericton, 2001-2005; *Black Sea Blue*, Rosemont Art Gallery, Regina; Mendel Art Gallery, Saskatoon; The Robert McLaughlin Gallery, Oshawa, Ont., 1995-1996 SELECT GROUP EXHIBITIONS *Illegal Art*, San Fransisco Museum of Modern Art Artists Gallery, San Fransisco, 2002-2003; *Perspectives: Canadian Women Artists*, McMichael Canadian Art Collection, Kleinberg, Ont., 2002-2003; *Art and Ethnicity*, Canadian Museum of Civilization, Ottawa 1991-1995; *Dangerous Goods*, Edmonton Art Gallery, 1990 AWARDS Canada Council B Grant, 1990 and 1991; Canada Council Project Grant 1986, 1987, 1988 and 1995; Ontario Arts Council Project Grant, 1987, 1988, 1989, 1991, 1993, 1994 and 1995; Toronto Arts Council, 2004, Social Sciences and Humanities Research Council of Canada, 2005 COLLECTIONS National Gallery of Canada; Canada Council Art Bank; Canadian Museum of Civilization; Winnipeg Art Gallery; Beaverbrook Art Gallery PUBLICATIONS *Blond With Dark Roots*, Shirley Madill, Ihor Holubizky, Janice Kulyk Keefer, Robert Enright, Art Gallery of Hamilton, Ont., 2001; *Black Sea Blue*, Carol Podedworny, Ihor Holubizky, Rosemont Art Gallery, Regina, 1995; *Natalka Husar's True Confessions*, Robert Enright, Donna Lypchuk, Woltjen Udell Gallery, 1991; *Milk and Blood*, Grace Eiko Thomson, Women in Focus,1988; *Behind the Irony Curtain*, Robert Enright, Ihor Holubizky, Garnet Press Gallery, 1986

Alexander Irving

BIRTH DATE May 9, 1962 RESIDES Toronto EDUCATION MFA, York University, Toronto, 2000; BFA, Nova Scotia College of Art and Design, Halifax, 1987 SELECT SOLO EXHIBITIONS *Political Science*, Diaz Contemporary, Toronto, 2006; *Video Rideo*, Robert Birch Gallery, Toronto, 2004; *Alexander Irving*, Robert Birch Gallery, Toronto, 2002; *Symptoms of Affection*, YYZ Artist's Outlet, Toronto, 2000; *One of Many*, Gallery 101, Ottawa, 2000 SELECT GROUP EXHIBITIONS *Inaugural Group Exhibition*, Diaz Contemporary, Toronto, 2005; *The Dark Side of Happy*, Art Gallery of Stratford, Ont., 2002; *Oasis*, Saidye Bronfman Centre, Montreal, 2001; *A Drawing Show*, Tracey Lawrence Gallery, Vancouver, 2001; *Self Help*, Mercer Union, Toronto, 2000 AWARDS

Exhibitions Assistance Grant, Ontario Arts Council, 2006; Artist
Grant for Mid-Career, Toronto Arts Council, 2004; Artist Grant for
Mid-Career, Ontario Arts Council, 2004; Artist Grant for Mid-
Career, Canada Council for the Arts, 2001; Exhibitions Assistance
Grant, Ontario Arts Council, 2000 WEBSITE diazcontemporary.ca

Jay Isaac

BIRTH DATE May 13, 1975 RESIDES Saint John EDUCATION Emily
Carr Institute of Art and Design, Vancouver, 1993-1997; Cardiff
Institute of Art and Design, Cardiff, Wales, 1996 SELECT SOLO
EXHIBITIONS *The Beauty of Things,* In This World, Now and Always,
Paul Petro Contemporary Art, Toronto, 2007; *Jay Isaac,* CUE
Foundation, New York, 2005; *Maritime Frazetta,* Greener Pastures,
Toronto, 2004; *New Age Philosophy,* Acuna-Hansen Gallery, Los
Angeles, 2003; *The Matlock Juxtapoze,* Mercer Union, Toronto, 2002
SELECT GROUP EXHIBITIONS *Art vs Real Life,* Morgan Lehman
Gallery, New York, 2006; *Darkness Ascends,* MOCCA, Toronto, 2006;
The Cave and the Island, White Columns, New York and Galerie
Kunstbeuro, Vienna, 2004; *Republic of Love,* Power Plant, Toronto,
2004; *Officina America,* Galerie d'art Moderna, Bologna, Italy,
2002 AWARDS Mid-Career Creation Grant, New Brunswick Arts
Council, Saint John, 2007; Creation Grant, Ontario Arts Council,
Toronto, 2000 and 2003; Level One Creation Grant, Toronto Arts
Council, Toronto, 2003; Emerging Artist Creation Grant, Canada
Council, 1998 PUBLICATIONS *Jay Isaac,* Cue Foundation, 2005;
Officina America, Renato Barilli, Galeria d'art Moderna, Bologna,
Italy, 2002 WEBSITE jayisaac.ca

Sophie Jodoin

BIRTH DATE June 8, 1965 RESIDES Montreal EDUCATION BFA in
Visual Arts, Concordia University, Montreal, 1988 SELECT SOLO
EXHIBITIONS *New Works,* Connexion Gallery, Fredericton, 2008;
Regiment, Edward Day Gallery, Toronto, 2007; *Diary of K; A Journal
of Drawings,* Newzones, Calgary, 2005; *Drawing Shadows: Portraits
of My Mother,* Edward Day Gallery, Toronto, 2004; *Figures Undressing,*
Edward Day Gallery, Toronto, 2003 SELECT GROUP EXHIBITIONS
Spitting Image, Edward Day Group Show at Art Mûr, Montreal, 2008;
Vast Beautiful System (Barely Holding Together), Tower Gallery,
Philadelphia, 2007; *Dancing to the Invisible Piper: Canadian Contemporary
Figure Art,* Art Gallery of Mississauga, Ont., 2006; *Body Notes,* FOFA
Gallery, Concordia University, Montreal, 2006 AWARDS Thomas More
Purchase Award, Thomas More Institute, Montreal, 2001; Elizabeth
Greenshields Grant, Elizabeth Greenshields Foundation, Montreal,
1999; Purchase Prize, The Eudice Garmaise Annual Exhibition of
Contemporary Quebec Artists, Montreal, 1995; FCAR, Grant for Study
& Artistic Development, Ministry of Cultural Affairs, Quebec, 1989
PUBLICATIONS *Regiment,* David Capell, Nanaimo Art Gallery, Nanaimo,
B.C., 2007; *Body Notes/Échos corporels,* Lynn Beavis, FOFA Gallery,
Montreal, 2006; *Drawing Shadows: Portraits of My Mother,* Bernard
Lamarche, self-published, 2004; *Re-Representation V,* John D. O'Hern,
Arnot Art Museum, Elmira, N.Y., 2001 WEBSITE sophiejodoin.com

Dan Kennedy

BIRTH DATE 1958 RESIDES Toronto EDUCATION AOCA, Ontario
College of Art, Toronto, 1983 SELECT SOLO EXHIBITIONS *Lost in the
Echo,* Edward Day Gallery, Toronto, 2007; *Dust of Oblivion,* Jonathan
LeVine Gallery, New York, 2006; *The Voice Mansion (Yammerhead's
Return),* Art Gallery of Peel, Brampton, Ont., 2006; *Factory Broken
Melody,* Sable-Castelli Gallery, Toronto, 2004; *Brilliant Disguise,*
Monte Clark Gallery, Vancouver, 2003 SELECT GROUP EXHIBITIONS
Buildup, Ottawa Art Gallery, Ottawa, 2008; *Friendly Fire,* Berman-
Turner Projects, Los Angeles, 2006; *That Obscure Object of Desire,*
Cambridge Gallery, Ont., 2004; *The Dark Side of Happy,* Stratford
Gallery, Ont., 2004 AWARDS Canada Arts Council Grant, 1995, 1996,
1998, 2004 and 2006; Ontario Arts Council, 1997, 2003, 2005 and
2007; Toronto Arts Council, 1996, 1999 and 2001; Governor's General
Medal, Ontario College of Art, Toronto, 1983 COLLECTIONS The
Canada Council Art Bank WEBSITE dankennedy.ca

Doug Kirton

BIRTH DATE October 3, 1955 RESIDES Kitchener, Ont. EDUCATION
BFA, Nova Scotia College of Art and Design, Halifax, 1978; MFA,
University of Guelph, Guelph, Ont., 1994 SELECT SOLO EXHIBITIONS
See True, Artcore/Fabrice Marcolini, Toronto, 2008; *Still Water and
Rain,* Kitchener-Waterloo Art Gallery, Kitchener, Ont., 2007; *Recent
Paintings,* Sable-Castelli, Toronto, 2004; *Times of Uncertainty,*
Museums London, London, Ont., 2001; *Times of Uncertainty,* MOCCA,
Toronto, 2000; *Times of Uncertainty,* University of Waterloo Art
Gallery, Waterloo, Ont., 2000 SELECT GROUP EXHIBITIONS *Huge,*
Artcore/Fabrice Marcolini, Toronto, 2007; *See You Tomorrow,* Agnes
Etherington Art Centre, Queen's University, Kingston, Ont., 2007;
Planes, Trains and Automobiles: The Art of Transportation, Helen
Christou Gallery, University of Lethbridge, Alta., 2005; *From New
Image to New Wave: Legacy of NSCAD in the Seventies,* Art Gallery
of Nova Scotia, Halifax, 2005; *Sampler: The 2nd KWAG Biennial,*
Kitchener-Waterloo Art Gallery, Kitchener, Ont., 2005 AWARDS
Ontario Arts Council Exhibition Assistance Grant, 2007; Kitchener-
Waterloo Arts Award (Visual Arts), 2004; Elected to the Royal
Canadian Academy of Arts, 2002; Ontario Arts Council Project Grant,
1996; Canada Council B Grant, 1996 PUBLICATIONS *Still Water and
Rain,* Rick Nixon, Kitchener-Waterloo Art Gallery, 2007; *Times of
Uncertainty,* Will Gorlitz, Museums London & the University of
Waterloo Art Gallery, 2000; *Art for a Threatened Environment,* Timothy
Long, Mackenzie Art Gallery, Regina, 1990; *Culture's Nature: Landscape
in the Art of Gerald Ferguson, Douglas Kirton, Jeffrey Spalding and David
Thauberger,* Peter White, Dunlop Art Gallery, Regina, 1987; *The
Romantic Landscape Now,* John Armsrong, Artspace, Peterborough,
Ont., 1986 WEBSITES dougkirton.com; artcoregallery.com; ccca.ca;
finearts.uwaterloo.ca/dougKirton

Mara Korkola

BIRTH DATE November 7, 1965 RESIDES Toronto EDUCATION MFA,
University of Texas, San Antonio, Texas, 1997; BFA, Wichita State
University, Wichita, Kansas, 1994; AOCA, Ontario College of Art,
Toronto, 1988 SELECT SOLO EXHIBITIONS *After Dark,* Nicholas
Metivier Gallery, Toronto, 2008; *Dusk to Night,* Douglas Udell Gallery,
Edmonton and Calgary, Alta., 2006; *Bilder,* Renate Schroeder Gallery,
Moenchengladbach, Germany, 2005; *Nocturnes,* Nicholas Metivier
Gallery, Toronto, 2004; *Commuter,* MacLaren Art Centre, Barrie, Ont.,
2004 SELECT GROUP EXHIBITIONS *Representation,* Jenkins-Johnson
Gallery, New York and San Francisco, 2007; *High Roads and Low Roads,*
Museum of Fine Arts, Florida State University, Tallahassee, Florida
and Okaloosa-Walton Community College Gallery, Niceville, Florida,
2006; *Push Play,* Mercer Union, Toronto, 2003; *Painting as Paradox,*
Artists Space, New York, 2002; *Synthetic Psychosis: Manufacturing
Dissent in Current Toronto Painting,* MOCCA, Toronto, 2002 AWARDS
Ontario Arts Council Grant to Visual Artists, 2001, 2002, 2005,
2007; Ontario Arts Council Exhibition Assistance Grant, 2002, 2003;
Canada Council for the Arts, 2001; Toronto Arts Council for the
Arts, 2000; Elizabeth Greenshields Foundation, Montreal, 1987, 1988
PUBLICATIONS *High Roads and Low Roads,* Palladino-Craig, Allys.
Florida State University Museum of Fine Arts (catalogue), 2006;
Commuter, MacLaren Art Centre, Barrie, Ontario, 2004 (monograph);
Synthetic Psychosis, MOCCA, Toronto, Ontario (catalogue), 2002

Peter Krausz

BIRTH DATE August 19, 1946 RESIDES Montreal EDUCATION
Bucharest Academy of Fine Arts, 1969 SELECT SOLO EXHIBITIONS
Helen's Exile, Forum Gallery, New York and Los Angeles, 2005; *Le
paysage selon Peter Krausz,* Musée Régional de Rimouski, Que., 2004;
Peter Krausz: les paysages, Musée d'art de Joliette, Que., 1999; *De Natura
(Humana),* Centre Saidye Bronfman, Montreal, 1992; *Journeys,* 49th
Parallel Gallery, New York, 1991 SELECT GROUP EXHIBITIONS *The
Contemporary Landscape,* Forum Gallery, New York, 2007; *Hyperliens,*
Galerie Graff, Montreal, 2006; *Art actuel, Présences québécoises,*
Château de Biron et Ferme du Buisson, France, 1992; *Stations, Les cent
jours d'art contemporain,* CIAC, Montreal, 1987; *Montreal tout-terrain,*
Clinique Laurier, Montreal, 1984 AWARDS Travel Grant, Canada
Council for the Arts, 2003; CRSH Grant, Université de Montreal,
1998; A Grant, Canada Council for the Arts, 1997; A Grant, Conseil
des Arts et des Lettres du Québec, 1997; Travel Grant, Ministère des
Affaires Internationales du Québec, 1992 COLLECTIONS Banque

Royale du Canada; Canada Council Art Bank, Ottawa; Jewish Museum, New York; Lethbridge Art Gallery, Alta.; Musée d'Art de Joliette, Que.; Musée d'Art Contemporain, Montreal; Musée des Beaux-Arts de Montreal; Musée des Beaux-Arts de Sherbrooke, Que.; Musée National des Beaux-Arts du Québec, Quebec City.; Toronto Dominion Bank PUBLICATIONS *Le paysage selon Peter Krausz*, Jocelyne Fortin, Musée régional de Rimouski, Que., 2005; *Peter Krausz, The Song of the Earth*, Forum Gallery, New York, 2002; *Peter Krausz: les paysages*, Denise Roy, Musée d'art de Joliette, Que., 1999; *Peter Krausz, Landscape and memory: entre chien et loup*, James Campbell, Galerie de Bellefeuille, Montreal, 1997

Anda Kubis

BIRTH DATE June 6, 1962 RESIDES Toronto EDUCATION MFA, York University, Toronto, 1992; BFA, Nova Scotia College of Art and Design, 1987 SELECT SOLO EXHIBITIONS *Stacks of Shine*, Galleri Tapper-Popermajer, Teckomatorp, Sweden, 2007-2008; *rock, teeter, sway*, Drabinsky Gallery, Toronto, 2006; *Airplay*, Elissa Cristall Gallery, Vancouver, 2006; *Equilibrium*, Newzones, Calgary, 2006; *Details*, Cambridge Galleries, Cambridge, Ont., 2001 SELECT GROUP EXHIBITIONS *Superplastic*, Drabinsky Gallery, Toronto, 2007; *Fuzz*, Newzones Gallery, Calgary, 2007; *Sliver*, Elissa Cristall Gallery, Vancouver, 2005; *That Obscure Object of Desire*, Cambridge Galleries, Cambridge, Ont., 2004; *Fluffy*, Dunlop Regional Art Gallery, Regina, 1999 PUBLICATIONS *Anda Kubis at Galleri Tapper-Popermajer*, Martin Hagg, Landskrona Posten, 2008; *Superplastic, and Certainly Uncertain*, Anete Ivsina, Drabinsky Gallery, 2007 WEBSITE andakubis.com

Eli Langer

BIRTH DATE October 21, 1967 RESIDES Toronto SELECT SOLO EXHIBITIONS Daniel Hug, Los Angeles, 2004, 2006, 2008; Paul Petro Contemporary Art, Toronto, 2001, 2007 SELECT GROUP EXHIBITIONS Rental Gallery, New York, 2007; Jack Hanley, Los Angeles, 2007; Contemporary Art Gallery, Vancouver, 2006; Ben Kauffmann, Berlin, 2006; Villa Warsaw, Raster Gallery, Warsaw, Poland, 2006 WEBSITE elilanger.com

Daniel Langevin

BIRTH DATE December 26, 1974 RESIDES Montreal EDUCATION BFA, UQÀM, Montreal, 1999 SELECT SOLO EXHIBITIONS *Stianes*, Galerie René Blouin, Montreal, 2007; *La raffinerie de l'usuel*, Centre de diffusion Clark, Montreal, 2005; *Printemps 2005*, Galerie René Blouin, Montreal, 2005; *La grande communion*, Espace virtuel, Chicoutimi, Que., 2003 SELECT GROUP EXHIBITIONS *Summertime in Paris*, Parisian Laundry, Montreal, 2006; *RBC Painting Competition*, MOCCA, Toronto, 2006; *États*, galerie B-312, Montreal, 2006; *Surfaces sensibles*, Centre d'exposition de BSP, Baie-Saint-Paul, Que., 2004 COLLECTIONS Royal Bank of Canada; ALDO Group, Montreal, Musée National des Beaux-Arts du Québec WEBSITE galrierereneblouin.com

Angela Leach

BIRTH DATE February 17, 1966 RESIDES Toronto EDUCATION AOCA, Ontario College of Art, Toronto, 1989 SELECT SOLO EXHIBITIONS *Abstract Repeat Series: Wave and Loop*, Wynick/Tuck Gallery, Toronto, 2007; *Angela Leach Shimmy*, Doris McCarthy Gallery, Scarborough, 2005; *Angela Leach Skip*, Durham Art Gallery, Ont., 2005; *Angela Leach Paintings*, Owens Art Gallery, Sackville, N.B., 2005; *New Works*, State Gallery, Vancouver, 2004 SELECT GROUP EXHIBITIONS *Pulse: Film and Painting After the Image*, Mount St. Vincent University, Halifax, 2006; *You Don't Want to Miss That Sh!t*, Gladstone Hotel, 2005; *Dimensionality*, YYZ Artists' Outlet, Toronto, 2005; *The Transformative Power of Art*, Art Gallery of Ontario, Toronto, 2005; *Extreme Abstraction*, Albright-Knox Gallery, Buffalo, 2005 AWARDS Arts Toronto 2000 Protégé Honours Selected by 1999, Toronto Arts Award Recipient, Robert Fones, Toronto, 2000 COLLECTIONS Art Gallery of Ontario; Donovan Collection and Hart House, University of Toronto PUBLICATIONS *Angela Leach Paintings*, Emily Falvey and Gordon Hatt, Southern Alberta Art Gallery, 2005 WEBSITE angelaleach.com

J.J. Lee

BIRTH DATE April 2, 1969 RESIDES Toronto EDUCATION MFA, York University, Toronto, 1999; BFA, Nova Scotia College of Art and Design, Halifax, 1992 SELECT SOLO EXHIBITIONS *Trace*, LOOP Gallery, Toronto, 2007; *Fabrication*, Elora Centre for the Arts, Ont., 2006; *Still Life With Tangents*, Lennox Contemporary, Toronto, and Gallery 96, Stratford, Ont., 2005; *Naturalia*, A Space Gallery, Toronto, 2001; *Dissection*, Artspeak Gallery, Vancouver, 1997 SELECT GROUP EXHIBITIONS *The Suitcase Show*, York Quay Gallery, Harbourfront Centre, Toronto, 2005; TD Centre/York University, Toronto, 2003; *Tracing Cultures: Cultural Differences and Migration*, Burnaby Art Gallery, B.C., 1997; *Topographies: Aspects of Recent BC Art*, Vancouver Art Gallery, 1996; *In the Absence*, St. Mary's University Art Gallery, Halifax, 1994 AWARDS Exhibition Assistance Grant, Ontario Arts Council, Toronto, 2005; Asian-Canadian Visual Arts Fund, North American Association of Asian Professionals, Toronto, 2004; Winner: Central Canada, RBC Canadian Painting Competition, Toronto, 2002; Mid-Career Project Grant, Canada Council for the Arts, Toronto, 2002; Mid-Career Artist Project Grant and Exhibitions Assistance, Ontario Arts Council, 2000 PUBLICATIONS *Tracing Cultures*, Burnaby Art Gallery, 1997; *Topographies: Aspects of Recent B.C. Art*, Vancouver Art Gallery, Douglas & McIntyre, 1996 WEBSITE jjlee.ca

Howard Lonn

BIRTH DATE 1959 RESIDES Toronto EDUCATION AOCA, Ontario College of Art, 1981 SELECT SOLO EXHIBITIONS *Silent Running*, Nicholas Metivier Gallery, Toronto, 2007; *Paintings*, Sable/Castelli Gallery, Toronto, 2002, 2004; *Works on Paper*, Espai 292, Barcelona, 2000 SELECT GROUP EXHIBITIONS *Kinesis*, Nicholas Metivier Gallery, Toronto, 2005; *Translinear*, McMaster Museum of Art, Hamilton, Ont., 1999 COLLECTIONS Art Gallery of Ontario, Toronto; Art Gallery of Hamilton, Ont.; McMaster Museum, Hamilton, Ont.; Torys, Toronto; Royal Bank of Canada, Toronto; Sun Life, Toronto WEBSITE metiviergallery.com

Sara MacCulloch

BIRTH DATE March 4, 1967 RESIDES Halifax EDUCATION BFA, Nova Scotia College of Art and Design, 1992 SELECT SOLO EXHIBITIONS *Paintings*, Studio 21, Halifax, 2007; *New Paintings*, Wynick Tuck Gallery, Toronto, 2006; *Paintings*, Katharine Mulherin Art Projects, Toronto, 2005; *Paintings*, Vanderleelie Gallery, Edmonton, 2005; *Paintings*, Anna Leonowens Gallery, Halifax, 1996 SELECT GROUP EXHIBITIONS *Home Town*, Tom Thomson Memorial Gallery, Owen Sound, Ont., 2007; *You Don't Want to Miss That Sh!t*, Gladstone Hotel, Toronto, 2005; *Landings*, Harbourfront Centre, Toronto, 2003; *NSCAD Second Century*, Art Gallery of Nova Scotia, Halifax, 2001; *In the Absence*, St. Mary's University Art Gallery, Halifax, 1994 AWARDS Individual Grant, Nova Scotia Department of Tourism and Culture, Halifax, 2007; Creation Grant (Mid-Career), Canada Council for the Arts, Ottawa, 2005; Creation Grant (Emerging Artist), Canada Council for the Arts, Ottawa, 2003; Travel Grant, Canada Council for the Arts, Ottawa, 2001; The Brucebo Scholarship, Canadian-Scandinavian Foundatiion, Montreal/Visby, Sweden, 1993 COLLECTIONS Canada Council Art Bank; Art Gallery of Nova Scotia; Department of Foreign Affairs, Embassy Division; Nova Scotia Art Bank; Gotlands Kunstmuseum, Gotland, Sweden; University of Iowa: Project Art, Iowa City; Heenan Blaikie Law Offices, Vancouver; Avmor, Montreal; TAB Investco, Oakville, Ont.; Sheraton Hotels, Halifax

Elizabeth McIntosh

BIRTH DATE September 17, 1967 RESIDES Vancouver EDUCATION MFA, Painting, Chelsea College of Art and Design, London, U.K., 1996; BFA, Honours, York University, Toronto, 1992 SELECT SOLO EXHIBITIONS *Elizabeth McIntosh*, The Balmoral, Los Angeles, 2008; *Fire at Full Moon*, Blanket, Vancouver, 2007; *Elizabeth McIntosh*, Parisian Laundry, Montreal, 2007; *Young Night Thought*, Diaz Contemporary, Toronto, 2006; *Elizabeth McIntosh*, Clementine Gallery, New York, 2002 SELECT GROUP EXHIBITIONS *Paint*, Vancouver Art Gallery, Vancouver, 2006-2007; *Spell, A Travelling Exhibition of Contemporary Abstraction*, Mendell Art Gallery, Saskatoon; The Robert McLaughlin Gallery, Oshawa, Ont.; Thames Art Gallery, Chatham, Ont., 2005-2006; *Aniconica*, Perugi Artecontemporanea, Padova, 2003; *Hungry Eyes*,

Dalhousie Art Gallery, Halifax, 2002; *All Tomorrow's Paintings*, Galleri Susanne Hojriis, Copenhagen, 2000 AWARDS Best Painting Exhibition 2003, Steam Whistle Arts Award, Toronto, 2004; Mid-Career Artists Grant, Toronto Arts Council, Toronto, 2003; Mid-Career Artists Grant, Ontario Arts Council, Toronto, 2001 and 2002; Explorations Grant, Canada Council for the Arts, Toronto, 1993 COLLECTIONS National Gallery of Canada, Ottawa; Bank of Montreal, Toronto; Royal Bank of Canada, Toronto; Ogilvy Renault, Toronto; Perimeter Institute for Theoretical Physics, Waterloo, Ont. PUBLICATIONS *Characters and Gesture as People Do, Jessica Stockholder and Elizabeth McIntosh in Conversation, Paint, A Psychedelic Primer*, Vancouver Art Gallery, 2006

Mark Mullin

BIRTH DATE October 5, 1969 RESIDES Calgary EDUCATION Summer Residency Program, Cooper Union School of Art, New York, 2005; Masters of Fine Arts, Concordia University, Montreal, 1998 SELECT SOLO EXHIBITIONS *New Prints*, Van Deb Editions Gallery, New York, 2007; *New York Suite*, Paul Kuhn Gallery, Calgary, 2007; *An Unfolding Sense of Order*, Art Gallery of Calgary, Calgary, 2007; *A Change in Pressure*, Paul Kuhn Gallery, Calgary, 2006; *Catalytic Mix*, Leo Kamen Gallery, Toronto, 2005; *Turbulent Flow*, State Gallery, Vancouver, 2003 SELECT GROUP EXHIBITIONS *Palm Beach 3 Contemporary Art Fair*, Paul Kuhn Gallery, West Palm Beach, Florida, 2008; *Alberta Biennialle of Contemporary Art – Living Utopia and Disaster*, Art Gallery of Alberta, Edmonton, Walter J Phillips Gallery, Banff, Alta., 2007; *New York Affordable Art Fair*, New York, Paul Kuhn Gallery, 2006; *About Time*, Nickle Arts Museum, University of Calgary, Calgary, 2006; *Cooper Union School of Art Summer Residency Exhibition*, New York, 2005; *RBC New Canadian Painting Competition Finalists Touring Exhibition*, Edmonton Art Gallery, Edmonton, New Brunswick Museum, Saint John, McMaster Museum of Art, Hamilton, Ont., Museum of Contemporary Canadian Art, Toronto, 2004 AWARDS Creation Production Grant, Canada Council for the Arts (Mid-Career Artist), Calgary, 2007; Project Grant, Alberta Foundation for the Arts, Calgary, 2006; Travel Grant, Conseil des Arts et des lettres du Québec, Montreal, 2003; Travel Grant, Canada Council for the Arts, Montreal, 2003; Creation/Production Grant, Canada Council for the Arts (Emerging Artist), Montreal, 2002; Research and Creation Bursary–B Grant, Conseil des Arts et des Lettres du Québec, Montreal, 2002 COLLECTIONS Museé de Québec, Collection Pret d'ouveres d'art; Art Gallery of Nova Scotia, Permanent Collection; Glenbow Museum, Permanent Collection; Rutger's University, Permanent Print Collection; Alberta Foundation for the Arts, Permanent Collection; Osler, Huskin & Harcourt, Montreal, Corporate Collection; Talisman Energy, Calgary, Corporate Collection; Opus Corporation, Calgary, Corporate Collection; Highpine Oil & Gas, Calgary, Corporate Collection PUBLICATIONS *Practice Makes Perfect—A World of Sweet Nothings*, Catalogue Essay for Robbin Deyo Exhibition; *Sweet Sensations*, Southern Alberta Art Gallery, Lethbridge, Alta., 2005 WEBSITE markcmullin.com

Suzanne Nacha

BIRTH DATE January 30, 1967 RESIDES Toronto EDUCATION MFA, York University, Toronto, 2003; BA, Fine Art, University of Guelph, Guelph, Ont., 1992; BA, Geography and Geology, McMaster University, Hamilton, Ont., 1989 SELECT SOLO EXHIBITIONS *The Geology of Morals*, Pari Nadimi Gallery, Toronto, 2003; *Terrane*, Tatar Alexander Gallery, Toronto, 2001; *Mined Sites*, Mercer Union, Toronto, 2001; *Minescapes*, Modern Fuel Gallery, Kingston, Ont., 2000; *What Does Happen*, Faktorie Gallery, Toronto, 1997 SELECT GROUP EXHIBITIONS *Sliver*, Elissa Cristall Gallery, Vancouver, 2005; *Parameters*, Galerie Wellerdiek, Berlin, 2003; *Synthetic Psychosis*, MOCCA, Toronto, 2002; *Land Form*, 1080 Bus Gallery, Toronto, 2000; *Tempus Fugit*, Robert McLaughlin Gallery, Oshawa, Ont., 2000 AWARDS *Grant to Visual Artists – Mid-Career*, Ontario Arts Council, Toronto, 2007; *International Career Development Grant*, Department of Foreign Affairs & International Trade, Toronto, 2003; *Ontario Graduate Scholarship*, Toronto, 2002; *Grant to Visual Artists—Emerging*, Ontario Arts Council, Toronto, 2001; *Creation/Production Grant for Emerging Artists*, The Canada Council, Toronto, 1999 PUBLICATIONS *Synthetic Psychosis*, David Liss, MOCCA Catalogue, Toronto, 2002; *Mining the Surface and More*, Jessica Wyman, Mercer Union Exhibition Catalogue Essay, Toronto, 2001; *Tempus Fugit*, Linda Jansma & Ihor Holubinsky, Oshawa Art Gallery Exhibition Catalogue Essay, The Robert McLaughlin Gallery, Oshawa, Ont., 2000 WEBSITE suzannenacha.com

Celia Neubauer

BIRTH DATE February 15, 1962 RESIDES Toronto EDUCATION Higher Diploma, Slade School of Fine Art, London, U.K., 1990 SELECT SOLO EXHIBITIONS *Tou*, Drabinsky Gallery, Toronto, 2007; *Fusion*, Drabinsky Gallery, Toronto, 2005; *Continental Drift*, Visual Arts Centre of Clarington, Bowmanville, Ont., 2003; *Heavens Burning*, Drabinsky Gallery, Toronto, 2001; *Sweep*, Leo Kamen Gallery, Toronto, 2000 SELECT GROUP EXHIBITIONS Drabinsky Gallery, Toronto, 2005; *Searching for the Sublime*, The Robert McLaughlin Gallery, Oshawa, Ont., 1999; *Loving the Alien*, Art Gallery of Mississauga, Mississauga, Ont., 1997; *Drawings*, Van Straaten Gallery, Chicago, 1997 AWARDS Project Grant, Ontario Arts Council, Toronto, 1998 and 1999; Heinz Jordan Scholarship, York University, Toronto, 1986 PUBLICATIONS *A Geography of Imagination*, Margaret Rogers, Visual Arts Centre of Clarington, 2002; *Searching for the Sublime: Recent Works of Celia Neubauer and Sara Nind*, Donald Brackett and Linda Jansma, The Robert McLaughlin Gallery, 1999; *Loving the Alien*, Stuart Reid, Art Gallery of Mississauga, Mississauga, Ont., 1997 WEBSITE celianeubauer.com

Sarah Nind

BIRTH DATE 1957 RESIDES Toronto EDUCATION PhD, European Graduate School, New York, 2008; MFA, York University, Toronto, 1994; B. Arch., School of Architecture, University of Toronto, Toronto, 1991 SELECT SOLO EXHIBITIONS *Mnemonic Structures*, Leo Kamen Gallery, Toronto, 2008; *Désir*, Newzones Gallery, Calgary, 2006; *Fictions*, Tom Thomson Memorial Gallery, Owen Sound, Ont., 2005; *(non)fiction*, Art Gallery of University of Waterloo, Waterloo, Ont., 2005; *Paysages Fragiles*, Art Gallery of Mississauga, Ont., 2003 SELECT GROUP EXHIBITIONS *Brooklyn Arts Festival Exhibition 25*, Triangle Gallery, Brooklyn, N.Y., 2007; *The Painted Photograph: David Bierk, Sarah Nind, Jaclyn Shoub*, Canadian Museum of Contemporary Photography, Ottawa, 2006; *Cold City Years*, The Powerplant Contemporary Art Gallery, Toronto, 2005; *Open Studio Exhibition*, Triangle Artists Workshop Studios, New York, 2004; *Department of Morbihans Alumni Exhibition*, Chateau Gallery, Rochefort-en-Terre, France, 2003 AWARDS Ville de Paris, Artist Residency, Cité Internationale des Arts, Paris, 2007; Canada Council for the Arts, Individual Artists Visual Arts Project Grant, Ottawa, 2006; Triangle Arts Association, International Residency, New York, 2004; Ontario Arts Council, Media Arts Film and Video First Projects, Toronto, 2002; Maryland Institute College of Art, International Residency Award, Rochefort-en-Terre, France, 2001 PUBLICATIONS *The Painted Photograph*, Canadian Museum of Contemporary Photography, Ottawa, 2006; *Spirit of the Art: The Donovan Collection at St. Michael's College*, OMNI Television, 2006; *Fictions*, Stuart Reid and Carol Podedworny, co-published by Tom Thomson Memorial Gallery and Art Gallery of University of Waterloo, 2006; *Paysages Fragiles*, Ian Carr-Harris, Open Studio Gallery, Toronto, 2001 WEBSITE ccca.ca

Nick Ostoff

BIRTH DATE September 10, 1974 RESIDES Toronto EDUCATION OCAD, Toronto, 1999 SELECT SOLO EXHIBITIONS *Peripheries*, Diaz Contemporary, Toronto, 2007; *Guide*, Katharine Mulherin Contemporary Art Projects, Toronto, 2005; *New Works*, Katharine Mulherin Contemporary Art Projects, Toronto, 2003; *A Slow Dissolve*, Bus Gallery, Toronto, 2001 SELECT GROUP EXHIBITIONS *Recent Paintings*, Diaz Contemporary, Toronto, 2007; *Contemporary Landscape Painting: See You Tomorrow*, Agnes Etherington Art Centre, Kingston, Ont., 2006; *Stellar Living*, Mercer Union, Toronto, 2006; *Recent Acquisitions*, Doris McCarthy Gallery, Toronto, 2005; *Landing*, York Quay Gallery, Harbourfront Centre, Toronto, 2003 AWARDS Project Grant, Ontario Arts Council, Toronto, 2006; Project Grant, Toronto Arts Council, Toronto, 2005; Shortlist for RBC Painting Competition, RBC, Toronto, 2005 COLLECTIONS Agnes Etherington Art Centre; Doris McCarthy Gallery; Kleinfeldt Mychajlowycz Architects; McCarthy Tetrault LLP; Osler Hoskin Harcourt; Royal Bank of Canada PUBLICATIONS *Art With Heart*, Casey House, 2007; *RBC Painting Competition Catalogue*, RBC, 2005 WEBSITE diazcontemporary.ca

Kelly Palmer

BIRTH DATE November 27, 1973 RESIDES Toronto EDUCATION Diploma of Fine Arts, OCAD, 1998 SELECT SOLO EXHIBITIONS *New Work*, Katharine Mulhern Gallery, Toronto, 2008; *Recent Work*, Katharine Mulhern Gallery, Toronto, 2006; *Fictive Space*, Pari Nadimi Gallery, Toronto, 2003; *Convection*, 1040 Bus Gallery, Toronto, 2001; *Lot*, 1080 Bus Gallery, Toronto, 2000 SELECT GROUP EXHIBITIONS *Flirt'n With Disaster*, Katharine Mulhern Gallery, Toronto, 2007; *Contemporary Painters*, Gladstone Hotel, Toronto, 2005; *Beyond/in Western New York*, Albright Knox Gallery, Buffalo, 2005; *Synthetic Psychosis*, MOCCA, Toronto, 2002; *RBC Canadian Painting Finalist Show*, City Hall Gallery, Ottawa, 2002 AWARDS Emerging Arts Grants, Ontario Arts Council, 2003; Emerging Arts Grant, Toronto Arts Council, 2002 COLLECTIONS The Royal Bank of Canada; Canada Council Art Bank PUBLICATIONS *Beyond/ In Western New York*, Albright Knox Catalogue, Buffalo, 2003; *Synthetic Psychosis*, David Liss, MOCCA Catalogue, Toronto, 2002

Pascal Paquette

BIRTH DATE December 14, 1973 RESIDES Toronto EDUCATION Graphic Arts, La Cité Collégiale, Ottawa, 1996 SELECT SOLO EXHIBITIONS *Fear by Popular Demand*, Artcore/Fabrice Marcolini, Toronto, 2003; *The Clarice and Eric Account*, Gooderham & Worts Historic Distillery, Toronto, 2002; *Sample*, Vain Gallery, Toronto, 2001; *Vancouver Urban*, Artcore/Fabrice Marcolini, Toronto, 2001 SELECT GROUP EXHIBITIONS *Sens et Mouvance*, La Galerie du Nouvel-Ontario, Sudbury, 2008; *Folklore*, Zero2one, Kitchener, Ont., 2005; *Ache 700 Cultural Centre*, Zalzburg, Austria, 2003; *Carta*, Galleria nocode, Bologna, Italy, 2001; *Human Remains*, Art Gallery of Sudbury, Sudbury, Ont., 2001 AWARDS Balkan Incentive Fund for Culture, European Cultural Foundation/Hivos/Open Society Institute, Amsterdam, 2007; Emerging Artist Project Grant, Toronto Arts Council, Toronto, 2003 PUBLICATIONS *La Foire International d'Art Contemporain de Paris Catalogue*, 2003 WEBSITE pascalpaquette.com

Catherine Perehudoff

BIRTH DATE 1958 RESIDES Saskatoon EDUCATION One year program in Weaving, Folk Art & Painting, Voss Folkehogskule, Voss, Norway, 1977; BA, Advanced, Art History, University of Saskatchewan, Saskatoon, 1981; Post-Degree Certificate, Elementary Education, University of Alberta, Edmonton, 1985 SELECT SOLO EXHIBITIONS *Impressions of Nature*, Newzones Gallery of Contemporary Art, Calgary, 2007; *Catherine Perehudoff*, Voss Folkehogskule, Voss, 1999; *Catherine Perehudoff*, Klonaridis Inc., Toronto, *1984, 1987 and 1991; Catherine Perehudoff*, Whyte Museum of the Canadian Rockies, Banff, Alta., 1990; *Catherine Perehudoff*, Centre D'Art, Baie-Saint-Paul, Que., 1989 SELECT GROUP EXHIBITIONS *Canadian Landscapes: Catherine Perehudoff & Graham Fowler*, The Gallery on Cork Street, London, U.K., 2008; *Triangle Artists' Workshop, Alumni 25th Anniversary Exhibition*, Brooklyn, N.Y., 2007; *Prairie Companion*, Art Gallery of Nova Scotia, Halifax, 2007; *Canadian Landscapes: Catherine Perehudoff & Graham Fowler*, The Gruen Gallery, Chicago, 1996; *Our Doukhobor Heritage, Contemporary Reflections*, West Kootenay National Exhibition Centre, Castlegar, The Grand Forks Art Gallery, Grand Forks, The Richmond Art Gallery, Richmond, B.C., 1995 and 1996 AWARDS First Time Producer's Award, Saskatchewan Motion Picture Association, Regina, 1995; Best Saskatchewan Documentary, Saskatchewan Motion Picture Association, Regina, 1995; Painting Gifted and Presented to Her Majesty, Queen Elizabeth, Queen Mother, Government of Saskatchewan, Regina, 1983; Saskatchewan Arts Board Grant, Regina, 1982; SGIO annual Juried Art Competition and Exhibition, Purchase Award, Saskatoon, 1978 COLLECTIONS Art Gallery of Nova Scotia, Halifax; Centre D'Art Baie-Saint-Paul, Que.; Edmonton Art Gallery, Edmonton; Institute of Pedagogy, Faculty of Art, Ostrava, Czechoslovakia; Kamloops Art Gallery, Kamloops, B.C.; Mendel Art Gallery, Saskatoon; Richmond Art Gallery, Richmond, B.C.; Robert McLaughlin Art Gallery, Oshawa, Ont.; Voss Folkehogskule, Voss, Norway; Whyte Museum of the Canadian Rockies, Banff, Alta. PUBLICATIONS *Canadian Landscapes, Catherine Perehudoff & Graham Fowler*, Keith Bell, Calvin Redlick, The Gallery in Cork Street, London, U.K., 2007; *At Home in Canada*, Nicole Eaton & Hilary Weston, The Penguin Group, 1995; *Treasured Moments*, J.M. Kurtz, Printwest Communications, 1997; *Canadian Who's Who*, University of Toronto Press, 1991-2008

Brad Phillips

BIRTH DATE February 8, 1974 RESIDES Vancouver EDUCATION Visual Arts Diploma, Toronto School of Art, Toronto, 1999; Interdisciplinary Program, Ontario College of Art, Toronto, 1996 SELECT SOLO EXHIBITIONS *No P.S.*, Monte Clark Gallery, Toronto, 2008; *No Comebacks*, Monte Clark Gallery, Vancouver, 2008; *Day by Day*, Wallspace, New York, 2007; *On Feeling Better*, Wallspace, New York, 2005; *1996*, Groeflin Maag Galerie, Basel, Switzerland, 2005 SELECT GROUP EXHIBITIONS *Draw*, Stolenspace Gallery, London, U.K., 2008; *The Monty Hall Problem*, Blum & Poe, Los Angeles, 2006; *Tiny Vices*, Spencer Brownstone Gallery, New York, 2006; *Darkness Ascends*, MOCCA, Toronto, 2006; *Summer Jam*, Peres Projects, Los Angeles, 2003 AWARDS Western Canada Winner, RBC Painting Competition, Toronto, 2003 COLLECTIONS Collection Hauser & Wirth, Zurich PUBLICATIONS *Hope Against Reason*, Text by Guy Maddin, TV Books, New York, 2008; *Paul Butler's Collage Party*, MOCCA, Toronto, 2008; *Suicide Note Writer's Block Drawings*, Cedertag Publishing, Stockholm, 2007 WEBSITES bradphillips.ca; monteclarkgallery.com

Sheila Provazza

BIRTH DATE September 29, 1956 RESIDES Glen Margaret, N.S. EDUCATION MFA, Cranbrook Academy of Art, Bloomfield Hills, Mich., 1981; BFA, University of Massachusetts, Dartmouth, Mass., 1978 SELECT SOLO EXHIBITIONS *In the Sweet By and By (a Panorama)*, Saint Mary's University Art Gallery, Halifax, 2005; Craig Gallery at Alderney Landing, Dartmouth, N.S., 2003; *Nazareth College*, Casa Italiana Gallery, Rochester, N.Y., 2002; *Il Ritorno d'Ulisse in Patria*, Anna Leonowens Art Gallery, Nova Scotia College of Art and Design, Halifax, 2000 SELECT GROUP EXHIBITIONS *Marion McCain Atlantic Art Exhibition*, Beaverbrook Art Gallery, Fredericton, 2000; *Stimuleye Gallery*, Toronto, 2004; *Far and Wide*, Art Gallery of Nova Scotia, Halifax, 1998; *Necessary Space*, Mount St. Vincent University Art Gallery, Halifax, 1991; *10%*, Minor Injury Gallery, Brooklyn, N.Y., 1987 AWARDS Creation Grant, Nova Scotia Department of Tourism, Culture and Heritage, Nova Scotia, 2004; Nova Scotia Art Bank Collection, Halifax; Hyatt Award, Rochester Memorial Art Gallery, Rochester, N.Y., 1985 COLLECTIONS Art Gallery of Nova Scotia, Permanent Collection, Halifax; Nova Scotia Art Bank Collection, Halifax; Mount St. Vincent University Art Gallery Collection, Halifax PUBLICATIONS *Sheila Provazza: In the Sweet By and By (A Panorama)*, Essay by Sara Hartland-Rowe, Saint Mary's University Art Gallery Catalogue, Halifax, 2005; *Artists in a Floating World*, Tom Smart, Marion McCain Foundation and The Beaverbrook Art Gallery, Fredericton, 2000; *Necessary Space*, Mount Saint University Art Gallery, Halifax, 1991 WEBSITE provazza.com

Ben Reeves

BIRTH DATE 1969 RESIDES Vancouver EDUCATION MA, Chelsea College, London, U.K., 1995; BFA, University of British Columbia, Vancouver, 1993 SELECT SOLO EXHIBITIONS *Smoke, Flowers, Cars*, Jessica Bradley ART + PROJECTS, Toronto, 2007; *Complicated Matter*, Museum London, London, Ont., 2006; *Ben Reeves*, Equinox Gallery, Vancouver, 2005; *Drawing Painting*, Oakville Galleries, Oakville, Ont., 2005 SELECT GROUP EXHIBITIONS *Works on Painting*, CSA Space, Vancouver, 2007; *Shifting Space*, Museum of Sichuan Fine Arts Institute, Chongqing, China, 2005; *High Points: Canadian Contemporary Art, Ten Years of Acquisitions*, Musée des Beaux Arts, Montreal, 2004; *Lines Painted in Early Spring*, traveling show originating at Southern Alberta Art Gallery, Lethbridge, Alta.; Galerie de l'UQAM, Montreal; Tom Thomson Memorial Art Gallery, Owen Sound, Ont.; Kamloops Art Gallery, Kamloops, B.C.; Koffler Gallery, Toronto; 2003-2004 PUBLICATIONS *For the Record: Drawing Contemporary Life*, Essay by curator Daina Augaitis, Vancouver Art Gallery, Vancouver, 2003 AWARDS Ontario Arts Council Mid-Career Artist Grant, Guelph, Ont., 2005; Canada Department of Foreign and International Trade, Visual & Media Arts Grant, London, Ont., 2005; Canada Council Emerging Artist's Grant, London, Ont., 2004; Canada Council Travel Grant, Vancouver, 2002; RBC Great Canadian Painting Competition, Winner, Western Canada, Vancouver, 2001

Mathew Reichertz

BIRTH DATE May 8, 1969 RESIDES Halifax EDUCATION MFA, Nova Scotia College of Art and Design (NSCAD), Halifax, 1999; BFA, Concordia University, Montreal, 1993 SELECT SOLO EXHIBITIONS *The Fight*, Art Gallery of Nova Scotia, Halifax, 2007; *Romanian Debacle*, Khyber Centre for the Arts, Halifax, 2004; *Necessary Man*, Anna Leonowens Gallery, Halifax, 1999 SELECT GROUP EXHIBITIONS *Sobey Art Award 2006*, Musée des beaux-arts, Montreal, 2006; *Roots and Shoots: Contemporary Art in Halifax*, Mount Saint Vincent University Art Gallery, Halifax, 2006; *RBC New Canadian Painting Competition*, MOCCA, Toronto; Bau-Xi Gallery, Vancouver; Galerie Sussex Gallery, Ottawa, 2005; *Reichertz, Wadden, Wiebe*, Sir Wilfred Grenfell College Art Gallery, Memorial University, Corner Brook, Nfld., 2004 AWARDS Shortlisted, Sobey Art Award, Sobey Art Foundation, Montreal, 2006; National Runner-up, Eastern Canadian Winner RBC New Canadian Painting Competition, Royal Bank of Canada, Toronto, 2005; Presentation Grant, Nova Scotia Department of Tourism and Culture, 2004; Creation Grant, Nova Scotia Department of Tourism and Culture, 2002; Commissioning Grant, Nova Scotia Arts Council, 2001 PUBLICATIONS *Sobey Art Award 2006*, Shauna McCabe, Art Gallery of Nova Scotia, 2006; *Salvage*, Renato Vitic, Khyber Centre for the Arts, 2004; *Artists in a Floating World*, Tom Smart, Beaverbrook Art Gallery, 2000 WEBSITE reichertz.ca

Derek Root

BIRTH DATE September 14, 1960 RESIDES Vancouver EDUCATION Painting (Hons.), Emily Carr Institute of Art and Design, Vancouver, 1985 SELECT SOLO EXHIBITIONS *Solo Exhibition*, Union Gallery, London, U.K., 2008; *Solo Exhibition*, Monte Clark Gallery, Vancouver, 2008; *Foreclosures*, East Van Studios, Vancouver, 2008; *Pictures of von Karajan*, Monte Clark Gallery, Toronto, 2006; *Selected Works*, Union Projects, London, U.K., 2004 SELECT GROUP EXHIBITIONS *Miami Basel*, Union Gallery, London, U.K., 2007; *Multiple Discipline*, Union Gallery, London, U.K., 2007; *Strange Identity*, Monte Clark Gallery, Vancouver, 2007; *Vancouver School*, North Vancouver School District, North Vancouver, 2006; *Passport to Painting*, 303 Gallery, New York, 2005 AWARDS P.S.1, Project Studio, New York, 1989 PUBLICATIONS *For the Record: Drawing Contemporary Life*, Daina Augaitis, Vancouver Art Gallery, 2003 WEBSITES monteclarkgallery.com; union-gallery.com

Matt Schofield

BIRTH DATE May 17, 1973 RESIDES Toronto EDUCATION BA, Hons. Art, McMaster University, Hamilton, Ont., 2000; AOCAD, Hons., Toronto, 1997; Off Campus Program, OCAD, Florence, Italy, 1996; Architecture/Art History, Carleton University, Ottawa, 1992 SELECT SOLO EXHIBITIONS *(almost) everything*, AWOL Gallery, Toronto, 2006; *Keeping a Distance*, Kabat Wrobel Gallery, Toronto, 2003; *Stills*, Propeller, Toronto, 2001; *Drawing a Crowd*, Propeller, Toronto, 1999; *Inaction Figures*, Propeller, Toronto, 19985 SELECT GROUP EXHIBITIONS *Williamsburg Square Foot*, AWOL Gallery, New York, 2005; *Alternating Currents*, McMaster Museum of Art, Hamilton, Ont., 2000; *SPF 30*, Meg Gallery, Toronto, 1999; *Ritual, Rhythm and Repeated Action*, Curated by Virginia MacDonnell, Propeller, Toronto, 1999; *Screen 2*, Curated by Stuart Reid, Propeller, Toronto, 1998 PUBLICATIONS *Ritual, Rhythm and Repeated Action*, Virginia MacDonnell, Propeller Exhibition Catalogue, 1999; *Screen 2*, Stuart Reid, Propeller Exhibition Catalogue, 1998 WEBSITE matthewschofield.com

Marc Séguin

BIRTH DATE March 20, 1970 RESIDES New York EDUCATION BFA, Concordia University, Montreal, 1995 SELECT SOLO EXHIBITIONS *Roadkill*, Corkin Gallery, Toronto, 2008; *Black Box*, Corkin Gallery, Toronto, 2007; *Les Démons*, Musée des Beaux-Arts de Montreal, 2004; *Les Rosaces*, Musée d'art contemporain de Montreal, 2000; *Nocturnal Solutions*, Artcore, Toronto, 1999 SELECT GROUP EXHIBITIONS *Recent Acquisitions*, Musée des Beaux Arts de Montreal, 2004; *ArtCité*, Musée d'art Contemporain de Montreal, 2001; *Canada 3 Perspectives*, Fondazione Bevilacqua La Masa, Venice, Italy, 2000; *Échanges et empreintes: gravures au vernis mou*, Musée du Québec, Québec City, 1999; *De fougue et de passion*, Musée d'art Contemporain de Montreal, 1997 AWARDS Artistic Achievement Award, Concordia University, Montreal, 2004; Prix Pierre Ayot, Ville de Montreal–AGAC, Montreal, 1998 PUBLICATIONS *Black Box: Marc Séguin*, Max Henry, Éditions Simon

Blais, 2006; *Marc Séguin 1996 to 2004*, Retrospective Catalogue, Stéphane Aquin, Stéphane Baillargeon, Robert Enright, Éditions 400 Coups, Montreal, 2004 WEBSITES corkingallery.com; marcseguin.com

Jaclyn Shoub

BIRTH DATE September 4, 1962 RESIDES Toronto EDUCATION BA, BSc, University of Guelph, Guelph, Ont., 1986; BFA, Nova Scotia College of Art and Design, Halifax, 1988 SELECT SOLO EXHIBITIONS *Heavy Traffic*, Tom Thomson Memorial Art Gallery, Owen Sound, Ont., 2007; *Snapshot Studies*, Wynick/Tuck Gallery, Toronto, 2006; *In Transit*, Art Gallery of Nova Scotia, Halifax, 2005; *At This Point in Time*, Wynick/Tuck Gallery, Toronto, 2004; *Road Work*, Tatar/Alexander Gallery, Toronto, 2002 SELECT GROUP EXHIBITIONS *The Painted Photograph*, David Bierk, Sarah Nind, Jaclyn Shoub, Canadian Museum of Contemporary Photography, National Gallery of Canada, Ottawa, 2006; *Variable Views: The Canadian Landscape*, Art Gallery of Mississauga, Ont., 2006; *Badlands*, Confederation Centre Art Gallery, Charlottetown, 2002; *Suburbia*, Curated by David Somers, Art Gallery of Peel, Brampton, Ont., 2001; *Persistent Documents*, Canadian Embassy, Tokyo, 2000 AWARDS Research and Creation Grant, Canada Council for the Arts, Ottawa, 2007; Visual Arts Grant, Canada Council for the Arts, Ottawa, 1998 and 1999; Visual Arts Grant (Mid-Career), Ontario Arts Council, Toronto, 1995, 1996, 1999, 2004 and 2007; Visual Arts Grant, Toronto Arts Council, Toronto, 1993 COLLECTIONS Art Gallery of Nova Scotia; Canadian Museum of Contemporary Photography, Ottawa; Canada Council Art Bank, Ottawa; Art Gallery of Mississauga; Corporation of Metropolitan Toronto; Lafferty, Harwood & Partners, Montreal; Jefferey Murphy Architects, New York; Kilmer Van Nostram, Toronto; State Street Trust, Toronto; FSA International, Toronto PUBLICATIONS *The Painted Photograph*, Andrea Kunard, Canadian Museum of Contemporary Photography, 2006; *Take Off*, Brian Piitz, Gallery 44 Centre for Contemporary Photography, 1991; *Suburbia*, David Somers, Art Gallery of Peel, 2001; *The Boys of Summer*, Laurin, Gordon, St. Mary's University Art Gallery, 1995; *Persistent Documents*, Ray Cronin, Le Mois de la photo a Montreal, Catalogue, 1995 WEBSITE jaclynshoub.com

Gerald Steadman Smith

BIRTH DATE December 15, 1929 RESIDES Ottawa EDUCATION MA (Studio Art), University of Saskatchewan, Saskatoon, 1979; BFA (Distinction), Mount Allison University, Sackville, N.B., 1976 SELECT SOLO EXHIBITIONS *Heads Up*, Ottawa City Hall Art Gallery, Ottawa, 2006; *An Artist's Journey*, Foyer Gallery, Ottawa, 2005; *Head Start*, Atrium Gallery, Ottawa, 2004; *Head Start*, Gloucester Gallery, Ottawa, 2004; *Varied Musings*, Foyer Gallery, Ottawa, 1997 SELECT GROUP EXHIBITIONS Foyer (Co-Op) Gallery, Ottawa, 1997 to present; Kanata Civic Gallery (Co-Op) Gallery, Kanata, 1991 to present; Mayor's 1st Annual Art Festival, Ottawa City Hall, 2006; Gallery 479, Ottawa, 2004; Pilar Shephard Gallery, Charlottetown, 1997-2007 AWARDS Graduate Studies Scholarship, University of Saskatchewan, 1997 and 1978; Art Grant, Saskatchewan Arts Board, Regina, 1979, 1981, 1984 and 1985; Gairdner Fine Art Scholarship, Mount Allison University, Sackville, N.B., 1975; Wood Scholarship, Mount Allison University, Sackville, N.B., 1974; Undergraduate Scholarships, Mount Allison University, Sackville, N.B., 1974 and 1975 COLLECTIONS Canada Council Art Bank, Ottawa; City of Ottawa (Kanata Senior's Centre); Kanata Baptist Church, Kanata, Ont.; Mendel Art Gallery, Saskatoon; University of Saskatchewan, Saskatoon; St. Thomas Moore Gallery, Saskatoon; Gairdner Fine Art Collection, Toronto; Victoria General Hospital, Halifax; Archelaus Smith Museum, Centreville N.S. WEBSITE geraldsmithartstudio.com

Shaan Syed

BIRTH DATE March 26, 1975 RESIDES London, U.K. EDUCATION MFA, Goldsmiths College, London U.K., 2006; AOCAD, Toronto, 2000 SELECT SOLO EXHIBITIONS Galerie Michael Janssen, Cologne, Germany, 2008; *Stage*, Birch Libralato, Toronto, 2008; *Arena*, Brown, London U.K., 2007; *Crowds and Constellations* (Travelling), Plug In ICA, Winnipeg; The Art Gallery of Windsor, Windsor, Ont., 2006; *Two Dogs*, Mercer Union Peephole, Toronto, 2004 SELECT GROUP EXHIBITIONS *Artfutures 2008*, Bloomberg Space, London U.K., 2008; *Foreground/Background*, Elementa Gallery, Dubai, 2008; *Where Something Becomes Nothing*, S1 Artspace, Sheffield U.K., 2007; *Distinction*, Galerie

Michael Janssen, Cologne, Germany, 2006; *Expect Relevance,* K3 Project Space, Zurich, 2002 AWARDS Warden's Purchase Prize, Goldsmiths College, London, U.K., 2006; Celeste Art Prize U.K., Student Section, 2006; Emerging Artist Grant, Canada Council for the Arts, 2002; Emerging Artist Grant, Ontario Arts Council, 2002; Emerging Artist Grant, Toronto Arts Council, 2002 COLLECTIONS American Bank, Oklahoma; Doris McCarthy Gallery, University of Toronto; Goldsmiths College, University of London; Royal Bank of Canada, Toronto; Stiftung Kunstlerhaus Boswil, Switzerland; UBS Art Collection, London U.K. PUBLICATIONS *Foreground/Background (Catalogue),* Swapna Tamhane, Elementa Gallery, 2008; *Sovereign European Art Prize 2007, (Catalogue),* 2007; *Shaan Syed: Crowds and Constellations,* Steven Matijcio, Essay by David Liss, Plug In Editions, 2006; *Celeste Art Prize, (Catalogue),* 2006

Monica Tap

BIRTH DATE April 3, 1962 RESIDES Toronto EDUCATION MFA, Nova Scotia College of Art and Design (NSCAD), Halifax, 1996; BFA, NSCAD, Halifax, 1990 SELECT SOLO EXHIBITIONS *Séance,* Margaret Thatcher Projects, New York, 2007; *One-second Hudson,* Wynick/Tuck Gallery, Toronto, 2007; *Grand River Chronicles: Séance.* Kitchener-Waterloo Art Gallery, Kitchener, Ont., 2007; *Travelling Show,* Wynick/Tuck Gallery, Toronto, 2005; *Paintings,* Southern Alberta Art Gallery, Lethbridge, Alta., 2004 SELECT GROUP EXHIBITIONS *Pulse: Abstract Painting and Film*, Mount St. Vincent University Art Gallery, Halifax, 2006; *Fabulous,* Dalhousie Art Gallery, Halifax, 2006; *The Big Abstract Show,* The Painting Center, New York, 2003; *Painting!,* University Art Gallery, Central Michigan University, Mount Pleasant, Mich., 2003; *The Single Tree,* London Regional Art and Historical Museum, London, Ont., 2000 AWARDS Residency Leader, Emma Lake Artists Workshop, Emma Lake, Sask., 2007; Residency Award, International Studio and Curatorial Program, New York, 2006; Research-Creation Grant, Social Sciences and Humanities Research Council, Ottawa, 2005 to 2008; Creation/ Production Grant: The Canada Council for the Arts, 2003; Mid-career Visual Arts Grant, The Canada Council for the Arts, 1998 PUBLICATIONS *One-second Hudson,* Sarah Beveridge, McLaren Art Gallery, Barrie, Ont., 2008; *Séance,* Matthew Brower, Kitchener-Waterloo Art Gallery, Kitchener, Ont., 2007; *Monica Tap: Paintings,* Stuart Ried and Nancy Tousley, Tom Thomson Memorial Art Gallery, Owen Sound, and Southern Alberta Art Gallery, Lethbridge, Alta., 2004; *Painting!* Buzz Spector and Julia Morrisroe, Central Michigan University Art Gallery, Mount Pleasant, Mich., 2003; *Contingency and Continuity: Negotiating New Abstraction,* Ron Shuebrook, MacDonald Stewart Art Centre, Guelph, Ont., 1999 WEBSITE monicatap.com

Renée Van Halm

BIRTH DATE July 11, 1949 RESIDES Berlin and Vancouver EDUCATION MFA, Concordia University, Montreal, 1977; Honours Diploma, Vancouver School of Art, Vancouver, 1975 SELECT SOLO EXHIBITIONS *Tourist,* Birch Libralato, Toronto, 2006; *Dream Home & Taste,* Kamloops Art Gallery, Kamloops, B.C., 2003; *Out-takes & Taste,* Equinox Gallery, Vancouver, 2002; *Dream Home,* Contemporary Art Gallery, Vancouver, 2002; *Anonymous Volumes,* Oakville Galleries, Oakville, Ont., 1994 SELECT GROUP EXHIBITIONS *Real Space,* Mahan Gallery, Columbus, Ohio, 2007; *Architypes,* Canadian Embassy, Tokyo, 2005; *Architypes,* Ivan Dougherty Gallery, Sydney, Australia, 2004; *Weak Thought,* Vancouver Art Gallery, Vancouver, 1998; *Vancouver Perspectives,* Taipei Fine Arts Museum, Taipei, Taiwan, 1997; *Songs of Experience,* National Gallery of Canada, Ottawa, 1986 AWARDS A Grant, Canada Council for the Arts, Ottawa, 1991, 1994 and 2001 PUBLICATIONS *Occasional Work and Seven Walks From the Office of Soft Architecture,* Lisa Robertson, Coach House Press, Toronto, 2006; *Architypes,* Charles H. Scott Gallery, Vancouver, 2004; *Dream Home,* Office of Soft Architecture & McKay, Sherry, Contemporary Art Gallery, Vancouver, 2002; *Canadian Art: From Its Beginnings to 2000,* Anne Newlands, Firefly Books, Toronto, 2000; *Art BC: Masterworks From British Columbia,* Douglas & McIntyre, Vancouver, 2000 WEBSITE reneevanhalm.com

Janet Werner

BIRTH DATE April 11, 1959 RESIDES Montreal EDUCATION MFA, Yale School of Art, New Haven, Conn., 1987; BFA, Maryland Institute College of Art, Baltimore, Maryland, 1985 SELECT SOLO EXHIBITIONS *Too Much Happiness,* Parisian Laundry, Montreal, 2008; *Buttercup I Love You,* Galerie Julia Garnatz, Cologne, Germany, 2007; *Up Here in Heaven,* Birch Libralato Gallery, Toronto, 2006; *Janet Werner,* Liane & Danny Taran Gallery, Saidye Bronfman Centre, Montreal, 2005; *Since first I cast eyes on you/Depuis mon premier regard sur toi,* Ottawa Art Gallery, 2002 SELECT GROUP EXHIBITIONS *Generation,* Art Gallery of Alberta, Edmonton, 2008; *Framed: The art of the portrait,* Art Gallery of Hamilton, Ont., 2007; *Prague Bienale, Lazarus Effect,* Prague, Czech Republic, 2003; *Posers,* St. Mary's University Art Gallery, Halifax, 2002; *Beautiful Stranger,* The Physics Room, Christchurch, New Zealand, 2002 AWARDS Canada Council Project Grant, 2007; Canada Council B Grant, 2004; Canada Council New York Studio, International Studio Program, N.Y., 2003; Conseil des arts et des lettres du Québec, A Grant, 2001; Canada Council Paris Studio, Cité Internationale des Arts, Paris, 1995 COLLECTIONS Collection of the Department of Foreign Affairs and International Trade, Ottawa; Collection Prêt d'œuvres d'art du Musée national des beaux-arts du Québec, Québec; Leonard and Bina Ellen Art Gallery, Montreal; Mackenzie Art Gallery, Regina; Owens Art Gallery, Sackville, N.B.; Mendel Art Gallery, Sasktoon; Winnipeg Art Gallery, Winnipeg; Senvest Colleciton, Montreal; Tedeschi Collection, Montreal; Aldo Group, Montreal PUBLICATIONS *Trust,* Lisa Mark, The Language of Eyes, Art Gallery of Mississauga, Ont., 2000; *Trance,* Wayne Baerwaldt, Mendel Art Gallery, 1998; *Lucky,* Carol Laing, The Silence of the World, Southern Alberta Art Gallery,1997; *Janet Werner,* Janice Williamson "Scat" and Colleen O'Neill "Figures and Fields," Sir Wilfred Grenfell Art Gallery, 1998; *Beautiful Losers,* Keindl, Anthony, Dunlop Art Gallery, 2000 WEBSITES birchlibralato.com; parisianlaundry.com; juliagarnatz.com

Etienne Zack

BIRTH DATE 1976 RESIDES Vancouver and Montreal EDUCATION Diploma of Fine Art, Emily Carr Institute of Art and Design, 2000 SELECT SOLO EXHIBITIONS *Authorshop,* Equinox Gallery, Vancouver, 2007; *New Paintings,* Project Art 45, Montreal, 2007; *According to This,* Bergen Kunsthall, Bergen, Norway, 2006; *New Works,* Galeria Marina Miranda, Madrid, 2004; *Awry,* Artcore, Toronto, 2003 SELECT GROUP EXHIBITIONS *Rien ne se perd, rien ne se crée, tout se transforme,* Musée d'Art Contemporain de Montreal, Montreal, 2008; *Paint,* Vancouver Art Gallery Vancouver, 2006; *Etienne Zack/Jorge Queiroz,* Thomas Dane Gallery, London, U.K., 2006; *In a certain place,* Nicole Klagsbrun, New York, 2005; *East International,* Norwich Gallery, Norwich, England, 2004 AWARDS First prize, RBC Painting Competition, Royal Bank of Canada, 2005; The Brissenden Scholarship, Vancouver, 1999; The Mary Catherine Gordon Memorial Scholarship, Vancouver, 1999 COLLECTIONS National Gallery of Canada, Ottawa; Musee d'Art Contemporain de Montreal; Musee des beaux-arts de Montreal; Royal Bank Collection; National Bank, Montreal; Toronto Dominion Bank; Heenan Blaikie; Canaccord Capital; Fasken Martineau Du Moulin; Granite Club, Toronto PUBLICATIONS *Paint* (Catalogue), Monika Szewczyk/Neil Campbell, Vancouver Art Gallery, 2006; *East International 2004* (Catalogue), Keith Wallace, 2004; *Overwhelming the Image* (Catalogue), Euginio Castro, Galeria Marina-Miranda, 2004; *Mixed Paint: Survey of Contemporary Painters,* Lavinia Garulli/Valentina Sansone/Francesca D.Shaw/Livia Zanelli, *Flash Art,* 2004 WEBSITES equinoxgallery.com; art45.ca

Balint Zsako

BIRTH DATE April 29, 1979 RESIDES Brooklyn, N.Y. EDUCATION BFA, Ryerson University, Toronto, 2002 SELECT SOLO EXHIBITIONS *Drawings From the Bernardi Collection,* MOCCA, Toronto, 2008; *Love Stories,* The Proposition Gallery, New York, 2007; *Drawn Negatives,* Drabinsky Gallery, Toronto, 2007; *Love Stories,* Spin Gallery, Toronto, 2006; *Bazsa Paradise,* Economist Gallery and LEE, Ka-sing Gallery, Hong Kong, 2005 SELECT GROUP EXHIBITIONS *Wilde Animals,* Wilde Gallery, Berlin, 2008; *Coercive Atmospherics,* Dumbo Arts Center, New York, 2007; *Dehuman,* Kenderdine Art Gallery, Saskatoon, 2006; *Whisper Down the Lane,* Esther M. Klein Art Gallery, Philadelphia, 2005; *Here Everything is Still Floating,* Katharine Mulherin Gallery, Toronto, 2005 WEBSITE balintzsako.com

established

Stephen Andrews

BIRTH DATE September 26, 1956 RESIDES Toronto SELECT SOLO EXHIBITIONS *Cartoon*, Power Plant Contemporary Art Gallery, Toronto, 2007; *A Deer In the Headlights Remix*, Platform Gallery, Seattle, 2007; *Forecast*, JB Gallery, Hart House, University of Toronto, 2006; *Stephen Andrews*, Commons Gallery, University of Honolulu, 2006; *The 1st Part of the 2nd Half*, Participant Inc., New York, 2004; *Stephen Andrews*, Cue Art Foundation, New York, 2004; *The 1st Part of the 2nd Half*, Nuova Icona, Venice, 2003; *The 1st Part of the 2nd Half*, Canadian Cultural Centre, Paris, 2003; *CMYK*, Paul Petro Fine Art, Toronto, 2001; *Likeness*, Helen and Morris Belkin Gallery, University of British Columbia, Vancouver, 2001; *Likeness*, Art Gallery of Windsor, Ont., 2001 SELECT GROUP EXHIBITIONS *Biennale de Montréal*, Montreal, 2007; *Gifts Go One Way*, Apex Gallery, New York, 2006; *This Ain't No Fooling Around*, Rubicon Gallery, Dublin, 2006; *Andrews and Blanchon*, Kendall Art Gallery, Miami, 2006; *Out of the Blue*, Abington Art Centre, Jenkintown, Penn., 2006; *Beyond Redemption*, Belkin Satellite, Vancouver, 2005; *Branded*, Paul Petro Fine Art, Toronto, 2005; *Thought Crimes*, Diverseworks, Houston, 2005; *Contemporary Erotic Drawing*, Diverseworks, Houston, 2005; *Contemporary Erotic Drawing*, Aldrich Contemporary Art Museum, Ridgefield, Conn., 2005; *Just My Imagination*, Museum London, London, Ont., 2004; *Sign and Sound*, Seoul Museum of Art, Seoul, 2003; *Think Canda*, Delhi, Chennai, Mumbai, 2002; *Crowds*, Hunter College, New York, 2001; *Subject Plural*, Houston, 2001 COLLECTIONS National Gallery of Canada; Art Gallery of Ontario; Art Gallery of North York; Canada Council Art Bank; Harvard University AWARDS Ontario Arts Council Project Grant, 2007; Toronto Arts Council Project Grant, 2007; Visual AIDS Bill Olander Award, 2007; Canada Council for the Arts Project Grant, 2007; Canada Council for the Arts, Trinidad Studio, 2005; Ontario Arts Council Project Grant, 2005 PUBLICATIONS *Stephen Andrews*, Atom Egoyan, Cue Art Foundation, 2004; *MosaiCanada: Sign and Sound*, Wayne Baerwaldt, Keunhye Lim, Seoul Museum of Art, 2003; *Likeness*, Annette Hurtig, Scott Watson, University of British Columbia, 2001

John Armstrong & Paul Collins

BIRTH DATES December 6, 1955 (Armstrong); September 11, 1955 (Collins) RESIDE Toronto (Armstrong), Paris (Collins) EDUCATION MA, Chelsea School of Art, London, U.K., 1980; BFA, Mount Allison University, Sackville, N.B., 1978; York University, Toronto, 1974-1976 (Armstrong); George Brown College, Toronto, 1977-1978; New School of Art, Toronto, 1976-1978; York University, Toronto, 1974-1976 (Collins) SELECT SOLO EXHIBITIONS *Lakeshore*, galerie ESCA, Nîmes, France, 2006; *Lakeshore*, Oakville Galleries, Ont., 2006; *Lakeshore*, Sir Wilfred Grenfell College Art Gallery, Corner Brook, Nfld., 2006; *Jim →*, Le Mois de la Photo à Montréal, Studio 1, Maison de la culture Côtes-des-Neiges, Montreal, 2005; *Lakeshore*, Centre for Photographic and Digital Arts, Winnipeg, 2004; *Lakeshore*, Truck, Calgary, 2003; *Jim →*, Artothèque de Caen, France, 2004; *Lakeshore*, L'Hôtel Galerie d'Art, Ecole régionale des beaux-arts Caen la Mer, Caen, France, 2004; *Jim →*, Robert Birch Gallery, Toronto, 2002; *Jim →*, Art Gallery of Sudbury, Ont., 2002; *Jim →*, Alliance Française, Toronto, 2002 SELECT GROUP EXHIBITIONS *Open - La Sirène*, La Générale, Sèvres, 2007; *The Logo Cities Show*, Montreal, VAV, 2007; *Sortir la tête*, Peuple et Culture Corrèze, Tulle, France, 2007; *Glo*, Archive, Toronto, 2006; *The Ironic Turn*, MOCCA, Toronto, 2004; *The Ironic Turn*, Owens Art Gallery, Sackville, N.B., 2004; *The Ironic Turn*, Kunsthalle Erfurt, Erfurt, Germany, 2003; *On the Wall Again*, La Soirée de la sirène, Paris, 2003; *The Ironic Turn*, Faux Mouvement and Chapelle des Trinitaires, Metz, France, 2003 AWARDS Canada Council Research/Creation Grant–International Residency Program in Visual Arts, Paris, 2007 COLLECTIONS Artothèque du Limousin, Limoges; Bibliotèque Nationale de France; Canada Council Art Bank; Centre National de l'Estampe et de l'Art Imprimé, Paris; Foreign Affairs Canada; University of Toronto Art Centre PUBLICATIONS *Image & Imagination: Le Mois de la Photo à Montréal 2005*, Martha Langford, McGill-Queen's University Press, 2005; *Lakeshore*, Cliff Eyland, Winnipeg: Platform Centre for Photographic and Digital Arts, 2004; *Lakeshore* (artist project), John Armstrong and Paul Collins, Truck, 2003; *Jim →*, (artist's book), John Armstrong and Paul Collins, Coach House Books and Art Gallery of Sudbury, 2002 WEBSITE johnandpaul.ca

Iain Baxter&

BIRTH DATE November 16, 1936 RESIDES Windsor, Ont. EDUCATION BSc., MA of Education, University of Art, Idaho; MA, Fine Art, Washington State University SELECT SOLO EXHIBITIONS *Television Works*, Corkin Gallery, Toronto, 2007; *Iain Baxter&*, La Villa Arson, Nice, 2006; *Photographs, etc.*, Corkin Shopland Gallery, Toronto, 2006; *Passing Through*, Art Gallery of Windsor, Ont., 2006; *Baxter - Any Choice Works, 1965–70*, Art Gallery of Ontario, Toronto, 1982; *N.E. Thing Co. Ltd. Polaroid Works*, The Hague, 1980; *N.E. Thing Co. Ltd.*, National Gallery of Canada, Ottawa, 1969 SELECT GROUP EXHIBITIONS *Les Ateliers de Rennes: Valeurs Croisées / Crossing Values*, Biennale Contemporary Art Fair, Rennes, France, 2008; *Weather Report: Art & Climate Change*, Boulder Museum of Contemporary Art, Boulder, 2007; *Food*, Bordeaux Museum of Contemporary Art, Bordeaux, 2004; *Soft Ware Show*, Guggenheim Museum, New York, 1972; *10th Sao Paolo Biennial* (Represented Canada in Photo-Print), Sao Paolo, 1969 AWARDS Honorary Doctorate of Fine Arts, Simon Fraser University, 2008; Honorary Doctorate, University of Windsor, 2007; York Wilson Prize, Canada Council for the Arts, Ottawa, 2007; Officer of the Order of British Columbia, 2007; Gershon Iskowitz Prize, 2006; Molson Prize in the Arts, Canada Council for the Arts, 2005; Member of the Order of Ontario, 2005; Honorary Degree, Doctorate of Literature, University of British Columbia, 2004; Governor General's Award in Visual Arts, 2004; Officer of the Order of Canada, 2002; Queen's Golden Jubilee Medal, 2002 PUBLICATIONS *Passing Through: Iain Baxter& Photographs 1958-1983*, with essays by Lucy R. Lippard et al., Art Gallery of Windsor, 2006; *Carte Blanche: A Compendium of Canadian Photographers*, Magenta Publishing For The Arts, Toronto, 2006; *Image and Imagination*, Martha Langford, McGill–Queen's University Press, 2005; *Six Years: The Dematerialization of the Art Object from 1966 to 1972*, Lucy R. Lippard, Praeger Publishers Inc., New York, 1973 WEBSITE corkingallery.com

Paul Béliveau

BIRTH DATE August 10, 1954 RESIDES Quebec City EDUCATION Baccalauréat, Laval University, Quebec City, 1977 SELECT SOLO EXHIBITIONS *Paul Béliveau*, Stricoff Fine Art, New York, 2008; *New Works*, Drabinsky Gallery, Toronto, 2008; *Paul Béliveau*, Robert Kidd Gallery, Birmingham, 2007; *Paul Béliveau*, Arden Gallery, Boston, 2007; *Paul Béliveau*, Galerie de Bellefeuille, Montréal, 2007 SELECT GROUP EXHIBITIONS *Are You Talking to Me? Conversation(s)*, Galerie de l'UQAM, Montréal, 2003; *MADE IN Canada : Contemporary Art from Montréal*, Plattsburgh State Art Museum, SUNY, 2001; *L'art québécois de l'estampe, 1940-1990*, Musée des beaux-arts du Canada, Ottawa, 1998; *In the Wilds Canoeing and Canadian Art*, McMichael Canadian Art Collection, Kleinburg, Ont., 1998; *200e anniversaire de la lithographie*, Bibliothèque nationale du Québec, Montréal, 1998 AWARDS Lauréat de Québec, Quebec City, 2006; Honneur national, prix d'excellence de l'AAPC, Quebec City, 2005; Prix des arts visuels, Videre, Que., 1997; Mention, 39th American Print Exhibition, Boston, 1987; 3rd Purchase Prize, Kelowna Art Competition, B.C., 1986 PUBLICATIONS *La lecture est une randonnée*, Guy Mercier, (catalogue), Galerie de Bellefeuille, Montréal, 2007; *L'atelier des apparences*, Bertrand Bergeron, Roland Bourneuf, Esther Croft, Gilles Pellerin, Marc Rochette, Jean-Sébastien Trudel, Lise Vekeman, L'instant même, 2004; *La collection du Musée national des beaux-arts du Québec. Une histoire de l'art du Québec*, Yves Lacasse, John R. Porter & col., Musée national des beaux-arts du Québec, 2004; *Les Humanités : New Work by Paul Béliveau*, Seamus Kealy, (catalogue), Drabinsky Gallery, Toronto, 2003; *Paul Béliveau, le théâtre des correspondances*, Dany Quine, (catalogue), Galerie de Bellefeuille, Montréal, 2001 WEBSITE paulbeliveau.com

Ron Bolt

BIRTH DATE October 13, 1938 EDUCATION Associate Diploma, Royal Conservatory of Music, 1961; Ontario College of Art, Toronto (non degree courses), 1959; Northern Technical School, Toronto, Gold Medalist, 1955 SELECT SOLO EXHIBITIONS Nancy Poole's Studio/Loch Gallery, Toronto, 1992 to present; Christina Parker Gallery, St. John's, 1992 to present; Gallery Moos, Toronto, 1983 to 1990; Albemarle Gallery, London, U.K., 2006; Confederation Centre Art Gallery, Charlottetown; Art Gallery of Nova Scotia, Halifax; McMichael Canadian Art Collection, Kleinburg, Ont., 1976; Queen's University, Kingston, 1975 SELECT GROUP EXHIBITIONS *What is*

Realism?, Albemarle Gallery, curated by Edward Lucie-Smith, London, U.K., 2005; Liu Hai Su Art Museum, Shanghai, 2000; Contemporary Art Museum, Guang Zho, China, 2000; Art Institute of Shen Zhen, China, 2000; Canadian Art Fair, Nagoya, Japan, 1994; 3rd Biennial Print Exhibition, Wakayama, Japan, 1989; 39th North American Print Exhibition, Boston, 1987; International Biennial Print Exhibit, Taipei, China, 1987; International Biennial Print Exhibit, Taipei, China, 1987; Canadian Printmakers, Bronx Museum, New York, 1982 AWARDS RCA Centennial Medallion, 2005; awarded a position on Three Rivers Journey, Canadian Parks and Wilderness Society (CPAWS), Yukon Territory, 2003; Queen's Jubilee Medal, 2002; Honorary Life Member: Mackenzie Art Gallery, Regina, Saskatchewan; Society of Canadian Artists, Government of Canada 125 Medal, 1992 COLLECTIONS Canada Council Art Bank; National Art Library, Victoria & Alberta Museum; Edward P. Taylor Research Library and Archives, Art Gallery of Ontario; Art Gallery of Nova Scotia; The Winnipeg Art Gallery; Art Gallery of Newfoundland & Labrador; Imperial Oil Ltd.; James Richardson & Sons Ltd.; McMaster Museum of Art PUBLICATIONS *The Snake River Suite*, CPAWS, 2006; *The Beat & the Still*, in collaboration with Norman Levine, North Edition, Toronto, 1990; *The Inner Ocean*, Merritt Publishing, 1980; *Acrylics*, Department of Culture & Recreation, Government of Ontario, 1976 WEBSITE lochgallery.com

John B. Boyle

BIRTH DATE September 23, 1941 RESIDES Peterborough, Ont. EDUCATION London Teachers' College, Ont., 1962; self-taught as a painter SELECT SOLO EXHIBITIONS Fukugan Gallery, Osaka, Japan, 2001, 2004; Nancy Poole's Studio, Toronto, 1998, 2001; *Canadology*, Tom Thomson Gallery, Owen Sound, Ont., 1994-1995; *Canadology*, Gallery of Peterborough, Peterborough, Ont., 1994-1995; *Canadology*, McClaren Art Centre, Barrie, Ont., 1994-1995; *Canadology*, The Gallery, Stratford, Stratford, Ont., 1994-1995; *Canadololgy*, Art Gallery of Newfoundland and Labrador, St. John's, 1994-1995; *John B. Boyle—Retrospective*, Museum London, London, Ont., 1991-1992; *John B. Boyle—Retrospective*, Rodman Hall Arts Centre, St. Catharines, Ont., 1991-1992; *John B. Boyle—Retrospective*, Beaverbrook Gallery, Fredericton, 1991-1992; *John B. Boyle—Retrospective*, Confederation Centre, Charlottetown, 1991-1992 SELECT GROUP EXHIBITIONS *Fragments*, Café Gallery Projects, London, U.K., 2006; *Fragments*, Tom Thomson Gallery, Owen Sound, Ont., 2006; *The 60's in Canada*, National Gallery of Canada, Ottawa, 2005; *Soundtracks*, Edmonton Art Gallery, Edmonton, 2003-2004; *Soundtracks*, University of Toronto Art Gallery, Toronto, 2003-2004; *Soundtracks*, MacKenzie Art Gallery, Regina, 2003-2004; *Artists From Ontario*, Lieutenant Governor's Suite, Queen's Park, Toronto, 2002; *Rielisms*, Art Gallery of Winnipeg, Winnipeg, 2001; *Rielisms*, Dunlop Gallery, Regina, 2001; *A Century of Canadian Drawing*, Dalhousie Art Gallery, Halifax, 1999; *Viewers Are Advised*, Glenbow Gallery, Calgary, 1997; *Oh Canada Project*, Art Gallery of Ontario, Toronto, 1996; *Regroupings*, McMichael Canadian Collection, Kleinberg, Ont., 1996 AWARDS Recipient of numerous awards from the Canada Council for the Arts and Ontario Arts Council COLLECTIONS National Gallery of Canada, Art Gallery of Ontario, Montreal Museum of Fine Art, Vancouver Art Gallery, McMichael Canadian Collection PUBLICATIONS *Inventing Tom Thomson*, Sherill Grace, McGill-Queens University Press, 2004; *Appearance and Reality*, Stephen Hogbin, Cambium Press, 2000; *Canadian Art in the Twentieth Century*, Joan Murray, Dundern, 1999; *Contemporary Canadian Artists*, Gale Canada, 1998; *Significant Treasures*, CFFM, 1997; *John B. Boyle, The Canadology Series 1988-1993*, Maggie Mitchell, TTMAG, 1994; *John B. Boyle: a Retrospective*, Barry Lord, LRAHM, 1991; *The Best Canadian Contemporary Art*, Joan Murray, 1987; *The Art of London*, Nancy Geddes Poole, 1984; *Contemporary Canadian Art*, Burnett – Schiff, 1983; *Landmarks in Canadian Art*, Peter Mellen, 1979; *The History of Painting in Canada*, Barry Lord, New Press, 1974 WEBSITE lochgallery.com

John Brown

BIRTH DATE 1953 RESIDES Toronto EDUCATION BA, University of Guelph, 1982; Ontario College of Art, Toronto, 1981; SELECT SOLO EXHIBITIONS MOCCA, Toronto, 2008; Olga Korper Gallery, Toronto, 2006; Olga Korper Gallery, Toronto, 2005; Carmen Lamanna Gallery, Toronto, 1990; Carmen Lamanna Gallery, Toronto, 1989 SELECT GROUP EXHIBITIONS Galerie Im Kornhauskeller, Pro Arte Ulmer,

Kunststiflung Ulm, Germany, 2003; *Painters 15: Canadian Painting Exhibition*, Shanghai, China, 2002; *Written Images*, Touring Exhibition: Art Gallery of Ontario, Toronto, 1987; *Ecrans politiques*, Musée d'art contemporain de Montréal, 1986; *Toronto Painting*, Touring Exhibition: Rodman Hall Arts Centre, St. Catharines, Ont., 1985 PUBLICATIONS *Écrans politiques*, France Gascon, Musée d'art contemporain de Montréal, 1985; *Toronto Painting '84*, David Burnett, Art Gallery of Ontario, 1984; *Expron*, Centre international d'art contemporain, 1984 WEBSITE olgakorpergallery.com

Chris Cran

BIRTH DATE December 27, 1949 RESIDES Calgary EDUCATION Diploma, Alberta College of Art, 1979 SELECT SOLO EXHIBITIONS *Novel*, TrépanierBaer Gallery, Calgary, 2006; *Chris Cran: The Return of the Beautiful Hayseed*, Clint Roenisch Gallery, Toronto, 2005; *Camera Obscura Theatre*, One Yellow Rabbit's High Performance Rodeo, Calgary, 2003-2005; *Inspirational Themes and Sublime Sales*, TrépanierBaer Gallery, Calgary, 2004; *Big Opening!!!*, Sable-Castelli Gallery, Toronto, 2003; *And Now It's Personal*, Owens Art Gallery, Sackville, N.B., 2003; *The Second Hundred Years*, TrépanierBaer Gallery, Calgary, 2000 SELECT GROUP EXHIBITIONS *Let Me Be Your Mirror*, Mackenzie Art Gallery, Regina, 2008; *The Biennale de Montréal 2007: Crack the Sky*, Montréal, 2007; *Artist's Artists*, University of Lethbridge Art Gallery, Alta., 2006; *The McIntyre Ranch Project*, Southern Alberta Art Gallery, Lethbridge, Alta.,2006; *The Perm Show*, Museum of Contemporary Canadian Art, Toronto, 2006; *About Time*, Nickle Arts Museum, University of Calgary, 2006; *The McIntyre Ranch Project*, Illingworth Kerr Gallery, Calgary, 2005 AWARDS Sonia de Grandmaison Scholarship, Banff Centre, 2005; In Memory of Keith Evans Scholarship, Banff Centre, 2005; The Alice and Harold Soper Scholarship, Banff Centre, 2005; Fleck Fellowship, Banff Centre, 2003; Induction into The Royal Academy of Arts, 2002 PUBLICATIONS *Abstract Painting in Canada*, Nasgaard, Roald Nasgaard, Douglas & McIntyre, 2007; *Alberta Art and Artists*, Patricia Ainslie/Mary-Beth Laviolette, Fifth House, 2007; *Chris Cran: Surveying the Damage 1977-1997*, Roald Nasgaard, Clint Roenisch and Nancy Tousley, Kelowna Art Gallery, 1998; *Bang! The Gun As Image*, Roald Nasgaard, Florida State University, Museum of Fine Arts, 1997 WEBSITE chriscran.com

Karin Davie

BIRTH DATE July 27, 1965 RESIDES New York and Victoria EDUCATION MFA, Rhode Island School of Design, Providence, 1989; BFA, Queen's University, Kingston, Ont., 1987 SELECT SOLO EXHIBITIONS *Karin Davie*, Aldrich Museum of Contemporary Art, Ridgefield, Conn., 2008; *Light Drawings & New Sculpture*, Mary Boone Gallery, New York, 2007; *Karin Davie: Dangerous Curves*, Albright-Knox Art Gallery, Buffalo, 2006; *Karin Davie, Underworlds*, Agnes Etherington Gallery, Kingston, Ont., 2006; *SITE Santa Fe*, Santa Fe, 2003 SELECT GROUP EXHIBITIONS *The Oppenheimer Collection*, The Nerman Museum of Contemporary Art, Kansas City, 2007; *Extreme Abstraction*, Albright-Knox Art Gallery, Buffalo, 2005; *Hypermental*, Hamburger Kunsthalle, Hamburg, Germany, 2001; *Hypermental*, Kunsthaus Zurich, Switzerland, 2000; *Post-Hypnotic*, The Contemporary Arts Center, Cincinnati; University Galleries, Illinois State University, Normal, Ill.; Chicago Cultural Center, Chicago, 1999-2000; *Projects 63: Karin Davie, Udomsak Krisanamis, Bruce Pearson, Fred Tomaselli*, The Museum of Modern Art, New York, 1998 AWARDS American Academy of Arts & Letters Award, New York, 1999; Pollock-Krasner Award, New York, 1999; Elizabeth Foundation Grant, New York, 1998; Canada Council Grant, Ontario, 1992 &1995; Pollock-Krasner Award, New York 1991 COLLECTIONS Albright-Knox Art Gallery; Art Gallery of Ontario; Kunstverein, Hamburg, Germany; Marimotti Collection, Reggio Emilia, Italy; Nerman Museum of Contemporary Art, Overland Park, Kan.; Neuberger Berman Art Collection, New York; Orlando Museum of Art; Rubell Family Collection, Miami; Seattle Art Museum; The Modern Art Museum of Fort Worth; Marx Collection, Berlin, Germany PUBLICATIONS *Karin Davie*, Barry Schwabsky and Lynne Tillman, Rizzoli, New York, 2006 WEBSITE karindavie.com

Christian Eckart

BIRTH DATE 1959 RESIDES Houston EDUCATION MFA, Hunter
College, CUNY, New York, (Painting), 1986; Alberta College of Art
(Sculpture), 1984 SELECT SOLO EXHIBITIONS *Pornopticon*, Clint
Roenisch Gallery, Toronto, 2005; *Einstein's Toaster–New Work by
Christian Eckart*, Galerie Thaddaeus Ropac, Salzburg, Austria, 2003;
Exformation, McClain Gallery, Houston, 2002; *White Album*,
TrépanierBaer Gallery, Calgary, 1999; *Various Logic*, Sidney Janis
Gallery, New York, 1997; *Disturbing Abstraction*, organized by Mark A.
Cheetham of the University of Western Ontario and presented at 6
venues across Canada, 1996; *Christian Eckart*, Abbaye Saint-Andre,
Centre d'Art Contemporain, Meymac, France, 1993 SELECT GROUP
EXHIBITIONS *The Shape of Colour: Excursions in Color Field Art, 1950-
2005*, Art Gallery of Ontario, Toronto, 2005; *Space Vehicles: Allusion
Objectified*, McClain Gallery, Houston, 2003; *Diskursive Malerei*,
Museum Moderner Kunst Stiftung Ludwig Wien, Vienna, Austria,
2002; *Pleasure of Sight & States of Being: Radical Abstract Painting Since
1990*, Florida State University at Tallahasee, 2001; *The Erotic Sublime
(Slave to the Rhythm)*, Galerie Thaddaeus Ropac, Salzburg, Austria,
1998; *Slittamenti/Transactions (I Love You More Than My Own Death)*,
45th Biennale di Venezia, Granai delle Zitelle, Guidecca, Venice, 1993;
Horn of Plenty, Stedelijk Museum, Amsterdam, 1989 COLLECTIONS
The Solomon R. Guggenheim Museum, New York; Museum of
Modern Art, New York; Museum Moderner Kunst Stiftung Ludwig
Wein, Vienna; The Brooklyn Museum; Art Institute of Chicago;
Stiftung Scaufler, Sindelfingen, Germany; Eli Broad and Eli Broad
Family Foundations

Ric Evans

BIRTH DATE January 10, 1946 RESIDES Toronto EDUCATION
OCA, Toronto, 1970 SELECT SOLO EXHIBITIONS *Approach*, Nicholas
Metivier Gallery, Toronto, 2006; *Toronto*, John Buckley Gallery,
Melbourne, Australia, 2004; *The Salt Paintings*, Sable-Castelli Gallery,
Toronto, 2003; *Ten Years, Art Gallery of Peel*, Brampton, 2000; *Axiom*,
Winchester Gallery, Victoria, 2000 SELECT GROUP EXHIBITIONS
Spell, Robert McLaughlin Gallery, Oshawa, 2006; *Critic's Select*, The
Shore Institute, Long Beach, New Jersey, 2006; *Square*, Nicholas
Metivier Gallery, Toronto, 2005; *Case Studies*, Harbourfront Art
Centre, Toronto, 1999 AWARDS Title, Royal Canadian Academy of
Arts, 2002; Canada Council grants, 1988, 1997 PUBLICATIONS *Ric
Evans Ten Years*, Gary Michael Dault, Steve Rockwell, Art Gallery of
Peel, 1999 WEBSITE metiviergallery.com, www.ccca.ca

Gathie Falk

BIRTH DATE 1928 RESIDES Vancouver EDUCATION University of
British Columbia SELECT SOLO EXHIBITIONS *Gathie Falk*, Vancouver
Art Gallery, Vancouver Retrospective Exhibition travelling to: National
Gallery of Canada, Ottawa, Norman Mackenzie Art Gallery, Regina,
Art Gallery of Nova Scotia, Halifax, Musee des Beaux Arts de Montreal,
Montreal, Robert McLaughlin Gallery, Oshawa, Ont., Beaverbrook
Art Gallery, Fredericton, 2000; *Gathie Falk: Dreaming of Flying*, Equinox
Gallery, Vancouver, 2007; *Retrospective, 1962-85*, Vancouver Art Gallery;
Chairs, Equinox Gallery, Vancouver, 1985; *Beautiful B.C. Multiple Purpose
Thermal Blankets*, Equinox Gallery, Vancouver, 1981; *150 Cabbages and
Borders*, Artcore, Vancouver, 1978; *East Border & Sculptures*,
Edmonton Art Gallery, 1977; *Herd II and Drawings*, National Gallery
Tour, 1976-77; *Single Right Men's Shoes*, Canadian Cultural Centre,
Paris, 1974; *Living Room, Environmental Sculpture & Prints*, Douglas
Gallery, Vancouver, 1968; *Paintings*, Canvas Shack, 1965 SELECT
GROUP EXHIBITIONS *Dress: Signal*, Art Gallery of Mississauga, Ont.,
2003; *ABCs of Pop Art*, Appleton Museum of Art, Ocala, Fla., 2000;
Cosmologies, Equinox Gallery, Vancouver, 1999; *Les Peintures*, Galerie
Rene Blouin/Galerie Lilian Rodriguez, Montreal; *The Rag Trade:
Gathie Falk, Yang Hong, Tony Mazzega*, Richmond Art Gallery, BC;
Hidden Values—Contemporary Canadian Art in Corporate Collections,
Exhibited: Art Gallery of Nova Scotia, The Edmonton Art Gallery,
McMichael Canadian Art Collection, Musee d'art contemporain de
Montreal, 1994; *Vancouver Now*, Walter Phillips Gallery, The Banff
Centre, Banff and touring to: London Regional Art Gallery, London,
Ont., Oboro, Montreal, Winnipeg Art Gallery, Winnipeg, 1985-87;
Aurora Borealis, Centre International d'Art Contemporain d'Montreal,
Montreal, 1985; *Reflections—Contemporary Art Since 1964*, National
Gallery of Canada, Ottawa, 1984; *Mere Morsels*, B.C. Tour from

Vancouver Art Gallery Extension Department, Vancouver, 1982;
Curnoe/Ewen/Falk/Moppett, Norman Mackenzie Art Gallery, Regina,
Nickle Art Museum, Calgary, 1982; *Issues in Clay*: Edmonton
University Art Gallery, Edmonton, Alberta College of Art, Calgary,
Banff Centre, Burnaby Art Gallery, 1981; *Some Canadian Women
Artists*, National Gallery of Canada, Ottawa, 1975 AWARDS Governor
General's Award in Visual Arts, 2003; Order of British Columbia,
2002; Order of Canada, 1997; Gershon Iskowitz Prize, 1990
PUBLICATIONS *Gathie Falk Visions*, Linda Sawchyn, Kelowna Art
Gallery, 2002; *Gathie Falk*, Robin Laurence, Bruce Grenville, Ian M.
Thom, Mayo Graham, Sarah Milroy, Douglas & McIntyre, 2000;
Performance in Canada, 1970-1990, Alain-Martin Richard & Clive
Robertson, Editions Interventions and Coach House Press, 1991;
Gathie Falk, Jane Lind, Douglas & McIntyre , 1990; *The Toronto Suite*,
Michael Torosian, Lumiere Press, 1989; *Foremost Women of the 20th
Century*, Melrose Press Ltd., Cambridge, England, 1987; *Gathie Falk
Retrospective*, Vancouver Art Gallery, 1985; *Gathie Falk Paintings*, Art
Gallery of Greater Victoria, 1985 WEBSITE equinoxgallery.com

Robert Fones

BIRTH DATE March 10, 1949 RESIDES Toronto SELECT SOLO
EXHIBITIONS *Drops*, Convenience, Toronto, 2007; Olga Korper
Gallery, Toronto, 2004; Olga Korper Gallery, Toronto, 2000;
Centennial Gallery, Oakville, Ont., 1998; S.L. Simpson Gallery,
Toronto, 1997; S.L. Simpson Gallery, Toronto, 1995; Presentation
House, Vancouver, 1994; *Project Room #3*, Mercer Union, Toronto,
1992; Carmen Lamanna Gallery, Toronto, 1990; *Robert Fones: Selected
Works 1979-1989*, The Power Plant, Toronto, 1989; Carmen Lamanna
Gallery, Toronto, 1987; Embassy Cultural House, London, Ont., 1984;
Carmen Lamanna Gallery, Toronto, 1979; A Space, Toronto, 1974;
20/20 Gallery, London, Ont., 1969 SELECT GROUP EXHIBITIONS
Dimensionality, YYZ, Toronto, 2007; *new photography*, Olga Korper
Gallery, Toronto, 2002 *House Guests*, Art Gallery of Ontario, 2001;
typecast, Wynick/Tuck Gallery, Toronto, 2000; *4 days at the white house*,
Toronto, 1999; *Sign Language*, Olga Korper Gallery, Toronto, 1998;
Rococo Tattoo, The Power Plant, Toronto, 1997; *Les Lieux communs*,
Musée régional de Rimouski, , Que., 1997; *Carambolage*, Biennial of
the Partner Regions 1, Staatliche Kunsthalle, Baden-Baden, Germany,
1992; *Working Truths/Powerful Fictions*, MacKenzie Art Gallery,
Regina, 1991; *Photographic Inscription: Art from Toronto*, Forum Fur
Kulturaustausch, Stuttgart, Germany, 1990 *The Collectors' Cabinet*,
Curt Marcus Gallery, New York, 1990; *Focus: Canadian Art From 1960
to 1985*, Art Cologne, 20. Internationaler Kunstmarkt, Cologne,
Germany, 1986; *Seven London Artists*, The Rothman's Art Gallery of
Stratford, Ont., 1970; *Swinging London*, University of Waterloo, Ont.,
1969 AWARDS Toronto Arts Award, Visual Art, Toronto Arts Council,
1999 PUBLICATIONS *These Goods Are Manufactured*, Oakville Galleries,
1998; *Head Paintings*, Coach House Books, 1997; *Historiated Letters*,
Jessica Bradley, Robert Bringhurst, Robert Fones, Presentation House
Gallery, 1994; *A Spanner in the Works*, The Power Plant, 1990; *Selected
Works 1979-1989*, Louise Dompiere, The Power Plant, 1989; *Field
Identification*, Art Metropole, 1985; *Anthropomorphiks*, Coach House
Press, 1971 WEBSITE olgakorpergallery.com

Sybil Goldstein

BIRTH DATE May 24, 1954 RESIDES Toronto EDUCATION BFA,
Nova Scotia College of Art & Design, Halifax, 1976 SELECT SOLO
EXHIBITIONS *How We Live*, Burston Gallery, Toronto, 2003; *Goldstein
& Abrams*, Loop Gallery, Toronto, 2001; *The Secret Life of Chatchkes*,
Loop Gallery, Toronto, 2000; *Sgraffito*, The Red Head Gallery, Toronto,
1998; *Shadows & Dreaming*, The Red Head Gallery, Toronto, 1996
SELECT GROUP EXHIBITIONS *Highly Recommended*, Headbones
Gallery, Toronto, 2007; *Home/Representation*, York Quay Centre,
Harbourfront Centre, Toronto, 2006; *Re:Collections*, Tom Thomson
Memorial Art Gallery, Owen Sound, Ont., 2003; *Antidote*, DeLong
Gallery, Toronto, 2003; *Tim Jocelyn & ChromaZone*, MacDonald
Stewart Art Centre, Guelph, Ont., 2000 AWARDS B Grant/Travel
Grant, Canada Council for the Arts, 1985; Exhibition Assistance,
Ontario Arts Council, 2006, 2003, 1997; Project Costs, Ontario Arts
Council, 1994; 1983; 1981; Exhibition Assistance, Ontario Arts Council,
2006, 2003, 1997 COLLECTIONS CIBC Wood Gundy, World Markets
Inc.; The Collection of the Corporation of the City of Toronto;
Macdonald Stewart Art Centre, University of Guelph; Tom Thomson

Memorial Art Gallery; University of Toronto Art Centre, University of Toronto PUBLICATIONS *Home/Representation*, Oliver Girling, Ashkenaz Festival, 2006; *The Art of Tim Jocelyn*, Sybil Goldstein, Gen. Ed., McClelland & Stewart Inc., Toronto, 2002; *Glass Front*, Yanover/ Brown, Canadian Art, Toronto, 2001; *Canadian Art in the Twentieth Century*, Joan Murray, Dundurn Press, Toronto, 1999 WEBSITE ccca.ca ; delonggallery.com

Will Gorlitz

BIRTH DATE 1952 RESIDES Guelph EDUCATION BFA, Nova Scotia College of Art and Design, Halifax, 1977 SELECT SOLO EXHIBITIONS Birch Libralato, Toronto, Ontario, 2005, 2008; *Nowhere If Not Here,* Kitchener-Waterloo Art Gallery, Kitchener, Ont., 2008; Winnipeg Art Gallery, 2007; Galerie René Blouin, Montréal, 2004, 1999, 1996, 1991; Sable-Castelli Gallery, Toronto, Ontario, 2002, 1998, 1996, 1994, 1992, 1991, 1990, 1988, 1987, 1986, 1985, 1983; Power Plant Contemporary Art Gallery, Toronto, 1994; *Real Time,* Centre culturel canadien, Paris, 1991; *Not Everyone,* Agnes Etherington Art Centre, Kingston, Ont., 1991; *Three Essays Trilogy,* Oakville Galleries, Ont., 1990; *Three Essays on the Theory of Sexuality,* Artspeak Gallery, Vancouver, 1989 SELECT GROUP EXHIBITIONS *Road Trip,* Elora Centre for the Arts, Ont., 2006; *Bloom,* Kitchener-Waterloo Art Gallery, Kitchener, Ont., 2004; *Épreuve de Distance,* Galerie de l'UQAM, Université du Québec à Montréal, 2003; *Painters 15,* Shanghai Art Museum, 2002 / MOCCA, Toronto, Ontario, 2003; *Regarding Landscape,* Art Gallery of North York / MOCCA/ the Koffler Gallery, Toronto, 2002

John Hall

BIRTH DATE January 17, 1943 RESIDES Kelowna, B.C. EDUCATION Instituto Allende, San Miguel de Allende, Mexico, 1966; Alberta College of Art, Calgary, 1965 SELECT SOLO EXHIBITIONS *ASCENDING PLEASURES II–John Hall's Still Life Paintings,* Vernon Public Art Gallery, BC, 2004; *Traza de Evidencia (Trail of Evidence),* Museo de Arte Moderno, Mexico City, 1994; *Imitations of Life: John Hall's Still-Life Portraits,* Agnes Etherington Art Centre, Kingston, Ont., 1989-90; *John Hall: Paintings, Tourist Series/Toy Series,* Southern Alberta Art Gallery, Lethbridge, Alta., 1982; *John Hall: Paintings and Auxiliary Works 1969-1978,* National Gallery of Canada, Ottawa, 1979-80 SELECT GROUP EXHIBITIONS *The Feast: Food in Art,* Art Gallery of Hamilton, Ont., 2005; *The Meanings of Death,* MacKenzie Art Gallery, Regina, 2002; *Seven Artists From Alberta: Art in This Region,* Canada House Cultural Centre Gallery, London, U.K., 1984; *The Hand Holding the Brush, Self Portraits by Canadian Artists 1825-1983,* London Regional Art Gallery, Ont., 1983-84; *17 Canadian Artists: A Protean View,* Vancouver Art Gallery, 1976; *Canada 4 & 3,* organized by the National Gallery of Canada for the Canadian Cultural Centre, Paris, 1971 AWARDS Alumni Award of Excellence, the Alberta College of Art and Design, 2002; Appointed Professor Emeritus of Art, University of Calgary, 1998; elected to membership in the Royal Canadian Academy of Arts, 1975 COLLECTIONS National Gallery of Canada; Art Gallery of Ontario; Glenbow Museum; Winnipeg Art Gallery; Canada Council Art Bank PUBLICATIONS *Alberta Art and Artists,* Patricia Ainslie & Mary-Beth Laviolette, Fifth House, 2007; *Masterpieces of Canadian Art from the National Gallery of Canada,* David Burnett, Hurtig Publishers, 1990; *Contemporary Canadian Art,* David Burnett & Marilyn Schiff, Hurtig Publishers in co-operation with the Art Gallery of Ontario, 1983; *The Best Contemporary Canadian Art,* Joan Murray, Hurtig Publishers, 1987; *Visions: Contemporary Art in Canada,* Essays by Alvin Balkind, Terrence Heath, John Bentley Mays, Diana Nemiroff and Charlotte Townsend-Gault, Douglas & McIntyre, 1983 WEBSITE mimesisfinearts.com

John Hartman

BIRTH DATE April 13, 1950 RESIDES Lafontaine, Ont. EDUCATION BA, McMaster University, Hamilton, 1973 SELECT SOLO EXHIBITIONS *Cities,* Charles Cowles Gallery, New York, 2007; *Cities,* Nicholas Metivier Gallery, Toronto, 2007; *Cities,* Jill George Gallery, London, U.K., 2007; *Cities,* Projets Art 45, Montreal, 2007; *Cities,* exhibition tour to: Art Gallery of Nova Scotia, 2007, Tom Thomson Memorial Art Gallery, Owen Sound, Ont., 2007, Art Gallery of Calgary, 2007, Winnipeg Art Gallery, Winnipeg, 2007, Southern Alberta Art Gallery, Lethbridge, 2007, University of Toronto Art Centre, 2008, Kenderdine Gallery, Saskatoon, 2008, Gallery Stratford, Ont., 2008 MacLaren Art

Centre, Barrie, Ont., 2008, The Rooms, St. John's, 2009 SELECT GROUP EXHIBITIONS *Far and Wide, the Paintings of David Alexander and John Hartman,* Art Gallery of Alberta, Edmonton, 2006; *Towards The Spiritual In Canadian Art,* Varley Art Gallery, Unionville, Ont., 2005; *Einstein's Brain,* McMaster Museum of Art, Hamilton, Ont., 2003; *Alignments: Contemporary Works from the Permanent Collection,* Art Gallery of Windsor, Ont., 2001; **Rediscovering the Landscape of the Americas,* Gerald Peters Gallery, Santa Fe, exhibition tour to: Art Museum of South Texas, Corpus Christi, 1997, Western Gallery, Western Washington University, Bellingham, 1997, Memorial Art Gallery at the University of Rochester, N.Y., 1997, Gibbes Museum of Art, Charleston, N.C., 1997 AWARDS First prize: "Manitou Dock," Great Canadian Printmaking Competition, Ernst & Young and Canadian Art Magazine, Toronto, 1995; Distinguished Alumni Award, McMaster University, Hamilton, 1994; 10,000 level Visual Arts Grant, Ontario Arts Council, 1994; Short-Term Grant, Canada Council, 1984; Winner, Editions 1 Printmaking Competition, Ontario Arts Council, 1974 COLLECTIONS Art Gallery of Ontario; British Museum; Art Gallery of Nova Scotia; Mendel Art Gallery; Winnipeg Art Gallery PUBLICATIONS *Cities: The Paintings of John Hartman,* Noah Richler, Stuart Reid, Dennis Reid, Altitude Press, 2007; *Big North: The Paintings of John Hartman,* Matthew Hart, Key Porter Books, 1999; *with minimal means: John Hartman Prints 1985-1995,* Kim Ness, McMaster Museum of Art, 1995; *Painting The Bay: Recent Work by John Hartman,* Jean Blodgett, Jeffrey Spalding, McMichael Canadian Art, 1993; *Christian Art,* Rowena Loverance, The British Museum Press, 2007 WEBSITE johnhartman.ca

Rae Johnson

BIRTH DATE March 28, 1953 RESIDES Toronto EDUCATION AOCA, Experimental Art, Toronto, 1980; New School of Art, Toronto, 1976 SELECT SOLO EXHIBITIONS *Sleeping Beauty,* Young Centre for the Performing Arts, Toronto, 2006; *Alice,* Fly Gallery, Toronto, 2006; *Rae Johnson/Stand,* Art Gallery of the University of Waterloo, Ont., 2003; *Dream Girl,* Art Gallery of Peterborough, Ont., 2000; *Immediate Environment,* Justina M. Barnicke Gallery, Hart House, University of Toronto, 1995; *Bambino Miracolo,* Canadian Cultural Centre, Roma, Italia, 1993; *Rae Johnson Paintings,* Carmen Lamanna Gallery, Toronto, 1989, 1988, 1986, 1984, 1983; *Madonna,* Mercer Union, Toronto, 1983; *Paintings Rae Johnson,* A Space, Toronto, 1979 SELECT GROUP EXHIBITIONS *If you go out in the woods today…,* Gladstone Hotel, Toronto, 2008; *TruespectrumTDot,* Loop Gallery, Toronto, 2006; *Where the Heart Lies,* Banff Centre for the Arts, 2005; *Diversity,* Office of the Lieutenant Governor of Ontario, The Hon. James K. Bartleman, Toronto, 2005; *Dislocated,* Edward Day Gallery, Toronto, 2003; *Art in the Workplace,* Toronto Arts Council, Toronto, 2002; *Paintings from the Permanent Collection, University of Toronto Art Gallery, Toronto, 2002; New Acquisitions,* Galerie d'art Leonard & Bina Ellen, Concordia University, Montreal, 1999 AWARDS Visual Arts Grant for Painting, Canada Council for the Arts, 1980, 1982, 1983, 1984, 1985, 1986; Visual Arts Grant for Painting, Ontario Arts Council,1982, 1984, 1985, 1986, 1990, 1995, 1999; Gold Award, Poster Design in Independent Film Category, Chicago International Film Festival, Chicago, 1985 COLLECTIONS Canada Council Art Bank; Hart House, University of Toronto; National Gallery of Canada; University of Toronto; University of Waterloo PUBLICATIONS *Rae Johnson/Stand: Moments from the Flesherton Pond and Ghost Plane Series,* Carol Podedworny, University of Waterloo, 2002; *Anthology of Literature,* (cover), Rosemary Sullivan, Oxford University Press, 2002; *The Monumental New City: Art and Community,* Natalie Olanick and Tom Folland, Mercer Union, Toronto, 1996; *Art, Sight & Language,* Ashleigh Moorehouse, Penumbra Press, 1989; *"Kanada: Ein Land In Der Schwebe"; Die Horen* (Zeitscrift fur Literatur, Kunst und Kritik), Hanover, 1986; *Toronto Painting '84,* David Burnett, Art Gallery of Ontario, Toronto, 1984; *Contemporary Canadian Art,* David Burnett and Marilyn Schiff, Hurtig Publishers Ltd., 1983; *Visions: Contemporary Art in Canada,* Douglas & McIntyre, 1983 WEBSITE ccca.ca

Gertrude Kearns

BIRTH DATE November 6, 1950 RESIDES Toronto EDUCATION self-taught at painting studio of artist Frederic Steiger (father); Piano Teacher Diploma, ACTM University of Toronto, Royal Conservatory of Music, Toronto, 1975; Piano Performer Diploma, ARCT University of Toronto, Royal Conservatory of Music, Toronto, 1973 SELECT SOLO EXHIBITIONS *United States of Being: The John Bentley Mays Portraits,* Lehmann Leskiw Fine Art, Toronto, 2005; *blue yellow black: abstract works, 1993-97,* Lehmann Leskiw Fine Art, Toronto, 2004; *UNdone: Dallaire/Rwanda,* Propeller Centre for the Visual Arts, Toronto, 2002; *Stills,* Propeller Centre for the Visual Arts, Toronto, 2001; *Dancers,* Peter Pan, Toronto, 1998; *Portraits,* The Rivoli, Toronto, 1998 SELECT GROUP EXHIBITIONS *Abstracts B/W,* The Drawers-Headbones Gallery, with solo *Colour Abstracts by Gertrude Kearns* in Project Room, 2007; *The Kingston Prize for Contemporary Portraiture 2007,* The Firehall Theatre, Gananoque, finalist in 2007 and 2005; *Important Canadian Art,* Sotheby's in association with Ritchie's Toronto, 2007; *Permanent installations, Canadian War Museum,* Ottawa, 2005; *Boots on the Ground,* Canadian Embassy Gallery, Washington D.C., 2005; *Monkey See Monkey Do,* SPIN Gallery, Toronto, 2004 AWARDS National Aviation Museum First Prize, national competition Struggle for Peace, 1995; Anthony Miles Award for Most Outstanding Work, Ontario Society of Artists, 1992; Merit award with Vosburgh Design Studio, Toronto Art Director's Club, Toronto, 1983 COLLECTIONS War Art Collection, Canadian War Museum; University of Toronto; Crown Life/CrownX Canadian Collection; Bruce Kuwabara, Rodney and Clare VanderMeersch PUBLICATIONS *Gertrude Kearns Abstract Works 1989-1992,* Peter Goddard and Julie Oakes, The Drawers-Headbones Gallery, 2007; *Important Canadian Art,* Sotheby's in association with Ritchie's, 2007; *Art and War,* Dr. Laura Brandon, I.B. Tauris and Co. Ltd., 2007 WEBSITE ccca.ca

Shelagh Keeley

BIRTH DATE 1954 RESIDES Toronto EDUCATION BFA (Hons.), York University, Toronto, 1977 SELECT SOLO EXHIBITIONS RAM Foundation, Rotterdam, 2008; *An Encyclopaedia of Memory and Slowness,* MOCCA, 2007; Galerie Annette de Keyser, Antwerp, Belgium, 2005; Nature Morte Gallery, New Delhi, 2004; Nexus Contemporary Art Center, Atlanta, 1999; Art Book, Amsterdam, 1998; Printed Matter, New York, 1998 SELECT GROUP EXHIBITIONS *Hysteria and the Body,* National Gallery of Canada, traveling exhibition, 2008; *Intrusions au Petit Palais,* Fonds municipal d'art contemporain (FMAC), Paris, 2007; Drabinsky Gallery, Toronto, 2006; *Material Devotion,* Jaipur Heritage International Festival, on-site installation, Jaipur, India, 2005; *For the Record—Drawing Contemporary Life,* Vancouver Art Gallery, 2003; *The 25th Anniversary Selections Exhibition,* The Drawing Center, New York, 2002; *The End: An Independent Vision of Contemporary Culture,* Exit Art, New York, 2000; *Sight / Insight: Visual Commentaries on the Physical World,* The New York Public Library, New York, 2000; *End Papers 1890- 1900 and 1990-2000,* Neuberger Museum of Art, Purchase, N.Y., 2000; *Raw Ideas, Large Scale Drawings,* John Gibson Gallery, New York, 1998; *Jeux de Genres,* Les Musees de la Ville de Paris, L'Espace Electra, Paris, 1998 COLLECTIONS The Getty Center for the History of Art and the Humanities; The Library of Congress, Washington, D.C.; Museum of Modern Art; Musée d'Art Contemporain, Montreal; National Gallery of Canada; Spencer Collection, New York Public Library; The Mattress Factory, Pittsburgh; Stedelijk Museum, Amsterdam; Van Abbe Museum, Eindhoven, Netherlands; Vancouver Art Gallery; Victoria and Albert Museum; Walker Art Centre; Yale University Art Gallery WEBSITE ccca.ca; drabinskygallery.com

Garry Neill Kennedy

BIRTH DATE November 6, 1935 RESIDES Halifax EDUCATION MFA, Ohio University, 1965; BFA, University of Buffalo, 1963; Ontario College of Art, Toronto, 1960 SELECT SOLO EXHIBITIONS *The Eight Banners,* Pickled Art Centre, Beijing, 2007; *The Colours of Citizen Arar,* Art Gallery of Nova Scotia, Halifax, 2007; *Nothing Personal,* MOCCA, Toronto, 2007; *Two New Wars,* Emerson Gallery, Berlin, Germany, 2006; *AN EYE FOR AN EYE,* Museum London, London, Ont., 2005; *You Scratch My Back and I'll Scratch Yours in the Colonial Room,* Articule, Montreal, 2004; *Fast, Free and Easy,* Goodwater Gallery, Toronto, 2003; *Garry Neill Kennedy: Work of Four Decades,* The Art Gallery of Nova Scotia, Halifax, 1999; The National Gallery of Canada, Ottawa, 2000 SELECT GROUP EXHIBITIONS *Orientalism & Ephemera,* Ottawa Art Gallery, 2007; *The Top 100 (The Art Metropole collection),* National Gallery of Canada, Ottawa, 2007; *I Will Not Make Any More Boring Art,* Printed Matter, New York 2006; *Shit Happens,* Canada Gallery, New York, 2006 (with Joanna Milanowska); *Failure of Intelligence,* McMaster University, Hamilton, 2005 (with Cathy Busby); *The 60s in Canada,* National Gallery of Canada, Ottawa, 2005; *Number Painting,* ARTport, Art Gallery of Nova Scotia, Halifax, 2005; *The Ironic Turn,* MOCCA, Toronto, 2003; *OTTO GOLD,* Owens Art Gallery, Mount Allison University, Sackville, N.B., 2003; *TIT FOR TAT on The Tantramar Marsh,* Faux Mouvement, Metz, France, 2003 AWARDS Visual Arts Book Award, Ontario Association of Art Galleries, 2007; Governor General's Award in the Visual Arts, 2004; Member, Order of Canada, 2003; Portia White Prize, Nova Scotia Arts Council, Halifax, 2000; Honorary Fellowship, Ontario College of Art and Design, 1993; Creation Grants, The Canada Council for the Arts, 1998, 2000, 2002, 2004, 2007/8; Canadian Silver Jubilee Medal, Governor General, 1977 COLLECTIONS National Gallery of Canada; Art Gallery of Ontario; Art Gallery of Nova Scotia; Vancouver Art Gallery; Beaverbrook Art Gallery PUBLICATIONS *Garry Neill Kennedy Superstar Shadow (1984-2005),* Diana Nemiroff et al, Museum London, 2006; *Garry Neill Kennedy: Work of Four Decades,* Diana Nemiroff, John Murchie, Emily Falvey, Jen Budney, Martin Barlosky, Art Gallery of Nova Scotia, National Gallery of Canada, 1999; *Garry Neill Kennedy: Wall Paintings & Related Works 1974-1995,* Jen Budney, Angelika Nollert, Portikus, 1998; *Garry Neill Kennedy: Wall Paintings & Related Works 1974-1995,* Roald Nasgaard, Martin Barlosky, Owens Art Gallery, 1996; *Recent Work,* Roald Nasgaard, Art Gallery of Ontario, 1978

John Kissick

BIRTH DATE January 24, 1962 EDUCATION MFA, Cornell University, 1987; BFA, Queen's University, 1985 SELECT SOLO EXHIBITIONS *Paintings on a pop song,* Leo Kamen Gallery, Toronto, 2008; *John Kissick: Recent Work,* Doris McCarthy Gallery, Toronto, 2005; *John Kissick: A Survey of Recent Painting,* MacDonald Stewart Art Centre, Guelph, Ont. 2004; *John Kissick: Survey of Paintings 1995-2000,* OCAD Gallery, Toronto, 2000; *Works: 1995-1997,* Hatton Gallery, Colorado State University, 1997 SELECT GROUP EXHIBITIONS *Cartographies,* Elissa Cristal Gallery, Vancouver, 2007; *Spell,* Mendel Art Gallery and Robert McLaughlin Gallery, 2005-6; *AbNext,* South Bend Regional Art Museum, South Bend, Ind., 2003; *Painters 15: A Survey of Contemporary Canadian Painting,* MOCCA, Toronto, 2003; *Painters 15: A Survey of Contemporary Canadian Painting,* Shanghai Art Museum, Shanghai, 2002; *Philadelphia International Art Competition Winners,* Medici Visual Art, Philadelphia, 1994; *Painting,* Owen/Patrick Gallery, Philadelphia, 1993 AWARDS Elected to the Royal Canadian Academy for the Arts, 2005; Penn State University College of Arts and Architecture Award for Outstanding Teaching, 1999; Institute for the Arts and Humanistic Studies Award in Art Criticism, 1997; Philadelphia International Art Competition Award in Painting, 1994; Pennsylvania Council on the Arts Fellowship in Art Criticism, 1992 PUBLICATIONS *Abstract Painting in Canada,* Roald Nasgaard, Douglas & McIntyre and the Art Gallery of Nova Scotia, 2007; *Carnival of Means,* Liz Wylie, (catalogue), *John Kissick: A Survey of Recent Painting,* Macdonald Stewart Art Centre, 2004; *John Kissick,* Kathleen Mendus-Dlugos, (catalogue), Leo Kamen Gallery/Institute for Arts and Humanistic Studies, 1995 WEBSITE johnkissick.ca

Harold Klunder

BIRTH DATE October 14, 1943 RESIDES Montreal and Flesherton, Ont. EDUCATION Central Technical School, Toronto, 1964 SELECT SOLO EXHIBITIONS *Harold Klunder: Amorphous Amoebae,* McClure Gallery, Montreal, 2007; *Inside the Picture: Harold Klunder,* Art Gallery of Peel, Brampton, Ont., 2005; *Harold Klunder: The Lethbridge Paintings,* Southern Alberta Art Gallery, Lethbridge, 2000; *Harold Klunder: Schoenberg XVIII 1982,* Trianon Gallery, Lethbridge, 2000; *Harold Klunder: In the Forest of Symbols,* Museum London, London, Ont., 1999; *Harold Klunder: Love Comes and Goes Again,* Tom Thomson Memorial Art Gallery, Owen Sound, Ont., 1996; *Harold Klunder Self Portraits (Large-scale Wood Block Prints),* Memorial University of Newfoundland Art Gallery, St. John's, 1992; *Harold Klunder: Paintings,* 49th Parallel Gallery, New York, 1990 SELECT GROUP EXHIBITIONS

ensemble, an exhibition of art and jazz, FoFa Gallery, Concordia University, Montreal, 2007; *Love/Hate: New found glory in the GTA,* MOCCA, Toronto, 2007; *Painters 15,* Shanghai Art Museum, Shanghai, *2002;* Travelled to: MOCCA, Toronto, 2003; *Defining the Portrait,* Leonard & Bina Ellen Art Gallery, Concordia University, Montreal, 2001; *VIII Graafika Triennaal 1989,* The National Gallery of Soviet Estonia, Tallinn, Estonia, 1989; *Freedom China,* Erindale Campus Art Gallery, University of Toronto, Mississauga, 1989; *Interaction,* The National Gallery of Soviet Estonia, Tallinn, Estonia, 1988; *Chile/Canada Exchange,* Galleria Carmen Waugh, Santiago, Chile, 1988 COLLECTIONS Art Gallery of Nova Scotia; Art Gallery of Ontario; Musée d'art contemporain de Montréal; Musée des beaux-arts de Montréal; Museum of Contemporary Canadian Art; National Gallery of Canada; The Nickle Arts Museum, University of Calgary; Noosa Regional Gallery, Tewantin, Queensland, Australia; Shanghai Art Museum; The Winnipeg Art Gallery PUBLICATIONS *Harold Klunder, Amorphous Amoebae,* James D. Campbell, (monograph), McClure Gallery, Visual Arts Centre, Montreal, 2007; *Harold Klunder, [Inside the Picture],* David Somers, (catalogue), Art Gallery of Peel, 2005; *Harold Klunder: The Lethbridge Paintings,* James D. Campbell, Southern Alberta Art Gallery, Lethbridge, Summer 2000; *Harold Klunder: Prints and Paintings,* Caroline Stone, Cliff Eyland, (catalogue), Art Gallery of Newfoundland and Labrador, St. John's, 1999; *Harold Klunder: In the Forest of Symbols,* Ted Fraser, (catalogue), Museum London, London, Ont., 1999; *Harold Klunder: Love comes and goes again,* Ihor Holubizky, Tom Thomson Memorial Art Gallery, Owen Sound, Ont., 1996

Dorothy Knowles

BIRTH DATE 1927 RESIDES Saskatoon EDUCATION BA, Type C, University of Saskatchewan, 1948 SELECT SOLO EXHIBITIONS *Dorothy Knowles,* Douglas Udell Gallery, Edmonton, 2008, 2007; *Dorothy Knowles,* Miriam Shiell Fine Art, Toronto, 2006, 2003; *Dorothy Knowles,* Mendel Art Gallery, Saskatoon; *Dorothy Knowles,* Edmonton Art Gallery, 1994; *Dorothy Knowles,* Glenbow-Alberta Institute, Calgary, 1994; *Dorothy Knowles,* Whyte Museum, Banff, 1994; *Dorothy Knowles,* Edmonton Art Gallery; Centre Saidye Bronfman, Montreal, 1982; *Dorothy Knowles,* Norman Mackenzie Art Gallery, 1982 SELECT GROUP EXHIBITIONS *Clement Greenberg: A Critic's Collection,* Palm Springs Desert Museum, Palm Springs, 2004; *Clement Greenberg: A Critic's Collection,* Portland Art Museum, 2001; *Qu'Appelle Valley: A Tale of Two Valleys,* McMichael Canadian Art Collection, Kleinburg, Ont., 2003, Mendel Art Gallery, Saskatoon, 2003, Mackenzie Art Gallery, Regina, 2002; *Five From Saskatchewan,* Saskatchewan Arts Board, Regina, 1983, Canada House, Paris, 1983, Canada House, Brussels, 1983, Canada House, London, U.K., 1983 AWARDS Three Canada Post Corporation stamps, 1982, 2006; Centennial Medal of Saskatchewan, Government of Saskatchewan, 2005; Order of Canada, 2004; Honorary Degree, Doctor of Laws, University of Regina, 1994; Saskatchewan Award of Merit, Government of Saskatchewan, 1987 COLLECTIONS The Art Gallery of Nova Scotia; The Art Gallery of Ontario; The Art Gallery of Windsor; Boston Museum; Glenbow Museum; Musee d'Art Contemporain, Montreal; National Gallery of Canada; Portland Art Museum; Rideau Hall; Vancouver Art Gallery PUBLICATIONS *Landmarks: The Paintings of Dorothy Knowles,* Terry Fenton, Hagios Press, 2008; *Clement Greenberg, a Critic's Collection,* Bruce Guenther and Karen Wilkin, Portland Art Museum and Princeton University Press, 2001; *Dorothy Knowles,* Bruce Grenville, Mendel Art Gallery, 1994; *The Best Contemporary Canadian Art,* Joan Murray, Hurtig Publishers, 1987; *Modern Painting in Canada: Major Movements in Twentieth Century Canadian Art,* Terry Fenton and Karen Wilkin, Hurtig Publishers, 1978

Wanda Koop

BIRTH DATE 1952 RESIDES Winnipeg EDUCATION DFA, University of Manitoba, 1972 SELECT SOLO EXHIBITIONS *Paintings by Wanda Koop,* BuroDijkstra, Rotterdam, 2006; *In Your Eyes,* Thetis Foundation, Venice, 2001; *Green Room,* National Gallery of Canada, Ottawa, 2000; *See Everything/See Nothing,* Contemporary Art Gallery, Vancouver, 1998; *Paintings for Dimly Lit Rooms—Les cent jours d'art contemporain,* Centre international d'art contemporain de Montréal, 1994 SELECT GROUP EXHIBITIONS *Arena: The Art of Hockey,* Art Gallery of Nova Scotia, Halifax, 2008; *Studio Models,* National Gallery of Canada, Ottawa, 2007; *Wunderkammer,* Lisa Couwenbergh Gallery,

Amsterdam, Netherlands, 2004; *Painters 15,* Shanghai Art Museum, Shanghai, 2002; *Dark O'Clock,* Museum of Modern Art, São Paulo, Brazil,1994 AWARDS Order of Canada, 2006; Doctor of Letters, Emily Carr Institute of Art and Design, 2007; Doctor of Letters, University of Winnipeg, 2002; Innovations Award in Art Creation, Manitoba Arts Council, 2000; Japan Fund Award, Canada Council for the Arts, 1994 COLLECTIONS National Gallery of Canada; Canada Council Art Bank; Musée d'art Contemporain de Montréal; Reykjavik Art Museum; Shanghai Museum of Modern Art PUBLICATIONS *Sightlines,* Timothy Long, MacKenzie Art Gallery, 2002; *See Everything/See Nothing,* Robin Laurence, Contemporary Art Gallery (Vancouver), 1998; *Portrait of an Artist: Wanda Koop,* Els Hoek, Southern Alberta Art Gallery, 1991; *Airplanes and the Wall,* Terrence Heath, Winnipeg Art Gallery, 1985 WEBSITE wandakoop.com

James Lahey

BIRTH DATE February 6, 1961 RESIDES Toronto EDUCATION BFA (Hons.), York University, Toronto, 1984 SELECT SOLO EXHIBITIONS *your imperfect history,* Flowers Gallery, Flowers Central, London, U.K., 2008; *you want to start over,* J. Cacciola Gallery, New York, 2008; *not for finding,* Nicholas Metivier Gallery, Toronto, 2007 *Index,* University of Toronto Art Centre, Toronto, 2007; *Index,* Maclaren Art Centre, Barrie, Ont., 2005; Fay Gold Gallery, Atlanta, 2006 SELECT GROUP EXHIBITIONS *Vantage Point,* recent acquisitions, Museum London, London, Ont., 2007; *On Abstraction,* Hart House, University of Toronto, 2004; *Recent Acquisitions 2003-2004,* Macdonald Stewart Art Gallery, Guelph, Ont., 2004; *Recent Acquisitions,* Art Gallery of Nova Scotia, 2003; *New Acquisitions,* Hunter Museum, Chattanooga, Tenn., 2002 *"Made in Canada" Contemporary Canadian Art in 2001,* Plattsburgh State Art Museum, SUNY, 2001-2002 AWARDS Royal Canadian Academy, 2001; Elizabeth Greenshields Foundation, Achievement Award, 1987; Ontario Arts Council, Materials Assistance Grant, 1985; Jack Bush Scholarship, York University, 1983 PUBLICATIONS *Ethics of Luxury,* Jeanne Randolph, YYZ Books/Plug In Editions, 2007; *Index,* Ihor Holubizky and Mark Kingwell, The Maclaren Art Centre, 2005; *Water Project,* (catalogues): The Maclaren Art Centre, Tom Thomson Memorial Gallery, Art Gallery of Windsor, and Robert Mclaughlin Gallery, 2003; *About Paint,* Art Institute of Southern California, Laguna Beach, 2001; *Heresy and Beauty; The Resistance of Memory; Ways of Knowing; Heavy Traffic in all Directions; Our Destiny,* (James Lahey 2000), Ihor Holubizky Galerie de Bellefeuille, 2000 COLLECTIONS Art Gallery of Nova Scotia, Halifax; Art Gallery of Peterborough, Peterborough, Ont.; Art Gallery of Windsor, Windsor, Ont.; The Justina M. Barnicke Gallery, Hart House, University of Toronto, Toronto; Edmonton Art Gallery, Edmonton, Alta.; Hunter Museum, Memphis, Tenn.; Kelowna Art Gallery, Kelowna, B.C.; London Regional Art and Historical Museums, London, Ont.; MacDonald Stewart Art Centre, Guelph Ont.; Tom Thomson Memorial Art Gallery, Owen Sound, Ont.; AT&T Canada; Banque Nationale; C.A. Delaney Capital Management Ltd.; CanWest Global; CIBC; Citibank; MasterCard USA; McCarthy Tetrault; Memory Pictures; Metcalf Foundation

Landon Mackenzie

BIRTH DATE 1954 RESIDES Vancouver EDUCATION MFA, Concordia University, Montreal, 1979; BFA, Nova Scotia College of Art and Design, 1976 SELECT SOLO EXHIBITIONS *Houbart's Hope,* Concordia University FOFA Gallery, Montreal, 2008; *New Worlds,* Confederation Arts Centre, Charlottetown, 2006; *Houbart's Hope,* Anna Leonowens Gallery, NSCAD, Halifax, 2005; *Double Vision,* Art Gallery of Greater Victoria, Victoria, 2002; *Tracking Athabasca,* MOCCA, Toronto, 2002; *Shadows of Davy's Gray,* Art Gallery of Sudbury, 2000; *Tracking Athabasca,* Espace 502, Montreal, 2000; *Landon Mackenzie: A Northern Retrospective 1977-1997,* Art Gallery of the Yukon Arts Centre, Whitehorse, 1999 SELECT GROUP EXHIBITIONS *Search/Research: Contemporary Landscapes,* Surrey Art Gallery, Surrey, B.C., 2008; Permanent Collection exhibitions, National Gallery of Canada, Ottawa, 2008, 2006, 2004; *Permeable Borders, Cartographic Illusions,* Simon Fraser University Art Gallery, Burnaby, B.C., 2007; *PAINT,* Vancouver Art Gallery, 2006-2007; *NSCAD in the Seventies,* Art Gallery of Nova Scotia, Halifax, 2005; *Artists and Maps: Cartography as a Means of Knowing,* Hoffman Contemporary Art Gallery, Lewis and Clarke College, Portland, Ore., 2003; *That Still Place/That Place Still,* Nickel Art

Gallery, University of Calgary, 2003 AWARDS Grant to Established Artists, Canada Council for the Arts, 2005; Queen Elizabeth II Jubilee Medal, 2003; A Grant, Canada Council for the Arts, 2003, 1999; First Prize, Third Quebec Biennale of Painting, 1981 COLLECTIONS National Gallery of Canada; Art Gallery of Ontario; Vancouver Art Gallery; Montreal Museum of Fine Arts; Art Gallery of Nova Scotia PUBLICATIONS *Canadian Paintings, Prints and Drawings*, Anne Newlands, Firefly Books, 2007; *Where is Here? Canada's Maps and the Stories They Tell*, Alan Morantz, Penguin Books, 2002; *Double Vision: Lisa Baldasara, Landon Mackenzie and Medrie MacPhee* (catalogue), Art Gallery of Greater Victoria, 2002; *Qu'Appell: Tale of Two Valleys*, Dan Ring, Trevor Harriot, Robert Stacey, (catalogue), Mendel Art Gallery, Saskatoon, 2002; *Canadian Art: From its Beginnings to 2000*, Anne Newlands, Firefly Books, 2000

Medrie MacPhee

BIRTH DATE 1953 RESIDES New York EDUCATION BFA, Nova Scotia College of Art and Design, Halifax, 1977 SELECT SOLO EXHIBITIONS *Under My Skin*, Michael Steinberg Fine Art, New York, 2006; *Back Stories*, ArtCore Gallery, Toronto, 2006; Kunstkabinet Hespert, Reichshof Hespert, Germany, 2003; Stadtische Galerie Haus, Siegen, Germany, 2003; Trier Galerie Haus, Trier, Germany, 2003; *Double Vision*, Art Gallery of Greater Victoria, 2002; *Dreamland*, Edmonton Art Gallery, Edmonton, 2001; Pari Nadimi Gallery, Toronto, 2001; *Flight in the Variable Zone* Mendel Gallery, Saskatoon, 2000 SELECT GROUP EXHIBITIONS *The Empire of This*, Claire Oliver Gallery, New York, 2007; *Horizon*, The Elizabeth Foundation, New York, 2007; The National Gallery of Canada, Ottawa, 2006; *Somewhere Out There*, Shroeder Romero Gallery, Brooklyn, 2005; *Strange Relationship*, Keith Talent Gallery, London, U.K., 2004; *Invitational*, 150 Cubic Meter Largas, Cologne, Germany, 2004; *A Dot That Went for a Walk*, Plus Ultra Gallery, Brooklyn, 2004; *Exquisite Corpse*, Bowdoin College Museum of Art, Maine, 2004; *In Polytechnicolor*, Michael Steinberg Fine Art, New York, 2004; *Slippage*, Collaborative Concepts, Beacon, New York, 2004; *Future Species*, D.U.M.B.O, Brooklyn, 2004; *Recent Acquisitions*, Edmonton Art Gallery, 2003; *Short Stories*, Winnipeg Art Gallery, 2002; *Recent Acquisitions*, National Gallery of Canada, Ottawa, 2002 AWARDS Flying Horse Editions, Residency, Orlando, 2006; American Academy in Rome, Visiting Artist, 2001; New York Foundation for the Arts, 1985, 1998; The National Endowment for the Arts, 1985; Canada Council for the Arts Established Artist Grant, 1996, 2000, 2004; Canada Council for the Arts Artist Grant B, 1979, 1985, 1987, 1988, 1992 PUBLICATIONS *Medrie MacPhee: Animal, Vegetable or Mineral*, Artefakte, Artefiktionen; *Transformationsprozesse zeitgenossischer Literaturen, Medien, Kunste, Architecktudren*, cover image and text, Angela Krewani, University of Heidelberg Press, 2000; *26 American Artists*, Mark Lambrecht, (catalogue), Campo Campo, Antwerp, Belgium, 1999; *Medrie MacPhee: Unnatural Selection*, Jonathan Goodman, Charles H. Scott Gallery Publications, Vancouver, 1999; *Bauen Fur Die Sinne - Erotik und Sexualitat in der Architektur*, Christian Thomsen, Prestel, 1996 (English edition 1998); *Medrie MacPhee*, Debra Bricker Balken, Owen Drolet and Donna Masini, Paolo Baldacci Gallery, 1995

Sandra Meigs

BIRTH DATE 1953 RESIDES Victoria EDUCATION MA, Philosophy, Dalhousie University, Halifax, 1980; BFA, Nova Scotia College of Art and Design, Halifax, 1975 SELECT SOLO EXHIBITIONS *Scenes for My Affection*, Susan Hobbs Gallery, Toronto, 2007; *Ride*, Susan Hobbs Gallery, Toronto, 2004; *Reverie, Swoon and The Newborn, Sandra Meigs*, The Art Gallery of Greater Victoria, 2002; *The Newborn*, Susan Hobbs Gallery, Toronto, 2001; *Pas de Deux, Sandra Meigs*, The Power Plant, Toronto, 1990 SELECT GROUP EXHIBITIONS *Telling Stories*, Agnes Etherington Art Gallery, Kingston, 2006; *Trip-In, the Ontology of the Imaginative Realm*, Susan Hobbs Gallery, Toronto, 2006; *The Shape of Colour*, Art Gallery of Ontario, Toronto, 2005; *Officina America, Biennale of Bologna*, Bologna, 2002; *Realities*, Ydessa Hendeles Foundation, Toronto, 1996 AWARDS Senior Artist, British Columbia Arts Council, 2004; International Studio and Curating Residency Program, New York, Canada Council for the Arts, 2003; A Grant, Canada Council for the Arts, 2002; A Grant, Canada Council for the Arts, 1999 COLLECTIONS National Gallery of Canada, Art Gallery of

Ontario, Ydessa Hendeles Foundation, Musee d'Art Contemporain PUBLICATIONS *Reverie, Swoon and the Newborn, Sandra Meigs*, Lisa Baldisera, The Art Gallery of Greater Victoria, 2002; *The Shape of Colour*, David Moos, The Art Gallery of Ontario, 2005; *Sandra Meigs: Pas de Deux*, Louise Dompierre, The Power Plant, 1990; *Dummies*, Barbara Fischer, Contemporary Art Gallery, 1998 WEBSITE sandrameigs.com

Kim Moodie

BIRTH DATE 1951 RESIDES London, Ont. EDUCATION MFA, Concordia University, Montreal, 1979; BFA, University of Western Ontario, London, 1974 SELECT SOLO EXHIBITIONS *Driftwood, Paintings and Drawings*, McIntosh Gallery, London, Ont., 2005; *Lieye, Paintings and Drawings*, Michael Gibson Gallery, London Ont., 2003; *Moodielingo*, Michael Gibson Gallery, London, Ont., 2001; *Kim Moodie: Recent Paintings and Drawings*, London Regional Art and Historical Museum, Ont., 1999; *Kim Moodie/Recent Images*, Gallerie Christianne Chassay, Montréal, 1995; *Kim Moodie, Drawings*, Illingworth Kerr Gallery, Calgary, 1994 Selected Group Exhibitions: *Black-Eyed Stars*, Museum London, Ont., 2007; *For Example*, Mount Saint Vincent University Gallery, Halifax, 2007; *Ideas of Order*, University of Toronto Art Centre, 2006; *The writing is on the wall*, Museum London, Ont., 2006; *Other Worlds*, Jessica Bradley Art and Projects, Toronto, 2005 AWARDS Ontario Arts Council Senior Artist Grant, 2001; Ontario Arts Council Project Costs Grants, 1993, 1991, 1986, 1985, 1979; Ontario Arts Council Material Assistance Grants, 2001, 1998, 1994, 1991, 1987, 1985, 1983, 1981; Canada Council for the Arts B Grant, 1998, 1987; Design Council of Canada, an award for best design in a Canadian magazine, 1997 for *Canadian Art*, Vol. 14, No. 3, fall 1997 COLLECTIONS The University of Toronto; Agnes Etherington Art Centre; Museum London; Art Gallery of Windsor; Art Gallery of Algoma; Montréal Museum of Fine Arts; Art Gallery of Ontario; University of Waterloo; Oakville Galleries; Canada Council Art Bank; Air Canada; St. Thomas Art Gallery; McIntosh Gallery; Social Science Centre, University of Western Ontario PUBLICATIONS *Just My Imagination*, Kim Moodie and David Merritt, Exhibition Curators, Museum London and the Artlab, University of Western Ontario, London, 2006; *Kim Moodie: Recent Paintings and Drawings*, James Patten, Museum London, Ont., 1999; *Murder*, John Yau, Smart Art Press, Santa Monica, 1995; *Essence and Persuasion; The Power of Black and White*, Anne Wayson and Melissa Banta, Anderson Gallery, Martha Jackson Place, Buffalo, 1995; *A Casual Totality: Kim Moodie Drawings*, Russell Kezierre, Illingworth Kerr Gallery, Alberta College of Art, Calgary, 1994; *Thinking Through Exchanges and the Work of Artists Teaching, Practice and Pedagogy*, Carol Laing, McIntosh Gallery, University of Western Ontario, London, 1992

William Perehudoff

BIRTH DATE 1918 RESIDES Saskatoon EDUCATION Fine Arts Course, Ozenfant School of Fine Arts, New York, 1950; Fine Arts Course in Painting, Drawing, Printmaking, and Murals, Colorado Springs Fine Art Center, 1949 SELECT SOLO EXHIBITIONS *William Perehudoff*, Poussin Gallery, London, U.K., 2008; *William Perehudoff*, Canada House, London, U.K., 2006; *William Perehudoff*, Mendel Art Gallery, Saskatoon, Edmonton Art Gallery, Edmonton, Glenbow Museum, Calgary, 1993-1994; *William Perehudoff*, Meredith Long Gallery, New York, 1978 and 1980; *William Perehudoff*, Waddington-Tooth Gallery, London, U.K., 1976 SELECT GROUP EXHIBITIONS *Poussin Review*, London Art Fair and the Poussin Gallery, London, U.K., 2008; *The Shape of Colour: Excursions in Colour Field Art, 1950-2005*, Art Gallery of Ontario, Toronto, 2005; *Clement Greenberg, A Critic's Collection*, Palm Springs Desert Museum, Palm Springs, 2004; *Clement Greenberg, A Critic's Collection*, Portland Art Museum, Portland, 2001; *14 Canadians, A Critic's Choice*, Hirshhorn Museum & Sculpture Garden, Washington, 1976; *7th Biennial Exhibition of Canadian Painting*, National Gallery of Canada, Ottawa, 1968 AWARDS Honorary Degree, Doctor of Laws, University of Regina, 2003; Order of Canada, 1998; Saskatchewan Order of Merit, 1994; Citation Award, New York State Association of Architects, 1989; University of Alberta National Award in Painting, 1978 COLLECTIONS Art Gallery of Nova Scotia; Art Gallery of Ontario; Art Gallery of Windsor; Glenbow Museum; Mendel Art Gallery; Musee D'Art Contemporain de Montreal; National Gallery of Canada; National

Gallery of Malaysia; National Gallery of New Delhi; Portland Art Museum PUBLICATIONS *William Perehudoff, Paintings 1967–1997,* Ken Carpenter, Poussin Gallery, 2008; *Abstract Painting in Canada*, Roald Nasgaard, Douglas & McIntyre and The Art Gallery of Nova Scotia, 2007; *Canadian Art in the 20th Century*, Joan Murray, Simon and Pierre Publishers, 1999; *At Home in Canada*, Nicole Eaton and Hilary Weston, The Penguin Group, 1995; *William Perehudoff*, Nancy Tousley, The Mendel Art Gallery, 1993

Tony Scherman

BIRTH DATE August 13, 1950 RESIDES Toronto EDUCATION MA, Royal College of Art, London, U.K., 1974 SELECT SOLO EXHIBITIONS *About 1865*, Georgia Scherman Projects, Toronto, and Winston Wächter Fine Art, New York, 2007; *Tony Scherman*, Galerie Haas & Fuchs, Berlin, 2004; *Chasing Napoleon*, Hunter Museum of Art, Chattanooga, (touring exhibition), 1999–2002; *About 1789*, Galerie Daniel Templon, Paris, 1997 SELECT GROUP EXHIBITIONS *Drawing Conclusions*, McMichael Canadian Art Gallery, Kelinburg, Ont., 2008; *Framed: The Art of the Portrait*, Art Gallery of Hamilton, Ont., 2007; *Dancing to the Invisible Piper: Canadian Contemporary Figurative Art*, Art Gallery of Mississauga, Ont., 2006; *Du corps a l'image*, Fondation d'Art Contemporain d'Ile-de-France & Fondation Guerlain, Paris, 2004; *Bra Joe from Kilimanjaro*, University Art Museum, University of Queensland, Brisbane, 2001 PUBLICATIONS *About 1865*, Essay by Lilly Wei, Georgia Scherman Projects, Toronto & Winston Wachter Fine Art, New York, 2007; *Pensées impensables (unthinkable thoughts)*, Essay by Ihor Holubizky, Kelowna, BC: Kelowna Art Gallery, 2004; *About 1789* (catalogue with text by Jacques Henric) Galerie Daniel Templon, Paris, 1997; *Chasing Napoleon/Napoleon Devisage*, Written by Hans Belting, David Moos and Jacques Henric, edited by Sanford Kwinter and designed by Bruce Mau Design, Cameron Books, 1999; *Rape of Io*, texts by Rainer Crone and David Moos, Sable-Castelli Gallery, Toronto, and Galerie Barbara Farber, Amsterdam, 1993; *Callisto*, text by Eve Förschl (German) Published by Galerie Pfefferle, Munich, 1993; WEBSITE tonyscherman.com

Gordon Smith

BIRTH DATE 1919 RESIDES West Vancouver EDUCATION Summer Studies in Art History at Harvard University, Boston, 1957; Advanced painting courses, California School of Fine Arts, San Francisco, 1950; Vancouver School of Art, 1945; Winnipeg School of Art under L.L. Fitzgerald, 1937 SELECT SOLO EXHIBITIONS Equinox Gallery, Vancouver, 2005; *On Reflection*, Equinox Gallery, Vancouver, 2002; Equinox Gallery, Vancouver, 1997; *Gordon Smith: The Act of Painting*, Vancouver Art Gallery, Vancouver, 1997; Equinox Gallery, Vancouver, 1995; Bau-Xi Gallery, Vancouver and Toronto, 1973–94; *Gordon Smith Recent Work*, Vancouver Art Gallery, 1988; Mira Godard Gallery, Montreal, Toronto and Calgary, 1977–85; *Gordon Smith*, retrospective organized by the Vancouver Art Gallery, 1976; *Ten Years of Painting by Gordon Smith*, touring exhibition organized by University of British Columbia Fine Arts Gallery, Vancouver, 1966 SELECT GROUP EXHIBITIONS *Les Peintures*, Galerie Rene Blouin/Galerie Lilian Rodriguez, Montreal, 1999; *Vancouver Art and Artists 1931-1983*, Vancouver Art Gallery, 1983; *Aspects of Canadian Printmaking*, group exhibition organized by Mira Godard Gallery, Toronto, 1979; *13 Artists from Marlborough Godard*, Marlborough Gallery, New York, 1974; *3rd Biennial of Modern Prints*, Santiago, Chile, 1968; *Ten West Coast Painters*, Stratford Festival, Stratford, Ont., 1960; *7 West Coast Painters*, University of British Columbia Fine Arts Gallery, Vancouver, 1959; *Guggenheim International Exhibition*, Guggenheim Museum, New York, 1957; *Canadian Biennial*, Ottawa, 1955 and successive biennials until 1967 AWARDS Order of British Columbia, 2000; Order of Canada, 1996; Art Leadership Award, Art Fair Seattle, 1993; Professor Emeritus, University of British Columbia, 1981; Allied Arts Medal, Royal Canadian Architectural Institute, 1974; First Prize, Biennial of Canadian Art, 1955; L.L.D., Simon Fraser University, 1973 PUBLICATIONS *Art BC: Masterworks From British Columbia*, Ian M. Thom, Douglas & McIntyre, Vancouver, 2000; *Gordon Smith: The Act of Painting*, Ian M. Thom and Andrew Hunter, Douglas & McIntyre, 1997 WEBSITE equinoxgallery.com

Michael Smith

BIRTH DATE 1951 RESIDES Montreal EDUCATION MFA Concordia University, Montreal, 1983; BFA (Hons.), St. Albans College of Art, Hertfordshire, U.K., 1971 SELECT SOLO EXHIBITIONS *Recent Works*, Nicholas Metivier Gallery, Toronto, Ontario, 2008; *Cradle of Words*, TrepanierBaer Gallery, Calgary, 2007; *Mass & Dissolution*, Galerie de Bellefeuille, Montreal, 2006; *Returning Skies*, Michael Gibson Gallery, London, Ont., 2006; *Wresting Vision*, TrepanierBaer Gallery, Calgary, 2006; *Wresting Vision, Earth & Air*, McClure Gallery, Montreal, 2006; *Light & Matter*, Nicholas Metivier Gallery, Toronto, 2005; *Recent Works*, Studio 21, Halifax, 2005 SELECT GROUP EXHIBITIONS *Selections from The Collection*, The Appleton Museum of Art, Ocala, Fla., 2006; Studio 21, Montreal Connection, Halifax 2005; Nicholas Metivier Gallery, Inaugural Exhibition, Toronto, 2004; *Line of Trees, Burning* (Gallery 1) Art Gallery of Nova Scotia, Halifax, 2003; *Works From The Collection*, The Appleton Museum of Art, Ocala, Fla., 2002; *The Single Tree*, London Regional Art Museum, London, Ont., 2000 AWARDS Conseil des arts et des lettres, Grant A, 2002; The Canada Council for the Arts, Arts Grant A, 2001; The Canada Council for the Arts, Arts Grant A, 2000; Conseil des arts et des lettres du Quebec, Short-term grant, 1995 PUBLICATIONS *Mass & Dissolution*, Isa Tousignant, Galerie de Bellefeuille, Montreal, 2006; *Returning Skies*, Brian Meehan, Michael Gibson Gallery, London, Ont., 2006; *Broken Ground: The Tangled Garden of Michael Smith*, Jeffrey Spalding, Galerie de Bellefeuille, Montreal, 2001; *The Single Tree*, Laura Millard, London Regional Art Gallery, Ont., 2000; *True North: The Landscape Tradition in Contemporary Canadian Art*, The Kaohsiung Museum of Fine Arts, Kaohsiung, Taiwan, 1999 WEBSITE trepanierbaer.com; metiviergallery.com; debellefeuille.com

Gary Spearin

BIRTH DATE October 15, 1958 RESIDES Forest, Ont. EDUCATION MFA, University of Guelph, 1997; BFA, Nova Scotia College of Art and Design, 1981 SELECT SOLO EXHIBITIONS *The Long Weekend*, Domestic Interior Gallery, London, 2008; *Name Paintings*, Edward Day Gallery, Toronto, 2005; *Opensignal*, Spin Gallery, Toronto, 2005; *Name Paintings*, Medicine Hat Museum and Art Gallery, Medicine Hat, Alta., 2004; *Name Paintings*, Kelowna Art Gallery, Kelowna, B.C., 2004; *Rred*, Galerie Glendon, Toronto, 2001; *The End The End*, Red Head Gallery, Toronto, 1997; *Living on Credit*, Art Gallery of Peel, Brampton, Ont., 1992; *Reverse Order*, Art Gallery of Hamilton, Ont., 1988; *Found and Lost*, Eye Level Gallery, Halifax, 1984 SELECT GROUP EXHIBITIONS *Recent Acquisitions*, Kelowna Art Gallery, Kelowna, B.C., 2004; *Synthetic Psychosis*, MOCCA, Toronto 2002; *Small Works Exhibition*, Pure Gallery, Taos, N.M., 2001; *Tempus Fugit*, Robert McLaughlin Gallery, Oshawa, Ont., 2000; *Re-Grouping*, McMichael Art Gallery, Kleinburg, Ont., 1996; *Shave '95*, Shave Farm, Somerset, U.K., 1995; *Volumes*, Red Head Gallery, Toronto 1991; *Art in the Environment*, Canada Centre For Inland Waters, Hamilton, Ont., 1990; *Variety*, Memorial Art Gallery, Cornerbrook, Nfld., 1985; *Non-Commodity Exhibition*, Castlegar, B.C., 1982 AWARDS B Grant, Canada Council for the Arts, 1983, 1984, 1995; Project Grant, Canada Council for the Arts, 1986, 1987, 1988; Explorations Grant, Canada Council for the Arts, 1984; Travel Grant-Germany, Canada Council for the Arts, 1987; Mid-Career Grant, Ontario Arts Council, 2001; Project Grant, Ontario Arts Council, 1992; Exhibition Assistance, Ontario Arts Council, 1987, 1988, 1991, 1992, 1994, 1995, 1998, 2003 COLLECTIONS Art Gallery of Nova Scotia; Kelowna Art Gallery; Osler, Hoskin, & Harcourt; Aber Diamond Company; Robert McLaughlin Gallery PUBLICATIONS *Name Paintings, A Play on Name*, Ihor Holubizky, Robert McLaughlin Gallery, Medicine Hat Museum and Art Gallery, Kelowna Art Gallery, 2003; *ART e NIM*, Foire Inernationale D'Art Contemporain, France, 2003; *Tempus Fugit*, Linda Jansma and Ihor Holubizky, Robert McLaughlin Gallery, 2000; *Synthetic Psychosis*, David Liss, MOCCA, *Redrospective*, Red Head Gallery, Sandra Rechico and Carol Laing, 2000; *Southwest Triennial*, Robin Metcalfe, Art Gallery of Windsor, 1997; *Spillage*, Ihor Holubizky, Red Head Gallery, 1996; *Re-Grouping*, McMichael Art Gallery, 1996; *SHAVE '95*, Somerset, U.K., 1995; *Unspeakable*, Nancy Campbell, MacDonald Stewart Art Centre, 1992; *Southwest Biennial*, Diana Nemiroff, Art Gallery of Windsor, 1991; *Reading the Water*, Burlington Art Centre, 1991; *Art in the Environment*, Canada Centre for Inland Waters, 1990; *Reverse Order*, Kim Ness, Art Gallery of Hamilton, 1987 WEBSITE garyspearin.ca

Jessica Stockholder

Born: 1959 RESIDES New Haven, Conn. EDUCATION MFA, Yale University, 1985; BFA, University of Victoria, 1982 SELECT SOLO EXHIBITIONS *Jessica Stockholder,* Mitchell-Innes & Nash, New York, 2006; *Jessica Stockholder Kissing the Wall: Works, 1988-2003,* Weatherspoon Art Museum, Greensboro, N.C., 2005; *Rawhide Harangue of Aching Indices As Told By Light,* School of the Museum of Fine Arts, Boston, 2005; *Sam Ran Over Sand or Sand Ran Over Sam,* Rice University Art Gallery, Houston, 2004; *First Cousin Once Removed or Cinema of Brushing Skin,* The Power Plant, Toronto, 1999 SELECT GROUP EXHIBITIONS *Paragons: New Abstraction from the Albright-Knox Gallery,* Buffalo and Doris McCarthy Gallery, Toronto; 2008 *Like Color in Pictures,* Aspen Art Museum, Colorado, 2007; *Whitney Biennial*, Whitney Museum of American Art, New York, 2004; Site Santa Fe, *Beau Monde: Toward a Redeemed Cosmopolitanism,* curated by Dave Hickey, installation: *Bird Watching,* NM, 2001; *Young Americans 2,* Saatchi Gallery, London, UK, 1998 AWARDS Lucelia Artist Award, Smithsonian American Art Museum, 2007; *Association Internationale des Critiques d'art,* New England Chapter, First Place Award for the Best Installation or Single Work of Art in a Boston Museum, 2007; August Seeling Preis, Freundeskreis Wilhelm Lehmbruck Museum e.V., Duisburg, Germany, 2001; John Solomon Guggenheim Fellowship Award, Visual Art, 1996; New York Foundation for the Arts Grant in Painting, 1989; National Endowment for the Arts Grant in Sculpture, 1988

Richard Storms

BIRTH DATE November 3, 1954 RESIDES Toronto EDUCATION MFA, York University, Toronto, 1983; BFA, University of Regina, 1981 SELECT SOLO EXHIBITIONS *New Works,* Birch Libralato Gallery, Toronto, 2007; *dogs, birds, a goose ... New Works by Richard Storms,* Birch Libralato Gallery, Toronto, 2006; *flatland: mappaintings 1992 to 1996,* 360, The Restaurant at the CN Tower, Toronto, 1998; *Points of Interest,* Kamloops Art Gallery, B.C., travelling exhibition including the Art Gallery of Hamilton and the Art Gallery of Windsor, 1995 SELECT GROUP EXHIBITIONS *Berlin/Toronto Gallery Exchange,* Gallerie Andreas Koch, Berlin, Germany, 2005; *Big Show,* Toronto, 2005; *The Tourist,* Art Gallery of Peel, Brampton, Ont., 1995; *What's Required: Natalie Olanick & Richard Storms,* Mercer Union, Toronto, 1995; *Mud,* Toronto, 1994 AWARDS Project Grant, Canada Council for the Arts, 1986, 1987, 1990, 1993, 1995; Project Grant, Ontario Arts Council, 1985, 1987, 1989, 1991, 2006; Project Grant, Toronto Arts Council, 2001

David Thauberger

BIRTH DATE 1948 RESIDES Regina EDUCATION MFA, University of Montana, 1973; MA, California State University, 1972; BFA, University of Saskatchewan, 1971 SELECT SOLO EXHIBITIONS *Land's End... and Other Prospects,* Nouveau Gallery, Regina, 2006; *David Thauberger and the Art of the Genuine Simulation—Moose Jaw Pictures,* Moose Jaw Art Museum, Moose Jaw, 2002; *David Thauberger Paintings: 1978-1988,* Mackenzie Gallery, Regina, 1988; *David Thauberger,* Canada House, London, U.K., 1985; *David Thauberger,* 49th Parallel Centre for Canadian Art, New York, 1981; *David Thauberger,* Glenbow Museum, Calgary, 1980 SELECT GROUP EXHIBITIONS *Regina Clay: Worlds in the Making,* Mackenzie Art Gallery, Regina, 2006; *Soup to Nuts: Pop Art and its Legacy,* University of Lethbridge Art Gallery, Alta., 1998; *Reflecting Paradise,* Expo '93, Taejon, Korea, 1993; *True North/Far West,* University of the Pacific Gallery, Stockton, Cal., 1987; *Pluraties 1980,* National Gallery of Canada, Ottawa AWARDS 1992, 1981 Canada Post, postage stamp design, Canada Day, 1992, 1981; Via Rail, Park Car, Mural Lounge, 1988; Sask. Expo '86, exterior mural design, Sask. Expo Pavilion, Vancouver, 1986 PUBLICATIONS: *Canadian Paintings, Prints & Drawings from the 18th to the 21st Century,* A. Newlands, Firefly Books, Ltd., 2007; *Beyond Wilderness: The Group of 7, Canadian Identity and Contemporary Art,* J. O'Brian and P. White, McGill-Queen's, 2007; *In the Wilds—Canoeing and Canadian Art,* L. Wylie, McMichael Canadian Art Collection, 1998; *David Thauberger Paintings: 1978-1988,* P. White and N. Tousley, Mackenzie Art Gallery, 1988; *Contemporary Canadian Art,* D. Burnett and M. Schiff, Hurtig Publishers, 1983

David Urban

BIRTH DATE 1966 RESIDES Toronto EDUCATION MFA, University of Guelph, Ont.; MA, University of Windsor, Ont.; BA, BFA Visual Arts, York University, Toronto SELECT SOLO EXHIBITIONS *Actual Fiction,* Corkin Gallery, Toronto, 2007; *Present Tense,* Art Gallery of Ontario, Toronto, 2002; *Transport to Summer,* Sable-Castelli Gallery, Toronto, 2000; *Farewell to an Idea,* Sable-Castelli Gallery, Toronto, 1996; *Reform School,* Galerie Barbara Farber, Amsterdam, 1994 SELECT GROUP EXHIBITIONS *Painters 15,* MOCCA, Toronto, 2003; *Recent Acquisitions,* Birmingham Museum of Art, Birmingham, Ala., 2002; *Abstraction,* Appleton Art Museum, Ocala, Fla., 2002; *Painters 15,* Shanghai Art Museum, Shanghai, 2002; *Group Show,* Galerie Barbara Farber, Amsterdam, 1997 AWARDS Royal Canadian Academy of Art, 2003; Canada Council for the Arts, B Grant, 1995; Ontario Arts Council Exhibition Grant, Toronto, 1993; Graduate Fellowship, University of Guelph, 1993; Ontario Graduate Scholarship, University of Guelph, 1993; Ontario Graduate Scholarship, University of Windsor, 1991 PUBLICATIONS *The Constructor: David Urban,* James D. Campbell, David Moos, Michael Gibson Gallery, 2005 WEBSITE corkingallery.com

Tony Urquhart

BIRTH DATE April 9, 1934 RESIDES Stratford EDUCATION Diploma, Albright Art School, Buffalo, 1956; Yale University summer school, 1955 SELECT SOLO EXHIBITIONS *Power of Invention: Drawings From Seven Decades by Tony Urquhart* (touring retrospective, Museum London, London, Ont.; Art Gallery of Newfoundland and Labrador, St. John's; Kitchener/Waterloo Art Gallery, Kitchener; and The National Gallery of Canada, Ottawa), 2002-2003; *Dialogues of Reconciliation: The Imagination of Tony Urquhart* (touring exhibition, Meridian Gallery, San Francisco; Art Gallery, University of California, Santa Cruz; Art Gallery of the San Antonio, San Antonio; Art Institute, San Antonio; Art Gallery of Peterborough, Ont.), 1991-1993; *Worlds Apart: The Symbolic Landscapes of Tony Urquhart* (touring retrospective, London Regional Art and Historical Museum, London, Ont.; Art Gallery of Windsor, Ont.; Art Gallery of Hamilton, Ont.; Art Gallery of Kingston, Ont.; Art Gallery of Regina), 1988-1989; *25 Years: Tony Urquhart* (touring retrospective-11 venues), 1971; Walker Art Centre, Minneapolis, 1960 SELECT GROUP EXHIBITIONS *Transforming Chronologies: An Atlas of Drawings,* The Museum of Modern Art, New York, 2006; *Crisis of Abstraction,* National Gallery of Canada, Ottawa, 1992; *La Boite,* Musee d'Art Modern De La Ville De Paris, Paris, 1976; *The Guggenheim International,* Guggenheim Museum, New York, 1958; *The Pittsburgh International Exhibition of Contemporary Paintings and Sculpture,* Carnegie Institute, Pittsburgh, 1958 AWARDS Member of the Order of Canada, 1995; Canada Council for the Arts, Senior Grant, 1979; Canada Council for the Arts, B Grant, 1963; Purchase Prize, The American Academy of Arts and Letters, New York, 1960; Guggenheim International, Canada awarded a prize for the best balanced section of five paintings (Gagnon, Riopelle, Shadbolt, Coughtry, Urquhart), 1958 COLLECTIONS National Gallery of Canada; Museum of Modern Art; Hirshhorn Museum; Art Gallery of Ontario; Museo Civico, Lugano, Switzerland; Victoria and Albert Museum; Walker Art Center; Vancouver Art Gallery; Winnipeg Art Gallery; Montreal Museum of Fine Arts PUBLICATIONS *Tony Urquhart: The Revenants-Long Shadows,* Joyce Zemens, University of Waterloo Art Gallery, 2002; *Power of Invention: Drawings in Seven Decades by Tony Urquhart,* by Terrence Heath, Museum London, 2002; *Warbrain,* poems by Stuart Mackinnon, drawings by Tony Urquhart, Penumbra Press, 1994; *Cells of Ourselves, Gary Michael Dault on his choice of 50 drawings by Tony Urquhart,* Gary Michael Dault, The Porcupine's Quill Press, 1989; *Reunion 1972,* Museum London, foreword by Michael Ondaatje; Worlds Apart: *The Symbolic Landscapes of Tony Urquhart,* Dr. Joan Vastokas, Art Gallery of Windsor, 1988; *In Search of Leonardo,* Matt Cohen, illustrations by Tony Urquhart, Coach House Press, 1985; *I Am Walking in the Garden of His Imaginary Palace,* eleven poems for Le Notre by Jane Urquhart, drawings by Tony Urquhart, AYA press, 1982; *The Broken Ark: A Book of Beasts,* Michael Ondaatje, 30 animal drawings, Oberon Press, 1969

Peter von Tiesenhausen

BIRTH DATE 1959 RESIDES Demmitt, Alta. EDUCATION Alberta College of Art, Major in Painting, Calgary, 1981 SELECT SOLO EXHIBITIONS *kleiner Mord*, Clint Roenisch Gallery, Toronto, 2007; *Blind Faith*, Mendel Art Gallery, Saskatoon, 2004; *Mecca*, Illingworth Kerr Gallery, Calgary, 2003; *Heaven/Hell*, MOCCA, Toronto, 2000; *Lebensläufe*, Kelowna Art Gallery, Kelowna, B.C., 1998 SELECT GROUP EXHIBITIONS *Mapping the Self*, (collaborative work with Sarah Alford), Museum of Contemporary Art Chicago, 2008; *Within a Budding Grove*, Clint Roenisch Gallery, Toronto, 2006; *The River*, (with Mario Reis), TrepanierBaer, Calgary, 2005; *There and Gone*, Galleria Klimy, Warsaw, Poland, 2005; *Hydrogen Song*, (with John Scott), Kitchener/Waterloo Art Gallery, Kitchener, Ont., 2000 AWARDS Project Grant, Alberta Foundation for the Arts, 2005; Alumni Award For Excellence, Alberta College of Art and Design, 2002; Established Artist Production Grant, Canada Council for the Arts, 2000; Project Grant, Alberta Foundation for the Arts, 1999 COLLECTIONS Osler, Hoskins & Harcourt; Edmonton Art Gallery; Carleton University Art Gallery; University of Toronto; Maclaren Art Centre; TD Bank; Tom Thomson Memorial Art Gallery; Royal Trust; Whyte Museum of the Canadian Rockies; Kelowna Art Gallery PUBLICATIONS *Reckonings*, John Bentley Mays, Michael Gibson Gallery, 2007; *Requiem*, George Harris, Two Rivers Art Gallery, Prince George, B.C., 2005; *Mecca*, Katherine Ylitalo, Illingworth Kerr Gallery, Calgary, 2004; *Deluge*, David Garneau, Southern Alberta Art Gallery, Lethbridge, 2001; *Lebensläufe*, Clint Roenisch, Kelowna Art Gallery, 1998

Carol Wainio

BIRTH DATE June 29, 1955 RESIDES Ottawa EDUCATION MFA, Concordia University, Montreal, 1985 SELECT SOLO EXHIBITIONS Wynick/Tuck Gallery, Toronto, 2007; Galerie René Blouin, Montréal (November 2006-January 2007); Wynick/Tuck Gallery, Toronto, 2004; Anna Leonowens Gallery, Halifax, 2003; Carleton University Art Gallery, Ottawa, 2003; *Days Arrayed*, Wynick/Tuck Gallery, Toronto, 2002; TrépanierBaer Gallery, Calgary, 2001 SELECT GROUP EXHIBITIONS *Build-Up*, Ottawa Art Gallery, 2008; *New Acquisitions*, Karsh-Masson Gallery, City of Ottawa Fine Arts Collection, 2006; Wynick/Tuck Gallery, Toronto, 2006; *Painters 15*, MOCCA, Toronto, 2003; *Painters 15*, Shanghai Art Museum, 2002; TrépanierBaer Gallery, Calgary, 2002 AWARDS Long-Term Grant, Canada Council for the Arts, 2008; Canada Council for the Arts, A Grant, 2004, 2003, 1998, 1993; Canada Council for the Arts, B Grant, 1992, 1985; Arts Grant, Ontario Arts Council, 2006, 2004, 2002, 2000, 1998, 1995, 1993, 1992, 1991 PUBLICATIONS *Carol Wainio: Les Registres du contemporain/Contemporary Registers*, Michèle Thériault, Musée d'art de Joliette, 2000; *Persistent Images*, York University, 1998; *Carol Wainio*, Serge Bérard, Contemporary Art Gallery, Vancouver, 1991; *Songs of Experience*, Diana Nemiroff and Jessica Bradley, National Gallery of Canada, Ottawa, 1986

Douglas Walker

BIRTH DATE 1958 RESIDES Toronto EDUCATION Ontario College of Art, Toronto, 1982 SELECT SOLO EXHIBITIONS *New Paintings*, Jennifer Kostuik Gallery, Vancouver, 2007; *Paintings*, Birch/Libralato, Toronto, Ontario, 2006; *Paintings*, Jennifer Kostuik Gallery, Vancouver, 2005; *The Roman Ending*, Kitchener-Waterloo Art Gallery, Kitchener, 2001; *Large Studies on Paper*, MOCCA, Toronto, 2001; *Pictures*, Tableau Vivant, Toronto, 1998; *Douglas Walker—A Future in Ruins*, Mendel Art Gallery, Saskatoon, 1992-1994; *Vitrines*, S.L. Simpson Gallery, Toronto, 1989; *Photography*, S.L. Simpson Gallery, Toronto, 1987; *Photodrawings*, S.L. Simpson Gallery, Toronto, 1986; *Douglas Walker*, YYZ, Toronto, 1985 SELECT GROUP EXHIBITIONS *The Light Fantastic*, Nicholas Metivier Gallery, Toronto, 2007; *Science Fictions*, Art Gallery of Nova Scotia, Halifax, 2000; *Rococo Tattoo: The Ornamental Impulse in Toronto Art*, The Power Plant, Toronto, 1997; *Urban Inscriptions*, The London Regional Art Gallery, London, 1992; *Perspective 90: Lee Dickson, Douglas Walker*, Art Gallery of Ontario, Toronto, 1990; *London Life Young Contemporaries*, London Regional Art Gallery, London, 1988; *Cultural Participation*, 77 Wooster Street, New York, 1988; *Brian Boigon, Douglas Walker, Speed, Neutralization, and the Spectacle of Sleep*, 49th Parallel, New York, 1988; *Comic Iconoclasm*, I.C.A., London, U.K., 1987 PUBLICATIONS *Perspective 90*, Michèle Thériault, Art Gallery of Ontario, 1990; *Urban Inscriptions*,

Michèle Thériault, Art Gallery of Ontario, 1991; *Douglas Walker, A Future in Ruins*, Bruce Grenville, Mendel Art Gallery, 1992; *Track Records: Trains and Contemporary Photography*, Marnie Fleming, Oakville Galleries, 1997 WEBSITE douglaswalker.ca

Shirley Wiitasalo

BIRTH DATE 1949 RESIDES Toronto SELECT SOLO EXHIBITIONS Susan Hobbs Gallery, Toronto, 2006; Galerie René Blouin, Montréal, 2005; Susan Hobbs Gallery, Toronto, 2004; The Power Plant, Toronto, 2000; Susan Hobbs Gallery, Toronto, 1999; Susan Hobbs Gallery, Toronto, 1997; Susan Hobbs Gallery, Toronto, 1995; Susan Hobbs Gallery, Toronto, 1994; Kunsthalle, Bern, Switzerland, 1993; Galerie Paul Andriesse, Amsterdam, 1993 SELECT GROUP EXHIBITIONS *Pulse: Film and Painting After the Image*, Mount Saint Vincent University Art Gallery, Halifax, 2006; *News from Nowhere*, Susan Hobbs Gallery, Toronto, 2005; *Dreamland*, Edmonton Art Gallery, 2001; *Les peintures*, Galerie René Blouin, Montréal, 1999; *Moira Dryer and Shirley Wiitasalo*, GreeneNaftali Gallery, New York, 1998; *René Daniëls/Shirley Wiitasalo*, Museum Haus Lange, Krefeld, Germany, 1994; *René Daniëls/Shirley Wiitasalo*, Art Gallery of York University, Toronto; Illingworth Kerr Gallery/Alberta College of Art, Calgary AWARDS Gershon Iskowitz Award, Toronto, 1998; Toronto Arts Award, Toronto 1993

CONCEPT
MaryAnn Camilleri

JURORS OF THIS COMPENDIUM
Clint Roenisch, Clint Roenisch Gallery
Robin Young, Art Patron
Robin T. Anthony, Art Curator, Royal Bank of Canada
Donald Brackett, Toronto-based Art Critic & Curator
Mark Buck, Canadian Art, Sotheby's (Canada) Inc.
Josette Lamoureaux, Assistant Director, Canadian Art, Ritchies Auctioneers
Brian Pel, Chair, Art Committee, McCarthy Tetrault LLP

EDITOR
Doug Wallace

ASSOCIATE EDITORS
Michaela Cornell
Craig D'Arville

ADVISORS
Clint Roenisch
John Nobrega

PHOTO EDITORS
MaryAnn Camilleri
John Nobrega
Clint Roenisch

DESIGN
The Office of Gilbert Li

PREPRESS
Clarity

PRINTING
1010 Printing International (China)

EXHIBITION CURATORS
Clint Roenisch, Clint Roenisch Gallery
David Liss, Artistic Director, Museum of Contemporary Canadian Art

THE MAGENTA FOUNDATION BOARD OF DIRECTORS
Doug Wallace
Clare Jordan
Craig D'Arville
Gayle Mathews

IN SPONSORSHIP WITH

Magenta would like to thank the Museum of Contemporary Canadian Art for
organizing the accompanying exhibition, November 15 to December 28, 2008.

museum of
contemporary
canadian art

SPECIAL THANKS TO
Clint Roenisch for his invaluable contribution to this book;
Scott Mullin, Alan Convery and Aaron Milrad for championing Magenta;
Michael Gaughan, Mark Fritzler and Paul Jerinkitsch of Clarity for their
superb colour work;
Chris Thomaidis for generously donating his services;
and the Canadian arts community, its artists and the participating galleries
for their support.

First Edition 2008
Published by The Magenta Foundation

The Magenta Foundation
151 Winchester Street
Toronto, Ontario, Canada, M4X 1B5
magentafoundation.org

Library and Archives Canada Cataloguing in Publication

 Carte blanche. Volume 2, Painting / Jane Urquhart, foreword ;
Clint Roenisch, essay.

Includes index.
Introduction in English and French.
ISBN 978-0-9739739-5-2

1. Painting, Canadian—21st century. 2. Painters—Canada—Biography.
I. Roenisch, Clint, 1968– II. Magenta Foundation

ND248.C37 2008 759.11 C2008-905711-2

Distributed in North America by
Consortium Book Sales and Distribution
cbsd.com